MW00572871

PROF BLOOD
AND THE WONDER TEAMS

The True Story of Basketball's First Great Coach

BY
DR. CHARLES "CHIC" HESS

This book is a publication of
Newark Abbey Press
Newark Abbey
528 Martin Luther King Boulevard
Newark, NJ 07102-1314

Library of Congress Control Number: 2003094286

ISBN 0-9664459-4-5 (Casebound)
 0-9664459-5-3 (Perfect bound)

Edited by Linda H. Hess

Designed by Christine Hess

Printed in the United States of America by BookMasters, Inc.,
Mansfield, Ohio.

Telephone orders 800-247-6553
Fax orders 419-281-6883
Orders by e-mail order@bookmasters.com

Acknowledgements

My sixteen-year journey researching and gathering information for *Prof Blood and the Wonder Teams: The True Story of Basketball's First Great Coach* afforded me the opportunity to meet a number of people who were thrilled to contribute to Ernest A. Blood's biography. In the process, they provided me with fond memories, good company and, on occasion, a place to stay and a warm meal. Many thanks to the following people whose assistance enabled me to put Prof Blood's life to print.

Present and former Passaic School District personnel:
Dr. Manlio Boverini, Larry Cirignano, Jack DeYoung, Lawrence Everett, David W. McLean, Karen Tomczyk, Samuel Z. Levine (PHS Class of 1929), and Erika Whilfford.

Sportswriters who provided valuable assistance:
Greg Gay, *Watertown Daily Times*; Larry Hart, *The Gazette Newspaper,* Schenectady, New York; Mike Kenney, *Newark Star Ledger*; Bob Burkard, *Bergen County Record*; Harvey Zucker, *Jersey Journal*.

Relatives of Members of the Wonder Teams:
Priscilla M. Saxer, daughter of Robert Saxer; Dick Knothe, son of Fritz Knothe; Garret G. Roosma, son of John Roosma; Ernest Ben Blood, second son of Prof Ernest A. Blood; Ernest Ben Blood, Jr. (and his wife Peggy), grandson of Prof Ernest A. Blood; Arlene and Donna Mickolajczyk, granddaughter and great-granddaughter of Prof Ernest A. Blood; Edythe Rohrbach, wife of Nelson Rohrbach, a Wonder Team player; Mary Jarmolowicz, wife of Chester Jarmolowicz, a Wonder Team player; Robert Thompson, Jr., son of Wonder Team player "Thousand Point" Bobby Thompson; and William C. Troast, son of William Troast.

Thanks to the individuals from countless high schools, universities, and public institutions for their assistance and contributions.

From New Jersey: A special thanks to Jean Ellis from the Julius Forstmann Passaic Public Library who, on innumerable occasions, assisted in the gathering of information for this biography.

Stephanie Bartz, Archibald Stevens Alexander Library at Rutgers University; Leslie Blatt, Orange High School Librarian; Sandra Carr, Hackensack High School Librarian; Doreen Carsetto, Montclair High School Librarian; Nydia Cruz, S. C. Williams Library at the Stevens Institute of Technology; Mary Kate Cullinan, Rutherford Public Library; Fr. Augustine J. Curley, O.S.B., St. Benedict's Prep Librarian and Archivist; Cindy Czesak, formerly of the Clifton Library; Bob Duxbury, Clifton Public Library; Jennifer Druce, Camden Country Library; Eleanor Harvey, Englewood Historical Society; Mimi Hui, Hasbrouck Heights Public Library; Sherri Kendrick, Cliffside Park Free Public Library; Dr. David Martin, The Peddie School Archive; James Stuart Osbourn, Newark Public Library; Korin Rosenkrans, Joint Free Public Library of Morristown and Morris Township; Patricia Sanders, Sprague Library in Montclair; Edward Skipworth, Rutgers University Library; Charles Webster, Trenton Public Library Historian; Jay W. Wolf, Englewood Public Library.

From Around the Country: Gerald F. Davis, Babson Library, Springfield, Massachusetts; David Carmichael, YMCA Archivist, St. Paul, Minnesota; Marynelle Chew, Joseph F. Smith Library, Brigham Young University-Hawaii; Thomas Churna, Kaneohe Public Library, Kaneohe, Hawaii; James H. Gano, Reading High School, Reading, Pennsylvania; Nancy Gentile, Robbins Library, Arlington, Massachusetts; Sylvia Hag, Clarkson University Library; John Heisler, Sports Information Office, University of Notre Dame; Kristen Hewitt, Franklin Branch of the Johnson County Public Library, Franklin, Indiana; Edward F. Holden, New Hampshire State Library; Nikki Kimbough, Syracuse University; Patty Lynn, University of Pennsylvania Library; Jayne Miller, Salem High School, Massachusetts; Krista L. Ovist, University of Chicago Library; Debra Pogue, United States Military Academy; Jane M. Subramanian, F. W. Crumb Library at SUNY at Potsdam; Margie T. Sullivan, Cambridge Ringe and Latin School, Massachusetts; Kristy Wood, SUNY at Potsdam.

Others who contributed insight or information to the text:
John Allen; Lit Atiyeh; Mark Auerbach; Peter Carlessimo; Al Cito; Edwin "Rip" Collins; Jack Dalton; Leon Edel, author of *Writing Lives* and *Telling Lives;* Paul F. Fanelli; Jack Feelan; Regina Fiscor; Fr. Jerome Fitzpatrick; Paul E. Gagnon; George Greenfield, Jr.; Tom Hardford; Martha Jacot Koen; Dennis A. Joyce, author of *Joe K: a Biography of Joe Kasberger*; Peter W. Radice, President of the Trenton High School Alumni Association; Dan Ryan; Douglas Stark; William Shapiro, Frank Sisson, Jr.; Seymour Zucker; Bernard "Beans" Lieberman; Al Malekoff; Raymond Van Handle; and Don Veleber-Waldrick.

A special thanks to Dr. Ruel Barker for introducing me to the pioneers in my profession. Without his enthusiasm and encouragement, this work may never have been started.

Most importantly, I want to thank my family, Linda, Christine, Rebecca, and Stephen, for their support and encouragement and for putting up with my Prof Blood "obsession." Without the patience and proof-reading efforts of my wife, Linda, and the technical support of my #1 daughter, Christine, this contribution to the history of basketball would never have been possible.

Charles "Chic" Hess

Table of Contents

FOREWORD
BY P. J. CARLESIMO

Numbers never tell you enough about a coach, but the incredible success enjoyed by Professor Ernest Blood's teams of Passaic High School will certainly catch your attention. My father, Pete Carlesimo, happened to attend St. Benedict's Preparatory School in Newark, New Jersey, back in the mid 1930's when Prof Blood was on the faculty. As a result, even though we grew up in Scranton, Pennsylvania, a few hours away from Passaic, New Jersey, where the Wonder Teams put up those incredible numbers, my brothers and I were often entertained by stories, most probably true, of a truly amazing teacher. Ernest Blood was much more than a coach, much more than a teacher, much more than any single word could ever hope to capture. To live and work coaching basketball in the metropolitan New York-New Jersey area for almost twenty-five years from the late 60's to early 90's whetted my appetite even more for information and insight into this Jersey legend. Finally, so many years later, Chic Hess provides us a fitting, comprehensive, and long overdue look at this unique individual.

A successful coach in his own right, Chic has brought an uncommon dedication to his task on this meticulously researched work. He took the time to detail many of the obstacles that Prof Blood confronted, not only on the basketball floor, but unfortunately, as can be the case, also off the floor as well.

There will be many parallels evident to anyone who has ever coached, no matter what the level, that reading about Prof Blood's adventures will certainly call to mind.

I've long believed that the purest form of teaching basketball is done at the high school level. The skills of the players are developed enough to be able to perform at a reasonably skilled level, yet the players are not so set in their habits to hinder them from learning the correct fundamentals and new skills. So many of us who have been privileged to coach or play our great game were profoundly influenced by a coach or coaches from our high school years. In addition, so many of the great high school coaches were content to remain at that level, inspiring a tradition of young players growing up, aspiring to play for these active coaching legends. To

a degree, their influence has been reduced by the emergence of the non-school basketball programs.

Fortunately, for me, growing up in Scranton, Pennsylvania, I had the opportunity to play for a coach of that stature, Jack Gallagher at Scranton Preparatory. Hopefully, there are still many young players who enjoy the opportunity to play for a Prof Blood; a Jack Gallagher; a Morgan Wooten from Dematha High School in Hyattsville, Maryland; a Jack Curran from Archbishop Molloy High School in New York City; a Bob Hurley of St. Anthony's High School in Jersey City, New Jersey; teachers of such excellence that they continue to set a standard for other coaches to aspire to.

Prof Blood was one of the first of this special breed. One of the many interesting revelations in Chic Hess's book is how often the success of his Passaic teams foreshadowed some trends still recurring in the modern-day game. For instance, how many school administrators, athletic directors, owners or general managers have cried for a coach whose fast-paced offensive style could inspire rabid fan support and put "people in the seats"? How many of today's players cry for a fast breaking, pressing style of play that allows them to put constant pressure on their opponents? It's easy to understand how the Passaic Wonder Teams captured the imagination of the entire basketball public. Even all these years later, it is almost impossible to comprehend such an unparalleled level of excellence.

As is often the case with the finest coaches, their teaching was not limited to the gym or basketball floor. You cannot maintain this level of success without an appreciation for hard work and discipline, an under-standing of sportsmanship and competitive ethics, and the ability to transmit these traits to your players. I remember my father, who was both a student at St. Benedict's Prep and, subsequently, returned as a football coach, telling of Prof Blood and his cool demeanor, the respect he commanded from his players and students, and that rare knack to be able to teach and motivate and organize and truly communicate with these students. A coach can experience a degree of success, even over a period of time, but when you can repeat this success consistently with different individuals playing for you and when you can duplicate this success at more than one institution, then you are separating yourself from even the most outstanding in your profession. This is exactly what Prof Blood was able to do.

There are always obstacles, or perceived obstacles, that can make a coach's job more challenging. These obstacles existed for Prof Blood and they exist for anyone coaching today. Some of us have enjoyed fantastic support from our administrators, our school boards, our fellow faculty members, and some of us have not. Parents can be our most

effective supporters or our most divisive opponents, intentionally or not. The politics of educational institutions on any level are no less ugly than those we read about every day in our local, state, and national governments. Dealing with these obstacles, unfortunately, is a critical element of successful coaching. Prof Blood charted an interesting blueprint for us to learn from and follow.

Yet, somehow, this great teacher has not received suitable recognition for all that he accomplished. It would probably not be a recognition that he would seek, but it is surely one he deserves.

Coaches both young and old at any level will enjoy learning of the exploits of one of our earliest legends. It is sad that it has taken so long for someone to undertake the research and to have the perseverance that Chic Hess has shown in bringing this work to print. So much of the information in Prof Blood's biography was little known until now. The author has not only done Professor Ernest Blood a fine service, he has told a story that basketball people needed to know. *Prof Blood and the Wonder Teams: The True Story of Basketball's First Great Coach* says it very well.

PREFACE

The Passaic High School "Wonder Teams" first caught my attention during my high school years outside of Philadelphia in the early sixties. I happened across a retrospective article about a northern New Jersey team coached by a Professor Ernest Blood — not a name one easily forgets nor, as it turns out, a man one easily forgets. His teams were dubbed the Wonder Teams by the local media. As my teammates and I were trying desperately to rally for a fourth win in a row, I couldn't help but think that Professor Blood's inconceivable streak had been conjured from the overactive imagination of the reporter. Who ever heard of a coach called "Professor Blood" anyway?

I was born and reared, until high school, in inner-city Philadelphia where everyone knew that basketball was the only real sport. I loved the game, couldn't get enough of it. After playing through high school and college, the next natural step for me was to become a basketball coach. Coaching would enable me to continue doing what I lived for. How lucky can one man be?

As the years passed, I stumbled upon more bits and pieces of information about these Wonder Teams and their coach. If the stories were to be believed, the professor may very well have been basketball's first great coach. I wanted to learn more about him, but I was too busy playing and coaching to do much about it.

At the age of forty-two, I once again found myself a full-time student, this time completing a Doctorate in Education. One day while between assignments, I started searching for the elusive, mysterious Professor Blood. I found him in the microfilm annals of old New York City newspapers. The more I learned about Blood and his teams, the more fascinated I became. His story was spellbinding. While I had studied the great, well known basketball coaches: Allen, Auerbach, Bee, Carlson, Holman, Iba, Lambert, McCracken, Rupp, Wooden, Newell, and Knight, not to mention outsiders like Joe McCarthy, Knute Kockne, and Vince Lombard, I came to find that this relative unknown was the most interesting of them all. But to my frustration, concise, comprehensive information about the man's career did not exist. For whatever reason, no one had

ever documented his life's work for the appreciation and education of future generations.

The reader should be aware that newspaper reporting during the early years of American sports was plagued with inconsistencies. For example, box scores (such as those reproduced here) occasionally contained discrepencies.

As I devoured every scrap of information I could about the successes and struggles of "Prof Blood," as he was known, I became hooked on his story. The affinity I felt for Prof and his teams overwhelmed me; I was driven to find out everything there was to learn about him. This ghost from basketball's infancy had found the keys to winning, and I had to know what they were.

An extraordinary story was unfolding before my eyes as I delved into the coach's history. Through old newspaper articles, family interviews, and even firsthand accounts from folks who were there as players and fans, I learned what Prof was like, what he believed, what values he held dear. His coaching methods, his philosophy, his personality, and more, all came to light as I dug deeper. I found how he learned the game and how he learned to teach it. I also discovered that he was plagued with the same problems countless coaches have had over the years: an unsupportive principal; a nearsighted, jealous, school board; and a disgruntled, influential parent. I began to feel an obligation to the man, his players and fans, and to the sport itself to share what I had found.

Because I once lived a life when each day was either a game day or a practice day, I felt I could relate to this coaching pioneer. But it wasn't until I came across Luther Halsey Gulick's (James Naismith's boss at the YMCA) "Clean Sport Roll" that I truly saw the world through Prof's eyes.

YMCA Clean Sport Roll

1. The rules of games are to be regarded as mutual agreements, the spirits or letter of which one would no sooner try to evade or break than one would any other agreement between gentlemen. The stealing of advantage in sport is to be regarded as stealing of any other kind.

2. Visiting teams are the honored guests of the home team, and the mutual relationships in all participants [are] to be governed by the spirits which is supposed to guide in such relationships.

3. No action is to be done, nor course of conduct is to be pursued which would seem ungentlemanly or dishonorable if known to one's opponents or the public.

4. No advantage is to be sought over others except those in which the game is supposed to show superiority.

5. Advantages which the laxity of the officials may allow in regard to the interpretation and enforcement of the rules are not to be taken.

6. Officers and opponents are to be regarded and treated as honest in intention. When opponents are evidently not gentlemen, and officers manifestly dishonest or incompetent, it is perfectly simple to avoid future relationships with them.

7. Decisions of officials, even when they seem unfair, are to be abided by.

8. Ungentlemanly or unfair means are not to be used even when they are used by the opponents.

9. Good points in others should be appreciated and suitable recognition given.[1]

Gulick reasoned that his Clean Sport Roll was appropriate and, indeed, all that was necessary because gentlemen would want to do the right thing. As for Blood, a YMCA product and physical director, he was not merely familiar with Gulick's philosophy on sportsmanship, he lived it. Throughout his career, Blood used Gulick's proclamation as an athletic beacon. Knowing Blood's allegiance to the Clean Sport Roll, one can easily predict Blood's reaction to many of the situations he later faced that related to fairness in athletics. There is no evidence that he ever wavered from or compromised any of Gulick's ideals in any of his personal or professional endeavors.

Professor Ernest A. Blood *was* basketball's first great coach, and his beneficence to the game has received inconsiderable recognition. His story, *Prof Blood and the Wonder Teams: The True Story of Basketball's First Great Coach,* is dedicated to the memory of what he represented and for his contributions to the game of basketball. It is a story that needs to be told.

CHAPTER ONE
THE ROAD TO NEW JERSEY

In the spring of 1915, Professor Ernest Artel Blood was the physical education teacher and basketball coach at Potsdam Normal School and Clarkson Memorial College of Technology in upstate New York. Unbeknownst to him, a sequence of events was unfolding that would lead him to another school where the situation would prove to be such that he would influence the very evolution of the new sport he coached. In the years ahead, his Passaic basketball teams' accomplishments would reach epic dimensions.

Potsdam Normal School was closing down its gymnasium to be remodeled into classrooms. While the scheduled construction was in the best interests of the school, it meant that Blood's passion would take a backseat. After nine years of Potsdam winters, Blood was ready to move on.

These were new times; the Puritans' influence and discouragement of sports and games had noticeably waned. With liberals and humanitarians working together for social reform, a new movement known as "Muscular Christianity" emerged to improve the physical health of the population. Blood and other pioneers in the new physical training profession were enjoying the ripple effects of this movement started by Catherine Beecher's 1856 book, *A Manual of Physiology and Calisthenics for Schools and Families,* as well as the need for physical activity created by urbanization and industrialization. In addition to placing the stamp of approval on exercise for females, Beecher's book advocated the induction of physical education into the American schools. With exercise and play now more acceptable to society as a viable means to maintain good health, Blood's skills were more in demand than ever.

The forty-two-year-old Blood was a polished, experienced professional, one of the few in the dawn of the new American physical movement. In addition to his stint in Potsdam, he had ten years of experience in physical training work in the Young Men's Christian Association where he taught all the physical activities known during that time. The Y's led the way in providing moral and physical guidance for young men in the growing cities. Blood's resume included a certificate from the highly regarded Dudley Allen Sargent Summer School for Physical Education

Teachers in Cambridge, Massachusetts, plus three additional years as a member of Sargent's summer school faculty. In addition, he had also earned a reputation as a coach of the new winter sport. In short, Blood was a hot commodity.

Yet another predominating factor would emerge to make Professor Blood's search for a new position easy: the escalating war across the Atlantic. Germany's unrestricted use of U-boat warfare and finally the sinking of the munitions-carrying, civilian cruise ship *RMS Lusitania* would propel the United States into the conflict. After almost two years of neutrality while Germany's aggression towards the United States continued, President Woodrow Wilson declared that to make the world safe for democracy, the United States would enter the Great War. With the country mobilizing to join our allies, younger physical education teachers, or "physical directors" as they were called, found themselves inducted into military service.

America received a wake-up call when it was discovered that many young men were not physically fit to be drafted. Belatedly, the new physical training departments in high schools were being structured to address this nationwide crisis. Because of Blood's reputation for motivating and training people for physical activity, his talents were considered a priority for national security.

In late July, Carl Ludwig Schrader, with whom Blood had worked while attending Sargent's Summer School, told him that Fred S. Shepherd, the superintendent of schools from Passaic, New Jersey, was looking to fill his physical director's position. With Blood's credentials and references, the application process and interview with Shepherd was a formality; Blood was contracted to start in September 1915. Years later, Blood was often heard to say, "I didn't want to waste time. I'm glad I made the shift to Passaic."[2]

Without delay, Blood mobilized his own troops, wife Margaret and their three children: Ernestine, 13; Paul, 12; and little Ben, who was 3. The family began the task of relocating to the busy industrial city. Blood didn't know anyone in Passaic, and no one there besides Shepherd had ever heard of him.

The city of Passaic is located in northern New Jersey, about twelve miles from New York City. Along with Paterson, its sister city to the northwest, they had become two of the country's most productive industrial cities (Paterson producing silk and Passaic producing wool). Passaic had been aptly labeled "the city of immigrants" because the majority of its citizens had entered via the portals of Ellis Island. Leaving behind political and religious unrest, immigrants found sanctuary in Passaic, a convenient, opportunistic place for many to pursue the American Dream.

Long before the influx of Dutch settlers and wave after wave of immigrants, the Lenni-Lenapi Indians were the first known inhabitants of the Passaic area. They called it the "Peaceful Valley." The next to arrive were the Irish, and soon after them, the remainder of Europe (English, Scottish, Austrians, Hungarians, Germans, French, Italians, Slovaks, Poles, Russians, Scandinavians, Hebrews and others) followed. There was also a small group of African-Americans (mostly former slaves) who found refuge there.

Because of the deluge of foreign imports, Passaic experienced an era of tremendous population growth. Census records indicated that by the early twenties, sixty thousand people, over half foreign born, resided in the Peaceful Valley. Residents found ample employment in the many mills and factories. The two most prominent companies were the German-owned Botany Worsted Woolen Mills and the Forstmann Woolen Mills. These two combined employed the majority of available workers. Because of the type of labor involved, women comprised half the workforce. The wages paid in the Passaic mills provided a better livelihood than that to which they were accustomed.

Passaic's strategic location had much to do with its growth as an industrial power. Its proximity to the New York harbor, its abundance of water (river and canal) for power and travel, the intersection of major railroads in the city, and plenty of eager workers all played major roles in making Passaic a prosperous blue collar city. The city's business district and theaters along Main Avenue attracted people via foot and railroad from the environs. Simply put, Passaic was a great place to live and work.

The Bloods were excited about moving to their new home in the Garden State. They looked forward to their modern, lively, busy new city. Ernest was especially anxious to apply his philosophy of physical training to Passaic's exploding school-aged population. Ernest knew what he had to offer, and he knew that it would make a difference in their lives. With a build like Mighty Mouse from years of lifting weights, Blood was an avid athlete with a high level of proficiency in all gymnasium activities. But what made Blood unique was his expertise in basketball; he could not only play well, he had a knack to teach others to do the same.

In the blue collar town where the Bloods were heading, a growing appetite for sports existed, although there were segments still relatively unfamiliar with basketball. It had only been twenty-four years since James A. Naismith, an instructor at the YMCA International Training School in Springfield, Massachusetts, invented the indoor game. The circumstances surrounding Blood's entrance into Passaic in his Model-T Ford belie the fact that he was the country's premier basketball coach.

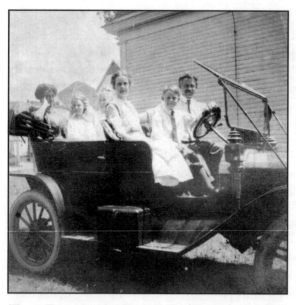

THE BLOODS' MODEL-T (CIRCA 1915)

There was nothing particularly noteworthy about Blood's welcome to Passaic, certainly nothing for anyone to be excited about. All the drama and pageantry was confined to the front and back seats of the Model-T. Certainly nothing about the passing of this event gave any indication of the far-reaching effects he would have on Passaic and the game he would popularize. The city of Passaic was about to embark on a basketball era, an era that not even Ernest Blood could have envisioned.

In contrast to Blood's inconspicuous ingress and his later value to the city, there was another event that had taken place just five years earlier: The President of the United States William Howard Taft had come to visit. Taft's arrival was referred to as "Passaic's greatest day." The newspaper headlines read, "Passaic In Blaze of Glory Welcomes Nation's Head." Over 40,000 people were on hand to greet the country's chief executive.[3] While Taft's visit was a major event, no one can say it had a lasting effect on the city.

Today, only New Jersey historians searching old microfilm for esoteric presidential tidbits would ever refer to Taft's visit while tales of Professor Blood continue to be popular. For almost eighty years now, Blood's accomplishments are relived and compared to those of any hotshot basketball team or player or whenever something extraordinary occurs in the world of basketball.

Perhaps a more appropriate comparison would be the arrival of an eighteen-year-old baseball pitcher in Boston, just a year before Blood's entrance into Passaic. This newcomer to the Red Sox team came seeking his first major league home run. Humble beginnings are usually where memorable historical figures get their starts, and that is how it happened for both the Sultan of Swat and our Professor Blood.

Chapter Two
Welcome to the Garden State
(1915-1916)

Approximately three months after a German torpedo sank the British passenger ship *Lusitania*, Blood and his family bid good-bye to friends and neighbors, leaving Potsdam and their Leroy Street home.

Upon reaching Passaic, the Blood's settled into a new home on Carleton Street, just around the corner from 31 Spring Street, which would later become home for the next thirty-five years. The family prepared for another school year with Ernestine in seventh grade, Paul in third, Margaret home with Ben, and Ernest focusing on his new assignment.

As the Passaic School District's physical director, Blood would be responsible for the physical training of grades one through twelve and the supervision of all sports in over a dozen schools. His biggest challenge would be managing his time as his expertise was needed extensively throughout the entire district. Instinctively, he started with the city's elementary schools. He began by visiting each school to meet the administrators, teachers, and students. He was like a general outlining his strategy.

To help relieve his insatiable appetite for teaching, Professor Blood wasted little time getting a part-time job in the evenings at the Passaic Young Men's Hebrew Association (YMHA) on Jefferson Street. The YMHA was a progressive organization interested in the physical, social, and moral welfare of the Jewish community. Although a gentile, Blood became a popular physical instructor whose classes were well attended. Participation in sports was an encouraged outlet for Jewish youngsters, and the YMHA's administration quickly realized Blood's value to their cause. Besides, many of Blood's future athletes would receive their start at the Jefferson Street facility.

The lone fall sport in Passaic was football, and many boys looked forward to the physical challenges it provided. In his youth, Blood was known for his football talents. At forty-two, he was still very coordinated, quick, strong, and rugged, indicating just how good he must have been in his youth. However, during his years with the YMCA's and at Potsdam, Blood's appreciation for football slowly waned. The multitude of serious injuries and even deaths that resulted from the sport had a profound effect on him. Just a few years before, a total of thirty young

PASSAIC HIGH SCHOOL (TODAY LINCOLN MIDDLE SCHOOL)

men across the nation had been killed playing football in the space of a single year. Reports of the causalities eroded Blood's opinion of the sport's lasting values and fed his fascination with basketball.

Not only football but sports in general were on the rise in America. This phenomenon was particularly true in and around metropolitan areas. Around the turn of the century, high schools had begun mimicking the colleges by including physical training and athletics in their curriculums. Many educators, some reluctantly, began to embrace the new physical experience finding its way into their curricula. Athletics and physical education were now recognized as valuable tools to teach many of society's cherished values, not just to improve the physical fitness of the youth. This new "American style" of physical education was replacing the monotonous calisthenics and gymnastic equipment work imported with the immigrants. Furthermore, the country's lack of physical readiness for military service led to the upgrade of physical education as a daily requirement for public school students and to a greater emphasis in physical fitness.

VICTIMS OF FOOTBALL 1901-12[4]		
	KILLED	INJURED
1901	7	74
1902	15	106
1903	44	63
1904	14	276
1905	24	200
1906	14	160
1907	15	166
1908	11	304
1909	30	216
1910	22	499
1911	11	178
1912	10	183

The Passaic schools needed a program to address the students' fitness needs which, up to that time, were not being met. The Passaic YMCA and YMHA were popular institutions, but they couldn't service everyone, most notably women and those without the necessary financial resources. With most moms and pops working various shifts in the factories and mills, the kids needed appropriate activities to fill their spare time. Furthermore, a natural allegiance to one's own countrymen provided a hotbed for competitiveness among the immigrant families in Passaic's crowded multi-ethnic neighborhoods.

While Superintendent Shepherd was well aware of Blood's reputation as a coach of the new indoor game, he did not insist that Blood tie himself down to coaching basketball or any sport. Nevertheless, Blood was not disappointed to learn that the high school was without a basketball coach for the coming season. Although his responsibilities were vast and time consuming, he couldn't resist coaching the team, even if it were for only one season until a permanent coach could be found.

When Blood arrived in Passaic, "basket ball" was still written in two words; they were officially combined into one in 1921. During basketball's infancy, revision of the rules was an on-going process. Blood followed these rule changes closely because he had ideas of his own about how the game was to be played. Everything about the game was new, so changes were to be expected, but what added to the confusion was the existence of three completely different associations: the Amateur Athletic Union (AAU), the Young Men's Christian Association (YMCA), and the Intercollegiate Association—each with its own set of rules.

On the advent of Blood's debut at Passaic High School, the three basketball rules committees consolidated into one called the Joint Rules Committee. The JRC would govern the rules of all levels of basketball with the exception of the professional leagues. The chief concern was to change the slow, rough style of play that prevailed to a cleaner and faster game. It was the initial intention of the organizers to keep what was best from each rulebook. In the final analysis, they adopted most of the rules from the popular college game. The Joint Rules Committee helped eliminate what plagued basketball as much as wireless technology helped improve communication.

The merging of the three sets of rules was a significant advancement and a much-needed boost for the fledgling sport. By compromising on different rule interpretations, the three competing groups enjoyed a uniformed game, thus eliminating the predicted bickering concerning what rules were being followed when two different teams from dissimilar organizations met.

Although Blood had and always would have his opinions about what was in the best interest of the game, he would respect and abide by the

official rules, regardless of what they were. He abhorred the roughness and lack of sportsman-like behavior that was threatening to take over the game. He also believed that roughness detracted from the scientific nature of the game. Blood knew why he enjoyed playing and coaching Naismith's game. He understood that the development of physical skills (passing, dribbling, shooting) was only an ephemeral side effect compared to the life skills (dedication, teamwork, self-discipline) that were developed through playing the game. In the great scheme of things, Blood as coach approached basketball as an educational tool, a means to an end.

After the high school's football season concluded on Thanksgiving Day with a 7-6 victory over the Alumni, the try-out schedule for basketball was announced. Blood had his plans, but he couldn't get started until he saw what he had to work with. The Passaic athletes didn't know Blood, so they were equally curious. It was an anxious moment for everyone that very first day of practice. An insightful anecdote of that first encounter has been passed down through the years.

The little man stood at the entrance to the locker room. Dressed in his instructor's uniform he was something to see.

He wasn't more than five-five from the soles of his sneakers to the top of his curly head. But he was built like a top, with the neck, shoulders and chest of a heavyweight boxer and a waist as slender as a chorus girl's.

Members of the high school basketball squad, freshly showered and dressed, gathered around him in a circle as he had directed. This had been their first practice session with the new coach. They regarded him curiously. All were taller than he. A few of the lankier youths fairly towered over him.

'Fellows,' he began, 'I think we ought to get to know each other better because that's going to save a lot of trouble for all of us. At the beginning of today's session, I outlined my ideas about how this game of basketball should be played.'

'I told you my game was a passing game. I told you that anyone who plays for me must sacrifice individual honors for teamwork. I told you we were going to shelve the old dribble game and pass, pass, pass.'

'Now I notice during practice that some of you apparently don't agree with my ideas. That's too bad because if you want to be on my team you'll have to play my style.'

'If there is anyone on this squad who feels he can't do that, I want him to walk out that door right now...And don't bother to come back.'

The players fidgeted under his steady gaze. Some of them were 'big shots' with the student body...outstanding athletes in all the major sports. But he was treating them like novices.

'What do you think we'd better do?' whispered one lad to the fellow alongside him.

'I think,' said his teammate, 'we'd better do what this little guy wants.'

That was the first and last threat of a revolt Ernest A. Blood ever faced during his 10 years as basketball coach at Passaic High School.[5]

The boys did learn to pass the basketball, but that wasn't all. Their new coach explained and demonstrated everything—shooting, physical conditioning, plays, strategy and more. Not only did he do whatever it was he asked them to do, he would do it better than any of them. During practice, they found him to be deadly serious at all times. It didn't take him long to capture their undivided attention, and he wasted no time in using their attentiveness to teach them basketball—his style of basketball.

During basketball practice with this "Professor," the boys quickly learned that the horsing around days were no more. After the initial grumblings and period of adjustment, they enjoyed their practices with the new coach. They found themselves learning and improving every day, and at the same time, they saw what made this intimidating man tick. He never failed to impress them with his passion, intensity, and knowledge but, most of all, with his confidence.

Blood swiftly taught the value of teamwork and that crucial "passing" ingredient they had previously lacked. He outlawed the dribble except when necessary. His team didn't realize that the game could be played so effectively without the popular dribble. Blood patiently but expeditiously convinced them that this would lead them to success.

In addition to working them hard in the fundamentals of the game, his young players noticed he was also teaching them how to handle themselves off the court. He paralleled everyday life situations with what they were doing in practice. He equated learning basketball skills to learning how to become successful in life (See Chapter 19). As their respect and admiration for the charismatic coach grew, he not only won the team's following, but he reached all the students he came into contact with as he traveled from school to school. For many, Blood became a very important

influence in their lives. Rather than calling him Professor Blood, they gradually began to address him merely as "Prof," but they uttered the title reverently.[6]

Finally, the time came to test Prof's passing strategy against a real opponent. The first game of the 1915-16 season was with Harrison from outside East Newark. No sooner had the ball been tossed into the air than the home team began displaying its superiority in floor work and shooting.[7] The new "passing offense" not only flummoxed Harrison, it dazzled the spectators. Passaic completely shut down their opponent, handily winning by an unthinkable margin of 83 to 10. The only question remaining that night was whether this had been a fluke or a sign of things to come.

With additional practice, Blood's teachings took root. As their conditioning improved, Prof drilled them longer. Court time was utilized to teach a variety of skills as well as how to handle various game situations. Players had to be prepared to call their own shots while on the court because rules at that time did not allow the coach to talk to or instruct his players while the game was in progress; only during time outs and at halftime was dialogue with the coach allowed.

Blood taught his theories on shooting for the goal, a skill that he had the boys practice over and over. Prof encouraged them to use whatever style (one hand or two) felt natural to them and to shoot two shots to their opponents' one. Aided by his ability to teach the art of shooting and how to score, they bonded with him and the game. His enthusiasm soon had them addicted to basketball, and their improvement came rapidly.

As their opponents fell one by one, the boys learned first-hand the wisdom of sacrificing oneself for the good of the team. They soon noticed that Prof only drilled them on offense; "Keep possession of the ball," he would tell them, "and pass it and pass it, and do it quickly." He showed them how to get open to receive a pass, what to do with the ball when they got it, and how to attack the various defenses they would encounter. Time was the only factor that limited Prof from teaching them more. As had Prof's teams in Potsdam, the players looked forward to their time with him.

In early February of this inaugural season, Leonia High School became the victim of a record-breaking offensive spectacle. The high-scoring Passaic boys went off on a never-before-seen scoring rampage. Basketball fans weren't accustomed to scores like the 101-16 pasting the red and blue Passaic boys gave Leonia. At a time when it was considered rare for a team to amass more than 30 points, here was Passaic scoring almost twice that every time they stepped on the court.

In awe of their own success, the players became disciples of Prof's system. They soon understood that when you pass the ball quickly, you get better shots at the basket, plus you get more of them—they liked that.

The only caveat was that the open man got the shot; therefore, everyone needed to know how to shoot. Listening, learning, passing, and shooting consumed every practice session, and convincing victories followed.

The team was disappointed when the game with the very successful St. Benedict's Prep team was canceled because of an untimely blizzard. Nevertheless, the victories that continued were as guaranteed as the woolen products flowing from the city's mills. The word was that no basketball team could match the "Boys from the Hill." It appeared as if their neighbors from Rutherford chose to cancel the remainder of their season rather than face Passaic. The Rutherford administration used the alibi that the sport was not cost-effective.

Including the two Rutherford forfeits, Blood's first team in the Peaceful Valley finished with a 20 and 0 record. The unblemished slate had team manager Clarence Starke and many fans trumpeting the team as unofficial state champs. New Jersey would have to wait three more years before the soon-to-be-formed New Jersey State Interscholastic Athletic Association (NJISAA) would sponsor the first state basketball championship tournament. Meanwhile, Passaic's loyal fans based their championship rights on a comparison of scores among the better teams in the state. The impressive summary of Blood's first season in Passaic is listed below.

1915-1916
PASSAIC HIGH BASKETBALL SEASON

December 4	Harrison High School	83	10	
December 8	Kearny High School	72	39	
December 10	Paterson High School	34	25	
December 21	at South Orange H.S.	39	17	
January 5	at Paterson High School	33	21	
January 8	Nutley High School	67	12	
January 15	at Leonia High School	71	10	
January 19	Stevens Prep	38	27	
January 22	Englewood H.S.	84	7	
January 29	Hackensack H.S.	46	22	
February 2	Orange High School	67	32	
February 5	Leonia High School	101	16	
February 8	St. Peter's Prep	49	18	
February 12	Rutherford High School	2	0	*forfeit*
February 16	Orange High School	60	31	
February 19	at Nutley High School	54	20	
February 22	Rutherford H.S.	2	0	*forfeit*
February 26	Englewood H.S.	52	26	
March 4	at Hackensack H.S.	41	23	
March 8	Central High School	79	12	

TEAM SCORING

	G	F	T
Raymond Banks	143	27	313
Edwin Van Riper	139	5	283
Peter Pettersen	92	1	185
Herman Schulting	79	38	196
Victor Jaffe	28	1	57
Carl Saxer	8	0	16
Arthur Hall	7	0	14
Total	**506**	**72**	**1084**

Following the official season, Passaic sought games with a couple of teams with impressive records. The players and fans, not Blood, wanted to prove Passaic was the best, but no talented team was interested in playing another game.

Captain Ray Banks and Eddie "Skinny" Van Ripper were seniors, but the other regulars, Peter Pettersen, Herman "Hoy" Schulting, and Victor Jaffe, would be returning for another season. The future for Passaic basketball looked bright; besides, Prof's Second Team had also completed their season undefeated.

Throughout Passaic, sports fans of all nationalities and occupations talked about the team's perfect record and about their unique style of play—so different from anything they'd ever seen. Prof's team had piqued the attention of sports fans throughout the city.

As if the talk of war were not a major concern, it was the Passaic basketball team that received the public's attention. Some of the local sports pundits were not quite sure what to make of the team's performance, but they agreed that Professor Blood was a nice addition to their city. Many of those who followed the team started inquiring about the new physical director who really seemed to know his business, especially basketball. Who was this Professor Blood? Where did he come from and how did he come by his knack for winning basketball games?

Chapter Three
Who is Prof Blood?

As a youngster, Ernest Blood was involved with baseball, football, wrestling, gymnastics, and fencing; he also excelled in the antiquated exercises performed with Indian Clubs and every other activity popular during the late 1800's. Whatever time was not used for taking care of chores and schoolwork, he spent playing.

His father, George Blood, was a year younger than his twenty-three year old bride, Ella Upham, when they married in 1871. George was from Mason Village, New Hampshire, and Ella from Hooksett, New York.

They settled in Manchester, New Hampshire, where they welcomed little Ernest to the family on October 4, 1872, just over a year after the wedding. Several years later, the family relocated to Fitchburg, where George performed fireman duties for the Fitchburg Railroad and Ella handled the homemaker responsibilities.

What marital difficulties led to George and Ella's separation are not known. What is known is that George eventually abandoned the family when Ernie was around five or six years old. Ella soon made a home for herself and her son in the historic Massachusetts

ERNEST, AGE 2

neighborhood of Charlestown. Charlestown was a small, friendly neighborhood within the city of Boston and here Ernest graduated from Harvard Kent Grammar School.

What does an athletically precocious child of a single mother do? There is evidence that Ernest was a habitue of the YMCA gymnasium in Charlestown. Besides playing sports, he enjoyed lifting weights to improve his physique. But perhaps most importantly, he found male role models in the YMCA. He looked up to the men at the gym, and because he was eager, talented, and mannerly, he was well received. The ubiquitous

Christian environment of the YMCA presented a safe, structured haven that provided him stability and direction. At the Y, Ernest excelled; his confidence and self-esteem were the beneficiaries of his athletic prowess.

Quick and rugged, Ernest was a gifted athlete. Old news articles reported that Blood spent some of his teenage years in the Boston/Salem area. A regular in the gym, Ernest naturally came under the tutelage of the Y's director, Professor Herbert Hubbert. It was Hubbert who coached the wrestling team when Ernest, at the age of fifteen, won the New England Championship for his weight class.[8] He passed up attending high school to help provide for his mother and himself, making his association with the YMCA all the more influential in his life. He gravitated to the ideals and philosophy of his second home. He absorbed everything the YMCA gymnasium had to offer.

On December 21, 1891, Ernest was nineteen years old and living in Nashua when James Naismith presented a unique new game at the International YMCA Training School in nearby Springfield. Because of the YMCA's network, it didn't take long for the game to spread to numerous

YMCA's throughout the country. Basketball was an immediate hit.

Even in its embryonic stage, Naismith's concoction proved fascinating to many, especially Blood. Basketball became more than just another reason to hang out in the gymnasium; it became his favorite activity.

ERNEST, AGE 17

Years later, Blood was known to say that he "took to it like a duck to water."[9] He could not foresee the role he would play in future years in the development of the game and its popularity. Coincidentally, Naismith's presentation of his new game preceded the opening of the immigrant registration facility at Ellis Island by little over a week. It would be the sons of some of these same immigrants who Blood would later coach.

Basketball quickly became Blood's passion. It had something special that kept him coming back for more. He not only enjoyed the physical challenges but also the mental and social stimulation it provided. The

scientific principles of the game challenged him, and he was fascinated with the synergism created by teamwork. The lure of the new indoor game pulled him further away from some of his other pursuits.

Around the time that Milton Hershey was trying to sweeten America's tooth with his milk chocolate bar in 1894, Ernest left his mother with his paternal grandfather at 12 Prescott Street in Nashua. Little is known about this time period, but it is known that Ella's new next door neighbor Nathan O. Prescott would soon take a liking to her. In 1903, they married after learning of the death of Ernest's father. Ernest was out of place in his present job as a Nashua store clerk. Without a high school diploma, his options were limited. Because of his upstanding reputation and a shortage of physical directors, he received his first position instructing at the YMCA in St. Johnsbury, Vermont. This was his first opportunity to get paid for gymnasium work.

ELLA UPHAM BLOOD

Blood could demonstrate almost anything in any area of the gym with proficiency. He was an original YMCA physical department prodigy, and he especially enjoyed performing for an audience. His reputation as a Christian gentleman and a role model for the YMCA's ideals also continued to grow. It was in St. Johnsbury that he first took advantage of his nascent basketball skills by tutoring others and coaching a team.

The St. Johnsbury position led to Blood's first financially rewarding position as an Assistant Physical Director at the Brooklyn Central YMCA. After a year in Brooklyn, Ernest returned home to Prescott Street and became the physical director at the Nashua YMCA. For the next ten years, Ernest lived and breathed the life of a YMCA physical director.

Sometime during or after his stay in Brooklyn, Ernest became acquainted with the YMCA's Leaders' Corps. The Corps was a program designed to provide physical directors with assistance teaching gymnastics classes. These leaders were recruited from a pool of motivated and athletically talented members. For twelve months, this small, select group conducted weekly meetings to learn the skills and theories of the Y's physical department. The main focus of the Leaders' Corps was the development of the all-around-man ideal—the physically fit Christian gentleman.[10]

After completing the Leaders' Class, these young men could continue training to become candidates for the Instructors' Class. The theory portion at this level of training included lessons in anatomy and physiology, in addition to information on exercising, training, personal purity (mind and body), and first aid. The trainees were taught the basic skills employed in the profession to the level of being able to teach them to others. This instruction included knowledge of performing and teaching skills on all of the apparatus—all of which was right down Blood's alley.[11]

The third and highest level of the Corps was that of Honorary Instructor. This distinction was for only the most physically, mentally, and spiritually qualified (to sustain the Christian influence, the YMCA governing body recommended that only Christian men be allowed to participate in the Corps). The Honorary Instructor level was all about theory. The Honorary Instructor was to have complete jurisdiction over the gymnasium during regular hours each week when the physical director was absent.[12] This brief description does not address the depth and breadth of the total Leaders' Corps. The program resembled a physical education activity curriculum similar to what can be found in colleges today, and Blood had to be skilled and knowledgeable enough to be the instructor.

In Nashua in the fall of 1897, he met a lovely, petite neighbor by the name of Margaret Thomas who lived a short walk away at 36 Prescott Street. Margaret, who was originally from Liverpool, England, was studying to become a schoolteacher. Ernest and Margaret most likely first met while she was walking by his house on her way to the Amherst Training School, which was just around the corner. Their friendship soon blossomed into romance.

In the late 1800's, the mission of the YMCA was to proselytize. Since its inception in England and adoption in Boston in 1851, its focus was to save young men from the moral corruption of the times. Because the physical departments shared the same goals, it was imperative that only gentlemen deemed to embody the utmost Christian values be appointed to physical director positions. Finding a man who personified Christian values and who was equally qualified in the gymnasium was not easy. To make the position even more difficult to fill, a man also had to be qualified and comfortable teaching Bible classes. Ernest Blood was such a man.

One of Ernest's many responsibilities within the YMCA was the boys' department. Because he enjoyed performing for an audience, he was often found in the middle of exhibitions demonstrating tumbling, apparatus work, and/or exercises with the Indian Clubs. Usually timid in social situations, his shyness disappeared when he performed. His personality and enthusiasm made him a popular and effective teacher; students gravitated

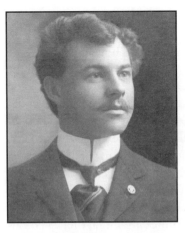

ERNEST BLOOD, 1899

to him and his programs. Blood's employment was a tremendous asset to the Y as his classes attracted new members.

The image Blood portrayed was described in a Pawtucket YMCA newsletter write-up when he was hired. The article related that Mr. Blood "possesses a noble, manly Christian spirit," and that "manly Christianity without cant is what count with young men to-day [sic]." He was the epitome of the man whom the YMCA desired for its physical director.[13]

In addition to his all-around talents in the gym, Ernest was increasingly gaining more experience and knowledge in basketball. He played through all the early changes and adjustments in the rules of the game. He witnessed the evolution of the dribble and the advent of foul shots and backboards. He didn't particularly agree with some changes, but on at least one change in particular, his presence may have had some influence.

Prior to 1897, it was the custom for the Y's two physical directors to play on the basketball team. Games at that time were played seven-on-seven. In 1896, Blood was the physical director for the youth program, and Diedal Stolte headed the men's department at the Brooklyn Central YMCA when the dispute arose. Because Blood and Stolte were so adept at playing basketball, their participation gave their teams a decided advantage. Although the YMCA employed the physical directors, the AAU, which governed the basketball rules, declared Blood and other physical directors as "professionals." As a result, the Y's began playing the five-on-five game that was soon made the standard.[14]

Another popular development in the game—about which Ernest had his opinion—was the dribble. As the dribble evolved, it became an offensive tool that provided an advantage to those who were fast and skilled. A good dribbling team quickly gained the edge in a game. In the mid-1890's, the successful Yale team actualized the dribble to such a degree that their style of play became known as "the dribble game."[15] Blood was not convinced; he spotted something that he didn't favor in the dribble. He reasoned that the disadvantages of the dribble outweighed its advantages because it encouraged individual play. In his opinion, individual play took away from the teamwork he valued. He decided early on that the dribble was not for him and he would build his team's game around another skill he believed more advantageous—the pass. He maintained

that the ball could be passed among teammates more quickly than a player could run.

Blood felt certain that he could train his players to play the game the way he envisioned it—by passing and shooting in lieu of the slower dribble and shoot. In addition to employing the talents of his players, he wanted his teams to have the advantage of the skills and strategies that he could teach them. While this idea seems obvious now, it was a fledging thought back then. The idea of "coaching basketball" would gain prominence later.

At the University of Kansas about a decade later, Dr. James A. Naismith was asked about making a career of coaching the sport he invented. Naismith's famous reply is a classic. "You play basketball; you don't coach it." His comment was directed to a player of his by the name of Forrest "Phog" Allen who was contemplating earning a living by coaching basketball. Before this same Phog Allen, who has been dubbed the "Father of Basketball Coaching," celebrated his twentieth coaching victory, Blood had recorded over 300.[16] Who should rightfully be referred to as "the Father"?

Having played and coached in so many games from its inception, Blood had definitive ideas about how the game should be played. While basketball was still in its embryonic stage, he began putting together a system of his own. The success of his teams reinforced his belief that all players be involved in the action. He trained his players to pass the ball and to sacrifice individual accolades for the good of the team. His reasoning was based on the belief that success in life required a cooperative effort with others. In his mind, it was the team aspect that validated basketball as a teaching tool to prepare kids for life as adults. Later, when Blood's undefeated teams became well-known, other basketball coaches came to study his team and copy his techniques and philosophy.

As basketball grew in popularity, it spawned a problem within the YMCA that had first nurtured it. Anyone who has played basketball and been smitten by its uniqueness can understand the problems that quickly arose. The architects of the small YMCA gymnasiums never envisioned Naismith's game. The little floor space available was usurped by the increasing numbers who only wanted to play basketball.

To the chagrin of many YMCA physical directors, those playing basketball would often swear, argue, and fight during and/or after their games. The Y was a Christian establishment, and this unruly behavior could not be tolerated. The physical directors, many of whom had no particular interest in the new game, became annoyed with the disturbances taking place in their sacred gymnasiums. Something had to give.

In his playing days, Blood remembered the game as very rough and physical. Back when it all began and for many years thereafter, a referee seldom stopped a game because of an infraction. A player had to survive

on his own, every man for himself. Players had freedom to play their opponent using methods that are illegal today. Basketball, as Blood recalled, resembled football so much that the rules committees had to constantly revise the rules and assign penalties to safeguard not just the players but also the fans.[17] The cages that enclosed the courts after the start of professional basketball served a dual purpose of protecting the players and fans from each other

The problem was becoming clear—basketball was outgrowing the YMCA. There was a movement within the Y to oust basketball from the association. Many physical directors felt the new game was ruining other established programs. After much debate on the merits of keeping basketball but with a renewed effort to maintain gentlemanly deportment, basketball was to be given its just time and space within the Y's program. This interpretation varied from place to place, and in some areas, namely Philadelphia and Trenton where basketball had become extremely popular, it was getting squeezed out of the Y entirely. It was this court-scheduling problem that forced basketball enthusiasts to rent other facilities for their games, and which, in 1906, led to the formation of teams that began playing basketball games for money. Professional basketball was born.

How Ernest Blood was affected by the turmoil over basketball is not clear. Was it enough to drive him away from the YMCA? He had to be aware of what was evolving in his profession. Another plausible concern for Blood was pecuniary compensation as YMCA employment hardly provided a wage to start a family. With basketball outgrowing the YMCA, was Blood experiencing the same metamorphosis? It was time to explore what other opportunities were available.

Around the turn of the century, a popular movement began in colleges to expand the curriculum by adding physical training and athletics. Independently, students were forming teams in the leading sports (rowing, football, baseball, track, and now basketball) and looking to schedule competition. But because of the large number of students sustaining injuries, it became prudent for college administrators to assume control of these athletic activities. College presidents were forced to look for qualified teachers to coach their athletic teams and to develop physical education programs.

This movement toward physical education and athletics exacerbated the shortage of qualified instructors and coaches. During the summer of 1905, Blood attended the first of four summer sessions at The Harvard Summer School of Physical Education conducted by the physical education guru Dr. Dudley Allen Sargent. Sargent's school was renowned for its cutting edge professional training by offering a rigorous and comprehensive curriculum. The staff and students who attended Sargent's

summer programs were literally a who's who of physical education professionals.[18]

Graduates of Sargent's training school produced qualified coaches and gymnasium instructors who were suddenly in great demand. Not only did Blood graduate after the 1908 summer session, but he was retained as a faculty member for future summer sessions. He became known as one of "Sargent's regulars." In future years, Margaret would take Ernestine and Paul to visit her family in Nashua, New Hamshire, for the summer while Ernest attended Sargent's school in Cambridge. With many of the best and brightest physical educators from all over the country and Europe working together each summer at the school, Blood was provided with valuable contacts, experiences and opportunities for professional growth. This background also had a profound effect on the development of the unique American style of physical education that emerged from the physical training systems that had arrived with the immigrants.

Sometime during Blood's association with Sargent, the new winter sport of basketball was added to the school's curriculum. Did Blood's knowledge and skill influence Sargent to include basketball? Who was the instructor for the basketball class? Logically speaking, who could Sargent have more qualified than Blood? These daily sessions in basketball skills and coaching were most likely the first basketball clinics ever held. The Cambridge summer school background put Blood in a very marketable position. He now had the credentials, connections and support to successfully seek a wide-range of positions in his field.

Margaret Thomas, Ernest's girlfriend from Nashua, may have been more concerned with Ernest accidentally killing himself in the gymnasium than his advancement in his profession. Years later, in a letter to her son Ben, Margaret told of the incident which took place in the Somerville Y's gymnasium in 1901, a couple of months before their wedding. While demonstrating in an apparatus class, Ernest was performing giant circles on the high bar when he lost his grip and flew through the air landing on his head. As he lay there unconscious, Margaret thought he might be paralyzed, if not dead. Upon regaining consciousness, he got up, regained his bearings, and finished

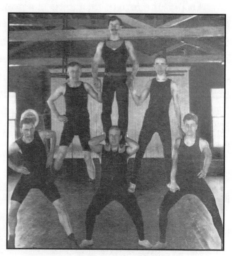

PROF, ALWAYS A DAREDEVIL, AT THE TOP OF THE PYRAMID

teaching the class. His "no fear" attitude and self-confidence marked Blood as different.

On June 19, 1901, a couple of months before the Wright brothers in Dayton, Ohio, designed a wind tunnel to test their theories of flight, Ernest and Margaret Thomas were in Nashua, tying the nuptial knot. She was a certified elementary school teacher and had been teaching at the Palm School in Nashua. They set up house in Somerville, at 25 Veazie Street. As Physical Director of the Somerville YMCA, Blood was expanding his reputation and prowess in the gym. On December 1, a few months before the arrival of their first child, Ernest was baptized and joined Margaret as a member of the Perkins Street Baptist Church.

**PRESIDENT
DR. THOMAS B.
STOWELL**

*copyright 1998, SUNY Potsdam
College Library*

Throughout his life, his commitment to Christian ideals would remain unflappable.

In the summer of 1906, Blood responded to President Dr. Thomas B. Stowell's invitation to join the Potsdam Normal School faculty. Stowell, a scientist by training, was a progressive leader; he ushered the school into a new era.[19] The caliber of social life on campus for the students was important to Stowell.[20] He believed that art, music, physical education, and athletics were all necessary segments of the college experience.[21] He was the type of school leader under whom creative people like Blood thrived. He recognized talent and empowered his staff to be absolute sovereigns in their areas of specialization.[22] This environment gave Blood the freedom to build a physical education program. With this new "Potsdam Spirit" in the air, the thirty-four-year-old physical director was enticed to end his YMCA career.

The YMCA archives have provided a brief sketch of Blood's employment records. His YMCA basketball coaching record taken from newspaper articles is included.

YMCA	DATES OF EMPLOYMENT	RECORD[23]
Brooklyn Central, NY	Oct. 1, 1896-July 1, 1897	33-2
Nashua, NH	Sept. 1, 1897-Oct. 1, 1898	54-2
Rutland, VT	Oct. 1, 1898-Sept. 1, 1899	16-1
Pawtucket, RI	Sept. 1, 1899-Sept. 1, 1900	75-10
Somerville, MA	Sept. 1, 1900-June 1, 1906	132-9
		310-24

Blood had been learning the game of basketball as it evolved since Naismith first tossed the ball into the air. His basketball experience and coaching record were unparalleled in the early years. After having served

POTSDAM NORMAL SCHOOL, 1911
copyright 1998, SUNY Potsdam College Library

what amounted to a ten-year apprenticeship in theory of human move-
ment, anatomy, physiology, physical training, sports psychology, and coach-
ing basketball, Blood emerged as a seasoned expert. In addition to his
physical skills, he was equipped with the aptitude, knowledge, and experi-
ence to excel at coaching the new indoor sport.

It was at Potsdam that Ernest first became identified as Professor
Blood. Heretofore, the title "Professor" had been added to a person's
title solely as a sign of respect. The appellation was commonly applied to
those who possessed a high level of knowledge or skill or both. For
someone as proficient in his field as Blood, Professor was an appropriate
title, and it was to stay with him for the remainder of his life.

A unique situation existed at that time at the Potsdam Normal School.
The New York State governing body responsible for education included
the grammar school, high school, and normal school under one adminis-
tration. Professor Blood held the position of physical director for all
grades (kindergarten through the normal school), and he was responsible
for all physical activities and sports teams. His family took up residence
a few blocks from campus where it was convenient to spend his days and
many evenings working with the students in the gym. He spent more
hours in the gym than he did at home. Before long, he had developed a
program that served to help students keep active and to better enjoy their
school experience.

What Professor Blood was accomplishing at the Potsdam school made
him a local celebrity. A good portion of his time was spent teaching
basketball skills to all grade levels and organizing intramural programs
that involved teams representing each class. The students admired Blood,
especially the athletes who occupied his time learning the finer points of
sports—especially basketball.

The basketball team at Potsdam Normal School was comprised entirely of high school-aged boys because there were only a couple of male students enrolled in the teacher training program at the normal school, and they were not athletically inclined. Blood's presence attracted students to the gym. With what was available, he organized a team to represent Potsdam in inter-school games.

A succession of lopsided victories showed that Professor Blood's top team, labeled the "Normal Five," were too strong for the other high school teams. More challenging competition was needed to test his boys. Under the name of Potsdam Normal School, Blood scheduled games with colleges, YMCA's, military teams, and eventually professional teams. With few exceptions, these teams met the same fate as the high school opponents. Out of necessity, Blood organized another team of "seconds" to play the high school schedule when the Normal Five (team picture below) were playing the college and professional teams. This situation eventually led to his practice of scheduling doubleheaders to provide game experience for all his players.

Without a doubt, the toughest opposition came when Potsdam hosted the professional, world champion Buffalo Germans. These match-ups occurred during the period when the Buffalo Germans were establishing their record 111 consecutive victories. During the 1909-1910 season, the Normal Five lost 47-19 to the world champs. After the game, player/coach Allie Heerdt was so impressed with the caliber of play from the Normal Five that he remarked, "We've seen more basketball played here today than ever before."[24] The Buffaloes claimed that Potsdam was the strongest school team they had played.

1910 POTSDAM NORMAL FIVE

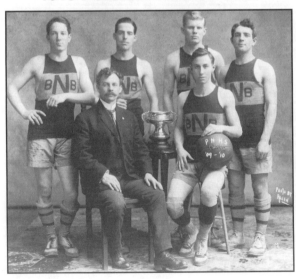

BACK ROW
(L TO R):
MAURICE LENNY,
LEO COMPO,
CARLTON
BROWNELL,
CHARLIE JACOT.
FRONT ROW:
COACH BLOOD,
RUFUS SISSON

The Professor's willingness to play the best illustrated that he did not shy away from the possibility of losing a game. All he desired for his boys was for them to be the best they could be. According to Blood, a basketball game was just a test; all games were learning experiences, and winning or losing was a by-product of the experience.

Secondary sources have claimed that the Normal Five on one occasion defeated the Buffalo Germans, but reliable records substantiating such a victory have never come to light. Credible records reveal that Blood's crack Normal Five lost ten games of the twenty-five played against an all-adult schedule in 1909-1910—thirteen of those games played on the road.[25]

Another rumor had Blood playing alongside his friend Allie Heerdt with the Buffalo German team, but records do not support this claim. In the rumor mill, Blood may have been mistaken for Chuck Taylor of Converse basketball shoes fame. Taylor, who later became "Basketball's Ambassador," did play with the Germans during their latter years.

Professor Blood was a big hit with the students. This sentiment is expressed in the comments made by a couple of students in their 1910-class souvenir book. The inscription reads:

A short time ago I overheard the following conversation between two pupils. The first one said, "There goes Miss Rose Reese, the flower of the Faculty. Can you conceive of anyone who would be more missed should she leave us?" The other answered, "I can think of only one who would be more greatly missed, and that is Prof. Blood, who is the life of the school."[26]

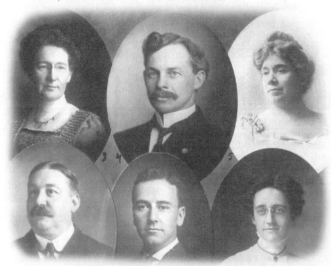

ERNEST BLOOD (CENTER TOP)
FROM POTSDAM NORMAL SCHOOL FACULTY COMPOSITE
Photo courtesy of Potsdam Public Museum Archives

In the *Watertown Times* of November 25, 1911, Blood acquiesced to a rare interview concerning the prospects for his team for the coming season. His comments reveal a little about the man and his team. He said:

We will adhere strictly to AAU rules this year and play a fast passing game that is by far the more interesting and scientific of the two games; and the only one that will win consistently, especially with such a light team. The Buffalo Germans use it and the University of Chicago, the champions of the west, use it.[27]

By the fall of 1912, Blood had turned forty and was responsible for another mouth to feed. A second son named Ernest Ben ("Butch") had arrived the day before the country's July 4th birthday. Was this why Blood accepted a second basketball assignment at the Thomas S. Clarkson Memorial College of Technology, or was it because of their beautiful new $20,000 palace of a gymnasium on Pierrepont Avenue?[28]

Another reason why Blood may have agreed to double up on his coaching duties was because many of his top players were planning to further their education at the local tech school. At that time, Clarkson was located immediately behind the high school/normal school grounds. If Blood were to coach there, he would have many of the same players for an additional two years. He knew that their success as high school kids would appear paltry compared to what they could accomplish next.

Blood's dual coaching duties did not jeopardize the success of either Potsdam or Clarkson. He immediately put the new Clarkson gymnasium to use by organizing a freshman squad in addition to his first team. As was

EXTERIOR AND INTERIOR OF CLARKSON'S GYMNASIUM (CIRCA 1912)

his wont, the Professor believed in having a large program. More boys on the team meant more boys he could influence.

A highlight of this era of Blood's career would have to include the encounters between his Normal Five and the City College of New York basketball team. The 1912-13 CCNY Beavers were already recognized

as a college powerhouse. Competing against the top teams in the northeast, CCNY had gone 16-4 the previous two seasons.[29] Leonard Palmer, the veteran CCNY mentor, agreed to play both of Blood's teams during the Christmas vacation in Potsdam.

The CCNY team opened on a Thursday with the Normal Five at the Potsdam gym and were quickly outscored 22-3 during the first half. The New York college students were overwhelmed with Potsdam's speedy passing offense. It wasn't until they learned that their opponents were high school kids that they became distraught, and by then, the 34-8 score was history.

NORMAL (34)		C.C.N.Y. (8)
W. Sisson	r.f.	Kaplan
Barclay	l.f.	Southwick
Wilbur	c.	Bradner
Lenney	r.g.	Sappoe
S. Sisson	l.g.	Schulberg

Shaffor substituted for Bradner in the last few minutes of play. Field baskets: W. Sisson 7, Barclay 6, S. Sisson 3, Bradner 1, Sappoe 1 and Shuburg 1. Baskets from foul line: W. Sisson 2, Schulberg 2.[30]

CLARKSON (27)		C.C.N.Y. (23)
Olson	r.f.	Southwick
Jacot	l.f.	Kaplan
Reynolds	c.	Bradner
West	r.g.	Sappoe
Bassette	l.g.	Schulberg

McNulty substituted for Bassette in the second half. Fields goals: Olson 3, Jacot 5, West 2, Southwick 6, Kaplan 2, Bradner 1. Goals from foul line: Jacot 5, Olson 2, Schulberg 4, Sappoe 1. Referee—Reynolds. Umpire—Kaplan. Timekeeper, Welker. Scorer—Sutherland.[31]

While leaving the court with their self-esteem dragging, the CCNY team begged for a rematch but in New York City. The Professor assured Coach Palmer that a rematch was a good idea. The following day didn't get any better for the CCNY quintet when they moved over to the new floor at Clarkson Tech. At first, the only ominous sign for CCNY was the sight of Professor Blood on the Clarkson bench. The city boys came out fast and led 13-12 at the half. It was anyone's game until the last five minutes when Clarkson secured a lead that CCNY could not overcome. The final score was 27-23.

Two weeks later, Blood took the Potsdam Normal Five on a four-game road trip that included the promised game with CCNY. He made NYC his first stop because he knew the strength and determination of the CCNY team, and he would rather play them while his boys were still fresh.

As one would expect, the CCNY team was ready, and they showed their readiness by manhandling the high school boys to a 12-6 half time lead. After the intermission, the New Yorkers "had little difficulty in holding their lead until within the last seven minutes. At this stage the Potsdam boys solved the City College strategy and formations and began to score rapidly." Potsdam came back to win 26-21.[32] A year later,

Prof's Clarkson Golden Knights defeated the powerful CCNY team again for the third time in two years.

In early February of the same season, St. John's College of Brooklyn (now St. John's University) came to play little Clarkson. The newspaper described the game as follows: "The game was straight basketball from the blowing of the whistle until time was called at the end of the second half. The teams were very evenly matched, with Clarkson possibly excelling somewhat in teamwork. At the end of the first half the score stood 13 to 12 in favor of St. John's." In the second half, the Clarkson boys rallied to win the game by a score of 21-17.

The following season, Clarkson and St. John's met again in Brooklyn. Captained by Luther Olson, a standout from Brooklyn, there was no stopping Clarkson as they socked St. John's again 29-23.

Towards the end of the 1912-1913 season, the Niagara University Purple Eagles came to play the two Potsdam schools. After trying to cope with the rapid passing attack of the Tech schoolers, (Niagara players: Kelleher, McCann, Jollon, Blake, and King), the Purple Eagles received a 45-33 trimming.[35] The following night, they lost again to the Normal Five in overtime 38-30.

CLARKSON (21)		ST. JOHN'S (17)
Jacot	r.f.	Driscoll
Olsen	l.f.	Tracey
Reynolds	c.	Mahoney
West	r.g.	Crenney
McNulty	l.g.	Buechell

Goals from field: Olsen 5, Reynolds 1, West 2, McNulty 1, Driscoll 1, Tracey 2, Mahoney 1, Buechell 2, Crenney 1. Goals from fouls: Jacot 3, Buechell 3. Referee—Reed, St. Lawrence.[33]

CLARKSON (29)		ST. JOHN'S (23)
Jacot	l.f.	Driscoll
Barclay	r.f.	Nichols
Maley	c.	McCaffrey
Olson	l.g.	Casey
West	r.g.	Mahoney

Score at the half: Clarkson 16, St. John's 8. Field goals from fouls: Olson 3, Mahoney 7. Referee—Tom Thorp, Columbia. Time of halves: 20 minutes.[34]

During Blood's last two seasons in Potsdam (1913-1914 and 1914-1915), his teams continued upstaging the likes of CCNY, Niagara, and St. John's. Blood agreed to play anyone who would fit into his team's schedule. One additional match-up with the University of Notre Dame is worth elaboration. On Friday, February 13, 1914, all the bad luck belonged to the Irish. Coach Jesse Harper was in the first of his five seasons as head coach of Notre Dame, and he had a primed group of veteran athletes. Harper was also the football coach at Notre Dame, and his gridiron assistant and protégé at that time was Knute Rockne. On this particular afternoon, Harper wished he had stuck with football because his men were no match for Clarkson.

NOTRE DAME (22)		CLARKSON (32)
Jimmy Cahill (C)	r.f.	Gray Barclay (C)
Bergman, Kenney	l.f.	Jacot
Mills, Fitzgerald	c.	Maden
Kelleher	r.g.	Olson, Reynolds
Nowers	l.g.	West, Bassett

Field goals: Kenney 2, Nowers 2, Kelleher 2, Cahill, Mills, Fitzgerald, Barclay 6, Jacot 2, Olsen 3, Maden, West, Reynolds. Foul goals: Cahill 4, Barclay 3, and Jacot. Referee—Dudea.[36]

The Fighting Irish mystique, which surfaced in later years, was not apparent to Harper. ND's long road trip had left them tired and heavy-footed— sitting ducks for the quick-passing, accurate-shooting Tech players. From the Notre Dame perspective, "the Gold and Blue five outplayed Clarkson but had hard luck in shooting; time after time the ball rolled around the rim but never went in. Every member of the Potsdam team, on the other hand, shot with great accuracy…all the luck favored Clarkson." At the half, Clarkson led 17-9, and it didn't get much better. Before leaving for what was undoubtedly a long ride home, they were heard saying to one another, "Who were those guys?"

The accuracy of the records that remain from the Potsdam Normal College basketball team during Blood's years is questionable. Although it can be ascertained that while Blood's Normal Five never lost to another high school team, they did lose more than reported to teams out of their class. Some sources claim that the Normal Five lost only two games under Coach Blood, but this does not hold up under scrutiny.

When questioned about the Coach Blood basketball era, Potsdam State University officials could not provide evidence to substantiate the fantastic records. A complete list of scores or season records for his crack Normal Five and/or his second teams were not unavailable for verification. It does appear that the figures researched do not agree with those that had been reported. Prof Blood reportedly kept a comprehensive personal scrapbook about his teams and his career. But until that book is found (if it still exists), a reliable account of his teams' wins and losses at the normal school will never be determined. On the other hand, Blood's 40-5 record at Clarkson is well documented.

Dismissing the exactness of coaching records, the performance of Professor Blood's teams in Potsdam from 1906 to 1915 was next to incredible. To people on the outside, his basketball coaching reputation overshadowed his excellence as a physical director. But on campus, he impressed his students more with his ability to teach the full gamut of physical activities.

On many occasions, Blood would, as the opportunity presented itself, execute impromptu exhibitions on any one of the available gymnastics equipment. Indeed, seldom would he pass on an opportunity to perform for an audience. But first and foremost, he is remembered most for

always conducting himself as a gentleman. His own personal behavior and that of his students (basketball players) reflected his commitment to exemplary deportment.

In July of 1915, Blood received notice from Carl Ludwig Schraeder, his friend and colleague at Sargent's Summer School, that there were vacant positions in his field in Lynn, Massachusetts; Binghamton, New York; and Passaic, New Jersey. They appeared to be excellent situations that required the skills and experience he possessed.

The Passaic job had what Blood wanted: physical training for all grades, athletic supervision, and possibly coaching basketball. After talking with Superintendent of Schools for the city of Passaic, Dr. Fred S. Shepherd, it was obvious that Blood was clearly the best candidate. The position would enable him to install his own system, practice his own theories, and build his own program from the ground up.[37]

Blood had earned a very good reputation and his request for support received a passionate response. Of the many references forwarded to Shepherd, the following two letters sum up the opinions about Blood during this period.

Dr. Freeman H. Allen of Colgate University in Hamilton, New York, wrote:

Dear Dr. Shepherd,

I knew Professor Blood for several years as an associate teacher at the State Normal School in Potsdam, N.Y. He was the Physical Director and was most successful. He has a pleasing personality though somewhat timid. He has remarkable self-control, is a good disciplinarian, and one whose influence is positive and wholesome. He is a Christian man, clean in life and thought. He is peculiarly [sic] well qualified as Physical Director for children and boys and girls of high school age. I believe he would be a splendid man for you.

> *Sincerely yours,*
> *F. H. Allen*
> *Colgate University[38]*

In a handwritten note, Dr. Thomas B. Stowell, the former President of Potsdam Normal School, sent the following recommendation:

Reply,
I have known Prof. Blood for many years,
1. He is a gentleman.
2. He is a master of his business.
3. He interests his classes-boys & girls.

4. I never had him refer a case to me for discipline.
5. He is a remarkable Coach at Basketball.
I endorse him without reservations.

> Thomas B. Stowell
> President State Normal School Potsdam
> 1889-1909
> Dept. of Education
> University Southern California 1909[39]

In subsequent interviews, the Potsdam basketball players expressed their fond memories of their former coach. He left them with more than memories of games won; he instilled in them a philosophy on life. Their remarks give insight into what Blood was like.[40]

Prof. Blood was a master teacher...he would stay in the gym until midnight teaching kids to play—Rufus L. Sisson, Jr. (Dartmouth University Basketball All American)

He seldom took time to eat. When not in the gym teaching bas-ketball he usually could be found at a drug store consuming large quantities of ice cream—Charles E. Jacot '15 (Clarkson College graduate in Electrical Engineering)

Prof. Blood was a master of technique and perfection.... He taught you every trick known in the game, and a lot that others never knew, but he would not condone anything less than the highest type of sportsmanship—Dr. Luther E. Olson '16 (former player and Clarkson Board of Trustees)

Blood used the college's conversion of the gymnasium into class-rooms as an opportunity to move forward in his field. He was a bit ambivalent over leaving the city, school, and students that he had enjoyed, and the prospects of more alluring challenges were too appealing to resist. He reasoned that there would be other kids who would come to mean as much to him as the Potsdam students. With visions of new challenges and in the prime of his life, the forty-three-year-old athletic coaching phenom turned his attention to Passaic.

Blood's exact basketball coaching record at the time of his move to Passaic appears impossible to calculate because of the dearth of reliable records. The Potsdam State University athletic department claimed to have no season-to-season records from the Blood Era. Discrepancies in reported scores of games and season records were rampant during the early years of basketball. The exactness of some reports on athletic events around and before the turn of the century has to be taken with a

degree of caution. In the case of Blood in Potsdam, five different sources could reveal five different variations of his team's stellar accomplishments.

Aside from Blood's reported 310-24 YMCA coaching record and 40-5 ledger at Clarkson College, it is difficult to come to consensus on other reported results during his nine years at Potsdam. For example, most sources in later years reported that Blood's high school coaching record at Potsdam was 68-0. What does appear to be reliable about this report, however, is that it coincides with the consensus that his "Normal Five" teams never lost a game to another high school.

Despite the fact that we know otherwise, most available sources today report Potsdam Normal School's record during the Blood years as 72 wins and 2 losses. This cannot be accurate because of the reliability of the 1909-1910 season's results indicating ten losses. In short, his exact record at the normal school may remain a mystery until more reliable information or a scrapbook from those years surfaces.

The fact remains, Blood, with over four hundred or possibly five hundred basketball victories to his name, was on his way to Passaic. He had been with the game almost from its inception and possessed more coaching experience than any of his peers. In the process, he developed a sound system of coaching. With the move to Passaic, the final stage was set for some of the most prodigious accomplishments in schoolboy basketball.

Chapter Four
Where's Blood?

Sometime before the start of the 1916-1917 school year, Prof Blood was informed that he would no longer be coaching the basketball team. The details of the change were not made public, but his reassignment may have been due to a shortage of male personnel, many of whom had recently joined the war effort. Who made the decision that Blood was not to coach?

Blood learned quickly that Mr. Arthur D. Arnold and he had different ideas regarding the importance of physical training and athletics in the high school. Their differences would continue and eventually escalate until four or five years later when they would erupt. How Blood actually felt about his reassignment is not known, but the two-year hiatus came during Blood's most productive years.

RUBE BRAMSON

Teaching assignments were changing from week to week as the military beefed up its response to the Great War. One physical training teacher lost to basic training was Rueben "Rube" Bramson, who, twenty-seven years later, became Passaic's basketball coach. Because of the shortage of male teachers, Blood shouldered an overloaded schedule of teaching and athletic supervision. The basketball coaching duties were turned over to Ralph E. Guillow who was appointed as the high school's physical training teacher.

Relieved of the basketball responsibility, Blood was able to spend more time visiting all the schools where he introduced his program of physical training. This opportunity enabled Blood to become acquainted with the more athletically gifted kids in the lower grades.

As the physical training programs in the lower grades prospered with Prof's attention, the high school basketball players were not faring as well. As with any coaching change, the atmosphere on the team was different. In the season's opener, Passaic hosted the talented St. Peter's Prep from Jersey City. The Prep's McLoughlin brothers proved a little

too much for Passaic and handed them a disappointing loss. Unable to find their teamwork in time, Passaic lost again at Blair Academy.

An SOS was sent out to Prof. Responding to the call of the players, Blood took over the team until the boys jelled. His influence was effective as the team went on to win the remaining ten games.[41]

No sooner had the 1917-1918 school year begun than a newly enacted law went into effect requiring all public schools to lengthen the school day by thirty minutes to provide extra time for physical training. America needed to prepare its youth physically for its inevitable involvement in the war.[42]

With Prof Blood remaining solely as the supervisor, a Mr. Ozmun was placed in charge of the basketball team. (Very little is known about Mr. Ozmun.) While Blood continued to produce results with the grammar school kids, the basketball team once again faltered. Ozmun took over just as the global Spanish Flu epidemic hit the Northeast. A coal shortage exacerbated matters by preventing some team members from practicing over the Christmas vacation. The season was riddled with problems. In short, the players' frustration was compounded by the knowledge that Prof Blood was nearby but not involved.

Although Ozmun's team won more than it lost, the internal problems could not be ignored. There was too much bickering on the team, and Ozmun's efforts to appease only made matters worse. Brief newspaper write-ups of his tenure implied that he had never won the respect of the players.

While school authorities had no complaints with the 12-5 record, had it not been for the frustrated players, complaining parents, and vocal fans, Ozmun may have been asked to stay on. Arnold's decision to bring Blood back was widely heralded throughout Passaic.

Blood's desire to coach again was no secret; he missed basketball. Resuming the coaching duties meant that he would have an overload of responsibilities. One area that he did not want curtailed was his work in the grammar schools. To teach kids to lead a healthy, active lifestyle, Prof knew physical training needed to begin in the lower grades—the earlier the better.

Shortly after the coaching change was announced, Prof expressed concerns regarding his salary. On July 2, 1918, Superintendent Shepherd informed Prof of a salary increase. He received the following letter at New Jersey's Camp Arapaho where he was employed as the summer camp director.

Dear Mr. Blood,

Last evening the Board voted to increase your salary one hundred dollars above that already granted for next year,

making your salary $2,000, and have changed the title of
your position to "Director of Physical Training."

Yours respectfully,
Fred S. Shepherd[43]

Now that Blood was settled in Passaic, he committed himself to directing summer camps. YMCA-sponsored summer programs provided opportunities for clean, wholesome fun away from the city. Because of his background, Prof was sought after for camp directorships. Summer camp was great for his kids, and it provided Blood with a summer income. The Blood's summer camp era spanned his children's teenage years. During these summers, Ernestine, Paul, and Ben either attended as campers or worked as counselors. Mrs. Blood was mainly a weekend warrior who would arrive on Friday and return home on Sunday.

THE 1918-1919 SEASON

While the Armistice of November 11, 1918, ended the Great War, Prof's reinstatement brought a halt to the conflicts affecting basketball at Passaic High. Now that Blood was back, optimism for the winter sport soared. After two years of neglect, the available talent just needed to be cultivated. He set out immediately to get the masses playing, firm in the belief that basketball was the best activity for all-around physical development. To encourage participation, he organized competition among the four classes. His attendance at these games served as a magnet for the school's athletes. The "place to be" after school soon became the high school's basement gym.

JOHN SIPP

JOHN ROOSMA

No sooner was the football season over than Prof greeted forty candidates for the team. Following a couple weeks of training, Prof picked his first and second teams. While the most experienced player was captain John Sipp, there was another tall, rangy youngster by the name of Johnny Roosma who had just returned to school. Johnny had quit school and entertained a dream of becoming a professional athlete. His brief leave from school ended after his father helped him realize that he would be better off if he secured an education first. His decision to return to school coincided with Prof's return.[44]

Blood unveiled his new recruits on December 8, 1918, by thrashing an Alumni team 42-10. The

44

most noticeable aspect of the new team was the return of the quick passing game reminiscent of Prof's team two years earlier. The December 13 edition of the *Daily Herald* reported to readers that "basketball [was] now a popular sport," and listed the team's schedule of games.[45]

PASSAIC	G	F	T	MONTCLAIR	G	F	T
Sipp	6	0	12	Thoburn	3	0	6
Roosma	2	9	13	Pettigrew	1	0	2
Lent	1	0	2	Schneidewind	6	6	18
Kerr	5	0	10	Tully	0	0	0
Tooker	0	0	0	Luachett	0	0	0
Totals	**14**	**9**	**37**	Lester	0	0	0
				Totals	**10**	**6**	**26**

Referee—A. G. Turner. Scorers—Hopper, D. Wilcox. Timers—Mayfield, Van Ripper. Score at half time: 29-18. Attendance 400.[46]

After three weeks of practice, Passaic opened on New Year's Eve by smothering North Plainfield 80-34, with Sipp and Roosma netting 26 apiece.

Fans were beginning to realize that Blood's team had something special. More people took note when the Montclair team, led by the alleged seven-foot center Schneidewind and a cast of six-footers considered to be contenders for state honors, arrived ready to play. Because Schneidewind controlled the tip-offs, the Passaic kids had to earn every point to secure this victory. The Montclair giant made his eighteen points look easy, but it was the superior shooting and physical conditioning of the Passaic team that was the real story. Astonishingly enough, the win over Montclair was accomplished without Herbert "Ike" Rumsey, the 5'10" jumping-jack center who was out sick. To play and win without Ike made this victory all the more special.

CHARLES LENT

One by one, Passaic's opponents fell. The boys learned the Blood system—pass it, pass it, pass it; play as a team and learn to sacrifice individualism for teamwork. As the victories came and the attendance swelled, the fans embraced the team's style of play.

The basketball team had something else to look forward to this season—the newly formed New Jersey State Interscholastic Athletic Association (NJSIAA) was organizing its first statewide basketball championship. After its eighteenth win of the season, a 55-11 pounding of Ridgewood, Passaic won the Northern New Jersey Interscholastic League (NNJIL) title and an invitation to the new state play-offs. In the sectional play-off, Passaic's teamwork was too much for Bloomfield (50-31) and

IKE RUMSEY

put Passaic in the state semifinals against a school from the coast resort town of Atlantic City. Trenton was the top team in the state as identified by the sports writers, but Passaic was a close second. On Friday, March 14, an excited Passaic squad and fans traveled to the 500 seat Ballantine Gymnasium at Rutgers College in New

PASSAIC				ATLANTIC CITY			
	G	F	T		G	F	T
Sipp	5	0	10	Rossler	3	0	6
Roosma	2	5	9	Cormack	1	0	2
Rumsey	0	0	8	Miller	2	8	12
Lent	3	0	6	Loeb	2	0	4
Kerr	7	0	14	Laws	0	0	0
Totals	**21**	**5**	**47**	**Totals**	**8**	**8**	**24**

Score by halves:

Passaic	29	27	**47**
Atlantic City	13	11	**24**

Referee—Carl Reed, Springfield YMCA.
Umpire—George P. Cartwright, Philadelphia.

Brunswick for the evening's second game with Atlantic City. In the tip-off game, it was Trenton versus Union Hill.

Leroy "Red" Smith, who had a cast of stars, coached the favored Trenton team. But Smith's boys, Sammie Turano, Harry Andrews, Captain Teddie Kearns, Walter Collender, and Jimmie Thropp, were upset 38-33 by a quick Union Hill squad. In the nightcap, Passaic put Atlantic City away early.

After a long emotional day, it was after 11:00 p.m. by the time the team arrived home in Passaic. The next morning, the players had to

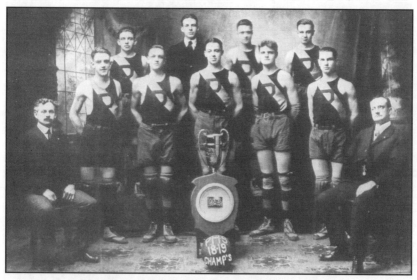

1919 PASSAIC BASKETBALL TEAM
FIRST ROW, LEFT TO RIGHT: COACH BLOOD, CHARLES LENT, JOHNNY ROOSMA, HERBERT "IKE" RUMSEY, JOHN SIPP, WILLIAM KERR. SECOND ROW: JOSEPH LEVENDUSKY, DONALD C. WILCOX (MANAGER), HAROLD TOOKER AND DOW H. DRUKKER, JR., PRINCIPAL ARTHUR D. ARNOLD

make the one hour return trip back for the final game with Union Hill scheduled for the early afternoon.

Midway through the first half, the tenacious Union Hill team, clad in their orange and blues, rattled Passaic with their aggressiveness. For years, second-guessers claimed that Passaic should have called a time out when

UNION HILL				PASSAIC			
	G	F	T		G	F	T
Benzoni	5	0	10	Sipp	1	0	2
Eckert	4	6	14	Roosma	1	10	12
Kensler	1	0	2	Rumsey	2	0	4
Bird	2	0	4	Kerr	1	0	2
Black	1	0	2	Lent	0	0	0
Totals	**13**	**6**	**32**	**Totals**	**5**	**10**	**20**

Score by halves:
Union Hill 22 10 **32** Fouls on UHHS, 15;
Passaic 10 10 **20** Fouls on PHS, 7.

Referee—Carl Reed. Umpire—George P. Cartwright.[51]

Union Hill rallied. Sports writers covering the game echoed similar sentiments. "Passaic should have called 'time-out' here, but for some reason or another Captain Johnny Sipp elected to play on."[47]

The general consensus of the fans was that the normally reliable Johnny Sipp lost his composure under the pressure. Teammate Roosma's opinion may have been influenced by his friendship with Dow Drukker, Jr., when he remarked, "If Prof had substituted Drukker for Sipp five minutes sooner, we might have won that game." Roosma was convinced that "Dow Drukker should have played more."[48] Nevertheless, Sipp went on to a stellar basketball career at Harvard University. Roosma further elaborated that Prof erred in choosing to return to Passaic the night before the game, feeling the long drive took its toll on the team. In Roosma's words, "We should have stayed at Rutgers…it was a mistake to drive home."[49]

Passaic's first half deficit of 22-10 was never made up, thus crowning Union Hill New Jersey's first state champions. The Union Hill defeat ended Prof's winning streak at forty-one games. After the game, Prof never mentioned anything about the loss—then or later. The game was

BALLANTINE GYM
Photo courtesy of the Special Collections and University Archives, Archibald S. Alexander Library, Rutgers, The State University of New Jersey

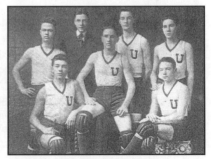

VICTORIOUS UNION HILL TEAM

47

over. "There was never an ill word [from Prof] about the defeat," Roosma recalled.[50] While Prof was able to peacefully put it behind him, the date of March 15, 1919, would long remain a bleak memory in the minds of the Passaic players and sports fans.

The team's success had a very noticeable effect on the school and community—the resurgence of pride and widespread interest in basketball was evident. In early Spring, Prof took advantage of the game's popularity by assigning his physical training teacher to supervise an inter-class league after school. The basement gym was filled with boys anxious to play basketball.

With basketball fever following the Spanish Flu epidemic, everyone wanted a dose of basketball. With Prof as the impetus behind the scenes, basketball was undeniably the sport *du jour*. The state runner-up team would be losing only Sipp to graduation. Add the returning nucleus to Passaic's second team, which had enjoyed another undefeated season, and future seasons were already looking good. Passaic wanted another crack at Union Hill. Everyone in Passaic was echoing the same cliché, "Wait 'til next year."

#	Date	Opponent	PHS	OPP
\multicolumn	**PASSAIC'S 1918-1919 SEASON**			
21	December 8	Alumni	42	10
22	December 31	North Plainfield	80	34
23	January 4	Montclair	37	26
24	January 11	Leonia	69	6
25	January 15	Hackensack	58	18
26	January 18	Englewood	37	23
27	January 22	Cliffside	53	1
28	January 28	Camp Merritt	79	28
29	January 29	Ridgewood	60	29
30	January 31	Leonia	63	9
31	February 5	Kearny	74	28
32	February 6	Emerson	54	33
33	February 7	Hackensack	41	12
34	February 12	Rutherford	55	11
35	February 15	Englewood	37	20
36	February 18	Cliffside	40	14
37	February 22	Rutherford	36	8
38	February 26	Ridgewood	55	11
39	March 7	Bloomfield	50	31
40	March 11	Alumni	39	27
41	March 14	Atlantic City	47	24
42	March 15	Union Hill	20	32 L[52]

Chapter Five
A System in Place
(1919-1920)

The Great War officially ended on June 28, 1919, in Paris with the signing of the Treaty of Versailles. The Big Four, George, Orlando, Clemenceau, and Wilson, met to decide how the victors would control the war's final prizes, the natural resources and wealth of Africa, Asia, and the Middle East. A solution to the problem that existed in the mind of the Passaic High School principal apparently was equally difficult. After the basketball team finished second in the state, Arnold was undecided about what to do with the coach.

During the summer, the school district hired another physical training teacher by the name of Amasa A. Marks. He had some basketball coaching experience that undoubtedly contributed to his hire. Arnold wanted Marks to teach the high school physical training classes and coach the basketball team, thus removing Blood from basketball. Arnold's agenda was to have Blood devote more time to the school district's physical training program, or was it a ploy to get him away from basketball?

The amiable 6'2" Marks was born in St. Claire, **AMASA** Pennsylvania, but grew up in Greenwich, Connecticut. **MARKS** He also attended Phillips Exeter Academy and later graduated from the Savage Institute of Physical Training. Marks was employed by the Bedford YMCA as a gymnasium teacher and later coached basketball at Erasmus High School. He also served as the supervisor of physical training at Glenn Falls High School.[53]

On the national scene, the cause of the influenza epidemic that accounted for 80,000 deaths was finally resolved. A period of optimism followed the World War years. Passaic's population was now over 60,000, and the factories that employed the people were bustling with productivity. The "Peaceful Valley" had become a boomtown.

The school year debuted with much excitement as Coach Ollo A. Kennedy's football team pulled off an 8-2 season. Shortly after football, Coach Marks greeted sixty enthusiastic basketball team candidates. It must have been a sight to see that many players packed into the tiny basement

basketball court. Today the old gym is used as a cafeteria, and the building has been renamed Lincoln Middle School.

The memories of the disappointing loss to Union Hill added spunk and spirit to these early practice sessions. The players had physically matured since last season; they were bigger and stronger and knew that they could be very good. They were confident and had high expectations for the season. What school could possibly stop them? Besides, Union Hill's star player, Benzoni, had gone off to Rutgers College.

EDDIE BENZONI

It did not take more than a couple of practices for the players to notice the change, and it wasn't good. Where was Prof? The players liked Coach Marks, but he didn't have the knowledge of the game, methods of teaching, nor the discipline to which they were accustomed. Problems quickly emerged. The boys were concerned that their goals for the season—defeat Union Hill and win the state championship—would elude them. They wanted Prof back, so they urged Karl Helfrich, the team manager, to do something. Helfrich went to the school board with the team's concerns. As a result, Arnold reneged his position and asked Prof to pick up the reins once again. On paper, nothing changed; Marks was still listed as the coach. In the eyes of the players, however, the change was profound; Prof, advisory coach or whatever the school wanted to label him, was back.

Presto! The players' concerns were put to rest as the new season was set to begin. Prof's presence in the gym, once again, was ubiquitous. His passion, knowledge, and air of authority filled the gym and with it returned the intensity and sense of purpose that had waned. Within a few practices, the ball movement, characteristic of last year's team, returned. Prof's presence had a way of motivating the group to perform at a higher level. For these boys and for those to follow, his image would become etched forever in their minds. They would all remember him saying, "Pass, pass, pass...don't hold it, don't dribble it...pass it, pass it!" Progress came quickly. Even Prof thought the team had promise, but he knew only time would tell.

GAME #1 Newark JC (Wednesday, December 17, 1919) at South Side HS, Newark. The first game is always difficult, especially when the team only had a short period of time to get ready. Passaic expected and received a hard-fought game, but the opposition tired out in the second half from chasing the Red and Blue boys around the court. Passaic's passing and shooting was so impressive that the fans applauded their

performance. The basketball losing streak was over. Final score: **Passaic 44-Newark Junior College 11.**

With additional time to practice over the Christmas holidays, the team had the chance to absorb more of Prof's wisdom and time to learn his plays. This allowed the boys to hone their skills thus making it more difficult for their next opponent.

PASSAIC				NEWARK JC			
	G	F	T		G	F	T
Lent	8	0	16	Finklestein	0	5	5
Roosma	8	8	24	Canfield	3	0	6
Drukker	0	0	0	Grossblatt	0	0	0
Rumsey	0	0	0	Anuario	0	0	0
Kerr	2	0	4	Rosenblum	0	0	0
Schneider	0	0	0	Shapiro	0	0	0
Totals	**18**	**8**	**44**	Mara	0	0	0
Passaic		21	23	Handler	0	0	0
Newark JC		9	2	**Totals**	**3**	**5**	**11**

Referee—Silverman. Scorers—Helfrich, Miss Johnson. Timers—Shin, Martin. Time of halves: 20 minutes.[54]

GAME #2 Springfield, Newark, (Wednesday, December 31, 1919) at Passaic HS. Dancing before and after the game was the highlight of this New Year's Eve record-breaking-gate-receipts ($150.00) game. The outcome revealed the devastation that awaited an ill-equipped opponent. It didn't matter that the undefeated visitors arrived with impressive victories to their credit. For future reference, note that substitute Dow Drukker scored two points but would score only two more points while seeing limited action for the remainder of the season. Final score: **Passaic 92-Springfield 2.**

PASSAIC				SPRINGFIELD			
	G	F	T		G	F	T
Lent	18	0	36	Mordof	0	0	0
Roosma	11	6	28	Reeves	1	0	2
Rumsey	5	0	10	Giry	0	0	0
Tooker	4	0	8	Clifford	0	0	0
Schneider	3	0	6	Richard	0	0	0
Keasler	1	0	2	**Totals**	**1**	**0**	**2**
Drukker	1	0	2				
Smith	0	0	0				
Totals	**43**	**6**	**92**[55]				

Sports enthusiasts throughout the city were all abuzz over the basketball team's score. With curiosity, the city waited to see what the boys were going to do with the strong New York University freshman team. The undefeated NYU freshmen, all high school stars, had bested five good opponents, including the West Point plebes, Columbia freshmen, Fordham freshmen, and Brooklyn Tech boys.

With the exception of the news that the Boston Red Sox had sold Babe Ruth to the Yankees for $125,000, the majority of the talk in Passaic focused on the outcome of the NYU freshman game. Many NYU alumni living in the area had seen the freshman club play and knew that Passaic

could be in big trouble. What added to the anticipation of this game was not the dancing scheduled before and after the game but the air of confidence exuded by Prof's boys.

GAME #3 NYU Freshman (Thursday, January 8, 1920) at Passaic HS. In an attempt to better utilize the abilities of his players to meet the NYU challenge, Prof moved Charlie Lent to guard and put ninth grader DeWitt Keasler at forward. With some nervousness, Keasler showed that he was deserving of the opportunity. The 5'10" center Herbert "Ike" Rumsey was all over the court entertaining the crowd with his agility and leaping ability.

For those few who were still unaware of the results the day after the game, the reactions ran from surprise to disbelief. The ardent fans were not too surprised to learn that Passaic had won, but the final score shocked them. The *Daily News* headline read: **PASSAIC HIGH SCHOOL BASKETBALL FIVE DEFEATS N.Y.U. FRESHMAN TEAM EASILY**.

It was an early season classic, but was it a harbinger of things to come? Sennert's Band played well for the dancing during the evening, and cheerleader Sturgis led the crowd through Passaic cheers and ballads. The college stars only managed two field goals. Could Passaic be that good? Final score: **Passaic 32-NYU Freshman 6.**

PASSAIC				NYU FRESHMAN			
	G	F	T		G	F	T
Roosma	5	6	16	Rosenfeld	0	0	0
Keasler	3	0	6	Ritter	0	2	2
Rumsey	4	0	8	Baxter	1	0	2
Lent	1	0	2	Duncan	0	0	0
Kerr	0	0	0	Moberg	0	0	0
Schneider	0	0	0	MacGratten	1	0	2
Totals	**13**	**6**	**32**	Throop	0	0	0
				Peterson	0	0	0
				Totals	**2**	**2**	**6**

Half time: 13-0, Referee—Deal, Paterson. Timers—Roosma and Gelman.[56]

GAME #4 Leonia (Saturday, January 10, 1920) at Leonia HS. The team experienced a letdown in their first Northern New Jersey League game with Leonia. Leonia's basket hanging (AKA cherry picking) strategy caught Passaic by surprise. Regardless, it was a lackluster game with little excitement and too many unnecessary fouls. Final score: **Passaic 58-Leonia 25.**

PASSAIC				LEONIA			
	G	F	T		G	F	T
Roosma	8	14	30	Kelly	2	1	5
Keasler	6	0	12	Nicholaus	3	0	6
Rumsey	7	0	14	Johnson	0	0	0
Lent	1	0	2	Sharp	0	10	10
Kerr	0	0	0	Clark	0	0	0
Schneider	0	0	0	Nicholas	2	0	4
Drukker	0	0	0	**Totals**	**7**	**11**	**25**
Smith	0	0	0				
Totals	**22**	**14**	**58**				

Score by periods:

	Passaic	27	31
	Leonia	11	14

Referee—Mr. Liberman. Timers—Roosma, Swenson. Scorer—Helfrich.[57]

GAME #5 Hackensack (Wednesday, January 14, 1920) at Passaic HS. On one of the coldest days of the new year, the team traveled to Hackensack. The sloppy play of the Leonia game was gone as Hackensack absorbed one of its worst defeats. The 27-3 score at half time was the best Hackensack had to offer because they failed to score in the second half. Final score: **Passaic 47-Hackensack 3.**

GAME #6 Englewood (Saturday, January 17, 1920) at Passaic HS. On the day after the federal government passed the Eighteenth Amendment—Prohibition— Passaic was doing some passing of their own. The Volstead Act officially banned beer, wine, and

PASSAIC	G	F	T	HACKENSACK	G	F	T
Roosma	6	7	19	Geraghty	0	1	1
Keasler	6	0	12	Koestner	0	0	0
Rumsey	6	0	12	Ward	1	0	2
Lent	1	0	2	Bock	0	0	0
Schneider	0	0	0	Brockner	0	0	0
Durkker	1	0	2	A. Pfluge	0	0	0
Tooker	0	0	0	H. Pfluge	0	0	0
Smith	0	0	0	**Totals**	**1**	**1**	**3**
Totals	**20**	**7**	**47**				

Score at half: 27-3. Referee—Joe Johnson. Scorers—Helfrich and Smith.[58]

PASSAIC	G	F	T	ENGLEWOOD	G	F	T
Roosma	9	2	20	Simmons	2	9	13
Keasler	7	0	14	Doyle	0	0	0
Rumsey	5	0	10	Klath	2	0	4
Lent	3	0	6	McCoy	0	0	0
Schneider	1	0	2	Katz	0	0	0
Tooker	0	0	0	**Totals**	**4**	**9**	**17**
Drukker	0	0	0				
Smith	0	0	0	Score at the half:			
Totals	**27**	**2**	**56**	30-6			

Referee—T. Wachenfeld. Timer—Shinn, Sullivan. Scorers—Helfrich, Campbell.[59]

liquor, but it did nothing to control the noisy, boisterous Passaic fans when they arrived for the Englewood game.

The crowd in the hilltop gym was in a rowdy mood. On this occasion, the fans were unusually boisterous. The paying customers did not appreciate Referee T. Wachenfeld's calls. They especially did not condone the three quick fouls—in one minute—called on Roosma. This was still the era of four fouls disqualifying a player. The spectators hissed almost everything that went against Passaic. Wachenfeld had to threaten the crowd with removal from the gym and/or forfeiture of the game if they didn't settle down. Final score: **Passaic 56-Englewood 17.**

GAME #7 Cliffside (Wednesday, January 21, 1920) at Cliffside Park. The high caliber of play from the previous game continued. It was at this juncture that Prof first saw signs of a possible state championship team. His team was quick, talented, and well-balanced with a capable player in each position. Captain Charlie Lent and Johnny Roosma were as fine as any duo in the state. He had young substitutes (Harold Swenson, Paul Blood, and Fritz Knothe) pushing the older subs and starters hoping to get playing time. Final score: **Passaic 67-Cliffside Park 10.**

GAME #8 Montclair (Saturday, January 24, 1920) at Montclair. The first real test for the team came against the crack Montclair team coached by John S. Nelson. Passaic led throughout, but at one point late in the fray, the lead was only two points. Passaic's teamwork startled everyone; it was an exhibition the likes of which had never been seen before. When Montclair made its final run, Passaic kept its poise. Montclair was a good team, and by season's end, they were rated number two in North Jersey and fifth in the state. Final score: **Passaic 29-Montclair 24.**

PASSAIC	G	F	T	MONTCLAIR	G	F	T
Lent	4	0	8	Scheifler	3	6	12
Roosma	4	7	11	DeFalco	2	0	4
Rumsey	1	0	2	Lundell	3	0	6
Schneider	1	0	2	Lankton	0	0	0
Kerr	1	0	2	Mueller	1	0	2
Totals	**11**	**7**	**29**	**Totals**	**9**	**6**	**24**

Referee—T. Wachenfeld[60]

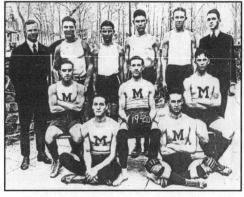

MONTCLAIR TEAM

GAME #9 Ridgewood (Wednesday, January 28, 1920) at Passaic HS. A tough little Ridgewood team visited Passaic with unrealistic expectations, although the game was not as much a runaway as the score indicated. At the end of the first half, Passaic led 12-6. Eventually Passaic's superior passing and shooting put the game on ice. Rumsey played rings around Dreier, Ridgewood's 6'5", two-hundred-pound center. Final score: **Passaic 40-Ridgewood 13.**

PASSAIC	G	F	T	RIDGEWOOD	G	F	T
Roosma	7	4	18	Kidder	1	4	6
Keasler	6	0	12	Fielding	2	1	5
Rumsey	2	0	4	Dreier	0	0	0
Lent	3	0	6	Fisher	1	0	2
Schneider	0	0	0	White	0	0	0
Kerr	0	0	0	**Totals**	**4**	**5**	**13**
Totals	**18**	**4**	**40**				

Referee—T. Wachenfeld. Timers—Harrit, Roosma, H. Shinn. Scorers—K. Helfrich, E. Sullivan.[61]

GAME #10 Leonia (Saturday, January 31, 1920) at Passaic HS. A reluctant Leonia team returned to Passaic for the rematch. In a lackluster affair featuring poor shooting, the outcome was never in doubt. Rutherford, Passaic's closest rival for the league championship, had beaten Leonia previously by only two points. Passaic's teamwork baffled the Bergen quintet. Final score: **Passaic 40-Leonia 13.**

GAME #11 Hackensack (February 4, 1920) at Passaic HS. Because Ike Rumsey, Milton Schneider, and sub Dow Drukker were home with the flu, the Hackensack squad arrived with a realistic hope for revenge. Nevertheless, the Golden Comets took their defeat gracefully as Passaic's makeshift lineup was enough. Final score: **Passaic 58-Hackensack 24.**

GAME #12 Rutherford (Thursday, February 12, 1920) at Columbia Park, Union Hill. Lincoln's birthday was also "Passaic Day" at the large Columbia Amusement Park court where Passaic overwhelmed Rutherford for the NNJIL championship. A noisy delegation (record crowd) of fans were jitney bussed all the way from various points in Bergen and Passaic counties to see the game.

The poor first-half showing by Rutherford disappointed their fans. Passaic was still without Rumsey (influenza), but there was never any doubt as Passaic led all the way. The former Passaic mentor Ralph E. Guillow guided the Bergen County boys to a respectable showing in the second half. Without Rumsey, the center jumps belonged to Rutherford, thus putting extra pressure on Passaic to get the ball.

Johnny Roosma would never forget this encounter because it cost him his two front teeth.[64] Final score: **Passaic 37-Rutherford 19.**

PASSAIC	G	F	T	LEONIA	G	F	T
Roosma	8	2	18	Kelly	0	0	0
Drukker	1	0	2	Nicholaus	2	0	4
Rumsey	4	0	8	Johnson	0	6	6
Lent	5	10	0	Sharp	1	0	2
Schneider	1	0	2	Clarke	0	0	0
Smith	0	0	0	**Total**	**3**	**6**	**12**
Total	**19**	**10**	**40**				

Referee—Mr. G. Cavallero, South Side High. Timers—Helfrich and Mr. Roosma. Scorer—Mr. Campbell. Half time score: 24-6.[62]

PASSAIC	G	F	T	HACKENSACK	G	F	T
Roosma	9	2	20	Geraghty	2	8	12
Swenson	1	0	2	G.Koestner	1	0	2
E. Rosman	2	0	4	Ward	2	0	4
Keasler	5	0	10	Pflugi	1	0	2
Lent	9	0	18	Bock	0	0	0
Smith	2	0	4	H.Koestner	2	0	4
Total	**28**	**2**	**58**	Zimmermann	0	0	0
				Hall	0	0	0
				Tallman	0	0	0
				Total	**8**	**8**	**24**

Referee—Joe Johnson. Scorers—Helfrich and Smith. Timers—Harritt, Roosma[63]

PASSAIC	G	F	T	RUTHERFORD	G	F	T
Roosma	6	5	17	Whitehill	5	0	10
Keasler	5	0	10	Gibson	3	0	6
Smith	0	0	0	Black	1	0	2
Lent	5	0	10	Lightfoot	0	0	0
Schneider	0	0	0	Wood	0	1	1
Swenson	0	0	0	**Totals**	**9**	**1**	**19**
Blood	0	0	0	Timers—Allan, Shinn.			
Knothe	0	0	0	Scorers—Helfrick.			
Totals	**16**	**5**	**37**	Referee—Joe Johnson.			

Score by periods:

Passaic	21	16	**34**
Rutherford	5	14	**25**[65]

GAME #13 Cliffside (Saturday, February 14, 1920) at Passaic HS. The local boys' poor performances against Cliffside can be blamed on two factors: the head colds caught while playing outside during the Rutherford game and, more importantly, the absence of Roosma who was attending the funeral of his sister who died suddenly the previous week. Without Roosma, Passaic was vulnerable. Prof knew Roosma was the player he could least afford to lose. But Ike Rumsey was back, so Cliffside Coach Robert L. Burns took his boys home with a loss. Note: Dow Drukker replaced Roosma, but he failed to score. Dow does not play again until the South Orange game on March 12. Final score: **Passaic 39-Cliffside Park 14.**

GAME #14 Hasbrouck Heights (Wednesday, February 18, 1920) at Hasbrouck Heights. The starting five was together for the first time in over three weeks, but adversity still lingered. The team's jitney bus broke down two miles from Hasbrouck Heights's Pioneer Club court. Since the trolleys were not running, the boys had to finish the trip tromping through snow and slush. In what would best be referred to as a masterpiece, Passaic dazzled the hometown boys into total submission. Final score: **Passaic 85-Hasbrouck Heights 14.**

PASSAIC				CLIFFSIDE			
	G	F	T		G	F	T
Keasler	4	3	11	McCloskey	1	6	8
Drukker	0	0	0	Emptage	1	0	2
Rumsey	7	0	14	Kirmayer	2	0	4
Lent	6	0	12	Greenleaf	0	0	0
Schneider	0	0	0	Martens	0	0	0
Smith	0	0	0	**Totals**	**4**	**6**	**14**
Swenson	1	0	2				
Totals	**18**	**3**	**39**				

Timer—Sullivan, Whitlin. Scorer—Helfrich. Referee—G. Cavallero.[66]

CLIFFSIDE BOYS

PASSAIC				HASBROUCK HEIGHTS			
	G	F	T		G	F	T
Roosma	9	11	29	Bridgewater	0	6	6
Keasler	9	0	18	Bilas	1	0	2
Rumsey	6	0	12	Pagano	1	0	2
Lent	8	0	16	Ingui	0	0	0
Schneider	0	0	0	Dolan	2	0	4
Swenson	5	0	10	**Totals**	**4**	**6**	**14**
Blood	0	0	0				
Smith	0	0	3	Time of periods:			
Totals	**37**	**11**	**85**	15 & 20 min.			

Referee—Green, Hackensack. Timers—Shinn, Golsey. Scorer—Helfrich[67]

GAME #15 Rutherford (Monday, February 23, 1920) at Montclair HS. On a bitter cold February afternoon, Passaic was scheduled to play at Rutherford's bandbox court, but Manager Karl Helfrich arranged for the game to be moved to Montclair's gym. The stockier Rutherford players led by Benny Gibson used their height and heavier weight well, but eventually it was to no avail against Passaic's quick execution. Final score: **Passaic 35-Rutherford 24.**

GAME #16 Hasbrouck Heights (Wednesday, February 25) at Passaic HS. A week after defeating Hasbrouk Heights, Passaic did it again. The visitors could come up with nothing new to stop Passaic's teamwork.

PASSAIC				RUTHERFORD			
	G	F	T		G	F	T
Roosma	4	12	20	Whitehill	2	2	6
Keasler	2	0	4	Gibson	7	2	16
Rumsey	3	0	6	Black	1	0	2
Lent	1	0	2	Lightfoot	0	0	0
Schneider	1	0	2	Wood	0	1	1
Totals	**11**	**12**	**34**	**Totals**	**10**	**5**	**25**

Score by periods:

Passaic	18	16
Rutherford	11	4

Referee—Joseph Johnson. Timer—Keating, Rutherford; Bross—Passaic. Scorer—Helfrich. Time of halves: 20 min.[68]

PASSAIC				HASBROUCK HEIGHTS			
	G	F	T		G	F	T
Roosma	2	4	8	Bridgewater	2	2	6
Keasler	5	0	10	Bilas	0	0	0
Rumsey	3	0	6	Pagano	1	0	2
Lent	10	0	20	Ingui	0	0	0
Schneider	1	0	2	Dolan	0	0	0
Gale	1	0	2	**Totals**	**3**	**2**	**8**
Swenson	2	3	7				
Knothe	3	0	6				
Blood	2	0	4				
Smith	1	0	2				
Totals	**30**	**7**	**67**[69]				

Referee—T. Wachenfeld. Time of periods: 17 mins. Timers—Harrie, Roosma. Scorer—Helfrich.

The 46-0 score at half time was one thing, but getting only three shots at the goal during the second half told the real story. Final score: **Passaic 67-Hasbrouck Heights 8.**

GAME #17 Ridgewood (Saturday, February 28, 1920) at Ridgewood. The hospitality of the Ridgewood players matched the freezing cold weather outside. The rough tactics of the newest league entry proved ineffective against fleet-footed Passaic. The husky Ridgewood boys' strategy was to hold the score down, but all they managed to do was hold their own score down. Dreier, Ridgewood's tall center, constantly tapped the ball on the way up to negate Rumsey's

PASSAIC				RIDGEWOOD			
	G	F	T		G	F	T
Roosma	8	8	24	Fielding	1	4	6
Keasler	7	0	14	Kidder	1	0	2
Rumsey	4	0	8	Dreier	2	0	4
Lent	1	0	2	Fisher	1	0	2
Schneider	1	0	2	White	0	0	0
Smith	0	0	0	Fox	0	0	0
Swenson	1	0	2	**Totals**	**5**	**4**	**9**
Totals	**22**	**8**	**52**				

Referee—Johnson; Timers—Craig, Sullivan; Scorer—Van Kuyck.[70]

leaping ability. Once the ball was in play, Rumsey ran rings around Dreier. The win gave Passaic the championship of the NNJIL with one game remaining. Final score: **Passaic 54-Ridgewood 14.**

GAME #18 Nutley (Friday, March 5, 1920) at Passaic HS. The play date was originally scheduled for a game with Emerson. When they cancelled, Passaic was left scrambling to fill the open date. With the play-off season just ahead, Prof wanted his team to stay sharp for the sectional play-offs. In his quest for a game, he arranged two.

A naïve but confident Nutley team rode into Passaic thinking that they could win a game. The visitors soon realized that they had erred as the on-slaught of the Red and Blue offensive swept them off their feet. The score was 22-5 at the half, but the worst was yet to come. Final score: **Passaic 61-Nutley 11.**

GAME #19 Englewood (Saturday, March 6, 1920) at Englewood. Playing without the ill Keasler put the spot-light on Roosma who had a field day outscoring the entire Englewood team. This was the final league game, and it appeared as though Passaic was peaking. Final score: **Passaic 54-Englewood 14.**

GAME #20 Newark Junior College (Monday, March 8, 1920) at Passaic HS. Newark was having a good season; its only loss was against Passaic in the season opener. This rematch was to be retribution. The visitors built their game around the dribble and quickly turned the fray into a very tough, fast, and furious game. This type of game provided good defensive experience for

PASSAIC	G	F	T	NUTLEY	G	F	T
Roosma	11	7	29	Kirkleski	1	0	2
Keasler	2	0	4	Ellison	0	0	0
Rumsey	6	0	12	Redmond	2	5	9
Lent	7	0	14	Slovik	0	0	0
Schneider	1	0	2	Hillman	0	0	0
Totals	**27**	**7**	**61**	Speary	0	0	0
				Ormsbee	0	0	0
				Totals	**3**	**5**	**11**

Score at half: 22-5. Referee—Johnson. Timers—Shinn, Gray. Scorers—Helfrich, Gilbert.[71]

PASSAIC	G	F	T	ENGLEWOOD	G	F	T
Roosma	10	6	26	Simmons	2	4	8
Rumsey	5	0	10	Doyle	2	0	4
Swenson	4	0	8	Klath	1	0	2
Lent	5	0	10	McCoy	0	0	0
Schneider	0	0	0	Katz	0	0	0
Totals	**24**	**6**	**54**	**Totals**	**5**	**4**	**14**

Timers—Sullivan, Shinn, Sullivan. Scorers—Helfrich, Amsoor.[72]

PASSAIC	G	F	T	NEWARK JC	G	F	T
Roosma	9	6	24	Handler	4	0	8
Swenson	4	0	8	Canfield	4	10	18
Rumsey	4	0	8	Rosenblums	1	0	2
Lent	5	0	10	Levine	2	0	4
Schneider	0	0	0	Shapiro	0	0	0
Totals	**22**	**6**	**50**	**Totals**	**11**	**10**	**32**

Score at half time: Passaic 21, Newark 12. Referee—Johnson. Timers—Sullivan and Shine. Scorers—Stern, Helfrich.[73]

Passaic. After adjusting to the dribble attack, Passaic controlled the remainder of the game. In a battle of styles of play, Prof's "passing game" won out. Playing with a severe head cold, Roosma still managed to pump in the baskets. Final score: **Passaic 50-Newark JC 32.**

Basketball tournament time was here again, which meant if you lost a game, the season was over. Because Passaic was located in the densely populated northern section of the state, those teams had to survive a more arduous twelve-team elimination tournament. The south and central sections had far fewer teams which provided an easier route to the state finals.

GAME #21 South Orange (Friday, March 12, 1920) at Stevens Institute, Hoboken. In Passaic's first play-off game, Prof's boys completely outwitted South Orange. It was a team victory with Roosma and Lent igniting the passing offense. With Passaic leading 32-13 at half time, Prof elected to give the second team (Leon Smith, Harold Swenson and Dow Drukker) an opportunity to offset South Orange's rough tactics by controlling the ball for nearly two minutes before scoring.

Prof's son Paul, a sophomore, scored six points and impressed the large Passaic crowd with his hustle and court savvy. Paul was respected by his peers; he was quick, skilled, feisty, and possessed leadership qualities, but it appeared as if he were in his father's doghouse. If anyone else had been the coach, Paul would probably have been playing more. The alleged riff was supposedly over football. The difference of opinion had the dad wanting his son to forgo the contact sport while Paul, a tough, stubborn kid, insisted on playing along with his friends. His decision cost him his father's good graces until it became obvious Paul deserved playing time. Prof wanted his son to earn it and Paul did—ten times over.[74]

As another point of reference, Dow Drukker's and Harold Tooker's names were never mentioned in any Passaic basketball publications again. Their names were listed in the school yearbook, but they did not appear in any of the team's pictures taken upon the completion of the season. Sometime between this game and the North Plainfield game, it is believed that both boys left the team.

The energetic cheerleader Pep Sturgis was on hand to lead Passaic's faithful. Thanks to his initiative, the Passaic followers put on a show of spirited support. It was a sensational exhibition of basketball that left future

PASSAIC	G	F	T	SOUTH ORANGE	G	F	T
Roosma	8	11	27	Burns	1	6	8
Keasler	2	0	4	Leisser	1	0	2
Rumsey	3	0	6	Harvey	3	0	6
Lent	4	0	8	Bird	0	0	0
Schneider	0	0	0	Nolan	1	0	2
Smith	0	0	0	Gibbs	0	0	0
Swenson	0	0	0	Childs	0	0	0
Rosman	0	0	0	Bradbury	0	0	0
Blood	3	0	6	**Totals**	**6**	**6**	**18**
Knothe	0	0	0				
Totals	**0**	**11**	**51**[75]				

59

opponents and first-time viewers impressed. Studying the Passaic team carefully was Union Hill's Coach Skeets Wright and his team. Final score: **Passaic 51-South Orange 18.**

NORTHERN NEW JERSEY PLAY-OFF RESULTS

North Plainfield 24-Rutherford 16 Montclair 40-Dickinson 24
East Side 37-Bayonne 25 Union Hill-bye
West Orange 30-Hoboken 24 Orange-bye

GAME #22 North Plainfield (Wednesday, March 17, 1920) at Stevens Institute, Hoboken. North Plainfield believed that they had a shot at Passaic. The only problem Passaic could have would be looking past North Plainfield to Union Hill. The headlines the following day in the *Passaic Daily News* read: "North Plainfield Quintet Falls Before Red And Blue," but the headlines did not tell the whole story.

PASSAIC	G	F	T		N. PLAINFIELD	G	F	T
Roosma	7	6	20		Wolden	3	0	6
Blood	2	0	4		Townley	1	10	12
Rumsey	8	0	16		Yates	0	0	0
Lent	3	0	6		Feaster	0	0	0
Schneider	0	0	0		Taylor	0	0	0
Knothe	0	0	0		G.Feaster	0	0	0
Rosman	1	0	2		Seibling	0	0	0
Swenson	0	0	0		**Totals**	**4**	**10**	**18**
Gale	0	0	0					
Keasler	1	0	2		Score at half-time:			
Smith	0	0	0		31-19[76]			
Totals	**22**	**6**	**50**					

Referee—Joseph O'Shea. Umpire—J. P. Courtney.

The rapid ball movement and intricate teamwork of the Passaic boys dominated North Plainfield. With the addition of each substitute, the fine display of team basketball continued uninterrupted. By half time, conversations were centered on the long-awaited rematch with Union Hill. Final score**: Passaic 50-North Plainfield 18.**

NORTHERN NEW JERSEY PLAY-OFF RESULTS

Union Hill 28-Newark East Side 18 Montclair 45-Orange 41
West Orange-bye

GAME #23 Union Hill (Friday, March 19, 1920) at Stevens Institute, Hoboken. For a year and five days, the city of Passaic and its team had been living with what was referred to as the "black stain." The rematch was on, and according to sports pundits, these were the top two teams in the state with Passaic given the edge.

At the midpoint, Passaic was up one, but it was the first seven minutes of the second half that told the story of the game. The commentary for those few moments when the game was up for grabs went like this. On

resumption of play, Roosma missed a foul shot, and a moment later, Union Hill's future mayor, Tom Eckert, stepped to the line and tied the score. The next time down the court, Eckert drilled one from the center of the court putting UH up two, 15-13. Seconds later, Eckert added another free throw as the crowd in orange and blue jumped for joy.

After Union Hill fouled Keasler, Roosma stepped to the foul line with the opportunity to close the score to a one-point deficit, but he missed. Jumping jack Ike Rumsey grabbed Roosma's rebound and flipped the ball back in. Next, Charlie Lent's one-hander from the side gave Passaic a 17-16 lead. Lent's basket was the signal for the Passaic delegation to toss their hats—and anything

PASSAIC				UNION HILL			
	G	F	T		G	F	T
Roosma	4	8	16	Eckert	3	10	16
Keasler	0	0	0	Poelletti	0	0	0
Rumsey	3	0	6	Kuensler	0	0	0
Lent	3	0	6	Solomon	3	0	6
Schneider	0	0	0	Kraus	0	0	0
Knothe	0	0	0	McCauley	0	0	0
Blood	1	0	2	**Totals**	**6**	**10**	**22**
Totals	**11**	**8**	**30**				

Score by periods:		
Passaic	13	17
Union Hill	12	10

Referee—Lieutenant J. P. Courtney, Lafayette and Easton, PA. Sideline—Mr. John Plant.[77]

UNION HILL TEAM

else not secured to the floor—into the air. For a few moments, the din of the crowd was deafening.

Once securing the lead at 17-16, the Blood boys went into their passing game, forcing UH to leave their five-man zone defense and go get the ball. For the remainder of the game, Passaic would go on to score thirteen points to Union Hill's six. As Passaic continued to score on lay ups, Coach Wright, his team, and the fans grew frustrated as the game slipped away.

The headlines of the *Passaic Daily News* the day after the game posed a thought-provoking idea, "Passaic High School Basketeers Next State Champions?" The game was reported to have been the most exciting basketball game ever played. Final score: **Passaic 30-Union Hill 22.**

The performance of senior Ike Rumsey was so impressive that immediately after the game, the athletic director at West Point invited Ike to come to the academy. The Passaic jumping jack center was literally all over the court.

The main mode of travel to Hoboken was via the Erie Railroad that bisected the city. Because of the team's prowess and its string of victories, the number of fans grew larger with each game. In the early days, coaches and players rode the train along with parents and fans. On this particular return trip, when the 10:44 pulled into the main station, the frenzied fans put on a show for the unsuspecting commuters. As the players and fans stepped off the train, a spontaneous snake dance commenced. Men, women, and children hung on and danced through the train station celebrating Passaic's greatest basketball victory ever.

The newspapers fed the frenzy created by the team's unprecedented success. The *Passaic Daily News* provided those who could not attend the game with a running score on their bulletin board window. Through a special telephone service direct from the newspaper office to the scene of the game, the fans were kept abreast of the action. The bandwagon was growing larger as basketball fans discovered how much fun it was to follow the team.

NEW JERSEY STATE BASKETBALL PLAY-OFFS

Asbury Park 51-Lakewood 30 Neptune 37-Perth Amboy 11
Montclair 24-West Orange 14

GAME #24 Montclair (Saturday, March 20, 1920) at Stevens Institute, Hoboken. The following evening, Passaic was back at Walker Gym in a rematch with Montclair, but this time it was for the championship of all northern New Jersey. Two months earlier, Passaic defeated Montclair by five points in a hard-earned win. But since then, Montclair had continued to improve with three impressive victories over Dickinson, Orange, and West Orange.

PASSAIC			MONTCLAIR			
	G	F	T	G	F	T
Roosma 1	14	16	Schiefler 2	8	12	
Keasler 2	0	4	DeFalco 1	0	2	
Rumsey 3	0	6	Lundell 3	1	7	
Schneider 0	0	0	Mueller 0	0	0	
Lent 1	0	1	Lankton 0	0	0	
Knothe 0	0	0	Crowley 1	0	2	
Blood 0	0	0	Taft 0	0	0	
Gale 0	0	0	Parker 0	0	0	
Totals 7	**14**	**28**	**Totals 7**	**9**	**23**	

Score by periods: **Passaic** 15 13
Montclair 12 11

Referee—Joseph O'Shea. Umpire—Brunn.[78]

Coach Nelson's team provided a different type of challenge than Union Hill. Passaic started quickly leaving little doubt who would eventually prevail, but the second half was another story. In rapid succession, Milton Schneider, Charlie Lent, and Johnny Roosma fouled out leaving only two Passaic regulars to lead the charge. Visions of disaster filled the stuffy gymnasium

as the hearts of the Passaic fans became lodged in their throats—it was panicsville.

One composed Passaic personage, however, sat on the Passaic bench. One by one, Prof inserted Fritz Knothe for Schneider, his son for Lent, and finally Raymond Gale for Roosma. The three substitutes teamed up with Rumsey and Keasler and went into their ball-control offense. The real show was just beginning. According to eyewitnesses, the ball was passed with lighting-quick speed for three nonstop minutes. It was an impressive display and enough to advance Passaic to the semifinal round.

Upon hearing the final whistle, hundreds of Passaic fans with hoarse throats tossed hats and coats into the air and hugged each other in relief. Never before had such a sight been witnessed at Hoboken's historic college. It was a game to remember. The strain of the final three minutes of play was not for the weak of heart. The *Passaic Daily News* headlines the next day read, "Passaic High Wins Second Championship by Defeating Montclair." Final score: **Passaic 28-Montclair 23.**

Because of Asbury Park's 39-19 win over Neptune, the four finalists for the following weekend's games would be Passaic versus Asbury Park, and Trenton opposing Atlantic City.

GAME #25 Asbury Park (Friday, March 26, 1920) at Ballantine Gym, Rutgers College. The Passaic team did not look sharp during the first half and for the first time all season found themselves down 19-18 at the intermission. Were the boys beginning to show signs of strain from the play-offs?

Sensing that it was the strain causing the lethargic play, Blood made an adjustment early in the second half that would be talked about for years to come. After having seen enough of his starters giving the game away, Prof inserted four subs, Knothe, Gale, Blood, and Smith, into the fray with Johnny Roosma. The subs entered the game full of energy and played a better game than the first unit. For the first time all game, fans smiled and cheered as the subs passed the ball while Roosma put the ball where it counted. Whatever was bothering the other Passaic starters did not seem to stop Roosma from scoring 17 for 19 on the foul line. Final score: **Passaic 45-Asbury Park 30.**

PASSAIC				ASBURY PARK			
	G	F	T		G	F	T
Roosma	10	17	37	Guyer	3	14	20
Keasler	1	0	2	Jeffries	3	0	6
Blood	1	0	2	Gallagher	2	0	4
Rumsey	1	0	2	Schwartz	0	0	0
Schneider	0	0	0	Purchase	0	0	0
Lent	1	0	2	Eskew	0	0	0
Knothe	0	0	0	Finley	0	0	0
Gale	0	0	0	Smock	0	0	0
Smith	0	0	0	**Totals**	**8**	**14**	**30**
Totals	**14**	**17**	**45**				

Half time score: Asbury Park 19, Passaic 18. Referee—Emmery. Umpire—Harry Wallum.[79]

In the evening game, Percy Davenport's 12 points for Trenton were enough to offset the 11 points by Atlantic City's Carmack to win 30-29. On the eve of the inaugural Daylight Savings Time, Passaic and Trenton were preparing to play for the second NJSIAA Basketball State Championship.

GAME #26 Trenton (Saturday, March 27, 1920) at Ballantine Gym, Rutgers College. The one-hour-less-sleep did not keep Passaic's center Ike Rumsey from two quick hoops that helped get a quick 5-0 lead. The seesaw battle throughout the first half ended with Passaic losing 19-18. During this stretch,

PASSAIC	G	F	T	TRENTON	G	F	T
Roosma	3	13	19	Meister	0	0	0
Rumsey	5	0	10	Davenport	1	12	14
Schneider	0	0	0	Emmons	3	0	6
Lent	1	0	2	Tettemer	1	0	2
Knothe	0	0	0	Riley	2	0	4
Gale	1	0	2	Bergen	0	0	0
Totals	**10**	**13**	**33**	**Totals**	**7**	**12**	**26**

Half time score: Trenton 19, Passaic 18. Referee—Harry Wallum.[80]

Trenton's Percy Davenport outscored Johnny Roosma 12 to 11. Back in Passaic for those following the game's progress on the newspaper's bulletin boards, this was not a cause for great concern because the boys were losing by the same score at half time the day before against Asbury Park.

Johnny Roosma and substitute Raymond Gale spearheaded an early spurt in the second half to put Passaic up 27-22. The Passaic lads came into the game outweighed by the husky capital city boys but made up for the deficit with their quick passing and teamwork. A very noticeable tactic of the Blood-coached boys was the patient backcourt passing offense as compared to the aggressive attacks on the basket by the Trenton team. Unable to find a handy way to score against the Passaic team's defense, Trenton's Davenport, Emmons, and Riley resorted to shooting from mid-court. Their remarkable accuracy kept them even with Passaic.

At the five-minute mark, Passaic was up by five, and with their passing offense at full throttle, they ran Coach Leroy "Red" Smith's boys in circles until an uncontested shot became available. Final score: **Passaic 33-Trenton 26.**

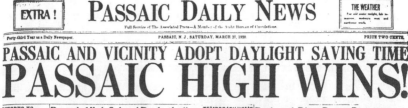

At the final whistle, the pressurized Passaic crowd surged on to the court. The unprecedented joy was to last for hours and spread from New Brunswick to Passaic. This was Passaic's greatest moment. In trying to address his players in the dressing room, Prof's emotions got the best of him. The spellbound players watched as Prof wept.[81] Prof, Mr. Invincible, their coach, sat teary-eyed and unable to control his speech. In the lives of all those present in the room, it was a moment as memorable as the game itself.

By comparing scores, the win over Trenton provided Passaic with the state's bragging rights. The two finalists for the prep school basketball championship were The Peddie School and Bordentown Military Academy. Trenton had defeated both teams earlier in the season thereby unofficially positioning Passaic as the state's premier schoolboy team.

The loss to Passaic concluded a fifteen-game season for Trenton as compared to Passaic's twenty-seven games. It is not known for sure, but Passaic's schedule was probably the fullest in the state. Prof, as Passaic's physical director, had some autonomy arranging team schedules unless overruled by the school board. The corresponding position at Trenton was occupied by Walter E. Short who also happened to occupy the position of secretary for the NJSIAA. This may help explain the favorable tournament draws that Trenton enjoyed for many years in the state basketball tournament.

Passaic's success of the past two years had not gone unnoticed. Interest in the team and game attendance had grown considerably especially among the area's young people. Students, faculty and numerous other adults from the prominent social section had also become smitten fans. The team's victories sparked a showing of Passaic pride.

Professor Blood taught a style of basketball that was noticeably different. First and foremost, he taught clean basketball and good sportsmanship. These traits, coupled with the team's style of play, were more enjoyable to watch than the constant dribbling and roughhouse tactics employed by many other teams. The Blood system of quick short passes provided Passaic with an advantage. Everyone loves a winner, and the team, coach, and school became the talk of the city and the envy of the state. It was a good time to jump on the team's bandwagon.

On Monday, an informal celebration was held at the high school to honor the players, managers, and coaches; Principal Arnold gave a short congratulatory speech. He announced that plans were underway to hold a public demonstration, reception, and celebration to honor the state champions. While Arnold tolerated the hoopla, he was becoming aware that winning a state championship created a diversion from his school's academic priorities.

In retrospect, it would be accurate to say that while the seasons passed and the victories came as predictably as the Erie Railroad passing Passaic's Main Street, not everyone was ecstatic about basketball's meteoric

PRINCIPAL ARNOLD

popularity. Successful coaches are frequently the targets of jealous criticism. Such is the life of winners; no one can please everyone, and Prof was no different. Winning can bring on problems totally different from those caused by losing.

Arthur Daniel Arnold, the principal since 1902, was Prof's first known antagonist. While the perceived lack of appreciation that Arnold directed towards Blood had existed for some time, its ugly head would not surface publicly for a couple more years. To better understand the school's leader, a closer look at him and his background will help.

PRINCIPAL ARNOLD

Arnold was very qualified for the position. He was a high school valedictorian and attended Dartmouth, where he was very active in college activities. He was a member of the Alpha Beta Phi Fraternity, and he delivered the commencement speech at his graduation.

As leaders in their professions do, Arnold wrote numerous articles for publication in educational journals and at one time served as the chairman of the New Jersey State Committee in charge of the state syllabus in history. His administrative experience prior to Passaic included the principalship at two schools in Massachusetts. Besides Dartmouth, he studied at Columbia, Harvard, and Rutgers Universities. He was also a member of the Masons, Director of the Rotary Club, and President of the Lions Club. As if this were not enough, he was a deacon and superintendent of Sunday School at the First Reformed Church.

Through Arnold's dedication, educational acumen, and innovative leadership, Passaic developed an academic reputation that many schools envied. So well known was Passaic's academic excellence that many universities would forego required entrance examinations for Passaic students. According to John Roosma, "Arnold was as good at his profession as Blood was at his."[82]

Years later, Roosma claimed that Arnold was caught in the middle between Blood and a few members of the school board.[83] As you will learn, Johnny Roosma was indebted to both Arnold and Blood for what they did for him. He carefully avoided juxtaposing the two men as adversaries.

The principal's position at most schools, especially at a high school, can be a very political position. In most influential offices, politics play a major role; Passaic was such a place. Arnold's educational astuteness aside, he was in a position where he had to be attuned to political factions to survive professionally. The effects of politics have to be kept in mind as the story of Prof Blood at Passaic High School continues.

Chapter Six
Serving Notice
(1920-1921)

The Nineteenth Amendment—Women's Suffrage—finally gave women the right to vote. Their fight had been a difficult one, but it was only the beginning in their quest for equality. The people in Passaic were enjoying a distinction that they had fought hard for as well, and their quest for more championships was also just beginning.

Shortly after the Thanksgiving Day football game with powerhouse Rutherford who dragged Passaic through the dirt (27-0), Prof Blood focused his attention on basketball tryouts. He and Mrs. Blood were pleased to see football end and relieved to know their son survived unscathed.

Since the advent of basketball as a popular sport, overzealous football coaches, especially those with losing teams, have denounced basketball coaches for refusing to let their athletes play football. In Prof's case, it is easy to understand how these inferences found their roots. Some hypothesized that Prof didn't want his players injured, which is exactly what happened to Fritz Knothe during his freshman year. A coach's influence, especially someone like Prof, cannot be discounted. It is a fact that most of Passaic's top basketball players were not involved with football—soccer, track, and baseball, yes—but not football.

The prospects for Passaic's new basketball team were very good. Johnny Roosma, who made first team all-state, led the list of returnees plus a herd of players coming up from the second team who had not lost a game in seven years. Bobby Thompson, a rangy six footer who Prof found playing in a YMCA game, appeared to be a ringer. Because Prof had a large number of players, he wanted to mold four groups of five.

It is interesting to note that senior Dow Drukker, Jr., was again out for the team. Why? Was it because he was influenced back by Roosma who was one of his good friends? Last season, Drukker was on the team, but as the season continued, his playing time diminished until his name was no longer mentioned. It is doubtful that he was cut because that was not Prof's style. Did Drukker realize that the younger players were better than he was? Was the reality of another season sitting on the

Johnny Roosma

bench too much to bear, or was he receiving some pressure from home?

It can be theorized that Dow Drukker's disassociation with the basketball team was related to Blood's eventual demise as the Passaic coach. Dow was an exceptional kid who came from a wealthy and prominent family. Dow's father, Dow H. Drukker, Sr., was a former congressman from the Seventh New Jersey Congressional District; he was a man of tremendous influence. His son, Dow, was a doer in school and was well liked by his peers. This year, his final year, he had the distinction of being the senior class president.

Like Johnny Roosma, Dow's ancestors were from Holland; in fact, Dow's father was born in the town of Sneek that was near where the Roosma family originated. They referred to themselves as Hollanders, and many of them settled in a section of Passaic known as Dutch Hill. As part of the student body's *crème de la crème* and sharing similar backgrounds, the two boys were friends, as were their parents. While keeping a physical distance from the basketball team, Dow's father would play a significant role in Blood's and Passaic's future.

The season opener was against an undefeated (3-0) East Side team. Before the game, referee Herbert Stein explained three new rules that were to be implemented.[84]

1. A player can be substituted for and put back into the game but once.
2. A jump ball under the basket would be taken out fifteen feet.
3. While holding the ball, it must be bounced before the foot is advanced.

GAME #27 East Side, Newark (Saturday, December 18, 1920) at PHS. The Newark boys were quick and physical and were willing to mix it up to win. The offense of the twin six-foot-one-inch forwards, Roosma and Thompson, and Passaic's teamwork were more than enough to offset the dribble game of East Side. In the second half, the visitors turned to a five-man defense to neutralize Passaic's quick passing attack. To stifle East Side, Passaic backed the ball out and proceeded to further frustrate them by passing the ball until they moved away from the basket. Final score: **Passaic 49-East Side 27.**

PASSAIC	G	F	T	EAST SIDE	G	F	T
Roosma	6	9	21	Bopp	3	0	6
Thompson	8	0	16	Sauer	3	0	6
Vonk	2	0	4	Rabin	1	0	2
Blood	2	0	4	Rosenberg	3	0	6
Knothe	1	0	2	Klein	1	5	7
Schneider	0	0	0	Humbenhauer	0	0	0
Grabiac	1	0	2	**Totals**	**11**	**5**	**27**
Keasler	0	0	0				
Rosman	0	0	0	Time of half:			
Swenson	0	0	0	20 minutes			
Totals	**20**	**9**	**49**				

Referee—Herbert Stein. Timers—Cargoy, Sullivan. Scorers—Fernacola, Schulting.

GAME #28 Passaic HS Alumni (Thursday, December 23, 1920) at Passaic HS. Despite the media dubbing the Alumni the "Has Beens," the Alumni team was confident. The game was filled with many fast, sensational plays in which the high school kids found themselves being pushed around. The physical mismatch was more than neutralized by the younger

PASSAIC	G	F	T	PHS ALUMNI	G	F	T
Roosma	3	14	20	Kolbe	1	0	2
Thompson	3	0	6	Pettersen	1	0	2
Vonk	1	0	2	Rumsey	3	2	8
Blood	1	0	2	Hall	2	0	4
Knothe	0	0	0	Kerr	0	0	0
Grabiac	0	0	0	Schulting	0	2	2
Totals	**8**	**14**	**30**	Prescott	0	0	0
				Saxer	0	0	0
				Totals	**7**	**4**	**18**

Referee—Mueller, Newark. Timers—Shinn and Sullivan, Scorer—Helfrich. Time of halves: 20 minutes.

boys' superior teamwork. The SRO crowd cheered as 6'3" Ira "Six" Vonk controlled the center jump against jumping jack Ike Rumsey. The intensity was at its highest when Vonk and Hall were ejected for their physical play. Final score: **Passaic 30-Alumni 18.**

The real revelation of the evening was the unveiling of two new gems, Ira Vonk and Bobby Thompson. Vonk, who had been developed on the second team the year before, was not as quick-footed as Rumsey, his predecessor, but he was five inches taller and had extra-long arms. He was an excellent rebounder who could control the center jumps after each score, plus he didn't take any abuse. Thompson, like Roosma, was a skilled athlete who had a gift for shooting the ball. They were two crucial pieces of the monster Prof was assembling to defend its title.

GAME #29 Newark Junior College (Friday, December 31, 1920) at Passaic HS. Before a record-breaking crowd, Prof's boys took it to a 6-2 Newark JC team. The only losses for Newark were the close games with St. Benedict's and The Peddie School. In a brilliant display of passing, shooting, and teamwork, Passaic buried the fast and aggressive veteran JC quintet. Besides Roosma, the difference in the game was Vonk who controlled the center tap allowing Passaic to stay on the offense. The college men had to make all their shots because they weren't going to get many. Final score: **Passaic 70-Newark Junior College 17.**

PASSAIC	G	F	T	NEWARK JR. COLL.	G	F	T
Roosma	12	14	38	Schwartz	4	3	11
Thompson	6	2	14	Canfield	2	0	4
Vonk	6	0	12	Walsh	0	0	0
Blood	1	0	2	Murphy	0	0	0
Schneider	0	0	0	Marra	1	0	2
Keasler	0	0	0	**Totals**	**7**	**3**	**17**
Grabiac	1	0	2				
Rosman	1	0	2	Time of halves:			
Swenson	0	0	0	20 minutes			
Totals	**27**	**16**	**70**				

Referee—Herbert Stein. Timers—Shinn, Rebele. Scorer—Sullivan.

GAME #30 East Side, Newark (Wednesday, January 5, 1921) at East Side. In a quick and aggressive game that was marred by poor sportsmanship, Passaic passed their first road test. Adverse, roughhouse playing conditions confronted the clean-playing Passaic boys throughout the game. The game resembled football with

PASSAIC	G	F	T	EAST SIDE	G	F	T
Roosma	4	9	17	Bopp	2	3	7
Thompson	2	4	8	Sauer	4	0	8
Vonk	1	0	2	Seiderman	0	3	3
Blood	2	0	4	Rosenberg	1	0	2
Knothe	0	0	0	Stein	0	1	1
Keasler	1	0	2	Benkert	1	0	2
Totals	**10**	**13**	**33**	**Totals**	**8**	**7**	**23**

Referee—Cavallero. Timers-Shinn and Sullivan. Scorer—Kidden. Time of halves: 20 minutes. Half time score: 15-7.

the fans yelling for a touchdown. While the East Side players employed tripping and pushing tactics, their fans were not to be outdone. The game was interrupted several times before the Newark fans finally realized the game would be forfeited if their rudeness did not stop. In the middle of the second half, Roosma and Seiderman, the 6'3 East Side center, were ejected from the game for fighting.

The identity of East Side's Benkert was questioned. A week earlier, Benkert played with the Newark JC team but under the name of Murphy. Who was this guy? Final score: **Passaic 33-East Side 23.**

GAME #31 Paterson (Saturday, January 5, 1921) at Passaic HS. The only obstacle standing in the way of Passaic's thirty-first consecutive victory was their neighbor from the "Silk City." Paterson Coach Andy Oakey prophesied that his team would give Passaic a run for their money. Expecting an emotional game on the heels of the East Side clash, Prof took a minute before the game to address the SRO crowd. He spoke to the audience about "clean sport." Around the turn of the century, the term clean sport referred to good sportsmanship.

Before the start of the game, a peculiar home court rule was clarified. Because the backboards and baskets were fastened to the walls, Passaic did not have an out-of-bounds area under the baskets. The official rules stated that any time the ball touched a wall, it would be referred to as out-of-bounds. While playing at Passaic, most teams never followed this interpretation; therefore, Passaic developed some uncanny plays executed off the wall. Pater-

PATERSON	G	F	T	PASSAIC	G	F	T
Byrnes	3	3	9	Roosma	3	3	9
Goode	2	0	4	Thompson	5	0	10
Riggenback	0	0	0	Vonk	3	0	6
Winkler	0	0	0	Grabiac	0	0	0
Knaus	0	0	0	Blood	3	0	6
Cole	1	0	2	Knothe	3	0	6
Baisch	0	0	0	**Totals**	**17**	**3**	**37**
Halstead	3	0	6	Scores by period:			
Totals	**9**	**3**	**21**	**Paterson**		4	7
				Passaic		21	16

son surprised everyone by requesting that the official rule be observed.

Back and forth it went as the two teams fought it out. Aided by Vonk's control of the center tap, Passaic's superiority took its toll. Final score: **Passaic 37-Paterson 21.**

PASSAIC HIGH SCHOOL'S BASKETBALL COURT

Small Balcony Above

GAME #32 Hackensack (Wednesday, January 12, 1921) at Passaic HS. The Hackensack team arrived with the Koestner brothers and a reputation earned by upsetting Rutherford. Without the injured DeWitt Keasler, Passaic had to shuffle their lineup. Learning from Paterson, Hackensack requested the same interpretation of the ball touching the wall rule. What the visitors didn't realize was that Prof had prepared his boys for the change in play. The request only served to arouse Passaic and create an optimal performance. By half time with a 41-10 score, the visitors were ready to go home. Final score: **Passaic 62-Hackensack 19.**

The headlines on the sports page of the *Passaic Daily News* on the day of the Englewood game read, "P.H.S. Has Won 32 Straight and Set Many Records Past 5

PASSAIC	G	F	T	HACKENSACK	G	F	T
Roosma	11	6	28	Tallman	0	0	0
Thompson	2	0	4	H.Koestner	2	0	4
Vonk	4	0	8	Schoonmaker	0	0	0
Knothe	7	0	14	Zimmerman	0	0	0
Blood	1	0	2	G.Koestner	3	0	6
Schneider	1	0	2	Block	0	0	0
Swenson	1	0	2	Breen	2	1	5
Grabiac	1	0	2	Hall	1	0	2
Rosman	0	0	0	**Totals**	**9**	**1**	**19**
Totals	**28**	**6**	**62**				

Referee—Mueller. Timer—Shinn. Scorer—Sullivan. Time of halves: 20 minutes.

Seasons." Pressure on the team was mounting, and it was coming from all sources. Rehashing the streak and bragging about winning another championship had become a favorite topic of conversation.

GAME #33 Englewood (Saturday, January 15, 1921) at Englewood. The hosts were shell-shocked before the game was over. The Bergen County fans were amazed by Passaic's brand of ball. In an act of compassion, Prof let the second stringers do most of the damage in the second half. If the technology had been available, Roosma's 40-point outburst would have made a good highlight film.

PASSAIC	G	F	T	ENGLEWOOD	G	F	T
Roosma	12	16	40	Mahoney	0	1	1
Thompson	3	0	6	Ferry	0	0	0
Vonk	2	0	4	Klatt	3	0	6
Knothe	1	0	2	McCoy	0	0	0
Keasler	2	0	4	Bauer	0	0	0
Blood	0	0	0	Springer	1	4	6
Schneider	0	0	0	**Totals**	**4**	**5**	**13**
Rosman	1	0	2	Referee—Toole.			
Swenson	0	0	0	Scorers—Sullivan,			
Grabiac	1	0	2	Hautain. Timers—			
Totals	**22**	**16**	**60**	Burbridge, Shinn.			

Score at half time: 28-7. Time of halves: 20 minutes.

After shaking hands with Prof, the Englewood coach said that he believed Passaic could defeat any team that he had ever seen and that they should be playing Columbia and other college teams. According to Johnny Roosma, it was at times such as these that Prof would warn the team with one of his oft-repeated expressions, "When you start thinking that you are getting good, it is when you start going backwards."[85] Final score: **Passaic 60-Englewood 13.**

GAME #34 Cliffside (Wednesday, January 19, 1921) at Passaic HS. True to Prof's warning following the previous game, Cliffside Park gave the locals all they could handle. Coach Samuel Longley's boys were 6-2 and full of confidence. Their strong defense allowed them to overcome forfeiting the tap because they made Passaic

PASSAIC	G	F	T	CLIFFSIDE PARK	G	F	T
Roosma	6	6	18	McCloskey	1	0	2
Thompson	0	0	0	Borrelli	0	0	0
Vonk	4	0	8	Vaughn	0	0	0
Knothe	0	0	0	Martens	1	0	2
Blood	1	0	2	Houk	1	9	11
Keasler	2	0	4	McDonald	0	0	0
Totals	**13**	**6**	**32**	**Totals**	**3**	**9**	**15**

Referee—Mueller. Timer—Shinn. Scorer— Sullivan. Time of halves: 20 minutes.

work for every basket. It didn't help matters that Thompson fouled out in the first half. (Note: The four fouls and you're out rule was in effect from 1910 to 1944.) Final score: **Passaic 32-Cliffside Park 15.**

GAME #35 Nutley (Saturday, January 22, 1921) at Passaic HS. In the preliminary game, the Passaic "Seconds" defeated Nutley. Passaic's two newspapers reported the game differently. The *Passaic Daily Herald* stated that the game was with the Nutley "Seconds," while the *Passaic*

Daily News did not specify which Nutley team was involved. If the game had been against another school's "Second Team," today it would be referred to as a junior varsity game. During this era, the Passaic "Seconds" were made up of some

PHS SECONDS	G	F	T	NHS SECONDS	G	F	T
Swenson	9	1	19	Hawley	0	7	7
Rosman	6	10	22	Ellison	6	0	12
Grabiac	7	0	14	Bennett	0	0	0
Blood	1	0	2	Rende	0	0	0
Saxer	2	0	4	Frost	1	0	2
Streckfuss	0	0	0	Heinz	0	0	0
Totals	**25**	**11**	**61**	**Totals**	**7**	**7**	**21**

talented teams. Their reputation was legitimate because they had not lost a game in eight years, nor would they fall short for another six years. Final score: **Passaic Seconds 61-Nutley 21.**

For the next season and a half, the victory over Nutley would not be included as one of the consecutive victories. Suddenly, at the beginning of the 1922-1923 season, this Nutley game appeared as game #35 among Passaic's vanquished. See the ninety-first game for details surrounding the inclusion of the Nutley game.

GAME #36 Belleville (Saturday, January 22, 1921) at Passaic HS. Prof experimented with his lineup for the Belleville game by moving Roosma to guard, inserting Keasler at forward with Vonk, and putting Thompson at center. These four players were tall, talented and rugged. With the rapidly emerging Fritz Knothe as the other guard, Passaic had a tall, athletic lineup. It was mainly these

PASSAIC	G	F	T	BELLEVILLE	G	F	T
Thompson	6	3	15	Reinhaut	1	0	2
Keasler	3	0	6	J.DiLeo	1	7	9
Vonk	5	0	10	Watters	0	0	0
Roosma	6	8	20	A.DiLeo	0	0	0
Knothe	2	0	4	Metz	0	2	2
Schneider	0	0	0	Riggs	0	0	0
Blood	0	0	0	Smith	0	0	0
Totals	**22**	**11**	**55**	Jacobson	0	0	0
				Totals	**2**	**9**	**13**

Referee—Mueller, South Side. Timer— Shinn. Scorer— Sullivan and Joe Adams. Time of halves: 20 minutes.

five and Paul Blood who crushed Belleville. Roosma, who was recognized by many authorities as the premier scholastic player in that part of the country, fouled out.

Belleville failed to score a field goal until the last three minutes of the game, but that was not unusual in a Passaic game. After leading by 38 to 3 at half time, Passaic slowed the game down and started spreading Belleville out and making them come after the ball. Prof favored this tactic because it gave his boys an opportunity to practice passing the ball. Final score: **Passaic 55-Belleville 13.**

GAME #37 Ridgewood (Saturday, January 26, 1921) at Ridgewood. On their small court, the home team put up a fight. Once Passaic adjusted to the crowded conditions, a 22-8 half time resulted. Following that, it

was full speed ahead until Keasler went down with an injury. Prof inserted his son for the big lefty and the popular passing attack picked up a notch leaving Ridgewood exhausted.

This game was sophomore Fritz Knothe's debut as a shooter. In the second half, the athletically gifted 5'8" sophomore staged a shooting exhibition by drilling five

PASSAIC	G	F	T	RIDGEWOOD	G	F	T
Roosma	7	13	27	Fielding	1	1	3
Thompson	5	0	10	Pinchney	0	0	0
Vonk	5	0	10	Zabriskie	0	3	3
Knothe	5	0	10	Aldrich	0	0	0
Blood	1	0	2	Batchelor	0	0	0
Schneider	0	0	0	Hiler	2	0	4
Swenson	0	0	0	Morrison	0	1	1
Grabiac	0	0	0	**Totals**	**3**	**5**	**11**
Totals	**23**	**13**	**59**				

Referee—Joe Johnson, Paterson High School. Scorer—Sullivan. Timer—Shinn and Drews. Time of halves: 30 minutes.

shots from the center of the court. This feat was uncanny for two reasons: first, he took the shots with no other teammates shooting in between; and second, the basket being shot at was bent and crooked. Final score: **Passaic 59-Ridgewood 11.**

GAME #38 Leonia (Saturday, January 29, 1921) at Passaic HS. When the score was 48-5 at half time, the visitors from Leonia saw reason to be optimistic—they felt it couldn't get worse, but they were wrong. The Red and Blue machine really began firing on all cylinders during the last five minutes as

PASSAIC	G	F	T	LEONIA	G	F	T
Keasler	8	0	16	Nichols	1	0	2
Thompson	15	0	30	Dahl	0	0	0
Vonk	4	0	8	Jablesnek	1	4	6
Knothe	4	0	8	Frank	0	0	0
Roosma	15	15	45	Duncan	0	0	0
Totals	**46**	**15**	**107**	Nyquist	0	0	0
				Totals	**2**	**4**	**8**

Score by periods:

Passaic	48	59
Leonia	5	3

they scored 37 points. This scoring binge bettered Passaic's official NNJIBL record 101-16 set against them in 1916. The offensive avalanche rekindled memories of the 144-27 thrashing Passaic handed Bloomfield in 1909.

Incidentally, Roosma, who scored his 100th free throw of the season, coached this game because Prof was away tending to other school matters. When Roosma finally located Prof after the game, he cajoled Prof into thinking that the team had lost but that he was not to be concerned because good sportsmanship prevailed. Believing the team had been defeated, Prof was said to have stoically mumbled, "That's too bad," before he realized Roosma was kidding. Final score: **Passaic 107-Leonia 8.**

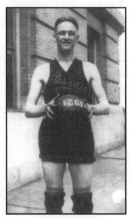

JOHNNY ROOSMA

GAME #39 Hackensack (Wednesday, February 2, 1921) at Hackensack. With a tough schedule the following week, the boys from the school on the hill tried not to exert themselves as they passed and shot their way through Hackensack. Prof started his tall team with Roosma at guard. Playing without the Koestner twins, the Hackensack boys could only hustle and hope. To balance things in the second half, referee Tewhill decided not to call any more fouls on Hackensack.

PASSAIC				HACKENSACK			
	G	F	T		G	F	T
Thompson	7	0	14	Paulison	2	0	4
Keasler	7	0	14	Hall	3	3	9
Vonk	4	0	8	Breen	0	0	0
Roosma	4	5	13	Pflugi	0	0	0
Knothe	1	0	2	Bocks	1	0	2
Totals	**23**	**5**	**51**	**Totals**	**6**	**3**	**15**

Referee—Tewhill, Horace Mann. Time of halves: 20 minutes. Score at half time: 37-7.

The play of day belonged to Bobby Thompson who sank a goal from near the sideline at mid-court. He wanted to pass it, but no one was open. His shot stayed in the air for what seemed like eternity until it finally reached the center of the rim. The Hackensack fans and players cheered Thompson for making the longest shot they had ever seen during a game on their court. Final score: **Passaic 51-Hackensack 15.**

GAME #40 Paterson (Friday, February 4, 1921) at Entre Nous Court, Paterson. With interest piqued because of the competitiveness of their previous game, a record crowd of 700 businessmen, women, and students crammed the small hall. Both quintets were emotionally keyed up for this intense sister-city rivalry. The *Paterson Morning Call* described the Passaic team as the "invincible wonder-boys."

Coach Oakley's boys were a little jittery playing

PASSAIC				PATERSON			
	G	F	T		G	F	T
Roosma	4	9	17	Byrne	0	1	1
Keasler	3	0	6	Goode	3	2	8
Vonk	4	0	8	Cole	4	0	8
Thompson	3	0	6	Baisch	0	0	0
Knothe	5	0	10	Halstead	0	0	0
Blood	3	0	6	Rea	1	2	4
Grabiac	1	0	2	Winkler	0	0	0
Rosman	0	0	0	Knaus	0	0	0
Totals	**23**	**9**	**55**	**Totals**	**8**	**5**	**21**

Referee—Moeller of Newark. Timers—Sullivan, Hall. Scores—Helfrich, Gilmore. Time of periods: 20 minutes. Score at half: Passaic 28, Paterson 11. Fouls: Paterson 20, Passaic 17. Disqualified for four personal fouls: Paterson—Byrne, Goode, and Baisch; Passaic—Keasler, Vonk and Thompson.

before such a spirited crowd. On the other hand, Passaic was hampered by Coach Oakley's five-man defense on the crowded floor. Regardless of the lopsided result, it was a spectator's delight. After the game, Joe Johnson, Paterson's physical director and former Crescent basketball star, volunteered, "The better team won." Final score: **Passaic 55-Paterson 21.**

GAME #41 Englewood (Saturday, February 5, 1921) at Passaic HS. Because of the referee's late arrival, the pregame warm-ups turned into an impromptu Passaic shooting exhibition. The fans enjoyed the shooting show; that was the good news. The bad news for Englewood was that the shooting show continued into the official game.

PASSAIC	G	F	T	ENGLEWOOD	G	F	T
Keasler	7	0	14	Clapp	0	4	4
Thompson	6	0	12	Springer	0	0	0
Vonk	7	0	14	Clark	2	0	4
Roosma	4	7	15	Terry	2	0	4
Knothe	4	0	8	McCoy	3	0	6
Blood	2	0	4	Been	0	0	0
Grabiac	1	0	2	Caswell	1	0	2
Totals	**31**	**7**	**69**	**Totals**	**8**	**4**	**20**

Score by periods:

Passaic	35	34
Englewood	10	10

Passaic's shooting, coupled with its typical passing and teamwork, did not provide Englewood with much hope. Late in the first half, Ira Vonk proved an old adage true, "When you're hot, you're hot...." While lying on the floor reaching for a loose ball, the big center tossed one into the basket.

The feature performer of the game was Joey McCoy, "the gentleman of color," who played guard for Englewood. "The little colored boy was a marvel on the court." He was in the game fighting every moment and was worthy of playing with more talented teammates. Joey was a regular jumping jack; the fans were impressed with his ability to rise to such heights. On jump balls, he got the tap no matter who he was matched against.[86]

Throughout the game, Joe McCoy had the appreciative fans on their feet. At one point, he ran high up the wall under the basket and almost stopped a ball from entering the basket. He was a sight to see. Another time, "chocolate-colored Joe" stopped a shot of Thompson's when he leaped and stuck his hand through the basket and pushed the ball away. Impressive as the move was, Thompson was credited with the two points.[87]

The Englewood boys were always willing to receive the colored lad's passes. They would yell, "Hey, Joe. Hey, Joe. Here, Joe," whenever he had the ball, but these same players would seldom pass him the ball in return. You can chalk this up as the reason why Englewood was not a better team. Without a doubt, the shinning star for the visitors was the dark figure of Joe McCoy.[88] Final score: **Passaic 69-Englewood 20.**

Winning games, especially winning so many consecutively, was attracting attention. Challengers from all over wanted to test Passaic's alleged superiority. One request for a game came from Lester Crasper, supervisor of athletics at Poughkeepsie. After reading about the 107-8 score of the Leonia game, Crasper compared the large margin of victory to one of Poughkeepsie's games from the previous year when they scored 112 points on Danbury, Connecticut. Crasper didn't believe Poughkeepsie was better; he merely wanted to expose his team and community to the

best. His request for a game, which was never scheduled, was the first of hundreds that followed as Passaic's victories mounted.

GAME #42 Montclair (Wednesday, February 9, 1921) at Passaic HS. The Montclair sharpshooters arrived at the school on the

PASSAIC	G	F	T	MONTCLAIR	G	F	T
Roosma	8	11	27	Moon	1	0	2
Thompson	6	0	12	DeFalco	3	1	7
Vonk	3	0	6	Lundell	0	16	16
Knothe	3	0	6	Mueller	0	0	0
Keasler	2	0	4	Crawley	0	0	0
Blood	1	0	2	Hinck	0	0	0
Grabiac	0	0	0	**Totals**	**4**	**17**	**25**
Totals	**23**	**11**	**57**	Referee—Harry Wallum.			

hill's gym a little smug owing to their 6-0 record. They were good, at least the best in Essex County. No one had forgotten the 28-23 scare from the previous season at Stevens Institute.

Montclair must have arrived on "Hawker Day," which would account for the uncharacteristically long outside shooting by Passaic. During one stretch, Thompson, Roosma, and Knothe each scored from distance in rapid succession making the score 36-12 at half time. After Roosma scored six points in succession during one run in the second half and Vonk gained the best of the talented Montclair center Lundell, Montclair was put to rest. It was an important win, and it decisively showed that Passaic was again state championship material. Final score: **Passaic 57-Montclair 25.**

GAME #43 Rutherford (Saturday, February 12, 1921) at Smith Academy. Rutherford moved the game to Smith Academy on Pennington Avenue because their home bandbox gym would not accommodate the Passaic masses. Pregame anticipation was heightened by Rutherford's football victory over Passaic several months earlier. To sweeten

PASSAIC	G	F	T	RUTHERFORD	G	F	T
Thompson	8	0	16	C.Dixon	4	5	13
Roosma	8	18	34	Bauer	0	0	0
Vonk	1	0	2	Gibson	2	0	4
Keasler	1	0	2	Carroll	0	0	0
Knothe	8	0	16	Lightfoot	1	0	2
Totals	**26**	**18**	**70**	A.Dixon	0	0	0
				Helwig	0	0	0
				Totals	**7**	**5**	**19**

Substitutions: A. Dixon for Gibson; Helwig for Lightfoot; Swenson, Blood, Roosma, Grabiac for Thompson, Vonk, Keasler and Knothe. Score at half: Passaic 36, Rutherford 8.

the pot, the very same football players who trounced Passaic on Thanksgiving Day made up the entire Rutherford basketball squad. They were strong, rough, and athletic, plus they were rapidly improving after a slow start. But typical of football players dressed in basketball uniforms, their ability to shoot the ball was noticeably lacking. Football was king at Rutherford just as basketball was at Passaic. This was never more evident than when Passaic scored nine straight times from the center jump without the ball ever touching the floor.[89]

The heated battle was witnessed by 800 spectators who jam-packed the court, stairways, balcony, and beams above the court. Another not-so-fortunate group of fans saw the game through the windows from the roof.[90] Final score: **Passaic 70-Rutherford 19.**

GAME #44 Cliffside (Wednesday, February 12, 1921) at Cliffside Park. Cliffside dreamed of a win, but after just five minutes, they woke up and, as good sports, accepted their fate. Kiraum, the Cliffside center, sported a football nose guard, probably to protect himself while he went toe to toe with Ira Vonk. While easily outplaying the Cliffside big man, Vonk and his antagonist were assessed double fouls for their sideshow antics. Final score: **Passaic 66-Cliffside Park 21.**

GAME #45 NYU Law School Freshman (Saturday, February 19, 1921) at PHS. Sixteen inches of snow made for an auspicious greeting for the NYU Law School Freshman team. The white

PASSAIC				CLIFFSIDE PARK			
	G	F	T		G	F	T
Thompson	2	0	4	McCloskey	2	0	4
Roosma	10	18	38	Barrelli	2	0	4
Vonk	2	0	4	Kiraum	1	0	2
Knothe	6	0	12	Martens	0	0	0
Keasler	2	0	4	Hauck	1	9	11
Blood	2	0	4	Vaughn	0	0	0
Saxer	0	0	0	Whalen	0	0	0
Garbiac	0	0	0	**Totals**	**6**	**9**	**21**
Swenson	0	0	0				
Totals	**24**	**18**	**66**				

Referees—Joe Walley, H. Quills. Time of halves: 20 minutes. Scorer—Sullivan. Timer—Shinn. Score at half time: 36-5.

PASSAIC				NYU LAW			
	G	F	T		G	F	T
Thompson	4	0	8	Lent	1	0	2
Roosma	11	19	41	Brill	2	3	7
Vonk	1	0	2	Kerr	1	0	2
Keasler	1	0	2	Chipernoy	3	1	7
Blood	2	0	4	Silverburg	1	1	3
Grabiac	0	0	0	Koplow	0	0	0
Knothe	3	0	6	Cohen	1	0	2
Totals	**22**	**19**	**63**	**Totals**	**9**	**5**	**23**

blanket of snow didn't keep the capacity crowd away, but it was the cause of a car accident that stopped four of the visitors from reaching Passaic. A makeshift outfit of NYU and local players (Eddie Brill, Charlie Lent, and others) became the forty-fifth victim. Overall, it was a lackluster match up, but it was included in the victory streak. Final score: **Passaic 63- NYU Law School Freshman 23.**

GAME #46 Rutherford (Tuesday, February 22, 1921) at Passaic HS. The snow that fell the day before cooled the pregame hype that surrounded the previous Rutherford game, but the Red and Blue boys couldn't let down against such a feisty group. The two pivot men, Vonk and Rutherford's Bauer, created such a stir that referee Jack Stein had to eject them. By half time, the handwriting on the wall read 23-6. Final score: **Passaic 61-Rutherford 14.**

Prof had been concerned that his team hadn't been challenged enough, but finding an extra game or two within the confines of the existing schedule was difficult. Prof learned that Commerce, winner of the NYC Championship, wanted nothing to do with his team, nor did Horace Mann or De LaSalle High Schools. Passaic manager Ed Sullivan contacted Carlton and Blair Academies, Newark Normal, and Bloomfield for a game, but the response was, "No, thanks."

PASSAIC				RUTHERFORD			
	G	F	T		G	F	T
Thompson	1	0	2	Kinghorn	0	0	0
Roosma	6	11	23	C.Dixon	1	8	10
Vonk	1	0	2	Bauer	0	0	0
Grabiac	4	0	8	Helwig	1	0	2
Keasler	8	0	16	Lightfoot	1	0	2
Knothe	5	0	10	**Totals**	**3**	**8**	**14**
Totals	**25**	**11**	**61**				

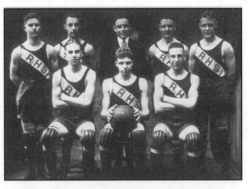

RUTHERFORD TEAM

Prof was faced with a dilemma—he wanted to participate in the annual national championship tournament at the University of Chicago. (Amos Alonzo Stagg, the famous football coach, who is also a member of the Naismith Basketball Hall of Fame, initiated this tournament in 1917.) However, the second round of the state play-offs conflicted with the national tournament. Because Passaic was the overwhelming favorite to repeat as state champs, someone hatched the idea that Passaic could receive a bye in the elimination process and go on to meet the elimination winner for the state championship. If the state association accepted this idea, Passaic could go to Chicago, win the big one, and return in time to defend its title.

Naturally, the Passaic populace thought that this proposal made sense, but Secretary Short and the NJSIAA would have nothing to do with the idea. Passaic had already signed a commitment to participate in the opening round of the state play-offs on March 5, at Stevens Institute in Hoboken against a yet-to-be-identified opponent. A potential standoff was in the making. Passaic's "courtesy" bye to the state finals would gain additional support as soon as the pairings for the first round of games were announced.

GAME #47 Ridgewood (Saturday, February 26, 1921) at Passaic HS. Because Fritz Knothe was ill and unable to play, the visitors were optimistic. At half time, the score read 39-0; the optimism was over. The highlight of the day was Johnny Roosma scoring 50 points and bettering

his old mark of 45 against Leonia. Final score: **Passaic 92-Ridgewood 4.**

GAME #48 Belleville (Wednesday, March 2, 1921) at Belleville. This time it was Bobby Thompson's turn to be sick. When the Belleville lads resisted the urge to roll over, Roosma called a time out and explained the adjustments given to him by Prof. From that point on, Passaic dashed to a 35-5 half time lead and never looked back. Final score: **Passaic 67-Belleville 15.**

When the pairings for the play-offs were announced, Passaic was pitted against East Side. A news story criticized Short for the match up because Passaic had already beaten the pugnacious

PASSAIC				RIDGEWOOD			
	G	F	T		G	F	T
Thompson	13	0	26	Fielding	1	1	3
Roosma	19	12	50	Pinckney	0	0	0
Vonk	6	0	12	Batchellor	0	0	0
Keasler	0	0	0	Aldrich	0	0	0
Blood	2	0	4	Morrison	0	0	0
Grabiac	0	0	0	Ball	0	1	1
Totals	**40**	**12**	**92**	Morbelli	0	0	0
				Totals	**1**	**2**	**4**

Referee—Mueller, Southside. Score at half time: 39-0. Time of halves: 20 minutes.

PASSAIC				BELLEVILLE			
	G	F	T		G	F	T
Keasler	4	0	8	J. DiLeo	1	0	2
Roosma	11	3	25	H.Smith	3	1	7
Vonk	2	0	4	J.Metz	2	2	6
Saxer	0	0	0	S.Riggs	0	0	0
Knothe	5	0	10	Jacobson	0	0	0
Grabiac	3	0	6	Carlough	0	0	0
Rosman	1	0	2	**Totals**	**6**	**3**	**15**
Swenson	2	0	4				
Blood	4	0	8				
Totals	**32**	**3**	**67**				

Newark quintet twice. What possessed Short to select East Side?[91]

The best team in the state, according to Passaic fans, should have been given a weaker opponent or at least a team they hadn't played twice. Prof was annoyed because he felt that the purpose of the play-offs was to provide the best teams an opportunity to play each other. Passaic had nothing to prove by beating East Side again, although East Side was a very difficult opponent for Passaic. Each of the two wins against East Side were bruising, hard-earned victories, and to defeat them again would not be easy.

Did Short, who was employed by the Trenton School District, want Passaic to lose or just get beat up some to improve Trenton's prospects? One thing was certain, Short and the NJSIAA were not about to do Prof and Passaic any favors. Short, like Prof, was not very tall, but he was Mr. Influential in the NJSIAA, and he did not appreciate anyone questioning, let alone defying, his authority. In a move that further aggravated Passaic, Short's pairings gave both Plainfield and North Plainfield byes in the opening round.

The pairing with East Side added pressure to an already hot topic—Passaic's desire to participate in the national tournament in Chicago on

March 10, 11, and 12. Meanwhile, Passaic's fore-most basketball fan, Joe Whalley, had all the financial details worked out for the trip to Chicago. The idea of going to the national tournament was gaining momentum. Prof favored going, but his better judgment told him it was not possible. The physical demands of traveling, playing five games in three days, and returning in time to defend their state championship were just some of the concerns.[92]

JOSEPH WHALLEY

All speculation ended when the team, Prof, and Arnold met. It was decided to abandon the invitation to compete for a national title in favor of the state tournament.[93] Upon hearing the news, many Passaic fans rationalized that this was the better choice because the teams in the national tournament were believed to be of lesser caliber than the teams found near home. With the NJSIAA's meal ticket's decision, Short breathed a sigh of relief, but he would remember Passaic's intentions.

GAME #49 East Side (Saturday, March 5, 1921) at Stevens Institute, Hoboken. True to form, the third East Side game did not come off without a couple of aberrations. First, Bopp, the East Side forward, was a February graduate. Midyear graduates were common during this era. The policy concerning midyear graduates had been very clear. Throughout the three-year history of the NJSIAA state basketball championship tournament, February graduates were not eligible for the play-offs. Because this was the policy, Passaic and many other schools chose not to play these athletes after they graduated.

On game day, Short reiterated that midyear graduates, such as Bopp, were ineligible. Contrary to the secretary's statement earlier in the day, Bopp went through the pregame warm-ups and played. Another fact of which Short was fully aware but did nothing about was the story of Benkert, the East Side guard. Earlier in the season, Benkert opposed Passaic with Newark JC and did so under the assumed name of Murphy.

The pregame quarrels over Bopp and Benkert were distracting, and Passaic quickly found themselves in an unfamiliar position—behind 5-4. In an uphill affair, Passaic took a 19-14 lead at half time and added to it throughout the game. Final score: **Passaic 40-East Side 28.**

PASSAIC				EAST SIDE			
	G	F	T		G	F	T
Roosma	5	12	22	Bopp	2	2	6
Thompson	3	0	6	Windus	4	0	8
Vonk	3	0	6	Seideman	2	3	7
Knothe	1	0	2	Benkert	2	2	6
Blood	2	0	4	Rosenberg	0	1	1
Keasler	0	0	0	Sauer	0	0	0
Totals	**14**	**12**	**40**	**Totals**	**10**	**8**	**28**

Score at half time: Passaic 19, East Side 14. Officials—Wallum and Loser.

At St. Benedict's Prep
Emerson 27-Verona 18
Boonton 33-West Orange 28
Montclair 56-Summit 27
Newark Central 35-Cliffside 30
Hoboken 31-Bloomfield 24
South Plainfield-bye

At Stevens Institute
South Orange32-Roselle 30
Orange 34-Somerville 28
Dickinson 45-Chatham 17
Passaic 40-East Side 28
Glen Ridge 32-Union Hill 27
Plainfield-bye

GAME #50 South Orange (Tuesday, March 8, 1921) at St. Benedict's Prep, Newark. By defeating Roselle, South Orange was now in Passaic's path. To pacify Newark fans, the game site was moved to Shanley Gym as a nightcap of a triple-header. Falling behind 7-5, Roosma called time out to talk with Prof, and South Orange was suddenly in trouble. Final Score: **Passaic 68-South Orange 18.**

PASSAIC	G	F	T	SOUTH ORANGE	G	F	T
Roosma	6	12	24	Carter	1	0	2
Thompson	4	0	8	Lessler	0	0	0
Vonk	5	0	10	Nolan	3	10	16
Knothe	4	0	8	Gibbs	0	0	0
Blood	3	0	6	Bird	0	0	0
Keasler	2	0	4	Proscholdt	0	0	0
Rosman	2	0	4	**Totals**	**4**	**10**	**18**
Swenson	1	0	2				
Grabiac	1	0	2				
Saxer	0	0	0				
Totals	**28**	**12**	**68**				

Referee—Charles Schneider. Umpire—Joseph O'Shea.

Before leaving the court after the game, Johnny Roosma was approached by umpire Joseph O'Shea. When O'Shea asked where he planned to go to college, John responded that he didn't know. O'Shea fired back, "You should go to West Point."[94] John was considered the top college prospect in the Northeast. Coach Frank Hill and his All-American Ed Benzoni were also recruiting John to attend Rutgers College.

RESULTS IN NORTHERN N. J. STATE HIGH SCHOOL BASKETBALL TITLE ELIMINATION GAMES, SECOND ROUND, MARCH 10, 1921

At St. Benedict's Shanley Gym
Newark Central 29-Boonton 24
Plainfield 46-Orange 35
Passaic 68-South Orange 18

At Stevens Institute's Walker Gym
Glen Ridge 31-Dickinson 28
North Plainfield 23-Emerson 21
Montclair 30-Hoboken 20

GAME #51 Plainfield (Friday, March 11, 1921) at Stevens Institute, Hoboken. When Passaic was extended a bye for the second round, Prof turned around and offered the bye to Glen Ridge. If Glen Ridge accepted, Passaic would play Plainfield. If Passaic defeated Plainfield,

Prof's boys would be guaranteed a meeting with Glen Ridge. Prof wanted to play Glen Ridge because they used a system very similar to his, and he wanted to see how his boys would react to playing a team very much like their own. Glen Ridge was very happy to accept the offer and get a free pass into the group finals.

On the day of the Plainfield game, the *Passaic Daily News* headlines stated, "P.H.S. Wonder-Team Plays At Stevens Gym This Evening." The article mentioned that the wonderful PHS basketballers would play again at William Hall Walker Gym. Looking back, this appeared to be when and where the appellation "Wonder Team" started.

Living up to their billing, Prof's protégés took the court before a capacity crowd and proceeded to destroy a bewildered Plainfield team. Shortly after leading 2-0, the Plainfield boys found themselves down 18-2 and then 25-2 before they found the scoreboard again. It was a new record-breaking performance for both a high and a low score in a state play-off game. Roosma outscored the entire Plainfield team by thirty points. Final score: **Passaic 70-Plainfield 8.**

PASSAIC	G	F	T	PLAINFIELD	G	F	T
Roosma	15	8	38	Snyder	0	0	0
Thompson	4	0	8	Randolph	1	0	2
Vonk	4	0	8	Brousse	1	2	4
Blood	3	0	6	Van Pelt	0	0	0
Knothe	4	0	8	Snowden	1	0	2
Keasler	1	0	2	Lourie	0	0	0
Grabiac	0	0	0	Ellis	0	0	0
Rosman	0	0	0	Shepherd	0	0	0
Saxer	0	0	0	**Totals**	**3**	**2**	**8**
Totals	**31**	**8**	**70**				

Score at half time: Passaic 40, Plainfield 5. Referee—Joseph O'Shea. Umpire—Mitchell.

RESULTS IN NORTHERN N. J. STATE HIGH SCHOOL BASKETBALL TITLE ELIMINATION GAMES, SEMIFINALS MARCH 11, 1921 AT STEVENS INSTITUTE

Montclair 37-North Plainfield 19 Newark Central-bye
Passaic 70-Plainfield 8 Glen Ridge-bye

GAME #52 Glen Ridge (Saturday, March 12, 1921) at Stevens Institute, Hoboken. The seasoned Passaic Indians found Glen Ridge easy prey. Passaic executed their short passing attack so perfectly that the Stevens Institute basketball coach, who was on the side watching, quickly summoned his team to the gym. Coach

PASSAIC	G	F	T	GLEN RIDGE	G	F	T
Roosma	7	11	25	McLean	0	0	0
Thompson	1	0	2	Paine	2	7	11
Vonk	3	0	6	Firman	0	0	0
Blood	3	0	6	Pratt	1	0	2
Knothe	4	0	8	Alling	0	0	0
Keasker	0	0	0	Bond	0	0	0
Grabiac	0	0	0	Ryan	0	0	0
Swenson	0	0	0	**Totals**	**3**	**7**	**13**
Rosman	0	0	0	Referee—Charles			
Saxer	0	0	0	Schneider.			
Totals	**18**	**11**	**47**				

Harris wanted his boys to see how the Passaic team passed and shot the ball. After the mismatch, the Glen Ridge coach volunteered that he had never seen a team play so near perfection. From the first minute, there were no doubts which team would advance. Passaic's first and second teams raced out to a 24-9 lead and coasted. Final score: **Passaic 47-Glen Ridge 13.**

NEW JERSEY STATE BASKETBALL TOURNAMENT

North Jersey Division
 Passaic 47-Glen Ridge 13
 Central 29-Montclair 27
 Atlantic City 24-Princeton 9

East Jersey Division
 Asbury Park 47-S. River 26
 Neptune 47-Lakewood 25
 Semi-Finals
 Asbury Park 48-Neptune 22
 Finals
 Trenton 41-Woodbury 9

South Jersey Division
 Trenton 51-Wildwood 14
 Woodbury 24-Collingswood 17
 Camden 36-Morestown 17
 Semi-Finals
 Trenton 24-Atlantic City 9
 Finals
 Woodbury 14-Camden 9

NEW JERSEY STATE BASKETBALL SEMIFINAL PAIRINGS
BALLANTINE GYM, RUTGERS COLLEGE,
NEW BRUNSWICK

Trenton vs. Newark Central, 8:30 p.m.
St. Benedict's Prep vs. Bordentown Military Academy, 3:30 p.m.
Passaic vs. Asbury Park, 4:30 p.m.
Peddie School vs. St. Peter's Prep, 7:30 p.m.
Central vs. Trenton, 8:30 p.m.

While awaiting the big games, the local sports fans began to examine the results of the recent National High School Basketball Tournament in Chicago. By comparing the scores of champion Cedar Rapids and a common opponent, it was deduced that Passaic would have been an easy winner. Cedar Rapids had defeated Crosby of Waterbury, CT, in the national semifinals by a score of 25 to 24. Before going to Chicago, Crosby hosted Hoboken and lost 36-31. Montclair proceeded to eliminate Hoboken from the play-offs by a score of 30 to 20. At mid-season, Passaic trimmed Montclair 57-25. Union Hill, who had also defeated Hoboken, lost to Glen Ridge 32-27. A week later and without breaking a sweat, Passaic took Glen Ridge 47-13. So there![95] All signs indicated that Blood's boys would have sailed through the windy city tournament.

When you are reputed to be the quickest shooter in the Northeast, every nimble-fingered shooter who ever took a shot at a hoop is aiming to challenge you. Such was the predicament facing Passaic as they emerged from the pack of elite teams. One of the first outside challengers was Stivers High School. On the eve of the semifinals, a game with Stivers, the winner of the Ohio State Basketball Championship for the previous three years, was in negotiations. Coach Guy Early's teams were the winners of 66 of their last 69 games, and he felt confident that they could upend the New Jersey kingpins. As were most of the challenges, this game was never played because of scheduling conflicts.

GAME #53 Asbury Park (Friday, March 18, 1921) at Ballantine Gym, Rutgers College. The Asbury Park team lived up to its billing as the "underdogs" as they were unable to mount a serious threat all afternoon. The Blood system was on display with quick, short passes; accurate shooting; and mass substitutions as the order of the day. Just when it appeared that Passaic was going to ease the pressure on Asbury Park, Prof sent in the much shorter substitutes. The comparatively diminutive Passaic subs were noticeably quicker than the first team, and they proceeded to shred their opponent and dazzle the crowd with their speed and lightning-quick passing. Even Secretary Short could not resist commenting on the performance of Passaic's second team, "I like that combination better than the big one. They pass the ball better."[96]

Without a doubt, the second unit was quicker, but the reason why was attributed to their experience working with Prof during practices. Prof was often the fifth man on the second unit during practice sessions, and he made them move the ball quickly. With this type of inducement, they became the first unit's most difficult opponent to defend.[97] Some observers close to the team wondered which unit would actually triumph were they to meet in a regulation game. Final score: **Passaic 57-Asbury Park 24**

Rutgers College Coach Frank Hill and his All-American Ed Benzoni were on the recruiting trail, and John Roosma was their prey. They were determined to recruit Roosma until a commitment could be obtained. For a while, it looked as if John would not get out of New Brunswick unless he promised to become a Scarlet Knight.

PASSAIC	G	F	T		ASBURY PARK	G	F	T
Roosma	10	6	26		Hildenbrand	5	6	11
Thompson	6	0	12		Blades	3	0	6
Vonk	2	0	4		Finley	1	0	2
Knothe	2	0	4		Smock	0	0	0
Blood	1	0	2		Schwartz	0	0	0
Keasler	1	0	2		**Totals**	**9**	**6**	**24**
Grabiac	0	0	0					
Swenson	2	0	0					
Saxer	0	0	0					
Rosman	1	1	3					
Totals	**25**	**7**	**57**					

STATE BASKETBALL TITLE COMPETITION GAME RESULTS

High School Division	Prep School Division
Passaic 57-Asbury Park 24	Peddie 36-St. Peter's 34
Trenton 28-Newark Central 27	St. Benedict's 42-Bordentown 28

Basketball connoisseurs felt Trenton was fortunate to beat Central and that they would pose little threat to Passaic. Everyone had Passaic as the class of the state. According to those in the know, if Passaic were to play the older prep champions, they would win handily.

The hot tip coming from Short echoed, "Watch Trenton." Early in the season, Trenton players had scholastic problems attributing to their losses against Atlantic City and Camden, but both losses were later avenged. Trenton was labeled the dark horse that was not to be taken lightly. "According to Mr. Short, Coach Earl [sic] Blood's Wonder Team is in for a real battle."[98] So much for the unbiased opinion of the man who orchestrated the tournament.

GAME #54 Trenton (Saturday, March 19, 1921) at Ballantine Gym, Rutgers College. The year before, Passaic had defeated Trenton on this same court for the same title (33-26), and Trenton was determined to prevent a reoccurrence. Coach Smith publicly stated that "Passaic had no defense." Prof ignored this obvious criticism because he knew it would not make any difference.

LEROY SMITH
photo courtesy of Trenton High School Yearbook, Bobashela

The cheers that greeted the Trenton squad as they entered the court were quickly swallowed up by the Passaic forces whose yells, cheers, and assortment of noise makers shook the walls of Ballantine Gymnasium. The "Wonder Team" had left the dressing room and entered the hall, and the hundreds of Passaic fans who were outside without tickets knew Passaic was on the court. The excitement was like nothing experienced before in a New Jersey schoolboy basketball game. This was the state championship; it was for all the marbles, and Prof's team was primed.

In the first half, it was a well-played, nip and tuck affair. Even though at one point Passaic held an eight-point lead, neither team could establish dominance over the other. This was a classic state championship contest with tension at its peak and emotions overflowing. Percy Davenport, Trenton's clever forward, tried roughing up Roosma and had to be warned by referee Harry Wallum to settle down. Later, Harker, the tall capital city center, and Ira Vonk were ordered to knock off their do-si-do duet. After the warnings were issued, the boys played top-notch basketball.

To the delight of their fans, the Trenton boys were playing their best basketball of the season. They were a fast, physical, and talented team who refused to be put away. At the midpoint, it was still anyone's game with the score 18-16 in Passaic's favor. While the Passaic fans were dissatisfied with their team's meager lead, Roosma and his mates were just glad to be ahead by two.

In the second half, Passaic altered their attack. Benefiting from the intermission with Prof, they were more prepared to get something going, and they did. For the first and only time all season, the Red and Blue boys were repeatedly challenged. With each Trenton surge, Passaic would hold on and reciprocate with a rally of its own.

Passaic had to adjust to Vonk's failure to control the tap against Harper who was taller and a year older. With Trenton getting the ball on almost every center jump, the best Passaic could do was steal it or rebound a missed shot. It was a disadvantage that was not going to go away. Prof spoke to his champions and told them it was "time to dig in, and go get the ball...." As the defense began breaking up the challengers' passing, a Passaic player would step up with a clutch basket.

Unable to penetrate Passaic's defense, Trenton opted for the long outside shot. This proved successful in the first half, but the law of averages began to catch up while the confidence and poise of the Passaic boys increased. For the second year in a row, Passaic was the state champion. Final score: **Passaic 42-Trenton 30.**

A triumphant procession of automobiles full of players and fans caravanned to Achtel-Stetter's Restaurant in Newark arriving at 6:30 p.m.

PASSAIC				TRENTON			
	G	F	T		G	F	T
Roosma	6	12	24	Davenport	2	8	12
Thompson	6	0	12	Emmons	1	0	2
Vonk	1	0	2	Harker	3	0	6
Knothe	1	0	2	Lenzner	0	0	0
Blood	1	0	2	Millman	1	0	2
Keasler	0	0	0	Cooper	0	0	0
Totals	**15**	**12**	**42**	**Totals**	**11**	**8**	**30**

Score by periods:

Passaic	18	24
Trenton	16	14

Roomsa made 12 of 18 fouls. Davenport made 8 of 10 fouls. Referee—Harry Wallum. Umpire—Joseph. O'Shea. Time of halves: 20 minutes.

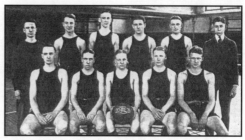

1921 TRENTON SQUAD

(NOT IN ORDER) PERCY DAVENPORT, ALDEN EMMONS, ALFRED BERGEN, EARL HARKER, ROBERT MILLMAN; SUBSTITUTES: ALBERT COOPER, CHARLES TILTON, JOSEPH LENZER, RONALD ROGERS; MANAGER: MEYER FREIDMAN, COACH: LEROY SMITH

photo courtesy of Trenton High School Yearbook "Bobashela"

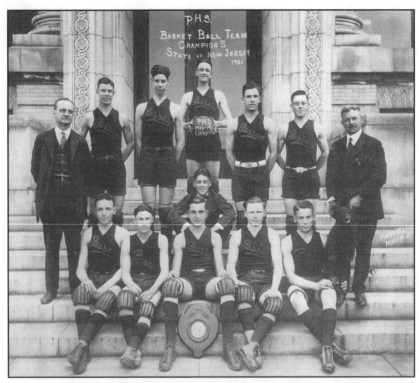

1920-21 STATE CHAMPS
(STANDING, LEFT TO RIGHT) **PRINCIPAL ARNOLD, BOB
THOMPSON, IRA VONK, JOHN ROOSMA, FRITZ KNOTHE,
PAUL BLOOD, COACH BLOOD WITH "ZEP."**
(CENTER) **MANAGER, ED SULLIVAN.** (SEATED) **DEWITT
KEASLER, ABE ROSMAN, JOHN GRABIAC, PINKY
SWENSON, BOB SAXER.**

for an impromptu dinner where the team was the guest of honor. Many
other occasions to celebrate a Passaic basketball team's success would
present themselves in the coming years. While the rosters changed each
year, it was Prof Blood who was to become known as the "Maker of
Champions." The celebrations in the Woolen City appeared as if they
would continue forever or for as long as Blood was the coach.

Passaic had a "Wonder Team," at least that was what people were
beginning to call them. Coincidentally enough, Passaic was not the only
Wonder Team in the country. There was another very talented high school
basketball team in Franklin, Indiana, called the "Wonder Five," but during
their four-year reign (1918-1922), they found a way to lose two, one, four,
and three games respectively per season.[99]

GAME #55 P. H. S. Seconds (Wednesday, March 30, 1921) at
Kanter's Auditorium. The final home games of the season were a fund-
raiser for the team's Easter vacation trip. The varsity and their Seconds

were to play in a preliminary game before two local pro teams—the "Caseys" from the Knights of Columbus versus the "Blue and Whites."

In the prelim, the "Seconds" had to play the first team without the help of Prof the player. He was always there for them in practice, but when they needed him for the big intersquad match, Prof was a spectator. The Seconds lost to the varsity but did manage to score the season's highest number of points for an opponent. Final score: **P.H.S. Varsity 65-P.H.S. Seconds 35.**

A peculiar note concerning the professional game was that it turned into a donnybrook affair. The schoolboys received a firsthand look at the professional game that was vastly different from Prof's system. When the Caseys' short-fused Ralph Powers and the Blue and Whites' Abe Schartoff squared off late in the first half, the fans and the police joined the fray. That was enough for referee Frank Hill to call the game off.[100]

GAME #56 Potsdam Normal HS (Saturday, April 2, 1921) at Potsdam. Prof had arranged for the two-time state champs to use their Easter vacation to travel by train to Potsdam for a couple of games with two of his former schools. Potsdam was Prof's old home, and the townspeople were so anxious to see him and his team play that all the stores closed their doors during game time.

Passaic's first game was against Potsdam Normal High School. To Paul Blood's surprise, he met a few players he knew from his days as a little kid growing up in Potsdam. When Paul's teammates realized that these were some of Paul's old friends, they decided to keep passing him the ball so he could be the high scorer. As it worked out, it wasn't his night; Paul could not make a basket to save his life.[101]

Playing in the Potsdam gym was a new experience for the Passaic team because of the supporting posts positioned in various locations on the court. The Potsdam kids used the posts to pick-off the pursuing Passaic players. It was a home court advantage that the Red and Blue boys had never encountered before. Regardless of the handicap, Passaic was too much for their hosts.[102] Final score: **Passaic 63-Potsdam 12.**

GAME #57 Potsdam Normal Alumni (Monday, April 4, 1921) at Potsdam. The second game scheduled was supposed to be against Clarkson Tech. After watching what happened to the Potsdam team, the Clarkson players decided they would rather not play. Instead, a group of Prof's former players from the old "Normal Five" days

PASSAIC				POTSDAM ALUMNI			
	G	F	T		G	F	T
Roosma	8	5	21	R.Sisson	1	2	4
Thompson	7	0	14	Jacot	3	0	6
Vonk	2	0	4	Reynold	2	0	4
Knothe	2	0	4	W.Sisson	2	0	4
Blood	2	0	4	S.Sisson	0	0	0
Keasler	0	0	0	Roach	2	0	4
Totals	**21**	**5**	**47**	**Totals**	**10**	**2**	**22**

quickly assembled to challenge Passaic.[103] When Rufus L. Sisson took the opening tap in for a quick score, it appeared as if Prof's Wonder Team could be in trouble. After the Sisson boys and Charles E. Jacot tired themselves out, the former members of the famed Potsdam "Normal Five" finally lost a game to a high school team. Final score: **Passaic 47-Potsdam Alumni 22.**

Historically, the Potsdam trip would be remembered most for the introduction of Zep, the team's black bear mascot. The less-than-one-week-old cub was given to Prof as a gift; his love for strange pets obviously dated back to his Potsdam days. The mystery surrounding the origin of the bear's name may lie in the accompanying pregame flyer. Is it possible that Zep was a Potsdam nickname given to Coach Blood? For more on the famed Passaic mascot, read chapter eighteen, "Zep."[104]

PROF AND HIS BEAR CUB "ZEP"

TONIGHT !

Passaic High School Again

=====AGAINST=====

'Zep' Blood's All Stars

Normal Alumni Re-enforced

'ZEP' BLOOD	STANLEY SISSON
WALT SISSON	EMMET ROACH
BOB REYNOLDS	RUFE SISSON
CHARLIE JACOT	WES WILSON

Can Age and Wisdom Overcome Youth?
Blood says, My Team will Win!
What Does He Mean?

Come and See! All Out Sure!

That Potsdam may see the Passaic Boys again in action we have arranged this game. The old boys are out to win. We need your support.

Game Called at 8 P.M. Tech Gym.

Admission 50c

All Up! = TONIGHT = All Up!

Upon the team's return home, an awards ceremony initiated by a citizens' committee headed by Mayor John McGuire was held in the school's auditorium to recognize their accomplishments. Team captain John Roosma and senior class president Dow Drukker, Jr., were the masters of ceremonies. Roosma, who had outscored all of Passaic's opponents combined during the season, presented the state championship plaque to a slightly chagrined Principal Arnold. After accepting the plaque on the behalf of the enthusiastic student body, Arnold joked that the school would soon need a special place for its trophies and reminded them that academic

achievements should go along with the athletic accomplishments.[105] In Arnold's mind, academic pursuits were taking a backseat to athletics, and he was struggling to handle it graciously.

How Johnny Roosma ended up at the United States Military Academy at West Point is another story, but for our purposes, no part of that story is more interesting than how Johnny came to qualify academically. According to Roosma, Arnold *gave* him the grades.[106] The details of this incident reveal a glimpse of Principal Arnold's *modus operandi*.

When Roosma met with General Douglas MacArthur, the Superintendent at West Point, the general noted that John's transcript reflected an average of only eighty percent, five points short of the Academy's entrance requirements. MacArthur told John to go back to Passaic and see if he could get the necessary grades. John went in to talk with Arnold. Upon hearing of John's plight, Arnold changed Roosma's grades to meet West Point's standard of eighty-five percent. "He gave me my marks. I was probably the first and last one he ever did that for," confessed Roosma.[107]

Why would a school principal engage in this obvious breach of ethics? As an academician with many years' experience, he had to realize the possible consequences of tailoring grades. An incident such as this today could lead to an administrator's dismissal. What could have influenced Arnold to take this risk? Was Arnold simply used to doing as he pleased in his administrative role? The probable answer is that John's affluent family had a strong bearing on Arnold's actions. The public was obviously not privy to this transcript adjustment. It is safe to surmise that if this transcript manipulation were made public, Arnold would have arranged to have his *derrière* covered.

This anecdote illustrates how Arnold responded in a manner that would augment his image with a respected, prominent family. Needless to say, Arnold's decision to change John's grades was appreciated by the Roosma matriarch and patriarch. Attendance at West Point helped launch John Roosma's distinguished military career, and it didn't hurt Arnold's career either.

Roosma's leadership attributes were recognized early, long before he entered West Point. His military service, including defending Pearl Harbor on the day of infamy in 1941, culminated with his promotion to the rank of colonel.

Whether or not Arnold did the right thing by sacrificing academic integrity is not the issue here. His propensity to act in a self-serving manner is.

CHAPTER SEVEN
THOUSAND POINT
BOBBY THOMPSON (1921-1922)

The new basketball season marked the thirtieth anniversary of the new indoor game. Aside from the first few months of those thirty years, Prof had been playing and/or coaching Naismith's creation. Prof was already forty-nine years old and a walking archive on the sport. This winter, he and his Passaic boys were going to experience a season for the ages.

This was an era of wonders. The Sultan of Swat had just completed his best season by hitting fifty-nine home runs. In his latest movie *The Sheik*, Rudolph Valentino had women swooning in the aisles. The "Wonder Five" at Franklin High School in Franklin, Indiana, coached by Ernest "Griz" Wagner, had been racking up some impressive basketball records of their own.[108] The Home Run King often struck out, Valentino didn't appeal to all woman, nor did the Franklin "Wonder Five" win every game. But in Passaic, the Passaic Wonder Teams never lost; they were beginning to appear invincible.

Passaic was an industrial city of about one square mile in area, and because of its location, it was within a couple hundred miles of most of the finest basketball in the country. Within commuting distance were many nascent basketball hot beds, but most notably, the densely populated areas of NYC, Trenton, and Philadelphia. Our story continues with Prof Blood and Passaic's newly christened Wonder Team becoming the envy and target of every other highly touted high school team.

Because of the notoriety, Prof's position with the team was secure. As far as public relations were concerned, it would have been an unpopular move to reassign him away from the basketball team. Principal Arnold did not appreciate the influence the team's success had on the school. Because of his educational philosophy, he interpreted the attention Prof's teams generated as a deterrent to academics.

The school's excellent academic reputation was overshadowed by the basketball team's success. The maestro behind it all was Prof Blood, one of the most popular figures in Passaic. His work as coach and physical director had upstaged Arnold's educational achievements. Playing second fiddle to Prof in the eyes of the public was a source of irritation for the principal. Because of his personal feeling, some of Arnold's efforts were

in opposition to Blood's. A conflict was brewing, and it was just a matter of time before it would erupt.

After first-year football coach Ray Pickett's season finished, Prof started basketball tryouts. The major loss from last season was Johnny Roosma who did enroll at West Point. This was the year that Prof was finally able to combine four teams into one. He staunchly advocated the value of large teams even though they were more difficult for a coach to instruct. Prof could overcome obstacles in coaching a large squad by enlisting the total attention of his players. You had to know what you were doing to play for Prof, and if you didn't, ten or more players were ready to take your place. Because of Prof's enthusiasm, seriousness, and rapport with the boys, their minds didn't stray when he was instructing.

The new captain was Paul Blood, Prof's son. The 5'7" guard's nickname during these years was "Stump," and like his daddy, he possessed the qualities of a leader. He was senior letterman in three sports. Next to Paul in the backcourt was the 5'9" junior Wilfred "Fritz" Knothe. Pundits were beginning to rate Fritz as one of the best scholastic basketball guards in the country—a true phenom. Before Fritz would graduate, he would earn his billing as a "once-in-a-lifetime athlete." He and Roosma were both first team all-state selections the previous season.

PAUL BLOOD

Two 6'1" veterans, junior DeWitt Keasler and senior Bobby Thompson, filled the Passaic forward positions. The left-handed Keasler had been a stalwart on the team since his freshman year. He was quick, rugged, and athletic, and because of his peculiar spin shots off the backboard, he was given the nickname "Twist of the Wrist." The other forward was mild-mannered Bobby Thompson who was a deft shooter from all angles, and when it was game time, he turned into a fierce competitor.

FRITZ KNOTHE

The returning center for the Red and Blue was 6'4" Ira Vonk. "Six," as he was called, did not take kindly to getting pushed around. His ability to control the center jump kept Passaic on the offensive. Add 6'5" forward/center Chester Jamolowitz to this aggregate, plus the undefeated Second Team which hadn't lost a game in eight years, and it spelled big trouble for the most optimistic opponents. Blood was assembling a force that would make news from coast-to-coast and beyond. Unfortunately, not everybody was as pleased as he was.

GAME #58 Dumont (Wednesday, December 14, 1921) at Passaic HS. The Dumont team from Bergen County arrived eager to challenge

the champions. Upon witnessing the pageantry of a Passaic opener, an aroused crowd, and a black bear leading a long line of Passaic players on to the court to the accompaniment of loudly sung cheers, the Dumont contingent was more eager for the trip home. The play started off like a whirlwind—center jump, tap, pass, and basket. Like a revolving door, this scenario was to repeat itself again and again throughout the game.

The highlight of this event was the introduction of Zep, the sixty-five pound black bear mascot. Zep wore a muzzle and was led by his trainer and wrestling partner Bennie Blood, Prof's number two son. If this were not enough, the singing that resonated from the worshipers made a Passaic game a spectacle. The Fire Marshall and the blue coated security policemen contributed to the escalating crescendo creating an intimidating environment. Final score: **Passaic 72-Dumont 2.**

GAME #59 Dover (Saturday, December 17, 1921) at Passaic HS. Before a capacity crowd of 800 fans, Prof realized his goal of dressing and playing four teams in one game. To get adequate exposure for his large squad, he scheduled double headers by bringing in two different schools. Playing two games in one day was not new to Prof; it was a scheduling ploy he used at Potsdam.

PASSAIC				DUMONT			
	G	F	T		G	F	T
Thompson	5	10	20	Gifford	0	0	0
Keasler	9	0	18	Bohme	1	0	2
Vonk	4	0	8	Luis	0	0	0
Knothe	3	0	6	Vogel	0	0	0
Blood	2	0	4	Major	0	0	0
Jarmalowitz	1	0	2	**Totals**	**1**	**0**	**2**
Rosman	7	0	14				
Saxer	0	0	0	Referee—Mueller,			
Merselis	0	0	0	South Side.			
Hamas	0	0	0	Timekeeper—Sullivan.			
Totals	**31**	**10**	**72**	Time of halves: 20 min.			

PASSAIC				DOVER			
	G	F	T		G	F	T
Thompson	13	3	29	Jankins	1	6	8
Keasler	5	0	10	Shorter	1	0	2
Vonk	1	0	2	Howell	0	0	0
Blood	8	0	16	Mathews	0	0	0
Knothe	2	0	4	Eghart	0	0	0
Rosman	6	4	16	**Totals**	**2**	**6**	**10**
Hamas	5	0	10	Time of halves: 20 min.			
Jermalowitz	5	0	10				
Saxer	4	0	8				
Blitzer	3	0	6				
Totals	**52**	**7**	**111**				

After the starters ran up a score of 60-6, Prof had the timer sound the whistle. Upon hearing the whistle, Prof called, "Second team in." The second team finished the game and played equally as well as the first group. Final score: **Passaic 111-Dover 10.**

GAME #60 Kearny (Saturday, December 17, 1921) at Passaic HS. A real sideshow began in the second game with Dave Tobey's team from Kearny High School. Young Tobey would go on to distinguish him-

self as an outstanding coach and referee. He was hoping the Passaic team would slow down after plastering Dover. Twenty-two years later, he would write *Basketball Officiating,* the first book ever on the subject. On this particular day, Tobey, a future basketball Hall of Famer himself, would get his first real exposure to an on-court avalanche.

While testing the strength of Tobey's boys, the score ran to 46-4 before Prof called, "Second team in." Rosman, Hamas, Saxer,

PASSAIC	G	F	T
Thompson	5	8	18
Keasler	2	0	4
Vonk	3	0	6
Blood	4	0	8
Knothe	5	0	10
Rosman	1	2	4
Hamas	4	0	8
Jermalowitz	2	0	4
Saxer	1	0	2
Blitzer	1	0	2
Soule	0	0	0
Freeswick	0	0	0
Zelinsky	2	0	4
Janowsky	0	0	0
Lucasko	0	0	0
Humphry	1	0	2
Troast	2	0	4
Merselis	0	0	0
Smith	1	0	2
Taylor	2	2	6
Totals	**36**	**12**	**84**

KEARNY	G	F	T
Blake	0	3	3
Mulford	1	0	2
Joel	0	0	0
Lury	0	0	0
Banalger	0	0	0
Siber	0	0	0
Scott	0	0	0
Jacobs	0	0	0
Totals	**1**	**3**	**5**

Time of halves: 15 min.

Jermalowitz and Blitzer jumped on the court. After watching a 22-0 run, Prof turned to the bench and said, "Third team in." Upon hearing their signal, Soule, Freeswick, Zelinsky, Janowsky and Lucasko ran on the court ready to pick up the action. Three minutes and four points later, Prof shouted out, "Fourth team in." It was at this point that the Dover team on the sideline and the Kearny team on the court stopped and glanced at each other and then looked over at Prof. They couldn't figure out where all the Passaic players were coming from! Final score: **Passaic 84-Kearny 5.**

It wasn't so much the 195 to 15 point totals for the two games that had fans talking; it was the efficiency and machinelike manner in which the Passaic boys performed that made the most startling impression. The fact that Passaic had four teams of almost equal ability all indoctrinated in the same system helped perpetuate the saga of Prof Blood and his "Wonder Teams." The cheering, the singing, and the black bear all contributed to the nonpareil ambience that was now Passaic basketball.

GAME #61 Newark Junior College (Tuesday, December 21, 1921) at Passaic HS. The Red and Blue boys got off to a slow start, but it hardly mattered because the JC players never got started. On top 45-1 at half time, Passaic raced to another win. As the game progressed, some fans grew disgruntled because the administration had restricted the use of the school's piano thus hindering their singing. Final score: **Passaic 80-Newark Junior College 4.**

Winning can create a monster. The team experiences a rapid increase in fans with tall expectations. The piano incident was one of the early indications of the monster syndrome. Other indications were the overly critical remarks about the team not "looking sharp" for every

PASSAIC	G	F	T	NEWARK JC	G	F	T
Thompson	10	14	34	Fedor	0	0	0
Keasler	2	0	4	Zimmerman	0	2	2
Vonk	7	0	14	Jaskowicz	0	0	0
Blood	4	0	8	Rubenfield	1	0	2
Knothe	2	0	4	Gross	0	0	0
Rosman	3	0	6	Unger	0	0	0
Hamas	0	0	0	**Totals**	**1**	**2**	**4**
Jarmalowitz	5	0	10				
Totals	**33**	**14**	**80**				

game and the disappointment when the team failed to score to the fans' satisfaction. Once the monster is created, it expects to be fed.

Some within the victors' own camp perceive the winning as coming at their expense. These few will covertly seize every opportunity to bring the winning to a halt. When a team wins too much, there will always be somebody who is not pleased, and this was beginning to take place in Passaic. Where it was taking place was most surprising.

GAME #62 Passaic Alumni (Saturday, December 24, 1921) at Kanter's Auditorium. The gala evening began with Prof introducing members of the alumni team and giving a brief account on each former player's activities. With the likes of Kolbe, Schneider, Rumsey, Lent, Jaffe, Macher, Swenson, and Campbell, they appeared ready to win one for the alumni. The graduates forced the Wonder Team to rise to the level of competition and then some. Behind Thompson's 23 points, the unblemished record remained intact. Final score: **Passaic 50-Alumni 27.**

Challenges were coming from all directions. Almost every successful basketball team within a reasonable distance wanted its licks with Passaic. Prof was in contact with Attleboro from Massachusetts; Crosby from Waterbury, Connecticut; and Poughkeepsie from New York, just to mention a few. Because of how the respective schedules matched up and the agreement reached concerning the guarantee, the Attleboro team chose to try their luck.

The Attleboro game was shaping up to be an interesting challenge. Attleboro basketball had a winning tradition, and their people were proud of their current 3-1 quintet. Their coach, Lester Purvere, was a former Passsaic resident. Prof offered a unique financial incentive to Purvere for this game; Attleboro was to receive a guarantee ranging from $25 to $200, depending upon the showing they made against the champs. Here is how the *Passaic Daily News* explained the extraordinary financial details.

Coach Blood told the Attleboro team that they could come on to Passaic and if the lads of Passaic High School beat them by more that fifty points, the visiting team was only to receive $25. If Attleboro held Passaic down to a forty-point lead, it was to receive $50 expense money. If the Massachusetts combination was that good that it could keep Passaic's lead down to thirty points they would be presented with a check for $100. They were offered $150 if the lads from top of the hill could only get a twenty point advantage and two one-hundred bills were offered Attleboro it they held Passaic to a ten point lead.[109]

This was vintage Prof—confident. There was never a word mentioned about the possibility of Attleboro beating Passaic.

GAME #63 Attleboro (Friday, December 30, 1922) at Passaic HS. Long before tap-off time, guards had to be placed at the doors to prevent the crowd from exceeding the 800-person capacity. At the opening center jump, the ball went tap, pass, pass to Paul Blood, and score. A fan yelled, "They're on their way again." Any thoughts of a fat payoff faded long before half time.

Unlike other games, Prof kept the playing time among his top seven men. Once the special guarantee arrangements were satisfied, Prof did what he could to hold the score down. A Massachusetts news-paperman's story expressed what happened. "The New Jerseyites did not miss a single shot and

PASSAIC	G	F	T	ATTLEBORO	G	F	T
Thompson	15	19	49	Davis	2	0	4
Keasler	8	0	16	H.Nerney	0	1	1
Vonk	5	0	10	W.Sharkey	0	0	0
Knothe	5	0	10	A.Sharkey	0	0	0
Blood	9	0	18	Seyboth	0	0	0
Jarmalowitz	4	0	8	N.Nerney	0	0	0
Rosman	0	0	0	**Totals**	**2**	**1**	**5**
Totals	**46**	**19**	**111**				

Half time score: 47-0. Scorer—Saunders. Timer—Joe Whalley. Referee—Harry Wallum.

towards the end of the game contented themselves with improving their floor work, not even trying to cage the basketball."[110] Attleboro's scorekeeper was dumbfounded by the time the game was over. "I've seen the Original Celtics in action, but this team can beat them," he said. Passaic's games were turning into a local show time with Zep carrying on, cheerleader Mike Kiddon leading the capacity crowd in cheers and singing, and the fans pleading for the century score. Final score: **Passaic 111-Attleboro 5.**

How and/or why Passaic continued to dominate its competition with no end in sight was a topic that remained on the lips of sports fans. Many theories were offered to explain this phenomenon. The home fans and other unbiased eyewitnesses gave credit to Prof Blood and his unique

system which emphasized the pass instead of the dribble. Others looked for more devious explanations to account for their overwhelming edge. Seeing was believing, and so it was with the visiting teams and their fans. Whenever the schedule permitted, the Doubting Thomases were encouraged to come, play, and see for themselves.

GAME #64 Keyport (Saturday, December 31, 1921) at Passaic HS. The South Jersey team from Keyport arrived with a recent win over Dickerson and a disappointing loss to Asbury Park under their belts. Those games did not prepare them for what awaited in Passaic. They became believers and departed a better team for the experience. The only real competition that night was the rough and tumble pregame wrestling match between Bennie Blood and Zep. Final score: **Passaic 106-Keyport 21.**

PASSAIC	G	F	T	KEYPORT	G	F	T
Thompson	10	14	34	Nedle	2	3	7
Keasler	16	0	32	Cuttfelt	0	0	0
Vonk	11	0	22	Carhart	5	4	14
Blood	3	0	6	Dane	0	0	0
Knothe	0	0	0	Anderson	0	0	0
Rosman	1	2	4	Roberts	0	0	0
Hamas	1	0	2	**Totals**	**1**	**3**	**5**
Jarmalowitz	1	0	2				
Saxer	1	0	2	Referee—Harry Wallum,			
Blitzer	1	0	2	Union Hill.			
Freeswick	0	0	0				
Zelinsky	0	0	0				
Janowsky	0	0	0				
Lucasko	0	0	0				
Humphrey	0	0	0				
Troast	0	0	0				
Totals	**45**	**16**	**106**				

GAME #65 East Greenwich Academy (Saturday, January 7, 1922) at Passaic HS. The Rhode Island champions rode into Passaic with an 8-1 record; their only defeat a 58-18 hammering at the hands of the famed Crosby team. The first bad omen for East Greenwich was their German Shepard mascot's

PASSAIC	G	F	T	E. GREENWICH	G	F	T
Thompson	7	22	36	Tinkoff	2	0	4
Keasler	6	0	12	Pollitt	4	0	8
Vonk	2	0	4	Thacher	0	0	0
Knothe	2	0	4	McDermott	0	1	1
Blood	4	0	8	Busk	0	0	0
Jarmalowitz	2	0	4	**Totals**	**6**	**1**	**13**
Totals	**23**	**22**	**68**				

Referee—Wallum, Union Hill. Scorers—Saunders, Passaic & Zeckhausen, East Greenwich. Timekeeper—Margetts. Time of halves: 20 minutes.

reaction to Zep; the police dog was ready to high tail it out of there. It was not long into the game before all the visitors felt as the dog did.

Because of the sensational play of "East Greenwich's 5'6" colored forward Frankie Pollitt," who was a two-time All New England selection at Rogers before transferring, they managed to hang close (27-6) for a

half. The play of the day occurred when Paul Blood dove between the legs of Pollitt and stole the ball away from the New England star. Final score: **Passaic 68-East Greenwich 13.**

GAME #66 Hackensack (Wednesday, January 11, 1922) at Hackensack. Traveling without DeWitt Keasler (academic difficulties) for the opener of the NNJIL provided the first dose of frustration for Passaic. The inexperienced hosts gave a good account of themselves, but the Passaic fans, who had become accustomed to a better show, went home disappointed. On a number of occasions, the champs let their emotions get the best of them, and their play reflected it. Hackensack's Coach Peters was pleased with his boys' showing.

The anomaly of the game was when all-state guard Fritz Knothe threw in a half dozen bombs from the center of the court. Prof believed it was not in a team's best interest to shoot from that far out but to work the ball in close for easier shots. As Prof learned more about Knothe's special qualities, it didn't take long for him to adjust. Final score: **Passaic 73-Hackensack 27.**

Crosby was anxious to play Passaic, but they insisted on a home and away contract. Crosby's dates were in conflict with scheduled NNJIL games, and traveling to Waterbury on any day but a Saturday would require missing school and that was against school policy. Prof wanted to meet Crosby or anybody else on neutral terms, but it would have to wait until after the regular season.

GAME #67 Englewood (Saturday, January 14, 1922) at Passaic HS. To accommodate a game with Matawan in the evening, Prof asked Englewood to play its game in the afternoon. The team's performance was still lackluster. When referee Harry Wallum failed to show up, Picinich, a former star player for Englewood, agreed to fill in until Wallum arrived.

PASSAIC				HACKENSACK			
	G	F	T		G	F	T
Thompson	12	13	37	Walters	2	15	19
Jarmalowitz	3	0	6	Mercier	2	0	4
Vonk	6	0	12	Dixon	1	0	2
Hamas	1	0	2	Sheridan	0	0	0
Knothe	7	0	14	McDermott	0	1	1
Blood	1	0	2	Sadlock	1	0	2
Rosman	0	0	0	**Totals**	**6**	**15**	**27**
Saxer	0	0	0	Referee—Wallum.			
Totals	**30**	**13**	**73**	Timer—Stokes.			
				Scorer—Voorhis.			

PASSAIC				ENGLEWOOD			
	G	F	T		G	F	T
Thompson	6	10	22	Mahoney	2	6	10
Jarmalowitz	7	0	14	Springer	1	2	4
Vonk	1	0	2	Clarke	1	0	2
Hamas	0	0	0	McCoy	1	0	2
Knothe	2	0	4	Klatt	1	0	2
Blood	2	0	4	Caswell	0	0	0
Saxer	1	0	2	**Totals**	**6**	**8**	**20**
Totals	**19**	**10**	**48**				

Score by halves:

Passaic	23	25
Englewood	10	10

The players took advantage of Picinich's "Let them play" attitude and began to mix it up. As poorly as Passaic performed, they were never in danger of losing. Final score: **Passaic 48-Englewood 20.**

GAME #68 Matawan (Saturday, January 14, 1922) at Passaic HS. Two hours before the eight o'clock game, a large pick-up truck with cold, stiff Matawan basketball players covered with hay arrived at PHS. They were a husky group, yet their only hope was that Passaic's poor shooting would continue. What a difference five hours can make. When Blood's troops returned to the gym after dinner starving for redemption, Matawan was their dessert.

Long before full court pressure defenses were in vogue, Prof's teams, even at Potsdam, used them. Prof called full court pressure "offensive defense." His thinking was based on the idea that when your team loses the ball, you immediately go after it until you get it back. This constant pressure was another reason for the frequently lopsided scores.

Matawan, the league leader from the Monmouth County League of South Jersey, found itself caught in this Passaic juggernaut. In the second half, Matawan's frustration began to mount. The visitor's hopes looked grim as Passaic baskets registered in mercurial fashion caused by the relentless defense. In a moment of complete frustration, upon securing a rebound, George Craig, Matawan's star player, found a way to circumvent the entire Passaic defense by letting loose with a long throw for the goal. From his position at the foul line, his heave was three-quarters length of the court away from the goal. To everyone's surprise, including George's, the ball went swish. The capacity crowd let out such an uproar that the game had to be stopped until the fans from both teams regained their composure. After the game, a small caravan of "believers" traveled south. Final score: **Passaic 109-Matawan 18.**

GAME #69 Cliffside (Wednesday, January 18, 1922) at Cliffside Park. Now that

PASSAIC	G	F	T	MATAWAN	G	F	T
Thompson	18	15	51	GCraig	2	10	14
Jarmalowitz	5	0	10	Van Pelt	1	0	2
Vonk	6	0	12	Schenck	0	0	0
Hamas	1	0	2	McNally	1	0	2
Knothe	3	0	6	Weber	0	0	0
Blood	7	0	14	Wooley	0	0	0
Rosman	1	0	2	R.Craig	0	0	0
Saxer	3	0	6	**Totals**	**4**	**10**	**18**
Margetts	0	0	0				
Freeswick	2	0	4				
Zelinski	0	0	0				
VanderHeide	1	0	2				
Totals	**47**	**15**	**108**				

Passaic fans had become accustomed to the growing win streak, they were disappointed if the team didn't score one hundred points. After another subpar performance at Cliffside Park, the surrounding newspapers

knocked the two-time undefeated champs. The home reporters spoke freely about how disappointed the fans were with the team.

Prof was not called the Grey Thatched Wizard for nothing. He understood human nature, but more importantly, he knew his team could not lose to a Cliffside team even without his talented forward DeWitt Keasler. If everything went well during the game, how motivated would the players be to improve? Prof knew when he wanted his boys to be at their best, and the game against Cliffside was not one of those times. The frown Prof wore after the game was more for effect than a reflection of his emotional state. Final score: **Passaic 43-Cliffside Park 17.**

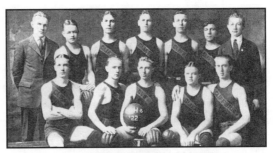

CLIFFSIDE PARK TEAM

(NOT IN ORDER) MARTENS, BORRELLI, HOUK, KIRMAYER, MACDONALD, MCCABE, LUEDERS, WELLINGHORST, JAS. WHELAN, JOS. WHELAN, COACH ROBERT BURNS, MANAGER KENNETH HOURIGAN

PASSAIC	G	F	T	CLIFFSIDE PARK	G	F	T
Thompson	7	17	31	Borelli	1	0	2
Jarmalowitz	0	0	0	McCabe	0	0	0
Vonk	1	0	2	Whalen	0	0	0
Hamas	1	0	2	McDonald	3	0	6
Knothe	1	0	2	Houck	1	5	7
Blood	1	0	2	Martens	1	0	2
Rosman	0	0	0	**Totals**	**6**	**5**	**17**
Saxer	2	0	4	Half time score: 18-8.			
Totals	**13**	**17**	**43**	Referee—Joe Johnson.			

GAME #70 Neptune (Friday, January 20, 1922) at Passaic HS. A talented Neptune team (one loss) was hoping to catch Blood's protégés still in their slump. Having addressed the recent deficiencies and with the return of Keasler, Passaic started to show their previous form. Oddly enough, the visitors used a passing attack similar to Passaic's. Two defenders fouled out trying to stop Bobby Thompson. Signs of what Prof covered in practice during the last couple of days were now evident. The passing was the finest it

PASSAIC	G	F	T	NEPTUNE	G	F	T
Thompson	9	10	28	Jacques	3	0	6
Jarmalowitz	3	0	6	Finkel	1	0	2
Vonk	0	0	0	T.Schlos'h	1	0	2
Hamas	0	0	0	B.Schlos'h	3	0	6
Knothe	4	0	8	Nary	2	8	12
Blood	9	0	18	VanNor'k	0	0	0
Keasler	2	0	4	Pearce	0	0	0
Saxer	2	0	4	**Totals**	**10**	**8**	**28**
Totals	**29**	**10**	**68**				

Referee—Harry Wallum, Union Hill. Scorers—Cohen and Jacobs. Time of halves: 20 minutes.

had been all season. The ball was passed quickly until a player was sprung open for a shot under the basket. Neptune had no answers to reverse the first half 35-11 trend. A hungry Passaic team did not let go of Neptune until the final whistle. Final score: **Passaic 68-Neptune 28.**

GAME #71 Ridgewood (Wednesday, January 25, 1922) at Passaic HS. Along with its ride into Passaic, the Ridgewood team rode into history. Within the flow of the Passaic offense, Bobby Thompson found the basket for 24 field goals. "Big Six" Vonk out-jumped and out-played Hiler, Ridgewood's two-time all-state football player. The ledger read 50-9 at half time, and that was the visitors' better half. Final score: **Passaic 101-Ridgewood 12.**

PASSAIC	G	F	T	RIDGEWOOD	G	F	T
Thompson	24	15	63	Pinkney	1	4	6
Jarmalowitz	3	0	6	Russell	0	1	1
Vonk	4	0	8	Hiler	1	0	2
Hamas	1	0	2	Jenkins	0	0	0
Knothe	2	0	4	Hall	0	0	0
Blood	1	0	2	White	0	1	1
Keasler	8	0	16	Terhune	0	0	0
Saxer	0	0	0	Morrison	0	0	0
VanderHeide	0	0	0	**Totals**	**3**	**6**	**12**
Totals	**43**	**15**	**101**				

Referee—Harry Wallum. Scorer—Dave Endler. Timer—Prescott. Time of halves: 20 minutes.

GAME #72 Eastern District of Brooklyn (Saturday, January 28, 1922) at Passaic HS. The Brooklyn boys earned impressive victories over De Witt Clinton and Commerce High Schools. While they were superior to the Blood boys in speed of foot, they lacked the passing and teamwork of Passaic. Eastern had hoped to dominate the locals with its speed, but they quickly learned they couldn't outrun the ball. Passaic's quick passing ran the speedy Brooklynites into the ground. Playing against an extremely talented opponent, the boys

IRA VONK

BOBBY THOMPSON

PASSAIC	G	F	T	EASTERN DISTRICT	G	F	T
Thompson	25	12	62	Meister	2	7	11
Jarmalowitz	1	0	2	Schulman	1	5	7
Vonk	6	0	12	Seligman	4	0	8
Hamas	1	0	2	Judas	0	0	0
Knothe	3	0	6	Zasuly	1	0	2
Blood	3	0	6	**Totals**	**8**	**12**	**28**
Keasler	5	0	10				
Saxer	0	0	0	Referee—Harry Wallum.			
Totals	**44**	**12**	**100**				

from Lafayette Street played their best game of the season. Bobby Thompson had a field day; he hardly missed a shot all afternoon. Final score: **Passaic 100-Eastern District 28.**

Passaic's runaway victories led critics from neighboring cities to posit reasons for the unheard of scores. Paul Prep, a sportswriter for the *Philadelphia Ledger,* provided some of the most obscure hypotheses for Passaic's achievements. One such theory Prep wrote was that at one time, schools in Northern New Jersey were known for having screen backboards. Screen or wire backboards enabled the home teams to find the soft spot that made it easier to score.[111]

Prep also noted in his column the fact that Passaic was originally scheduled to play the Philly champs, South Philadelphia, not the Eastern District team. Prep merely reported that the game was canceled, not mentioning that it was the Philly boys who called off the game. No reason was given for the cancellation, but it was later learned that their starting forward and center had become ill.[112]

The *Philadelphia Ledger* reporter went on to cast doubt over Bobby Thompson's scoring escapades writing that it wasn't possible for a school-boy to accomplish such numbers. Prep further reasoned that Passaic had to play all their games at home under "homer type" conditions to win so many games, not to mention winning by such large margins.

In actuality, of the seventy-two games in the streak, only thirty-eight were played at home. During the 1920-21 season, Passaic played fifteen at home and sixteen away, and the previous year, they played eleven at home and fifteen away. Only during the current season was the home/ away balance not equitable. Thus far, during the 1921-22 season, Passaic hosted twelve of the fifteen games played. The alleged reason for this imbalance was Prof; he reasoned that since PHS was the marquee team, opponents should come to Passaic or meet on a neutral court.[113] Or was Prof under some pressure from the principal over the number of games played and its effect on the boys' academic performances?

GAME #73 Hackensack (Wednesday, February 1, 1922) at Passaic HS. Passaic had been playing their best basketball of the season when Hackensack trotted into town. The Hacks did nothing to change that trend as they were quickly run back out. The headlines in the *Passaic Daily News* said it all, "Century Scores Coming Regularly At High School." For the last three games, and for the seventh time that season, the boys in Red and Blue scored over one hundred points. Typical basketball scores for this era were in the teens, twenties, or thirties. The winning streak and the outlandish scores were attracting the attention of the news media from across the state as well as the surrounding states.

The return of DeWitt Keasler (out since the Neptune game) marked the turning point when Passaic started to jell once more. The bushy-

haired lefty had a distinctly unique shooting style that opponents found difficult to stop. In an effort to prevent Passaic from hitting the century mark again, Hackensack stalled during the final minutes. Final score: **Passaic 103-Hackensack 20.**

Earlier in the season, Walter E. Short announced that the state finals were going to be held in Tren-

PASSAIC				HACKENSACK			
	G	F	T		G	F	T
Thompson	11	9	31	Walters	0	10	10
Jarmalowitz	7	0	14	Sadlock	2	0	4
Vonk	3	0	6	Mercier	3	0	6
Hamas	0	0	0	Dixon	0	0	0
Knothe	4	0	8	Pfluge	0	0	0
Blood	6	0	12	**Totals**	**5**	**10**	**20**
Keasler	13	0	26	Referee—Wallum.			
Rosman	0	0	0	Timer—Drukker.			
Saxer	2	0	4	Half time score: 54-11.			
Humphrey	0	0	0				
VanderHeide	1	0	2				
Margetts	0	0	0				
Totals	**47**	**9**	**103**				

ton because, according to him, the tournament had outgrown Rutgers' Ballantine Gym. Even though the Trenton arena could accommodate a much larger crowd, the change of venue was not viewed as a popular move by the basketball referees and the schools from the northern portion of the state.

The people from the more densely populated northern part of the state argued that most of the better teams were from the North Jersey. They believed that there were at least a half dozen northern schools better than any from the other sections, so why should they play off to eliminate each other? Besides, it was too far and too expensive for the two northern semifinalists and their fans to travel.

Prof viewed the change of site as unfair, and he publicly stated that Passaic would not go to Trenton for the state finals. He would allow his team to participate in the preliminary rounds, but they would not make the trip to Trenton. Prof also objected to the use of postgraduates (PG's), as was the case last year. He wanted the NJSIAA to enforce their PG's policy. His ultimatum did nothing to further endear him to Short and the state association.[114]

GAME #74 Williams Prep, Stamford, Connecticut (Saturday, February 4, 1922) at Passaic HS. In spite of arriving late because of a flat tire on the drive down, Williams Prep was a confident team. They had sixteen wins already, and their starting forward Haggerty was the nephew of Horse Haggerty who played with the Original Celtics. Decked out in their conspicuous green uniforms and with a Haggerty and Leonard in the line up, it appeared that Passaic could have been playing the Original Celtics.

Instead, a reign of terror unlike any in the brief history of the game came to a close against the New England prep schoolers. In a span of

eleven days, Passaic topped the century mark four times, far exceeding the norm. Playing without the services of center Ira Vonk who was ill, Passaic still managed to play an almost flawless game. Jermalowitz and Keasler had great games, but it was the record-breaking performance of Bobby Thompson (69

PASSAIC				WILLIAMS PREP			
	G	F	T		G	F	T
Thompson	27	15	69	Dillon	0	0	0
Jarmalowitz	14	0	28	Mourke	0	1	1
Keasler	14	0	28	Haggerty	0	0	0
Knothe	9	0	18	Fitzimmons	0	0	0
Blood	1	0	2	Leonard	2	0	4
Totals	**65**	**15**	**145**	Pender	0	0	0
				Totals	**2**	**1**	**5**

Half time score: 62-5. Referee Hoy Schulting, Dartmouth. Scorer—Saunders. Timekeeper—Edward Sullivan. Time of halves: 20 minutes.

points) that propelled him into the history books of scholastic basketball. Bobby garnered thirty-nine points in the second half when Passaic outscored the visitors 83-0. Representatives from Newark Central and Hoboken witnessed the carnage, and they tried unsuccessfully to appear unimpressed. Final score: **Passaic 145-Williams Prep 5.**

After suffering their humbling ordeal, it was the opinion of Prep's Captain Jack Dillon that Passaic could defeat Crosby by fifty points. If a game with Crosby could be scheduled, Dillon and his team would want to see the game and root for Passaic.

Thompson's outburst surpassed a number of known records. Bobby broke Dave "Nanny" Goldstein's sixty-four point school record in the 144-27 romp on December 30, 1908, against Bloomfield. He also eclipsed Johnny McNab's sixty-five points scored for the old Paterson Crescents when they defeated the Montereys 123-1.[115] The 145 total would not be bettered for another thirty years.

Bobby Thompson's scoring spree for the last four games totaled 225 points—averaging 56.3 per game. Here is a summary:

Game #71	January 25	Ridgewood 101-12	63 points
Game #72	January 28	Eastern Dist. 100-28	62 points
Game #73	February 1	Hackensack 103-20	31 points
Game #74	February 4	Williams Prep 145-5	69 points

Thompson' sixty-nine point performance stood as the state record until Bob Verga from St. Rose in Delmar bettered it in March 1963 at the Atlantic City Convention Hall. Before the season finale, Thompson would go on to set more individual scoring marks that would endure for years.

GAME #75 Englewood (Wednesday, February 8, 1922) at Englewood. In a fast, rough and tumble, seventeen-minute half, Passaic was made to earn its sixth league win. Two of Englewood's players, McCoy and Springer, were looking to pick fights with Thompson and

Knothe respectively. With emotions high and elbows and fists raised, Passaic displayed its versatility by winning on the road and under adverse conditions. The respected referee, Joe Johnson from Paterson, did well by controlling the fray. Vonk, who had been ill, returned for a

PASSAIC	G	F	T	ENGLEWOOD	G	F	T
Thompson	9	15	33	Mahoney	5	6	16
Jarmalowitz	2	0	4	Springer	2	0	4
Vonk	2	0	4	Clark	1	0	2
Blood	4	0	8	McCoy	0	0	0
Knothe	3	0	6	Klatt	1	0	2
Keasler	10	0	20	Cooke	2	0	4
Totals	**30**	**15**	**75**	**Totals**	**11**	**6**	**28**

Referee—Joe Johnson. Timer—Prescott. Scorers—Smith and Saunders. Score at half time: 40-19. Time of halves: 17 minutes.

brief appearance. Final score: **Passaic 75-Englewood 28.**

A couple of days later, arrangements were made to host the Philadelphia All-Scholastic team who were just beginning an exhibition tour. The team was comprised of all midyear graduates (PG's). The game was scheduled to put to rest the wails of the critics that PHS was playing setups. Emmanuel Belloff, a prominent sports writer from the *Philadelphia Ledger*, picked the Philadelphia team. The scribes from the City of Brotherly Love declared its team all but invincible. In the world of sports, this game was generating interest not only in the Passaic area, but the entire tri-state area as well.

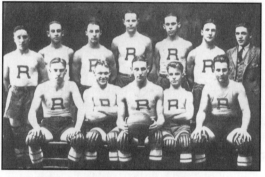

1922 RUTHERFORD TEAM

(STANDING) WEBSTER, BOSE, HELLWIG, BLACK, GREEN, LOTHIAN. (SEATED) DIXON, LIGHTFOOT, BAUER, VULTEE, WILLIAMSON

photo courtesy of Rutherford High School Yearbook, The Rutherfordian

GAME #76 Rutherford (Saturday, February 11, 1922) at Rutherford City Hall Court. While waiting for the Philadelphia team, Passaic had to confront Rutherford in the most

PASSAIC	G	F	T	RUTHERFORD	G	F	T
Thompson	5	12	22	Williamson	2	1	5
Jarmalowitz	4	0	8	Dixon	1	3	5
Keasler	4	0	8	Bauer	0	0	0
Knothe	4	0	8	Lightfoot	0	0	0
Blood	1	0	2	Webster	0	0	0
Vonk	0	0	0	Vultee	1	0	2
Totals	**18**	**12**	**48**	**Totals**	**4**	**4**	**12**

Referee—H. Stein, Plainfield HS. Timers—Wallace, Rutherford; Prescott, PHS. Scorers—Sohst, Rutherford; Saunders, PHS. Score at half: 27-8. Time of halves: 17 minutes.

physical game of the season. Once an opponent realized it had no chance to win, a typical tactic was to try maiming the finesse-minded Passaic boys. Rutherford's football-like strategy, the dinky court, and the seventeen-minute halves were the real reasons for the crowd-pleasing low score. Final score: **Passaic 48-Rutherford 12.**

An interesting score of another game played the same day was the 52-27 trouncing Montclair handed Trenton. These intersectional games often illustrated the strength of the North Jersey teams as compared to the remainder of the state. Passaic was well aware of Montclair's quality baskctball team.

GAME #77 Philadelphia All-Scholastic (Monday, February 13, 1922) at Passaic HS. The hype surrounding this special game was immense. Regular season tickets were not accepted for this classic match up. A gym full of spectators (700 to 800) and sports writers were on hand to see the grandest schoolboy basketball attraction ever remembered—the Passaic Wonder Team versus the Philadelphia All-Scholastics. Passaic Mayor John R. McGuire received a warm round of cheers from the crowd when he entered the gym.

The lineup for the invincible Philadelphians included forward Morris Abrams and center Louis Sherr from South Philadelphia. At the other forward position was James Mullin from West Catholic, who was rated the second best forward in the city. From Germantown and West Philadelphia came the guards John Lungren and Howard Stevenson respectively. The two substitutes were Louis Cherchesky of Central and Robert Wetter from Frankfort.

From the inception of the game, Philadelphia had been known as a great city for developing basketball talent. The All-Scholastic players were no exceptions, and player for player, they were better physical specimens than the Jersey boys. The good news for Passaic was that "Big Six" Vonk was back in uniform, but he was far from being fully recovered from his recent illness.

Each of the all-stars was a skilled veteran, but what gave the Blood cohorts the edge was their ability to play as a unit, and that was evident as well. With the team factor continuously giving Passaic the advantage, the Red and Blue boys' score slowly crept ahead. The visitors knew all the tricks in the book. In an effort to stop the highly touted Thompson from scoring, John Lungren, who was built like Hercules, literally hung on Thompson. Thompson managed to shoot and make only one shot. Lungren's instructions were to "stick" to the high scoring forward, but it cost Lungren and the rest of the Philly boys in personal fouls. As a result, Thompson canned 23 of 27 foul shots. When the talented center Louis Sherr fouled out, Prof requested that he be permitted to continue playing because his presence was so important to the visitors' game.

As the game continued, it became obvious to the all-stars that they could not stop Passaic's quick passing attack. From the pregame publicity, the visitors were of the opinion that Passaic was mostly a one-man team. By game's end, Philadelphia realized the error in its strategy. Passaic played as a team; it didn't matter who scored. Tonight it was Knothe's and Jarmalowitz's scoring that was responsible for Philly's downfall. It was a fiercely fought game as every point was hard earned.

Belloff and the players agreed that Passaic outclassed them with their teamwork but that they would like a rematch when missing player Goldblatt from Southern could be with them. In spite of the demoralizing result, the All Stars were good sports. Philly's play and demeanor were appreciated with cheers all evening from the Passaic clientele. Final score: **Passaic 57-Philadelphia All-Scholastic 30.**

PASSAIC	G	F	T	PHILADELPHIA ALL-SCHOLASTIC	G	F	T
Thompson	1	23	25	Abrams	0	0	0
Jarmalowitz	5	0	10	Wetter	2	8	12
Keasler	2	0	4	Mullin	0	0	0
Knothe	6	0	12	Cherchesky	0	0	0
Blood	2	0	4	Sherr	4	0	8
Vonk	1	0	2	Lungren	1	0	2
Totals	**17**	**23**	**57**	Stevenson	2	4	8
				Totals	**9**	**12**	**30**

Score at half time: Passaic 28, Philly 13. Referee—Harry Wallum. Time of periods: 20 minutes.

GAME #78 Cliffside (Wednesday, February 15, 1922) at Passaic HS. The Cliffside Park administration was adamant in its request for Passaic to make two changes before its game in Passaic. The Bergen County school wanted the two baskets moved out from the wall. A unique feature of the Lafayette Street court was that there was no out-of-bounds area under the baskets, and the home court rule made it possible to play caroms off the wall. In recognition of the request and to abide by the letter of the rules, Prof decreased the length of the court by three feet by having a carpenter move the baskets into the court and paint a new line.

Cliffside's second request was to have a referee other than Harry Wallum because he was "too good." Wallum was regarded as one of the

PASSAIC	G	F	T	CLIFFSIDE PARK	G	F	T
Thompson	12	20	44	Borelli	3	0	6
Jarmalowitz	7	0	14	McCabe	1	0	2
Vonk	2	0	4	Whalen	0	0	0
Keasler	7	0	14	McDonald	0	2	2
Knothe	1	0	2	Houck	2	6	10
Blood	2	0	4	Martens	1	0	2
Rosman	0	0	0	**Totals**	**7**	**8**	**22**
Saxer	1	0	2	Half time score: 42-10.			
Hamas	0	0	0	Referee—Joe Johnson,			
Rosman	0	0	0	Paterson High School.			
Totals	**32**	**20**	**84**	Timer—Prescott.			
				Scorer—Endler.			

best refs in the state with a reputation for fairness. Cliffside didn't want him because he knew too much about the game and they felt that he called too many fouls. None of the alterations made much difference in the end result. The close score from their last encounter was not duplicated. In a lackluster game due mostly to the letdown after the Philly game, Passaic cruised to an easy win. Final score: **Passaic 84-Cliffside Park 22.**

A showdown had been in the making between Passaic and the NJSIAA concerning the location of the state finals. Prof had officially entered his team, but he had gone on record as stating that he would not take his team to Trenton because it was too far away. Secretary Short was not happy with Prof's plans. It was no secret that Passaic was the attraction that drew the fans and the lucrative gate receipts. Short warned that in five or six years, only Passaic would regret Prof's decision to withdraw. The tension from this war of words was building as play-off time drew near.

The history of the New Jersey Interscholastic Athletic Association goes back to 1917 when it was formed by twenty-one schools as the New Jersey Football Association. A year later, it included all sports and adopted its present name. The association helped to bring organization to what was a chaotic situation. Short had been with the association since its inception and would continue his involvement for the another thirty-years.

Conflicts of interest and egos prevented these two gentlemen from ever appreciating each other. A great deal of what Short imposed on state athletics was often looked upon as being dictatorial in nature. In the next few years, Blood and Short would be destined to become celebrated adversaries.

GAME #79 Fordham Prep, NY, (Saturday, February 18, 1922) at Passaic HS. The Fordham Prep game was a roughhouse game if ever there was one. The melee resembled the old-fashioned basketball style when the game was first introduced and blocking and tackling were common. The only way for the New Yorkers to keep Passaic from scoring was to hammer, hold, push, and trip them. It was their bulk and brawn against Passaic's speed and finesse. The brutal tactics upset the Passaic players and fans. By half time, Prof sensed that a possible riot was in the making so he took the matter into his own hands. After a heated discussion at mid-court with referee William Cooke, a collegiate official from Columbia University, Prof, in his ever confident and authoritative manner, turned and spoke to the exasperated Passaic spectators.

It's pretty hard to control an audience, but I want all of you people to know that we are held responsible for anything that may happen. Some of you have been quite expressive in

your remarks regarding the officiating and never before in over 1,000 games that I have been instrumental in staging, has there ever been a demonstration like this afternoon. 'That's right,' interrupted someone from the crowd. Every team that has ever appeared on the Passaic court has gone away with a good word to say for the officiating, the players on our team and the spectators who witness our contest. We want the team that is here today to go away and be able to say the same thing. The official (Mr. Cooke) is doing the best that he knows how—'We want a square deal shouted someone.' The official is doing the best that he knows how…. The college game is not as clean as the high school game. They get different material, the game is a lot rougher. If this game is kept cleaner, it will be more to the liking of Passaic people. I have no criticism to make of the officiating—but it is not as clean as Passaic people are accustomed to witnessing.[116]

As Prof appealed to the fans, Father Arthur Shea from Fordham stood alongside. Father Shea mentioned that it was Passaic who selected Cooke from the list of two who were recommended. Fordham did not want Wallum because it was not pleased with his work during a previous game that he officiated in NYC. That's when Passaic fan Pop Cavanaugh called out in his foghorn voice, "Well, of all the corkscrews that I ever saw, he's the crookedest." When this remark of Pop's prompted a big laugh from the easily swayed audience, Prof immediately directed the police to "remove that man from the gym."[117]

The Passaic athletes never doubted who was in charge when Prof was around, but it was only after this spontaneous challenge to the angry multitude for good sportsmanship that all of Passaic knew who was running the show. If the game was unable to proceed in a fair and equitable manner, Prof would have called it off. The little professor was in charge, and no one thought that it would be prudent to challenge him any further.

The game proceeded without further incident, which doesn't imply that the officiating improved only that the reaction to it changed. All Fordham Prep players fouled out but were allowed to remain in the game. At the discretion of referee Cooke, the Passaic team

PASSAIC	G	F	T	FORDHAM PREP	G	F	T
Thompson	4	16	24	Martoccio	2	0	4
Jarmalowitz	3	0	6	Marron	0	0	0
Keasler	2	0	4	Meahan	1	0	2
Knothe	2	0	4	Freeman	5	4	14
Blood	0	4	4	Fanning	0	0	0
Vonk	0	0	0	Weis	0	0	0
Saxer	0	0	0	**Totals**	**8**	**4**	**20**
Totals	**11**	**20**	**42**				

Score at half time: Passaic 16, Fordham Prep 5.

was compensated for each additional infraction with two foul shots. Fordham managed to commit thirty-five fouls to Passaic's eight. Final score: **Passaic 42-Fordham Prep 20.**

GAME #80 Rutherford (Wednesday, February 22, 1922) at Passaic HS. On Washington's birthday, several hundred Rutherford fans became upset when they arrived too late to get into the gym. For almost a year, Passaic games had become popular, citywide social events. With Zep doing his part, the singing and cheering created an ambiance unique to area basketball games. As in the game before, several vocal fans became disenchanted with the officiating and started taunting the officials.

Quickly intervening, Prof directed his comments to the offenders' unsportsmanlike conduct. He told them that if their behavior continued, he would have them removed from the gym and give their seats to those less fortunate outside. He wanted the fans to uphold Passaic's reputation and to be good sports themselves.

Because Prof set the example by conducting himself as the ultimate role model and because his players did the same on the court, the game proceeded without incident. Jealous critics never knocked Prof or his teams for their pursuit of victory in lieu of the highest level of good sportsmanship. Final score: **Passaic 54-Rutherford 21.**

PASSAIC	G	F	T	RUTHERFORD	G	F	T
Thompson	6	12	24	Williamson	1	3	5
Jarmalowitz	2	0	4	Dixon	2	6	10
Keasler	6	0	12	Bauer	0	0	0
Knothe	3	0	6	Lightfoot	1	0	2
Blood	3	0	6	Green	1	0	2
Vonk	1	0	2	Vultee	0	0	0
Saxer	0	0	0	Boes	1	0	2
Totals	**21**	**12**	**54**	Black	0	0	0
				Totals	**6**	**9**	**21**

Referee—Herb Stein, Plainfield. Umpire—Lozier, Trenton. Score at half time: Passaic 27, Rutherford 9.

The citizens of Passaic were beginning to realize that the success of the basketball teams was largely due to Blood's influence. Since the previous March, there was a move afoot by a nucleus of people to do something special for him. After the second state championship, the idea to recognize and reward Prof began to pick up momentum, but it was not until businessman Harry Miller's letter about Prof to certain prominent citizens did the idea get in high gear. His letter was met with enthusiasm, and as a result of his inquiry, a Citizen's Group was formed for the purpose of raising a purse for Prof.

Mayor McGuire was one of the first to respond. He would gladly participate in recognizing the coach. Abram Greenberg supported the mayor's wishes by adding that this was a civic responsibility that was long overdue. The distinguished Dr. David I. Steiner said that he would like nothing better than to serve on such a committee. Even John Kelly

indicated that it would be an honor to be on a committee to raise a purse for such a fine man as Ernest Blood. With this group's influential support, a movement by the citizens of Passaic was started to reward the coach for his contributions to their city.

The day before the Ridgewood game, Short announced that the state finals would be moved from Trenton to Princeton University. This move avoided an inevitable Blood/Short showdown. It was interpreted as a victory for Passaic and all North Jersey which was divided into two districts, Newark and Metropolitan. In the Metropolitan District, Passaic was slated to play Emerson.

Because Prof was not overly concerned with Ridgewood, their next scheduled opponent, he accepted Coach Harry Fisher and John Roosma's invitation to visit West Point as guest for the annual Army/Navy game. A large party, which included Mrs. Margaret Blood and Harold Saunders, Passaic fans, and the team, watched as Roosma led Army over Navy 25-21. It was a proud day for the Passaic visitors as they watched their boy score fifteen points in Army's most important game.

GAME #81 Ridgewood (Saturday, February 25, 1922) at Ridgewood HS. The ill effects of spending the day at West Point became evident. Unlike other opponents, Ridgewood was able to control the ball for extended periods of time. Passaic scored in streaks, but overall, it was a ragged game. Thompson's 835 point total for the year surpassed Roosma's 822. No one could remember a schoolboy ever scoring more points in one season. Final score: **Passaic 70-Ridgewood 16.**

PASSAIC	G	F	T	RIDGEWOOD	G	F	T
Thompson	8	10	26	Pinkney	1	4	6
Jarmalowitz	10	0	20	Carter	1	0	2
Vonk	1	0	2	Hiler	3	0	6
Hamas	0	0	0	Jenkins	0	0	0
Knothe	3	0	6	McIntosh	0	0	0
Blood	1	0	2	Terhune	1	0	2
Keasler	7	0	14	**Totals**	**6**	**4**	**16**
Saxer	0	0	0				
Rosman	0	0	0				
Totals	**30**	**10**	**70**				

Referee—H. A. Stine, Plainfield. Scorer for Ridgewood—Kiebe, Ridgewood YMCA; for Passaic—Harold Saunders. Timekeeper—Joe Walley. Score at half time: 29-9. Time of halves: 20 minutes.

GAME #82 Montclair (Wednesday, March 1, 1922) at Montclair HS. This was a game that many fans had been looking forward to. In preparation for the biggest game in Montclair's history, Coach John S. Nelson had his boys playing their best basketball. They were undefeated and had impressive wins over Trenton and Asbury Park. Montclair people believed, as many others did, that if the Wonder Team was to get whooped, it would be at the hands of Montclair.

With fifteen hundred delirious fans jammed into a gym built for only one thousand (with another 500 wandering around outside), Blood's boys illustrated why they were the elite of scholastic basketball. As in the past, it was their superior shooting, passing and teamwork that made the difference. They noticed that the Red and Blue boys could not only pass the ball with either hand but their passes were well timed and quickly executed.

Montclair put up a good fight and made Passaic work. No aspersions were directed towards the home team; nevertheless, it was fortunate for Montclair that Passaic was only interested in winning the game and not concerned with registering a high score. Skeets Wright from Union Hill and other coaches who were scouting agreed that Passaic could easily have scored many more points if that had been their intent.

In the second half, Fritz Knothe collided with Montclair's center Donald Mitchell. The trauma from the force broke both of Knothe's front teeth and knocked him out cold. He was carried from the court, but after regaining consciousness, he reentered the game. Knothe was one of a kind! His court vision and ability to whip a bullet pass with a flick of the wrist of either hand labeled him the *avant-garde* guard of New Jersey basketballers.

After the game, there were no "Doubting Thomases" leaving the gym. All in attendance, even those who had climbed in the upstairs windows, were in agreement that they had just seen one of the greatest teams ever to trot on to a court. "Doesn't look very bright for Central," "Guess they'll cop the old state title again," and "They can say what they like about Passaic playing poor teams, but I want to see the team that can beat Passaic" were some of the remarks heard at courtside.

Several weeks prior to playing Montclair, Prof requested that the game be canceled. Prof had not scheduled this game; Arnold had made all the arrangements. Because Montclair was such a powerful team, Prof thought that as it was so late in the season, it would be better to meet Montclair in the play-offs.

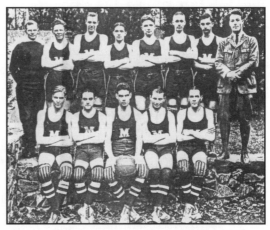

1922 MONTCLAIR TEAM

(NOT IN ORDER) DEFALCO, NOON, MITCHELL, CRAWLEY, HINCK. (SUBSTITUTES) FRENCH, DURNING, RUSSELL, KAVENY, FORREST, CARLESON. COACH JOHN NELSON, MANAGER CHARLES LUTZ.

photo courtesy of Montclair High School Yearbook, The Amphitheatre

The Montclair authorities did not want to hear about a cancellation. Not only did they believe they could win, they wanted the inordinate gate receipts the game would surely garner. This may explain Prof's postgame remarks, "The Montclair team brought this defeat on themselves in advance due to the fact that they insisted on the game being played." Final score: **Passaic 39-Montclair 19.**

GAME #83 Eastman College, New York, (Saturday, March 4, 1922) at Passaic HS. After the excitement of the Montclair game, there was another letdown. Without cheerleader Mike Kiddon present to add buoyancy to the game's atmosphere, the locals started off a little flat. Before Passaic could get started, they found themselves down 5-0. It was all up hill in the first half as Passaic worked for their 24-16 lead. With the help of a healthy Vonk, who was back in top form after his bout with the grip, Passaic rolled in the second half. Final score: **Passaic 62-Eastman College 26.**

PASSAIC	G	F	T	MONTCLAIR	G	F	T
Thompson	8	9	25	DeFalco	2	0	4
Jarmalowitz	4	0	8	Noon	1	7	9
Keasler	2	0	4	Mitchell	1	0	2
Knothe	1	0	2	Hinch	2	0	4
Blood	0	0	0	Russell	0	0	0
Vonk	0	0	0	Crawley	0	0	0
Saxer	0	0	0	**Totals**	**6**	**7**	**19**
Totals	**15**	**9**	**39**				

Half time score: Passaic 18, Montclair 6. Fouls called on Montclair team: 16; on Passaic team: 13. Referee—Herb Stein, Plainfield. Umpire—Harry Wallum.

PASSAIC	G	F	T	EASTMAN COLL.	G	F	T
Thompson	8	12	28	Roberts	4	0	8
Jarmalowitz	9	0	18	Simmons	3	9	15
Keasler	0	0	0	Nya	1	1	3
Knothe	3	0	6	Pinker	0	0	0
Blood	2	0	4	Hayden	0	0	0
Vonk	3	0	6	Hannah	0	0	0
Saxer	0	0	0	**Totals**	**8**	**10**	**26**
Rosman	0	0	0	Referee—Wallum, Union			
Hamas	0	0	0	Hill. Timer—Joe Whalley,			
Humphrey	0	0	0	Passaic. Scorer—Harold			
Goldstein	0	0	0	Saunders, PHS.			
Totals	**25**	**12**	**62**	Time of halves: 20 min.			

PASSAIC	G	F	T	EMERSON	G	F	T
Thompson	3	5	11	MacCallum	1	1	3
Jarmalowitz	2	0	4	Hutch	1	0	2
Keasler	3	0	6	Bower	0	0	0
Knothe	6	0	12	Steinmetz	0	4	4
Blood	2	0	4	Baldini	0	2	2
Vonk	1	0	2	Papalia	1	0	2
Saxer	0	0	0	**Totals**	**3**	**7**	**13**
Rosman	1	1	3				
Hamas	0	0	0	Score by periods:			
Humphrey	0	0	0	**Passaic**	**25**	**17**	**42**
J.Thompson	0	0	0	**Emerson**	**6**	**7**	**13**
Hansen	0	0	0	Referee—Harry Wallum,			
VanderHeide	0	0	0	Union Hill, Umpire—			
Totals	**18**	**6**	**42**	Herb Stein, Plainfield.			

GAME #84 Emerson (Thursday, March 9, 1922) Stevens Institute, Hoboken. Under instruction from Prof to take it easy, Passaic commenced the defense of its crown. This first game was a classic example of how Passaic would let the ball and the opponent do the work. Emerson from West Hoboken was a quick, scrappy little team, but was no match for the bigger, stronger, equally quick, better shooting Passaic outfit. Two-time, first team all state Knothe startled the crowd with six long bombs from West New York. Before the half, Passaic's third team was getting playing time and Emerson had not yet scored a field goal. Final score: **Passaic 42-Emerson 13.**

NORTHERN NEW JERSEY DIVISION PLAY-OFF RESULTS

Metropolitan District
(at Stevens Institute)
Passaic 42-Emerson 13
Rutherford 33-Clifton 22
Union Hill 44-E. Rutherford 13

Newark District
(at St. Benedict's Gym)
Orange 40-Sommerville 32
Montclair 48-Summit 23
Belleville 36-West Orange 14
Central 31-Glen Ridge 20

GAME #85 Rutherford (Friday, March 10, 1922) Stevens Institute, Hoboken. Content to just win and move on, Passaic toyed with their Bergen County foes. The score was 19-8 at half time, but Passaic was always in complete control of the game. Playing without the services of DeWitt Keasler, who was sidelined with the sprained ankle from the previous game, the Blood boys still did not have to exert themselves to advance. Because Passaic played without much emotion, their style of play was described as "cold and calculating."

PASSAIC	G	F	T	RUTHERFORD	G	F	T
Thompson	1	5	7	Williamson	0	0	0
Jarmalowitz	5	0	10	Dixon	4	3	11
Rosman	1	0	2	Lightfoot	1	0	2
Knothe	3	0	6	Green	0	0	0
Blood	3	0	6	Vultee	0	0	0
Vonk	1	0	2	Black	0	0	0
Saxer	0	0	0	**Totals**	**5**	**3**	**13**
Totals	**14**	**5**	**33**	Referee—Harry Wallum.			
				Umpire—Carl Bauman.			

After the contest, the Rutherford team and their fans were delighted with the final tally because it was the lowest number of points the Wonder Team had been held to all season. Another first for the season occurred because someone other than a Passaic player was high scorer for the game. Final score: **Passaic 33-Rutherford 13.**

New Jersey State Tournament Divisional Results

North Jersey Division
Orange 39-Montclair 34
Central 48-Belleville 29
Metropolitan Division
Passaic 33-Rutherford 13
Union Hill-bye
Central Division
Asbury Park 38-Neptune 26

South Jersey Division
Princeton 29-Morristown 10
Princeton 40-Woodbury
Camden-Collingswood 21
Atlantic City 45-Haddonfield 18
Trenton 36-Hightstown 23
Trenton 25-Camden 23
Atlantic City 41-Princeton 19

Because it was Union Hill in the Metropolitan Division that received the bye, Passaic became their next opponent. Union Hill had tough kids who were well coached. Courtney "Skeets" Wright (along with his brother) was a professional basketball player who knew how to play physical basketball—especially on defense. His gritty teams were known for their aggressive but clean style of play. Like Prof in Passaic, Wright was the physical director at Union Hill.

GAME #86 Union Hill (Saturday, March 11, 1922) Stevens Institute, Hoboken. The champions were not given an easy road to the finals, nor were they asking for one. Because of Union Hill's bye, they had the opportunity to rest the night before the game and observe Passaic play. This was Passaic's third game in as many days. Prof did not grimace at all when he made the decision to keep Keasler out of the game because of his injured ankle. Only a coach can appreciate the magnitude of this decision; DeWitt Keasler, a three-year veteran, was not going to play in the biggest game of the season.

In the dressing room prior to the big game, Prof set the tone for his players. Prof never concerned himself with the thought of losing; therefore, neither did his players. They knew that they had an advantage, and it was Prof. It was from him that they acquired their salient air of invincibility that, in turn, intimidated opponents. This was all well and good, but the Union Hill kids were gamers themselves who had a certain mystique of their own. They were not about to roll over and play dead for anybody, and Prof knew it. This was the picture when he, his

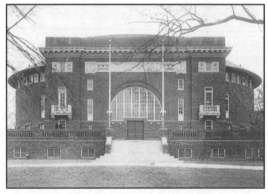

WALKER GYM AT STEVENS INSTITUTE
photo courtesy of Stevens Institute of Technology

two sons, managers, the team, and the bear ran on to the floor in Walker Gym for the top spot in the Metropolitan District.

The rowdy Passaic fans were ready to do whatever it took to cheer their boys on to victory. A cantankerous Hoboken crowd added noise and tension to the mix. The roar of the local Hudson County fans nearly lifted the roof off Walker Gym

1922 UNION HILL SQUAD
WITH COACH COURTNEY "SKEETS" WRIGHT

when Skeets Wright's boys jumped out to an early lead. Bobby Thompson had just missed his fourth foul shot in a row as opposing fans cheered and danced in the aisles. The local followers shouted phrases like, "Union Hill is Passaic's jinx," and "The Wonder Whos are in trouble," as the Passaic faithful sat and waited for their boys to jell. Stakes with 3 to 1 odds were being offered by some of the Wonder Team fans, but still there were no takers.

Finally, when Passaic gathered themselves, tied it up, and then went ahead 9-5, Wright could see the inevitable coming. In his excitement, the respected coach stepped on to the playing court and immediately drew a foul from Newark umpire Charlie Schneider. Retribution sent Thompson to the line, and he upped the score to 10-5. Moments later, it was half time and Passaic was on top 12-8.

The tricks of the trade learned by Wright while playing professional basketball were instilled in his troops. The street-hardened Union Hill boys were not finished; they would fight to the last man. It was do or die; for them, there was no tomorrow. The second half turned into a dogfight with tension mounting on and off the court. Observers agreed that this was the real championship game.

PASSAIC				UNION HILL			
	G	F	T		G	F	T
Thompson	0	13	13	Boxer	2	11	15
Jarmalowitz	1	0	2	Kruse	0	0	0
Rosman	0	0	0	Stewart	0	0	0
Knothe	2	0	4	Falting	1	0	2
Blood	4	0	8	Krause	1	0	2
Vonk	0	0	0	Soloman	0	0	0
Saxer	0	0	0	Halligan	0	0	0
Humphreys	0	0	0	Strohl	2	0	4
Totals	**7**	**13**	**27**	**Totals**	**6**	**11**	**23**

Score by periods: **Passaic** 2 10 7 8
 Union Hill 3 5 2 13

Referee—Harry Wallum, Union Hill. Umpire—Charles Schneider, Newark.

One by one, the fouls on Krause, Soloman, Boxer, Strohl, Kruse, and Stewart took their toll. Late in the third quarter, team leader and future mayor of Weehawken, Charley Krause fouled out. The tenacious Krause was credited with a first by "holding" Bobby Thompson scoreless from the field. Passaic had the orange and blue jerseys spread out all over the court chasing after the ball, but their efforts were futile. Boxer, Wright's scoring ace was exhausted. Losing 23-14 in the final stanza, the challengers rallied to bring the score within four 23 to 19. The hero in the final minutes of the game for Passaic was Paul Blood who drilled two of his four clutch field goals from mid-court to secure a safe lead. Final score: **Passaic 27-Union Hill 23.**

NEW JERSEY STATE TOURNAMENT DIVISIONAL FINALS

Metropolitan Division	**North Jersey Division**
Passaic 27-Union Hill 23	Central 27-Orange 24
Central Jersey	**South Jersey**
Asbury Park 38- Neptune 26	Trenton 22-Atlantic City 21

The Hoboken fans did not prove to be gracious hosts. Because of their unbridled jealousy, they were incensed over Passaic's victory. One incident had a Hoboken fan punching a boy in the face only because he was from Passaic. The unsportsmanlike behavior displayed by the Hoboken fans was something Prof would, if at all possible, avoid in the future. It was an aberration to his concept of clean sport.

The undefeated Hoboken High School team decided not to participate in the play-offs but entered the annual University of Pennsylvania Basketball Tournament in Philadelphia. Some people believed this decision was made to avoid a game with the "Wonder Team." Hoboken was defeated in the semifinals of the Philly tournament 40-30 by the great Crosby team who won the tournament by downing West Philadelphia 38-29. The testimonial game committee tried desperately to schedule Crosby for March 31, at the Paterson Armory.

The pairings for the state semifinals at Princeton's 2300 seating capacity Palmer Gym had Passaic with Trenton at 7:30 and Newark Central with Asbury Park immediately after. The heavy favorites were the two undefeated Northern Jersey teams, Passaic and Central. Since mid-season, many Central fans had been shooting their mouths off about how their team was going to knock-off the so-called Wonder Team.

The city of Passaic, meanwhile, was undergoing extensive plans to determine how they would celebrate their third consecutive state championship. Prof and the boys were using the Paterson Armory court to prepare. Upon entering the drill shed, he had the boys help him measure off an 80 by 50-foot court, which were the dimensions of the Princeton

University court. More importantly, Keasler's ankle was getting stronger, and it appeared he would be ready for Percy Davenport and the rest of the Trenton boys.

GAME #87 Trenton (Friday, March 17, 1922) at Princeton University. Prof approached Short before the game to show the association secretary a news article that he had received from a Trenton fan. The article from a Trenton newspaper referred to some of the Trenton players as being associated with a professional team. Prof handed Short the article. After reading the news piece, Short returned it to Prof and said, "You wait; I'll get you." Prof looked at him for a moment but didn't say anything. He immediately went back to his team's dressing room, but the animosity between the two men was growing. The article in question read as follows:

TRENTON PROFESSIONALS CHALLENGE ALL-STARS

The Trenton Professionals, headed by George Glasco, star forward of the Cotesville [sic] Club of the Eastern League, issued a challenge to A. G. Wesley's North Trenton Club which has defeated the strong Madonna Five and the strong South Philadelphia Hebrew Association Five, both of which clubs are composed of former Eastern League men.

The Trenton Professionals have played independent ball throughout the season, and have met many strong clubs, including the strong Philadelphia Eastern League Club at New Auditorium Hall in South Philadelphia, the Philadelphia club winning the game by a close score of 35 to 33.

Frank Spair, who managed the Trenton Professionals, says that Mr. Wesley's claim to the independent championship of Trenton is disputed and that a game can be arranged at the Junior High School [sic] court as soon as his club is ready.

Other members of the Trenton Professionals are Mickey Meister, star forward of the Laurel and Trenton High School fives: Red Lansing, Sammy Turano, of the Kingston Club of the New York State League, and Davenport, of the Trenton High School five.[118]

Unlike Prof's relationship with Short, the result of the game was obvious to everyone. The gallant but outmatched Trenton players were also aware of the outcome. It was fortunate for Trenton that Prof was only interested in winning and not in the margin of victory. When the score read 27-7, Prof changed the tempo to one of total ball control. Passaic kept Trenton on defense most of the second half, and when

Davenport fouled out, all hope for an upset took the bench. Final score: **Passaic 41-Trenton 24.**

The shocker of the evening was Asbury Park's upset victory over Central that set the stage for the following day. Asbury Park was given little to no chance of win-

PASSAIC	G	F	T	TRENTON	G	F	T
Thompson	4	13	21	Davenport	2	12	16
Jarmalowitz	2	0	4	Maister	1	2	4
Keasler	4	0	8	Clark	0	0	0
Knothe	2	0	4	Tate	0	0	0
Blood	0	0	0	Tilton	0	0	0
Vonk	1	0	2	DelGuardio	2	0	4
Rosman	1	0	2	**Totals**	**5**	**14**	**24**
Totals	**14**	**13**	**41**				

ning by fans on both sides, but the Asbury team was not ready to concede anything.

Passaic was in a festive mood. Hardly a citizen in the surrounding area, even in Clifton and Rutherford, was not affected by the excitement. Because it was possible for only a small percentage of the population to actually attend the game in Princeton, the American Legion Post came up with a clever system for the J. L. Prescott Company to let the citizenry know the outcome of the game. The J. L. Prescott Company would use its factory whistle to signal not only who won the game but also indicate the score. If the homeboys lost, it would sound one long blast. If Passaic won, it would give it two long blasts. A series of short blasts and pauses would indicate the actual score. The magnitude of interest and excitement generated was unprecedented in the history of schoolboy basketball in the northeastern states and possibly anywhere else in the country.

GAME #88 Asbury Park (Saturday, March 18, 1922) at Princeton University. The script was suddenly unveiled when, on the opening tap, Passaic scored in two seconds. Jermalowitz tapped to Knothe who batted it to Blood who sent a lead pass to Keasler who cut to the basket for the lay-up. The sound of the opening whistle to signal the start of the game was still in the ears of the three thousand plus fans when the ball arrived at the rim. Asbury Park was now in the lion's den.

Whenever Bobby Thompson was in the act of shooting his sixteen free throws, referee George Cartwright would talk to him. This annoying

PASSAIC	G	F	T	ASBURY PARK	G	F	T
Thompson	3	12	18	Barkalow	2	0	4
Jarmalowitz	1	0	2	Stone	0	4	4
Keasler	5	0	10	Finley	2	5	9
Knothe	5	0	10	Barr	2	0	4
Blood	2	0	4	Smock	1	0	2
Vonk	1	0	2	Johnson	0	0	0
Hamas	0	0	0	Cooper	4	0	8
Rosman	0	0	0	**Totals**	**11**	**9**	**31**
Totals	**17**	**12**	**46**				

Score by periods: **Passaic** 18 15 5 8

Asbury Park 4 10 9 8

Referee—George P. Cartwright. Umpire—Phillip G. Lewis. Timer—Charlie Schneider.

procedure appeared to be an attempt to distract him and cause him to miss. Did Cartwright want Passaic to lose?[119] This unprofessional behavior could have been costly to Passaic if the game had been close.

For two days, people from different parts of the state were getting their first glimpse of the Wonders from Passaic. The Passaic style of basketball was very different. It was the quick passing and teamwork that made it unique, and watching the boys perform changed the minds of the staunchest Doubting Thomases.

With the exception of a brief spell in the second half when the vacation resort players staged a rally, Passaic was in complete control. Passaic's constant quick passing tired the challenging defenders. To make matters worse for Asbury Park, the Wonders had a better than average shooting day making it the best many had ever witnessed. Backcourt wizard Fritz Knothe led the long-range exhibition with five. Spectators and sports writers sat in awe as Passaic substitutes entered the game, and the style and tempo never changed. Final score: **Passaic 46-Asbury Park 31.**

The celebration that followed the third undefeated state championship season would remain in fans' memories for the rest of their lives. The few who had to walk home from Princeton missed the reception

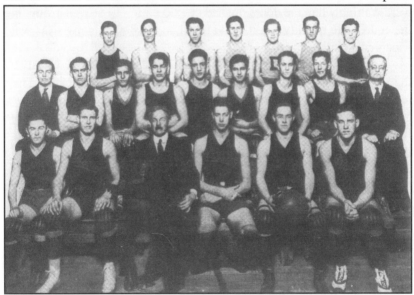

1921-22 PASSAIC HIGH SCHOOL TEAM
BOTTOM (LEFT TO RIGHT): ABE ROSMAN, ROBERT THOMPSON, COACH BLOOD AND ZEP THE BEAR, IRA VONK, PAUL BLOOD, WILFRED KNOTHE. CENTER: RALPH PRESCOTT, ROBERT SAXER, MICHAEL HAMAS, HENRY JANOWSKI, CHESTER JERMALOWITZ, SAM BLITZER, CHARLES HUMPHREY, ELMORE TAYLOR, PRINCIPAL ARNOLD. TOP: WILLIAM TROAST, WALTER MARGRETTS, BLASE ZILENSKI, EDWARD LUCASKO, HOWARD SOULE, ALLEN SMITH, JOHN FREESWICK.

awaiting the heroes. As planned, the J. L. Prescott Company whistle sounded out the two long blasts to inform the anxious fans that their local heroes were still state champs.

As the caravan of cars arrived in the Peaceful Valley, other factory whistles joined Prescott's whistle in a cacophony of whistles and noise-makers creating a New Year's Eve Times Square atmosphere. The team and fans were greeted by well wishers lined up three and four deep along the streets wanting to applaud the boys. A brass band greeted and saluted them as they entered Main Street where a players' parade was begun. Prof Blood and the boys were the toast of the town, and it was going to remain that way until fate would intervene.

GAME #89 Binghamton, NY, (Wednesday, March 22, 1922) at Paterson Armory. Four days after securing its third state crown, the first of two testimonial games was planned in the Paterson Armory. The fans came by the thousands using every possible means of conveyance. The crowd of 4,500, possibly the largest ever to see the Wonder Team play, jammed the drill shed. It was an eclectic Passaic congregation mixed with a thousand curious Paterson sports lovers who made up the audience. Many of them had never seen the champs in action. Hundreds were waiting when the doors opened at 7:00 p.m. The seats surrounding the court were quickly filled, and after that, the 800 balcony seats were occupied equally as fast.

The Binghamton boys entered the court and were greeted warmly by the partisan crowd. Coach Ray Bailey had a good 14-6 team. Their remarkable shooting accuracy in the warm-ups entertained the spectators. Their pregame performance was so impressive that it prompted Passaic fan Scotty Wilson to yell out, "Better save some of them points for the game because what you get you will earn." So confident of their team's ability, the Passaic fans viewed the snappy, well-drilled, pregame warm-up put on by the New Yorkers as the *hors d'oeuvre* to the main meal. The talented Bingoes were the first of the "fatted calves" scheduled by the Blood Testimonial Committee.

This was a Passaic event, and the Passaic sports fans were there en masse. Cheerleaders Mike Kiddon and his assistant Hans Jacob had the crowd in the palms of their hands as they led the people through some blood-tingling cheers. The roar of the crowd in the drill shed nearly expanded the walls when the Passaic team approached the court, plus that was the signal for the band to play. To the cheering of the 4,500, the Boy Scout band led them around the perimeter of the court. Prof Blood was in front with his son Paul who was in charge of Zep, followed by the other members of the team. The parade was a spectacle; it was Passaic basketball pageantry at its best. The pregame discord caused by the bands, cheerleaders, and frenzied spectators eventually synchronized,

BINGHAMTON CENTRAL HIGH SCHOOL TEAM

photo courtesy of Binghamton Central High School Yearbook, Panorama

creating a grand crescendo that had become a trademark of the show-time atmosphere surrounding Passaic games.

While referee Wallum was explaining the specific court rules to the captains, seven-year-old Benny Blood and Zep became engaged in a wrestling match in the middle of the court. The tussle continued until the bear got the upper paw and flattened Benny's body to the floor. This sideshow had the audience in a frolicsome mood as the main event was about to begin.

After a few minutes, Bobby Thompson's foul shot broke the ice and the rain of Passaic baskets began. It wasn't long before Prof began his shuffling of players; all the while, the quick precision-like passing and shooting continued. By the mid-mark, Passaic was up twenty, and the locals were content to spread the New Yorkers out and commence the passing offense that ran the Binghamton defense ragged. The guests, who were led by Art Bowen, Rodney Van Atta, and Louie Bonnell, played an aggressive but clean style of basketball. Several of the visitors commented that they thought Passaic was the greatest team they had ever seen in scholastic circles. Final score: **Passaic 55-Binghamton 34.**

The highlight of the evening included Bobby Thompson's 978th point of the season. Also, Passaic Commissioner Abram Preiskel announced that the Blood Testimonial Committee had raised $3,000 dollars. It was also reported that Crosby was not interested in coming to Passaic for a testimonial game. When contacted, Crosby personnel indicated that their basketball season was over.

PASSAIC	G	F	T
Thompson	6	8	20
Jarmalowitz	6	0	12
Keasler	2	0	4
Knothe	2	0	4
Blood	3	0	6
Vonk	4	0	8
Hamas	0	0	0
Rosman	0	1	1
Hansen	0	0	0
Saxer	0	0	0
Totals	**23**	**9**	**55**

BINGHAMTON	G	F	T
Canfield	1	0	2
Bonnell	2	0	4
Bowen	3	6	12
Smith	1	0	2
Barberson	1	0	2
VanAtta	6	0	12
Clark	0	0	0
Douglas	0	0	0
Totals	**14**	**6**	**34**

Score by periods:

Passaic	34	21
Binghamton	14	20

Referee—Harry Wallum.
Fouls: Thompson 8-13, Rosman 1-1, Bowen 7-11.

An invitation for the second testimonial game was extended to Hoboken with a guarantee of $350. The Hoboken people had always wanted to play Passaic, but instead of accepting the offer outright, they came back with a counter offer of 500 dollars. After Passaic accepted the counter offer, Hoboken came back again with a demand for 1,000 dollars. Hoboken's Coach Dave Walsh finally declined the invitation without explanation. Passaic next talked with Brockton whose team had just won the New England championship, but not wanting to risk spoiling its championship image, it declined.

The testimonial game opponent was settled when the Knights of Reading High School from Berks County, Pennsylvania, agreed to come to test their skills against the so-called "Wonder Team." As Philadelphia, Trenton, and New York City, the city of Reading has a proud basketball tradition. Every year, Reading was one of the best teams, if not the best, in the tough Central Penn League. During the previous year, they had won the University of Pennsylvania Tournament by defeating West Catholic of Philadelphia 38 to 20. After accepting the game, the word out of Reading was, "Have your best team ready for us—we're going to bust that long string of victories."[120]

GAME #90 Reading (Friday, March 31, 1922) at Paterson Armory. The weatherman conjured up a storm for the evening, allowing only 2,500 people to attend. Those who did attend never forgot the events that took place. The Reading boys were all business; they had come to upend the Wonder Team. They put a man-to-man defense on Passaic unlike any other. Their guarding resembled the professional style—aggressive and physical. Stott, Reading's rugged guard, held Thompson scoreless from the field in the first half. Until the Wonders were able to adjust to the Reading's intensity, it was difficult finding an open man. The half time score (12- 9) indicated the problems the Reading defense was creating.

Sensing the gravity of the situation, Prof cancelled his half time wrestling show with Zep. He instructed his cohorts on the best strategy to counter the challenger's defense. The offensive coach that he was, Prof believed that Reading's defense could also be its Achilles' heel. By using the entire playing court and increasing the speed and number of passes, his boys would run Reading ragged. Prof always preached, "Stay on the offensive," and he reminded his team of this strategy.

Adhering to Prof's directions, the second half was a different story. The famed Passaic passing offense proceeded to first take the legs, then the heart, and lastly the spirit from the courageous Reading team. Within the context of the Passaic system, Bobby Thompson led the second half resurgence with six baskets, all coming within the last ten minutes. Because he was so involved in the game, Bobby was not aware of the strain his actions were having on the Passaic viewers.

Once the Passaic lead indicated that a victory was imminent, the entire focus of the 2,500 fans turned to how many more points Bobby Thompson needed to reach the one thousand mark. When he needed only eight more points with six minutes remaining, the fans became frantic. With fans from all corners of the drill shed yelling for Bobby to shoot, he continued following the flow of the Blood teamwork system. His teammates wanted Bobby to shoot, but the only system they knew was geared for the open man to shoot. Within the four-minute mark, Thompson found himself in the right spot for two quick goals in succession. With the passing of each second, the spectators were working themselves into coronaries.

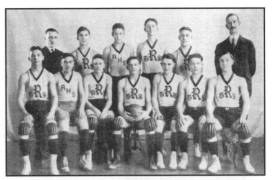

READING HIGH SCHOOL TEAM

(NOT IN ORDER) NORMAN HUMMEL, JAY REGAR, HENRY STOTT, FRANK ESTERLY, HAROLD SHEELER, BENNY BERMAN, LEROY SPONAGLE, CHARLES MILLER, EARL WENGER, EDWIN SCHAEFFER, STANLEY SPROESSER. MANAGER PAUL STEINER, COACH HARRY C. HENRY

photo courtesy of Reading High School Yearbook, The Epitome

PASSAIC	G	F	T	READING	G	F	T
Thompson	6	10	22	Wenger	1	0	2
Jarmalowitz	3	0	6	Sheeler	0	0	0
Keasler	1	0	2	Miller	0	0	0
Knothe	3	0	6	Hummel	2	0	4
Blood	3	0	6	Regar	0	10	10
Vonk	2	0	4	Stott	1	0	2
Totals	**18**	**10**	**46**	**Totals**	**4**	**10**	**18**

Score by periods:
Passaic 12 34
Reading 9 9

Referee—Harry Wallum
Fouls committed by
RHS: 16, PHS: 16.
Time of halves: 20 min.

After adding two foul shots, he was within two of becoming the first schoolboy to score one thousand points in a single season. It was no longer the Reading defense that was the concern, it was the lack of time.

As the timer's clock ticked down to less than fifteen seconds, Knothe regained possession of a loose ball. Fritz spotted the great forward clamped by two Reading defenders about ten feet out from the side of the basket. Without hesitating, he tossed Thompson a high pass. Catching the ball at the top of his jump, Bobby landed and immediately faked right, ducked under one defender, turned, and jumped to release Passaic's final shot. A hush fell over the armory as the ball made its slow journey to the hoop. As the ball filled the cylinder, the crowd erupted. Hats and coats were thrown into the air. As women danced in the aisles, boys did handsprings

"THOUSAND POINT BOBBY THOMPSON"

along courtside. The crowd ran on to the court in jubilation as the game came to a halt. With that last basket, Bobby suddenly became "Thousand Point Bobby Thompson," a moniker he would wear for the rest of his life. Final score: **Passaic 46-Reading 18.**

As you would have it, the day after Thompson's epic accomplishment was April Fool's Day; consequently, many believed the newspaper account of the one thousand point season to be a hoax.

The magnitude of Thompson's accomplishment is brought into perspective by the fact that it took forty-six years before another New Jersey schoolboy, John Somogyi from St. Peter's in New Brunswick, would duplicate the feat. Thompson's record need not be minimized because he had the advantage of the one-person shoots all free throws rule. The rule of the day certainly did help Thompson contribute to his point total, but Thompson spent large segments of many games on the bench watching the second, third, and fourth teams play. If Prof's philosophy emphasizing teamwork hadn't prevailed, Thompson would easily have netted an additional few hundred points.

The basketball team was making the city of Passaic famous. The news of Passaic's streak was receiving coverage in newspapers throughout the country. This type of publicity was something the Chamber of Commerce could not buy. Because the majority of Passaic's population was either immigrants or first generation Americans, their identification with the invincible Wonder Team increased their civic pride. The adulation for the little professor who engineered all the success was growing each day.

Arnold was annoyed with the attention generated by the basketball team's victories. His concern, and rightly so, was the educational process. He saw a misplacement of priorities that had basketball before academics. Arnold witnessed teachers and students spending a disproportionate amount of time discussing the basketball team.

Were others aware of the pressure that was building between the coach and principal? The tension would not become public until, like a volcano, it would erupt and engulf the entire community. It would be almost another year before the populace would be made aware of the nitpicking harassment endured by the Wonder Team coach.

What exactly was Arnold's objection? Was it the inordinate number of games the team played? Was Arnold concerned about Prof's team embarrassing other schools with the huge margins of victory? Could

there have be hard feelings over the money Prof received from the testimonial games, giving him a higher income than the principal? Was the fame and celebrity status Prof was accorded a source of friction? The exact cause was difficult to ascertain, but conjecture indicated jealousy.

Prof's commitment to the team took a great deal of his time; was it interfering with his other duties? Did Arnold think that the athletic tail was beginning to wag the academic dog? Was Arnold not able to see the larger picture? Prof had created something never experienced before and it was good for the city. With all of his administrative acumen, couldn't Arnold find a way to capitalize on the merits of his physical director?

In circumstances such as this, it was inevitable for the ugly head of jealousy to intervene. Prof, the architect of the trailblazing system, was just doing his job as he understood it. Nevertheless, the community's reaction to his teams' victories had put him in a difficult position with his employer. Arnold and those of a like mind were anxious to return to the former days before basketball took center stage—something had to give.

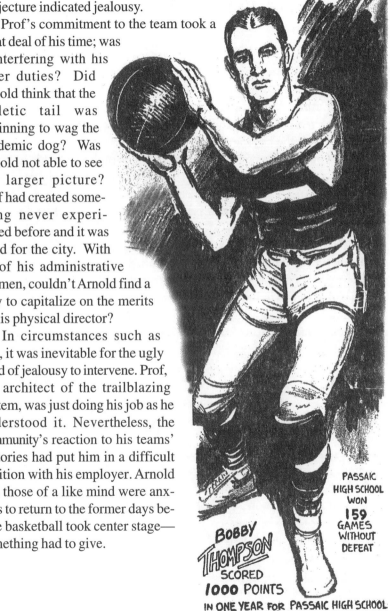

RIPLEY'S BELIEVE IT OR NOT
—Registered U. S. Patent Office—

BOBBY THOMPSON
SCORED 1000 POINTS
IN ONE YEAR FOR PASSAIC HIGH SCHOOL
New Jersey

PASSAIC HIGH SCHOOL WON 159 GAMES WITHOUT DEFEAT

Chapter Eight
The Country Takes Note
(1922-1923)

As football season neared its midpoint, Blood announced that he may no longer coach basketball. He indicated that he might turn basketball over to Amasa A. Marks who, on paper, had been the official coach for the past two years. Prof was only volunteering until Marks became more acquainted with the boys and Blood's system.[121]

Why would Prof who was recognized as one of the top in his field and so valuable to the city want to step aside? Without question, the team's success had earned Passaic a great deal of free publicity. The high school's basketball team was a source of pride and recognition, and Prof was the reason. The thought of him stepping down was not good news. The scenario reeked of foul play, and people were grappling to know why.

Upon further investigation, Prof explained his situation. He had been sacrificing his health and family to perform all of the duties the administration had assigned to him. It had become physically impossible for him to continue performing all the responsibilities of physical director, teacher, and coach. According to Prof, winning championships wasn't what it was all about. If the people felt that winning was so important, then a "champion coach" needed to be hired. He could no longer justify compromising his health and school responsibilities for basketball.

Prof had been spending an inordinate amount of time taking care of interscholastic athletics, but was his hesitancy to continue coaching just a bargaining tool? Was it possible that he was seeking public support? After seven years of working with Arnold, was this his new way of negotiating? Now that he was fed up with the harassment, he began making his feelings known. Sharing his concerns with the press had to irritate the administration even more. Initially, Prof was just a department head, but because of his teams' successes, he had grown into a valuable asset to the city. Was Prof beginning to use his popularity to counter his harasser? To all of the above, it appeared so.

To make the basketball situation more dismal, DeWitt Keasler and Fritz Knothe spoke of joining a semi-pro basketball team. If this happened, it would exclude them from further amateur competition. The disturbing

DECEMBER 21, 1922, PASSAIC DAILY NEWS

news about Prof followed by that of Knothe and Keasler did not bode well in the basketball-crazy town.

The Knothes were irritated with the school for not paying a $25.00 dental bill resulting from an injury sustained in the previous season's Montclair game. In light of all the money the school made because of the team, the Knothes felt that their request was not unreasonable. The school refused to pay up in order to avoid setting a costly precedent.[122] Fritz, who lost his father a few years before, was the ninth of ten children, so the request was not viewed as unreasonable. Some believed this was the

real reason for Fritz saying that he would no longer play for the high school. As for Keasler, he was just following Knothe.

KEASLER AND KNOTHE

In the midst of the public outcry over losing the famous coach and the team's only two proven players, Prof intimated that the current court material was the best in the school's history. In his opinion, Passaic was loaded with promising young players who would continue the tradition. Still, many were afraid to think what would happen if Prof weren't there.

As expected, people began to speak up and question why the principal wasn't doing more to make Prof available to the team, especially since he was so important to the city. Surely someone else could be found to lead calisthenics for grammar school kids to allow Prof to do what it appeared only he could do.

A letter to the *Passaic Daily News* sports editor by Billy McCann, the popular athletic director of Brighton Mills, was published on October 19, 1922, and summed up how the Passaic people felt about Blood's reasons for stepping aside.

To Mr. Greenfield, Sporting Editor:

Every man is worthy of his hire. Why should there be any question about what should be done in the High School Basketball situation this year? Far be it from me to attempt to tell the Powers That Be what they should do, for I feel they surely know their business and their line of business is far above me, but if they want to please the people at large they will relieve Prof Blood of all routine work and put him in charge of the High School Basketball team at an increase of 100 percent salary, and to my mind we would even then be getting him dirt cheap at that.

He is worth a gold mine to the good old town of Passaic and we treat him like a mine of mud instead! Here we have a coach worth $10,000 per year to us or any other town, and we don't take advantage of him. There are many cities and colleges that would pay that amount and call it a good investment.

I can't agree with you Mr. Sporting Editor that it is up to the Chamber of Commerce or the Rotarians. Prof Blood is not looking for charity or sympathy. He's too much of a he-man for that. He has always given the best he had, and health permitting, I am sure he will do the same in the future.

I don't blame him for not wanting to undertake the job this year under the conditions, for he would have his work cut out for him and earn every cent he would get, building up a team from nothing.

Most of us don't seem to appreciate the work of a coach. He can't take his time and build up a smooth running machine and then rest on his oars; he must keep building and rebuilding and then start all over again at least every four years, not counting the disappointments he has to contend with after weeks, and months of work and worry getting some cog to fit nicely, only to find that owing to injury or some other circumstance over which he has no control, it has gone for naught. He must then start all over again.

I for one, feel quite sure and I think most people in Passaic feel the same, and would like to see the Board of Education or who-ever has the authority, to consider and put Prof Blood where he can do the most good for our good old town. And as he put us on the map, so will he keep us there if given a square deal.

For the good of sport and Passaic,

Billy McCann

McCann's letter expressed how the masses felt about Prof. Why couldn't the principal acquiesce and be more supportive? What was motivating Arnold? Was he acting on his own or were others influencing him? Many years later, retired Colonel John Roosma, who had reason to speak in a conciliatory manner, felt that Arnold was caught in the middle between Blood and several members of the school board.[123] A school principal occupies a politically capricious position. Was Arnold merely looking out for his own career?

Prof practiced his profession with a passion. Since the days when he worked his way up though the ranks of the YMCA, he taught with a passion. He was a consummate role model for his profession; he lived it by practicing what he preached. The fiery passion that drove him and enabled him to inspire his students and athletes was being snuffed. It was the continuous current of resistance he had to endure at the hands of the principal that he found most disheartening.

Prof was serious about turning the day-to-day coaching responsibilities over to Amasa Marks, but these feelings most likely vacillated from week to week. The administration's lack of appreciation for his work annoyed him, and in defense, this was his reaction to it. While his love for

the kids and the game never wavered, the conditions under which he had to work sapped his enthusiasm.

When Coach Marks started practicing for the new season, Prof would stop in the gym and observe the boys running through his drills. He really couldn't stay away. Once practices started, it didn't take long for Keasler and Knothe to heed Prof's advice and report to the gym. Shortly after the dynamic duo returned, Prof entered the gym dressed in his gym togs ready to take over.

Had Prof realized that his wounded feelings were only hurting the players and himself? Using basketball to teach the boys about how to be successful in life was what he enjoyed. Regardless of his behind-the-scenes joust with Arnold, he decided to continue coaching only because it hurt more to stay away.

Prof's presence on the court made everything move with more pep and snap. He was a natural motivator who participated in their drills and scrimmages. This was his way of showing how he wanted the game played. Their old physical instructor amazed the new players who remembered him from their grammar school days. It seemed as though Prof's knowledge of basketball was endless; he would teach them new skills and strategies every day. With Prof back, Knothe and Keasler took the role of team leaders by helping to teach Blood's system to the younger boys.

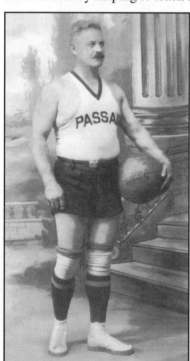

COACH BLOOD

While many throughout the world were still incredulous over Howard Carter's recent discovery of the tomb of King Tutankhamen, it was what Prof was about to unveil that would pique the interest of all of New Jersey and eventually the country. Prof had some treasures of his own he wanted to show off. The grand unveiling was set to coincide with the Cape May County champs' arrival on the hill— Ocean City High School.

GAME #91 Ocean City (Thursday, December 21, 1922) at Passaic HS. Another SRO crowd heralded the home opener. The local newspapers had been counting the fallen as the streak grew, and they predicted that this game would be the ninetieth consecutive victory. Fans arrived early only to be disappointed that the little gym had already filled to capacity long before game time.

Elmer Unger, a former Passaic physical instructor coached Ocean City. Unger was familiar with Prof, and he was an advocate of his passing game. The Ocean City contingent arrived confident that they could end the Passaic streak because they thrashed Woodbine 69-19 in their opening game. Was Ocean City ready? As it turned out, they were clearly out to sea. It wasn't until after the game that they began to realize what had actually happened.

From the outset, the frantic Passaic fans were chanting, "We want a hundred." The Red and Blue boys put the pedal to the metal and never let up. The three-time state champs completely overwhelmed Ocean City. When the 100th point was scored, hats and coats were thrown in the air—and this was barely sixteen minutes into the game. At that time, Prof selected another group from his squad of thirty-five, fully uniformed reserves to continue the mercy killing.

While no one expected this performance, it was the talent and poise of the players and how they executed the short passing offense that stood out. Where did these new players come from? For example, Prof unveiled Fred Merselis, a 6'4" sophomore center, and two young basketball phenoms Milton Pashman and Meyer "Moyer" Krakovitch. Pashman was very quick and a gifted shooter, and the solidly built Moyer appeared to be the second coming of Knothe—excelling on defense, ballhandling, and passing.

The fans had to look twice at Mike Hamas; the little boy who occupied a seat on the bench last season. As an eleventh grader, Mike managed to score thirty-seven points for the season. While becoming addicted to shooting baskets, Mike had grown a head taller since the previous season. After the last state championship, fans in his neighborhood gave the good-natured kid some money in appreciation for the team's fine showing. Mike used it to purchase the neighborhood's only basketball rim which he set up in the lot by his

PASSAIC	G	F	T	OCEAN CITY	G	F	T
Hamas	10	4	24	Boswell	1	0	2
Keasler	11	7	29	Barron	2	0	4
Pashman	6	0	12	S. Adams	1	8	10
Merselis	9	0	18	T. Adams	0	0	0
VanderHeide	1	0	2	Blackman	0	0	0
Knothe	3	0	6	Gibb	0	0	0
Krakovitch	5	0	10	**Totals**	**4**	**8**	**16**
Blitzer	0	0	0				
J.Thompson	0	0	0	**Foul Throws—**			
Freeswick	3	0	6	Hamas—four of four;			
Pomorski	1	0	2	Keasler—seven of twelve;			
Lucasko	0	0	0	S. Adams—eight of fifteen.			
Janowski	0	0	0				
Russell	0	0	0	Score by periods:			
Totals	**49**	**11**	**109**	**Passaic** 26 30 25 28			
				Ocean City 3 5 4 4			

Duration of quarters: 10 minutes. Referee—Harry Wallum. Timer—Drew. Scorers—H. W. Saunders and R. Fitzgerald.

father's saloon. After shooting baskets all summer, Mike had become a dead shot from all angles. The prognosis was unanimous; Passaic was about to have another Wonder Team season. Final score: **Passaic 109-Ocean City 16.**

When all of Passaic heard the score, they also learned that it was actually the ninety-first win in a row, not the ninetieth. The correction was made after George H. Greenfield, the Sports Editor of the *Passaic Daily News*, congratulated Prof on the ninetieth straight win. Prof begged to differ, claiming it was the ninety-first in a row.[124]

MICHAEL HAMAS (RIGHT) WITH FRED MERSELIS

Even though Prof could not pinpoint the exact date of the missing game, Greenfield did not want to question Prof's sincerity; therefore, it became the ninety-first. In researching the streak, Greenfield never did locate and verify the missing game, but one did appear when the list was published after the 100th victory. Greenfield had quietly inserted the Nutley game as the 35th victory.

The only problem with Greenfield's solution to this missing game mystery was that the Nutley game was billed as a "Seconds" game which meant that none of the Passaic regulars played; only the

JOHN VANDER HEIDE

second-string players participated. Today, this could be referred to as a preliminary game. It remains debatable whether the Nutley game should count as part of the streak.

When the Ocean City score became public, the entire state learned that Passaic still reigned as basketball's top dog. Ira Vonk, now 6'5", was still in school but scheduled to graduate in February. Because he would not have been eligible for the play-offs, Prof elected not to play him. With sophomore Fred Merselis and his backup 6'1" John Vander Heide developing as centers, Prof was set with another solid nucleus.

SHOTS·AND·PASSES < ¡ BY ¡ > The Three Basketeers

SPORTS PAGE LOGO USED BY PASSAIC DAILY NEWS REPORTER GEORGE H. GREENFIELD AND HIS STAFF.

Keasler was a quick, strong, tough, agile 6'1" lefty who knew Prof's system from all positions. While Keasler could shoot from distance, he was particularly adept along the narrow baseline and around the basket. He was recognized by many as the best forward in New Jersey high school basketball. DeWitt's running mate was the solidly built, 5'9" Fritz Knothe, the *avant-garde* of scholastic point guards. Not only were his offensive and defensive skills a few levels above everyone else's, he was a charismatic leader—a coach on the court. If nothing more were added to his athletic resume, he would be severely slighted. Fritz was that once-in-a-generation athlete who refused to lose. He did not have to score points to beat you, but he could and would if he had to. Fritz's forte was his passing and defense. He was the leader that drove Passaic's Wonder Teams, and since his junior year, his mere presence intimidated the opposition.

Several open dates remained on the schedule, and team manager Royal Drew was working to find the best opponents. Requests were coming in from all directions wanting to schedule home and away games. Passaic was locked into a league schedule that did not afford many open dates. Plus, the school's policy against missing classes because of athletics didn't allow much leeway to take on challengers.

ROYAL DREW

Another troublesome topic was the limited capacity of the school's gym. Because of the complaints from the many who could not see their Wonders in action, this was a problem that was becoming a public concern. When the news was announced of a new armory to be built in Passaic, the concern was whether it would be large enough. Many thought it was a disgrace that the biggest attraction in the city had to be held in an undersized school basement.

The Charleston and Jazz were the rage of the country, but around Passaic, nothing compared with the Wonder Team in popularity. The success of Prof's teams was continuing to make the city famous, and the pride being generated from it was visible in all facets of Passaic life. The team was the talk of the town, state, and now, as they approached their 100th consecutive victory, they were gaining national attention.

GAME #92 Schenectady, New York, (Saturday, December 30, 1922) at Passaic HS. The undefeated visitors were a crack outfit who had reached the semifinals of their state play-offs the previous year. This was the eighth game for the confident and determined New Yorkers. Coach Eddy of Schenectady told Prof that his team was ready to give Passaic a real game. Adding to the pregame suspense, it was learned that Milton Pashman was ill and unable to play.

Coach Eddy's assessment was true; his team was ready. After ten minutes of play, the boys in Red and Blue were up 9-5 and feeling the effects of top-notch competition. Schenectady's all-state forward Francis X. Casey was giving the home team fits with his exploits. Casey had a knack for stealing Merselis's center taps thus stopping the celebrated Passaic offense.

Without Knothe, Schenectady could have been a nightmare for Passaic. Mike Hamas's free throw shooting (20 for 26 for the game) and the sixteen point half time lead managed to console the fans. Reporters representing at least a dozen different newspapers were on hand, but none more important than the

PASSAIC				SCHENECTADY			
	G	F	T		G	F	T
Hamas	4	20	28	Casey	4	5	13
Keasler	4	0	8	Sibel	0	0	0
Merselis	0	0	0	Ford	0	0	0
VanderHeide	0	0	0	Fodder	0	0	0
Pomorski	0	0	0	Conner	1	0	2
Knothe	2	0	4	Baldwin	0	0	0
Blitzer	2	0	4	Gray	2	0	4
Krakovitch	0	0	0	Deveau	1	0	2
Totals	12	20	44	Totals	8	5	21

Score by quarters:

Passaic	9	23	33	44
Schenectady	5	7	13	21

reporter from the Associated Press who was making Passaic scores available to the entire country. Final score: **Passaic 44-Schenectady 21.**

GAME # 93 NYU Freshman (Saturday, January 6, 1923) at Passaic HS. Some people thought Prof had erred by scheduling such a talented outfit so early in the season. Prof's lack of concern for playing a team with former high school standouts was made clear in a pregame interview. His comment, "Why, they're merely a team of stars," was not meant to negate the importance of individual talent but to emphasize the value he placed on teamwork.

Throughout the Lafayette Street gym, hearts skipped a few beats as Coach McCarthy's impressive looking freshmen struck first. Gottlieb, the explosive guard from Hoboken, led the attack on the Wonders, but the stars were soon given a lesson that was not to be

PASSAIC				NYU FRESHMAN			
	G	F	T		G	F	T
Hamas	4	19	27	Hogan	4	0	8
Keasler	5	0	10	Gottlieb	3	5	11
Pashman	3	0	6	Nichols	1	7	9
Herman	1	0	2	Whalen	1	0	2
Merselis	2	0	4	Siegel	0	0	0
Knothe	2	0	4	McConville	0	0	0
Blitzer	0	0	0	Griffin	0	0	0
Krakovitch	3	0	6	Hillenback	0	0	0
Totals	20	19	59	Callo	0	0	0
				Amsell	0	0	0
				Totals	9	12	30

Fouls committed: Passaic 23-N.Y.U. 23. Fouls scored: Hamas—19 for 23; Hogan—0 for 3; Gottlieb—5 of 10; Nichols—7 of 10. Time of periods: 20 minutes. Referee—Harry Wallum. Scorer—Harold W. Saunders. Timer—Royal Drew. Half time score: 26-17, PHS.

forgotten. As Prof had inferred before the game, his squad's teamwork would prove to be the deciding factor.

For a preseason game, Passaic was in rare form. Unlike the NYU players, Blood's boys seldom let the ball touch the wooden floor. Ignoring the opponent's athleticism and basketball skills, Prof used the occasion to experiment with many different combinations to learn how his new boys would react to competing on this level. Final score: **Passaic 59-NYU Freshman 30.**

It would seem unfair by today's standards to have Harry Wallum as the referee for so many games, but this was a common practice in the early years. Prof and other basketball authorities had respect for Wallum's character and knowledge of the game. His whistle was in great demand, but he appreciated the opportunity to call Passaic games.

Like Prof, Wallum was among the first generation of ardent lovers of the indoor game. Harry Wallum grew up in Union City, and in the 1917-18 season, he coached a young Union Hill team with Ed Benzoni to a 10-0 record before bowing to a more experienced Dickinson team. Prior to his one-year stint at Union Hill, he played professional basketball in the old cage circuit with the Paterson Crescents.

Passaic opponents never failed to compliment the accuracy and fairness of Wallum's decisions as referee. Never during the years Wallum called Passaic games did a guest complain; to the contrary, everyone praised his work. Many commented that he actually favored the visiting teams. Even NYU's Gottlieb, the Hoboken graduate, admitted that Wallum's work could not have been better.

Passaic's Greatest Scholastic Basketball Player—A Model for Future Court Stars

AR-GG-G-G AR-G-G-G-G GURGLE

SHUT UP, WOT-CHER LAFFIN' AT?

HE WANTS TO BECOME A DENTIST WHEN HE GROWS UP.

Fritz SHOOTS HIS DAILY DOZEN EVERY MORNING BEFORE BREAKFAST

ARCH WHITEHOUSE

COACHES ALL OVER THE COUNTRY, HOLD KNOTHE UP AS THE 'MODEL BASKETBALL PLAYER.'

THERE Y'ARE, THERE'S SOMETHING TO SHOOT AT

Y-YES, SIR

WILFRED "FRITZ" KNOTHE

SWEETEST LITTLE BASKETBALL PLAYER I EVER SAW'

SO SAYS HARRY WALLUM

GAME #94 Hackensack (Wednesday, January 10, 1923) at Passaic HS. While the game of Mah Jongg with its racks and tiles was capturing the attention of the nation, in Passaic, it was the Wonder Team's quest of the coveted 100th consecutive victory that had dominated the city's curiosity. Via the Associated Press, the streak of the Passaic Wonder Team had piqued the attention of sports enthusiasts across the nation. *The New York Times* had given Blood's undefeated cagers front-page coverage alongside the Naval Academy write-ups. The col-

MOYER KRAKOVITCH

lege teams, such as Yale, Princeton, Cornell, Colgate, Dartmouth, CCNY, and Fordham, were finding their write-ups on the inside pages.

In their previous game, Hackensack had defeated Rutherford thus accounting for the Golden Comets' naivete. They left town in shock just two hours later. The dazzling speed of the Passaic boys' passes and the accuracy of their shots in the first, third, and final quarters overwhelmed the Bergen County visitors.

By securing nineteen field goals, Mike Hamas proved to be an able successor to Thousand Point Bobby Thompson. With the sensational play of Keasler and Knothe, the results were never in doubt. The absence of freshman luminary Moyer Krakovitch, owing to scholastic shortcomings, provided Prof the opportunity to introduce two other promising future Wonders, Nelson Rohrbach

PASSAIC	G	F	T	HACKENSACK	G	F	T
Hamas	19	4	42	Mercier	3	1	7
Keasler	12	0	24	Mabie	0	6	6
Merselis	6	0	12	Bollerman	1	0	2
Pashman	0	0	0	McGowan	0	0	0
Herman	1	0	2	Zabriskie	1	0	2
Knothe	4	0	8	Sadlock	1	1	3
Blitzer	1	0	2	Greenleese	0	0	0
Freeswick	0	0	0	**Totals**	**6**	**8**	**20**
VanderHeide	0	0	0	Ten minute quarters.			
Rohrbach	1	0	2	**Passaic**	20	14	30 28
Totals	**44**	**4**	**92**	**Hackensack** 1	8	6	5

Fouls called on Passaic: 10; on Hackensack: 2. Fouls Scored: Hamas—four for four; Mercier—one for five; Mabie—six for nine; Sadlock—one for four. Referee—Harry Wallum. Scorer—Harold W. Saunders. Timer—Royal Drew.

and John Freeswick. Final score: **Passaic 92-Hackensack 20.**

GAME #95 Englewood (Saturday, January 13, 1923) at Englewood HS. A 10:30 a.m. game on the road did little to deter the Passaic "Royal Rooters" from showing up nor from keeping the Wonder Team from staging another spectacular performance. The nucleus of a new social group from Hudson County, called "basketball junkies," paid their money to size up the Wonders. The style of basketball they witnessed opened their eyes but left them speechless.

Other than their star Allison Cobbs, dubbed the "Dusky Warrior" by the media, the Englewood team offered little challenge to the champions. Like a veritable black streak, Cobbs took on the Wonders, and it was his lone point that accounted for the host's total half time score. But it was in the second half that Cobbs showed his real offensive talents.

ENGLEWOOD'S ALLISON COBBS
photo courtesy of the Englewood Public Library

Meanwhile, the fourteen-year-old Merselis showed some offensive talents of his own. Fred was all over the court using his size and intelligence; near the baskets, he stifled the entire Englewood team. Merselis's work coupled with the others left little opportunity for any Englewood player to stand out except Cobbs. While Cobbs's efforts were all of an individual nature, the crowd couldn't help but marvel at his athleticism. The following morning, the front page of the *Passaic Daily News* reported what had already become a foregone conclusion: **PASSAIC HIGH SCHOOL VICTORIOUS AGAIN**. Final score: **Passaic 89-Englewood 20.**

The fact that Joe Johnson was the referee was somewhat ironic. Johnson was a popular, former local athlete and professional basketball player who was now the physical director/basketball coach at Paterson. His team was currently undefeated and billed by the Paterson newspaper as the tallest team in the state. The newsmen had the city of Paterson all

PASSAIC			ENGLEWOOD			
	G	F	T	G	F	T
Hamas 12	11	35	Brarman 3	0	6	
Keasler 9	0	18	Cobbs 4	6	14	
Merselis 10	0	20	Chamberlain 0	0	0	
Knothe 1	0	2	Bertels 0	0	0	
Blitzer 0	0	0	Pittman 0	0	0	
Pashman 3	0	6	Whelan 0	0	0	
Krakovitch 3	0	6	Farenelli 0	0	0	
Pomorski 1	0	2	**Totals 7**	**6**	**20**	
Freeswick 0	0	0	Score by periods:			
Burg 0	0	0	**Passaic**	43	46	
VanderHeide 0	0	0	**Englewood** 1	19		
Herman 0	0	0	Time of periods: 20 min.			
Totals 39	**11**	**89**	Referee—Joe Johnson.			

hyped up for a challenge game with the Wonder Team. The two neighboring industrial cities' high schools haggled over the pecuniary arrangements for a game to be played at the Paterson Armory. The media's bubble burst two days later when Hackensack trimmed the tall Silk City quintet 39-32.[125]

As the notoriety of the win streak grew, new jealousies kept pace. In many instances, the news media was the catalyst fueling hard feelings and creating controversies. So what's new? A good example was James B. Egan, the sports editor of *The Hudson Observer* in Hoboken. In an attempt to glorify his talented Hoboken team, Egan enjoyed trying to find

fault with Prof and his team. Egan wrote that Passaic played a weak
schedule; plus, it did not include any games in Hudson County. Egan and
other sports writers became so disparaging that Passaic's official score-
keeper Harold W. Saunders wrote a reply:

January 12,1923
Mr. James B. Egan, Sporting Editor
The Hudson Observer, Hoboken, N.J.

Dear Sir:

*My attention has just been called to your sport editorial re-
garding the Passaic High School basketball team. Under-
standing the frame of mind in which it is written probably
better than most folks in this section of the state, as my daily
business takes me to certain parts of your well-known county
and gives me an opportunity to mingle with its citizens. I am
answering it by calling your attention to the following facts:*

*The only joke teams that Passaic played last season were the
two Hudson County teams, Emerson and Union Hill....
Passaic will not play home and home games with the Hudson
County teams as the Hudson County courts are not con-
structed in accordance with the regulations governing the
playing court.*

*Hudson County teams realizing the drawing power of the
champions naturally would like to book them to fill their coffers,
hence the howl when they are ignored by the Passaic team.*

*As for a committee of experts arranging their schedule surely
you know that they are members of the N.N.J.I.L., and have ten
games in that league, before they book any other opponents. On
any open dates they fill in with any team that is willing to meet
them without holding out for a guarantee of a thousand dollars.*

*Of course, teams like Eastman College, East Greenwich Academy,
Philadelphia All-Scholastics, Fordham Prep, Binghamton,
Reading, Pa., and Montclair are more or less weak opposition
for the champions, but they are considered pretty classy outfits
as compared with some of the teams you list as worthy opponents
for the Passaic team.*

*These teams were picked by the Honey Dew Melon commit-
tee you refer to to fill in between the league games last year
and as most of them were from out of the state and were*

accompanied by newspaper men from their home towns, we Passaic citizens had an opportunity of having unbiased news-papermen say what they really thought of the team that had earned the right to be called champions.

Before pulling such a 'bone' as you remark about the Honey Dew Melon you should have thought about the three champion-ships in a row that Coach Ernest A. Blood has brought to Passaic. For your information and guidance Prof puts his O. K. on every game scheduled and I have just called him up to ask if they used melons or basketball in their games and he assured me that they were basketballs, so it might be possible that you are wrong Mr. Egan.

Out in this neck of the woods we are generous winners and good losers. All we want is a square deal. We ask no odds and we give none. We have a basketball team here that we think is good and will continue to think so until they are beaten in a fairly played game by a better team. This may happen tomorrow, next week, next month, or next year....

The action of an undesirable element after the elimination games at Hoboken last season was a rank outrage. Passaic rooters were beaten as they left the grounds. The year before that as Hoboken went down to defeat, the condition that existed was a blot on the name of your mile square city. If articles of the kind that I complain of were left unwritten, it would go a long way toward curbing the element that is so easily stirred to action when they imagine that they have a grievance.

Play the game hard and clean. Give credit where credit is due. Leave unkind things unsaid and you're doing a good job. That's all anyone can ask of you and that's all we ask out here in Passaic. Is it too much?

> *Yours for fair play,*
> *Harold W. Saunders*

The media frenzy created by the win streak enticed comments from fans far and near. Every fan had something to say about some aspect of the Wonder Team. As the team approached the century mark, the entire country, as well as a variety of foreign countries wanted to theorize what made the Passaic Wonder Teams unbeatable. When it was revealed that the winning was not because of a home court advantage or the paucity of talented opponents, it became clear that the team's success had a lot to do with the coach's system.

GAME #96 East Rutherford (Tuesday, January 16,1923) at Passaic HS. Coach Jimmy Mahon's hustling troops cruised into Passaic riding a four-game winning streak and sure they could give the champs a run. Prof countered with a parade of seventeen players against the Bergen County kingpins. At the close of the first period, the visitors were relieved to see Fritz Knothe leave the game because of a severe cold he'd caught over the weekend while visiting Coach Eddie NcNichol at the University of Pennsylvania.

The dominating play of Merselis had Prof grinning. The young center controlled every jump ball and dominated play around the baskets. The opening tip-off went like this: Merselis tipped to Knothe who passed to Keasler running to the basket for a lay-up, all within a couple seconds. Final score: **Passaic 83-East Rutherford 19.**

GAME #97 Cliffside Park (Wednesday, January 17, 1923) at Passaic HS. Three wins shy of the 100th straight victory, the Red and Blue machine had to play without their Captain Knothe. From the bleachers, Fritz watched Hamas and Keasler heat the gym with their shooting. The visitors' Nick Borrelli, an all-state football player, took advantage of Fritz's illness and young Krakovitch's inexperience to become a one-man wrecking crew.

PASSAIC	G	F	T	EAST RUTHERFORD	G	F	T
M.Hamas	8	5	21	Konikowski	1	11	13
Pashman	1	2	4	Horwath	0	0	0
Keasler	6	0	12	Stead	1	0	2
Merselis	13	0	26	McMahon	1	0	2
Knothe	2	0	4	Clark	0	0	0
Blitzer	0	0	0	Cuneo	0	0	0
Krakovitch	2	0	0	Ryan	1	0	2
Burg	0	0	0	**Totals**	**4**	**11**	**19**
Rohrbach	1	0	2				
VanderHeide	0	0	0	Score by quarters: 10 min.			
Pomorski	1	0	2	**Passaic** 25 18 20 20			
Freeswick	1	0	2	**E. Ruth.** 5 4 2 8			
Herman	1	0	2				
Gee	0	0	0	Fouls scored: Hamas—5 for 7;			
Hanson	0	0	0	Konikowski—11 for 16.			
Lucasko	1	0	2	Referee—Harry Wallum.			
S.Hamas	1	0	2	Scorers—Saunders, Murphy,			
Totals	**38**	**7**	**83**	Timers—Drew, Conroy.			

PASSAIC	G	F	T	CLIFFSIDE PARK	G	F	T
M.Hamas	12	11	35	Ressler	3	0	6
Pashman	2	0	4	N.Borrelli	4	15	23
Merselis	2	0	4	Silsby	0	0	0
Keasler	9	0	18	F.Borrelli	0	0	0
Krakovitch	3	0	6	Whelan	0	0	0
Gee	0	0	0	Becker	2	0	4
Freeswick	1	0	2	Ertz	0	0	0
S.Hamas	1	0	2	**Totals**	**9**	**15**	**33**
Blitzer	1	0	2				
Herman	1	0	2	Score by halves:			
Lucasko	0	0	0	**Passaic** 41 34			
Rohrbach	0	0	0	**Cliffside** 17 16			
VanderHeide	0	0	0	Fouls scored: Hamas—10			
Pomorski	0	0	0	for 17; Borrelli—15 for 20.			
Totals	**32**	**11**	**75**	Referee—Harry Wallum.			
				Scorer—Harold Saunders.			

Coach A. L. Gemme took his entourage home claiming a moral victory. At the same time, the coach was loud in his praise for the Wonders. He made it clear that he had never seen anything that could compare with them. Cliffside's thirty-three points were the most scored against the Wonders thus far. They were a proud and happy group as they boasted how they came close to defeating the Wonder Team. Final score: **Passaic 75-Cliffside Park 33.**

The anticipation and suspense surrounding the century game was building with each victory. Saturday, January 27, had been an open date from the beginning of the season, and Prof had been searching for a high-powered opponent to fill the date. He tried to book Asbury Park who had just defeated St. Benedict's Prep, but Asbury Park's Coach J. Melville Coleman elected to delay the confrontation until the state play-offs.

The two teams Prof really wanted were Hoboken and Union Hill, but both declined. Later, Skeets Wright, who declared that Union Hill would be a better opponent than Hoboken, would recant his objections and propose meeting Passaic in the Paterson Armory. In the meanwhile, the gossip over who would be the 100th victim increased.

Were other highly touted teams leery of meeting the Wonder Team? Ed Sullivan, a twenty-two-year-old sports writer for the *New York Evening Mail* (later of TV fame), reported that he, Ed Thorp (basketball expert and President of the Metropolitan League), and Jack Murray (former coach of Columbia University) agreed that Passaic had the greatest scholastic team in the country.[126]

Prof's intention was to play the best possible opponent, but the critics believed he was looking for a patsy to guarantee a victory. The day after the Cliffside game, Prof announced his plans for the one-hundredth game.[127] Prof's desire was to play any high school team in the United States that cared to play on the open date—Saturday, January 27, at 3 o'clock. All Prof promised in return were team expenses and a square deal.

Prof's declaration went on to respectfully invite the following sports writers to select the team to be played:

- James B. Egan, Prof Blood and Wonder Team critic, Sporting Editor, *The Hudson Observer*, Hoboken.

- Jack Farrell, basketball expert of the *New York Daily News*, formerly Sporting Editor, *Hudson Dispatch*, Union Hill.

- Ed Sullivan, *New York Evening Mail.*

- Johnny Schields, Sporting Editor, *Newark Evening News.*

- Abe Green, Sporting Editor, *Paterson Evening News.*

The public challenge issued by Prof and picked up by the Associated Press served two purposes—it silenced the critics and shifted the responsibility to find a worthy challenger to the *ad hoc* game committee. Knowing Garfield and Ridgewood would not present any problems for his team, the Grey Thatched Wizard busied himself with preparing his team for the big one.

GAME #98 Garfield (Saturday, January 20, 1923) at Passaic HS. Coach Hughie Walders brought a small band of do-or-die athletes for their first court confrontation with Passaic. The Bergen County boys caught the Wonders looking ahead. For the first five minutes, the over-confident Wonders stood around waiting for something to happen, and the 4 to 1 deficit vouched for their efforts.

After Prof relocated Fred Merselis to a more comfortable position on the bench to resume his nap and delivered a sobering message, the Wonders exploded. Up to this point, Coach Skeets Wright, who was a witness to the flaccid effort, was enjoying the thought of playing Passaic. All of those thoughts and the Garfield optimism came to a halt as the Wonders switched into high gear. Suddenly, the Garfield boys appeared to be slow dancing with partners doing the Charleston.

The offensive attack that followed was another episode augmenting the Wonder Team's legend. The familiar rapid ball movement, the frequent cuts to the ball, plus a team-wide shooting exhibition of mythical proportion left the spunky visitors to die a hero's death in the line of duty. As many Wonder Team opponents had lived through in the past, Garfield was about to have an on-court experience they would never forget. Final score: **Passaic 96-Garfield 25.**

With all the hubbub about the hundredth game and what could be a record for scholastic basketball teams, George H. Greenfield, the sports editor of the *Passaic Daily News*, asked Oswald Tower for his input.[128] Tower was a member of the basketball rules committee, editor and rules interpreter, and editor of the popular

PASSAIC	G	F	T	GARFIELD	G	F	T
M.Hamas	10	14	34	Sider	0	0	0
Keasler	9	0	18	VanderVliet	0	0	0
Merselis	2	0	4	Micklus	0	0	0
Knothe	3	0	6	Piela	3	0	6
Krakovitch	5	0	10	Wolchko	2	7	11
Pashman	5	0	10	Dolan	0	0	0
Freeswick	1	2	4	Hampton	4	0	8
Pomorski	2	0	4	Bizik	0	0	0
S.Hamas	1	0	2	Horwath	0	0	0
Gee	2	0	4	**Totals**	**9**	**7**	**25**
Sattan	0	0	0	Fouls scored:			
Burg	0	0	0	Hamas—14 for 21;			
Totals	**40**	**16**	**96**	Freeswick—2 for 2;			
				Wolchko—7 for 12.			

Score by periods: **Passaic** 22 23 24 27
 Garfield 3 4 6 12

Referee—Harry Wallum, Scorers—Saunders, Pennineo.

Spalding Basketball Guide. In 1959, Oswald Tower was among the first to be inducted into the Naismith Basketball Hall of Fame as a "Contributor." Tower wrote back expressing his recollections concerning scholastic records:

Dear Mr. Greenfield:

I have your letter with reference to basketball records. I regret to say that records covering the history of basketball have not been compiled. The only way to compile such statistics would be to go through a complete file of basketball guides. Occasionally the records of good teams are missing from the guides, and therefore this process would involve a degree of inaccuracy.

I think it is safe to state however, that Passaic High School has broken all scholastic records in the matter of consecutive victories and points scored, in it's [sic] wonderful career during the past four years. No such achievements have come to my attention on the part of any other team; and I feel sure, because of my close contact with basketball throughout the country for many years, that such records, if made, would have been brought to my notice.

Passaic is to be congratulated upon producing such teams, and I hope to be able to extend my personal congratulations to Coach Blood and to the team.

Very truly yours,

Oswald Tower

Of the scores of challengers who voiced interest in participating in the hundredth game without demanding conditions of their own, two teams began to emerge from the heap—St. Mary's Academy from Ogdensburg, New York, and Danbury in Connecticut. Powerhouse teams such as Crosby with its thirty-three game win streak and instate rival Hoboken both demanded a home and away arrangement. Commerce from NYC with its thirty-one game win streak already had a game for that date and was not interested in rescheduling to accommodate Passaic.

Crosby and Hoboken had additional stipulations—they wanted to play on a neutral court, and Crosby wanted to bring its own officials. One official named by Crosby was William Cooke the gentleman from Columbia University who called the Fordham Prep debacle the year before. Because of its reputation, Crosby would have been the match favored by most fans. Last season, Crosby easily defeated Hoboken in the finals of the prestigious University of Pennsylvania Tournament.

The rumor was that St. Mary's had been chosen to be the streak's 100th victim. In all the excitement, the boys in Red and Blue had almost forgotten that they still had to play Ridgewood. A circus atmosphere surrounded Passaic. It was media frenzy; everyone wanted a story and a picture of the team. Any information about the professor-coach and his Wonder Team was news; Passaic had the attention of newspapers across the country.

GAME #99 At Ridgewood (Wednesday, January 24, 1923) at Ridgewood HS. In all the excitement, Referee Tewhill, who hailed from NYC, was caught off guard by the pageantry of a Passaic game. When there was no preliminary game, it was Blood's policy to have his younger players on the court fifteen to twenty minutes before his regulars. For their workout, they performed a variety of quickly executed passing drills. After Tewhill watched this large, impressive, well-organized, and fully uniformed team warm-up for ten minutes, he decided to blow the whistle for the start of the game. At that moment, no one was more dumfounded than Tewhill when he saw the "real" Wonder Team running on the court. His confusion was compounded by the fact that, in his own words, he had been watching "the greatest exhibition of passing I had ever seen."[129]

If ever there was an overlooked team, it was Ridgewood. Prof was not concerned; he knew his boys were ready to play. Coach Ford of Ridgewood had every reason to feel like the appetizer before the entree. His concerns were quickly justified as Passaic dazzled his boys and fans with all the characteristics that earned them the Wonder Team label. The Ridgewood players did not have the luxury afforded their fans—to just sit in the bleachers with their mouths agape in amazement. Final score: **Passaic 91-Ridgewood 13.**

Considering the conditions placed on the one-hundredth game, the five sports writers recommended St. Mary's Academy as the best available opponent. With their impressive credentials, a confident St. Mary's team agreed to play. The previous season, they were 20-3 and played an impressive schedule. Their three losses were at the hands of Plattsburg, Central of Syracuse (who went on to win the

PASSAIC				RIDGEWOOD			
	G	F	T		G	F	T
Hamas	15	11	41	Russel	2	0	4
Pashman	0	0	0	Pinckney	1	3	5
Keasler	13	0	26	McAllen	2	0	4
Merselis	6	0	12	Hall	0	0	0
Knothe	3	0	6	Kay	0	0	0
Krakovitch	3	0	6	Jenkins	0	0	0
Totals	**40**	**11**	**91**	Thompson	0	0	0
				Totals	**5**	**3**	**13**

Score by quarters: 10 minutes each.
Passaic 20 35 14 22
Ridgewood 0 2 4 7

Fouls scored: M. Hamas—11 for 14; Pinckney—3 for 9. Referee—Tewhill, Horace Mann HS. Scorer—Saunders. Timer—Drew.

state championship), and the highly touted Christian Brothers Academy to whom they lost by one point.

This year, the St. Mary's players were taller, heavier, and more offense-minded. With an 11-1 record, they had already avenged one of last year's losses to the always-powerful Central. Their lone setback was at the hands of a vintage Plattsburg team. Two days before the century battle, St. Mary's downed Masten from the Buffalo area (last year's state runners-up), one of the strongest contenders for the current New York state title. The St. Mary's coach, Father Robert Booth, told Prof before the game that "if Passaic defeats us today, you can take it for granted that you have beaten the best in New York state."[130]

The guarantee promise made to St. Mary's had the Passaic administration worried that they might not recoup enough money at the gate to break even. After a couple of telephone calls, the game was moved to the Paterson Armory. Prof's main concern with moving the game to the Armory was safety. He feared that the crowd could grow unruly and beyond the control of his officials. This change accomplished a number of things:

- It more than quadrupled the number of people able to attend and it kept the admission price at fifty cents.

- It not only guaranteed the financial success of the game, it illustrated that playing at the Paterson Armory was a good public relations venture.

- It made it easier for one hundred thousand sports fans to later say that they were there the day that Passaic won their one-hundredth game.

- It raised the ire of Hoboken and Union Hill who moaned that they would have agreed to play if they had known it would be held at the armory.

Basketball hysteria had engulfed Passaic. Wonder Team fans were all abuzz over the "Battle of the Century." Various fans were forming an assortment of committees to arrange for everything from special jitney bus transportation, a brass band, loving cups, and postgame celebration dinners to organizing the local factories to sound their whistles once the game was decided. More hype was added to the event when Paterson radio station WBAN agreed to be the first ever to broadcast a high school basketball game. The bandwagon was becoming crowded.

GAME #100 St. Mary's, NY, (Saturday, January 27, 1923) at Paterson Armory. Hours before the doors opened, the crowd gathered along Market Street in front of the Paterson drill shed, the sight of the

most publicized and talked about basketball game in the history of scholastic sports. It was a cosmopolitan array of spectators who made a beeline for the choice balcony and court level seats when the doors were swung open. Coach James A. MacIntyre and his team from Morristown High School were among the first to enter. The tall, young Scotsman wanted his players to see what it was that made Passaic so wonderful.

Before a couple thousand fans were turned away, in rushed factory workers, businessmen, sports writers, teachers, doctors, lawyers, grammar school kids and Flapper girls. Infiltrated into the crowd were high school and college basketball coaches hoping to come away with some of Prof's secrets. But most prevalent were the curiosity seekers who would be getting their first glimpse of the Wonder Team. They all had one goal in common—to get a seat.

LINEUPS FOR THE BATTLE OF THE CENTURY

PASSAIC			ST. MARY'S		
Fritz Knothe	5'8"	170	Gerald Norman	6'1"	155
DeWitt Keasler	6'0"	160	Ralph Adams	5'9.5"	153
Mike Hamas	6'1"	165	George McKittrick	6'1.5"	159
Fred Merselis	6'4"	180	Earl Fleming	5'10"	163
Moyer Krakovitch	5'8"	160	Frank LaMacchia	5'8"	165
Milton Pashman	5'9"	135	Joe Cummiskey	5'8"	145
Sam Blitzer	5'8"	155	Joseph Hollis	6'0"	149
John Freeswick	5'9"	142			

On a slick armory court before a throng of 6000 plus, St. Mary's started the game in their five-man (zone) defense. The boys from Lawrence County quickly proved themselves a worthy opponent. With Fritz Knothe picking up his third foul in the first quarter, a chill spread over the confident Passaic fans. It was a spectacle watching two outstanding teams probe for a weakness to exploit. But it soon became apparent that Passaic would have the upper hand.

The crowd appreciated the brilliant play of St. Mary's. Owing to the three technical fouls Wallum called on Hamas, Keasler, and Krakovitch for leaving the court between the third and fourth quarters to retrieve their sweaters, Fleming nonchalantly sank the three free throws. Thanks to the technical fouls, St. Mary's set a new record for points scored against a Wonder Team.

The same familiar attributes of the Blood cohorts proved to be the deciding factors—especially the shooting. The great week that had Keasler shooting the ball well continued as he literally lit up the gym with a variety of shots from all angles. With Knothe directly or indirectly involved with every basket and successful defensive maneuver, it did not

take long for first-time viewers to witness that what was said about Knothe was true.

Immediately after the history-making game, Prof, who was all smiles, commented half jokingly to the newspapermen seated at the elongated press table, "What do you sports writers mean picking such a soft one for Passaic?" The congratulations and compliments came in droves. It took over fifteen minutes for the Passaic players to get back to their dressing room following the final horn.

B. R. Stevenson from the *Philadelphia Public Ledger* admitted that in all his years of covering scholastic basketball, he had never seen anything that compared with Prof Blood's team. He was most impressed with their passing, quickness, execution, and especially their shooting. After congratulating Prof, Father Booth declared that he had never seen a better high school team nor had he and his boys ever been treated in a more fair and sportsmanlike manner. The St. Mary's coach even admitted that he felt Harry Wallum's officiating favored his team. Final score: **Passaic 59-St. Mary's 38.**

PASSAIC	G	F	T	ST. MARY'S	G	F	T
Hamas	6	7	19	Norman	4	0	8
Pashman	1	0	2	Adams	7	0	14
Keasler	12	0	24	McKittrick	0	0	0
Merselis	3	0	6	Fleming	4	8	16
Knothe	2	0	4	LaMacchia	0	0	0
Krakovitch	2	0	4	Cummiskey	0	0	0
Freeswick	0	0	0	Hollis	0	0	0
Gee	0	0	0	**Totals**	**15**	**8**	**38**
Pomorski	0	0	0				
Herman	0	0	0				
Blitzer	0	0	0				
Totals	**26**	**7**	**59**				

Score by quarters: (10 min)
Passaic 15 14 12 18
St. Mary's 5 8 10 15

Referee—Harry Wallum. Scorers—Saunders and Fr. Booth. Timers—Royal Drew and Alexander Cummings.

After the game, Charles W. Foley, a wealthy businessman from Montclair (46 Union Street), presented a large, attractive loving cup to the team to commemorate their record-breaking feats. Foley was a highly motivated/enthusiastic sports fan who had been taking a special interest in the popular Wonder Team. Much more will be learned about Foley later.

The atmosphere created by the Wonder Team transformed Passaic into a sportsman's utopia. Those living in the surrounding towns as well shared the pride of the Passaic fans; Passaic County was Wonder Team territory. Joe Cummiskey, the St. Mary's guard, was impressed with Passaic. Years later he would return to write sports for the *Herald-News* and broadcast sports over its WPAT radio station.

On the following Wednesday, after playing in the most highly publicized scholastic game in the history of the sport, the Wonders were scheduled to play again. Their opponent from Naugatuck in Connecticut was not your ordinary high school outfit. The "Greyhounds" were not only the

defending state champions, they were also the last to defeat the famed Crosby team. The visitors were an impressive looking group with a 7-0 record. Their coach, P.J. Foley, had scouted the St. Mary's game, and he was convinced that his "men" could stop Passaic.

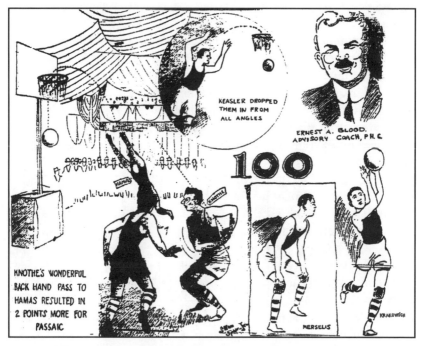

KEASLER DROPPED THEM IN FROM ALL ANGLES

ERNEST A. BLOOD. ADVISORY COACH, P.H.C.

KNOTHE'S WONDERFUL BACK HAND PASS TO HAMAS RESULTED IN 2 POINTS MORE FOR PASSAIC

MERSELIS

KRAKOVITCH

NEWSPAPER CARTOONISTS CAPTURED THE 100TH WIN FOR THE AGES

GAME #101 Naugatuck (Wednesday, January 31, 1923) at Passaic HS. For a few reasons, this game was different from the start. First, the evening was begun with one minute of silence in memory of Simon "Si" Roosma, father of former star Johnny Roosma, who had died two days before from an injury sustained in a car/train accident. During the tribute, Prof wept. Second, the Naugatuck players appeared much older than the boys in Red and Blue, which is saying a lot because Passaic players were fine looking physical specimens. Third, unlike any other previous opponent, Naugatuck attacked. They were not interested in keeping the score respectable; they were seriously expecting an impressive victory at the expense of the Wonder Team. Fourth, the Wonders were without their starting center, 6'4" Fred Merselis, who had suddenly come down with a severe case of the grip and was bedridden. Fifth, the visitors brought 250 fans who were every bit as confident as their team but much noisier. The visitors were certain that they would come away with a victory because they believed they had the invincible team, not Passaic.

The Greyhounds set an aggressive pace from the outset and caught the Wonders off guard. With muscle and sheer athletic acumen, Naugatuck took the action right to the boys in Red and Blue. Passaic's 19-14 lead at half time vouched for the dogfight that was in progress. It was as if someone were asking, who are these guys? The "Nauguys" were all about six feet tall and very solid physically. Their star forward, Bill Harvey, was a three-time All-New England player whose reputation had not been exaggerated. Harvey's teammate Linskey was reputed to be over twenty-one years old but appeared even older because he was balding.

At the half, Prof moved Hamas from the center position to his more familiar forward slot and inserted the inexperienced John Vander Heide. When Hamas was returned to his old position, the speedy pass work quickly appeared. A rally ensued because Vander Heide was able to control the tap over Bloomquist, Naugatuck's center, which put Passaic immediately on the offensive. The normally reserved Prof was seen cheering and slapping Coach Amasa Marks on the back. After the game, the Naugatuck followers (including their Mayor Harris Whitemore) were obviously let down; they had just witnessed something that they had thought couldn't happen.

The challengers did not appreciate the pregame rumor that the Passaic center was sick and unable to play. They felt that it was not good sportsmanship to make up a story just to help throw off their game and gain an advantage. The Naugatuck delegation was slightly vexed when they learned that neither of the two boys who played center (Hamas and Vander Heide) was Passaic's regular starting center. They were left with little to say when they learned that there was a 6'4" center who was not at the game, and they lost nonetheless. Final score: **Passaic 44-Naugatuck 26.**

Just before the Naugatuck game, it was learned that Father Booth from St. Mary's had offered Passaic 600 dollars for a return game (it was never played) in the Ogdensburg Armory. As an extra inducement, Father Booth asked Prof to bring Harry Wallum along to officiate. If Wallum was not available, then Prof could name any other referee of his choice. The trust

PASSAIC				NAUGATUCK			
	G	F	T		G	F	T
Keasler	6	0	12	Harvey	6	0	12
Pashman	0	0	0	Andrew	2	0	4
Hamas	6	8	20	Lockwood	0	0	0
VanderHeide	0	0	0	Bloomquist	1	0	2
Pomorski	1	0	2	Shea	0	0	0
Knothe	2	0	4	Chevalier	0	0	0
Krakovitch	3	0	6	Linskey	2	0	4
Totals	**18**	**8**	**44**	R.Foley	1	2	4
				Totals	**12**	**2**	**26**

Score by quarters: 10 minutes.

Passaic	12	7	18	7
Naugatuck	4	10	6	6

Fouls scored: Mike Hamas—8 for 11; Bill Harvey—0 for 7; Roy Foley—2 for 4. Referee—Wallum. Scorer—Saunders.

these two sportsmen shared with one another was what Prof believed should be evident in all sporting endeavors.

GAME #102 Cliffside Park (Friday, February 2, 1923) at Cliffside Park. Returning to league play, Prof was not only without Merselis (still sick), but now Krakovitch (academics) was also missing. The young guard's absence did not help the flow and rhythm of the Passaic game. Prof further disrupted cohesiveness by inserting Eddie Sockatis, a new freshman who had just returned to school. The low hanging beams over the Cliffside court also contributed to Passaic's difficulties. All these factors helped produce a very subpar first-half performance. After receiving Prof's instructions during the intermission, Knothe rallied his teammates to a respectable second half.

To the delight of the Hudson County fans who wanted Passaic to lose, the twelve-point Passaic lead at half time was a source of joy and provided sufficient reason to shoot their mouths off. Even Skeets Wright, who was in attendance, smiled during Passaic's first half misfortunes. Final score: **Passaic 69-Cliffside Park 27.**

A sportswriter from

PASSAIC				CLIFFSIDE PARK			
	G	F	T		G	F	T
M.Hamas	14	9	37	Ressler	4	0	8
Pashman	0	0	0	N.Borrelli	3	3	9
Rohrbach	0	0	0	Mundi	0	0	0
Keasler	6	0	12	F.Borrelli	1	0	2
VanderHeide	1	0	2	Whelan	1	0	2
Knothe	3	0	6	Becker	3	0	6
Sockatis	0	0	0	Ertz	0	0	0
S.Hamas	0	0	0	**Totals**	**12**	**3**	**27**
Blitzer	3	0	6				
Pomorski	3	0	6	Score by halves:			
Totals	**30**	**9**	**69**	**Passaic** 27 42			
				Cliffside 15 12			

Fouls scored: Hamas—9 for 9; Borrelli—3 for 3. Referee—Moore, Horace Mann. Scorers—Saunders, Scars. Timers—Martins, Drew.

the *Bergen Evening Record* reminded his readers that last season Prof had extended an offer to play Hoboken and Union Hill in Passaic. At the time, Prof stated that if Passaic didn't defeat them by at least twenty-five points, he would agree to play them on their courts with any referee of their choice. His offer was flatly rejected. Now with all the talk of the Hudson County schools unable to schedule a game with Passaic (with their home and away stipulation), the same sportswriter reminded his readers of their reluctance to play the previous season.

Because of Hoboken's coaches' (Dave Walsh and Frank Corrigan) refusal to take Prof up on last season's offer, Prof was asked again if he would extend the offer? The Wonder Team coach repeated his offer to the Hoboken coaches by saying, "I told them that if Passaic didn't beat them by twenty-five points on our court, they could have a return game at Hoboken." After a moment of silence, Prof reiterated, "And what's more, the offer still stands." As another inducement, Prof added that Wallum

need not be the referee, but others such as Charley Schneider or Tewhill from Horace Mann would suffice.[131] While the same offer was extended to Union Hill, no game ever came from the offer, but this never stopped Jim Egan of the *Hudson Observer* from his disparaging write-ups.

GAME #103 Clifton (Wednesday, February 7, 1923) at Passaic HS. The first basketball game ever played with neighboring Clifton was closely contested at least for a quarter. Coach Harry Collester's visitors were led by Ray Bednarcik, a short, stocky athletic dynamo, and high-scoring Joe Tarris who gave the flat champions all they could handle. Bednarcik was a one-man gridiron wrecking crew, but as many other football standouts, he had trouble shooting the ball. Final score: **Passaic 67-Clifton 29.**

With all eyes on Passaic, newspapermen and other basketball coaches were anxious to see them play. Their only problem was getting into the gym. Because seats were at a premium and with hundreds of fans turned away from every game, the doormen (custodians) became the final authorities over who would see the game. After traveling many miles to Passaic, newsmen would become

PASSAIC	G	F	T	CLIFTON	G	F	T
Hamas	8	11	27	Bednarcik	1	0	2
Keasler	11	0	22	Tarris	3	9	15
Merselis	3	0	6	Reasor	5	0	10
VanderHeide	0	0	0	DeMattia	0	0	0
Knothe	6	0	12	Argauer	0	0	0
Krakovitch	0	0	0	Chimenti	1	0	2
Blitzer	0	0	0	Karp	0	0	0
Sockatis	0	0	0	**Totals**	**10**	**9**	**29**
Pomorski	0	0	0				
Totals	**28**	**11**	**67**				

Score by periods: (10 minute quarters)

Passaic	9	22	25	11
Clifton	5	5	9	10

Fouls scored: Hamas—11 for 16; Tarris—9 for 17. Referee—Harry Wallum. Scorers—Saunders and Wellenkamp. Timers—Shershin and Drew.

disgruntled at getting turned away or given the third degree. This was a problem Prof had no control over because the Athletic Council controlled that end of the business. In spite of creating hard feelings with the sports reporters, the publicity they created with their write-ups was unprecedented in high school annuals.

GAME #104 Hackensack (Saturday, February 12, 1923) at Hackensack Armory. Over one thousand spectators, mostly Hackensack people, jammed their armory to see Passaic play. They marveled and cheered the Wonders as they worked their system of precision pass work. In one sequence, the Passaic offense scored from the center jump with their patented, tap, pass, and score variety, and immediately followed it with Knothe sinking a shot from three-quarter court. The game was a mismatch that everyone, with the exception of the Hackensack team,

appreciated. The bad news was Knothe injuring his ankle in the second half. Final score: **Passaic 70-Hackensack 28.**

GAME #105

Rutherford (Monday, February 12, 1923) at Passaic-Lincoln's Birthday. Over an hour and a half before tap-off, a capacity crowd was on hand. The friendly rivalry between the two schools was never more evident than during the clash of cheering sections led by Passaic's Melosh "Mike" Kiddon and Rutherford's "Peanuts" Ogilvie. For the past few years, Rutherford had experienced a great deal of athletic success and, in the process, created a large, vocal cheering section. Led by legendary coach Jack Wallace, they had the best football team in the state, and like the Wonder Teams in basketball, they had put together a string of undefeated seasons. The two cheerleading gurus (Kiddon and Ogilvie) were both products of this athletic frenzy.

Coach Voile Dupes's team was led by his four-sport standout Gene "Gook" Hellwig plus a good supporting cast who

PASSAIC	G	F	T	HACKENSACK	G	F	T
M.Hamas	11	2	24	Mercier	4	0	8
Keasler	12	0	24	Sullivan	1	7	9
Merselis	2	0	4	Bollerman	4	0	8
Pashman	0	0	0	McGowan	0	0	0
Herman	0	0	0	Zabriskie	1	1	3
Knothe	6	0	12	O'Shea	0	0	0
Blitzer	1	0	2	**Totals**	**10**	**8**	**28**
Krakovitch	2	0	4				
VanderHeide	0	0	0	10 minute quarters			
Totals	**34**	**2**	**70**	Score at half: 41-18			

Referee—Harry Wallum. Scorer—Kaplan, PHS. Timers—Royal Drew, PHS; Smith, HHS.

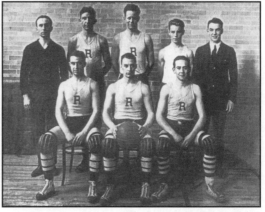

1923 RUTHERFORD HIGH SQUAD

PASSAIC	G	F	T	RUTHERFORD	G	F	T
Hamas	7	6	20	Williamson	1	0	2
Keasler	7	0	14	Bose	1	0	2
Merselis	5	0	10	Black	2	0	4
Knothe	2	0	4	Vultee	1	0	2
Krakovitch	1	0	2	Hellwig	0	4	4
Pashman	1	0	2	Atkinson	0	0	0
Blitzer	0	0	0	**Totals**	**5**	**6**	**16**
Herman	0	0	0				
Totals	**23**	**6**	**52**				

Score by periods: (10 min. quarters)

Passaic	16	8	11	17
Rutherford	1	6	5	4

Fouls scores: Hamas—6 for 8; Williamson—2 for 8; Hellwig—4 for 7. Referee—Wallum. Scorers—Saunders, Johnson. Timer—Lee.

were ready to test the best team they would ever play. Using the five-man zone defense designed to keep the score down, the visitors quickly found themselves down 16-1. Knothe's bad ankle limited him; however, he was enough to control the game. Final score: **Passaic 52-Rutherford 16.**

GAME #106
Englewood (Wednesday, February 14, 1923) at Passaic HS. With Keasler serving as captain in place of the injured Knothe, Passaic rolled over Coach Herbert Spencer's boys. In a display of speed, passing, teamwork, and shooting, Passaic ran up a new league record for points. At half time with the score 71-10, Mike Hamas was well on his way to a new school record of 29 field goals. His record-setting performance was made possible by Fred Merselis's ability to control the tap. When Merselis tapped in the century point, hat, coats, and scarves went flying into the air. Final score: Passaic 133-Englewood 18.

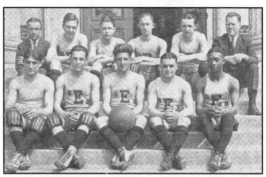

ENGLEWOOD HIGH SCHOOL TEAM
photo courtesy of Englewood Public Library

PASSAIC			ENGLEWOOD			
G	F	T		G	F	T
M.Hamas 29	5	63	Brarman 3	0	6	
Keasler 11	0	22	Cobbs 0	5	5	
Merselis 9	0	18	Cark 0	0	0	
S.Hamas 0	0	0	Bertels 0	0	0	
Blitzer 1	0	2	Pittman 0	3	3	
Pashman 2	0	4	Whelan 2	0	4	
Krakovitch 6	0	12	**Totals 5**	**8**	**18**	
Pomorski 3	0	6				
Freeswick 0	0	0	Referee—Harry			
Gee 0	0	0	Wallum. Scorers—			
VanderHeide 0	0	0	Saunders, Doyle.			
Herman 3	0	6	Timer—Royal Drew			
Totals 64	**5**	**133**				

GAME #107
Plattsburgh, New York, (Friday, February 16, 1923) at Passaic HS. The pregame hype surrounding the visitors focused on their chronological ages. Prior to the game, Plattsburgh Superintendent Elmendorf had assured Prof that only

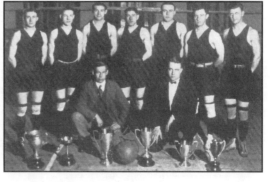

PLATTSBURGH HIGH SCHOOL TEAM

eligible players would accompany the team to Passaic. Plattsburgh's Advisory Coach C. J. Kilbourne and Coach Charles Goodwin (a former Yale captain) arrived with a husky, physically mature group of players and appealed to Prof to let his over-aged (ineligible) players participate.

Francis Haron had attended Plattsburgh Normal School and decided to return to high school. Captain Clifford Good was a PG participating for his fifth season, and M. Osttrander, by his father's admission, had celebrated his twenty-first birthday some time before. Without the players in question, it wouldn't have been much of a game, so Prof decided to let everyone play. To Plattsburg's surprise, the Passaic fans cheered Prof's verdict, and to their further surprise, the Passaic followers continued to applaud their efforts throughout the game.

With Knothe back in action, Passaic bewildered the visitors with a style of basketball they had never seen before. Just when the upstaters' paralysis was to become permanent, Knothe re-injured his ankle and left the game. Sensing an opportunity for resurgence, Plattsburgh continued

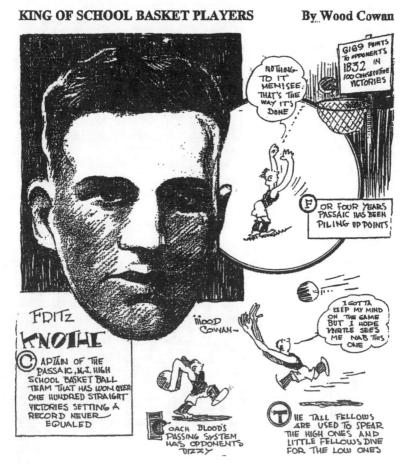

KING OF SCHOOL BASKET PLAYERS By Wood Cowan

their rough style of play and held the leaderless Red and Blue boys scoreless from the field in the second quarter. Plattsburgh's good fortunes did not last, however, because late in the third quarter, Knothe returned to lead another surge. W. Sweeney, the Plattsburgh starting guard, admitted that Passaic had a great team with "mighty clean players." Final score: **Passaic 61-Plattsburgh 17.**

GAME #108
Montclair (Saturday, February 17, 1923) at Passaic HS. Playing for the fifth time in eight days and again without the help of Knothe but with the aid of an ill Keasler, a lesser Wonder Team hosted Montclair. What this year's edition of Coach John Nelson's team lacked in skills, they made up for in spunk.

Too often during the afternoon game, Passaic strayed from their famed passing system and looked anything but a Wonder Team. The over use of the dribble and poor shot selection were the problem. Was it overconfidence or the

PASSAIC	G	F	T	PLATTSBURGH	G	F	T
Hamas	7	19	33	Ostrander	3	0	6
Keasler	7	0	14	Clark	3	0	6
Merselis	5	0	10	F. Haron	0	0	0
Knothe	1	0	2	Good	1	3	5
Krakovitch	1	0	2	Mehan	0	0	0
Herman	0	0	0	Sweeney	0	0	0
Brown	0	0	0	Brown	0	0	0
Blitzer	0	0	0	W.Haron	0	0	0
Totals	**21**	**19**	**61**	**Totals**	**7**	**3**	**17**

Score by periods: (10 minute quarters)

Passaic	20	6	11	24
Plattsburgh	3	6	6	2

Fouls scored: Hamas—19 for 24; Ostrander—0 for 2; Good—3 for 7. Referee—Harry Wallum. Scorer—Harold W. Saunders. Timer—Clark Emery.

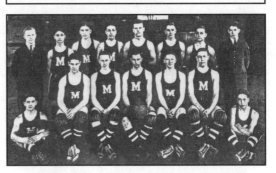

1923 MONTCLAIR HIGH TEAM

PASSAIC	G	F	T	MONTCLAIR	G	F	T
M.Hamas	9	6	24	Durning	0	0	0
Keasler	11	0	22	Mylod	3	0	6
Merselis	1	0	2	Carlson	2	0	4
Freeswick	1	0	2	Kaveny	2	9	13
Krakovitch	2	0	4	Maher	0	0	0
Pashman	3	0	6	Russell	4	0	8
Blitzer	1	0	2	**Totals**	**11**	**9**	**31**
Herman	1	0	2	Score by periods:			
VanderHeide	1	0	2	**Passaic**	23 19 14 12		
Pomorski	1	0	2	**Mont.**	9 2 9 11		
S.Hamas	0	0	0				
Totals	**31**	**6**	**68**				

Foul scores: Hamas—6 for 10; Kaveny—9 for 17. Referee—Harry Wallum. Scorer—Harold W. Saunders.

absence of Knothe and an ailing Keasler that caused the chaos? Sportswriter Fred Bendel from the *Newark Ledger* warned that the greatest danger that Passaic faced was not from the competition but from overconfidence and listening to adulation. Final score: **Passaic 68-Montclair 31.**

GAME #109 Greenwich, Connecticut, (Monday, February 19, 1923) at Passaic HS. Gerald Morgan, coach of the Greenwich team, was once responsible for knocking out a couple of Prof's front teeth. The incident occurred during a scrimmage when Prof coached Morgan back in Potsdam. Morgan later captained the football and basketball teams at St. Lawrence University. Before the start of the game, Prof announced to the packed gym that Morgan was a former player of his and that they were going to see Greenwich using the Passaic offense. The Greenwich boys were sporting an impressive 24-2 record.

Playing without DeWitt Keasler (bronchitis), the home team's quickness, shooting, and poise proved to be too much for the Connecticut boys. The only thing hotter than the boys in Red and Blue was the fire at the Davis & Catterall Handkerchief Mill a short distance away at 168 Seventh Street. The visitors were good sports as they received a first-class lesson on how to run their offense. When Holmes and Boles fouled out, Prof instructed official scorer Harold Saunders to allow them to continue playing.

PASSAIC	G	F	T	GREENWICH	G	F	T
Hamas	10	15	35	Clifford	4	0	8
Pashman	5	0	10	Wilson	4	3	11
Merselis	3	0	6	Reynolds	0	0	0
Pomorski	0	0	0	Raymond	0	0	0
VanderHeide	1	0	2	Boles	1	0	2
Knothe	4	0	8	Galvin	0	0	0
Krakovitch	5	0	10	Holmes	3	0	6
Herman	0	0	0	**Totals**	**12**	**3**	**27**
Blitzer	0	0	0				
Totals	**28**	**5**	**71**				

Score by period: **Passaic** 29 42 56 71
Greenwich 8 16 22 27

Time of periods: 10 minutes. Scorers—H. W. Saunders, Passaic; Webster, Greenwich. Timers—Royal Drew, Passaic; Peck, Greenwich. Fouls: Hamas—15 for 20; Wilson—3 for 7. Referee—Harry Wallum, Union Hill.

Final score: **Passaic 71-Greenwich 27.**

Secretary Short's pairings for the state play-offs had Passaic matched with recent rival Montclair. But the more interesting news was that Northern New Jersey was to be divided into three divisions: Hoboken, Newark, and Elizabeth. The shifting of the Wonder Team to the Newark Division was not good news for the Newark teams. More than politics was involved in redirecting Passaic out of Hoboken. A rough crowd that followed the Hoboken team had been primed by Jim Egan's columns in the *Hudson Observer.* This undesirable element had become increasingly more hostile towards Passaic. It was still fresh in the minds of many (especially Prof's)

of the attacks on Passaic fans during the previous season by malicious Hoboken fans after play-off games in Hudson County. Even Short, who had been threatened, feared for his safety after these same games.

Hudson County teams were delighted to learn that Passaic was moved to Newark. Not so happy was Orange's coach Carl Seibert who had high hopes of getting his team to Princeton for the state semifinals. Complaining vigorously, Seibert said, "I don't think it is square to switch Passaic into our division. Well, why didn't you put either Union Hill or Hoboken in our division? Why did it have to be Passaic?" Skeets Wright suggested that Passaic be kept completely out of the tournament until the finals, but this was quickly shot down by Short.[132] While it was a reprieve for the Hudson County schools, it was viewed as the kiss of death for the schools in Newark. No one wanted to play Passaic, at least not until the finals.

GAME #110 Rutherford (Thursday, February 22, 1923) at Rutherford HS. The new Rutherford gym was a little bandbox. The baskets were hung on the walls allowing the ball to bounce off the walls and still be in play. The present Wonder Team was not used to this variation of play. Having the walls at the ends of the court could make the game more a test of strength than a game of skill, which was the way football coach Jack Wallace's boys preferred to play. The metal basketball rims had a peculiar spring to them. If the ball did not go in cleanly, it was unlikely that it would go in at all.

On Washington's birthday and with Keasler still out with bronchitis, the Wonders ventured into a Rutherford snare. The poor acoustics in the little basketball room with over 650 noisy fans made communication impossible. The athletic Rutherford boys were pumped up and willing to take advantage of any edge they could get. These Rutherford athletes had been making it a habit of beating their neighbors in the annual Thanksgiving Day football game, but today was going to be their most coveted victory of them all.

Thanks to Russell "Beef" Williamson's scoring heroics, Rutherford held the lead for most of the first quarter. If it weren't for Hamas's two free throws in the final seconds, the score would have been tied; instead, Passaic had to be pleased with a 10-8 lead. It was going to be a long time before Rutherford would forget that famous first quarter; oh, how they celebrated. With hardly any space to pass the ball against Rutherford's zone defense, Passaic's situation did not improve.

In the third quarter, Knothe took over the game. Usually he was content to control a game with his defense and passing, but the way this game was going, Fritz sensed something extra was needed. Three times in succession, he let it fly from beyond the mid-court mark—all net. For Knothe, losing was not an option. The Passaic captain rallied his troops and squashed his host's dream of an upset. The Wonder Team's two

time, first-team all-state guard continued to connect from the mid-court area and added one quick drive to the basket that finished with a natural looking left handed lay-up. Final score: **Passaic 51-Rutherford 25.**

PASSAIC			RUTHERFORD				
	G	F	T	G	F	T	
Hamas	8	9	25	Williamson 4	11	19	
Herman	1	0	2	Bose	0	0	0
Merselis 4	0	8	Black	2	0	4	
Knothe	7	0	14	Vultee	0	0	0
Krakovitch 1	0	2	Hellwig	1	0	2	
Pashman 0	0	0	Atkinson 0	0	0		
Totals	**21**	**9**	**51**	**Totals 7**	**11**	**25**	

Score at end of quarters: (10 minutes)
Passaic 10 23 39 51
Rutherford 8 15 23 25

Referee—Harry Wallum. Scorers—Harold Saunders, PHS and Arch Whitehouse, Rutherford. Timers—Royal Drew and Lee, Rutherford.

BUFFALO GERMANS

After the one hundredth victory against St. Mary's Academy, the fans and media next set their sights on the world record for consecutive wins set by the Buffalo Germans of professional basketball fame. In the thirty-four years that the Buffalo Germans toured the country, they accumulated a record of 761-85. During the period 1908 to 1911, they amassed a victory streak of 111 games, and Passaic was going to tie this record if they defeated Paterson.

If you are not familiar with basketball's first famous professional touring team, a brief background may help. In 1904, F.W. Burkhardt, the Physical Director of the German YMCA on Genesee Street in Buffalo, organized a junior team to represent his Y. Burkhardt was one of James A. Naismith's students who played in the first basketball game at the International YMCA Training School. His junior team members were all friends (Allie Heerdt, Al Haase, Ed Miller, Art Reimann, Jay Bayliss and John Dueer) and good athletes.

Through team cohesion and dedication, the German YMCA's junior team experienced one success after another. They first received national recognition in 1901, when they won the Pan-American Exhibition Tournament against some of the country's top teams. Three years later, they won the championship again at the World's Fair in St. Louis. After winning the World's Championship for the second time, the Buffalo Germans turned professional and went on tour.[133]

Three of the 111 victories came at the expense of Prof's Potsdam Normal team. Prof scheduled the Buffalo Germans because he was an advocate of their style of play that emphasized the pass. He was also a

friend of the team's Captain Allie Heerdt, but unlike some reports, Prof was never a member of their team.

Remembered as basketball's first world champions, the Buffalo Germans were inducted into Naismith's Basketball Hall of Fame in 1961. The other teams currently honored in the hall are Naismith's first YMCA basketball team, the original Celtics, Harlem Renaissance, Passaic High School Wonder Teams, and the Harlem Globetrotters.

GAME #111 Paterson (Saturday, February 24, 1923) at Paterson Armory. In their biggest game, the Silk City boys rose to the occasion and played their most inspired ball. On the other hand, a flat Passaic team was having the off day of the year. DeWitt Keasler, who was still recovering from his illness and should have sat out, didn't reach the rim with his first few shots. After taking a dozen shots without making one, Prof replaced him with Milton Pashman.

After playing even for a quarter, the Wonder Team started firing away, but little was hitting the mark. Nevertheless, the Paterson people were delighted to rehash the eighteen-point nail bitter. To lose by such a small margin was a moral victory, and it was reason to celebrate. The shooting statistics revealed another picture of the game. Passaic shot 20 for 78, while Paterson was 12 for 40. Final score: **Passaic 46-Paterson 28.**

PASSAIC	G	F	T	PATERSON	G	F	T
Hamas	9	6	24	Barker	1	4	6
Keasler	0	0	0	Singer	3	0	6
Pashman	1	0	2	WSinnegan	4	0	8
Merselis	3	0	6	H.Sinnegan	2	0	4
Knothe	4	0	8	Newton	2	0	4
Krakovitch	2	0	4	Marinowski	0	0	0
Blitzer	0	0	0	**Totals**	**12**	**4**	**28**
Herman	1	0	2				
Totals	**20**	**6**	**46**				

Score at the end of quarters (10 minutes each):
Passaic 10 26 31 46
Paterson 10 13 20 28

Scorers—H. W. Saunders, Passaic; Byrne, Paterson. Timers—Joe Whalley, Passaic; Cappio, Paterson. Referee—Harry Wallum, Union Hill.

By defeating Paterson, the Wonders tied the twelve-year-old record of the Buffaloes. The Germans lost their 112th game (16-17) to Frank J. Basloe's team from Herkimer, NY. Because they had no regular home court, only twenty-three of the German's 111 wins were played in Buffalo. In compiling their streak, the Wonders scored three times as many points as the Germans scored during their run of victories.[134]

Some confusion arose concerning the Buffalo's actual record. The Associated Press reported that the record was 111, but Prof had his reason for believing the record was 110. When asked about the AP's article, Prof declared that he had positive knowledge the record was 110. As he recalled, it was while he coached the Potsdam Normal team that the Herkimer team called him requesting a game. For a sixty-dollar guarantee,

he booked the Herkimers. Two weeks later, Prof received a call from Frank J. Basloe informing him that they would no longer come for sixty dollars. When Prof inquired why, Basloe said his team had just defeated the Buffalo Germans and stopped their streak at 110 games.[135] Basloe's justification was that because they were the champions of the world, they wanted a $200 guarantee.[136]

GAME #112 Ridgewood (Monday, February 26, 1923) at Passaic HS. The epoch-making game lacked the glamour of an historical event. Playing their eighth game in sixteen days and having no difficulty defeating Ridgewood a month earlier, Passaic's competitive juices were not flowing. At the final whistle, seventeen Passaic boys were able to say they played in the game that broke the world's record.

The Wonders had been showing signs that something was amiss. It didn't take a basketball genius to notice the team's inconsistency and lack of enthusiasm. Was the publicity that was putting Passaic on the map and making the Woolen City famous also going to the boys' heads? The adulation was taking its toll. Final score: **Passaic 62-Ridgewood 11.**

The news of the day was Newark Central's win over Asbury Park (39-30). Previously, Central had knocked off St. Benedict's Prep (31-29) labeling them a legitimate threat to Passaic. The

PASSAIC				RIDGEWOOD			
	G	F	T		G	F	T
M.Hamas	7	5	19	Pinckney	0	2	2
Hamas	2	0	4	Marx	1	1	3
Freeswick	0	0	0	Carr	1	0	2
Pashman	2	7	11	Sheffield	2	0	4
Gee	0	0	0	Kay	0	0	0
Keasler	5	0	10	Carson	0	0	0
Hanson	0	0	0	Jenkins	0	0	0
Rohrbach	0	0	0	Terhune	0	0	0
Pomorski	0	0	0	**Totals**	**4**	**3**	**11**
Merselis	2	0	4				
VanderHeide	1	0	2	Score by quarters:			
Lucasko	1	0	2	**Passaic** 17 32 52 62			
Knothe	2	0	4	**Ridgewood** 5 6 10 11			
Blitzer	1	0	2				
Herman	1	0	2				
Margetts	0	0	0				
Krakovitch	1	0	2				
Totals	**25**	**12**	**62**				

Timers—Royal Drew, Passaic; McGowan, Ridgewood. Scorers—H. W. Saunders, Passaic; Morrison, Ridgewood. Referee—Tewhill, Horace Mann High School.

NJSIAA play-off system matched Harry "Doc" Sargent's team from Central with Carl Seibert's 15-0 Golden Tornadoes from Orange. One of these two fine teams was going to end its season early.

On the day of the Clifton game, the news that rattled Passaic was about Knothe's shoulder injury. Sometime after the previous day's photo session by the *New York Evening Telegram* that interrupted practice, Fritz noticed a sharp pain in his right shoulder. After throwing a ball, he felt something snap in his shoulder. Examined later by Fritz's family physician,

Joseph F. A. Rubacky, his shoulder was X-rayed and immobilized. The newspaper's report of Rubacky's diagnosis was vague but referred to the injury as an "acromion process strain, or a strain to the uppermost portion of the shoulder socket."[137]

When it rains, it pours. A couple hours before setting out to play Coach Harry Collester's resurgent Clifton team, the fortunes of the Wonder Team were about to receive another blow. Starting forward Keasler was experiencing a relapse of bronchitis, and he had been ordered back to bed. Like Knothe, when DeWitt would be back in action was unknown.

GAME #113 Clifton (Wednesday, February 28, 1923) at Paterson Armory. The Clifton boys were preparing for the biggest basketball game of their lives. Forty minutes before tap-off, they were on the armory court warming up before an unusually small, but predominately Clifton crowd.

At the other end, Passaic was running late. To make matters worse, there was an out-of-town photographer in the dressing room taking pictures of the world record holders. After hair combing and posing, the famous Wonder Team trotted on to the court. Clifton did not appear to be a threat. The only real question was how many points would they lose by?

Playing without Keasler and Knothe, the young Wonders earned

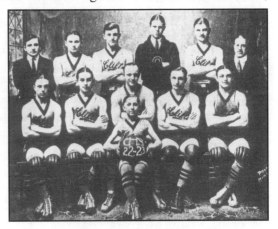

CLIFTON HIGH SCHOOL TEAM
photo courtesy of Clifton High Yearbook, The Reflector

a 9-3 first quarter lead. The usual Passaic ho-hum script continued for another seven minutes into the second stanza as they pushed their lead to 21-3. Early in the second quarter, Krakovitch called time out after injuring his side. To keep Moyer in the game, Prof moved him to the standing guard position away from the action. During the time out, Prof made some substitutions.

Clifton's captain Ray Bednarcik had had enough; if he was to preserve any self-respect before his home crowd, it was time for his team to make its move. In the last three minutes of the half, Bednarcik, Joe Tarris, and their big center DeMattia scored a few baskets and caught Passaic completely flatfooted. The energetic Bednarcik inspired his assault troops, Emil Bondinell, Murray Karp, and Art Argauer, to a higher level. This sudden surge by the Clifton boys electrified the crowd and caused Passaic to unravel.

In the third quarter, it was all Clifton. The maroon and gray uniformed boys ran through the depleted and rattled Wonder Team. Clifton began making shots that they had never made before; everything they threw up went in. In what seemed like the blink of an eye, the score was 22-22, and it was to be nip and tuck the rest of the way. At the close of the penultimate quarter, the Passaic boys were sitting on a gaunt two-point lead (28-26) and receiving their first real test of character.

With Clifton baskets coming in rapid succession, the score evened out at 30-30. While the Clifton fans were hysterical, the few Passaic faithful were embarking on the secondary stages of shock. The crowd was in such a frenzy that the game had to be stopped for the police to keep the fans off the court. While hysteria reigned, the most composed person in the drill shed was Prof. He was sitting ramrod straight leaning a bit forward, and the only visible signs of emotion were his hands as he frequently ran them through his wavy hair.

During his many years in basketball, Prof had seen games like this before; it was possible for a sure win to turn into a horror show. He could see his boys entering into the early stages of rigor mortis. During the reversal of fortune, Prof's air of confidence and calmness may have been a facade, but his boys couldn't tell. He spoke to them in a soothing tone and explained what they needed to do. Because of Bednarcik, Clifton had them on the run, and the Grey Thatched Wizard could see the lack of confidence in their eyes. Frightened stiff, they attentively listened to Prof. His solutions to their uncertainties were coupled with a reassuring smile as he sent them back on to the court.

As crunch time continued, it was Moyer Krakovitch, Harry "Truck" Herman, and Mike Hamas who kept their wits and didn't crack under the strain. As time ticked down to the one-minute mark, Clifton took a one-point lead (33-34). This was the first time since the ill-remembered Union Hill game of 1919 that Passaic was behind with less than a minute to play. In the final seconds, Mike Hamas emerged as hero and game saver by burying a field goal and immediately following it

PASSAIC	G	F	T	CLIFTON	G	F	T
Hamas	3	14	20	Bednarcik	6	0	12
Pashman	0	0	0	Tarris	3	8	14
Hanson	1	0	2	Reasor	0	0	0
Merselis	0	0	0	DeMattia	3	0	6
VanderHeide	1	0	2	Karp	0	0	0
Krakovitch	5	0	10	Chimenti	1	0	2
Herman	1	0	2	Argauer	0	0	0
Totals	**11**	**14**	**36**	**Totals**	**13**	**8**	**34**

Score at the end of each period:
Passaic 9 21 28 36
Clifton 3 14 26 34

Played in 10 minute quarters. Timers—Hoyt, Passaic; Schroeder, Clifton. Scorers—Saunders, Passaic; Wellenkamp, Clifton. Umpire—Tewhill, Horace Mann High School. Referee—Harry Wallum, Union Hill.

up with a foul shot seconds before time expired. Final score: **Passaic 36-Clifton 34.**

It was an emotionally gut-wrenching game in which the anxiety ran the spectrum. This was the scene that Fritz Knothe walked into with his arm in a sling as he entered the armory. Against instructions, he and a few friends made the belated trip to Paterson expecting to learn of a typical Wonder Team victory. Knothe was shocked, as was everyone, when the news of the game spread. The commotion generated by the unfathomable thought of a near upset had the Paterson newspaper erroneously reporting the game as a three point Passaic victory (37-34).

Clifton followers rationalized that they could have, would have and should have won. Pandemonium reigned during the final minutes. Some Clifton fans believed that the big fish got away because the Passaic timekeeper doomed them by holding up the clock. It may sound comforting for Clifton people to hear, "Our boys should have won that game," but to believe they were cheated was not true. It wasn't true for two reasons. First, it was a home game for Clifton, and they supplied the official timer. Second, Prof would not have accepted a victory had it been obtained by cheating.

In the case of the referee, Wallum was contracted by the Clifton authorities because of his reputation, knowledge, and ability to control a game. Even in defeat, the Clifton people lauded the veteran referee's fairness. He upheld his propensity of favoring Passaic's opponent by never calling Bednarcik for walking every time he started his dribble. Wallum was consistent; he allowed Bednarcik a couple of steps in the first quarter, and he never deviated. He continued to ignore the obvious walking violation throughout the entire game, and everyone knew it. Prof never said a word.

The Passaic team and community had become complacent and over-confident. Clifton was a wake up call; the Wonders could lose to an average team, and now everyone knew it, especially the Wonder Team. So proud was Clifton of their accomplishment that in remembrance, the box score of the famous effort appeared in their school yearbook, *The Reflector.*

GAME #114 Montclair (Thursday, March 1, 1923) at Shanley Gym, Newark. The next evening, Passaic traveled to St. Benedict's Prep to meet Montclair in the first game of the play-offs. This was Passaic's fifteenth game in thirty days. Prof would have liked to have had a couple of days to heal. Oddly enough, it was Arnold who, for personal reasons, wanted a couple of these games added to the schedule.

Passaic was still without their two main veterans, the injured Knothe and the bedridden Keasler, and there was no telling when either would return. Sensing the urgency of the situation, Passaic's loyal fans were

back in full force. There were enough fans milling around outside Shanley Gym to pack it five times. The security policemen had to call for reinforcements to control the crowd. Inside the gym, it was an excited, predominately Passaic gathering that cheerleader Mike Kiddon had worked into a frenzy.

Captain Knothe was sitting in the bleachers with his arm in a sling while his team prepared to jump it up with Montclair. Taking no chances with the basketball, the undirected Passaic five were content to pass it around at a safe distance from the Montclair defenders. Thanks to Mike Hamas, Passaic managed to score three points for the first quarter while shutting out Montclair.

Sensing Passaic's apprehension, Montclair decided to guard closer. Lacking a sense of purpose, a confused Passaic team began to malfunction. For those who were used to seeing the Wonder Team, what they observed was hard to fathom. The game was turning into a replay of the night before at the Paterson Armory. Losing faith, the Passaic fans sat there with their hearts in their throats. To their dismay, their Wonder Team was coming apart at the seams. With Hugh "Red" Durning supplying most of Montclair's offense, the Essex County foes had control of the game and a 12 to 8 lead as they triumphantly ran off the court at half time.

Sitting in the stands with 500 other Passaic fans, Knothe initially had been contributing his share to the roar of the cheering section. But when the momentum shifted and he saw his teammates making mistakes, running scared, and looking confused, Fritz sat motionlessly watching and grimacing with each miscue.

Moments after his team left the court, Knothe slowly stood up, stepped off the bleachers, and walked across the gym floor. Grasping for a sign of hope, the Passaic fans spotted their wounded gladiator and let out a loud cheer. Seemly unaware of his effect on the crowd, Fritz's stride steadily quickened as he approached the stairs leading down to his team's dressing room. As he disappeared through the doorway, the Passaic fans glimpsed a ray of light that Fritz's moral support might help.

As Fritz passed through the doorway, he didn't notice Frank Hill, the Rutgers College coach standing nearby. (Author's note: Coach Hill had previously held the head basketball coaching positions at St. Benedict's Prep, Seton Hall, and Rutgers simultaneously.) Reading the look in Fritz's eyes as he entered the stairwell, Hill curiously followed him into the dressing room. The first words out of the captain's mouth upon entering the locker room were, "Eddie, gimme your uniform." In the blink of an eye, Eddie Lucasko had his jersey off. Turning to Prof, the Wonder Team captain said, "I'm playing."

With a nod of approval and overlooking the fact that Knothe was under a doctor's care, Prof said, "Okay." The nature of the injury was

FRITZ KNOTHE

one with which Prof had prior experience. Many years previously, Prof twice sustained a dislocated shoulder in a basketball game while playing for the Nashua YMCA team. The joint was put back in place both times and he completed the game.[138] Last season, his son Paul had what appeared to be the same type of shoulder injury leading him to believe that Fritz could play if it were wrapped properly. With the arm strapped to his side, it was not likely that Knothe could harm it any further.

Coach Hill, who was a friend of Prof's, began preparing Knothe to play. Wraps were applied to his right shoulder and around his chest preventing the arm from moving away from the body. After securing the arm to his side, the jersey was gingerly pulled over his head. As the team was about to head back up to the court, someone noticed that the jersey was on backwards. To prevent any delay, Hill told Knothe to leave the shirt that way because it would bring good luck, and if he were to move it, Hill would knock his block off. Knothe did not care which way the jersey faced; he just wanted to get on the court. So it was with the captain back at the helm, that a rejuvenated Wonder Team charged up the stairs looking for Montclair.

The outburst from the Passaic fans when Knothe was spotted leading the team on to the court created a loud stir. The fans were not quite sure if Fritz was there to lend moral support or try to play. The doubts were soon erased as the word spread that Fritz was going to play; he was going to play! Mike Kiddon picked up on it and a chant began, KNOTHE, KNOTHE, KNOTHE! The excitement disrupted the Montclair team's warm-up. When their curiosity got the best of them, they turned to find the source of the uproar. It was as if they had spied Beowulf's Grendel; they stopped in their tracks and could only stare at their most feared nemesis. The sight of Knothe in uniform left them visibly shaken.

The response from the fans was mild in comparison to the orgy of delirium that took place when Fritz started the third quarter. Exuberant fans, overwhelmed with joy, literally hugged one another as they jumped

into the air. With everyone on his feet, the ball was tossed into the air to resume play.

Knothe's effect on his team was immediate. In spite of four-year-starter DeWitt Keasler's absence, the presence of Fritz Knothe changed the game. His young teammates, once timid and afraid to initiate action, now responded with confidence. The confidence they had been lacking was now plastered all over their faces. Passing was the next obvious sign; the hesitancy was replaced with quickness and snap. The sight of the one-armed menace harassing the offense and darting into the passing lanes was responsible for the resurgent Passaic defense. When a bullet pass from Fritz to Pashman at mid-court resulted in a shot that he would not have taken in the first half tied the game, the gym rafters rattled. When, seconds later, Knothe and Pashman connected again on the same play to go ahead 15-13, the response from the fans nearly blew the roof off. By the end of the third quarter, Passaic was back on top 18-16.

Shortly after the start of the final quarter, Knothe dribbled down the center of the court through a crowd with his left hand for a lay-up to widen the lead. Moments later, in frustration and without any provocation, Montclair's Charles Mylod deliberately crashed into Knothe in an apparent attempt to dampen his effectiveness. Mylod's action brought an immediate reaction from the spectators. To their credit, it was the Montclair fans who took the lead in showing their disapproval by hissing for several minutes.

It was the unassuming boy wonder Fritz Knothe's unquestionable leadership, self-confidence, and ability that saved the day for Passaic. Defying doctor's instructions and the risk of further injury, the captain was compelled by a sense of duty to delay the inevitable event; a loss was not going to occur during his watch. Final score: **Passaic 31-Montclair 20.**

PASSAIC				MONTCLAIR			
	G	F	T		G	F	T
Hamas	2	9	13	Durning	4	0	8
Herman	0	0	0	Mylod	1	0	2
Merselis	1	0	2	Carlson	3	0	6
Janowski	0	0	0	Kaveny	0	4	4
Krakovitch	4	0	8	Maher	0	0	0
Pashman	3	0	6	Russell	0	0	0
VanderHeide	0	0	0	Spinelli	0	0	0
Knothe	1	0	2	**Totals**	**8**	**4**	**20**
Totals	**11**	**9**	**31**				

Score at the end of periods (10 min. quarters):
Passaic 3 8 18 31
Montclair 0 12 16 20

Timer and scorer—H. W. Saunders, PHS. N.J. State Association Timer—Leroy Smith, Trenton HS. N.J. Association Scorer—E. F. Connelly, Trenton Times. Referee—H. A. Stein, Plainfield HS. Umpire—Joe Johnson, Paterson HS.

An interesting side story to the Passaic/Montclair game was the reaction of the Rutherford fans to the announcement of the Passaic score

at their game with Emerson. While at the Stevens Tech gym in Hoboken before a predominately Hudson County crowd, Rutherford had their hands more than full with the Hudson County representative. When Passaic's score was announced, the Hudson County spectators cheered the good news. In response, Rutherford cheerleader, Peanuts Ogiville, led a few cheers for Passaic. It was a remarkable demonstration of one school's support for another.

Immediately after the tough loss to Emerson, no one in Stevens gym was aware of the Passaic results, so all the Rutherford players and local fans remained on the floor until the final score was announced. An uproar from the Rutherford delegation followed the Passaic victory announcement, and a snake dance on the gym floor spontaneously ensued. With the loss of Rutherford and Clifton, the entire focus of the Passaic area was on the Wonder Team. The numbers of contenders for top honors was narrowing. As it turned out, the upset of the evening was the elimination of Central.

NORTHERN NEW JERSEY HIGH SCHOOL BASKETBALL CHAMPIONSHIP PLAY-OFFS

At Newark
Passaic 31-Montclair 20
Orange 46-Central 31
Belleville 31-Glen Ridge 29

At Elizabeth
Battin 29-Plainfield 20
New Brunswick 42-Roselle Park 40
North Plainfield 29-Madison 27

At Hoboken
Morristown 31-Clifton 27
Emerson 31-Rutherford 24
Ridgefield Park 33-Dickson 23

As was the *Passaic Daily Herald's* ilk, a comment by their Sporting Editor Wendell Merrill questioned Prof's wisdom of playing an injured player. Merrill questioned whether or not a victory was worth risking an athlete's career. His question was certainly an interesting one that may have been discussed by the school's administration. Passaic's other newspaper, the *Passaic Daily News,* looked for ways to praise Prof.

On the day of the West Orange game, the *Passaic Daily News* reported that Mayor McGuire received a communication from Murray Hulbert, acting mayor of NYC. In the letter, McGuire's assistance was requested to arrange a game at Madison Square Garden between the Blood protégés, who were being hailed by newspapers throughout the country as champions of the United States, and the champions of the Public School Athletic League of NYC. The first part of that letter follows:

City of New York *March 1, 1923*
Office of the Mayor

Hon. John H. McGuire
Office of Mayor
Passaic, New Jersey

Dear Mr. Mayor,

On behalf of the Mayor's Committee on Municipal Athletic Activities of this city, I am charged with the very pleasant duty of extending through you to the champion public high school basketball team of Passaic, a cordial invitation to participate in a game with a similar team of players in this city; the game or games if necessary, to be held in the Madison Square Garden, New York City, at a date mutually agreeable....

GAME #115 West Orange (Saturday, March 3, 1923) at Shanley Gymnasium. With one day to prepare, Prof devoted most of the time to restoring the team's confidence. He reminded them that they were an offensive team, and offensive teams attack. Practice resumed without Keasler who was still recovering from bronchitis and fever and Knothe who was with his family physician Dr. Rubacky getting fitted for a protective harness for his shoulder. The doctor revealed that the injury was not as severe as initially thought and that Fritz was cleared to play.

Interest in the team was at such a high pitch that fans were advised to arrive at Shanley Gym a couple of hours before game time to ensure admission. With 1200 fans jammed into the little building and a larger number outside, Passaic took the court to an ovation that lasted nearly five minutes. The handful of West Orange fans kept pretty tight lipped as they watched the spectacle of a Wonder Team game.

Cheerleader Mike Kiddon was euphoric. He had the crowd to him-

PASSAIC				WEST ORANGE			
	G	F	T		G	F	T
Hamas	3	6	12	Buhler	3	9	15
Pashman	1	0	2	Quallo	1	0	2
Rohrbach	0	0	0	Schroll	2	0	4
Merselis	6	0	12	Walsh	0	0	0
Knothe	2	0	4	Jennings	1	0	2
Krakovitch	2	0	4	**Totals**	**7**	**9**	**23**
Janowski	1	0	2				
Herman	0	0	0				
Totals	**15**	**6**	**36**				

10 minute quarters.
Score at the end of quarters:

Passaic	14	29	34	36
West Orange	3	8	13	23

Timer and scorer—H.W. Saunders, PHS. NJ State Association Scorer—Leroy Smith, Trenton HS. NJ State Association—Charles Schneider, Central HS. Referee—Frank Hill, Rutgers and Seton Hall. Umpire—Morris E. Midkiff, Colgate.

self; they were like putty in his palms. Spirited Mike led the fans through all the Passaic cheers in a display of school and civic pride unequaled in Passaic history. The out-of-town news media could only marvel, as did Union Hill's Skeets Wright, at the excitement generated by Passaic's fans.

Intimidated by the very atmosphere, the West Orange five were overwhelmed from the outset. At the half, it was 29-8, and conversations inevitably turned to the next game with Orange. Final score: **Passaic 36-West Orange 23.**

Some good news was about to bring Passaic's adversities to an end. The first was the postponement of the Orange game because a suitable playing site was unavailable. This gave the Wonders needed time to recuperate. Secondly, Dr. Frederick F. C. Demarest, who attended to Keasler, reported that the worst of his illness was over.

The Erie Railroad was contracted by the *Passaic Daily News* to get fans to the Orange game by making runs through Clifton, Passaic, Passaic Park, the Rutherfords, and on to Jersey City. The *Passaic Daily News* front-page headlines on March 8, read: **THE DAILY NEWS SPECIAL TRAIN WILL CARRY FANS TO PASSAIC-ORANGE GAME**.

A fund was started to pay the expenses of the high school band so it could play during the game. The match-up with the 17-0 Orange "Golden Tornadoes" was suddenly the most publicized game in Passaic history.

Local gamblers endeavored to use the Wonder Team's popularity as a ride to prosperity. It would have been difficult to find anyone without an interest or stake in the fate of the team from the high school on the hill.

The *Passaic Daily News* was planning to keep the locals informed of the play-by-play via their scoreboard and megaphone system at their plant. Unlike the last couple of years when victory was assured, the masses were not just jumping on the bandwagon; they truly believed that their support was needed for victory #116.

At the crest of the pregame excitement, the *Passaic Daily News* started the Bermuda Contest. In what amounted to a popularity contest, the newspaper was going to give the three people receiving the

BURMUDA TRIP VOTING COUPON

This coupon entitles the person whose name appears below ONE VOTE in the *Passaic Daily News* voting contest. The three persons getting the highest number of votes will be given a free trip to BERMUDA.

Name _____
 Street _____
 Ciy of Borough _____
Voter's Name_____
Organization_____
-or-
Address _____

 Write plainly and forward to BERMUDA CONTEST, EDITOR, Passaic Daily News.

most votes an all-expenses-paid vacation to Bermuda. The winners would leave New York City on April 2, aboard the *Fort Hamilton* steamer and return April 8. The surrounding area of Passaic (Garfield, Clifton, Lodi, the Rutherfords, Lyndhurst, Wallington, and Carlstadt) became enthralled with the circulation gimmick.

Northern New Jersey basketball fans closely followed the elimination process.

NORTHERN NEW JERSEY HIGH SCHOOL BASKETBALL CHAMPIONSHIP PLAY-OFFS
Emerson 32-Battin 20
Ridgefield Park 36-North Plainfield 30
New Brunswick 28-Morristown 20

OTHER SCORES IN THE NEW JERSEY STATE PLAY-OFFS
Asbury Park 55-Neptune 46
Trenton 37-Glassboro 13
Millville 27-Atlantic City 21
Pleasantville 35-Woodbury 29
Collinswood 28-Wildwood 24
Camden won forfeit from Vineland

GAME #116

Orange (Saturday, March 10, 1923) Jersey City Armory. A monster Passaic crowd engulfed Jersey City's Fourth Regiment Armory on Glenwood Avenue just off Hudson County Boulevard to see the "Battle of Jersey." Both teams were undefeated, but of particular interest was the teams' similar style of

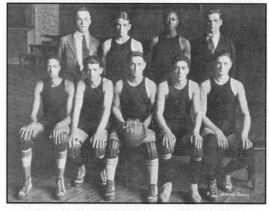

1923 ORANGE HIGH SCHOOL

play. Coach Carl Seibert taught Blood's offensive system of quick short passes. On paper, this was how the two teams matched up.

PASSAIC (25-0)				ORANGE (17-0)			
Name	Pos.	Ht.	Wt.	Name	Pos.	Ht.	Wt.
Hamas	F	6'1"	165	Art Federici	F	5'4"	160
Keasler	F	6'1"	160	Joe Federici	F	5'6"	160
Pashman	F	5'8"	135	Edd Jones	C	6'2"	165
Merselis	C	6'4"	180	Paddy Winkler	G	5'6"	145

Knothe	G	5'8"	170		
Krakovitch	G	5'8"	160		
Herman	G	5'9"	170		

Ray Murphy	G	5'11"	155
Maurice Hopkins	G	5'9"	150

Skeets Wright's pregame prediction that Passaic would lose was fresh in the minds of the 7200 viewers when Passaic was only up one at the quarter. Orange's lightening quick Art Federici was not to be stopped as he ran wild the entire first half while Paddy Winkler led a third quarter surge that challenged the Wonders' resolve. Up by four points going into the last quarter, Prof inserted an energized Keasler for the final run. It was in this quarter that the "Golden Tornadoes" learned that when the Passaic Wonder Team was functioning properly, it was in a class by itself. Final score: **Passaic 63-Orange 44.**

PASSAIC				ORANGE			
	G	F	T		G	F	T
Hamas	6	15	27	A.Federic	11	14	36
Keasler	8	0	16	J.Federici	3	0	6
Merselis	3	0	6	Jones	1	0	2
Krakovitch	3	0	6	Winkler	0	0	0
Knothe	2	0	4	Murphy	0	0	0
Pashman	2	0	4	Hopkins	0	0	0
Herman	0	0	0	**Totals**	**15**	**14**	**44**
Totals	**24**	**15**	**63**				

Score by periods: Referee—Frank Hill.
Passaic 12 18 12 21 Umpire—Charles Schneider.
Orange 11 10 17 6

Putting away the last serious North Jersey challenger, the Wonder Team qualified for the state semifinals for the fifth consecutive year. The state's final four consisted of Ridgefield Park, Camden, Asbury Park and Passaic. It looked as if the Wonders had nothing but smooth sailing ahead.

CHAPTER NINE
"SHUT UP AND SIT DOWN"

After the big Orange game, you would think everyone would be in good spirits, but not so. The events that were to unfold at the Passaic School Board meeting on the following Monday, March 12, 1923, would start changing the Camelot-like life of the Passaic Wonder Team and their nonpareil coach Prof Blood. The feelings and emotions unleashed at the BOE meeting were like that of a volcano no longer able to contain itself as the turmoil within the school went public. The news would shock the citizenry who would be at a loss for an explanation.

The front-page headline in the *Passaic Daily News* on Tuesday was a harbinger of what was to follow:

Speaker Evans Expels Mrs. Feickert From Assembly Chamber

PASSAIC DAILY NEWS

CITY IS STIRRED BY CENSURE OF BLOOD

Stories of what took place at the board meeting swept through the city and beyond like a wildfire. The action of a few board members had aroused the ire of people from every walk of life. Never before had there been such outspoken indignation than what occurred over this calamity.

Prior to the regular school board meeting, Prof was asked to join in the Educational Committee's discussion concerning the invitation of New York City's Acting Mayor Murray Hulbert to play on March 1. Those serving on the Education Committee were President Robert D. Benson, Mrs. I. Waters Sylvester, J. Frank Andres, Principal Arnold, and Superintendent Shepherd. Mr. Hulbert had issued an invitation to the Wonder Team, and after Shepherd made the contents of the challenge known, Arnold expressed a descending opinion pointing out that their arduous schedule was wearing on the boys. Prof countered by adding that the boys were in good physical condition and that the schedule was not too

strenuous. Arnold rebutted that the schedule was also interfering with the players' academic progress.

Andres, who was of the belief that playing so many games was not good for growing boys' health, asked Prof if basketball was a strenuous game. Blood replied that it was a strenuous game, but it was not strenuous the way Passaic played it. (This was a reference to the large number of players Prof enlisted during a game, the high degree of teamwork employed, and the use of brain power to overcome physical force.) Blood explained that he knew how to take care of the boys; at the same time, he realized that he was talking to a group of individuals who had never attended a Passaic basketball game.

Frustrated with the board's lack of understanding, Prof emphasized the fact that the people in Germany, France, and China knew more about the basketball team than the Passaic School Board. Prof was referring to the feature articles on the Wonder Team that had been reported in the newspapers of those countries. Unaccustomed to being addressed in this manner, school board president Benson committed a major *faux pas* for a man in his position by shouting at Blood, "Oh, shut up—sit down."

Benson's surprising breach of etiquette silenced the room, as many feared what might happen next. Suddenly, Benson realized that his only safe haven was the room full of people and Blood's reputation for being a gentleman. In a tone of voice that substituted for a grip around the throat, Blood fired back that he had a right to be heard and that he would not shut up. He also added that no man had the right to tell him to shut up.[139]

Because the doors to the office were partially open, those waiting in the lobby easily overheard the stentorian conversation. Friends, supporters of Prof, and newspapermen were astonished by what they were hearing. The spectators' vantage point improved as the members moved across the hall for the regular business session of the school board meeting. An infuriated Prof followed his accuser and antagonist into the lobby stating that he had a right to be heard because the accusations were false.

Not wanting to push his luck, Benson ignored Prof and called the regular BOE meeting to order. Prof picked up his hat and coat and headed for the door. His quick exit from the room surprised a few basketball fans and newsmen who were gathered around the door's keyhole to catch a glimpse of any further verbal spats. Upon the completion of school business, Andres moved (seconded by Charles G. Erickson) for the board to move into Executive Session. Erickson indicated that he did not know what it was all about but seconded it anyway.

During this heated discussion, Andres expressed his indignation over Blood's behavior and declared that he would resign before he allowed himself to be subjected to it again. He wanted Blood censured for speaking to Benson the way he had. Shepherd spoke up in Blood's defense by

stating that he was aware of what Blood stood for and that Blood had been doing good work in the schools.

It often takes time to determine what motivates people, but in the case of Andres, that time was very short. Andres revealed what was on his mind when he brought up the topic of the $2000 that Prof received from last year's testimonial games. The money received from sources outside the school's jurisdiction was a sore spot for Andres and obviously some others as well. He was of the opinion that Blood was well paid for the job he did.

The next day at a Rotary Club meeting, board member John J. Breslawsky revealed his feelings when a few fellow Rotarians informed him that they felt the team had put Passaic on the map. Breslawsky replied, "We don't need that kind of publicity." One Rotarian told Breslawsky that he was in favor of collecting money to pay Coach Blood the salary he deserved. Skipping over the pecuniary issue and trying to say something they couldn't object to, Breslawsky stated that "if it were a question of ordinary education or basketball, ordinary education was going to win."[140]

The final piece of business that resulted from the inflamed Executive Session was the resolution, proposed by Andres and seconded by Erickson, that all basketball games for "benefit or commercial purposes" be prohibited. This spiteful display of policy making was directly aimed at eliminating future testimonial games for Prof, and it also squashed the NYC high school game. But another resolution that would have limited the number of games in one week at two was rejected.

From that point on, the basketball controversy was a news media circus fed by the timing and the personalities involved. In an interview after the meeting, Prof made public for the first time the difficulties that he had experienced and explained the frustrations that he had encountered during the eight years working under Principal Arnold. Unbeknownst to the legion of fans, Arnold had been making Prof's life miserable and subjecting him to repeated humiliations. Prof had had enough, and he was not going to take it any longer.

Prof brought up the topic of the irritating notes that he periodically received from Arnold after games. He received one such letter following the previous Montclair game. The note, published in its entirety, read:

Dear Mr. Blood: At the time the basketball schedule came before the Council for adoption you will recall that I objected to playing four games occurring in one week on the grounds that it would wear out our boys. I wish at this time to state again that in my judgment the team would be in better condition now it they had had fewer games.

Very truly,
Arthur D. Arnold

The Montclair game was a state scheduled play-off game over which Prof had no control. The evening before playing Montclair in Newark, Prof and the team were at the Paterson Armory playing Clifton in a game that Arnold had arranged. The principal scheduled the Clifton game against Prof's wishes by forcing it through the Athletic Council. Prof was getting it from Arnold at both ends, something school administrators do well.

A citizens' committee was quickly formed, and a mass meeting at Smith Academy was arranged to protest the action taken by the school board. Scores of followers, including Nicholas O. Berry, Edmund Sennert, Joseph Whalley, Victor Jaffe. Harold W. Saunders, Abram Freeswick, Charles Knothe, Manuel N. Mirsky, Abe Greenberg, Al Lichtenberg and Harry Miller, were adamant in their desire to get some answers to who was behind all of this opposition to Prof and, more importantly, why.

Passaic fans were outraged by the senseless and ill-timed actions of the school board. Jealous adversaries of Passaic (Hoboken and Union Hill) took delight in the chaos, but even they could not understand what the school board's objections were. Many prominent and some not-so-prominent citizens were interviewed and expressed similar disbelief. Most wanted school board President Benson ousted, along with the others who were objecting to Prof Blood's coaching.

On this day of infamy, the *Passaic Daily News's* editor, George M. Hartt, stated his opinion in a front-page editorial.

HOUNDING BLOOD FROM PASSAIC

The Chamber of Commerce, hard pressed as it is, would give $10,000 if anyone could show it how to achieve as much favorable publicity for Passaic as Coach Blood and his team have bathed it in.

Now, because of some peculiar form of mental aberration or obtuseness, the Board of Education, which employed Mr. Blood, and which ought to glory in what he and the team have done, is trying its level best to destroy all the great benefit of the favorable publicity so freely given.

'There is something rotten in Denmark.'

The fans who were interviewed expressed similar opinions. They either criticized the board and principal and supported Blood or admitted that they were unaware of the facts, but supported Blood anyway. Two popular perspectives emerged from the growing controversy. The first one was best expressed in the form of a letter received by the Sporting Editor of the *Passaic Daily News*:

Passaic, March 12, 1923

Dear Sporting Editor: Enclosed find one dollar with which to start a fund to defray the expenses of the members of the Board of Education of our fair city, to see the game at Princeton.

We feel that if our honorable board would see some of the spirit and enthusiasm shown by the citizens of Passaic they would be better qualified to control the destinies of the team.

Yours for fair play,
Anthony Re
A.J. Blair

P.S. If suggestion is not acted on you may donate this to the band fund.

The second popular perspective was voiced by John Kennell of the Board of Health. Kennell and others believed the argument of the schedule being too long was only a ruse to cover something else. He thought there was something personal between Blood and someone else. The question was who?

In its headlines, The *Passaic Daily Herald* revealed another facet of the growing dispute. Its Extra Edition headlines read **PASSAIC-NEW YORK GAME TO BE PLAYED**. As a direct slap at the Board of Education's decision to prohibit games for "benefit or commercial" purposes, the Board of Commissioners met at City Hall and unanimously voted to accept the invitation to play the NYC public school champions. This action by the city commissioners took the matter of arranging the game out of the hands of the BOE. The commissioners were going to work directly with Coach Blood and bypass the BOE in making game arrangements. A major clash between two

ARE YOU FOR BLOOD OR ARE YOU FOR THE BOARD OF EDUCATION?

So important is the action of the Board of Education in unofficially censuring Coach Ernest A. Blood that the Daily News believes the people of Passaic should have an opportunity to say what they think about it. The use of this ballot is suggested. Before voting, read all the facts of the case. Then mail the ballot to the editor of the Daily News, and don't be afraid to sign your name and address. Anonymous ballots will be discarded. Cross out the word "approve" or "disapprove" according to your conviction:

I **approve/disapprove** the degree of support given by the Passaic Board of Education to the High School Basketball team during the present season and its unofficial censure of Coach Ernest A. Blood.

Signed —————————————————

Address ————————————————

different political camps was in the making.

The *Passaic Daily News* quickly put together another publicity gimmick to go along with their Bermuda Contest. With a mail-in ballot (recreated left), the newspaper began tabulating the number of those who were in favor of Blood and those who were for the school board.

Besides prophets, popes, and anointed ones, those on earth who are closest to God are school board members. They control the fate of principals and superintendents, not to mention teachers and coaches. As a rule, every town, city, or community has its own ego-bloated, Enlightened Ones to reckon with, and the city of Passaic was no exception. The Passaic BOE members in the midst of this very public fray were:

Robert Dix Benson, President	John J. Breslawsky
Charles G. Erickson	Alfred Ehrhardt
Mrs. I. Waters Sylvester	F. Frank Andres
Mrs. George A. Terhune	Edwin Flower
Dr. John Szymanski	Joseph M. Gardner, Secretary

WEDNESDAY, MARCH 14, 1923
DAY #2 OF THE CONTROVERSY

The magnitude of the dispute was repeated once again on the front pages of the city's newspapers. The *Passaic Daily Herald* started off with:

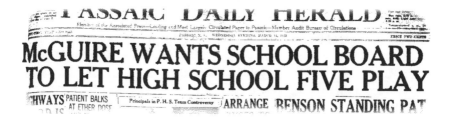

The city commissioners continued their talk of an investigation into the problems and proceeded to arrange a game with the NYC champs. Benson, who was not planning to resign, informed the commissioners (via the newspapers) that they had no legal right to usurp the authority of the school board in any matters that pertained to the city's schools. That was the law! And as for an investigation, he declared, there was nothing to investigate. At the heart of the disagreement, according to Benson, was the matter of who ran the high school, the school board and principal or Mr. Blood?

During the previous evening, 1500 supporters met at Smith Academy at the request of the Citizens' Committee to organize their efforts and get some answers. Many people were called to the podium, but the most

prized speaker (Prof) was also the most reluctant. Before getting dragged to the stage, Prof evaded comment by indicating that it would take too long to explain because the difficulties went back eight years. The crowd begged to hear from the Grey Thatched Wizard. As he ascended the stage, the throng began to applaud and continued their applause for several minutes.

Prof began his account of events by explaining that for the past eight years he had been the target of insults and humiliation. Finally, during the school board meeting held the previous evening, he decided he was not going to take it any longer. Insults had been his lot after winning each championship for the past three years. At the mention of Arnold's name, the crowd began to hiss. Prof promptly raised his hand for them to stop, indicating that he found that response distasteful.

The coach related how Arnold was opposed to an Athletic Council in the first place because he felt he would be unable control it. Another one of Arnold's excuses for not wanting an Athletic Council was because of the ongoing friction between the Jews and Gentiles. According to Arnold, the Jews and Gentiles would never get along with one another.

Prof related that one of Arnold's first attempts to subjugate his will over the council was when he invited Miss Krueger, the girls' physical training teacher, to join the council. Arnold told Krueger that he was going to give her $25 dollars for her department. This pleased her, and she thanked him for it. In exchange, Arnold wanted her to vote with him on an issue that Blood was opposing. Krueger couldn't do that because she felt it wasn't right, and she expressed her feeling to him. Arnold insisted that she had to because he was the principal. Upon hearing this, the crowd began hissing again. Again, Prof raised his hand for them to stop. Arnold warned Krueger that if she didn't cooperate, she would be sorry. Not intimidated, Miss Krueger followed her conscience. As a result, Arnold made her job as difficult for her as he could.

The Krueger/Arnold feud continued to escalate until it reached a point where Arnold hurled an insult at Miss Krueger. She immediately submitted a letter of complaint to the superintendent. Because of the complaint, Arnold was summoned to appear before a committee of the board, and Prof was asked to attend and testify. In Prof's testimony, he spoke truthfully and comprehensively about all he knew of the situation, which further alienated Arnold from him.

The gathering sat motionless and dumbfounded as Prof continued his chronicle of frustration. Then Prof said that there was once an incident with former manager Donald Wilcox. Wilcox had written a letter to the manager of another organization called the Casey's, challenging them to a game for the city's championship. When Prof heard about it, he told Donald that he was wrong for doing that. Arnold also got wind of it and

told Prof that Wilcox should be disciplined. When a meeting was called between the three of them, this is what Arnold said, "Donald Wilcox is one of the best mangers we have ever had. I won't stand to have you criticize him!"

While his listeners shook their heads in disbelief, Prof continued with the story of the preseason baseball rally held shortly after winning last season's basketball state title. At that rally, baseball captain Walter Margetts invited Prof to speak. After speaking, Mike Kiddon started to shout a cheer presumably for Prof, but Arnold told him to sit down. Since Prof knew that both Margetts and Kiddon were presently in attendance, he asked them if his account of the rally was accurate, and both shouted out that it was very accurate. Margetts was later reprimanded for calling on Prof to speak. Arnold was angry over the amount of time the assembly took, and he told the students that if they ever used up that much time again, they would not be allowed to have another assembly. As it turned out, the assembly ended on schedule anyway.

Prof mentioned that he attended the school board meeting the other evening prepared to explain how he trained the team. "I was ready to tell them how I work to instill qualities of character, good citizenship, and healthy living. I wanted to emphasize that boys who fail to practice these things don't fit into my scheme of things. I wanted to say that during all my experiences as a teacher of physical education, I have never asked a boy to do anything that was illegal, unfair or even to commit a foul to gain an advantage. Is there anyone here who can say that I did not act in the best interest of my boys? If so, I want him to speak up right now!" Prof hesitated and reiterated, "Come now, if there is anybody, speak up; do not be afraid," he urged. The silence continued, making it that much more dramatic. Suddenly, a loud and sustained burst of applause erupted.

Prof continued with the startling allegation that on the previous morning, every member of the team had been called out of class to the principal's office to be grilled about whether he had been overworked. "The parents here this evening will vouch for what I am saying. In the 158 games that I have coached, the average margin of victory has been forty-two points." (Applause rang out) "Wins of this nature do not place much strain on the players, and in most games, a large number of players are used. In one game this season, we used seventeen boys, more on a few occasions last season."

When Arnold asked these same players if they had been worn out by the tiring schedule, they replied in the negative. When he asked if they had played too many games, they again answered no. Arnold insisted they must be tired. By this time, Arnold was desperate to prove his point; he wanted to hear a player say that he was tired and worn out, but he could find no one who would substantiate that claim.

The thought of Arnold complaining about the twenty-six games being too much prompted Prof to remember Mr. Kenaston from the New York Military Academy. In a subsequent conversation with Mr. Kenaston, Prof learned that Arnold promised Mr. Kenaston a game with his academy team. Now why would Arnold, who was complaining about too many games, try to schedule an additional game?

Prof admitted that while he had received some money last season from the testimonial games, he had never received money for expenses. He added that while practicing with the boys, he had had five of his teeth knocked out. "It has been said that true happiness may best be found in service—not by going out and seeking it. The loss of those five teeth is partial proof of the happiness I have derived from the service I have freely given to the boys and the teams. Mr. Andres had mentioned something about the money I received from the testimonial games. My only comment to that is that I would gladly return the $2000 dollars if he were willing to sacrifice his five front teeth."

Prof gave other examples of his discouraging work situation. "I have not told you one-tenth of what I have experienced because some memories are too unpleasant to retell. I have said enough, and I hope you now have some idea what my existence has been like these past eight years." Upon completing his emotional address and returning to the rear of the hall, Prof sat and wept for nearly half an hour.

After Prof spoke, the assembly gathered to draft a resolution calling for the city commissioners to request the resignations of President Robert Dix Benson and other members of the school board.

> **WHEREAS**, The basketball team representing Passaic High School has by its exceptional skill, clean playing, thorough training and faithful adherence to the rules of training, established an unequaled record for consecutive victories and in consequence thereof brought fame and increased glory to this city; and
>
> **WHEREAS**, The achievement of the basketball champions is the direct and natural result of the masterly guidance and preparation of Advisory Coach Ernest A. Blood; and
>
> **THEREFORE, BE IT RESOLVED**, That it is the spirit of this meeting that Coach Blood's work is beyond just criticism; that he has rendered invaluable service to the school system and the city in general; and
>
> **BE IT FURTHER RESOLVED**, That President of the School Board, Robert D. Benson, be and he is hereby publicly censured for his impolite, un-American and despicable conduct at last

night's meeting of the Board of Education when he told Coach Blood to shut up when Mr. Blood was answering the cowardly attacks of his malingers; and

BE IT FURTHER RESOLVED, That the Commissioners of the City of Passaic request the resignation of said Robert D. Benson and any other members who took the same position he did.

The *Passaic Daily News* reported the growing rift between the school board and Mayor McGuire and his city commissioners with these headlines:

COMMISSIONERS REPUDIATE SCHOOL BOARD--DEMAND MADE BENSON RESIGN

Initially, many felt that because the mayor appointed the school board, he had the right to replace them. Once named to the board, a person became part of the supreme policy-making group governing the district's schools. As long as the board abided by the laws of the land, they did not have to listen to the mayor or the commissioners. With their autonomy in school matters protected by law, they were empowered to do as they pleased, even if the entire city disagreed.

Prof's comments at Smith Academy drew the line in the sand. His complaints were aimed directly at Arnold. When questioned about Prof's checkmate allegations, Arnold replied that he did not wish to make any statement at that time, but if an investigation were to be held, he would be pleased to give whatever information he could. He refused to comment any further on the topic.

What was almost forgotten in all of the uproar was the semifinal game scheduled for Friday at Princeton. Of lesser interest was the Camden-Trenton game to be played that evening, and Passaic was to play the winner. It was taken for granted that under normal circumstances, Passaic was capable of defeating any challenger. The question was what effect would the present controversy have on the team's performance? For the students' convenience and to legalize the students' absences, which were already guaranteed for Friday, the high school's dismissal time was changed to 12:15 p.m.

The *Passaic Daily News* continued reporting the Bermuda Contest standings. The votes for Prof had him positioned as an early favorite against thirty other hopefuls. Not too far behind the Wonder Coach were his two main aces, Knothe and Keasler, in fourth and sixth places

respectively. The day-to-day, front-page coverage of the free Bermuda trip was not only a novelty, it further accentuated Prof's popularity.

After one day of ballot receipts for the "Are You for Blood or Are You For the Board of Education?" public opinion poll, the tally was 117 to 1 favoring Blood. The one vote for the board was later changed to a vote for Blood when it was learned that the person submitting it was confused by the ballot and mistakenly X'ed the wrong response. What made this poll and the Bermuda Trip Contest more interesting was the fact that the newspaper published the names and addresses of everyone involved.

The Bermuda Contest and the opinion poll of the *Passaic Daily News* provided a means for Prof's celebrity status to reach superstar proportions. As far as the *Passaic Daily News* was concerned, Prof was a fine man, the best at his profession, and the city was fortunate to have him. Until events warranted otherwise, the *Daily News* was determined to champion all of his causes and accomplishments.

Because of the questions surrounding Prof's coaching salary and the elimination of benefit games, the *Passaic Daily News* reported that some wanted to know where the money was going. The public's sudden interest in gate receipts was beginning to open a can of worms for the Athletic Council. For example, what was Passaic's share of the money paid by the 7,200 fans at the Orange game in Jersey City? Who had the money? Why couldn't a financial breakdown of the money be given to the public after each football and basketball game? As more people became aware of the controversies, the number of people seeking answers to everything related to athletics increased.

THURSDAY, MARCH 15, 1923
DAY #3 OF THE CONTROVERSY

Passaic's next opponent was determined at the Camden YMCA when Camden defeated Trenton 27-22. Pundits did not have Camden as the same caliber as many of the northern teams. Meanwhile back in Passaic, members of the BOE were meeting to figure out how they could justify the restriction on their coach and limits placed on their team's activities. The *Passaic Daily Herald* captured the school board's proactive strategy with the following headlines: **SCHOOL BOARD DIRECTS PROBE IN PASSAIC SCHOOL ATHLETICS.**

School board president Benson and board members Ehrhardt, Andres, Breslawsky, and Erickson met privately at the Peoples' Bank Building office of their attorney, Henry C. Whitehead. The reason for the meeting was to discuss the entire basketball situation and to receive legal advice.

Benson refused to call the meeting that Mayor McGuire had requested indicating that there was no need for it. He was referring to the board's

authority in school matters, and the board was claiming this was a school matter. As far as the board was concerned, if any investigation was deemed necessary, it was going to be conducted by them, not someone else. A couple of concerns that the board wanted to address were Blood's behavior at the board meeting and his accusations directed at Arnold during the Smith Academy meeting. The board also wanted more control over athletics, especially basketball. It was their intent to completely revamp their method of athletic supervision so they could have control over decisions that they considered important.

Benson announced that the board was appointing a special committee to investigate. The board's special committee consisted of Andres, Ehrhardt, and Breslawsky whose task it was to look into the concerns and report their findings at the next board meeting.

A touchy topic the board never fully addressed was Blood's salary. Prof was paid a flat amount for his duties as the city's physical director. As far as the board was concerned, Blood could assume any role he felt was best to service the students. If he wanted to take the lead role in coaching a team, that was his prerogative. In its opinion, Blood was sufficiently compensated for his work with the basketball team. Amasa Marks was the person assigned as the official coach, but everyone knew that Marks, who assisted Prof, was just an easygoing guy who knew very little about coaching basketball.[141]

An ironic backlash from the publicity generated by the Passaic basketball controversy was the position taken by sportswriters in other cities. Many writers who had previously capitalized on Passaic's fame by carving out a niche for themselves as critics of Prof Blood and the Wonder Teams were now supporting and praising him. One strident critic was James B. Egan, from the *Hudson Observer*. Turning one hundred and eighty-degrees, Egan wrote that he wished Prof had been in Hudson County. He failed to comprehend, after what Prof had accomplished, how anyone in Passaic could find fault with him and his work with the basketball team. His conclusion on the spectacle was that the Passaic school board was stocked with some very small men.

The public outcry overflowed to nearby Garfield. The *Garfield News* felt compelled to include its opinions in this front-page editorial calling for the removal of Principal Arnold:

THE TRUE ARTHUR D. ARNOLD

At last the people of Passaic have come to know the true Arthur D. Arnold. For twenty years this individual has been the hounding spirit among the faculty of the Passaic High School. For these many years this individual, narrow minded and unable to see praise or honor hurled on others—poisoned by his own ignorance of publicity, is being brought into the lime light so that the public can really tell what and who he is. Passaic's higher institution has suffered because of Arnold's presence as head of the institution. The present controversy wherein he has been hounding Prof. Blood is only the first of the many unpleasant affairs entertained by instructors. Others have swallowed their medicine of abuse and gone elsewhere. Others have not been able to obtain sufficient public backing to fight back. Arnold's removal from the Passaic High School is absolutely needed if that institution is going to progress. He is certainly an impediment in the road to its future welfare.

The Blood controversy is only a small incident to those of the past. A glance into the columns of the Passaic dailies will recall the Homer Underwood troubles of a few years ago; the difficulties of Former Superintendents Wheeler and Woodley. If these men could only be reached and questioned they would soon reveal some mighty unpleasant incidents.

Arthur D. Arnold ought to be removed as head of the Passaic High School. Let us hope the people of Passaic have at least found out what he is and who THE TRUE ARTHUR D. ARNOLD HAS BEEN. Men of his caliber—men who will poison the future welfare and success of a communities' [sic] good name just for his own personal jealous reasons has no place in a public institution.

Demand Arnold's resignation. Let Passaic get rid of him and the quicker we say the better![142]

FRIDAY, MARCH 16, 1923
DAY #4 OF THE CONTROVERSY

Amidst the rumbling, the team cloistered themselves in the gym at the nearby #10 School to practice. It remained to be seen what effect this controversy would have on the boys and Prof. The full throttle of pregame preparation was in progress by the basketball followers: special buses and trains, a brass band, megaphones and electric scoreboards set up by the two newspapers, and factory whistles to herald the anticipated victory.

With victory on the court a foregone conclusion, the real battle that had both sides mobilizing their forces was on the politically charged home front. *Passaic Daily Herald* readers were greeted with: **MAYOR NAMES CITIZENS' COMMITTEE TO PROBE TROUBLE AT HIGH SCHOOL.**

In response to pressure exerted by prominent Passaic citizens who felt it would be a shame for Passaic to lose Blood, Mayor McGuire quickly appointed his own committee. Because of this unprecedented interest, the Mayor declared this a civic matter with the citizens deserving the right to know the complete story. He named Judge Walter C. Cabell, George M. Hartt (Editor of the *Passaic Daily News*), and Emmett A. Bristor (Editor of the *Passaic Daily Herald*) to thresh out the controversy and to decide if the invitation to play the game with the NYC champs should be accepted.

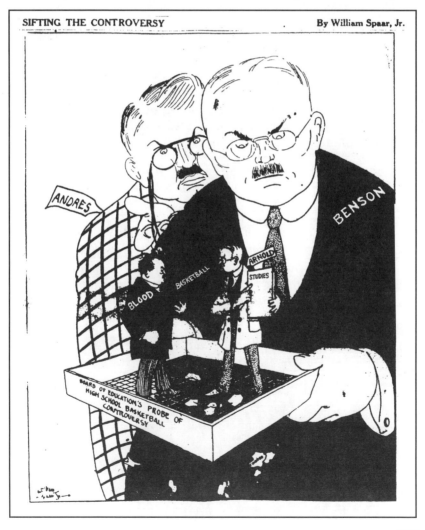

SIFTING THE CONTROVERSY By William Spaar, Jr.

The ringleaders of this pro-Blood Citizens' Committee were Nicholas O. Beery, Manuel N. Mirsky, William R. Vanecek, Harry Miller, Harold W. Saunders, and Edmund B. Sennert. They were entrusted with the task of representing the 1500 people who attended the meeting at Smith Academy and the many thousands who could not attend. The ire of these men was first aroused by the "Public Be Dammed Attitude" of the school board, but it reached its highest pitch when they learned of the dealings that surrounded the resolution drawn up by J. Frank Andres to censure or oust Blood.

In the Executive Session of that fateful school board meeting, the board gave Andres permission to draft a resolution to censure Blood. The resolution was in response to Blood's unseemly conduct in replying to President Benson's order to shut up. A day after writing the resolution, Andres postdated the resolution and had it mailed to the other members requesting it to be incorporated in the board's minutes.

THE RESOLUTION

Whereas, the unbridled speech and shameful action of Ernest A. Blood toward President Robert Dix Benson and other members of the Board of Education in the board rooms tonight constituted a flagrant case of insubordination and violated every rule of good behavior and

Whereas, such conduct on the part of a department head is disgraceful, demoralizing and destructive of discipline in the schools, be it

Resolved, that the said Ernest A. Blood be properly censured for his conduct; that he be requested to apologize to President Benson and the other members of the Board for his sorry exhibition of temper, and that failing to do so, said Ernest A. Blood is hereby asked to resign his position as director of physical education in the public schools of Passaic, New Jersey. Be it further

Resolved, that a copy of these resolutions be forwarded to Ernest A. Blood by Superintendent Fred S. Shepherd.

The effect of this resolution on the city was like throwing kerosene on a bon fire. Anyone vaguely familiar with what was going on had an opinion. The following is an editorial that appeared in the *Newark Ledger* defending Prof:

BLOOD VICTIM OF JEALOUSY?

And now for Blood and Passaic. Blood is hired by the Board of Education to act as "physical director of the Passaic schools."

Blood coaches the High School team in his spare time. There appears to be nothing wrong with Blood, but plenty of narrow-mindedness and jealousy on the part of the Board of Education.

Most any city of Passaic's size would rejoice at the success of the team and the wide publicity of its basketball successes— the successes of a strictly home-bred team of amateurs.

In big cities like St. Louis and Boston, which Passaic possibly could follow without fear of ridicule, the businessmen welcome professional baseball teams because they put the "name of the city on the map." If Boston needs that—does not Passaic?

And Passaic's team is not a professional team in the game for the glorification of Coach Blood, or for the mercenary objectives of lining a professional promoter's pockets with silver.

Happily the city fathers of Passaic seem wiser than its Board of Education. Blood need not worry about his future. Scores of offers would be made the day he resigned. Indeed Blood would be sadly lacking in spunk if he didn't accept one of these offers, and leave town as ungrateful as Passaic appears to be flat on its back.

Now we have two committees, one appointed by school board President Benson to represent the school board and the other appointed by Mayor McGuire to represent the people of Passaic. Aside from Benson, whose business was out of state, the school board was comprised of members of the city's woolen industry known as the Woolen Counsel. The Citizens' Committee, urging the mayor to do something, believed that there was some ulterior motive behind this entire controversy. William R. Vanecek thought that one person could be behind the entire high school mess, but who? Vanecek saw a trail from Andres to Julius Forstmann, the wealthy Passaic industrialist who would finance the city's new library eighteen years later. Was there something to the fact that Andres took his orders from Forstmann?

We do know that Robert Dix Benson was no *nouveau riche*. He was a tenth generation American who could trace his family back to John (Binson) Benson. Between 1630 and 1640, John Benson was one of the 20,000 Puritans who fled England to escape the religious persecutions of King Charles I. In a long line of accomplished lineage, Robert Dix inherited an "in" with the Tide Water Oil Company from his father Byron David Benson who was its president. In time, he worked his way up to the company's presidency himself. With his financial future secure and an aristocratic philosophy firmly intact, he ventured into Passaic community affairs.[143]

ROBERT DIX BENSON

photo courtesy of "History of Passaic and Its Environs" by William W. Scott. Vol. 2 (c. 1922). New York: Lewis Historical Publishing Comp., Inc.

Benson was a former member of the Passaic City Counsel, the very council now challenging him. In 1918, the former mayor (Seger) appointed him to the school board, and in 1921, he was reappointed by then Mayor McGuire. For many years, Benson served as a trustee and later president of the Passaic Public Library—thus the connection with Forstmann.[144]

The controversy at the school was adopted by those involved in the city's politics. With political, business, and religious factions all at work and compounded by basic human weaknesses, a civic mess was developing.

Andres was on Benson's committee to investigate the Blood/Arnold problems, but in light of his unpopular resolution, he astutely decided to resign. He did not want anyone to claim the committee's findings were biased. In his place, Benson appointed Charles G. Erikson to join Ehrhardt and committee chairman Breslawsky.

On this same day, the *Passaic Daily News* ran this two-part front-page headline:

PASSAIC DAILY NEWS

Full Associated Press News Service—Special United Press Service—International News Photo Service

MAYOR M'GUIRE ORDERS INVESTIGATION
Eugene Newman Gets Off With $1,000 Fine; Many Sign Petitions
ARNOLD EXPOSED BY FORMER TEACHER

The paper's expose of a former Passaic teacher's experiences with Principal Arnold was an eye opener. Martin P. Parker from 65 Bond Street in Passaic was a science teacher from 1914 to 1918. At the time of the Blood/Arnold controversy, he was employed as a chemist with Passaic's New York Belting and Packing Company. His story dealt directly with Arnold's style of leadership.

Parker's odyssey started when he asked Arnold for a recommendation as he was preparing to leave teaching for work in the business sector. He thought he had a good relationship with Arnold because he had been reappointed for three successive terms. When Parker used Arnold's name on an application, the company wrote to Arnold for more informa-

190

tion. During his interview with that company, Parker was confronted with Arnold's handwritten response, labeled "PERSONAL." The contents of the letter dumfounded him; it read:

Mr. Parker has never taught chemistry in our day school, his work at first being in Biology and now in General Science.

In the Evening School he started a class in Chemistry but he could not hold them. The class soon dwindled and was abandoned.

I do not think he would get along with men. He is very irritable with our pupils and also autocratic. I think he will overcome this in time. Parker is an American. About research work I do not think he has had experience along this line.

Very truly,
Arthur D. Arnold
Principal of High School
March 9, 1918

The New York Belting and Packing Company eventually hired Parker as a chemist anyway. In the event that he decided to return to the field of education, he decided to ask Arnold for another letter of recommendation, but one that he could carry with him. Arnold obliged and gave him the following letter to take with him:

Passaic High School, Passaic, New Jersey
Arthur D. Arnold, Principal
Homer K. Underwood, Vice-Principal

April 3, 1918

To Whom It May Concern:

This certifies that Mr. Martin P. Parker has been a member of the High School faculty for nearly four years; that he is a young man of excellent scholarship having graduated from the four-year course of Bridgewater, Mass., Normal School in 1919 and from Teachers College, Columbia University, with a degree of B.S., in 1913.

As a teacher he has the power of interesting and inspiring his pupils. As a co-worker he is always loyal to the Principal of the building and to all his associates.

We regret exceedingly that he finds it best to leave the teaching profession and take up his work as a chemist.

We wish him the best of success in his field of labor.

Very truly,
Arnold D. Arnold
Principal of High School

On the last day of school, Parker asked Arnold about the two vastly differing letters of recommendation written only twenty-five days apart. Arnold replied that he had a perfect right to do as he pleased. When Parker disagreed, Arnold said, "What are you going to do about it? If you do anything about it, I'll deny it. You can do anything you want. I have a record of fifteen years' integrity in Passaic and nobody will believe you." Parker never solved the mystery behind the two letters.

In an interesting development that only added to Arnold's enigmatic administrative record, both newspapers published this letter (March 18, 1923) as part of the Parker story. Every teacher in the high school signed this letter expressing support for Arnold.

To Whom It May Concern:

We, the undersigned teachers of Passaic High School, wish to express our belief and conviction that Mr. Arnold has always acted with the best interest of the High School at heart. We hereby extend to him a vote of our confidence and assurance of our loyalty.

A letter signed by the high school faculty, engineered by Vice Principal Daniel Dahl, had to be an aberration in American education. It could be the last time a large high school faculty had one hundred percent consensus on an eristic issue. Or was this an indication of the grip Arnold had on his teachers? Oddly enough, Amasa A. Marks and the other coaches and physical instructors all signed the letter. Was their decision to sign because they did not want to appear to be taking a stand against the principal and would rather not have to face any possible repercussions?

Arnold was well respected as an educator. The academic reputation of the high school was held in high esteem, and his efforts, no doubt, were at least partly responsible. According to Jack DeYoung, who played on Passaic's last state championship team of 1929 (First Team All-State), and who spent his entire professional life teaching school in Passaic, "Arnold was a staid individual who never laughed. He didn't believe sports belonged in the schools, so naturally this would bring him in conflict with Prof and all the publicity the Wonder Teams were receiving. The two men had different philosophies concerning the value of sports in education. Needless to say, he and Prof didn't get along very well."[145]

Later that day at Princeton's Palmer Gym, a SRO crowd plus the Paterson Boy Scout Brass Band, courtesy of the *Passaic Daily Newspaper's* band fund, greeted the Wonder Team as they took the floor for the 7:30 p.m. semifinal game. While Bergen County's Ridgefield Park and Asbury Park were scheduled to play the nightcap, all the hype surrounded the boys from Passaic.

GAME #117 Camden (Friday, March 16, 1923) Palmer Gym, Princeton. Sparing no expense, Prof hired taxicabs to get his boys to Princeton—all eighteen of them. Super fan Joe Whalley chaperoned the team and led the caravan of taxies in the pouring rain to Palmer Gym for the first game of the doubleheader. Over one thousand fans made the trip while those left behind prepared to gather at the newspaper buildings to hear the game relayed over the telephone lines.

Passaic's quick 10-0 lead prompted Prof to commence his game-long flurry of substitutions. Regardless of which five of the eighteen players he used, Passaic's distinct style of play was evident. No sooner did a Passaic boy break a sweat than he was replaced by a teammate. The scorekeepers and newsmen had more than their hands full trying to document changes in the lineup. Opposing fans were dumbfounded. "The way they pass the ball..." was often heard repeated over and over again by first-time attendees.

With the exception of Camden's center Louis Fols, the overmatched Philadelphia neighbors were not in the same league with Prof's protégés. Even though a state championship game was at stake, all Prof wanted to do was win in a sportsmanlike manner, play every player, and have it appear effortless in the process. Because no Passaic school board members were present, the word traveled back home about the "overworked Passaic team" and how each boy hardly broke a sweat. The win pitted Passaic against Asbury Park who had played the same five boys the entire game to defeat Ridgefield Park 42-27. Final score: **Passaic 40-Camden 21.**

PASSAIC	G	F	T	CAMDEN	G	F	T
M.Hamas	7	9	23	Lobley	2	0	4
S.Hamas	1	0	2	Merion	1	0	2
Keasler	1	1	3	Hullerburgh	3	0	6
Pashman	0	0	0	Fols	0	9	9
Russell	0	0	0	Carson	0	0	0
Freeswick	0	0	0	Baylie	0	0	0
Merselis	1	0	2	**Totals**	**6**	**9**	**21**
Rohrbach	0	0	0				
Pomorski	0	0	0	Score by periods:			
Vanderheide	0	0	0	**Passaic** 12 21 37 40			
Knothe	5	0	10	**Camden** 3 8 13 21			
Krakovitch	0	0	0				
Herman	0	0	0	10 minute quarters			
Blitzer	0	0	0	Referee—Schneider.			
Burg	0	0	0	Umpire—Wallum.			
Margetts	0	0	0	Scorers—Saunders and			
Lucasko	0	0	0	E.F. Connelly, Trenton Times.			
Janowski	0	0	0	Timer—Leroy Smith,			
Totals	**15**	**10**	**40**	Trenton HS.			

Back at the Daily News Building where the game was being relayed via the telephone and megaphone system, a large, spirited crowd with umbrellas braved the cold and rain to enjoy their Wonder Team's victory. Their exuberance could be heard blocks away as they sang songs and shouted cheers. As Prof was running his third and fourth teams in and out, some wisecracker shouted out, "Put in Arnold and Andres."

SATURDAY, MARCH 17, 1923
DAY #5 OF THE CONTROVERSY

By sunrise, everyone knew the Wonder Team was going to win their fourth consecutive basketball state championship that evening. By virtue of their win over Ridgefield Park, Asbury Park was finally to come face to face with the eye of the tiger—the Passaic Wonder Team.

That same morning, the *Passaic Daily News* front-page headline read:

MAYOR INSISTS ON AN INVESTIGATION

In the best interest of the community, Mayor McGuire dictated that the grave accusations be probed. The controversy had affected the city to such a degree that the public's right to know would be served. It had become a civic matter, and the allegations needed to be substantiated publicly in a meeting involving all parties.

Responding as if the mayor were usurping the authority of the school board, Benson refused to call the requested public meeting. It is interesting to note that all communication was conducted via letter, not in person or by telephone. The two sides, Benson and the school board representing Arnold and McGuire and the citizens' committee representing Blood, were conducting their skirmish in the newspapers.

President Benson's Committee
John J. Breslawsky, Chairman
Alfred Ehrhardt
Charles G. Erikson

Mayor McGuire's Committee
Judge Walter C. Cabell
Editor George M. Hartt, *Daily News*
Editor Emmett A. Bristor, *Daily Herald*

As far as Benson was concerned, the heart of the dispute boiled down to whether Blood and his sympathizers or the BOE would control and direct the school's athletic activities. Benson pompously reminded the mayor that the BOE had sole authority over all school matters including athletics. His committee was to advise him if any changes were necessary

to the school's regulations regarding the scheduling of games, qualifications of players, or any other matter currently under contention. Benson wanted to be sure that the BOE had full control of everything Blood was doing. Furthermore, Benson believed many were blowing the embroilment out of proportion. His perception that the training of Passaic basketball teams was regarded as more important than the proper education of Passaic's young people disturbed him.

The stage was set. The questions were abundant, and the committees were appointed. Now the city was waiting for the respective groups to replace the problems with answers. What role the mayor's committee was to play was a question mark as all judicial authority was on the side of the BOE.

As the dispute over basketball mounted, the positions taken by the two Passaic newspapers became more defined. The editor and writers for the *Passaic Daily News* were decidedly pro-Blood. They, like many others, believed that Prof was the most knowledgeable coach in the brief history of basketball. Blood stood for all the right things: America, sportsmanship, and clean living. Through his efforts, the city of Passaic was becoming recognized throughout the country, and because of this, the *Passaic Daily News* became his advocate.

The *Passaic Daily Herald* had always taken a much more guarded approach to what it wrote about Blood and this difference became more pronounced at this time. In fact, the *Herald* frequently portrayed Blood in a less flattering manner than did its competitor. Benson went so far as to compliment the *Herald* for its unbiased reporting.

It's interesting to note that a prominent manager at the *Herald* was Dow H. Drukker, whose son of the same name was a Wonder Team member when the momentous streak began. The former Congressman had social, business, and/or political relationships with numerous presidents and owners of the various woolen factories. As previously mentioned, numerous members of the school board were prominently involved with the woolen factories. One can posit that Drukker's personal and business interests may have influenced the coverage of the professor.

In a strategic defensive move, Arnold secured Passaic alumnus Harry H. Weinberger as his legal counsel. In Weinberger's first statement to the press, he elected not to offer an opinion on the controversy until both sides had been heard. The headline on the *Passaic Daily Herald* read: **WEINBERGER COMES FORWARD IN ARNOLD'S DEFENSE; PASSAIC PLAYING ASBURY PARK IN FINALS AT PRINCETON**.

Meanwhile, the *Passaic Daily News* continued to enable the public to show their support for Prof by responding to its Bermuda Contest and its other straw vote popularity contest "Are You for Blood or Are You For the Board of Education?" In the Bermuda Contest, Prof had a sizable

lead with Keasler a distant second. In the straw poll, Blood had 576 votes while the BOE garnered three. In the court of public opinion, Arnold and the board were taking a beating.

As if Passaic didn't have enough to talk about, there was still the big game with Asbury Park ahead of them. Coach J. Melville Coleman had wisely evaded the Wonder Team as long as he could. James Bradley, the founder and developer of the Asbury Park Ocean Resort in Ocean Grove, couldn't have done better than Coach Coleman in building his 31-5 team. The seashore resort's boys had impressive wins over The Peddie School and St. Benedict's Prep, the two best prep basketball teams in the state. Coleman's iron five were prepared for the most memorable game of their basketball careers.

GAME #118 Asbury Park (Saturday, March 17, 1923) Palmer Gym, Princeton. The Central Jersey university town was alive with followers of the two finalists. Many fans stayed overnight in the nearby state capital of Trenton. High school and college coaches along with sportsmen and curiosity seekers poured into the Ivy League town to see what the most highly publicized scholastic team looked like. Some came to learn the secrets of the Passaic system while others came to critique them. Regardless of their reasons for coming, they would all leave with similar impressions regarding the flair with which Prof's boys played the game. Passaic's secret was no secret at all; as a team, they just passed and shot the ball unlike any other. In the process, they exhibited a brand of clean basketball that was admired by the most ardent critics.

Before the game commenced, Blood learned from NJSIAA Secretary Walter Short that Phillip G. Lewis from Philadelphia was to be one of the game's officials. Prof had a prior agreement with Short that Lewis would not officiate any Passaic play-off games. Passaic had been plagued with questionable calls in the past when Lewis refereed. Short consoled Prof by informing him that Lewis was only the umpire, not the more crucial referee. But when the game started, and with Prof's total disapproval, Lewis assumed the role of referee.

With over 4000 excited spectators ready to see the *corps d'elite* of New Jersey lock horns, Asbury Park center Clarence Barkalow controlled the opening tap. After both teams fired a few blanks, Keasler hit a couple quick field goals that ignited Passaic, and soon the game was in full throttle; the Passaic Show was on. Moments later, Keasler picked up two quick dubious fouls (soon after, a third) and had two of his other baskets nullified by referee Lewis—one for walking and one for stepping on the end line.

Asbury Park Captain Bill Finley, Max Barr, and the quick little forward Emil Stone were all in good form. Their game was a solid one; they knew how to play, but to defeat the Wonder Team, they would have to make the most of their shots. Barkalow could outplay young Merselis at the center

position, but overall, the Passaic boys were taller, stronger, quicker, and much better shooters.

As the game progressed, Prof became annoyed with Lewis's officiating. Especially disturbing was how Lewis tossed the ball on jump balls—they weren't straight. Prof accepted questionable calls as part of the game, but not deliberately tossing the ball to give one team an advantage. At the end of the first quarter, Prof told Lewis if he didn't throw the ball up straight, Prof was going to stop the game, come out on the court and inform the crowd of what Lewis was doing. As if that weren't enough, Prof added that he would take his team off the floor. He also informed Short of his intentions. From that point on, the ball was tossed up correctly, and Passaic proceeded to run over Asbury Park.[146]

At half time, Prof questioned Short about why Lewis was the referee after Short had twice promised that Lewis wouldn't be. Short's only comment was, "I changed my mind." Prof was a man of his word and expected the same of others. This underhanded method of administering sports really abraded him. Late in the third quarter with Passaic in charge 43-24, Keasler fouled out for the first time in his career. Without saying a word, but almost in tears, Keasler made his way to the bench.[147]

After the game, when most observers were still marveling over Passaic's style of play, referee Phillip G. Lewis boasted that at least three teams in Philadelphia could stop Passaic.[148] Had Lewis been allowed to officiate those games, he probably would have been correct.

The deciding factor, besides the physical size of the Passaic boys, was the remarkable shooting of the perennial champs. The shorter Asbury Park players had to rely on their outside shooting, and on this particular day, it wasn't there. Late in the second quarter when the score read 25-9, Prof started his parade of substitutes. In the second half, a disgruntled Asbury Park fan was heard to say, "It's all right to get beat by the first and second teams, but when they put in the third team, that's an insult." Final score: **Passaic 54-Asbury Park 29.**

PASSAIC	G	F	T	ASBURY PARK	G	F	T
M.Hamas	7	11	25	Stone	2	7	11
Keasler	7	0	14	Cooper	0	0	0
Merselis	2	0	4	Barkalow	7	0	14
Knothe	0	0	0	Finley	1	0	2
Krakovitch	4	0	8	Barr	1	0	2
Freeswick	1	1	3	Nary	0	0	0
S.Hamas	0	0	0	Gallagher	0	0	0
Herman	0	0	0	**Totals**	**11**	**7**	**29**
Pashman	0	0	0				
Vanderheide	0	0	0	Score by periods:			
Janowski	0	0	0	**Passaic**	11	14 18 11	
Gee	0	0	0	**Asb. Prk.**	7	9 8 5	
Rohrbach	0	0	0				
Lucasko	0	0	0	Referee—Philip G. Lewis.			
Margetts	0	0	0	Umpire—Charles Schneider.			
Blitzer	0	0	0				
Totals	**21**	**12**	**54**				

After watching Asbury Park sustain the worst licking of any state finalist, Coach Zahn of Princeton University remarked, "That (Passaic) is the greatest high school basketball team in the country."[149]

Like a breath of fresh air amid the controversy, the *Passaic Daily Herald* and the *Passaic Daily News* reported Passaic winning their fourth straight state championship in special game-day extra additions. The *Herald's* headline read: **PASSAIC WINS, 54-29**; while the *Daily News* sported the headline **PASSAIC WONDERS STATE CHAMPS: 54-29.**

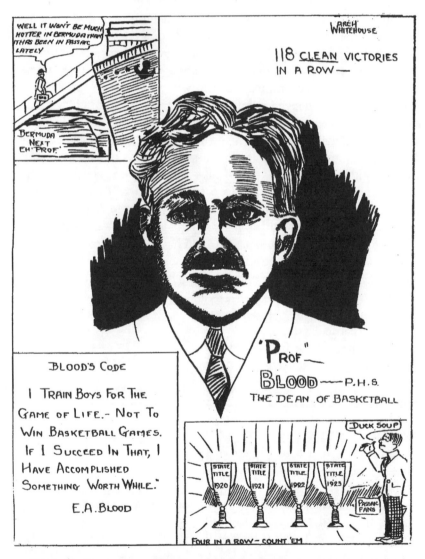

CARTOON APPEARING ON THE FRONT PAGE OF THE SPECIAL GAME-DAY EDITION OF THE PASSAIC DAILY NEWS BENEATH THE SUB-HEAD "MAN OF THE HOUR."

Mayor McGuire's committee received a setback when both newspaper editors declined a position on his investigating committee. They claimed it was not in the best interest of the newspaper profession to put themselves in such a role. The mayor had acted too hastily in appointing the journalists as committee members for such a controversial issue. It would take him days to find replacements, and he would proceed more carefully before releasing their names to the public.

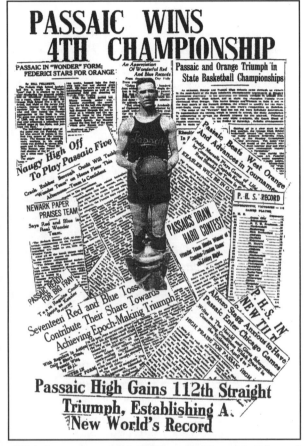

In the meanwhile, Weinberger, Arnold's attorney, was meeting with the Blood supporters. Weinberger met with William R. Vanecek, Manuel N. Mirsky, and Nicholas O. Beery of the Citizen's Committee in his office to ascertain if they could help bring Blood and Arnold together to avoid tarnishing the name of Passaic. They all agreed that the dispute was giving the city a black eye and should be resolved quickly.

During the meeting, Vanecek expressed his belief that the Wool Council controlling the Board of Education controlled Arnold. This must have touched a nerve because a verbal spat ensued. When emotions calmed down, Weinberger admitted that the BOE had acted unfairly in their dealing with Blood, especially the way they talked to him at the school board meeting. Weinberger's main concern was the unfavorable publicity plaguing his client. He wanted to see Blood and Arnold put their difficulties behind them and to redevelop a working relationship. Weinberger's diplomacy skills were being tested as he took on the wrath

of public opinion. Damaging editorials, such as this one from the *Newark Call* weighing in on the Passaic fiasco had to be neutralized.

"PASSAIC'S BASKETBALL FERMENTS"

The much-mooted question as to the part that athletics may properly play in our public schools is now prominently to the fore in the neighboring city of Passaic, where last week 2,000 highly indignant citizens in mass-meeting adopted a resolution condemning the Board of Education and recommending its dismissal by the City Commission. The anger of the citizens was aroused over the unsympathetic treatment accorded the Passaic High School's basketball team and its coach, Mr. Blood.

Passaic is pardonably proud of its basketball team, which for years has held the State championship, which has lost but one game out of 158 and which in the last four years has scored 116 consecutive victories—a world record. Mr. Blood, the coach, is the physical instructor at the high school and is given most of the credit for building up what in Passaic is fondly called the 'wonder' team.

Unfortunately the members of the Board of Education are not basketball fans. It is said that not one member has ever been present at a game. While almost everybody else in Passaic regards the splendid record of the basketball team with enthusiasm and deserving of honor the members of the school board look on it coldly and are wont to murmur that the time spent in basketball practice and playing might better be devoted to scholastic studies. At any rate, when Coach Blood went before the board and asked permission to accept an invitation from Acting Mayor Hulbert of New York to meet a picked team from the New York high schools in Madison Square Garden, his plea was rejected with scant ceremony. At the same time the board expressed its disapproval of a movement by citizens to arrange for a benefit game for Mr. Blood.

All of which has stirred Passaic mightily. As a topic of discussion it has displaced politics, Coue, golf, bridge and the Passaic Valley sewer. The people are out for Blood—for Coach Blood and, incidentally, the blood of the Board of Education. Nothing will satisfy them but the prompt decapitation of every member. Naturally the school children share in the excitement, and the result is not likely to affect favorably their studies or to improve the general school morale.

Coach Blood is said to be lacking diplomacy, but on the face of things it would seem as though the Board of Education not only lacks diplomacy but also tact, sympathy and a knowledge of human nature. It would not have hurt the board had it shown some appreciation of the basketball team's prowess and with a wise exhibition of tactful sympathy it could have restrained any excess in the sport without arousing violent antagonism and making itself the target of popular vengeance. The whole matter seems to have been unwisely handled and for a time, at least, the schools will be the sufferers.

The *Passaic Daily News* continued their unrelenting support for Blood. In their "Are You for Blood or Are You For the Board of Education?" poll, the voting had risen to 629-3 favoring Blood. The other front-page popularity gimmick, the Bermuda Contest, was continuing to antagonize the school officials. In this race, Blood, Keasler and Knothe were running first, second and fourth respectively. In the face of the support for Blood, Weinberger's advocacy skills and persuasive abilities were losing the battle to manipulate public opinion.

TUESDAY, MARCH 20, 1923
DAY #8 OF THE CONTROVERSY

More than a week had elapsed since the infamous school board meeting where Benson told Blood to "shut up" as Prof attempted to defend himself. Like foolish pugilists, the school's administration and the Blood sympathizers prepared to continue their public hostilities. Little by little, it began to dawn on people that this regrettable confrontation was to have no ultimate victor. But, with different motivational factors supplying the fuel for the two antagonists, the controversy continued.

Mayor McGuire was pleased with the conciliatory frame of mind in which the two opposing committees found themselves as they met in his City Trust Building office. Both camps believed the issues could be resolved. The *Passaic Daily News* reflected that sentiment in their headline:

PASSAIC DAILY NEWS

·Full Associated Press News Service—Special United Press Service—International News Photo Service·

PASSAIC, N. J., TUESDAY, MARCH 20, 1923. PRICE TWO CENTS

RESOLVE BLOOD-ARNOLD CONTROVERSY

Trying to capitalize on the feelings of the moment and find an expedient solution to his client's predicament, Weinberger suggested a private meeting where this delicate issue could be brought to a close. Not liking Weinberger's idea, the mayor was emphatically opposed to anything but

a public hearing. The two groups agreed that they wanted the Mayor to mediate and that all the facts should be made known.

When Weinberger was asked why Arnold had not replied to Blood's accusations concerning his eight years of humiliation, he replied with a rebuttal that would become more of a classic as the controversy continued. "His side of the story," said Weinberger, "will be made known at the proper time and place, and we demand the right to be heard by the authorities constituted to settle it." He went on to say that his attempt to bring a quick settlement to the problem was so that Blood could remain in his position. "We don't want to lose him. And, if it comes to a trial, Prof may have to go." Upon hearing this, Nicholas O. Beery quickly added that Arnold may also have to go. "We may lose both of them, but we don't want that to happen," concluded Weinberger.[150]

Weinberger proved to be the skillful finagler. Sensing that no quick solution to the controversy would show itself, Weinberger made it clear that Arnold had nothing against Blood, and he frequently reminded everyone that he thought Blood was a splendid coach. "The principal of the high school does have the right to disagree with Mr. Blood in certain matters, and he has the right to express his opinion to the coach if he thinks the basketball team is overworked to the extent that it interferes with academics." Weinberger's rhetoric was designed to soften and placate the Blood supporters' offensive, and it was working.

In one breath, agreeing that it was in the best interest of Passaic for Blood to remain, Weinberger added that one of the provisions of any settlement had to include Blood's retracting any wrongful statement made against Arnold. Speaking as a true legist (contradicting himself from the day before), Weinberger said that he did not criticize the BOE for any of its actions because the board had a perfect right to act as it deemed proper, for its members were the sole judges of the conduct of its officers. As far as Arnold's conduct as principal was concerned, it had been one hundred percent above board. Using the press to his best advantage, Weinberger shifted the spotlight away from his client by telling the media that everyone had agreed the controversy was not one between Blood and Arnold or Arnold and Blood but between the BOE and Blood.

On this same day, the *Herald* ran a short story on Prof's salary since coming to Passaic. The dates and amounts were as follows:

E. A. BLOOD'S SALARY SINCE HE CAME HERE

1915-1916	$1,600	1920-1921	$3,000
1916-1917	$1,700	1921-1922	$3,200
1917-1918	$1,800	1922-1923	$3,200
1918-1919	$2,000	1923-1924	$3,400
1919-1920	$2,100		

Salary guidelines during the Blood era were not defined as they are today, and because of the uniqueness of Blood's contributions as compared to his salary, his remuneration was often a topic of discussion. Besides Superintendent Shepherd, the people who decided his salary were either ignorant of his work, jealous of his success, or both. The few thousand dollars Prof was given during last year's testimonial game touched upon the nerves of the principal and some board members. The additional money issue and their differing philosophies on the value of athletics in the schools served to further exacerbate their relationship with Blood.

Another frequent topic of discussion was whether or not Prof was getting paid for his basketball coaching. As far as the BOE was concerned, Prof was paid to supervise athletics; he could do the coaching if he chose or he could assign it to one of the other physical instructors. It was their opinion that Prof's salary included sufficient reward for his time and efforts. Blood never shared those sentiments.

Meanwhile, Prof and the team were enjoying the spoils of victory by canvassing the banquet circuit. Manager Lewis M. Granat honored the team at the local Playhouse, and they dined at the Hygeia Hotel restaurant. It was a gala that included many short speeches, acknowledgments, and a special appearance by Zep. The bear, who had outgrown his mascot duties (too dangerous), had been cloistered in Blood's cellar, but tonight Zep was scheduled to wrestle Paul Blood to the delight of all present.[151]

The highlight of the evening was Prof's talk. While perceived by some to be a reticent man, Prof was nothing of the sort when talking about his purpose in life. His messages often produced goose bumps. "The only kind of training I believe in is right living. Right living is the best training," said Prof. He continued on saying, "Our lives are the reflection of what we think and feel. Think and feel on a high plane, with higher emotions, and you will live a higher life. We are what we make ourselves."[152]

Prof dwelt at some length on the value of athletics in the development of manhood and of his ideals in the training of boys, not merely to become great basketball players, but to become right-living men with healthy, normal viewpoints on life. These were the points he emphasized in his teaching.[153]

The players were used to giving Prof their full attention when he addressed them, but here were parents and ardent fans sitting motionless as the coach spoke. His words touched them—all of them. It was no secret that Prof knew how to inspire, and on this occasion, everyone witnessed what their sons had been receiving in daily doses. They sat quietly, rapt as the man responsible for the aura that surrounded the city brought his message to a close. After a short pause, a tremendous ovation ensued, followed by three big cheers led by Mike Kiddon.

It was the first day of spring, and with each passing day, the school authorities had become more anxious for a quick, agreeable solution to the huge mess. The BOE had its committee, but after looking at the situation, they came to the realization that there were no formal charges to act on. From their perspective, there was nothing for them to do regarding the feud, and because the mayor's committee was not finalized, Benson's committee shifted their attention to how the high school athletic program was supervised. Their intention was to revise certain athletic regulations so the BOE would have more control.

Committee chairman Breslawsky, whose inelegant comments about Blood and basketball at the outset of the controversy inflamed many, learned to choose his public comments more carefully. Breslawsky wanted the entire ordeal to end by having the two men shake hands in friendship and resume their work for the honor and glory of Passaic and its schools. His sentiments were captured by this *Passaic Daily Herald* headline:

BRESLAWSKY WOULD END CONTROVERSY

When Prof was asked about the stalled investigations and how he felt regarding his remarks about Arnold, he said, "I stand by every statement I made, and I am ready to prove them if necessary. The pity is that the conditions which I mentioned existed, not that they came to light." Coming from a man whose reputation for honesty and integrity was widespread, this statement had to be a concern for those interested in safeguarding Arnold's career.

Both newspapers carried an editorial by Edward Allen Greene, a prominent Passaic citizen. In his lengthy commentary titled, "A Plea For Sanity," Greene accused George M. Hartt, the editor of the *Passaic Daily News,* as the chief offender in the Blood War. Greene accused the newspaperman of pouring gas on the flame with his slanted coverage. His plea for sanity called for the warring parties to stop acting like children and, for the good of Passaic, to come to a settlement. His bipartisan editorial did not alter how the *Passaic Daily News* continued reporting the controversy. Its next headlines stated:

DEMAND SQUARE DEAL FOR COACH BLOOD

Hartt defended his newspaper's course of action by indicating that had it not responded in the way it did, the BOE—according to admissions already officially made—would have reprimanded Blood in such a way that he would have been driven from Passaic. To have Blood leave Passaic under those unjust circumstances would have been enough to make the city blush with shame.

Hartt had this to say in response to Greene's editorial:

> *The Daily News has instigated nothing. It did not insti-gate the secret proceedings of the Board of Education a week ago Monday night. It reported them.*
>
> *It did not instigate the mass meeting of protest a week ago last night. It reported it.*
>
> *It did not instigate Mr. Andres's resolution. It exposed and killed it. It did not instigate the public indignation. It reflected it.*
>
> *It did not instigate the communications which have flooded the editor's desk—most of which were so vitriolic that they were not printed.*
>
> *It did not instigate the so-called charges against Mr. Arnold. It printed them, and demanded their investigation.*

Again, reformed Blood critic Jim Egan of the *Hudson Observer* in Hoboken was heard. Commenting on Mayor McGuire's desire for a complete and thorough investigation, Egan knew Blood welcomed such an investigation, but he wondered if Blood's opponents were really of the same mind. He went on to reiterate his comments on the controversy from the previous week. There was something, according to Egan, behind the attack on Blood that had not as yet come to the surface. He felt confident the mayor's committee would eventually reveal the source of the unethical treatment of Blood. Egan was not alone with his hunch. The publicized problem was not the actual underlying problem; there had to be more to this than that which met the eye.

An update on the "Are You for Blood or Are You For the Board of Education?" public poll provided additional support for Blood. The tally had Prof with 732 people for him and three against. You can't please everybody. Currently the top three vote recipients in the Bermuda Contest were Knothe, Blood, and Keasler.

THURSDAY, MARCH 22, 1923
DAY #10 OF THE CONTROVERSY

Following the newspaper editors' decline of Mayor McGuire's invita-tion to be members of his committee to investigate the Blood/Arnold-School Board controversy, everyone was anxious to learn of their replace-ments. The *Passaic Daily News* reported the latest on the athletic alter-cation with this headline:

Without the mass meeting at Smith Academy, the mayor's support for an investigation, and the *Daily News* coverage, Prof would have been in the same position as Parker and the other mistreated teachers— defenseless. The debacle would have ended with Blood either forced to resign or railroaded with a dismissal for insubordination.

The key to getting to the bottom of this conflict was the mayor's committee. Until the committee was officially named, the issue was at a standstill. The BOE's committee had not yet met, and they were not sure when a meeting was to take place. Committee chairman Breslawsky's solution was for the two men to shake hands and make up—end of problem. "No way" was the response. This was, for a number of reasons, impossible. Prof had had enough of Arnold's *modus operandi*, and now the public would not condone it either.

As time passed, confusion over the delayed investigation increased; it also meant that the NYC title game between Commercial and Commerce High Schools was getting closer. The outcome was to decide who would meet Passaic in the challenge game. At the outbreak of the controversy, the City Commissioners passed a resolution granting the Wonder Team permission to play the popular challenge match. Now no one knew for sure if the big game would be played or not.

When asked about the game, Blood indicated that he was ready to play any team. He preferred to meet Crosby, but the eventual opponent did not matter. The scholastic fans in the large metropolis were thrilled with the thought of seeing Passaic play their city champs. The game would be played in the Seventy-first Regiment Armory, and an estimated 15,000 New Yorkers would attend.

FRIDAY, MARCH 23, 1923
DAY #11 OF THE CONTROVERSY

McGuire's selections for his committee to investigate the controversy were finally made public. The *Passaic Daily News* continued its lead story coverage of the uproar with this headline:

MAYOR M'GUIRE NAMES INVESTIGATORS

The mayor selected Samuel P. Vought and Edward C. Vannaman to serve along with Judge Walter C. Cabell. Vought was one of Passaic County's leading real estate brokers and a prominent member of the Elks Club. Vannaman was a partner in the Hart-Vannaman law firm and served as president of the Passaic Lions Club. With Judge Cabell, who presided over the local District Court, the mayor's committee was final-ized. The three men immediately began to gather facts and information with the goal of bringing the controversy to a quick and amicable settlement.

In the wake of the mayor's appointment, another fuss over a school matter arose between our two main antagonists. This new glitch centered

on a school-sanctioned fund-raising dance that was scheduled for the following day at Smith Academy. Capitalizing on the success of the Wonder Team, the affair was billed as the "Wonder Dance," and after gaining approval from the principal, it was publicized throughout the school. Arnold was undoubtedly not aware of the ramifications of involving amateur athletes in a fund-raising event.

When word of a dance involving the Passaic basketball team reached the offices of the NJSIAA, the Amateur Athletic Association, and the Intercollegiate Athletic Association, red flags were unfurled. They each declared that if any of the basketball players participated, they would immediately lose forever their amateur status.

At first, the aspersions were directed at Prof because he should have known better. It was soon learned that Prof was never informed of the dance, and when questioned, he again expressed his feelings to the media. "It is just another example of what has happened at the high school," he explained. "I understand Mr. Arnold sanctioned the dance and permitted announcements to be made. I would never have allowed it, for it would disqualify the players from participating in any more high school, college or amateur athletics of any kind." Blood concluded his feelings on the matter by saying, "Here is a matter for which I, as director of physical education, should rightfully be responsible, yet I was never consulted and the principal allowed it to go on."

The dance was first organized by basketball manager Royal Drew and his predecessor Edward Sullivan. Their lack of foresight led them to associate the popular Wonder Team with their event. Aside from the loss of amateur status by the players, it was a

ROYAL DREW

good idea. The dance was held successfully; however, it was held without any association from the Wonder Team.

The "Are You for Blood or Are You for the Board of Education?" voting was becoming more and more of a landslide. The latest tally had 806 for Blood and 3 for the BOE. The Bermuda Contest was equally revealing with Knothe, Blood, and Keasler still three of the top four vote getters.

SATURDAY, MARCH 24, 1923
DAY #12 OF THE CONTROVERSY

While the mayor's newly appointed committee was planning its investigation, the 1922 Testimonial Committee (over thirty members) was reorganizing for another go at a second testimonial game for Prof. The strong feelings by many leading Passaic citizens to fairly compensate Prof for what he was doing for the city were again expressed. As far as they were concerned, Prof was a Passaic treasure worth protecting. Prof

had put Passaic on the map. His presence was cherished, and the masses did not want to entertain thoughts of his leaving for greener pastures. A token of their appreciation in the form of a monetary reward from a testimonial game was again their solution.

The *Passaic Daily Herald* prefaced their coverage of another testimonial game with: **EFFORT BEGUN TO STAGE BLOOD TESTIMONIAL GAME**.

That evening, the Blood Testimonial Game Committee met at the City Trust Company Building. The objective of their meeting was to figure how to get the BOE to rescind their resolution banning games for benefit or commercial purposes, but they were unsure as how to best approach the board. Aside from jealousy or revenge, it was difficult to understand how such a resolution was ever conceived in the first place. It was looked upon as a direct affront to efforts favoring additional compensation for Blood.

Meanwhile, Prof was spending the weekend in Troy, NY, as the celebrity guest of their YMCA. The citizens of Troy had embraced the game of basketball and were ecstatic to have the successful coach in their midst. Prof would be ushered from one speaking engagement to another the entire weekend. They wanted to share him with the entire city, especially their youth. Billed as "The Grand Old Man of Basketball," Prof received the royal carpet treatment from the New Yorkers.

Prof's chaperones introduced him as the coach of the greatest basketball team the world had ever known—a man who made men of boys. According to Prof, his mission was to help boys grow properly. The success of his teams was merely incidental, stemming from their unselfish teamwork. His job was not that of a basketball coach, but one of a character builder. More emphasis was put on making men than on shooting baskets. Prof's message, which was spoken with passion, did not go unnoticed. When he spoke, one could hear a pin drop; no one wanted to miss a word.[154]

MONDAY, MARCH 26, 1923
DAY #14 OF THE CONTROVERSY

At the City Trust Building on Saturday, the committee decided that it was useless to ask the BOE to rescind their resolution banning benefit games. The gathering believed that since the BOE had never officially gone on record as opposing additional games, the challenge from the NYC champs could be played. Another solution that received favorable attention was the idea to host a vaudeville performance at one of the local theaters with the proceeds going to Blood. In keeping with their propensity for reporting the news from a pro-administrative point of view, the *Passaic Daily Herald* captured the attention of the populace with this pedantic headline: **SCHOOL MAY PLAY BUT NOT FOR BLOOD**.

Breslawsky, chairman of the athletic committee, went on record as saying that the BOE would not oppose a game if it were conducted by school authorities and a complete financial report indicating the disposition of funds was submitted. The news of this development prompted legions of smiling faces. When Arnold was apprised of the board's position on the game, he immediately and graciously acquiesced by acknowledging the board's authority. Because the BOE had full authority, he would support such a mandate even if he had previously spoken out against playing more basketball games. Arnold's sudden reversal on the issue illustrated his survival instinct.

The Big Apple's basketball championship was decided on Saturday with a decisive 29-21 Commerce victory. After dribbling to an 11-11 half time stalemate, Commerce dominated Commercial of Brooklyn. The Passaic fans in attendance claimed the superior play of the Wonder Team would produce a thirty to forty-point victory. When Prof was asked for his prediction, the Grey Thatched Wizard modestly indicated that Passaic would beat Commerce by twenty points. He must have seen them play.

The big news that the *Herald* failed to report was that the New Yorkers withdrew their challenge. The "difficulties" that existed in Passaic were cited as the reason for this change of heart. Besides, the Jewish holidays were to begin the following weekend thus eliminating many of Commerce's players for religious reasons.

On this same day, the *Passaic Daily News* redirected the news back to the investigation. It reported that Judge Cabell planned to conduct open hearings to get to the facts. His committee would hear testimony from anyone having information relating to the controversy. The entire story was summarized in the headlines stating:

PASSAIC DAILY NEWS

Full Associated Press News Service—Special United Press Service—International News Photo Service

Forty-Sixth Year—Passaic's First Daily PASSAIC, N. J., MONDAY, MARCH 24, 1925.

MAYOR'S COMMITTEE TO CONDUCT FULL AND FREE PROBE OF ARNOLD-BLOOD CASE

The hearing would begin as soon as possible at a time and place to be announced.

On the lighter side, the Bermuda Contest had entered the white-knuckle period with just three days until closing. The "Are You for Blood or Are You for the Board of Education?" voting continued to be a landslide endorsement for Blood. The tally for Blood had reached 856 while the BOE still remained at merely 3 votes. The balloting was officially over on March 26, but the newspaper would continue to accept votes for the next couple of days.

In an effort to divert public attention from the controversy, *Daily Herald* reporter Merrill related that the undefeated New York state champions from Port Chester were interested in playing Passaic. If it were up to Blood, he would agree to play any worthy team. The news article was designed to arouse public interest in a NJ-NY clash of basketball titans: **BLOOD READY TO PIT TEAM WITH NEW YORK CHAMPIONS**.

Expressing his views on the alleged challenge, Prof said that he would have issued his own challenge to any high school team in the country if this controversy had not started. Merrill did not mention in the article that the ultimate decision to play Port Chester would be made by the BOE, not by Blood.

On the investigative front, the two committees had joined forces in an apparent sign of good faith to coordinate their efforts. The school board's committee had begun assisting the mayor's committee in scheduling hearings at which people would testify. The public, meanwhile, was getting impatient with the slow pace of the investigation.

With Arnold scheduled to give testimony, a demonstration that many believed could prove very damaging to his cause, Breslawsky summoned Blood for a talk. As a way out and to bring finality to the controversy, Breslawsky presented Blood with a letter he had written for Prof to sign and return to him. The letter read as follows:

My Dear Mr. Breslawsky,

> *Our conversation of a few days ago has been very much on my mind. I regret extremely all that has happened. After mature reflection, I feel that it was unfortunate that I spoke at all at the Smith Academy meeting. I did not want to speak, but was induced to do so, and I was in no shape to speak. I am convinced that under the excitement of the occasion, I spoke too strongly, and on calm reflection, I feel that I was not altogether just to 'Prof' Arnold. I can see now that what I was inclined to consider slighting treatment on his part was, no doubt, not intended so much by him, and can be satisfactorily explained. I feel sure that 'Prof' Arnold and I can get along together, and clear up the situation, and that by reaching, in a friendly way, a perfect understanding, we can continue to work together for the young people of Passaic. I would appreciate it if you would let 'Prof' Arnold know that such is my feeling, and ascertain his attitude.*

Please accept my thanks for the very fair and friendly position which you have taken in this matter.

Respectfully yours,
E. A. Blood

Prof responded to Breslawsky with this letter:

Dear Mr. Breslawsky:

I have given due thought to the matter of the letter, addressed to you, which you handed to me on Tuesday with the request that I copy it, sign and return it to you. I beg to say that I cannot sign the letter.

Permit me to advise you that I have sent a copy of your letter to Judge Cabell as a matter of information for the Mayor's Committee.

Respectfully yours,
E. A. Blood

WEDNESDAY, MARCH 28, 1923
DAY #16 OF THE CONTROVERSY

Just as a record-breaking cold wave arrived, a sign of progress came. The city's most awaited event was finally scheduled to take place. The committees had arranged for Arnold to appear and address the charges Blood had made public over two weeks before. The principal had previously expressed his desire to tell his side of the story at the "proper time." In light of the fact that the BOE's committee was co-sponsoring the investigation, it appeared that the proper time had finally arrived. The *Passaic Daily Herald* nailed down Arnold's pending announcement with this headline: **ARNOLD TO TELL HIS STORY TO PROBERS NEXT WEEK**.

Unlike initially announced, Arnold's meeting was to be a private preliminary meeting designed to get to the facts. Breslawsky spoke of a public meeting that would come later. To avoid chaos, the time and place of the private meeting with Arnold was kept confidential. When a *Passaic Daily News* reporter asked Arnold about appearing at the scheduled hearing, he refrained from replying except to refer the matter to his counsel Weinberger. It was the intention of the committees to call Blood next.

Besides reporting on the latest news concerning Arnold's scheduled meeting, the *Passaic Daily News* also covered Blood's reaction to Merrill's write-up in the *Daily Herald* about the challenge game with Port Chester from the previous day. The headline read: **CALL ARNOLD AS FIRST WITNESS IN PROBE—PORT CHESTER NOT CHALLENGED**.

Prof took exception to Merrill's article, and he did it publicly in the newspaper of Merrill's competitor. Blood believed that the *Herald's* article was written not only with malicious intent but also for mercenary purposes. Blood referred to the article's contention that he desired to challenge Port Chester as nothing more than a myth. Prof especially did not appreciate Merrill portraying him as flagrantly opposing the BOE's rules when this was decidedly not the case.

Proceeding with disregard for any amicable future working relationship with the *Passaic Daily Herald*, Prof initiated a news release to the Associated Press correcting the misleading *Herald* news story. Here is how the AP handled the Port Chester retraction:

Passaic, N. J., March 28—

Ernest A. Blood, head coach of the Passaic High School basketball team, today emphatically denied the report that he would challenge the Port Chester High School team of Port Chester, New York, champions of the Empire State.

Mr. Blood characterized the report as "ridiculous" in view of the recent ruling of the Passaic Board of Education forbidding the world champion team from participating in any games for commercial or benefit purposes, and placing the control of the team's activities in the hands of the board....

THURSDAY, MARCH 29, 1923
DAY #17 OF THE CONTROVERSY

While the committees had their heads together preparing a timeline for their investigation, they were informed that Prof Blood would not be available the following week. Because of his desire to cooperate, he agreed to appear before the two committees the very next day. Blood's appearance before the committees and Arnold's the next week were to be preliminary meetings held in private sessions. The times and places for these hastily arranged meetings were also kept confidential.

The big news of the day was the final results of the Bermuda Contest. The *Passaic Daily News* reported: **"Prof." Blood, Keasler and Mrs. Lefferts Win Bermuda Contest**.

The small caption over the write-up stated, "Director Blood Receives 13,764 Votes, Leading Nearest Rival by 1937." The contest winners were to receive a free trip to Bermuda scheduled for Easter week. The top three vote getters were scheduled to sail on the *S. S. Fort Hamilton* on the following Monday morning. The final tally of votes was as follows:

"Prof." Ernest A.Blood, 31 Spring Street, Passaic **13,763**
DeWitt Keasler, 158 Sherman Street, Passaic **11,827**

Mrs. Joseph H. Lefferts, 67 Marsellus Place, Garfield **11,406**
Mrs. Edson S. Shorter, 439 First Street, Carlstadt **11,240**
Wilfred (Fritz) Knothe, Bond Street, Passaic **10,278**
Miss Frances Tierney, Aycrigg Avenue, Passaic **7,417**
Emil W. Haag, 208 Hope Avenue, Passaic **6,409**
Eugene (Gook) Helwig, 15 Ridge Road, Rutherford **5,344**
Miss Helen Kruger, 15 Prescott Avenue, Clifton **807**
Jack Wright, 20 Hepworth Place, Garfield **161**
Edward Frey, Madison Street, Carlstadt **148**
William Petraseh, 29 Semel Avenue, Garfield **88**
Robert Driscoll, 82 Washington Place, Passaic **84**

The public interest in this publicity stunt was such that a crowd of basketball fans gathered at the newspaper office into the late hours wanting to learn the fate of their sport's heroes. With so many last-minute votes, the task of tallying was too cumbersome to complete before many had to leave without knowing the final results.

Shortly after the top three winners were announced, a drive was started by some of the diehard fans led by R. H. Dunseath, Harold W. Saunders, and Abe Freeswick to finance a ticket for their all-state guard Fritz Knothe. The celebrated gesture was so warmly received that the idea was expanded to also include the other three starters. As it turned out, all five starters and Prof and Mrs. Margaret Blood planned to leave the frigid cold weather for Bermuda.

FRIDAY, MARCH 30, 1923
DAY #18 OF CONTROVERSY

The BOE's and the Mayor's committees were preparing to have their first meeting with one of the principle antagonists (Blood) in the high school dispute. To the delight of both committees, the investigation was finally moving forward.

SATURDAY, MARCH 31 1923
DAY #19 OF THE CONTROVERSY

The news of Blood's testimony to the investigating committees leaked to the public. Prof reiterated his experiences working with Arnold. So graphic were his accounts of specific occurrences that Judge Cabell, chairman of the mayor's committee, influenced Prof to suppress his testimony. The final piece of the puzzle would come next week when Arnold would present his testimony regarding Blood's accusations.

MONDAY, APRIL 2, 1923
DAY #21 OF THE CONTROVERSY

On Monday morning, the winners of the contest sailed off to Bermuda. The Wonder Team party consisted of Prof, Mrs. Blood, and the Passaic Big Five: DeWitt Keasler, Fritz Knothe, Mike Hamas, Fred Merselis, and Moyer Krakovitch. It was Easter holiday vacation, and they were off for a fun-filled, five-day getaway from the controversies that had engulfed Passaic for the past few weeks.

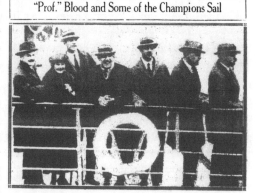

"Prof." Blood and Some of the Champions Sail

While the public's interest in the investigation was showing signs of waning, it was still very much an issue with those involved. With Prof and the players away, the committees' attention centered on Thursday's meeting scheduled with the principal. As you will recall from the very beginning of the basketball dispute, Arnold had indicated his willingness to answer Blood's accusations, but as he said, he would do it "at the proper time." Everyone agreed that the proper time had arrived.

TUESDAY, APRIL 3, 1923
DAY #22 OF THE CONTROVERSY

Spring came in like a lion, and the lion decided to stay for awhile. The wait for spring-like weather was secondary to the speculation concerning Arnold's approach when facing the committees. While the public was unaware of all the details surrounding Arnold's meeting, they wanted some answers. The dispute had become an obvious source of embarrassment for the city.

WEDNESDAY, APRIL 4, 1923
DAY #23 OF THE CONTROVERSY

The committees and attorneys were scurrying about in preparation for Arnold's long-awaited meeting. What was to occur next in the long, annoying controversy was nothing short of completely unexpected and shocking.

THURSDAY, APRIL 5, 1923
DAY #24 OF THE CONTROVERSY

An unpredictable turn of events came in the form of an application to the New Jersey Supreme Court for a *writ of certiorari,* which would effectively stop the investigation. Judge Richard J. Baker of the law firm Baker & Baker in Garfield instituted the writ at the request of none other than Dow H. Drukker. Early that morning, Judge Baker traveled to the Hoboken home of Supreme Court Justice James F. Minturn to personally submit the application for the investigation-halting writ. The *Passaic Daily News* captured the essence of the writ with the following front-page headline: **INVOKE COURT TO STOP ARNOLD PROBE**.

According to Justice Minturn, the purpose of the *writ of certiorari* was to test the legality of Mayor McGuire's committee appointments and their right to gather testimony. The question remained, did they have the legal authority to conduct this inquisition? The immediate effect of Drukker's intervention was to further delay investigation until arguments could be heard, and the arguments could come as late as the first Sunday in May. Baker readily admitted that the reason for the writ was to prevent Arnold from testifying that evening (or possibly ever). "I think the idea is that the whole controversy should be stopped," concluded Baker.

The *Passaic Daily Herald* headline explained the purpose of the writ another way:

PASSAIC DAILY HERALD

Member of the Associated Press—Leading and Most Largely Circulated Paper in Passaic—Member Audit Bureau of Circulations

FIFTY-FIRST YEAR—NO. 9261 PASSAIC, N. J. THURSDAY EVENING APRIL 5, 1923 PRICE TWO CENTS

COURT ACTION STOPS BASKETBALL PROBE

The key figure in the controversy suddenly, inexplicably became Dow H. Drukker. His *writ of certiorari* halted the investigation that had consumed the city and the surrounding area for the past few weeks.

Drukker was part owner of the *Passaic Daily Herald*, construction magnate, and former congressmen, but most crucial to our story, he was the father of young Dow Drukker, Jr., who had played on the basketball team during the Johnny Roosma era. Drukker had been following the controversy with keen interest. He was amazed and astonished by statements appearing in the *Passaic Daily News* concerning the feud.

The contents of Drukker's *writ of certiorari* revealed his feelings on the controversy and the hype the *Passaic Daily News* was giving the investigation. He believed that because the proceedings were entirely irregular, in contravention of existing laws, and without legal precedents, they should be suspended immediately.

Drukker believed the mayor's committee was not a legally constituted body. As far as he was concerned, because the committee did not have the proper authority (McGuire's committee never claimed to have authority), it did not have the legal right to interrogate witnesses and conduct such proceedings. His conclusion was that McGuire's committee's role in the investigation was a farce and a travesty of justice. Quoted directly from the writ, Drukker concluded that he "respectfully prays that a *writ of certiorari* be granted staying the said committees from conducting any further action and determine whether said committees are legally justified in proceeding in the manner which they are attempting."

By his own admission, Drukker was very interested in the investigation of the controversy. Why? What was his motivation for getting involved? How acquainted was he with Arnold? Was he trying to save Arnold from embarrassment if the truth were revealed? Many questions can be asked along these lines, but they are unanswerable except by conjecture.

Let's state what is known. Congressman Drukker's son was an accomplished young man, but as a basketball player, he was mediocre. During the 1918-1919 season, his sophomore year, he saw very little playing time. During the infamous loss to Union Hill in the state finals, some were of the opinion that Prof should have substituted Dow Drukker, Jr., in the game. That evening, Johnny Sipp had an unusually poor game, but Prof elected to stay with him. John Roosma believed that if Prof had put Drukker in the game five minutes sooner, the state championship game could have been won.[155]

How did Drukker, Sr., react to his son sitting on the bench believing his son could perform better than another player whose performance was hurting the team? It's a scenario replayed during every high school game when parents are spectators. It is a difficult situation for any parent to see his or her child sit the bench during a game. It can also create a jeopardous

situation for the coach if the father is influential. The congressman was capable of providing many things for his seven children, but he couldn't get his son off the Passaic bench; it was out of his control. Prof deprived his son of this once-in-a-lifetime opportunity.

Drukker's family connections with Passaic basketball did not end with his son. Three other Drukkers were involved with basketball at the school. Dow Junior's younger brother, Richard, was one of the last boys, if not the last, to play on Passaic's Second Team. The Second Team, at that time, was comprised of boys who were not among the varsity's top ten players. As his brother

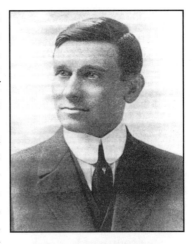

DOW H. DRUKKER
"History of Passaic and Its Environs"
by William W. Scott. Vol. 2 (c. 1922). New York:
Lewis Historical Publishing Comp., Inc.

before him, Richard was a good kid, but he saw very little playing time; actually, he may have spent more time serving as a manager. On the other hand, Louise and Gertrude Drukker, Drukker, Senior's daughter and niece respectively, were good players for the girls' team.

Fate played a role in that the advent of the Blood-Wonder Team era and the arrival of the Drukker children at Passaic coincided. With all the excitement about basketball at his kids' school, the all-powerful Mr. Drukker was helpless in getting his son more playing time on the high school team. Exactly what resentment or animosity was created by this predicament cannot be fully documented, but many telltale signs of Prof's problems emanated from it.

When Prof first became aware of Drukker's dissatisfaction is not known. Drukker's meddling may have begun before or around the time of the Union Hill loss. But it was the *writ of certiorari* that first publicly revealed Drukker's involvement. Drukker was a successful man who was used to being first; his ambition and talents merited it. In fact, he always stressed the importance of being first to his employees. To him, unlike the multitude, Passaic basketball was a source of frustration. His children and niece were exceptional young people, but they did not bask in any of the attention heaped on the Wonder Teams, and in his mind, Prof was the reason why.

Drukker's view of Blood's personal role in stifling his children may explain why he was willing to go to great lengths to support Arnold. Blood's authority over the basketball program had to be minimized, and because Drukker could not do it himself, Arnold and the BOE became his tentacles. Drukker had undoubtedly been in communication with his

friend and business associate, school board president Benson. Drukker and Benson were powerful men, men of means who had tremendous influence over other men of importance in and around Passaic.[156] They were wealthy, intelligent men who thrived in the cutthroat world of business and politics. They also had a good relationship with Arthur D. Arnold. The politically astute Arnold made it his business to win the favor of the local power brokers. They admired the job he had done as principal and, more than likely, understood the methods of leadership he practiced.

Drukker had already made inroads by securing Prof's main publicity agent, the *Passaic Daily News*. To what lengths would he go to get what he wanted without getting his own hands dirty? After having gone to the Supreme Court of New Jersey to achieve his aims, what more would he do?

One source of Prof's difficulties was becoming clear. All of his upstanding intentions, straightforwardness, and public support had little influence because he was in political waters over his head. Compared to the political power and influence of these men, Prof was in a different league. Public sentiment no longer carried any clout in this dispute. Prof was up against men who not only controlled the rooks, bishops, and knights but also the kings and queens of the Passaic polity. Prof was a coach and physical educator not a politician or major businessman. He was not equipped to succeed in a dispute with these behemoths of civic affairs. Being right had little bearing on the outcome of a joust with Drukker and Benson. It was becoming obvious that the jurisprudence of this controversy was going to be legally rigged, and the rigging was not going to be in Prof's favor.

FRIDAY, APRIL 6, 1923
DAY #25 OF THE CONTROVERSY

As if there were any citizens in New Jersey who were still unaware of the *writ of certiorari*, the *Passaic Daily News* chose this headline: **INVESTIGATORS BOW TO COURT ORDER**.

The committees were in a quandary over the court's sudden intervention. After meeting, the committees decided, out of respect for the court, that the investigations should cease while their right to function was reviewed. A regular meeting of the school board was scheduled for Monday, and Breslawsky was prepared to report a summary of his committee's activities. After that, the board would decide the next step in sifting through the charges alleged by Blood.

In reaction to the *writ of certiorari*, Nicholas O. Beery, the chairman of the citizens' committee, called a meeting for the following day to discuss future strategies. Beery viewed the writ as a colossal blunder on the part of the anti-Blood forces. Because Arnold no longer had to testify,

many felt that Blood's allegations were far more serious than initially stated. The intent of the writ, according to Beery, was to intimidate, and he did not feel it was going to work.

Meanwhile, Prof, Mrs. Blood and the Big Five were enjoying Bermuda. What new developments would arise once the *S. S. Hamilton* returned to port would have to wait for Monday night's board meeting.

SATURDAY, APRIL 7, 1923
DAY #26 OF THE CONTROVERSY

It appeared as if the future of the feud would be decided at the next meeting of the BOE. Some were beginning to doubt whether it had any future at all. The *Passaic Daily Herald* ran this headline and a brief story: **EDUCATION BOARD TO HEAR REPORTS ON BLOOD INQUIRY.** Many planned to attend the meeting to learn the latest word on the investigation.

SUNDAY, APRIL 8, 1923
DAY #27 OF THE CONTROVERSY

As the Bermuda Contest winners arrived home, they were greeted by friends at the pier. The Bloods were delighted with the trip. "Everything was just lovely," said Mrs. Blood. "The boat trip was fine, and the island was beautiful. We enjoyed every minute of the week." They toured the island and enjoyed the beautiful view from the Giggs Hill lighthouse. The players had fun swimming at the hotel pool and caught rides on the waves at Elba Beach.[157]

MONDAY, APRIL 9, 1923
DAY #28 OF THE CONTROVERSY

The primary purpose of the BOE meeting was to address the basketball situation that had propelled a local interest story to state and national attention. In a brief article published by the *Passaic Daily Herald* titled **BASKETBALL TO BE CHIEF CASE UP AT MEETING**, it was reported that the controversy was scheduled to be discussed at the BOE meeting that evening. It is interesting to note that this was where the row originated. It was anticipated that the board would assume control of the investigation by adopting its own procedure.

Judge Cabell took public exception to the writ. His feelings were hinted at in the headlines of the *Passaic Daily News* with this write-up: **JUDGE CABELL ATTACKS PURPOSE OF THE DRUKKER WRIT**.

According to Cabell, an "appropriate return to this writ is a statement that there are no such complaints, etc., and no such record, that is, to send up nothing. The legal effect of this writ is nothing. What is its practical and moral effect each succeeding day will show. It is quite clear the

purpose of those who induced the justice of the Supreme Court to issue this writ was to prevent citizens from exercising their (inalienable) right of inquiring into public affairs, or at least to embarrass and intimidate them."

A transaction receiving very little media attention had Dow H. Drukker, who owned fifty percent of the *Passaic Daily Herald*, purchasing 230 (or 11.5%) of the two thousand total shares of the preferred capital stock of the *Passaic Daily News*.[158] Seven years later, George M. Hartt and Rudolph E. Lent decided to sell their controlling interests in the *Passaic Daily News* to Harry H. Weinberger. As planned, Weinberger resold the newspaper to the *Herald's* owners. Two years after Hartt's and Lent's sellout, Drukker engineered the merger of the two Passaic newspapers into *The Herald-News*.[159] The rest is history.

TUESDAY, APRIL 10, 1923
DAY #29 OF THE CONTROVERSY

BLOOD ORDERED TO MAKE GOOD ON ARNOLD CHARGES. The *Passaic Daily Herald* captured the public's attention with this headline. At the well-attended board meeting with the two main antagonists absent, the board wanted Blood's charges in writing clarifying the details of his humiliation working under Arnold for the past eight years.

In a less harsh tone, the *Passaic Daily News* printed this caption: **SCHOOL BOARD TO HEAR BLOOD'S CHARGES**.

President Benson's special committee drafted a resolution calling for Blood to present his charges. The resolution was unanimously approved by the board (Board Member Dr. John Szymanski was absent), and it read as follows:

> *"**WHEREAS**, Mr. Ernest A. Blood is alleged to have made public charges regarding the conduct of Mr. Arthur D. Arnold, as affecting Mr. Blood's work in the public schools of this city, and*

> *"**WHEREAS**, both gentlemen are employees of this board, and it is desirable for the well-being of the school system, that any such charges as may be made, be presented to this board, before whom they may be formally examined into and adjudicated, as provided by law.*

> *"**BE IT RESOLVED**, that Mr. Blood be and is hereby directed to formulate and present to this board in writing, any charges, if any against Mr. Arnold as he may feel himself entitled to prefer, to the end that this board may examine into and adjudicate the same, as provided by law and that*

the secretary of this board promptly cause a copy of this resolution to be delivered to Mr. Blood."

Referring to the recent Supreme Court petition, President Benson informed those present at the meeting that Drukker's *writ of certiorari* did not take any power from the BOE. As far as the well being of the school system was concerned, the writ did not prevent the board from investigating the actions of its employees. Benson concluded by adding that if Blood decided not to file any charges, there was nothing the board could do. Another option, according to Benson, was for the board to try Blood for making public accusations against Arnold that he could not substantiate.

The second part of Breslawsky's report explained the committee's plans for restructuring the school's athletics by redefining how they would be administered. The recommended restructuring was designed to give the board total control. This would be accomplished by placing athletics under the direct supervision of the Athletic Council. Breslawsky's restructuring would delineate clear lines of authority and responsibility. The new guidelines also reiterated a previous board edict that no games for commercial or benefit purposes by any team would be allowed.

Another gem gleaned from the committee's research concerned the academic standing of the basketball players. When compared to their non-athletic peers, this year, athletes were less accomplished academically. The committee learned that only one of the eighteen boys on the squad had a grade in English better than the passing mark, and many of Blood's players had to repeat some subjects several times. Despite the fact that this was never an issue in previous years, the committee inferred that the basketball schedule was solely responsible for these lower marks and recommended that the new Athletic Council arrange future athletic activities so that scholastic achievement not be jeopardized. The Board also noted that when comparing the ages of all Passaic athletes to their non-athletic classmates, they found the athletes to be nearly a year older. The board did not note that this is often the case in athletics as every month counts in the physical development of young men, thus the older children often have the athletic edge.

WEDNESDAY, APRIL 11, 1923
DAY #30 OF THE CONTROVERSY

When probed for his reaction, Prof preferred not to discuss the board's resolution directing him to put his complaints in writing. In other school board action, Prof and Principal Arnold were both reappointed for the ensuing school year. The principal's yearly salary was fixed at $4,400

which did not reflect an increase over the previous year. The physical director's salary was increased to $3,500, which was $300 more than the current year. No reasons or explanations were given.[160]

FRIDAY, APRIL 13, 1923
DAY #32 OF THE CONTROVERSY

Continuing their attempt to influence public opinion by subtly slanting the coverage of the controversy, the *Passaic Daily Herald* proclaimed this headline: **MEETING MONDAY TO STIR UP BLOOD ROW**.

The Citizen's Committee (William R. Vanecek, Manuel N. Mirsky, Nicholas O. Beery, Harold W. Saunders, and Robert Walker) decided to meet again at Smith Academy. The two main items on their agenda were the *writ of certiorari* granted to Dow H. Drukker and the resolution directing Blood to put his charges in writing.

According to Vanecek, the committee was working closely with Blood. He assured the newspapers that written charges against Arnold would be made, if not by Blood, then by someone else. Vanecek wanted to refrain from further speculation until after Monday's meeting.

SATURDAY, APRIL 14, 1923
DAY #33 OF THE CONTROVERSY

The following day, the news broke that city counsel Albert O. Miller, Jr., who was representing McGuire, served notice to Judge Baker (counsel for Drukker), the recorder of the writ. Miller planned to appear before Supreme Court Justice Minturn to have the writ squashed. His message was made clear to the *Passaic Daily News* readers with this front page lead story: **CITY COUNSEL MILLER WILL MOVE TO HAVE DRUKKER WRIT VACATED**.

Counselor Miller was of the opinion that Drukker's writ was without weight and his move to have it vacated would be successful. The writ was primarily directed at the Mayor's committee, although it also included Benson's committee.

It was the consensus of the Mayor's committee that if Prof put his charges in writing, the entire burden of proof would fall upon him. This implied that any similar evidence from others, even though from different situations, might be viewed as irrelevant and immaterial. If another body of citizens brought charges against Arnold, then Blood could appear as one of the main witnesses, along with others if need be. "It is not right for the Board of Education to expect Mr. Blood to bring charges formally, and I am of the opinion that he will not. It looks now as if the Citizens' Committee will have to make the formal charges against Mr. Arnold," informed Counsel Miller.

MONDAY, APRIL 16, 1923
DAY #35 OF THE CONTROVERSY

On the day of the second mass meeting at Smith Academy, many of Prof's friends were reviewing their present situation. Naturally, Counsel Miller's rebuttal to Drukker's investigation-halting *writ of certiorari* was of particular interest. Miller asserted that the writ was unique in New Jersey legal history because it contained "nothing." There were no complaints, orders or proceedings. He remarked that it was just as Judge Cabell said on April 7.[161] In laymen's terms, the writ was a fabrication. It was all Drukker. He used his personal clout and influence to get the writ presented and accepted.

TUESDAY, APRIL 17, 1923
DAY #36 OF THE CONTROVERSY

The first "break" in the Arnold/Blood controversy finally arrived after six weeks of running in circles. During their meeting, the Citizen's Committee decided to bring formal charges against the principal. They claimed Arnold was not acting in the best interests of either the city or the students. It was agreed that funds would be raised by popular subscription to be used for hiring a lawyer to pursue their case against him.

Among the approximately 150 people attending the meeting, some were not enthusiastic about the direction in which the committee was heading. For one, there was Grover P. James, a local attorney, who was concerned with the negative publicity the city was receiving because of the controversy. He concluded that everyone would be better off if the matter were dropped.[162]

Charles A. Miller, who was a candidate for one of the commissioner positions in the upcoming elections, echoed James's opinion. Miller added that if he were in a position of authority, he would call the men together, talk the whole matter over, and agree to something "or the fur would fly." Miller and James were not alone in their opinions of the continuing effects of the media-frenzied investigation.

In reply to their valid opinions, Citizen Committee Chairman Vanecek said that "Mr. Blood cannot let bygones be bygones, and neither can the people of Passaic in this case." While the emotions of the group were high, the idea to proceed or retreat was put to a vote; they agreed overwhelmingly to go forward with charges against Arnold.[163] While the support for Blood was real, the masses were becoming embarrassed by the negative publicity reaching neighboring cities and beyond.

Thursday, April 19, 1923
Day #38 of the Controversy

While there was a lull in Passaic's disputatious Arnold/Blood affair, Prof busied himself with another calling. Since winning the first state championship, Prof had been accepting speaking engagements at youth sports banquets. The publicity from his team's exploits and now from the media attention via the controversy had elevated Prof's name and that of the Wonder Team to household names. Consequently, Prof became a powerful after-dinner speaker in great demand. All altruistic reasons aside, Prof was paid well for his public monologues.

At one such banquet for the Industrial Athletic Association held at the Bayonne YMCA, Prof noticed that in the program alongside his name was printed "Coach of Passaic 'Wonder' basketball team." His intended topic, "Victory Is Only Incidental," was preempted by the caption that caught his attention. He told the gathering that the name "Wonder Team" did not originate in Passaic and that he personally regarded the term as distasteful. Prof told them that he and his players never claimed anything. The boys, he said, were not wonders, just good athletes trying to do their best.

Prof also spoke about his thoughts on winning and how, in the Passaic philosophy, victory was only incidental. The main goal of athletics, he related, was the inculcation of ideals, honor, and the right spirit in the boys so that they could receive the best training for the game of life. As silence saturated the hall, his remarks came as a revelation to all those present. The only news they ever heard about Prof Blood and his unbeatable teams came from Hudson County newspaper sportswriters who only embellished the accomplishments of their county teams. For his remarks, Prof was greeted with a hearty ovation as the crowd realized what the Passaic coach stood for. Two days later, Prof was off to Elmira to address another crowd eager to learn what he and his Wonder Teams were all about.[164]

Saturday, April 21, 1923
Day #40 of the Controversy

And then it happened. The news of Supreme Court Justice Minturn's decision regarding the writ hit the newsstand. The decision was bigger news in the Passaic area than when a German torpedo drained the air from the hull of the ocean liner *Lusitania* almost eight years earlier. The *Passaic Daily News* headline proclaimed it loud and clear: **MINTURN DISMISSES DRUKKER WRIT**.

Early Saturday morning, Miller and Baker met with Minturn in his Hoboken chambers. In dismissing the writ, the Supreme Court Justice announced that any duly-appointed committee had the right to look into

224

and investigate a matter of public welfare. In the opinion of the court, the committee named by the mayor was of such a nature.

Addressing Baker, who was trying to have the investigation terminated, Minturn said, "If these people (referring to those to whom the writ was directed) have committed any breach of the peace or any crime, why don't you bring them before the grand jury?" The Supreme Court Justice went on to say that Drukker's right did not supercede the right of any other citizen, and for that reason, he was not entitled to the writ.

Compelled to report on the same decision, the *Passaic Daily Herald* confined their coverage of the writ's fate to a small, bottom of the front-page write-up. Their version included this advice from Minturn to Baker, "If illegal steps occurred, the remedy would lie in an indictment rather than a *writ of certiorari*...." Minturn did not regard Mr. Drukker's position as that of a vitally interested party to the inquiry as he had nothing to lose. Baker's retort was that since Drukker was a taxpayer, he had a right to protest the proceedings as "unlegal," although he did not claim that they were "illegal."

Miller wanted it known that the purpose of the investigation was not to stir up trouble among opposing factions, but to smooth things over and to allay the fear of losing Blood because of his clash with the administration. Finally, Minturn declared that there was no reason why the investigation could not proceed.[165]

Over forty days had passed since Prof was told to "shut up," and now with Judge Minturn's ruling, many of the Blood supporters felt vindicated. You might think that now with the path clear to pursue Arnold that the investigations into the problems would proceed quickly. But instead, the strangest thing occurred. The controversy that had engulfed the community's attention was suddenly redirected by the concerns for the approaching elections for the five city commissioner positions.

The length of time, civic embarrassment, the overturning of Drukker's writ, and the elections caused public attention to shift. It was apparent that Prof's job was not in jeopardy; no one within the school was talking publicly of ousting him. Prof was riding the crest of popularity while in the court of public opinion, that is known for its short memory, Arnold was all but convicted of abusing his authority and unfavorably targeting Blood's activities. It had become obvious that the brouhaha generated by the controversy was good for no one, nor did it enhance the city's reputation.

Blood never put his complaints about Arnold in writing as the BOE had requested. The BOE had been searching for a means to bring the feud to a close; consequently, they weren't planning any follow-up to Minturn's decision. The board had voted themselves the supreme authority over all athletic matters thus eliminating any squabble over who was in charge.[166] Besides, it was baseball season, and the season of shooting

oneself in the foot was over. Making yourself the laughing stock of the state did not appeal to anyone anymore—it had apparently become time to move on.

While politics played a central role in the basketball controversy; ironically enough, it was the city's political elections that finally buried the issue. The elections that caught the public's attention were so controversial that the headlines of the two daily newspapers covered almost nothing else for the next several weeks. How the city was to be governed and by whom were the new "in" topics. Mayor McGuire, Abram Preiskel, John J. Roegner, Anton L. Pettersen, and John R. Johnson were declared the victors, but not without much ado. Johnson defeated former Commissioner Frederick F. Seiper by eleven votes, and a highly publicized recount was conducted. After much fuss, the recount did not change the election's results, but it did sidetrack the public's interest. The Blood/Arnold troubles were old news. Without bothering to look back, many were anxious to talk about something new.

The only basketball news appetizing enough to report concerned 6'4" Fred Merselis who was unanimously elected by his peers as next year's captain. The only glitch to this refreshing news was that big Fred was planning to transfer to Pawling Prep School located about eighty miles directly north of Passaic. Accompanying Fred's bulletin were reported rumors that other players were considering jumping ship as well. Sports writers, letters to the editors, and editorials conjectured that these reports were a result of the dispute. Would there be more fallout from the ugly coach/principal controversy?

To the satisfaction of many, the commissioners' election finally put an end to the basketball controversy by diverting already waning public interest. Before long, summer and fall would come and go, and another basketball season would capture the public's interest. After the controversy of this season, what would the Grey Thatched Wizard do for an encore?

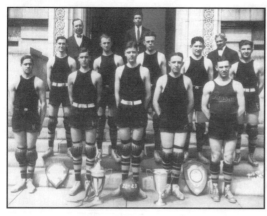

PASSAIC
BASKETBALL TEAM,
1922-23 NEW
JERSEY STATE
CHAMPS

CHAPTER TEN
PASSAIC KEEPS WINNING
1923-1924

"Oh, so you're from Passaic, the home of the "Wonder Team." This was how most people were greeted when their interests took them away from home. The recognition was a source of pride for the Peaceful Valley dwellers. The fame of the basketball team located on Lafayette Street had reached all corners of the country and some foreign countries. Renewed pride followed Passaic residents when they ventured from home.

The mood of America in the early 20's was upbeat, and there was no better example of this mood than in Passaic. The Bill Gates of the 1920's was Henry Ford whose mass production of automobiles was changing America. The factories in the Woolen City were working around the clock. While Americans, in general, experienced pride and prosperity following the Great War, Passaic people had the same hubris, but they also had the Wonder Team to boast about.

When the ugly controversy from the previous season surfaced, it was looked upon as a black eye that Passaic would have liked to forget. The Senate investigations involving the Harding administration and the naval oil reserves at Teapot Dome, Wyoming, were small potatoes for the Passaic populous when compared to what was at stake with the Blood/Arnold controversy.

With human nature as it is, hard feelings from last year's controversy had to linger. A new season was approaching and people were hoping for a fresh start. The talent lost from graduation and the unexpected transfer of 6'4" Fred Merselis had the city on edge, but the major concern was for Prof. He had intimated again that he would no longer be involved with the team. His schedule of school-related activities left him little time with the boys. Prof's requests for assistance went unanswered. One would have thought that because of what the team had done for the city, the school authorities would have provided Blood with some release time.[167] The assistance received from Amasa Marks, the official head coach, was minimal.

FRED MERSELIS

As the countdown to the first practice continued, the fans talked about the prospects of another Wonder Team. Blood whetted their appetites for the new season by explaining why, after losing six of the top nine players from last year's team, Passaic had ample talent to continue winning. Just as all of the city's factories were at top production, so were Prof's many talent outlets—especially the YMCA, YMHA, city recreation department leagues, and various Athletic Club teams. The most fruitful program of all was Prof's elementary school physical training program. No superstars like Roosma, Thompson, or Knothe were on the scene, but there were many young athletes with good fundamentals to choose from. The only serious question unanswered was whether or not Prof would be there.[168]

Was the friction between Blood and the Athletic Council going to continue? The animosity exhibited last season by John J. Breslawsky towards Blood and the basketball team's accomplishments was still a public concern. What effect did the ill feelings play in Prof's hesitancy to commit to working with the team? Sports Editor Greenfield commented on this topic; he expressed the public's concern about how important it was for these two men to get along. Pleading with the two men, the sports editor first addressed Prof by saying,

> The people of Passaic know that without your inimitable instruction, your ability to fire and enthuse the boys who will uphold the honor and notable record of the Red and Blue this season, the possibilities of continued success of the type we have been accustomed to, are at best slim.

> Mr. Breslawsky, it is within your power to so cooperate with Coach Blood during the impending season that the desire of the people of this city for an uninterrupted string of victories can be satisfied.

> The Daily News believes it is interpreting the wish of this entire community when it requests you, Mr. Breslawsky, to get together with "Prof" Blood, and between the two of you arrive at some plan whereby PHS's basketball team may be served to the extent that nothing, except the inability of the players themselves to repeat the achievement of their predecessors, shall stand in the way of attaining once more the heights of basketball accomplishments.[169]

The next day, newly elected captain Sam Blitzer led over fifty Red and Blue hopefuls at the first practice. With players packed wall-to-wall, Coach Amasa Marks put the boys through a few of Prof's drills. The big news of the day was that Prof had consented to coach; his responsibility to the boys transcended his negative feelings. While not attending the

practice session because of other school commitments, it was the anticipation of his presence that carried the practice.[170]

How would you feel if your team gave you an enthusiastic round of applause when you finally arrived in the gym during the final minutes of the team's second practice? That's what happened to Prof. After missing the first practice and having missed almost the entire second practice, Prof made his entrance into the gym.

Coach Marks called the boys over so Prof could speak to them. As he spoke, they hung on his every word. Prof told them that they had the material to do what other Passaic teams had done. All they had to do was get the winning spirit, be absolutely loyal to their school, and live a clean life. If they were willing to make the necessary sacrifices, they could repeat the accomplishments of their predecessors. After the inspiring message that made them feel as if they could conquer the world, he sent them home. Because Prof was back, fifty excited boys walked home looking forward to the next day's practice.[171]

At the start of the following day's practice, the players were let down because Prof was absent. But in the waning minutes of what had turned into a desultory practice session, Prof bounced into the gym and instantly injected new life into the boys. He first emphasized the importance of hard work and using one's head at all times. If the brain is engaged, he told them, it would increase one's efficiency. He reiterated his time-proven philosophy that the best defense was a strong offense and then proceeded to show the boys some of his new plays. The first game was a week away, and Prof could see that much improvement was needed. The development of Passaic's renowned teamwork was going to take time.[172]

Team manager Albert Maczko was fielding requests for games from all over the country. To exacerbate the critics' desire for more challenges, the NJSIAA had requested that Passaic limit their schedule to twenty games thus influencing other teams to do likewise.[173] Most requests for games stipulated a home and away agreement that wasn't possible because of administrative restrictions and/or league commitments. The first game Maczko arranged was with a veteran Patchogue team from Long Island. The only information available about these challengers was unreliable, but it was believed that their record from the previous season was 8-1.

This season also marked the introduction of the rule requiring a fouled player to shoot his own free throws. What effect the new rule would have remained to be seen.

Adding excitement to the anticipated season opener was the new Passaic Armory. The modern military drill shed afforded the team a larger facility than the antiquated basement high school gym. The week prior to the opener, Prof put the boys through rigorous workouts on the

new court. Watching practices from the armory's balcony had become a popular attraction for parents, city officials, and former players.

The new Passaic drill shed court (45x79) came equipped with a good lighting system but slightly undersized, temporary backboards. The low hanging rafters made it impossible to shoot long, high arched shots. A small balcony was built over one end of the gym and the press tables were placed along the opposite side at mid-court. This, hopefully, was to be the new home court that everyone had been looking forward to.

As was his wont, Prof took time at the end of the first armory court practice to wow the curiosity seekers. Shooting from a distance near mid-court, Prof proceeded to launch one handers over the low beams supporting the roof. As the balls swished through the basket, the players and fans hooted and hollered their approval. Prof loved to put on a show; he was amazing, and he belonged to them.[174]

For final preparations, Prof squeezed in skull sessions, inter-squad scrimmages, and an alumni game against the likes of Knothe, Hamas, Paul Blood, and others. The graduates fell 40-32 to the new Wonders. In spite of the over-dribbling and individual play displayed by the new team, it still didn't appear that Patchogue would present a challenge. The night before the first game, the eyes of the sporting world were on Passaic. Many of those outside Passaic believed the losses in personnel would mark the end of the Wonder Team era.

A couple of hours before game time, a Wonder Team crowd gathered outside the new upgraded home court—Passaic Armory. It quickly became apparent that the drill shed was still not large enough. Within half an hour, the new facility was packed with 1500 fans with high

PASSAIC ARMORY

expectations. Over one thousand fans left stranded outside were not a happy group. While many decided to go home, others considered it a challenge to find a way into the under-guarded military compound. Ingress was accomplished for many through broken basement windows and doors pushed open by friends already inside. The few policemen assigned for the evening were overwhelmed.[175]

GAME #119 Patchogue, Long Island, (Friday, December 21, 1924) Passaic Armory. Coach Emery had his boys on the court early; the Passaic fans quickly labeled them "impressive." It was soon learned that Patchogue's record the previous year had actually been 18-1, and, yes, most of their boys were returnees. In spite of being taken back by the pageantry of a Passaic game, the visitors had come down from New York with one objective in mind and that was to go home winners.

In their five-man (zone) defense, the tall visitors stifled the inexperienced Wonders for a 6-8 advantage after the first nine-minute quarter. Using the game as a learning experience for both the players and coaches, Prof continuously substituted throughout the game. Under pressure from the surprisingly strong visitors, the Wonders began arguing among themselves and that prompted a spontaneous five-man substitution. Using various combinations of substitutes, especially with the contributions of Al Gee, Passaic climbed back to hold a 12-8 edge at the midway mark.

From the pack emerged sophomore Moyer Krakovitch to direct the young Wonders through their stage fright. Passaic was playing tentatively and was unable to get the ball as Nelson Rohrbach was out-jumped by Marron, the visiting center. As Patchogue made its final run during the last quarter, the effective Blood System was thrown to the wind as the game turned into a helter-skelter sandlot scrimmage. Final score: **Passaic 24-Patchogue 18.**

GAME #120 Newark Prep, (Wednesday, December 26, 1923) Passaic Armory. Following the opening scare, many doubted that the Red and Blue boys were any wonders at all. Before 800 spectators on the day after Christmas, Passaic found themselves up

PASSAIC				PATCHOGUE			
	G	F	T		G	F	T
Pashman	1	2	4	Springham	2	0	4
Adams	0	0	0	Meehan	1	1	3
Freeswick	0	2	2	Marron	1	0	2
Gee	2	0	4	Magurk	3	1	7
Rohrbach	1	1	3	Mezzotti	1	0	2
Cantor	0	1	1	Losee	0	0	0
Krakovitch	2	1	5	Bignal	0	0	0
Russell	1	1	3	**Total**	**8**	**2**	**18**
Blitzer	1	0	2	Score by periods:			
Janowski	0	0	0	**Patchogue** 8 0 13 18			
Total	**8**	**8**	**24**	**Passaic** 6 12 19 24			

Referee—Hoy Schulting, Dartmouth. Scorer—H. W. Saunders, Passaic; Mr. Walters, Patchogue. Timers—Al Maczko, Passaic; Bert Carey, Patchogue.

against an eclectic crew. It seemed as though every basketball player in Newark who did not have a game that evening made the trip ready to play with the Newark Prep team.

Like Prof, the Newark coach substituted players in and out of the game, and it quickly turned into mayhem. In the words of an eyewitness, "…if the gentlemen who designed the amateur basketball rules could have looked on last night, he would have been eighteen jumps ahead of a fit. No such perfect exhibition of the fine art of hacking, wrestling, pushing, holding and gentle assassination has ever been witnessed in Passaic…."[176]

Prof was aware of the ringers but decided it was worth the challenge. The roughhouse tactics of the masquerading cagers ignited a competitive spark in many of the young Wonders. Two of the mystery guests were identified as Newark Central stars Sward and Shapiro. With a continuous parade of players entering the game, the Wonders took their game to the marauders. In the carnage, five of the Prepsters were ejected on fouls and Johnny Freeswick was carried off the floor with a bruised knee. Final score: **Passaic 51-Newark Prep 24**.

PASSAIC	G	F	T	NEWARK PREP	G	F	T
Pashman	3	4	10	Millman	3	0	6
Freeswick	1	2	4	Williams	0	0	0
Adams	2	1	5	Shapiro	1	1	3
Gee	1	1	3	Broemell	0	0	0
Rohrbach	5	6	16	Smith	1	0	2
Cantor	0	1	1	Rees	0	0	0
Krakovitch	1	4	6	Schwartz	3	3	9
Blitzer	0	0	0	Jacobson	2	0	4
Russell	1	1	3	Yeager	0	0	0
Janowski	0	0	0	Becca	0	0	0
Pomorski	1	1	3	Martino	0	0	0
Totals	**15**	**21**	**51**	Feldblum	0	0	0
				Totals	**10**	**4**	**24**

Score by periods:
Newark Prep 5 11 16 24
Passaic 14 23 25 51

Referee—Hoy Schulting, Dartmouth. Scorers—H. W. Saunders, Passaic; S. Bernhaut, Newark Prep. Timers—Al Maczko, Passaic; P. Smith, Newark Prep.

GAME #121 Ocean City, (Saturday, December 29, 1923) Passaic Armory. Elmer Unger, the former Passaic physical training teacher, was back again but with a more experienced team. Unger's expectations were soon shattered as the Wonders jumped to an 80-0 lead after three-quarters. At the thirty-two minute mark, Milton Pashman, attempting to get more room while in-bounding the ball, pushed Ocean City's Huff which resulted in a successful free throw and the end of a possible shut out.

The young Wonders were firing on all cylinders (plus 25 assists) and ran all over the South Jersey hopefuls. When the visiting Captain Baron walked off the court completely exhausted, he flung himself on the floor saying to his teammate (Smith), "You go try and stop them, I am really dead." Final score: **Passaic 122-Ocean City 6**.

Signs of the Wonders becoming overconfident were noticeable; overconfidence may have been impossible to avoid. Large doses of adulation can be detrimental to anyone, but when it is constantly directed at the age group of these boys, it can be catastrophic. Prof had his hands full. He had to deal with those who were jealous of him and his team's accomplishments, and he had a team of young kids who were led to believe that they were invincible. To compound Prof's challenge, the boys did not shoot well from the foul line. The new rule requiring each player to shoot his own foul shots had not been a plus for Passaic.

GAME #122
Drake Business College, (Saturday, January 5, 1924) Passaic Armory. In the 2:00 p.m. opener, the substitutes played havoc with the business college team. From a purist's viewpoint, it was

PASSAIC	G	F	T	OCEAN CITY	G	F	T
Pashman	5	0	10	Blackman	0	0	0
Adams	2	0	5	Huff	0	1	1
Freeswick	0	0	0	Gordon	0	0	0
Gee	8	1	17	G.Smith	0	0	0
Pomorski	2	0	4	T.Adams	0	0	0
Rohrbach	13	3	29	Selvagn	0	0	0
Cantor	1	3	5	Pleggi	2	0	4
Krakovitch	13	3	29	Baron	0	1	1
Janowski	4	0	8	**Totals**	**2**	**2**	**4**
Russell	2	4	8	Score by periods:			
Blitzer	3	1	7	**Passaic** 24 48 80 122			
Totals	**53**	**16**	**122**	**O. C.** 0 0 0 6			

Referee—"Hoy" Schulting, Dartmouth. Scorer—Harold Saunders, Passaic. Timer—Al Maczko, Passaic. Scorer and timer for Ocean City—E. R. Ferguson.

PASSAIC	G	F	T	DRAKE	G	F	T
Hansen	7	2	16	Deasmond	0	1	1
Adams	3	0	6	Smith	0	0	0
Hasbrouck	1	0	2	Dorfeld	0	0	0
S.Riskin	1	0	2	Macks	0	0	0
Gee	1	0	2	Kornhoff	0	0	0
Krakovitch	2	0	4	Peacock	0	0	0
Harwood	1	0	2	Gaydos	0	1	1
Pomorski	1	0	1	A.Johnson	0	0	0
Cantor	2	0	4	**Totals**	**0**	**2**	**2**
Wall	0	0	0	Score by periods:			
Burg	1	0	2	**Passaic** 15 34 46 55			
Janowski	0	0	0	**Drake** 1 1 1 2			
Greenberger	1	1	3	Referee—Harold Saunders,			
Sattan	1	0	2	Central Board. Scorers—			
P.Riskin	3	0	6	Al Maczko, Passaic;			
Russell	0	0	0	George Roedell, Darke.			
H.Blitzer	1	0	2	Timers—C.Johnson,PHS;			
Totals	**26**	**3**	**55**	Miss N. Scanlan, Drake.			

entertaining to see so many players programmed to quickly pass the ball and play the game so unselfishly. An event more unusual than the score occurred when John J. Breslawsky was spotted in the bleachers. It was the first time anyone could recall a BOE member attending a basketball game. Final score: **Passaic 55-Drake Business College 2**.

GAME #123 Garfield, (Saturday, January 5, 1924) Passaic Armory. Coach Hugh D. Walders's purple and gold chargers came into the drill

shed for the 3:00 p.m. game thinking upset. The boys from across the brook were 3-0, and a Garfield newspaper predicted a defeat for the overconfident Wonders.

Led by the tall, feisty Garfield center, Stanley Piela, Passaic's neighbors presented a challenge until they ran out of gas. The pace was too quick, and by the second half, Passaic had their way with them. Final score: **Passaic 65-Garfield 18**.

The next game matched two teams with 5-0 records, but the real caveat was the site of the game—the Hackensack Armory. If the home crowd and height factor were not enough to throw Passaic's game off, the slippery floor was. While they were all tall, the team included the tallest player in the state, 6'6 Howie Bollerman. Bollerman's elongated arms and all-around athletic attributes were going to control the taps and rebounds. No one doubted that this was the best basketball team Hackensack had ever produced.

Another recorded first took place this night—Breslawsky was again in attendance; the first away game attended by him or any other BOE member. Did this mean that he was becoming a fan? An estimated four hundred of the one thousand who squeezed into the armory were from the Woolen City. Along with Breslawsky's entourage were Arnold, plus doctors, lawyers, dentists, politicians and many others from the privileged class. Coach Skeets Wright and his Union Hill team were also there to see what they could learn for future reference.

GAME #124 Hackensack (Tuesday, January 8, 1924) at Hackensack Armory. Passaic's floor game appeared superior to that of Coach John W. Steinhilber's boys. But the home crowd frenzy in the diminutive armory and the decided height advantage of the Hackensack team stifled Passaic's effectiveness. Hackensack's talented senior forward Everett Mercier was dominating the Passaic defenders because they were too slow, too short, or too inexperienced. Because of Mercier, Hackensack took a one-point lead at the half.

PASSAIC	G	F	T	GARFIELD	G	F	T
Pashman	3	3	9	Horwath	3	0	6
Adams	0	0	0	Micklus	0	0	0
Freeswick	3	2	8	Wolchko	2	1	5
Gee	9	2	20	Piela	2	2	6
Rohrbach	3	1	7	Sebo	0	1	1
Cantor	0	0	0	Bizik	0	0	0
Russell	3	0	6	Winters	0	0	0
S.Blitzer	0	0	0	C.Luneski	0	0	0
Janowski	0	0	0	**Total**	**7**	**4**	**18**
M.Krakovitch	5	5	15				
Total	**26**	**13**	**65**				

Score by ten minute quarters:
Passaic 12 23 41 65
Garfield 2 8 15 18

Referee—Tewhill, Horace Mann HS, NYC. Scorers—Harold W. Saunders, Passaic; Joseph Pemtino, Garfield. Timers—Al Maczko, Passaic; John Dolan, Garfield.

With the smell of upset in the air, the teams headed for the dressing rooms. Prof began explaining what needed to be done to turn the game around by telling his reserve center Maurice Cantor to glue himself to Mercier. Maurice's six-foot frame, long arms, and agility enabled him to do exactly as told. The adjustment worked perfectly. Mercier had to tire himself out just to get the ball, and when he did, Maurice was there to block either his shot or his path to the basket.

Outscoring Hackensack 14-7 in the third quarter, the Wonders outshot the opposition (57 to 40), and outassisted (19-4) the Bergen County boys into submission. Milton Pashman put on a shooting exhibition from what would be three-point range today, demoralizing the taller foes.

The scare proved once again that a Wonder Team could be beaten, at least until Prof could deliver his half time instructions. (Remember, at this time, giving instructions from courtside was not allowed). When questioned about his "winning combination," Prof remarked that "there was no one winning combination. It depended on the situation, and tonight it was the tall substitute Cantor matching up and stopping Mercier. In the next game, it could be an entirely different situation."[177] Final score: **Passaic 52-Hackensack 39**.

PASSAIC			HACKENSACK					
	G	F	T		G	F	T	
Pashman	11	1	23	Greenleese	2	2	6	
Gee	7	4	18	Mercier	7	4	18	
Freeswick	1	0	2	Bollerman	3	6	12	
Rohrbach	2	0	4	McGowan	1	1	3	
Blitzer	0	0	0	O'Shea	0	0	0	
Russell	1	0	2	Krohn	0	0	0	
Janowski	1	0	2	**Total**	**13**	**13**	**39**	
Cantor	0	0	0	Score by period:				
Krakovitch	0	1	1	**Passaic**	11	25	39	52
Total	**23**	**6**	**52**	**Hack.**	8	26	33	39

Referee—First Half: Al Livingston, Paterson. Second Half: Harry Wallum, Union Hill. Umpires—First Half: Harry Wallum, Union Hill. Second Half: Al Livingston, Paterson. Scorers—H.W. Saunders, Passaic; J.E. Clark and G. E. Thomas, Hackensack. Timers—Al Maczko, Passaic; Miss Leffingwell, Hackensack.

GAME #125 Englewood (Saturday, January 12, 1924) at Passaic Armory. The Millionaire City boys did not muster much resistance. In his first coaching assignment, Coach Lavin, a former Syracuse University captain, was treated to a trip to the pinnacle of amateur basketball. It was a basketball banquet, and his team was the main course.

The Wonders struck quickly and erased any doubt of the outcome. The game was played in four quarters of eight, nine, eight, and nine minutes. It would have been better to call the game at half time as a multitude of distractions caused the caliber of play to sink to new lows. If it weren't for the presence of another BOE member, Mrs. George A. Terhune, or Passaic's runaway lead that zapped the intensity of the game, it could

have been blamed on newspaper photographers. During halftime, cameramen were frantically snapping pictures of the famous Wonders.

Nevertheless, Passaic won its 125th game in a row. Charles W. Foley presented Prof with a large, handsome, silver loving cup for reaching the 125 mark. Of all the basketball fans who hitched themselves to the Passaic bandwagon, none deserved more recognition than super fan Foley. Foley,

PASSAIC	G	F	T	ENGLEWOOD	G	F	T
Pashman	11	5	27	Reiger	1	0	2
Adams	1	0	2	Smith	0	0	0
Hansen	0	0	0	Meek	0	0	0
Gee	3	0	6	Brown	0	1	1
Freeswick	2	0	4	Pitman	1	2	4
Cantor	3	0	6	Murberg	0	1	1
Blitzer	1	0	2	Brarman	3	1	7
Russell	0	0	0	Shirk	2	2	6
Krakovitch	6	0	12	**Total**	**7**	**7**	**21**
Pomorski	1	0	2				
P.Riskin	0	0	0				
Janowski	0	0	0				
Rohrbach	3	2	8				
Total	**31**	**7**	**69**				

Score by quarter:
Passaic 15 44 55 **69**
E.H.S. 3 10 14 **21**

Referee—Harry Wallum, Union Hill. Scorers— Harold W. Saunders, Passaic; A. Steiner, Englewood. Timers—Al Maczko, Passaic; H. Hobian, Englewood.

who enjoyed a vicarious thrill by latching on to the famous team, promised to donate another cup if the win streak reached 150. Final score: **Passaic 69-Englewood 21**.

The exploits of the Wonder Team caught the attention of Damon Runyon, the renowned columnist from the New York *American*. Because he wrote for the William Randolph Hearst newspaper organization, the colorful Runyon reached millions of readers throughout the country. Thanks to Runyon, there wasn't a sports fan alive who did not have access to stories about the Wonder Team and their coach. In cities and hamlets across the nation, Passaic's winning streak was collecting followers.

An easy way to get publicity was to become associated with Passaic. St. John's Prep School in Brooklyn was successful in doing exactly that by contacting Damon Runyon with the idea of a challenge game. The challengers insinuated that Passaic's record was achieved by playing "setups."

During the previous five years, St. John's Prep had won 106 of 113 games. In the process, they defeated two PSAL champions, the Glenn Falls champs, and the champions of the prestigious University of Pennsylvania Tournament, but they did not wish to play Passaic when invited for the big century game during the previous season. All the talk about challenging Passaic made it interesting for fans, but the bottom line was that the Passaic BOE would have the final say.[178]

A great deal of speculation was heard at the time about the dollar value for the free publicity afforded by Damon Runyon's basketball

articles. Vincent D. Clausen, an advertising agent, estimated that if the Passaic Chamber of Commerce purchased similar newspaper space, the cost would run approximately $150,000. He reminded his interviewers that advertising space is not read with the same degree of interest as sports news.[179]

GAME #126 Cliffside (Wednesday, January 16, 1924) at Cliffside Park. On a stormy winter evening in Cliffside's small gymnasium, the Wonders put forth a spunkless effort that drew Prof's ire. Call the Passaic effort a case of mental and physical paralysis. The game statistics bear witness to Passaic's overall ineptness: 5 for 23 for the team on the foul line, 2 for 22 from the field for Krakovitch, and 26 for 97 from the field for the team.

The inclement weather did not keep Union Hill's coach Skeets Wright and his team from scouting. It was a good game for Wright's boys to see because the Wonders were far from impressive. Had Prof allowed the fiasco to continue on purpose? Final score: **Passaic 61-Cliffside Park 29**.

PASSAIC	G	F	T	CLIFFSIDE	G	F	T
Pashman	11	2	24	Borelli	1	1	3
Freeswick	0	0	0	Stumpf	0	0	0
Gee	4	1	9	Loretta	1	0	2
Adams	1	0	2	McGrath	5	0	10
Hansen	0	0	0	Burns	1	0	2
Hasbrouch	0	0	0	Doyle	0	0	0
Rohrbach	7	1	15	Ressler	4	4	12
Pomorski	1	0	2	**Total**	**12**	**5**	**29**
Cantor	2	0	4				
Russell	0	1	1	Score by 10-min. quarters:			
P.Riskin	0	0	0	**Passaic** 12 23 38 61			
Janowski	0	0	0	**Cliffside** 10 20 29 29			
Krakovitch	2	0	4				
Total	**28**	**5**	**61**				

Referee—Tewhill, Horace Mann HS, NYC. Scorers—Harold W. Saunders, Passaic; R. Munde, Cliffside. Timers—Al Maczko, Passaic; M. Civetta, Cliffside.

GAME #127 Pearl River, Long Island, (Friday, January 18, 1924) Passaic Armory. All teams with impressive records coming into Passaic from outside the area arrived with confidence and dreams of being the one, and Pearl River was no exception. A sign-wielding entourage of a couple hundred self-assured Long Islanders entered the armory dressed in school colors and armed with noisemakers.

The 5-1 Pearl River team had an additional reason to feel positive about this game— Passaic's high scorer Milton Pashman was out with an infected toe. Pashman's doctor, Leo Joyce, predicted at least a week of recovery time.

Eddie "Pony" Hansen was chosen to replace Pashman, and his effect on the team was like a spark to gasoline. The Little Pony scored seventeen points in the first and third quarters, the only quarters in which he played. The rapid passing game of the Wonders proved to be too

much for Pearl River. Their first-year coach E. F. Bragaw, a Springfield College graduate, was helpless as he watched in admiration the precision-like teamwork of Passaic. Final score: **Passaic 69-Pearl River 13**.

A fan would never have thought that the new foul shot rule would make Passaic more susceptible to defeat. Under the old rule, allowing one designated player to take all the shots, Passaic prospered. Because of the dismal shooting from

PASSAIC				PEARL RIVER			
	G	F	T		G	F	T
Freeswick	4	0	8	Garaventa	2	2	6
Adams	1	0	2	Patterson	0	2	2
Hansen	8	1	17	Buckley	0	0	0
Gee	4	4	12	E.Langer	2	1	5
P.Riskin	0	0	0	R.Langer	0	0	0
Rohrbach	5	1	11	Mariani	0	0	0
Cantor	2	1	5	Serrell	0	0	0
Pomorski	0	0	0	O'Leary	0	0	0
Blitzer	2	0	4	**Total**	**4**	**5**	**13**
Burg	0	0	0	Score by periods:			
Russell	1	0	2	(10 minutes each)			
Janowski	0	0	0	**Passaic** 14 29 50 69			
Krakovitch	4	0	8	**P.R.** 3 7 7 13			
Total	**31**	**7**	**69**				

Referee—"Hoy" Schulting, Dartmouth. Scorers—"Hal" Saunders, PHS; R. Langer, PR. Timers—Al Maczko, PHS; Ed Blackwell, Jr., PR.

the foul line, Charles W. Foley stepped up again to grab the spotlight. Foley sponsored a contest for all the Passaic players and offered expensive prizes, three gold medals and nine Spalding basketballs, to the winners. Exactly what was it that motivated Foley, a Montclair resident, to get so involved with the team? Today, sport psychologists would have a picnic analyzing Foley's affinity for the team.

GAME #128 Ridgewood (Wednesday, January 23, 1924) at Passaic Armory. It was almost as cold in the armory as it was in the night air outside. The freezing conditions made it more difficult for the fans to get roused. The ambiance usually associated with a Passaic game was missing. Was the constant winning rendering the fans complacent or was it the weather? Cheerleader Leslie Fleming squandered his energy trying to get the crowd involved in the game. Could it have been Ridgewood's 3-4 record?

To compound the fans' apathy, Passaic put on a wretched exhibition filled with mental lapses, ill-advised shots, and too much dribbling. The value of Moyer Krakovitch and Milton Pashman became more obvious; Eddie Hansen was not ready to fill Pashman's shoes. With Pashman still laid up, Moyer had no one to fire his bullet-like passes to, thus causing the Passaic machine to sputter.

This brief conversation between two "We'll love you no matter what" Passaic fans described the mood of many while leaving the armory. "The only 'wonder' part about the team was that it won the game," said one fan. "Yeah!" said his companion. "The saphead who calls 'em a wonder

team needs to have his upper story over-hauled."[180] Final score: **Passaic 38-Ridgewood 22.**

The Wonder's game had some problems that needed attention. The major stumbling block affecting the players was the constant pressure not to lose. For Prof, it was a coaching situation laden with atypical challenges. The Grey Thatched Wizard had created a monster, but he,

PASSAIC	G	F	T	RIDGEWOOD	G	F	T
Freeswick	2	3	7	Johnston	1	1	3
Gee	3	0	6	Willoughby	1	0	2
Hansen	0	2	2	Hopper	0	0	0
Rohrbach	6	1	13	Sheffield	0	0	0
Pomorski	2	0	4	Stark	0	0	0
Cantor	0	0	0	Carr	4	1	9
Blitzer	0	0	0	Pinkney	4	0	8
Russell	2	0	4	**Total**	**10**	**2**	**22**
Janowski	0	0	0	Score by periods:			
Krakovitch	1	0	2	**Passaic**	9	20 30 38	
Total	**16**	**6**	**38**	**Ridgewood** 2 9 16 22			

Referee—"Hoy" Schulting, Dartmouth. Scorers—"Hal" Saunders, Passaic; Ralph Ellis, Ridgewood. Timers—Al Maczko, Passaic; George Arzberger, Ridgewood.

more than anyone else, was capable of guiding his young players through the many minefields that lay ahead.

Prof, the master psychologist, knew how to motivate. He understood with an acute feel for what was going on. "The team slump according to Prof was traceable to one thing—failure to pass the ball. Too much dribbling, too little headwork in the offensive department, and a consuming ambition to shoot, shoot, shoot...."[181] Coaches today can be comforted to learn that, in many ways, basketball players haven't changed much over the years.

GAME #129 Jamaica, Long Island, (Saturday, January 26, 1924) Passaic Armory. Within the first twenty seconds, Passaic was up four-zip, and the boys never looked back. Passaic's game completely turned around. Why? Prof's passing game was back. Jamaica was victimized by the best exhibition of passing all season, and as the passing improved, so did the shot selection.

PASSAIC	G	F	T	JAMAICA	G	F	T
Pashman	9	2	20	Tyson	2	0	4
Adams	0	0	0	Sullivan	3	0	6
P.Riskin	1	0	2	Hamm	0	1	1
Hansen	3	1	7	Guardino	0	0	0
Freeswick	6	4	16	Powell	3	0	6
Sattan	0	0	0	Price	1	0	2
Rohrbach	4	1	9	Freidell	0	0	0
Pomorski	0	0	0	**Total**	**9**	**1**	**19**
Blitzer	1	0	2				
Burg	0	0	0	10-minute quarters			
Janowski	0	0	0	Score by quarter:			
Russell	0	0	0	**Passaic** 28 45 69 89			
Cantor	3	0	6	**Jamaica** 3 9 11 19			
Gee	3	0	6	Referee—Harry Wallum,			
Krakovitch	10	1	21	Union Hill. Scorers—			
Total	**40**	**9**	**89**	Harold Saunders, PHS;			

Buddy Lippe, Jamaica. Timers—Al Maczko, PHS; Curtin, Jamaica.

The fans were relieved to learn that their Wonder Team was back. Pashman's return accompanied a stellar, all-around team performance. Final score: **Passaic 89-Jamaica 19**.

Meanwhile, behind the scenes, Prof was turning his attention to the season's state basketball tournament. He was concerned about the expenses to be incurred from participation in the tournament. Since the tournament's inception in 1919, teams had always absorbed their own expenses. Thanks to Passaic, the NJSIAA was on sound financial ground, and Prof, as others, believed that the NJSIAA should provide financial assistance to the participating schools.[182]

Prof proposed that the teams making it to the semifinals be reimbursed for their expenses. In addition, the receipts from the championship contest be split three ways—fifty percent to the association and fifty percent to be divided evenly between the two schools competing for the championship. If Passaic's conditions were not agreed upon, Prof informed them, Passaic would pass on the tournament. In lieu of the tournament, Prof would schedule some of the many challengers clamoring for instant notoriety if they defeated or came close to defeating the Wonder Team.[183]

It was common knowledge that the level of talent was down from the previous season. Last year's top teams were rebuilding while most of the remaining good teams were playing postgraduates who were ineligible tournament players. Conjecture had Hackensack as possibly the second best team in the state. If Passaic defeated Hackensack in their second meeting, as was the assumption, and should the Wonders not participate in the state tourney, it would mean that Passaic had beaten the probable state champs twice. No one could say that Passaic stayed out of the tournament because it feared the opposition.[184]

The seditious conditions spelled out by Prof were liable to produce dire consequences. The NJSIAA was run by a small group of men who were used to dictating their rules, policies, and procedures. They were not apt to consider procedures dictated to them. The most dictatorial of them all was Walter Short. Now that Prof's conditions were on the table, Passaic and the rest of the state waited for the NJSIAA's reply.

GAME #130 Trenton Normal (Friday, February 1, 1924) at Passaic Armory. An opportunity to play Trenton State Normal School presented itself when Coach Langmack scheduled St. Benedict's Prep in nearby Newark. If Trenton stayed overnight, the collegiate team could also

NJSIAA SECRETARY, WALTER SHORT

play Passaic. Langmack knew Ernestine Blood, Prof's oldest child, as she was a student in Trenton's physical education teacher-training program.

Langmack was a disciple of Blood's short passing offense, and a game against Passaic could prove to be a valuable learning experience. The possibility of defeating the Wonder Team was a prospect that was not out of the question either. By stepping out of their class to tangle with older opponents who were studying to be physical education teachers, the young Passaic kids had to rely on their system—smarts, teamwork and passing—or lose.

In the team's best effort of the season, the first squad finessed their way to decided advantages in the first and third quarters just to see the second and third teams give part of it back during their second and fourth quarters. The substitution pattern provided a good learning experience for the nonstarters, but it messed up the local gamblers who were wagering on a twenty-five to fifty point spread. You can't please everybody! Final score: **Passaic 48-Trenton State Normal School 33**.

PASSAIC				TRENTON NORMAL			
	G	F	T		G	F	T
Pashman	6	1	13	Hoffman	4	0	8
Rohrbach	1	2	4	Newman	1	1	3
Freeswick	6	0	12	Burns	1	3	5
Blitzer	1	0	2	Casswell	3	0	6
Krakovitch	3	1	7	Fannegan	0	0	0
Hansen	0	1	1	Collender	3	5	11
Gee	2	0	4	**Total**	**12**	**9**	**33**
Pomorski	0	0	0				
Cantor	1	0	2	Game played in four			
Russell	1	1	3	10-minute quarters.			
P.Riskin	0	0	0	Score by period:			
Janowski	0	0	0	**Passaic** 15 26 37 48			
Goldstein	0	0	0	**Trenton** 8 19 23 33			
Totals	**21**	**6**	**48**				

Referee—Harry Wallum, Union Hill. Scorers—"Hal" Saunders, Passaic; R. Lecher, Trenton. Timers—Al Maczko, Passaic; Ed Monahan, Trenton Normal.

GAME #131 Clifton (Saturday, February 2, 1924) at Passaic Armory. The degree of interest given the neighborhood clash was obvious by 12:30 p.m. Everyone remembered last year's thriller played in the Paterson Armory. Was this going to be another unforgettable game? Over three hours before the 4:00 p.m. game time, long lines were forming in front of the drill shed.

Clifton's physical, rough and tumble tactics took Passsaic out of their patient passing attack. The rough stuff employed by Coach Harry J. Collester's boys took its toll as three Clifton players, Vincent Chimenti, Emil Bondinell, and Emil Bednarcik, fouled out while Blitzer did the same for Passaic. Emil Bondinell, Stanley Burgraaf, Arthur Arguer, and big George Kulick supplied the Clifton offense. The Wonders did not help themselves by shooting a miserable twelve for thirty from the charity stripe. Final score: **Passaic 38-Clifton 21**.

Never known for his postgame speeches, Prof turned the team over to Marks and headed for St. Benedict's Shanley Gym where the Bees were hosting Trenton State Normal School. The college men just edged out the prep boys (32-30), underscoring Passaic's decisive win the previous night. After the game, Prof visited with Rev. Father Cornelius Selhuber, Rev. Father Jerone Flanagan, Rev. Father John Doyle, J. L. Martin, John M.

PASSAIC	G	F	T	CLIFTON	G	F	T
Pashman	5	6	16	Burgraaf	2	0	4
Freeswick	3	0	6	Argauer	1	0	2
Hansen	0	0	0	Chimenti	0	0	0
Gee	1	0	2	Barna	1	0	2
Rohrbach	1	2	4	Kulick	1	1	3
Cantor	1	0	2	Bednarcik	0	3	3
Blitzer	0	0	0	Bondinell	1	3	5
Russell	0	2	2	Kendall	0	2	2
Krakovitch	3	2	6	**Total**	**6**	**9**	**21**
Total	**13**	**12**	**38**				

Score by 10-minute periods:

Passaic	10	20	28	38
Clifton	6	9	13	21

Referee—E. Fred Moller, Newark. Umpire—Ed "Corky" Corriston, Grantwood. Scorers—H. W. Saunders, Al Maczko, Mike Shershin. Timer—Joseph Gardner and Frank Shershin.

Fish, Bernard M. Shanley, Jr., William Dunn, John A. Ford, and Harry Baldwin. The postgame bull session centered on scholastic and collegiate athletics, and the time spent further endeared Prof to them.

Chapter Eleven
Round Two

The country was saddened the day after the Clifton game with news of the passing of former President Woodrow Wilson. Wilson had served as both professor and president at nearby Princeton University and later as the state's governor. Wilson, who was no stranger to Passaic, was an appreciated and popular man whose loss was sadly mourned. The news that was to follow Wilson's internment, however, would have a far greater impact on Passaic.

Without warning, Tuesday afternoon's Athletic Council meeting got off on the wrong foot. The new scrap started when Arnold moved to appropriate $300 for Joseph M. Gardner, Secretary of the BOE. The remuneration was for his services as treasurer of the council responsible for handling all game receipts.[185]

Arthur D. Arnold, Paul L. Troast, Ernest Blood, Robert Prescott, John J. Breslawsky, football coach G. Raymond Pickett, basketball coach Amasa Marks, Ronald Spinning, and Joseph Gardner were present at the meeting. Student members in attendance included basketball manager Albert Maczko, basketball captain Samuel Blitzer, baseball captain Edward Hansen, soccer captain Irving Burg, Arthur McCabe, and Charles Palmer. Prof, who was not opposed to the payment, felt that the coaches (Marks, Pickett, and he) were equally deserving of compensation. The money that Gardner was to receive would come from the athletic treasury, the same fund that the coaches' work was responsible for producing. According to Prof, if Gardner were to receive compensation, then to be fair, the coaches who were directly responsible for raising the money should be equally rewarded.[186]

In the discussion that followed, no action was taken on Prof's logic. Arnold called for a vote on his resolution that was to pay Gardner the $300. "All those in favor say 'Aye,'" said Arnold. Trustee Breslawsky and two others voted in the affirmative. "All those opposed say 'No,'" said Arnold. Before the others had time to respond, Arnold called out: "So ordered; the motion is carried!"[187]

Prof immediately protested by demanding a written ballot on the motion. "You're too late; it has already been voted on," Breslawsky retorted,

thus signaling the official ringing of the bell for Round Two. Provoked by their surreptitious procedure, Prof claimed he was entitled to a written ballot because nine members of the council who may have been opposed to the resolution did not have ample time to vote.[188]

Unknown to everyone present except those who participated in the voting, Gardner's stipend was unanimously agreed upon at a regular school board meeting on January 21. In order to follow proper procedure, permission for approving the money first had to go through the Athletic Council. Knowing the circumstances, it is easier to understand their Machiavellian antics.

Prior to the bell, the council had decided, in similar fashion, to enter the team in the state tournament thus overriding Prof's objections. He was against entering unless the team's tournament expenses were paid by the NJSIAA.[189] Troast, the alumni representative to the council, and Breslawsky took exception to the coach's plan. Troast believed that Prof should abide by the wishes of the state's athletic association. To emphasize his position, Prof declared that "under no circumstances would he lead a Passaic team to the state tournament if the State Athletic Association did not pay Passaic's expenses."[190]

An added twist to the scenario unfolding was the presence of Union Hill's coach Skeets Wright. Skeets had been waiting in the hallway to see Prof about scheduling a game. Responding to Skeets's inquiry as he was heading out the door, Prof said, "I'm through; you'll have to see Coach Marks."

Without hesitating, Marks replied, "So am I. If everybody but us can get paid out of the funds we are responsible for raising, I can't see any sense in coaching. No, sir; I'm through too."[191]

"Talk to Captain Blitzer," continued Prof. "He's captain and he can get the boys together to play Union Hill."

"No, sir," replied the wide-eyed captain. "I won't play and I don't think the other boys will unless you and Mr. Marks are behind us."

Wright indicated that he wouldn't consider playing unless the coaches were there. As the sun set that evening, Passaic, the Home of the Wonder Team, was without a coach, an advisory coach, and a team.[192]

After having time to reflect on the situation, Prof decided that he would "stick with the team until February 22," the date of the Rutherford game. In the meanwhile, he and his coaches would draft a letter to the Athletic Council demanding that the resolution on Gardner's compensation be reconsidered to include the payment of some slight reward to the coaches. "If the meeting is agreed to, and justice is done, we will go ahead as usual and put all that we have at our command behind the team. If not, we are through on Feb. 22."[193]

Breslawsky's reaction was solicited the next day over the telephone by the *Daily News*. To the "We're through" attitude of the coaches, Breslawsky replied, "Perhaps it is all for the best." When questioned whether or not he felt Prof and the team had done something for the city, the board of education member replied, "Well, there is such a thing as being too much of a good thing. It wouldn't do Passaic any harm if the basketball thing wasn't so big. Perhaps a little cold water on the whole proposition and we would be better off."

"What harm does it do?" asked the reporter.

"It tends to engender a spirit among the men supposed to be in control that doesn't argue well for their influence on the boys," was his reply.[194] It was not clear what Breslawsky meant by his remark, but his feelings were obvious.

When asked about the matter of the coaches entitlement to remuneration for their extra work, Breslawsky said, "If they are dissatisfied, then they should send a written notice to the board."

"Isn't it true," asked the reporter, "that when Marks and Picket recently talked to you about extra compensation, you told them that if they didn't like their jobs, they didn't have to stick?"

"No, I didn't use those words. I did say that if they were dissatisfied with their conditions, it was an easy matter for them to change them. You can construe this as you like."[195]

It was common in other high schools for coaches to receive extra compensation for their coaching duties. Skeets Wright indicated that his school board paid him $500 extra for the time he spent with the basketball team. At Rutherford, Jack Wallace was rewarded with a check for $1500 for winning football championships.[196]

"Well," said the reporter, "it looks as if there will be no team unless Mr. Blood's request is granted. The people are certainly interested if there is to be no more team. How about that?" the reporter asked.

"Perhaps it will be for the best," Breslawsky slyly answered.

"Then you will do nothing in regard to another meeting and taking a written ballot on the Gardner question?" asked the reporter.

"Absolutely not. The matter is closed as far as I'm concerned," Breslawsky confirmed.[197]

Breslawsky wanted to make it clear that Blood was not the coach and that he should have no interest in this matter. "He was offered the coaching job and declined; that's why Marks was given the position. Marks and Picket both have contracts to coach their respective teams, and they are responsible for the work in those areas. Blood is only an outsider.... He (Blood) can help in the coaching of his own volition if he wants to, but it is not compulsory for him to do it. If he is interested in the boys and

thinks that it helps them to have him with them, the BOE does not object. But in this matter he has no interest."[198]

To add credence to his point, Breslawsky presented a signed copy of Amasa A. Marks's contract. It read as follows:

"I herewith agree, if reappointed teacher of physical training in the schools of Passaic, to discharge any duties in connection with after school activities and coaching in the High School and elementary grades that the Director of the Department and the Superintendent of school may determine.

Amasa A. Marks[199]

At the end of the interview, Breslawsky intimated that he had spoken off the record "because there are certain matters that are of a personal nature and should not get into the newspapers. If we have anything to give out, we give it out after the meeting. Anyway, those are not public matters that should go into the newspapers. The newspapers have nothing to do with it. If every little thing that came off at the meetings got into the newspaper, it wouldn't look so good. For the sake of general harmony we have barred the reporters to insure that no erroneous impressions get out."[200]

The Athletic Council's policy concerning public disclosure was in direct contrast to the policy of the Passaic School Board for their scheduled monthly meetings.

As the reporter continued his probing into Breslawsky's reasoning, it became clear that other members of the board and administration shared his mentality. "Do you believe," the reporter asked Breslawsky, "that the public should have something to say about the way things are run?"

"Absolutely not," came the emphatic response. "The members of the BOE are fully capable of handling these matters and if they are not, they should look for other jobs. It is the school authorities who have the paramount say."[201]

If Wednesday's *Passaic Daily Herald* front-page headline, **BLOOD QUITS H. S. TEAM**, weren't inflammatory enough, then Thursday's **BLOOD TELLS HIS PLAYERS WHY HE QUIT** was. This head-line and its story written by Sport Editor Robert Irwin was based on biased, taken out of context misinformation. The intent of Irwin's article was to start a witch hunt to discredit Prof.

Calling Prof a quitter did not go over well with Prof, and he didn't mince words in his excoriation of Irwin's article. "This is a deliberate attempt on the part of the *Herald* to accuse me of 'grand stand' play, something I had not the remotest idea of doing. It is just another example of the underhanded work of the Drukker interests to injure me and the

high school team, the same interests that twisted things around during the trouble last year."[202] Continuing on about Drukker in the *Herald*, Prof said, "Ever since Drukker bought an interest in it (*Passaic Daily Herald*), he has tried to get control. They would print anything to give me a dirty dig."[203]

In a brief interview at the school's gym with the two local newspapers, Prof vented his feelings. Item by item, Prof continued his denunciation of Robert Irwin's vindictive portrayal of him. Turning to face Irwin who was present, Prof said, "It is lucky for you that I am a [gentle] man or I would have changed your features for you."

As the players sat there smiling to themselves at Irwin's discomfort, the *Herald* man attempted to make a feeble explanation. "I know I pulled a 'boner;' a real 'boner,'" said Irwin. "I admit it was a big mistake, and I did you an injustice. But I've only been here four months and I've been panned for everything, while other sports writers around the state have been knocking and nothing is said about it."[204]

According to Prof, Irwin's writing was like that from other cities. Prof felt that a local newspaper should be giving the home team fair treatment. "It was your reporting," said the irritated coach, "that gives those others (newspapers) something to pick on."

Still feeling very uncomfortable, Irwin said, "I'll give you anything you say." He was heard to murmur a few more apologies before realizing it might have been better to just close his mouth.[205]

At this point, the bigger issue for Prof was not the $300 but the breach in the procedure for voting. The real issue was whether the members of the council, who were entitled to a vote on any matter that came up, would be allowed the simple privilege of casting a vote.[206] Prof's ultimatum was still in effect.

Oddly enough, the sports editors in the out-of-town newspapers, such as Hoboken, Union Hill, and Hackensack, came forth with articles supporting Prof. In their praise for the coach and denunciation of the school board, they had some interesting things to say. Egan from the *Hudson Observer* in Hoboken, who was no lover of Prof or Passaic, commented about the malicious influence of the BOE and its jealousy over Blood's success. Speaking for his readers, he wrote, "If Passaic doesn't want him, we do."[207]

In the lull created by the resumption of basketball controversy and to keep the players active, Prof gave the boys permission to play on teams at the YMHA and YMCA. All the fuss going on did not change the fact that Hackensack was coming to the armory for the biggest game of the year. The largest crowd to attend a basketball game in Passaic was at the last game against Clifton, and that number was about to be eclipsed against Hackensack. The affairs of the school and the basketball team were once again beginning to resemble a circus.

The attention garnered by the basketball team was causing a reaction from Arnold and some members of the BOE. In their opinion, the notoriety from the basketball team was obstructing the mission of the school—to academically educate its students. The educational process would carry on much more smoothly if they could just take some air out of those basketballs.

Instead of going away, the basketball monster grew even bigger as Prof entered into an agreement to play Union Hill on his "last day" deadline of February 22. Wright and Prof contracted to split the gate receipts fifty/fifty. The real hitch was playing Rutherford earlier on the same day. Rutherford agreed to move their game to the afternoon allowing the game of greater public interest to be played in the evening. Some worshipers of the streak questioned Prof's judgement of playing a league game on the same day as their arch nemesis.

The day before the Hackensack game, the interest in the latest basketball events was captured with this front-page headline in the *Passaic Daily News*:

 # PASSAIC DAILY NEWS

Full Associated Press News Service—Special United Press Service—International News Photo Service.

PASSAIC, N. J., FRIDAY, FEBRUARY 8, 1924.

ANOTHER BASKETBALL WAR LOOMS

Briefly, the write-up told of how the controversy was the topic of the town and how the citizens were hoping to avoid another WAR like last season. If need be, some prominent citizens (headed by City Counselor Manuel N. Mirsky) were ready to form committees to look into the problem.

When Superintendent Shepherd was asked to comment on whether or not Prof was within his right to quit coaching, he replied, "Blood is in charge of the department and he could delegate duties with the board and my approval." The reporter questioned Shepherd about an alleged supplemental

208

contract entered into a few years before without the board's knowledge. (Note—This is the first mentioning of Prof and another contract existing.) The superintendent added, "There has been too much newspaper publicity and notoriety about the basketball team. I do not think I will show any contract to the newspapers unless instructed to do so by the Board of Education."[209]

In a personal communication to Blood from the superintendent, whom Prof genuinely respected, Shepherd offered the following advice:

February 9, 1924

Mr. Ernest A. Blood
31 Spring Street
Passaic, New Jersey

Dear Mr. Blood:

It has been a cause of deep regret to me personally and to many citizens to read in the daily papers the subject matter which they have carried regarding the controversies over basketball and other matters growing out of it.

Let me request you, in the interest of everybody concerned, to desist from any further comment or discussion with any one about it. If fuel is not added to the fire, it will soon burn itself out. The controversy waging in the newspapers is benefiting no one and in my judgment is a distinct injury to the best interests of the schools of Passaic.

The Athletic Council has no authority to hire or pay teachers or coaches. That is the function of the Board of Education alone. If the agreements made with the Board for compensation are not satisfactory to you and your associates in your department, you have the right of appeal for a hearing before the Board. That is the only place where such things should be discussed and settled. Such matters never have been, never can be, and never will be settled through newspaper discussions.

Even though you may think the newspapers misrepresent you, the wisest policy is to say nothing. Therefore, I again request you, please, to drop the discussion at once and if you have any grievances, I will arrange an opportunity for you to present them directly to the Board as quickly as possible. Meanwhile, I believe it in your power to bring an end to the situation by yourself ceasing to talk about the matter publicly or to any one who will publicly report you, and by settling your grievances with the only authority that has power to settle them; namely, the Board of Education.

It seems to me to have been a mistake of judgment to have brought the basketball team into any differences you or your associates may have had with the Athletic Council. The boys should have been left entirely out of the situation and should be from now on. I must therefore request that you do not further discuss these controversial matter with the boys. Settlement must be with the Board of Education.

The new rules and regulations of the Board of Education as finally printed have just come to my hands. Article 15 on page 61, about the middle of the page, says: "The Physical Director shall have general supervision of all the athletic activities in the school system and shall be responsible to the Superintendent of Schools for the proper conduct of athletics in all the schools." Therefore, under such responsibility I must request you to cease further discussion of the matter excepting before the proper school authorities, where your grievances can be and should be settled.

I find also that the new rules say in Section IV, page 8, "It shall be the duty of the (Athletics) Committee to supervise the work of the physical training department and the athletic activities of the various teams.

"This Committee shall have supervision over the grounds and property devoted to athletic purposes belonging to the Board of Education, the purchase of all supplies and equipment for athletic purposes, and the control of revenue from the renting of the grounds and playing of the teams."

Hoping that I have wisely outlined the procedure I desire you to follow and expecting to give you my fullest assistance so far as it is possible for me to do so, I am

> *Yours respectfully,*
> *Fred S. Shepherd*
> *Superintendent*[210]

Sage advice as it was from the school district's top administrator, Prof was not swayed in his pursuit of fair treatment. In Prof's mind, Shepherd's counsel would not change the resistance and ill treatment to which those in the athletic council had subjected him. Naturally, Shepherd did not want the public bickering to continue; it was not good PR.

As always, Prof was willing to place his quest for fairness in a winner-take-all situation. If unsuccessful, then so be it; he was no longer going to be dictated to by those who he felt had resentful intentions. As time passed, it became more obvious that from here on out, he would openly contest any treatment that he perceived as unfair. An amicable solution

was beginning to look like a long shot. As was Prof's wont, this was going to be a fight to the finish.

GAME #132 Hackensack (Saturday, February 9, 1924) at Passaic Armory. Playing before the largest crowd ever to see a basketball game in Passaic, a tall, confident, and athletic Hackensack team jumped all over Passaic. With the exception of Pashman and Krakovitch, the game was a physical mismatch. Four and a half minutes into the fray, the Wonders were down 7-0 with no relief in sight.

Led by Hackensack's big man Howie Bollerman and all-around athletic dynamo Everett Mercier, Passaic panicked and resorted to long heaves from outside. Shots that on other occasions would have gone in were going in and out or rolling around the rim and falling off. As the game progressed, Passaic's frustration mounted. Pashman, claiming he could not find an open teammate to pass to, continued firing away from way outside. With twenty-three of his thirty-six shots coming from outside, the entire Passaic offense malfunctioned. As each desperate, long bomb failed to find its mark, the groans of the Passaic fans could be heard as far away as Secaucus. The half time score did not adequately portray the gut-wrenching experience for both Passaic's players and fans. The 131 game streak was about to be snapped.

The half time intermission was Prof's time. He could see the defeated look in the boys' eyes. Speaking in a low, calm voice as if there were really nothing to worry about, he began explaining what he had just seen. Listening carefully to the man they had idolized since grade school, they absorbed his every gesture. "We will win this game if you get back to your short passing offense," he promised. "There is plenty of time left, but we must pass the ball quickly—don't hold it, pass it, pass it," said Prof. "Do it, and your game will come back, and you will be fine."

Following Prof's advice, the transformation started. Without hesitating, the Red and Blue boys returned to the floor where their tight-lipped, shell-shocked fans sat in a state of mourning. Sensing that

PASSAIC				HACKENSACK			
	G	F	T		G	F	T
Pashman	6	1	13	McGowan	1	0	2
Freeswick	9	3	21	Seilheimer	0	0	0
Hansen	0	0	0	O'Shea	0	0	0
Rohrbach	1	0	2	Bollerman	7	1	15
Blitzer	1	0	2	Greenleese	3	2	8
Cantor	0	0	0	Fast	0	0	0
Gee	0	0	0	Mercier	2	3	7
Krakovitch	2	0	4	**Total**	**13**	**6**	**32**
Total	**19**	**5**	**43**				

Game played in four 9-minute periods.
Score at the end of each period:

Passaic	8	16	33	43
Hackensack	11	22	23	32

Referee—Harry Wallum, Union Hill. Official scorer—Harold S. Saunders. Official timer—Albert Maczko. Scorer for Hackensack—George St. Thomas. Timer for Hackensack—A. P. Frost.

the end was near, the fans did not know whom to feel more sorry for, themselves or the team. The fans had no idea how the players felt. How could they sense the revitalization and renewed faith unless they were also in the dressing room?

And the rest is history. Just as Prof had foretold, pass the ball quickly and the shots will come. The boys did as instructed, and soon the ball was sailing through the hoop with regularity. Passaic's seventeen to one surge in the third quarter was the *coup d'etat* that stole the game. Never was a more inspired rally needed to turn the tide of defeat into victory than the display of team basketball in the decisive third quarter. Final score: **Passaic 43-Hackensack 32**.

In an unprecedented change in policy, the NJSIAA announced that they would pay traveling expenses for all teams entered in the state tournament. Short and his NJSIAA board must have come to the conclusion that it was in their best interest to consider Prof's ultimatum. Their change of heart included paying traveling expenses for ten players, one manager, and one coach. The new policy did, however, fall short of Prof's idea to have the finalists share in the championship game receipts.[211]

It is difficult to say nice things about an opponent who continues to beat you. Now that Wonder Teams had come and gone, it became abundantly clear that Prof was the consistent factor. As a backlash to the pettiness of the Passaic principal and school board, outside newspapers adopted a more appreciative perspective of their out-of-town nemesis. For example, Ross H. Wynkoop, the Sports Editor of the *Bergen Evening Record* of Hackensack, a long time Prof critic, had this to say after watching his Hackensack team lose yet another one to Passaic.

CREDIT TO BLOOD

Never before has Coach E. A. Blood so plainly proven his mastery of the basketball problem as he did last Saturday. The Grey-thatched wizard answered the call when Passaic needed him the most, and he answered it in typical Blood style. What he told the boys in the dressing room during the halves will never be known, but certain it is he told them how to win the game. He told them and they possessed the skill and the courage to obey his wishes to the letter.

Just before the start of the game, the Passaic spectators arose to pay tribute to Coach Blood as he marched along the side of the court. As he came from the dressing room in the second half, no voices were lifted in his praise. However, there was no uncertainty in the little mentor's strut. His shoulders were just as square, his step was just as firm, and his head was held just as high as it had been in the moments of his greatest

triumphs. He was the master, the leader, and he showed it in every movement. This writer has been uninspired by 'Prof.' Blood on numerous occasions. He has objected to some of his thoughts and actions many a time and oft. But one of his biggest thrills of the day was to see the little man facing impending defeat, but refusing to acknowledge it by the merest gesture as he took his customary place along the sidelines.

Apart from the story, and apart from the subsequent result, the Passaic fans missed a chance to cheer Coach Blood when a cheer would have been a real testimonial. They overlooked a golden opportunity, and even the thought that they were stunned by the outcome of the first half, does not pardon them, even for a momentary spell, for losing the greatest of all assets—faith.

It may not, but it should teach the Passaic fans a great lesson.[212]

GAME #133 Rutherford (Tuesday, February 12, 1924) at Rutherford. While playing relaxed and confident in the Rutherford bandbox gym before 400 fans on Lincoln's birthday, Passaic played vintage Bloodball. The Wonders shot and passed their gracious host into a state of paralysis. It was five and a half minutes into the game before Charlie McKenna opened the scoring for Rutherford with an outside bomb.

Up comfortably at half time, Prof turned the team over to Amasa Marks and departed with super fan Charles W. Foley. When curious fans inquired why Prof was leaving early, someone jokingly added that he was off to New York City's Aeolian Hall for the opening of George Gershwin's *Rhapsody in Blue,* which was the only other work that could match his team's first half performance. The truth, of course, was that Prof was heading to Shanley Gym to see Union Hill defeat St.

PASSAIC				RUTHERFORD			
	G	F	T		G	F	T
Pashman	5	1	11	Fabris	0	1	1
Freeswick	8	2	18	Webster	2	0	4
Rohrbach	5	1	11	Russell	0	0	0
Blitzer	2	0	4	Davie	1	0	2
Krakovitch	2	0	4	McKenna	4	2	10
Gee	1	0	2	Ball	0	0	0
Hansen	0	0	0	Breslin	0	0	0
Pomorski	0	0	0	**Total**	**7**	**3**	**17**
Cantor	0	0	0				
Russell	0	0	0	Game played in two 8-min.			
P.Riskin	0	1	1	and two 9-min. periods.			
Adams	1	0	2				
Wall	0	0	0	Score by quarter:			
Goldstein	0	0	0	**Passaic**	16 34 48 53		
Janowski	0	0	0	**Rutherford**	4 8 11 17		
Totals	**24**	**5**	**53**				

Referee—Harry Wallum, Union Hill. Official scorer for Passaic—Harold W. Saunders. Scorer for Rutherford—Harold Bernard. Official timer for Passaic—Albert Maczko. Timer for Rutherford—Albert Gryson.

Benedict's Prep. After viewing an awesome first half of basketball, it had to be an interesting ride to Newark, as the wealthy Wonder Team booster basked in the company of the famous coach. Final score: **Passaic 53-Rutherford 17**.

The day before the Englewood game, Prof sent a telegram to Short, stating that if Passaic was entered in the tournament, such action was taken without proper authorization—his authorization. He wanted to make it clear that Passaic was not entered. His telegram eliminated the possibility of a Passaic forfeit if the NJSIAA went ahead and made its pairings without Passaic (Prof) ever intending to play. By entering the team in the tournament, the administration usurped the authority they had vested in Prof. Exercising the authority given to him by their rules, Prof decided that it was not a good idea for this team to enter the play-offs. The reasoning he gave was that it would be too much mental and physical pressure for his young team. He elaborated on the pressure the boys were under trying to uphold the winning streak.[213]

Prof resented the Athletic Council's sudden interference into what had always been his domain. The welfare of the players was Prof's primary concern, and he knew what was best for his team better than they did. The players stated that they wanted to participate in the tournament, but because of their confidence in Prof, they supported his decision. As one player said, "Prof knows best what to do. If he says we shouldn't go in, why that settles it. And I wouldn't think of going in unless he was with us."[214]

In an attempt to make Prof the antagonist, the *Herald* played up the angle of the disappointed players. Short informed the *Herald* that he was ignoring Blood's telegram, and if Passaic didn't play, they would be eliminated by forfeit. Short also inquired as to who represented the high school, Blood or the administration?[215]

According to Prof, Passaic had nothing to gain by going into the play-offs. Hackensack had been defeated twice, and Union Hill was next. With the talent level in the state down, who else was there to challenge Passaic? Prof was right; if Passaic defeated Union Hill again, who could criticize them for passing on the opportunity to play even weaker teams? The basketball team's efforts, Prof rationalized, would be better spent accepting challenges from more competitive teams interested in making a reputation for themselves by knocking off Passaic.[216]

The *Herald* also quoted the passage in the recently adopted athletic manual clarifying Prof's responsibility for scheduling games. The manual read: "Schedules of games are to be arranged by the managers with the advice and consent of the physical director, and with the approval of the Athletic Council." The Athletic Council, on the other hand, would rather refer to this passage in the manual, which stated, "Athletics of the High

School shall be under the supervision of an Athletic Council, who shall have full power to control its athletic activities for the best interest of the school."[217]

The day of the Englewood game, the *Herald's* front-page headline read: **BLOOD AGREES TO STAY**.

After two hours of cajoling, pleading, bribing, and squabbling, the members of the Athletic Council finally talked a reluctant Blood into entering the team in the state tournament. Prof would be relieved of any responsibility for physical or scholastic disasters that might occur.[218] In the process, Prof also received another concession from the administration. As a bargaining tool to persuade Prof to enter the play-offs, the administration agreed to temporarily relieve him of his teaching duties, thus providing more time to focus on the coming tournament. In view of the work Prof had done in Passaic and the publicity the city had received because of the teams' successes, many felt this was a concession that should have been made a long time before.[219]

While concessions were made and agreements brokered, the meeting was fraught with tension. Throughout the meeting, Prof went around and around with Breslawsky and Troast. Breslawsky reminded Prof that the position he took on the matter of the play-offs wouldn't help his standing with the public to which Prof replied, "I never work for a 'standing with the public,' but just for what I thought was right." Continuing to probe Prof's reasons for objecting to entering the play-offs, Troast said he remembered hearing "finances" as the reason for Blood not wanting to enter. "Well, we can see what we look for," replied Prof. As Troast took exception to the remark, Arnold, who chaired the meetings, declared Prof out of order. Prof insisted that he was within his right because he had the floor. Prof continued by explaining that since the boys inherited a 118 game win streak, a certain strain accompanied each game. "I'm responsible for their health, so I will proceed accordingly," declared Prof.[220]

The point Prof kept trying to get across to Breslawsky was the issue of the illegal play-off application. With the help of the superintendent's interpretation of the school's policy towards scheduling athletic games, it was Prof's decision, not the administration's. Only after Breslawsky acquiesced to the school's written policy did Prof agree to "officially" enter the state tournament, but Breslawsky needed to withdraw his "illegal" application. After consenting to do so, Prof agreed to enter the team and coach the boys through the finals. At that point, it has been alleged, everyone in attendance applauded.[221]

Early Saturday morning in the superintendent's office before the 10:00 a.m. Athletic Council meeting, Prof and Shepherd discussed the contents of the letter below. It is unknown whether or not the letter was actually written at this point in time, but Prof would not receive a copy of it until

the following Tuesday. Caught in the middle of the controversy, Shepherd wanted to clarify certain points with Blood. Prof would have liked to grant his boss his cooperation, but as future events continued to run counter to his sense of fairness, he was unable to do so.

February 16, 1924

Mr. E. A. Blood
31 Spring Street
Passaic, N. J.

Dear Mr. Blood:

> *It seems to me that whether or not you and the high school physical training teachers shall be paid more than you are now paid in compensation for your duties, including the responsibilities of after school athletics, and the question whether the basket-ball team shall go on into the contest for the state championship are two entirely distinct questions which have been confused apparently by the position which you took when the Athletic Council voted the compensation to Mr. Gardner and to Mr. Spinning.*
>
> *It has been the expectation of the team, of the school and of the public that our basket-ball team, if successful in winning the League championship, would participate in the contest for the State championship the same as in former years. Since, therefore, the rules of the Board say that you are responsible to the Superintendent of Schools for the proper conduct of athletics in all the schools, I now request that you waive your objections to the team entering the contest for the state championship. Protect yourself, if you wish to do so, by the statement that it is contrary to your best judgment and that you agree to it on condition that you will not be held responsible for the outcome to the team physically or scholastically; that in waiving your judgment in favor of the position of the Athletic Council they assume such responsibilities, but that you will do your best to bring the team through to victory on the basket-ball court and without injury to them physically or scholastically so far as it is within your power.*
>
> *Do not discuss salary matters again with the Council. The place for such discussion is in the Board. The matter will be taken up there as soon as you desire to meet them and I can arrange a meeting.*
>
> *Differences in interpretation of the rules of the Board should also be taken up with the Board and settled by them.*

Let me request you again not to carry to the public through the newspapers controversial matters. The Board is not talking about them to the newspapers. Why therefore should you on your side do so? All such differences of opinion should and must be settled with and by the Board of Education if you are not willing to abide by the decisions of the Athletic Council or of the Superintendent of Schools.

Let me say again that I write this in a spirit of cooperation and of desire to assist you in every way possible in your work for the schools of Passaic.

<div align="right">

Yours respectfully,
Fred S. Shepherd
Superintendent[222]

</div>

GAME #134 Englewood (Saturday, February 16, 1924) at Englewood. Passaic found shooting the ball in the Millionaire City to their liking. It was a marvelous display of passing and long-range shooting. With the offense showing signs of clicking, it appeared that Prof was turning attention to the team's defense. One of Prof's main defensive clichés, "Follow the ball without let up," was clearly evident against Englewood.

A crowd of Union Hill fans taunted the Passaic players throughout the game. Proceeding as if the antagonists could not be heard, the Red and Blue boys gave the hecklers plenty to think about. Final score: **Passaic 54-Englewood 18**.

PASSAIC	G	F	T	ENGLEWOOD	G	F	T
Pashman	12	1	25	Meek	1	0	2
Freeswick	5	0	10	Pitman	1	1	3
Rohrbach	4	1	9	Reiger	2	1	5
Blitzer	1	1	3	Brarman	2	0	4
Krakovitch	3	1	7	Shirk	0	0	0
Hansen	0	0	0	Cattelle	0	0	0
Gee	0	0	0	Smith	0	0	0
P.Riskin	0	0	0	Brown	2	0	4
Russell	0	0	0	**Total**	**8**	**2**	**18**
Total	**25**	**4**	**54**				

Game played in two 8-minute and two 9-minute periods. Score by period:

Passaic	18	30	46	54
Englewood	4	5	8	18

Referee—"Corky" Corriston, Central Board. Official Scorers—Harold W. Saunders; Alfred Steiner, Englewood. Official Timers—Albert Maczko, PHS; Herbert Holran, Englewood.

GAME #135 Rutherford (Friday, February 22, 1924) at Passaic Armory. On Washington's birthday, Rutherford was accorded the same respect George Washington's troops received at Valley Forge—they were completely overlooked. That was the situation that Coach Voile A. Dupes wanted for his team. Dupes graciously consented to having his game moved to accommodate the Union Hill game. Since the 52-17 drubbing

ten days before, Rutherford had shown remarkable improvement. Rutherford had ideas of their own—they wanted to catch Passaic looking ahead. The stage was set for an ambush. The day before the *Passaic Daily News's* front page heralded: **HUNDREDS UNABLE TO GET TICKETS FOR THE BIG GAME**.

Trying not to exert themselves against Rutherford, Passaic's first outfit miscued their way to a two-point, first quarter lead in the 2:00 p.m. game of the doubleheader. Squandering copious playing time, the second and third units played nearly perfect headless basketball, which was why, at the midway mark, Passaic entered the dressing room losing by one.

The third quarter belonged to Freeswick and Pashman as Passaic rallied to a 25-16 advantage. It was at this point that Prof instructed the starters to hit the showers and go home. Turning to his headless Wonders who played the second quarter, Prof said, "Well, it is up to you guys."

Over one thousand fans gasped in disbelief, "What's Prof doing? This game is not over with yet." The fans were right; it was far from over. As they watched the first unit leave the court, an opportunistic Rutherford team seized their reprieve with renewed vigor.

Responding to the confidence Prof showed in them, the second and third squads and a couple from the fourth team gave it their collective best. Shuffling players in and out, the scrubs held on for the win. Final score: **Passaic 29-Rutherford 19**.

PASSAIC	G	F	T	RUTHERFORD	G	F	T
Pashman	3	1	7	Fabris	1	1	3
Freeswick	5	0	10	Webster	1	0	2
Rohrbach	1	0	2	Russell	0	0	0
Blitzer	0	0	0	Davie	0	1	1
Krakovitch	1	0	2	Krelling	0	0	0
Gee	2	0	4	Ball	2	1	5
Hansen	0	0	0	Breslin	0	0	0
Pomorski	0	0	0	Whitman	1	2	4
Cantor	1	0	2	McKenna	2	0	4
Russell	0	0	0	**Totals**	**7**	**5**	**19**
P.Riskin	0	0	0	Score by quarter:			
Adams	1	0	2	**Passaic** 9 12 25 29			
Burg	0	0	0	**R.H.S.** 7 11 16 19			
Greenberger	0	0	0				
Janowski	0	0	0	Referee—Harry Wallum.			
Hasbrouk	0	0	0	Scorer—David Kaplan.			
Zielinski	0	0	0	Timer—Albert Maczko.			
Totals	**14**	**1**	**29**				

As if he had nothing else to do, immediately after the game, Prof rushed off to Ridgefield Park to help Carl Erickson's team against Norwood from Massachusetts. Coach Erickson was attending his father's funeral in Pennsylvania and needed someone to coach his team. On a hectic day in between games, a couple of hours before the biggest game of the season, Prof dashed off to fill in for his friend. Erickson would later return to his team and lead them to the initial state championship held in the new Class B (330 student enrollment) state tournament.

GAME #136 Union Hill (Friday, February 22, 1924) at Passaic Armory. It was billed as the "Second Battle of the Century." Union Hill was a basketball town, and Coach Skeets Wright's team was having an outstanding season (21-2) against the top teams in the Northeast. As their coach, the Union Hill players specialized in defense, in addition to being tough and talented. When you played Passaic, you had nothing to lose; therefore, Union Hill felt loose—they had nothing to lose. The match-up was one of systems, the short passing offense versus the five-man zone defense.

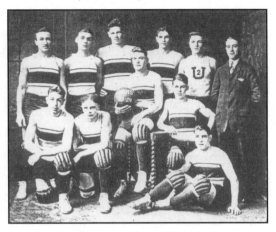

UNION HILL TEAM

This was the game that everyone wanted to see. The news media from the surrounding states descended on Passaic, and reporters from newspapers in Indianapolis and Cincinnati also crowded in. It turned into a scalper's and gambler's Nirvana. Only ticket holders were allowed near the armory; all precautions were taken to assure that this game would not get out of hand. On game day, the *Passaic Daily Herald* ran this front-page headline: **PASSAIC H. S. PLAYING UNION HILL TONIGHT**.

This is how the New Jersey titans of 1924 compared on paper:

PASSAIC	Age	Height	Weight	Year
Milton Pashman	17	5'9"	137	11
John Freeswick	17	5'10"	145	12
Nelson Rohrbach	16	6'1"	152	11
Sam Blitzer	18	5'9"	161	12
Moyer Krakovitch	17	5'9"	163	10

UNION HILL	Age	Height	Weight	Year
Bill Kruse	17	5'5"	138	11
Milton Waldman	18	5'5"	150	12
Harry Itzkowitz	17	5'5"	138	11
John Connors	16	6'2"	151	11
Ben Soloman	17	5'6"	148	12
Joe Wilson	18	5'9"	154	11

The game-by-game results for Union Hill were:

27	George Washington	29 (L)	31	Lincoln	14
30	DeWitt Clinton	28	15	Dickinson	14
31	Commercial	18	33	Dickinson	31
26	Alumni	25	19	Central	9
16	NY Stock Exchange	8	31	St. Benedict's	20
26	Newark Prep	13	38	St. Benedict's	29
16	Brooklyn Tech	2	51	North Attleboro	25
51	Harran High	25	15	Dean Academy	2 (L)
39	Stevens Prep	2	39	Foxboro	20
27	Commerce	23	49	Gloucester	20
28	Asbury Park	16	54	Jamaica	20
35	South Orange	23			

A half-hour before the opening tap, every inch of the armory was packed. Cheerleader Leslie Fleming was joined by his predecessor Mike Kiddon, and they had the new structure swaying to Passaic's favorite cheers and songs. It was *deja vu* with Roosma, Thompson, and Knothe all over again. All of the winning had left many in the Peaceful Valley with a blasé attitude about the accomplishments of the new Wonder Team, but tonight was different. Union Hill's cheerleading section, led by Frankie Battafareno, was overwhelmed. The ambience in the gym created an unforgettable scene.

Shortly before tap-off, Prof was nowhere to be found, although his return from Ridgefield Park was expected momentarily. His absence became the topic of conversation in the armory. No one from Passaic wanted the game to begin without Prof. You can imagine the overwhelming relief felt by the crowd and the warm welcome given to Prof when he calmly walked across the court as the teams completed their warm-ups. The Grey Thatched Wizard had just steered Ridgefield Park to a 31-19 win over Norwood, and now he was going after a basketball "hat trick."

Rohrbach's control of the opening tap was one of the few good things Passaic managed in the entire first quarter. The Union Hill boys were fired up and set in their infamous five-man defense. The Wonders were nervous, tight, and experiencing stage fright before the largest crowd ever to see a basketball game in the Woolen City. The challenger's 9-4 lead projected images of the 1919 state finals.

By now, no one in the drill shed was in his seat save the official timer, scorer, reporters, coaches, and team substitutes. At the moment of peak excitement when tension and excitement were running wild, Prof took control of his team. He gathered his boys around him, looked them in the eyes, and reminded them to play smart. Prof told Pashman to curtail his

long-range, offensive *feu d'artifice* because it was disrupting the team's offense. The impulsive sharpshooter would be more effective, according to Prof, if he looked to pass the ball more often.

As Passaic's passing commenced, the open men began to appear. More often than not, it was Johnny Freeswick who was found near the basket, and John adroitly finished the play. His quick six points got the Red and Blue boys loose,

PASSAIC	G	F	T	UNION HILL	G	F	T
Pashman	3	2	8	Soloman	4	1	9
Freeswick	6	2	14	Siegel	0	0	0
Rohrbach	0	2	2	Wilson	2	1	5
Blitzer	4	1	9	Conners	0	1	1
Krakovitch	0	1	1	Kruse	3	1	7
Total	**13**	**8**	**34**	Waldman	1	0	1
				Itskowitz	0	0	0
				Total	**10**	**4**	**24**

Game played in four eight-minute periods.
Score by period: **Passaic** 4 16 27 34
 Union Hill 9 12 17 24

Referee—Lawrence S. Hill, Director of Physical Education in Albany, NY. Referee—A. John "Doc" Sheps, Belmont Avenue School, Newark. Official Scorer—Harold W. Saunders, PHS. Scorer for UH—Fred Holtje. Official Timer—Albert Maczko, PHS. Timer—Samuel Zerman, UH.

dence, and signaled the beginning of the end for Union Hill.

The remainder of the game was a tribute to the Blood system. Wright's boys were put on the run, something that their defense was not designed to counter. Once establishing control of the game, it was clear which was the superior team. The day after the game, the *Passaic Daily Herald's* first liner read: **2000 SEE PASSAIC H.S. WIN 136TH STRAIGHT**.

Final score: **Passaic 34-Union Hill 24**.

Immediately after the game, Skeets Wright came over to congratulate Prof. While shaking hands, he said with sincerity, "The best team won." Wright's concession made it unanimous; under normal circumstances, no one in the state could defeat Passaic. After defeating the top two Passaic wannabes, Hackensack and Union Hill, Prof wanted to play top challengers from out of state.

CHAPTER TWELVE
BATTLE OF WILLS

On the day of the Cliffside Park game, Prof's ambivalence towards entering the state play-offs resurfaced. Breslawsky had failed to notify Short that Passaic was not entered until Prof said so. On Sunday, February 24, Prof called Breslawsky to inform him that the newspapers had Passaic listed to play Orange in a play-off game the following week. When Breslawsky confirmed the newspaper's accuracy, Prof told him that Passaic was not entered. When Breslawsky reiterated the schedule, Prof said that Passaic couldn't possibly be entered because he hadn't sent the entry. "That doesn't change it; we're entered just the same," answered Breslawsky.

The February 27th edition of the *Passaic Daily News* reported the latest skirmish:

 PASSAIC DAILY NEWS

ANOTHER BASKETBALL WAR BREAKS OUT

Breslawsky continued to ignore his promise to Prof. He also ignored the school's written policy which clearly stated that the scheduling of games was to be arranged by the managers with the advice and counsel of the physical director and with the approval of the Athletic Council. But the school board member still insisted on calling the shots. His only jurisdiction in the matter rested in the policy which stated that if the Athletic Council disapproved of a game advised by the physical director, it had the authority to veto it.

Now that it had come to a head, the big question on everybody's mind was who was right? Who had the final authority to say whether the team should or should not play? Was it Prof, the developer of Wonder Teams who, for the past five years, had run up a string of 136 consecutive victories? Or was it political appointee Breslawsky who recently advocated "throwing cold water on the basketball program"? For Prof, it was a matter of principle; he was not going to back down.

Reaching a point of no return, Prof held his ground. Breslawsky was ignoring Prof's authority that was vested in him by the BOE in its written policy. Equally egregious to Prof, Breslawsky had broken his promise. The reason Prof was so emphatic was because he needed some clout when dealing with Short and the state athletic association. Few understood what a fight Prof had to go through in these tournaments to get a square deal. It was a constant battle for him to get fair playing conditions for his team. A typical example of the hassle for fairness occurred in the state finals during the previous year with Asbury Park. As stated, Short assigned Phillip Lewis to officiate after twice promising not to do so.

To exacerbate matters, Short ignored Prof's notice concerning Passaic's unofficial entry. When Short called Breslawsky to inquire about the status of the entry form, the school trustee replied that Passaic was definitely entered. Taking a bit of delight in Prof's chagrin, Short acknowledged that the NJSIAA accepted the authority of the BOE, and if Passaic didn't show up for the game with Orange, Passaic would forfeit.

On the same day, the *Passaic Daily Herald* took a familiar approach: **BLOOD TURNS BACK UPON CHAMPIONSHIP**.

The *Herald* reported that Prof had promised the Athletic Council that he would enter the team in the tournament. But the newspaper failed to mention the stipulation that the council was supposed to inform Short that Prof had the final authority. The *Herald* asked Prof if he would take the team through the tournament if the Athletic Council were to withdraw the entry. Showing his disgust and frustration, Prof said that he didn't know what he would do. For the moment, what Prof knew for sure was that Passaic's team was not legally entered.

When Amasa Marks was interviewed, he stated that he would like to know who his boss was. Marks felt it would be unfair for him to take the team because of how the boys responded to Prof. On a number of occasions in the past, Marks had publicly stated that he never wanted to be the coach. Blood and the superintendent had forced the coaching position upon him. So, count Marks out; he was not coaching the team without Prof.

Another battle was on, and it was deadlocked. Prof was certain of two things, Passaic was not legally entered in the tournament and he was through coaching. If Prof was not going to coach, the players were not intending to play. For the moment, it was a standoff.

GAME #137 Cliffside (Tuesday, February 26, 1924) at Passaic High School. By the time Coach A. L. Gimme's boys arrived to play, it was almost three hours past the 3:30 start time. Tired of waiting around, all but 134 of the original 700 plus fans went home. Stepping in from the cold, the Cliffside boys walked into a tornado of Passaic passing and shooting. In spite of playing without the aid of Moyer Krakovitch, who

had been injured during the last minute of the Union Hill game, and with Prof rotating players, Passaic was not challenged. Final score: **Passaic 66-Cliffside Park 31.**

By now, Superintendent Shepherd was caught in the middle and compelled to represent the wishes of his BOE. The morning after the Cliffside game, he again met with Prof allegedly to discuss the contents of the letter below. It is interesting to note that the

PASSAIC				CLIFFSIDE			
	G	F	T		G	F	T
Pashman	6	5	17	Mundi	5	2	12
Freeswick	10	0	20	Stennek	0	1	1
Gee	1	0	2	Loretta	0	1	1
Adams	1	0	2	McGrath	0	2	2
Hansen	1	0	2	Burns	4	0	8
Hasbrouch	0	0	0	Ressler	2	3	7
Rohrbach	4	1	9	**Total**	**11**	**9**	**31**
Pomorski	0	1	1				
Cantor	1	2	4				
Russell	0	0	0	Score by quarters:			
P.Riskin	1	0	2	**Passaic** 22 42 54 66			
Janowski	0	0	0	**Cliffside** 4 6 17 31			
Blitzer	2	0	4	Referee—Corky Corriston,			
Zielinski	1	0	2	Cliffside. Scorer—H. W.			
Burg	0	1	1	Saunders, PHS. Timer—			
Greenberger	0	0	0	Al Maczko, PHS. Timer			
Wall	0	0	0	and scorer for Cliffside—			
Total	**28**	**10**	**66**	H. W. Heldorn.			

actual letter was never presented to Prof. (*"In consulting with Mr. R. D. Benson, President of the Board, it was decided this evening not to send this communication to Mr. Blood, but to file it as a memorandum of the fact."* This was the inscription written at the top of the letter in Shepherd's handwriting that was placed in Blood's personnel file.)

February 27, 1924

Mr. E. A. Blood
31 Spring Street
Passaic, N. J.

Dear Mr. Blood:

This morning I asked you into conference regarding basket-ball differences which I felt, and still feel, are due in the first instance to misunderstanding. When I stated that I thought it was honest misunderstanding you said you thought it was dishonest misunderstanding. I tried to explain why in my judgment it was honest misunderstanding. You constantly interrupted me by taking exceptions to my statements, because of which I was unable fully to state my understanding of the situation. You grew constantly more excitable and unreasonable. You then said the team, nevertheless, was not entered for the State contest. I then stated that I thought it had been and was. Whereupon you evinced great anger, declared you would not talk any longer with me

about it and left my office abruptly, saying as you went out you would fight to the finish.

Let me say with deepest regret that such unwarranted action on your part was the finish so far as my part in the matter is concerned.

I was not present at the meeting of the Athletic Council when it voted to enter the State tournament. You have said that such action was against your advice given at the time and was therefore null and void. I am also informed that you did not vote "no" to the motion when it was put. Therefore, under parliamentary rules silence giving consent, the motion was thought to be legitimate and properly carried. Later, you state, that on inquiry by Mr. Short of the State Athletic Association from the High School Principal as to whether or not Passaic was going in, Mr. Spinning, the Secretary of the Council, was instructed by the High School Principal to inform Mr. Short—and did so over the 'phone—that the team was entered. This is what I believed to have been the honest misunderstanding of the Council. You say that you did not have to vote, that you had already advised against it and that was sufficient. There is where the honest difference of opinion lies. Later you took the position that the team had not entered and so informed Mr. Short.

Another meeting of the Council was then called a week ago last Saturday. To make a long story short, that meeting closed with your reluctant consent to go on with the State Tournament giving such personal assistance to the team as your physical strength would permit, with the understanding that you waived any responsibility for the outcome to the team physically or scholastically. Following the meeting, in the lower corridor and in the presence of Mr. Breslawsky and Mr. Arnold I requested you to inform Mr. Short of your change of attitude. As I remember you then again insisted that the team had not been entered. If that were the case, of course your notification to Mr. Short of change of attitude would have entered the team.

Those of us who were present at the meeting of the Council all separated happy in the confidence that all differences had been adjusted and that things would move along smoothly. Several days later—I think it was last Wednesday, possibly Thursday morning—I was surprised to learn from you on inquiry that you had not communicated with Mr. Short. I pointed out to you then that that should be done in order to set yourself right not only with the State Association but with the understanding of everybody concerned.

265

I learned last Monday morning that the evening before you sent a telegram to Mr. Short, Secretary of the State Athletic Association, that the team would not enter, which of course was contrary to everybody's understanding, and as I told you last Monday morning, was in my judgment a great mistake on your part; that it was my judgment we had gone too far in the matter to back out and should not do so. You were obdurate, however, forcing me to say as we parted company at the door to my apartment that if you would not go on with it, thus living up to the understandings in the meeting of the Council a week ago last Saturday, I would be forced to relieve you entirely of the responsibility and place the team in the hands of Mr. Marks, to which you replied that if I did that you would tell Mr. Marks not to do it.

You and I had both been of the impression that the members of the Council did not agree with my interpretation of the particular rule of the Board sanctioning the principle that you should have the full responsibility for deciding the scheduling of games subject only to the veto power of the Council. You said repeatedly that you thought the Council should have rescinded its motion approving the entering of the team in this State contest. It occurred to me while at lunch that day that there might still be a possibility of cooperation if I could get the Council to rescind that motion and decided to make such effort providing you would say to me that you would then go ahead with the State contest. So I immediately called you on the 'phone and asked you whether you would inform Mr. Short of your change of attitude and go on with the State Contest providing I could get the Council to rescind the motion. You, however, were non-committal and would not say whether you would or would not. Nevertheless I immediately took steps to bring this about, but learned in doing so that my interpretation of the rule was accepted by the Council as the correct interpretation. Therefore there was no principle at stake to be adjusted and the matter had been regarded as settled finally at the meeting of the Council held a week ago last Saturday. This I have already stated above.

This morning I called you into conference in order to make these final developments in the situation clear to you, with the up-shot, however, before we had gone very far, stated above.

The rules of the Board make you responsible to the Superintendent of Schools for the proper conduct of school athletics. This is the first time within my remembrance that we have

radically differed regarding policies for the best course to be followed. You have tried, I think, heretofore to carry out any suggestions that I made for your department. On my part I have endeavored to define your powers and authorities in such fashion as would make your work agreeable and effective.

Your action and words this morning, however, make it impossible for us to cooperate. Your words and manner in leaving my office were entirely unwarranted and amount to practical defiance of the responsibilities and authority vested in the Superintendent by the Board.

I regret very much this break. I think your work with the children in the schools and with the boys of the various teams has been excellent; that the ideals that you try to instill through their sports make, if followed, for the finest character. Personally our relations have always been friendly and frank.

Since your words and attitude this morning, however, coupled with the temper shown amounted practically to insubordination, I am now forced much against my wish, with the consent of the President of the Board, to suspend you from further school duties and responsibilities until decision of the Board upon your restoration or removal. Personally I hope it may be restoration following full acknowledgment on your part of amenability to the Board of Education and its administrative officer, the Superintendent, in all matters of school policy and administration.

This step which you have forced me to take is not prompted by one spark of personal feeling against you but is accompanied by a feeling of deep personal sorrow and regret that such action must be taken.

> *Yours sincerely,*
> *Fred S. Shepherd*
> *Superintendent*

A *Passaic Daily News* reporter tried to get a comment on the play-off situation from Breslawsky, but the BOE member finally realized it was better to say nothing. When asked if he intended to let Passaic forfeit the game, he started to reply but hesitated as if to consider what he was going to say then said, "Oh there's no use in talking about it. You'd only spread eagle it on the front page of your newspaper."[223]

Breslawsky & Co. were beginning to realize that even with all of their considerable importance, they weren't going to get the team to play without Blood's approval. They were still stuck on that little passage in their athletic manual, "…the Board of Education shall have final decision in all matters."[224]

School Board President Benson supported the efforts of his man Friday—a.k.a. Breslawsky. Benson favored having Marks coach if Blood continued to refuse. Trustee Erikson, who was also backing Breslawsky, accused Blood of trying to be the whole "cheese" in the basketball situation. Trustee Ehrhardt also wanted the team entered with or without Blood, but the other BOE members, Joseph M. Saab, Mrs. I. W. Sylvester, and Mrs. George A. Terhune, did not want to comment until all facts were known.[225]

After assessing the situation, Breslawsky decided to call another Athletic Council meeting. It was speculated that the purpose of the meeting was to finally concede full authority to Blood so the team could be legally entered and participate. It would be a difficult pill for Breslawsky & Co. to swallow because it would mean waving the white flag.[226]

Before Breslawsky's meeting, Prof was interviewed to learn his apprehension about entering the state play-offs. Blood was a man of high principles, and he faithfully lived those principles. His statement to the press is presented here in its entirety.

THE STATEMENT

At the last Athletic Council meeting, considerable time was consumed urging me to take charge of the basketball team in the State Tournament with the understanding that the council approve responsibility and authority and having a strong feeling for harmony, I finally said that I will do what I can to help, nothing more until I asked Mr. Breslawsky to notify Mr. Short that the council entry sent in by Mr. Spinning was not valid and that Mr. Blood would make the proper entry. Mr. Breslawsky said that it would be better for me to send in an entry with an explanation. I agreed to do so in my own way, but having so much to do because of the Union Hill game and other extras, and the drawing not being until next Tuesday two or three days elapsed during which time Mr. Breslawsky's exception to Dr. Shepherd's interpretation was made known and strongly emphasized by him in his conversation with me recently.

All of my first objections to entering the tournament were also intensified and a strong sense of duty compels me to say that I cannot give either personal aid or consent for Passaic High School to enter the State Tournament at this time, and have sent a telegram to Mr. Short to this effect.

While I regret being forced to take this stand I cannot help but feel that a man, capable of filling the position of Director of Physical Education should be given credit for working for the best interest of the majority. If such credit is not given then something is wrong with the man or the people who judge his methods.

Regarding Tournament

Why should Passaic not enter the tournament? Health is the first consideration. Tournaments are all right for some boys and bad for others, not only as regards to healthy growth of body but also mind and morals.

The big thing in life and games is not to win but to acquire the essentials that produce a winner which are the eternal qualities that have made all men and nations great. Physically, they are strength, speed, quickness, endurance, skill and accuracy; mentally, acquisition and application of knowledge, leadership, intelligence and quick thinking and morally, honesty, loyalty, bravery, courage, generosity, unselfishness, self control, etc.

With such a program and with every effort to lay such a foundation for the game of basketball for the game of life, Passaic teams have just naturally won so many games that recognition has become nation-wide and I am reaping trouble through a misunderstanding of my aims and desires.

The personnel of teams change. In the past the boys could play within their strength and not subject themselves to overstrain. The same conditions do not apply now. The great strain comes to the teams that go to the finals and play two hard games in two days. This may be all right for some, but very unwise and unhealthy for others and who is in a better place to judge the Passaic team than myself?

The reason for not entering the national Tournament in Chicago, although I have always thought success was about certain, was the fact that too many games have to be played in too short a time finishing the semifinals and finals on the same day.

While this would have been a big personal boost I had an inner conscience that I had no right to gamble with the boys' health. Some boys I was sure could stand such a trip, but not all.

There have been several evidences lately indicative of conditions not conducive to good health and good representation.

I ought not take the boys into the State Tournament this year, for my physical, mental and nervous condition does not warrant it, overwork, and the strain of abnormal conditions have left me in a rundown condition each year for several years and this year more than ever, because of the continued interference of the very one who should aid the director and his plans.

This interference and inability to see the true aim of all sport, the building of character above the glory of victory, is indeed disgusting and heart-sickening.

I am convinced that my duty to my work in the public schools, which is the big job for which I am especially engaged, is one that should not be neglected for the basketball tournament. My duty to the boys of the team and their parents to whom I feel a keen responsibility, my duty to my own family and self contain sufficient reasons supported by thirty years of training boys so that I would be unfaithful to conscience and the call of duty, as I know it, if I did not advise against going in the State Tournament.

I know criticisms will come from all directions. Being accused of so many funny things about winning games and all coming from ignorance of conditions, methods, aims and objections, I can expect just as many funny things to be said such as afraid of losing a game, afraid of being beaten, etc. Even 'yellow,' and 'coward' have already been thrust at me by some coaches that have tried hard to impart enough brawn to their own teams to turn out a winner, but with poor success.

I have now directed High School boys through 280 games of basketball with one defeat. Nothing to brag about, but I wonder how many more victories would have been scored had I the bravery of my critics in this matter.

Two hundred and fifty boys composed the teams and I never had the same team two years in succession during the 280 games, and the mystery of this success has been growing and is now attracting the entire country.

MANHOOD THE OBJECTIVE

This secret, that so many have and are guessing at, is not a secret at all, and is not nearly so strange as the motive that impels a man or men to vote for a motion that compels the man responsible for the results to assassinate every ideal that has contributed to the playing success of the boys under his teaching. Passaic plays for MANHOOD.

The regular schedule is followed and the team is expected to grow in playing ability as well as manhood as the season draws to a close.

Papers and townspeople speak with pride of Passaic's representative young men making good. This is the only true advertising 137 consecutive wins means, nothing but regret if the young men contributing to that record don't make good in life. So far, the boys of the past twenty years have made good to a remarkable degree and the reward that has kept me working for and fighting for the right as I have seen fit are the results in the

lives of the boys and their letters of friendship and appreciation throughout the country.

The big objective of the Blood idea is manhood—if it were all to win there would be no cause for this explanation.

Playing just to win doesn't win the game consistently and for life never. No boy can play on a Blood-directed team and play dirty and everybody knows it. Preference naturally goes to boys whose minds can think ahead of their feet and hands.

Moral growth must round out the player so we can say with pride as a member of Passaic High and feel in our hearts 'There stands a man who looks and acts a part of the record that has given P. H. S. its basketball reputation.'

I have given my best for the boys to lay the foundations of manhood on solid rock. The boys have built through clean play the record that stands so high as to attract attention beyond our own domain.

Short and long shots have been taken at it and myself from many quarters, but I have never attempted an explanation or defense, knowing what I was working for was bringing results.

FIGHTS FOR PRINCIPLE

Only when the foundation was in danger have I taken the stand to fight for my rights as a duty I am by honor and training bound to protect.

If my position does not carry authority with responsibility then it means nothing and the foundation for success, as I have planned it, is exposed to unnecessary degenerating influences.

My advice not to enter the tournament this year I knew would be and is very unpopular. The boys want to play, of course, that is the only kind of boys that could make a Passaic team. The parents and public, in general, want Passaic to play. So does the Council, the State Athletic Association, and more than all, I believe, myself.

If it is easier to stay out of the tournament than to go in, then the ascent of Niagara Falls is easier than the descent.

Basketball is but one game in the system of physical education. Its value must be judged by its contribution to life in the sense of being used as a 'means to an end' which is manhood.

True to a sense of duty, I advised against popular sentiment, personal ambition and desire, only after I became convinced that conditions and circumstances were such that Passaic's entry in the tournament would not be justified as a means to the right end.

This is the big job of my position—passing judgment on the vital things concerning the health of the boys and girls of Passaic's schools.

We all make mistakes, and I am open to reason on all such questions, but no man should vote against such a question against the advice of a man who is the responsible party, and I know of no similar case on record outside of Passaic.

For some time now I have been regretfully impressed with the overemphasis placed on Passaic's winning. Before coming to Passaic, I had been victorious in one hundred scholastic starts without a defeat and nobody knew it and all was well. When I came to Passaic it was with the ambition to develop here a system of physical education that would be on a par with what the basketball teams have proved to be for I believe that the representative teams should be a true reflection of the physical education of a city: that is that a team is not great because too much time is given to the boys who are already good, but the standard of work is so high that there is an abundance of good material that more easily responds to effort for improvement.

This, then, is my objective here or elsewhere, to assist nature in her marvelous work of making men and women by sound standards of physical education and high ideals in sports and all conducive to good health.

The following day, the *Passaic Daily News's* lead statement was: **Athletic Council Rescinds Its Action and Will Back "Prof" Blood**.

As predicted, the outcome of the Breslawsky's Athletic Council meeting gave Prof full authority over the team. Breslawsky made the formal announcement in his eloquent resolution as follows:

THE RESOLUTION

WHEREAS, A dispute has arisen as to the correct construction of certain rules in the New Manual of the Board of Education, and as to where the authority rests as to the legal entry of the team in the State Tournament, and

WHEREAS, The Athletic Council has only in mind the best interest of the High School and the team, and desires to secure the co-operation of Mr. Blood with the team in the State Tournament; therefore

BE IT RESOLVED, That the action of the Athletic Council at its meeting on February 5th and 16th, be and hereby is rescinded; and the secretary of the Athletic Council is hereby directed to

notify the proper official of the State Athletic Association of its action; and be it further

RESOLVED, that the Athletic Council hereby requests Mr. Blood to so enter the team in the State Tournament that there will be no doubt of the legality of the entry.[227]

After smugly delivering his resolution, Breslawsky directed his comments to Blood by saying, "Our previous actions have been rescinded, doing exactly what you want us to do. The council is doing everything humanly possible to satisfy you, satisfy everybody."

Blood immediately objected to the last paragraph in the resolution that requested him to enter the tournament so there would be no doubt of the legality of the entry. Breslawsky defended it by saying that it was to let the public know how the council felt about the matter. Prof replied that the public already knew. "Well," said the school trustee, "we have been put in the position where we seem obstructionists. That's why we make the request to you to enter. It's not obligatory on your part. You don't have to if you don't want to." Prof reminded him that the council's power was a negative one, and it was superfluous to insert that paragraph. Responding in a tone that sounded as if he were licked, Breslawsky finally consented to strike it out.[228]

Following through on what was agreed upon, Prof sent a telegram to Short asking for entry into the tournament providing Passaic would not have to play a Hudson County team in Hudson County. After receiving the wired message from Blood, Short immediately telephoned Blood. Prof again told Short that he would send the entry if the above stipulation was honored. Prof claimed that Short accepted and he asked Blood to write to him. Prof replied, "No, you write me," and Short agreed by saying, "All right." It finally appeared that the path was clear for Passaic to go for its fifth straight state championship.

WALTER SHORT

GAME #138 Ridgewood (Wednesday, March 5, 1924) at Ridgewood. Ridgewood earned the name "Jinx Team" by giving Passaic a tussle for the second time. Playing as if they had nothing to lose, Ridgewood stayed within striking distance of the distracted Wonders. Overcoming the effects of a week's layoff, Prof's mass substitutions, and the small court, the boys played well enough to win. Final score: **Passaic 35-Ridgewood 21**.

With some doubts cast on their aura of invincibility, the fifth edition of the Wonder Team was set to enter the perils of the state play-offs. Prof's guidance was needed now more than ever. Without the true stand-out

players of previous teams, the only edge the young Passaic boys had now was their coach.

On the eve of the first game, Passaic was still not officially entered. There was nothing in writing, only the verbal agreement between Prof and Short, and Short had not yet followed up with the confirmation letter that he had agreed upon. The first order of business Prof wanted to conduct when he arrived at Stevens Gym was to speak with Short about their conditional entry. Unable to locate Short, Prof had two choices, not play the game, which would appear ridiculous, or play it without being officially entered.

PASSAIC	G	F	T	RIDGEWOOD	G	F	T
Pashman	7	0	14	MacAllen	1	0	2
Hansen	0	0	0	Stark	0	0	0
Russell	0	0	0	Willoughby	0	2	2
Hasbrouch	0	0	0	Hopper	0	0	0
Gee	0	2	0	Sheffield	3	0	6
Freeswick	3	1	7	Fermier	3	0	6
Rohrbach	2	2	6	Carr	0	0	0
Cantor	0	1	1	Young	2	1	5
Pomorski	0	0	0	**Total**	**9**	**3**	**21**
Blitzer	0	0	0				
P.Riskin	0	0	0				
Janowski	0	0	0				
Adams	0	0	0				
Burg	0	0	0				
Krakovitch	1	3	5				
Total	**13**	**9**	**35**				

Game played at RHS Gym in two 8- and 9-minute quarters.
Score by periods:

Passaic	7	14	30	35
Ridgewood	3	9	13	21

Referee—"Hoy" Schulting, Dartmouth. Official Scorer—"Hal" Saunders. Official Timer—Al Maczko. Timer for RHS—J. Talbot. Scorer for RHS—Ralph Ellis.

GAME #139 Orange (Saturday, March 8, 1924) at Walker Gym, Stevens Institute. A spat with game officials arose when it was learned that Charles Schneider from Central in Newark was chosen to referee. Prof protested the choice and wanted to speak with Short who, it was soon learned, was not in the gym. Presenting his position to the game officials, Prof successfully negotiated for Harry Wallum, who was the assigned umpire, to split the refereeing duties with Schneider.

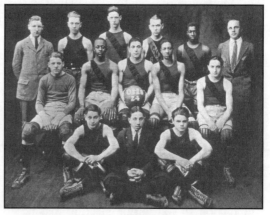

1924 ORANGE HIGH SCHOOL TEAM
photo courtesy of 1924 Orange High School Yearbook

Playing tight, shooting 0-7 from the foul line, and receiving poor treatment from referee Schneider, Orange was up at the end of the first quarter. Slowly finding their confidence as well as their offensive rhythm late in the second quarter, Passaic started to click. As the crowd chanted,

"Come on, Passaic. Let's go," the Wonder Team's game returned. With Krakovitch's seven assists and Pashman's hot hand, Passaic's passing game took big center Edd "Lanky" Jones out of the game and sliced up the remains of the Orange team. Final score: **Passaic 48-Orange 19**.

PASSAIC	G	F	T	ORANGE	G	F	T
Pashman	9	3	21	J.Federici	2	4	8
Freeswick	4	3	11	Smolensky	0	0	0
Hansen	0	0	0	Miles	0	0	0
Adams	0	1	1	Cooper	0	0	0
Rohrbach	3	3	9	Jones	0	2	2
Pomorski	0	0	0	Elia	0	0	0
Blitzer	0	2	2	McQuilkin	0	0	0
Russell	0	0	0	Lipetz	0	0	0
Krakovitch	2	0	4	Murphy	3	3	9
Gee	0	0	0	**Total**	**5**	**9**	**19**
Total	**18**	**12**	**48**				

Score at the end of each quarter:
Passaic 2 16 30 48
Orange 6 11 14 19

Referee—First half—Charles Schneider, Central HS. Umpire—First half—Harry Wallum, Union Hill. Alternated in second half. Official scorers and timers for NJSIAA—William H. Francis, Stevens Institute; Saunders, Passaic.

NEW JERSEY CLASS A STATE TOURNAMENT RESULTS

North Jersey
Montclair 26-Clifton 25
Central 21-S. Orange 20
Morristown 23-Bloomfield 18
Union Hill 30-Bayonne 14
Hackensack 31-West NY 12
Hoboken 26-Dickinson 22
Rutherford 20-Battin 8

South Jersey
Trenton 15-Camden 13
Woodbury 37-Bridgeton 32
Trenton 26-Atlantic City 21
Collingswood 55-Woodbury 22

A visitor at the Orange game was millionaire William W. Cohen, Chairman of New York City Mayor John F. Hylan's Committee on Municipal Athletic Activities. Dr. A. K. Aldinger, Commissioner of Physical Education in the New York schools, also accompanied Cohen. The special guests sat on the Passaic bench alongside Prof. The purpose of their visit was to invite Passaic to play another benefit game, but this time it was to raise money to support the American Olympic Games Fund.[229]

After hearing the details of their proposition, Prof was in favor of the game. The visitors were informed that they would have to take the matter up with the BOE which had passed a resolution the preceding year forbidding such contests. If the board agreed to the offer, all they'd have to do would be to rescind their resolution from last year.[230]

Breslawsky tried to persuade his peers to honor the resolution that his committee spearheaded. In a twisted paraphrasing of Prof's request, he told them that "Mr. Blood did not care to have the boys overtax themselves and in order to have the team enter the tourney we had to grant him immunity of blame for any injury that may occur to them. I do not think that he would want this game after telling us the boys were not strong enough for the tourney." [231]

To accommodate the New Yorkers' request for an Olympic Fund game, the BOE waved the ruling from the previous year by a 5-3 vote prohibiting benefit games. Trustees Crowley, Erikson, Erhardt, Terhune, and Naab were in favor of setting the rule aside for this set purpose while Flower and Sylvester were opposed only because of procedural reasons. Breslawsky was not in favor of the game at all. The outcome paved the way for the Wonder Team to be featured (second game) in a double-header scheduled for Madison Square Garden or one of the larger armories.[232]

A few days later, Prof clarified the Olympic Fund game situation. He refused to authorize the game on the grounds that it was against the school board's policy. He reasoned that he did not want the school to be in violation of its own ruling from the previous year. Prof felt that the one game special waiver was not right. A rule was a rule; it should either be enforced consistently or removed from the books. Blood's interpretation of their maneuvering caught everybody by surprise.

Later still, Prof would reconsider the game when he learned that his decision created a hardship for the Olympic Fund people. When he learned that William Cohen from the Mayor's Committee had reserved an armory at considerable expense, Prof did not want such a great cause to be short-changed because of his reaction to the antics of the BOE.[233] A game was agreed upon for March 28, with the best possible opponent.

GAME #140 Potsdam Normal (Wednesday, March 12, 1924) at Passaic Armory. Playing the gracious host, Prof asked all the Potsdam people to stand and be recognized with a round of applause. Prof proudly introduced two outstanding former players from his Potsdam years, Rufus Sisson and Carlton Brownell. Both men later played at Dartmouth where Sisson was recognized as captain of the All-American team.

Potsdam had their best team since Prof's years at the school, but they could present nothing more than a workout for the peaking Wonders. Passaic had more difficulty getting used to the new glass backboards than anything presented by Potsdam. Final score: **Passaic 57-Potsdam 30**.

GAME #141 Central (Friday, March 14, 1924) at Walker Gym, Stevens Institute. The Central boys were the Newark City champs, but they were not rated as one of the state's elite. Media and fans had this game penciled in as an easy win. Passaic entered the game overconfident,

and Central made them pay for it. Employing an intelligent game plan, Coach Harry "Doc" Sargent had his team prepared for Passaic.

Passaic's nonchalance cost them the early lead, and that was all Central needed. The Newark boys, in Passaic fashion, pulled the ball back to spread out the Passaic defense. Their overconfidence had them stuck in the quicksand of their opponent's stalling tactics, and the situation grew worse by the minute. The 7-11 deficit

PASSAIC				POTSDAM NORMAL			
	G	F	T		G	F	T
Pashman	3	5	11	Wade	1	1	3
Freeswick	8	2	18	Deans	0	0	0
Rohrbach	5	2	12	Liston	0	0	0
Blitzer	1	0	2	E.Sullivan	1	0	2
Krakovitch	4	0	8	Page	0	0	0
Hansen	0	1	1	Rutherford	0	1	1
P.Riskin	0	0	0	Swan	6	1	13
Gee	2	0	4	M.Sullivan	5	1	11
Cantor	0	0	0	**Total**	**13**	**4**	**30**
Pomorski	0	1	1	Game played in two 8-			
Russell	0	0	0	and 9-minute quarters:			
Burg	0	0	0	Score by quarters:			
Janowski	0	0	0	**Passaic** 15 22 39 57			
Adams	0	0	0	**Potsdam** 5 15 25 30			
Total	**23**	**11**	**57**				

Referee—Harry Wallum, Union Hill. Scorer for Potsdam—William O. Page. Official scorer—Saunders. Official timer—Maczko. Timer for Potsdam—Ruffus Sisson.

at the end of the first quarter said it all, plus it set the tone for the remainder of the game. Spreading Passaic's defense out over a large court presented nightmarish consequences for the four-time defending state champs. The number of points they trailed by was growing, and by half time, Central sat firmly on a six-point lead. Passaic's "in the bag" victory and aura of invincibility was fading fast.

Two determined teams showed up primed for action at the start of the second half. Central could taste victory and was anxious for the kill of a lifetime, while Passaic sobered and, instructed by Prof, was finally ready to play. It was an uphill battle, and Central, who still had control, was bent on keeping it. Point by point, Passaic hustled, passed, and shot their way back into the game. Following the action on the court, the fans jumped, yelled, shrieked, laughed, and cried. The din could be heard in Mahwah. By the end of the third quarter, Passaic had come back and held a two-point lead.

The most heart-throbbing time was yet to come. Through the heroics of Sward and Wienkiewitz, Central took a three-point lead (28-31) with four minutes left to play. The excitement generated by the thought of witnessing history in the making created an eerie atmosphere throughout Walker Gym. Anyone who was not a Passaic fan was thrilled with anticipation over the demise of the Wonder Team. Some Passaic women fainted; others openly cried. Die-hard fan Joe Whalley, who had only missed one game throughout the entire streak, had to leave the building

because he couldn't bear to watch. If you were from Passaic, it was a devastating experience—imminent doom and the end of life as we know it, all packaged into one.

At the commemorated four-minute mark, team captain Sam Blitzer was fouled with the opportunity to score two. After sinking his first one, he chased down the rebound of his errant second shot. No sooner were his two hands on the ball than he fired a quick pass to Rohrbach for a deuce. With the crowd still in an uproar, Krakovitch stole the ball on the ensuing center jump, and rifled it to Pashman. The sudden plucking of the heart strings of the deserving Central players coupled with the frustration of trying to defend Passaic's spread out passing offense was a gut-wrenching experience for everyone, regardless of his affiliation. The winning streak was preserved for another game. Final score: **Passaic 41-Central 34**.

PASSAIC	G	F	T	CENTRAL	G	F	T
Pashman	5	2	12	Rosen	1	2	4
Freeswick	6	1	13	Lang	3	3	9
Gee	0	0	0	Wienschiewitz	3	0	6
Rohrbach	4	3	11	Sward	4	1	9
Blitzer	1	1	3	Zimmelbaum	3	0	6
Krakovitch	1	0	2	**Total**	**14**	**6**	**34**
Total	**17**	**7**	**41**				

Game played at Stevens Institute in four 8-minute quarters. Score by periods:

Passaic	7	14	28	41
Central	11	20	26	34

Referee—Harry Wallum, Union Hill. Umpire—Morris E. Midkiff. Official timer and scorer for Passaic—Harold W. Saunders. Official scorer and timer for the NJSIA—William H. Francis.

NEW JERSEY CLASS A STATE TOURNAMENT RESULTS

North Jersey
Union Hill 30-Hackensack 26
Morristown 27-Montclair 26
Hoboken 30-Rutherford 20
Hoboken 19-Union Hill 15

Central Jersey
Asbury Park 41-New Brunswick 27
Asbury Park 30-Neptune 28
New Brunswick 42-Chattle 16

South Jersey
Trenton 18-Collingswood 10

GAME #142 Morristown (Saturday, March 15, 1924) at Walker Gym, Stevens Institute. The Passaic team took the floor at 3:35, five minutes past the scheduled start time. After an abbreviated warm-up, the Wonder Team played well enough to hold the "Marvel Team," as they proudly named themselves, without a field goal for the first quarter. Passaic's style of play turned sloppy at the beginning of the second quarter when Prof began substituting *en masse*. Appearing tired and finding it

difficult to get enthused about the Marvel Team, the Wonders played even with them for the rest of the game.

Disheartened by Prof's constant substitutions, a Morristown fan said, "How ya ever going to beat 'em? They got this year's flag won and they're giving next year's team a chance."[234]

The outstanding efforts of young Charlie Baker, who was the first mustached black player to oppose the Wonders, kept Morristown in the game. Final score: **Passaic 30-Morristown 21**.

PASSAIC	G	F	T	MORRISTOWN	G	F	T
Pashman	4	1	9	Reiley	0	0	0
Freeswick	4	4	12	Terreri	0	0	0
Gee	0	0	0	Griffin	1	2	4
Adams	0	0	0	Salny	3	0	6
Pomorski	0	0	0	Perry	0	4	4
Rohrbach	2	0	4	Mintz	0	0	0
Blitzer	0	0	0	Baker	3	1	7
Cantor	0	0	0	Reed	0	0	0
Krakovitch	2	1	5	**Total**	**7**	**7**	**21**
Total	**12**	**6**	**30**				

Game played at Stevens Institute, Hoboken.
Time of periods—Four 8 minute quarters.
Score at the end of periods:

Passaic	12	20	24	30
Morristown	3	9	16	21

Referee—Harry Wallum, Union Hill. Umpire—Edward Corriston, Grantwood. Official scorer and timer for PHS—Saunders. Official timer and scorer for NJSIAA—William H. Francis, Stevens Institute.

Following the Morristown Marvel Team's defeat, Passaic's season reached a crossroads. The semifinals of the state tournament were next, but the all-important question now was how the NJSIAA and its secretary were going to react to Prof's ultimatum. Blood was not going to lose any sleep over anything Short was planning. In the meanwhile, he was looking into scheduling additional games to help his boys continue their improvement.

If Short was going to make good on his promise to keep Passaic out of Hudson County, then Passaic would continue in the state play-offs. If Short was planning to challenge Prof's plea for fair play, then Prof would finish the season on his own accord. What was to take place next was anybody's guess.

Chapter Thirteen
Prof Takes on the NJSIAA

Prof decided to avoid playing games with Hudson County teams on their turf because of his experiences over the past several years. A local court or a neutral court would be fine but not a court in Hudson County. Now that the final four Class A teams had been determined (Passaic, Hoboken, Trenton, and Asbury Park), the possibility of meeting Hoboken in the designated Jersey City Armory in Hudson County had become a reality. Prof responded by adamantly reiterating that he would refuse to allow his team to play Hoboken, a Hudson County team, in Hoboken. Also, because of past experiences, he wanted the referee and umpire to be acceptable to both teams.

The unsavory reputation of Hudson County sports fans was well documented. Both Prof and Short had endured unpleasant run-ins with Hudson County fans, Hoboken's in particular. On more than one occasion, Passaic fans were accosted while attending away games there. Short was aware of these problems and once cautioned Prof about the hazards. Knowing the likelihood of these problems arising by scheduling the semifinal and final games in the Jersey City Fourth Regiment Armory and the probability of Passaic playing there, why weren't the NJSIAA authorities more concerned with fairness and safety?

In Prof's eyes, this issue was not about winning or losing but all about fairness and safety. The purpose of the tournament was to stage an elimination series of games to determine the best team in the state and to conduct it under conditions where none of the teams would have an advantage over another team.[235]

Passaic players and fans had a reputation for good sportsmanship, but their enthusiasm paled in comparison to the rabid actions of some Hoboken followers who were notorious for their shortcomings in sportsmanship. In particular, they were infamous for their threatening remarks and undisguised hostility towards Passaic. "If we don't win, there'll be hell to pay," was what could be expected from the rowdy element that was more often than not a part of the Hoboken contingent.[236]

Amidst the latest squabble, Prof wasted no time scheduling a game with neighboring Paterson. The Silk City boys had grown up watching

the professional teams play, hence their propensity for rough and tumble basketball. Their new young coach Earl Grey, who starred as a player at St. Peter's Prep and Villanova, was anxious to test his boys against the vulnerable Wonder Team.

GAME #143 Paterson (Monday, March 17, 1924) at Passaic Armory. The rivalry between the two cities was evident by the intensity of effort displayed by the players and fans. Keeping the Paterson squad on defense for most of the game, the Wonder Team exhibited flashes of excellence.

Captain Sam Blitzer, who had been improving steadily throughout the season, had become Mr. Steady in the Passaic offensive attack. The nervousness and lack of confidence that had marred his play were gone. Sam had turned into the court leader that Prof had hoped he would be. Final score: **Passaic 33-Paterson 13**.

PASSAIC			PATERSON				
	G	F	T		G	F	T
Pashman 3	4	10	Singer	1	1	3	
Freeswick 3	0	6	Goldstein 0	0	0		
Rohrbach 2	1	5	Music	1	1	3	
Blitzer 2	0	4	McCue 0	1	1		
Krakovitch 3	2	8	Slack	0	0	0	
Russell 0	0	0	Clements0	0	0		
Total 13	**7**	**33**	Haymen 1	0	2		
			Krieger 1	2	4		
			Total 4	**5**	**13**		

Score by quarters:
Passaic 5 14 29 **33**
Paterson 2 4 10 **13**

Referee—Edward "Corky" Corriston. Official Scorer—Harold W. Saunders, Passaic. Official Timer—Albert Maczko, Passaic. Timer for Paterson—Albert Livingstone. Scorer for Paterson—William Goldsmith.

In the meanwhile, Prof was unwavering in his resolve concerning the semifinals' locale; he was not going to allow his team to play a Hudson County team in Hudson County. He recommended that the two North Jersey teams (Passaic and Hoboken) be matched up with Trenton and Asbury Park from the southern part of the state. This is what he had hoped Short would do. However, the same problem could arise in the finals if the favored northern teams faced each other.

Blood was a constant thorn in Short's side. This was the sixth year the NJSIAA had been conducting state basketball finals, and each year, Short had Blood to deal with in one way or another. Union Hill had made it to the finals once in 1919; Trenton, where Short was the Physical Director, made it in 1920 and 1921; Asbury Park was successful in 1922 and 1923. Prof's team, on the other hand, was in the final every year. From the inception of a state championship, Short had monopolistically dictated policy, and with Blood's unyeilding adherence to sportsmanship and fair play, there was bound to be an annual clash of personalities.

It was difficult for a man such as Prof, who knew what a fair deal was all about, to accept the terms mandated by Short during these early

years of the state tournament. Everything about Prof's system, methods, and philosophy was years ahead of his contemporaries. Time has proven the wisdom of his innovative ideas, but for now, he was a pioneer fighting for correctness and fairness. Short's actions were dictated by the financial bottom line. The two men were not on each other's Christmas card list.

The board of trustees of the NJSIAA and participating schools were invited (Prof claimed he never received an invitation) to the Robert Treat Hotel in Newark for the pairings for the semifinal games. Prof asked Passaic School Board Secretary Joseph M. Gardner, Jr., to deliver the following letter:

March 17, 1924

Mr. Walter E. Short
Robert Treat Hotel
Newark, New Jersey

Dear Sir:

This is to inform you that the Passaic High School basketball team, winner in the Northern New Jersey section in the State Tournament, will compete in the sectional finals only under the following conditions: Passaic will play no Hudson County team in Hudson (Newark, Orange or Elizabeth are acceptable).

Officials must be acceptable to the competing schools.

The above is in no way a request for favor, but is in the interest of healthy sport and is approved by the Athletic Council of the Passaic High School.

> *Sincerely yours,*
> *Ernest A. Blood*
> *Director of Physical Education*[237]

The NJSIAA people did not react well to Prof's letter; in fact, they were irate. They immediately removed Passaic from the tournament and reinstated Morristown (overlooking more worthy opponents such as Union Hill, Hackensack, Central, or Collingswood) and paired the schools exactly opposite to the pairings that Prof had suggested. They rejoiced over their decisions as if they were really sticking it to Prof. Because of their response, it was official. On March 18, the *Passaic Daily News* front-page headline informed the public:

P.H.S. TEAM OUT OF STATE TOURNEY.

Never did Prof second-guess his decision. There was a distinct difference between right and wrong, and this decision, while ruffling many

WALTER SHORT (SEATED, THIRD FROM LEFT) AND THE NJSIAA BOARD OF DIRECTORS

feathers, was clearly the right thing to do. Prof would not be an "I told you so" by entering the tournament and then have his team subjected to malicious or dangerous behavior. It was never about winning or losing— never. The fact that he was exonerated from any liability resulting from possible mishap did not matter to him; in his mind, withdrawing was just the correct thing to do.

Once the facts surrounding the team's withdrawal from competing for their fifth straight state championship were known, Prof received overwhelming support from Passaic fans. True to form, the *Passaic Daily Herald* would search and find someone who had a contrary opinion. In addition to Breslawsky & Company, the anti-Blood newspaper found James H. Donnelly, the city's overseer of the poor, who was getting free publicity by sticking his nose into the affair. Donnelly told the newspaper that he had been in touch with Short and many other basketball fans, and most of them were disgusted with Prof's attitude. He believed that if Blood didn't want to go through with the tourney, he should resign and let Fritz Knothe coach the team.[238]

Short became more and more annoyed and frustrated with the predicament presented by Prof. The NJSIAA had bowed to Prof's demand for reimbursement of play-off game expenses. But when Passaic was the only team to submit charges for meals ($49.50), transportation via taxis ($76.00), and three paid admissions ($1.50) totaling $127.00 for the first

round game with Orange at Stevens Institute, it made the hairs on Short's neck stand up. This figure was in contrast to South Orange's reimbursement request of $2.40 for round trip bus rides at ten cents a fare for twelve from Orange to Newark.[239]

Short didn't want to move the game to the Orange or Elizabeth Armories because they were too small. If fewer people were to attend the games, the gate receipts would be affected. In reference to Blood's quitting the tournament, Short said that it could only mean that he (Prof) was afraid of losing.[240]

Charles E. Lillis from Dickinson High School in Jersey City, who sat on the NJSIAA's Board of Trustees, said that Blood's letter was a slur against Jersey City. He questioned why Blood would ever think that the Jersey City Armory was not a neutral court since both teams had only played there once in the past year. He went on to say that Passaic was permitting itself to be run by a very temperamental gentleman who had eliminated all sense of fair play from the sport. Because Blood was quitting, Lillis believed that Blood possessed a yellow streak.[241]

Obviously, the critics were biased men who had varying interests in the game. Anyone acquainted with Blood knew that he was a true sportsman with integrity. For the safety of his players and fans and to further the cause of clean sport, Prof's principles never wavered. He had decided his team would not participate, and he didn't look back; he had other things to do.

The following day, the headlines in the *Passaic Daily News* read:
PASSAIC HIGH TEAM WILL PLAY HOBOKEN.
Meanwhile, Hoboken's Coach Dave Walsh wanted to play Passaic in the Olympic Fund game. Prof immediately accepted Walsh's challenge to play Hoboken on a neutral floor, which was what he wanted in the first place. Before anyone could get too elated, Coach Walsh puzzled everybody by taking back his challenge. Walsh's only explanation was that he meant to say St. John's Prep from Brooklyn. The following day, the *Passaic Daily News's* headline retraction read:
HOBOKEN HIGH SCHOOL BACKS DOWN.
Growing speculation had it that Hoboken would not look good if the new state champions got walloped by the team that was supposedly "too chicken" to play and had quit. When the Olympic Fund organizers asked Prof it he would meet St. John's Prep, he happily consented.[242]

Meanwhile, the state tournament was underway.

NEW JERSEY STATE BASKETBALL SEMIFINALS

Hoboken 26-Morristown 20
Trenton 40-Asbury Park 22

In an attempt to meet expenses, Short decided to move the games into the evening hours, making it more convenient for spectators to attend. At the last moment, the NJSIAA also raised the admission fee from 50 cents to one dollar.[243] These moves were necessary to offset the financial void created by Passaic.

Short continued to express his displeasure with Blood and the pro-Blood camp by denying a *Passaic Daily News* reporter a seat at the press table (according to Short's orders). The reporter was eventually admitted after much discussion.

And so, with the support of their fans, Prof and his Wonder Team sat out the 1924 New Jersey State Tournament. In the final game, Hoboken, as expected, went on to defeat Trenton for the state title. However, the conclusion of the state tournament did not signify the end of the season for the Wonders. Prof and the boys were hustling to prepare for their next opponent.

GAME #144 New Britain, CT, (Saturday, March 22, 1924) at Passaic Armory. New Britain's Coach George M. Cassidy had been stalking the Wonder Team. He had a talented team whose record was 23-1, and two of those wins were against college teams. Cassidy's boys defeated New Haven, the defending New England State champs, and New Haven defeated Naugatuck, and Naugatuck defeated Crosby and Wilby—both excellent teams.[244] To help get an edge, New Britain came to Passaic to scout the Passaic-Union Hill game in late February.

After watching Union Hill lose to Passaic, Cassidy acknowledged that Passaic had a good team but confidently predicted that his boys would defeat Passaic.[245] As billed, the challengers were talented, and they did give Passaic a good run. The major difference between the two teams was that the visitors did not have a system. If the

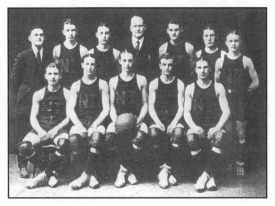

1924 NEW BRITAIN TEAM
photo courtesy of 1924 New Britain High School Yearbook

Red and Blue boys had followed their own system more closely, they would have won by more than twenty points. Playing for the gallery, there were times when all they wanted was to shoot. In the third quarter, the Passaic boys changed their offensive strategy and began shooting from long range; as a result, they failed for the first time to score a field goal in a quarter.

If you were a coach, how would you like to see these statistics? Pashman shot 2 for 20, Freeswick 4 for 20, and Rohrbach 3 for 17. It wasn't until the score was 15-11 early in the fourth quarter that the boys went back to Blood's short passing offense and quickly put the game on ice. Final score: **Passaic 25-New Britain 13**.

William W. Cohen, who represented Mayor Hylan's Olympic Fund Committee, finally came up with an agreeable solution. Their plan was to have a doubleheader with St. John's Prep from Brooklyn opening up with Hoboken, the newly crowned New Jersey state champ. The main event of the doubleheader was the pairing of the highly touted Christian Brothers Academy (CBA), the champion of two leagues and the virtual title holder in their class from Buffalo to Albany, with the Wonder Team.

While playing a rigorous schedule, CBA's record was 17-2, but one of their two losses was by one point to Aquinas at Rochester, which was later avenged with a five-point win. A couple of weeks after Aquinas's defeat, Aquinas went on to win the National

JOHN FREESWICK

PASSAIC			NEW BRITAIN				
	G	F	T		G	F	T
Pashman	2	2	6	Zehrer	1	0	2
Freeswick	4	0	8	Gierochowski	0	0	0
Rohrbach	3	1	7	Neipp	1	2	4
Blitzer	0	0	0	Deloin	0	1	1
Krakovitch	2	0	4	Gorman	0	0	0
Total	**11**	**3**	**25**	Belser	3	0	6
				Total	**5**	**3**	**13**

Game played in four eight-minute quarters.
Score by quarters:

| **Passaic** | 5 | 14 | 15 | 25 |
| **New Britain** | 4 | 7 | 7 | 13 |

Referee—Edward Corriston, Central Board. Official Scorer—Saunders. Official Timer—Maczko. Scorer and Timer for NB—Kenneth Saunders and Lionel Depot.

Catholic Basketball Tournament in Chicago by soundly defeating Cathedral of Sioux Falls, SD, 30-0, and two days later, downing Detroit University High School 16-6 for the championship.[246] CBA's other loss came at the hands of St. John's Military Academy at Manilus, New York, who later won the prep school championship at the University of Pennsylvania Tournament. CBA had not lost a home game in three years, and during the same span, they had lost only four games to high school teams.

Once the Olympic Fund game contract was signed, Prof set out to prepare his team for one of Passaic's most memorable basketball moments. To help prepare his team, Prof scheduled a doubleheader of his own as a pregame tune-up. Prof invited Don Bosco Institute and East Rutherford to be appetizers prior to the main course.

Neither team, Don Bosco nor East Rutherford, was weak. Don Bosco had just trounced Paterson at Paterson. East Rutherford split its two games with Ridgefield Park (Class B State Champs) and won the Bergen County League championship. East Rutherford featured Steve Hamas, brother of Passaic's own Mike "Dead Shot" Hamas, who would later become a contender for the heavyweight boxing title.

GAME #145 Don Bosco (Tuesday, March 25, 1924) at Passaic Armory. It was a day of vintage Passaic basketball; the boys were focused. Prof's adage, "A great offense is the best defense," was the script for the day. They were near the end of their season, and the fruits of Prof's efforts were evident throughout the Don Bosco game—quick short passing, teamwork, and good short shots. Prof was coaching them up for CBA, and the play-

PASSAIC				DON BOSCO			
	G	F	T		G	F	T
Pashman 4	0	8		Rurak	0	1	1
Hansen 0	1	1		Zawrlinski	0	0	0
Russell 3	0	6		Kasyaka	0	0	0
Hasbrouck 1	0	2		Grono	0	0	0
Gee 0	0	0		Kwasnieuski	0	2	2
Adams 0	0	0		Zalewski	1	0	2
Freeswick 11	0	22		Biernacki	1	2	4
I.Krakovitch 0	0	0		Olbrych	0	0	0
Rohrbach 3	0	6		Jak	0	0	0
Cantor 0	0	0		Dembowski	2	0	4
Pomorski 1	0	2		**Totals**	**4**	**5**	**13**
Wall 0	0	0					
Riskin 0	1	1		Game played in four			
Harwood 0	0	0		8-minute quarters.			
Blitzer 0	0	0		Score by quarters:			
M.Krakovitch 0	0	0		**Passaic** 16 18 38 50			
Janowski 0	0	0		**Don Bosco** 1 6 11 13			
Burg 1	0	2					
Totals 24	**2**	**50**					

Referee—Edward Corriston, Central Board. Official Scorer—Harold W. Saunders. Official Timer—Albert Maczko. Timer and Scorer for Don Bosco Institute—B. Okulski.

ers sensed it and responded. Final score: **Passaic 50-Don Bosco 13**.

GAME #146 East Rutherford (Tuesday, March 25, 1924) at Passaic Armory. Coach Jimmy Mahon's boys presented a stonewall defense, and it was accomplished without fouling once during the entire game. Some people felt, as Prof did, that committing fouls was a sign of poor sportsmanship and a sign of weakness. Once the ball was in Passaic's hands, it stayed there. From player to player, the ball moved with increasing quickness and acumen, and the carefully selected shots kept finding the basket. Final score: **Passaic 40-East Rutherford 10.**

After two more days of covering and reviewing everything he believed necessary, Prof had his team ready. The team was ready for the Big Apple and any opponent. The pregame hype leading to Friday evening's game was greater than ever before. The New York media was covering the event—it was the biggest scholastic basketball game ever. A record was set for advanced ticket sales. Public transportation schedules for trains, subways, taxis, and ferries were adjusted to accommodate the anticipated throng.

PASSAIC				E. RUTHERFORD			
	G	F	T		G	F	T
Pashman	4	0	8	S.Hamas 0	0	0	
Freeswick	6	0	12	McMahon 0	0	0	
Russell	1	0	2	Duchardt 0	0	0	
Hasbrouck	6	0	12	Dunn 0	2	2	
Rohrbach	1	0	2	K.Stazerski 0	0	0	
Cantor	1	0	2	Ryan 4	0	8	
Blitzer	0	0	0	Nichols 0	0	0	
P.Riskin	0	0	0	Schibler 0	0	0	
Burg	0	0	0	M.Stazerski 0	0	0	
Krakovitch	0	0	0	**Totals 4**	**2**	**10**	
Gee	1	0	2				
Totals	**20**	**0**	**40**				

Game played as second part of double header at the Passaic Armory in four 8-minute quarters.
Score by quarters:

Passaic	12	20	30	40
E. Rutherford	2	6	8	10

Referee—"Corky" Corriston, Cliffside. Official Scorer and Timer—Saunders and Maczko, Passaic. Timer and Scorer for ERHS—Samuel Davidoff and George Hassenlopp.

More than anticipation was brewing in New Jersey. The evening before the Olympic Fund game, the NJSIAA passed a resolution suspending Passaic High School. The suspension was "for having withdrawn from their State Basketball Tournament without just cause" and because of "subsequent articles that appeared in papers alleging discrimination and unfairness towards Passaic by the executive committee." The suspension also stipulated that Passaic's charges had to be proven before the school would be reinstated.[247] This affected all sports teams at Passaic High. As annoying as the NJSIAA's decision was, all Prof cared about was getting his team to the armory in the Bronx.

Outside the armory at the scheduled start time of 8:00 p.m., basketball mania and pandemonium reigned. The crowd inside was estimated at between 9,000 and 12,000; the crowd marooned outside was between 3,000 and 4,000. Whether inside or out, no one had an inkling of the controversy that was stirring in the bowels of the building.

When Prof arrived, his entrance was heralded by a small group of Passaic rooters who spotted him in the doorway. They began shouting his name—Blood! Blood! Blood!—before most could even see him. Once inside, others quickly noticed the source of the excitement—it was

the Grey Thatched Wizard, the Maker of Champions—their hero. In a very short time, the entire Passaic section was on its feet yelling, and the fans from the other schools, not to be outdone by the Passaic fans, added to the din as Prof's triumphant march continued all the way down one side of the hall. As Prof walked to his seat near the press table, his reception continued. The ebullient fans' appreciation for the wonder coach persisted unabatedly during his introduction to different officials.[248] The ear-shattering acclaim did not cease until he took his seat. Prof had entered the building.

No sooner was Prof seated than he was asked to join a meeting in progress in one of the back offices. A debate had ensued between Hoboken personnel and game officials. The Hoboken people were taking issue over the order of the games. They believed Hoboken was to play in the second game and Passaic vs. CBA in the preliminary. (Don't laugh. Hoboken was serious.) Because Hoboken was the state champ, they believed their game against St. John's Prep should be the featured game. Coincidentally, both schools had challenged Passaic in the past, and each time when Passaic accepted, they had backed out. Within the last ten days, Hoboken had once again refused another opportunity to play Passaic, and yet here they were jangling for top billing.

While Prof went around and around with the Hoboken coaches and administrators over the sequence of the games, James H. Mulholland from Mayor Hylan's Committee arrived to clear the air. Mulholland was direct and succinct. He said that the main event was Passaic and CBA—let the games begin. The giant crowd enjoyed the longer-than-usual delay by spirited cheering—one school group at a time. Passaic fans lead by Mike Kiddon and Leslie Fleming stunned many in the armory by cheering for the other schools, even Hoboken. This diffused the possibility of any spectator hostility.

Hoboken's pride was assuaged with the public announcement that the first game featuring Hoboken and St. John's Prep was not a preliminary game. This announcement was necessary before Coach Walsh would allow his team to take the court. Unbeknownst to the crowd, this was the reason why the games started an hour and fifteen minutes late.

The newly crowned state champions quickly and abruptly had their scepter broken by the Brooklynites of St. John's Prep to the tune of 44-29. The aftermath of the Hoboken manhandling soon subsided, and the hordes of basketball fanatics sat back and waited for the crown jewel of the evening. In moments, the fabled Passaic Wonder Team ran on the floor for what was to be the culmination of an era. CBA Coach Edward J. Kearney, a student at the University of Syracuse, cunningly did not predict victory but did mention that Passaic would know they were in a ball game.

The air tingled with energy; no one in attendance would ever forget the feeling of anticipation as the fans waited for the tip-off. For the next hour, like Beowulf's Heorot, the stability of the large drill shed would be tested. Unaffected by the thunder of the crowd, a couple of New York scribes discussed their predictions. One said, "Defeat (for CBA) is almost certain." Another added, in a tone more serious than the other, "More meat for the Passaic lion."

GAME #146 Christian Brothers Academy (Friday, March 28, 1924) at NYC Armory. The Purple and Gold-clad Syracuse boys were impressive looking. Their big men were tall, and the guards were quick. They played with a confidence that foretold their successes. From the way the armory shook, it was obvious who it was that the majority of the crowd wanted to see win. While respected for their accomplishments, Passaic was a source of jealousy, and the multitude wanted to see them cut down to size.

1923 C.B.A. BASKETBALL TEAM
(FIRST ROW, LEFT TO RIGHT) MESMER AND DUTTON; (SECOND ROW) EISMANN, ALLEN, CAPTAIN BYRNES, DWYER, DRAIS; (THIRD ROW) MANAGER DAWSON, HEARN, O'HARRA, COACH KEARNEY

Now that the state champions were humbled, all attention was focused on Passaic. As for the crowd supporting CBA, they were wasting their time because Prof had his boys primed. The poise and finesse of Passaic was nothing short of spectacular. Quick scores by Pashman, Freeswick, and Blitzer prompted a CBA time out. Passaic was functioning again like a well-oiled machine with their famed passing attack in high gear.

Speedy, pint-sized guard Freddy Mesmer's dribbling gave the Passaic guards trouble as he scampered his way through their defense. Freddy's and Bill Allen's performances kept CBA within striking distance throughout the second quarter. Nevertheless, Passaic was content with their 18-10 advantage at the intermission. In the third quarter, Prof instructed his boys to put CBA on the run. Passaic pulled the ball out and invited CBA to come and get it. After spreading the Syracuse defense, Passaic's passing ran the frustrated defenders into the ground.

By the end of the third quarter, the Wonder Team was in the midst of a performance the likes of which had never been seen. To the anti-Passaic crowd's chagrin and to CBA's demise, Passaic's offense controlled the ball for most of the second half. The passing, teamwork, and shooting spoke volumes for the reasons why Passaic's famous win streak was about to reach 147. Final score: **Passaic 29-Christian Brothers Academy 17**.

PASSAIC				CBA			
	G	F	T		G	F	T
Pashman	4	2	10	Drais	0	0	0
Freeswick	2	3	7	Dwyer	0	0	0
Rohrbach	2	0	4	Byrne	0	0	0
Blitzer	1	0	2	Eiseman	1	2	4
Krakovitch	2	2	6	Allen	1	1	3
Total	**11**	**7**	**29**	Mesmer	4	2	10
				Total	**6**	**5**	**17**

Game played in four eight-minute quarters.
Score by quarters:

Passaic	12	18	25	29
CBA	4	10	12	17

Referee—P. C. Reddick, Springfield College. Umpire—R. Boyson, Springfield College. Scorer and timer for PHS—Harold W. Saunders. Scorer and timer for the Mayor's Committee—Arthur T. Carroll and Dr. Meylan.

Prof believed in passing versus dribbling because it was quicker, it took less physical effort, and it encouraged teamwork. He also liked to win with the least amount of effort—"Make it look easy," was one of his favorite sayings. Once Passaic had the lead, CBA couldn't get the ball to come back. Even the critics realized that Passaic's score could have been much higher. With the monstrous crowd serving as witness, the Passaic boys illustrated why they were called the Wonder Team. Prof believed that the best way to teach basketball was to teach it as if you were teaching the game of life—do it cleanly, intelligently, and nourish it with group cohesiveness—teamwork.

Playing one outstanding game in the Big Apple was worth more publicity for the Wonder Team than the first one hundred victories. Comments from the New York scribes follow.

Joseph Gordon of the *New York Evening World*—"Passaic's five husky lads showed CBA and 10,000 spectators how the game of basketball should be played. CBA could seldom get into scoring position. If Passaic wanted to, the score could have been worse."

Howard V. Valentine of the *New York Evening Telegram*— "At no stage did CBA ever have a chance to win. They were simply up against class that could not be denied. Rohrbach's controlling the taps made it that much easier for PHS to dictate the tempo."

Alfred Dayton of the *New York Evening Sun*—"The passing last night was nothing short of miraculous. I doubt there is a team in their class that can defeat them. The shooting, at least from the floor, was sensational, and the teamwork spoke loudly of the fact that the coach will not stand for any individual starring."[249]

Because the games were played back to back, it was inevitable that pundits would compare the merits and deficiencies of the teams. It was agreed that Hoboken looked terrible. It was estimated that if the newly crowned champs had clashed with Passaic instead of St. John's Prep, they would have lost by forty points. In the Hoboken game, the points were accrued by the sheer physical effort of speed and strength—no system or finesse; whereas, in the featured game between Passaic and CBA, the distinguishing trademarks were headwork, speedy passing, and teamwork. All Prof wanted to do was win and make it look easy. Up by eight points at half time, he instructed his boys "to play easy and not try to run up a large score."[250]

By 3:00 a.m., the deluge of fans in their automobiles and chartered buses returned home, making Passaic's Main Avenue look like any normal Friday evening at 11:00 p.m. With most cars and busses adorned with signs reading, "We Are From Passaic, #147," etc., as in previous years,

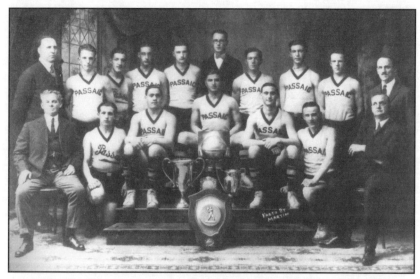

1923-24 UNDEFEATED PASSAIC HIGH SCHOOL TEAM
(BOTTOM, LEFT TO RIGHT) COACH E. BLOOD, IRVING BERG, MOYER KRAKOVITCH, SAM BLITZER, MILTON PASHMAN, EDWARD HANSON, PRINCIPAL ARNOLD. (TOP) A. MARKS, AL GEE, PHIL RISKIN, STANLEY ADAMS, NELSON ROHRBACK, ALBERT WACZKO, JOHN FREESWICK, MAURICE CANTOR, ROBERT RUSSELL, JOE GARDNER.

their return home in the early hours of the morning was a good reason for another impromptu celebration. Every restaurant was crowded, and fans stood on corners discussing the team's latest victim. It was a significant victory against a celebrated opponent, and Passaic was in the mood to whoop it up.

While the excitement surrounding the Wonder Team's successes was still an occasion for celebrating, the spontaneity from the newness it once had created showed signs of ebbing. As was evident last season, the school's administration turned a deaf ear to any post-season victory assemblies. As far as the administrators were concerned, the less said the better. In contrast to how the administration felt, the streak caught the nation's attention, and it was plastering the city's name in newspapers across the country.

Prof's notoriety continued to place him in great demand as a featured speaker. The YMCA's in Portsmouth, New Hampshire, again in Rahway, and now in Paterson were negotiating for some of Prof's time and wisdom. His new topic that referred to the moral and physical development of American youth was "The Fork in the Road."

Like a relentless headache, Passaic's spring sports suspension by the NJSIAA persisted. The worst kept secret was Short's vindictiveness towards Prof. Short could not dictate to Prof; in fact, he greatly resented how Prof, while appealing for fairness, was dictating to him. Prof refused to be forced to abide by policies that were contrary to his sense of fairness. Short's only avenue of revenge against Prof was the school's suspension.

Disregarding his comments of almost a week before, Short was now saying that Passaic did act within its right by dropping out of the tournament and that it was not mandatory for Passaic to continue on into the semifinals of the state play-offs. In the final accord, the members of the NJSIAA executive committee felt Passaic had acted in an unsportsmanlike manner by withdrawing with such short notice. It was poor sportsmanship on Passaic's (Prof) part that Orange, Central, and Morristown were not given a fair show as a result of Passaic's action.[251]

Another indication of Short's vindictiveness was the *Newark Sunday Call's* New Jersey All-State selections. Short had some influence with the sports department at the *Call*, and through his urging, Passaic players were not recognized. Realizing the injustice, the *Hudson Dispatch* from Union Hill and the *Newark Ledger* both produced their own All-State teams that included Pashman and Krakovitch and other Passaic players.[252]

The suspension was turning into a real sore spot for Passaic. The Passaic athletic teams and fans had had an unblemished record for cleanliness and fair play and to learn that they (baseball and track) were to be

punished for poor sportsmanship did not sit well. All this because Short had a grudge against Prof.[253]

Finally, after many delays, a meeting was set for Friday, April 25, at the Robert Treat Hotel in Newark. At the meeting, Short was in position to be both the prosecutor and judge presiding over Passaic's interscholastic athletic future. In the meanwhile, all spring sports at the high school were suspended.[254]

Short's vendetta against Prof was becoming more obvious. The latest news dealt with Charles W. Foley who was informed by a high official in the NJSIAA that he "should keep his hands off Passaic, as we are going to see that Passaic High does not compete against any teams as long as Mr. Blood is in charge."[255]

At the regularly scheduled April school board meeting, the members discussed their strategy for countering the association's suspension. Most members of the board voiced their dissatisfaction with the suspension, especially Edwin Flower who was most supportive of Blood for looking out for the welfare of the team and its fans. But it was Breslawsky who voiced his exceptions to Prof's meritorious deeds with the following address to the board:

> *This matter should not have been brought to the place it has been. The trouble has been caused by the physical training director of this city and the state officials. The latter should have acted with the physical training director and the board's representative, but instead has confined all its questions to the physical training director.*

> *Mr. Blood has never recognized the authority of the Board of Education in these matters at all. At the last meeting the board waived the rule so that the benefit game could be played. When the matter was brought up at the Athletic Council meeting Mr. Blood said that the board had no right to waive the rule, but could have rescinded it.[256]*

The irony in this was that it was Breslawsky who initially usurped Prof's authority by directing the athletic secretary to submit the tournament application and then fought Prof on the issue every inch of the way. It was Breslawsky who, on numerous occasions, revealed his disdain for Prof and his basketball team; on the other hand, when he shouldn't have become involved, he couldn't keep his nose out of Prof's business.

Before the board meeting adjourned, Benson appointed an *ad hoc* committee to confer with the high school's Athletic Council and secure the services of Henry C. Whitehead to represent the school in the standoff with the NJSIAA. He named the following men to the committee:

Crowley, Shepherd, Gardner, Breslawsky, and Arnold.[257] With the exceptions of Shepherd and Gardner, one would be hard pressed to assemble a poorer group to represent Blood in a hearing with the NJSIAA. The solution they were concocting was not about what was best for the teams, fans, or the city, but more about how to best get Prof. The goal of both the board and Short was to neutralize the man whose influence was responsible for so much good in the school, city, and in the game of basketball.

In addition to the banquet speaker circuit, Prof found time to take the team to Yankee Stadium to see the Red Sox game. Krakovitch, Freeswick, and Pashman caught Babe Ruth's attention as he warmed up near the dugout. The affable Babe stopped throwing and came over to talk to the excited boys. When the Babe realized who they were, he shook their hands (Prof included) and confessed that he knew nothing about shooting baskets, but he would try to shoot one into the bleachers for them. The Yankees ran all over the Red Sox with fifteen runs, and Babe collected a single, a double, a walk, and a strike out. It wasn't until the top of the eighth that Babe came through with his promise and sent one into the bleachers.[258]

The newspapers produced this headline and story in the *Passaic Daily News* the following day:

P. H. S. SUSPENSION TO BE LIFTED.

The initial charge against Passaic of unsportsmanlike behavior for withdrawing from the tourney was just a smoke screen camouflaging the NJSIAA's real intentions. It was determined that the suspension would be lifted as soon as, but not before, the school authorities identified the person with whom the NJSIAA must deal in the future. This identification had to be recorded in writing and signed by the superintendent, school board president, and principal. It was the following phrase in the agreement that revealed the association's real ambition and animus for Prof. "It is suggested in the interests of harmony that someone other than Mr. Blood be designated."[259]

During the long-awaited NJSIAA hearing in Newark concerning the school's suspension, Whitehead questioned Secretary Short about the alleged conversation Prof and Short had regarding their agreement that Passaic would not have to play a Hudson County team in Hudson County. Short owned up to the telephone conversation he initiated after receiving Blood's telegram, but he denied any promise to switch the location of the game. He did remember saying that he would accept the late post-season entry, but he carefully avoided any mention about the letter. It was significant that nothing was ever put in writing. It meant that Passaic was the only one of the sixty-four teams in the state's play-off competition who participated without a written agreement.[260]

Whitehead's continual questioning disturbed Short. The attorney asked Short if he had stated last year that Passaic should not play in Hudson County. The secretary answered that his stipulation at that time was that "Passaic shouldn't play in Hoboken." No explanation followed to explain why he was now trying to force Passaic to do exactly what he had previously stated they should not. At his first opportunity to change the focus of the hearing, Short embarked on a lengthy diatribe denouncing Passaic's (Prof's) dictatorial attitude.[261]

While venting about Prof, Short brought up the issue of the game officials. Since the inception of the tournament five years before, Short had always reserved the right to pick the officials. The actual assignment of officials, with a couple of exceptions, was not completed until meeting with the respective coaches. During Short's diatribe, it was revealed that for one reason or another, Prof hadn't been notified (this year) that the meeting was to be held.[262] This would explain Prof's surprise and indignation at courtside when the game officials were identified.

Until this point in the meeting, Prof was not in attendance because of a prior commitment. Upon entering the room and after being seated, NJSIAA President MacArthur, who was presiding over the meeting, briefed Blood about what he had missed and asked him for his comments. Prof offered these words:

> *I've just come from delivering an address on 'Good Sportsmanship' at the Paterson YMCA. The automobile was slow and I am sorry to have kept you waiting. If I disliked you enough, I'd wish you possessed a record of over 100 victories, and all that goes with it. It is difficult for you to realize the conditions that have arisen, not only with outsiders, but with townspeople and those from within.*
>
> *The record means nothing to me. But to the boys it means a great deal. Our team this year was in a transitory period. They were at a dangerous age. It was necessary to see to their growth. On this account, I was strenuously opposed to any post-season games this year. In fact, advocating before the season started that only league games be played. Yet I was practically forced to allow the team in the tournament, but the Athletic Council took over the entire responsibility for what might happen....*[263]

Prof continued by rebuking his athletic council for going against his judgment and not supporting him. He went so far as to intimate that the entire trouble experienced with the NJSIAA was due primarily to the council's insistance that the team be entered in the tournament. He referred to the telephone conversation that had been mentioned previously in Short's

testimony to Whitehead. In the course of that conversation last year, he and Short agreed that Passaic should not have to play a Hudson County team in Hudson County. "Referee Harry Wallum, one of the state's most respected game officials, told me, on numerous occasions, that I would be a fool to ever play in Hudson County." Prof went on to explain that he had nothing against the Hoboken team, players or coaches. He objected to how their newspaper wrote its coverage of the games. In Prof's opinion, the paper's style of reporting had a negative effect on their fans to the point that all sport and fellowship became lost.[264]

ERNEST BLOOD

The problem, according to Prof, was the record; it was the drawing card. Prof had been offered large sums of money to have his team play certain games that he, of course, refused. Because of the record, the boys had been under a great strain. For that reason, Prof opposed participation in the tournament for this group of boys.[265]

Prof aimed his first question concerning the letter Short allegedly agreed to write confirming the conditional entry directly at the state's athletic secretary. Prof asked, "Mr. Short will at least agree that he told me he would write me, won't he?" Silence reigned while Short searched for the appropriate response. After much hesitation, he finally denied everything except saying that he would accept an entry from Passaic.[266]

Visibly distraught over Prof's line of questioning, Short flew into his second tirade of the evening. He accused Prof of trying to "run things" and of adopting a suspicious attitude towards the officials of the association. No sooner had his harangue run out of gas than Prof retaliated by saying that if Short wanted to bring personalities into it, then he wanted to add a few comments of his own. As the speechless spectators looked on, Prof told of the time that he caught Short in a lie. Several years before, Short wanted to hold the state finals in Trenton, his home city. According to Short, the Princeton University facility had been unavailable. By chance, Prof learned from Howard Opie who scheduled use of the gym that Short

never inquired about its availability as he said he had. When Opie was informed of what Short was saying and planning to do, he confronted Short. The eventual outcome was that a contract was drawn up to hold the finals in Princeton.[267]

Prof went on to mention how referee Phil Lewis refused to throw the ball up straight in the championship game at Princeton, placing Passaic at a huge disadvantage. In another incident, during Bobby Thompson's final game against Asbury Park, referee Cartwright made it obvious that he was trying to distract Thompson while he shot his fouls. Thompson, who was in attendance at the meeting, stood up and verified the accuracy of Prof's testimony.[268]

Prof maintained that these and similar other reasons were the cause of his disdain for the tournament. In a comic spectacle worth the ride to Newark, Prof's talion had Short nervously shuffling through a mass of papers positioned at his side. Before concluding his testimony and sitting down, Prof said, "I have never asked for any special favors. All I have asked for are my rights. It is good sportsmanship to stick up for your rights."[269]

During the course of the hearing, it became clear that Short did not want to deal with Blood. All those present, however, wanted to learn who was running the show in Passaic. NJSIAA President MacArthur said the association was at a loss to know with whom they were dealing. The situation presented too much confusion because one man entered the team and another withdrew the entry. The stipulation for lifting the suspension came down to Passaic identifying the person who had the authority and with whom they would deal.[270]

Prof regretted the confusion but indicated that it was the result of Short's dealings with irresponsible Passaic personnel. As an example, he mentioned the time Breslawsky told the NJSIAA that a committee of 500 Passaic residents wanted to appear before the association to put the team back in the tournament. "I suppose," Prof toyed, "it was nearer five than five hundred." Nonetheless, at this point, MacArthur was willing to wipe the slate clean if a central authority could be established.[271]

Remaining consistent in their portrayal of Blood, the *Passaic Daily Herald* ran this marquee headline:

STATE GROUP WON'T DEAL WITH BLOOD.

Because they shared one common goal, one could surmise that the NJSIAA and the Passaic authorities were working in unison to wrestle control of athletics away from Prof, but that was beyond proving. In spite of his righteous intentions, Prof could see the handwriting on the wall. If this was the way in which control of competitive athletics was going to be administered, then he didn't want any part of it. Frustrated and disgusted, all he could do was review his options and go from there.

Whether Shepherd met with Prof again to brief him on the direction the school was about to take regarding control of athletics is not known. While their resolves would not become public for over two weeks, Prof and the school authorities appeared headed for a split as both parties went about planning their respective courses of action. In the letter below, Prof made an appealing plea to be relieved of the responsibility of supervising high school athletics.

May 5, 1924

Dr. Fred S. Shepherd
Superintendent of Schools
Passaic, N. J.

My Dear Dr. Shepherd:

My last annual report of the physical department of last year concluded with the statement: that 'It may be a good thing to train a high school girl or boy in a game, but it is far greater and more worth while to interest and help the grammar school pupil to become the best high school material possible. To put this into effect will require all my time supervising and directing the work of the grades. I would respectfully ask that I be relieved from the responsibility for the high school competitive athletics, and devote all my time to the grammar schools.

Another school year is nearing its close and I am more than ever convinced that my request to be relieved from the responsibility for the high school athletics was for the best interests of the city.

All difficulties of the past have arisen, directly or indirectly, from the abnormal interest in one sport, basketball.'

The unequaled success and record established resulted in conditions, local and general, unparalleled in any sport. Unwise publicity, false statements, misrepresentation, jealousies and unsuccessful attempts to commercialize and exploit the boys cast their shadows before, and my recommendation of last year has now been proven sound. The same foresight that made the record possible saw clearly the inevitable results, and, true to the duty of my position, I made the above recommendation in order to safeguard the health and proper growth of the players, and to establish a more normal attitude among the general public in regard to winning championships and making records.

The grammar school problem here is immense. Real organization is urgent. The problem is too big, and possibilities too great for the director of physical education to divide his time with high school competitive sports, and I again respectfully ask that I be relieved of the responsibility of all high school competitive athletics.

> *Respectfully yours,*
> *Ernest A. Blood*
> *Director of Phys. Edu.*

On May 13, the day after the next school board meeting, the newspapers brought the public up to date with this headline:
"PROF." BLOOD RETIRES FROM HIGH SCHOOL ATHLETICS.
The newspapers published Prof's letter and stated how the school trustees unanimously granted his wishes. Presenting the facade that Prof's request was the catalyst for administrative restructuring, Superintendent Shepherd, covering every inch of his rear end, introduced Passaic's new athletic policies.

The former system of administering athletics, according to Shepherd's comments, proved to be weak and ineffective because it was too decentralized and it confused responsibilities. The solution was to place the principal in charge of organizing and directing all extracurricular athletics. This meant that Arnold would oversee the Athletic Council and become the new supervisor for the physical education teachers and coaches. Shepherd called it centralization of responsibility with responsibility.[272]

Shepherd's whitewash continued by revealing that Prof's double duties as the school district's physical director and supervisor of interscholastic sports had caused him physical breakdowns as far back as two years before. He praised Prof for his gallant work and unmatched results. Reiterating Blood's request, Shepherd explained how Blood felt that his time and energies were focused in the wrong direction. He explained that Prof questioned putting all his efforts into a select few when the work of building strong bodies and character for all the boys and girls should have been his primary concern.[273]

To further tighten their control of all athletic matters, the Athletic Council was going to amend Article 16, Section 2 of the BOE manual dealing with school athletics. The change would mean that the captains of the various teams and the physical director would be eliminated from membership on the Athletic Council. Additional amendments stated that the selection of candidates for teams would be subject to the approval of the principal who would take into account both physical and scholastic eligibility. The schedule of games would be arranged by the Athletic Council who alone would be authorized to enter teams in games and tournaments.

To clarify who would attend the meetings of the NJSIAA, the Athletic Council's chairman or his designee would serve as the school's representative.[274]

To finally get the association's athletic suspension lifted and to serve as a final epithet to Prof's ouster as Passaic's decision-maker for athletics, the Athletic Council presented this resolution to be immediately forwarded to the NJSIAA.

> **"Resolved**, that the New Jersey State Interscholastic Athletic Association be requested hereafter to address all official communications and have all official dealings with the Athletic Council authorized under the rules of this Board, addressing all communications in care of the Athletic Council, and that a copy of this resolution be forthwith forwarded to Mr. Walter E. Short, Secretary of the New Jersey State Interscholastic Athletic Association.
>
> James A. Crowley
> John J. Breslawsky
> Alfred Ehrhardt[275]

Those men who sought Prof's demise must have been a happy group. They'd won! They'd fixed it so that they could run the basketball team the way they wanted it run. The man responsible for developing strong bodies and outstanding character in the city's youth had finally been removed. Long live the names and memories of these shortsighted men. Greenfield's piece in the newspaper perhaps said it best when he wrote, "The treatment this man received will ever remain a blot on the fair name of Passaic."[276]

Because many believed that Prof would return as he always had in the past, only a mild uproar followed the announcement. The prospects for next season where very bright, much, much better than they had been for the season just concluded. The team's leading scorer and possibly the most talented forward in the state, Milton Pashman, was elected captain. There was a good chance, even without Prof, that the team would breeze through an undefeated season once again.[277]

Before the school year was over, Prof accepted the Physical Directorship for the Jefferson Street YMHA. Prof's enlistment once again, as when he had first arrived in Passaic in 1915, was considered the *coup d'etat* of the year. Prof wasn't obligating himself to coach any of their teams, but if he did, he would be reunited with many of his former Jewish players. Add Pashman and Krakovitch to that pool of talent who would possibly choose to do double duty with the high school and YMHA teams. Prof's duties at the YMHA would start on September 1, and his hours

would be in the evening so they wouldn't conflict with his other school duties.[278]

Blood had been involved with basketball since the year Naismith started it. Now at the age of fifty-two, was Prof concluding his coaching career? If he never coached another game, his legacy as a basketball pioneer would be secure. For the time being, however, the muscular, energetic, little physical educator was content to enjoy his summer. He was not seriously considering leaving Passaic, nor was he entertaining thoughts of ever coaching at Passaic High School again. The handwriting was on the wall; the end of an era was imminent.

Chapter Fourteen
"Who Needs Blood?"
(1924-1925)

With so much optimism nationally and locally regarding the economy and with national pride at an all-time high, it wasn't a time for the people to lament over the tribulations of a basketball coach. Overall, life in Passaic was good and getting better. The outlook for another Wonder Team was also good. The school had more talented basketball players than ever. Another undefeated season was a realistic goal—even without the Little Napoleon of Basketball.

Notre Dame's Knute Rockne responded to his new one hundred thousand dollar contract (over ten years) by producing what Grantland Rice would tag the "Four Horsemen." In Northern New Jersey, football coach Jack Wallace, the Knute Rockne of Rutherford High School, received a bonus of over one thousand dollars from his school board for his stellar coaching accomplishments. After building Rutherford's football program, Wallace accepted the head football coaching position at Rutgers College.

In contrast, Prof Blood, with more career basketball victories than any other coach, continued his work as a public school employee teaching children the values of physical exercise and clean living. For his reward, Prof was defrocked of some duties and relegated to the role of an athletic pariah by the NJSIAA and his school administration.

Contrary to human nature, the lack of appreciation afforded Prof did not sour the fifty-two-year-old nor did it diminish his desire to coach again. Persistent rumors, which had the townspeople worried, had Prof defecting and taking his talents elsewhere. As worried as the Passaic people were over Prof's future allegiance, no one would have faulted him for leaving after what he had been through.[279]

Those close to the team could see right through the principal's and BOE's façade. They presented a supportive face in public as they covertly de-emphasized basketball's effect on the school and, consequently, the entire city. They didn't want the winning to stop; they merely would have preferred to see the team lose a few games now and then. Breslawsky's cohorts sought power and control; all the excitement over the basketball success did not massage their egos unless they were the individuals in control.

On the first day of practice, Coach Amasa Marks was looking at a talent-laden team with candidates from both sides of the Erie Railroad tracks. The returning stars, Milton Pashman, Moyer Krakovitch, and Nelson Rohrbach, were positioned around a bigger, stronger, and much improved Stanley Adams. Sam "Mucky" Goldstein, a tough, athletic little guard who was reared in the local YMHA program, was also on the roster. Under Prof, one can posit that it would have been possible to divide talent of this depth into two teams, both capable of winning it all. Marks had the coaching assistance of football/baseball coach Ray Pickett and former player Fritz Knothe. Knothe dropped out of college to return home to terrorize the local basketball/baseball amateur leagues before going off to play professional baseball.[280]

RAY PICKETT

If ever anyone were caught in the hot seat, it was Coach Marks. He didn't want the head coaching position; it was forced upon him. Liked by everyone, Marks understood little about the finer points of coaching basketball. All he knew was what he had gleaned from observing Prof.[281] The constant comparison to the Old Master must have been frustrating. Nevertheless, the administration was pleased to deal with him rather than Prof.

As the new Physical Director of the YMHA, Prof spent his evenings supervising its programs. His time was more flexible now that he no longer had the responsibility of the high school interscholastic program. A good percentage of Prof's players were Jewish boys who received their first athletic opportunities at the YMHA. Many second-generation Jewish immigrants took pride in their athletic prowess, and the YMHA basketball team became a valuable Americanization tool for the Jewish community.

Members of the school's Athletic Council learned that Irving H. Burg, the new basketball team manager, had twice scheduled three games in a single week. The Athletic Council quickly revised Burg's schedule by instituting a new policy permitting only two games per week, except for state tournament games. The council also decided to make up a deficit ($471.18) in the athletic treasury. To conserve money, they decided to save the fee they paid to play their home games in the Passaic Armory and return all games to the dark, cramped high school gym.[282]

The pregame hype surrounding the opening game with challengers from outside the area lacked the attention of previous seasons. But nationally, the unprecedented winning streak was still an attention-getter.

Win streak or not, the return to the drab, antiquated basement gym deterred attendance, but the local fans' expectations for winning were enormous.

GAME #148 Pearl River, Long Island, (Saturday, December 20, 1924) at Passaic HS. Skeptics were relieved as Passaic flashed signs of the usual brilliance against Pearl River. They were veterans, and they showed it with their skills and savvy. The opener was an acceptable performance, but it was marred with bouts of individualism. Many of the scoring opportunities came off individual efforts that impressed the less sophisticated fans. The one who impressed the fans the most was the fleet-footed Milton Pashman who dazzled the crowd with a plethora of outside shots and clever dribbling. Pashman's performance was eye-catching, but it was not typical of a Wonder Team player.

PASSAIC	G	F	T	PEARL RIVER	G	F	T
Pashman	11	3	25	Lynch	0	0	0
Adams	9	1	19	Munkelt	2	0	4
Harwood	3	0	6	Heiser	0	0	0
Novitsky	0	0	0	O'Leary	1	1	3
Russell	0	0	0	Elchoen	0	0	0
Rohrbach	4	2	10	Mariano	3	1	7
Wall	1	0	2	Slade	0	1	1
Pomorski	0	0	0	Swendell	0	0	0
Krakovitch	4	0	8	**Total**	**6**	**3**	**15**
Goldstein	1	0	2				
Rebele	0	0	0				
Janowski	0	0	0	10-minute quarters			
Total	**33**	**6**	**74**				

Scorer—Abraham B. Greenberg. Timer—Irving H. Burg. Referee—Roy Schulting, Passaic

Author's Note: The discrepancy in the numbers was most likely because of new score-keeping personnel.

Final score: **Passaic 74-Pearl River 15**.

Charles W. Foley was at it again. This time, the wealthy Montclair fan promised to provide another loving cup in the event that the locals won their 150th straight game. He was also making news with on-going letters to the newspaper's sports editors feeding the never-ending chatter surrounding Passaic basketball. As Foley continued to become more associated with the Wonder Team as its "super" booster, he began to emerge as their unofficial spokesman, a role he relished.[283]

While Foley was successful in aligning himself with the team, he received no reciprocity from the administration. When it was learned that archrival Union Hill had granted Foley a season pass to their basketball games, many Passaic fans feared he would switch his allegiance. During a visit to the high school to admire the other cups he'd donated, the visit turned into an embarrassing moment when it became apparent that no one could find the cups. A couple of weeks before, Foley had offered the Passaic BOE a check for $1000.00 to start a fund for the

construction of an athletic stadium. He never received a reply from the school recognizing his offer.[284]

GAME #149 Jamaica, Long Island, (Saturday, December 27, 1924) at Passaic HS. The Red and Blue boys showed only spasmodic spurts of their old form. By Passaic standards, their performance was not pretty. A Wonder(less) team struggled every inch of the way against a foe that Union Hill had defeated (32-10) the week before. Too much individualism and dribbling were the feature of the day, and it was mostly the doing of Captain Pashman. It didn't help matters to have Nellie Rohrbach exit quickly with four fouls. A bright spot was Passaic's other All-State player Moyer Krakovitch who played spectacularly in every category.[285]

Moments before the start of the game, super-fan Joe Whalley accompanied the Grey Thatched Wizard across the court to the corner of the gym. As a gentleman, Prof did not comment on the team's ragged performance; he didn't have to. While Prof was not thrilled with the game, Hackensack's Howie Bollerman and his teammates, who were also in attendance, left feeling quite good about what they had seen. The win did earn a loving cup from Max Rutblatt, local sporting goods store owner who had promised the cup if the team's win streak reached 149. Final score: **Passaic 63-Jamaica 36**.

PASSAIC	G	F	T	JAMAICA	G	F	T
Pashman	4	5	13	Winters	1	0	2
Adams	8	3	19	Schemeal	3	1	7
Harwood	4	0	8	Beck	0	0	0
Rohrbach	4	0	8	Hagien	0	0	0
Pomorski	3	0	6	Powell	2	2	6
Krakovitch	3	1	7	Hamm	0	0	0
Russell	1	0	2	Friedel	4	0	8
Goldstein	0	0	0	Bayles	5	2	12
Rebele	0	0	0	Patten	0	1	1
Totals	**27**	**9**	**63**	Loy	0	0	0
				Totals	**15**	**6**	**36**

Time of quarters—Ten minutes. Scorer—Abe Greenberg. Timer—Irving H. Burg. Referee—Herman W. Schulting, Jr.

Looking to remedy the team's ills, Marks enlisted the services of former Wonder Team members home from college for Christmas. A scrimmage with Mike Hamas, Johnny Roosma, and Paul Blood, who had become the Drake Business School basketball coach, helped the boys prepare for their 150th milestone game with Arlington.[286]

From the approximately two hundred challenges that Joseph M. Gardner received for Passaic's centennial and a half game, the list was culled to twenty. Assisting Gardner was none other than Foley. From the twenty, Arlington, recognized as the Massachusetts state champ, emerged as the top contender. Local challengers Union Hill and Hoboken were not considered as strong as Arlington.[287]

The 150th game was an historic event that was receiving publicity everywhere the sports wire news service reached. The Paterson Armory was secured, and special arrangements were made to film the game and show it later at the new Montauk Theater. After the screening at the Montauk, Passaic's Harry Stein and Jacob Fabian of Fabian Enterprises planned to present the film to the school.

GAME #150 Arlington, Massachusetts, (Saturday, January 1, 1925) at Paterson Armory. Arlington's Coach Ralph C. Henricus was confident his boys would give Passaic a good game if not snap the streak. His confidence swelled further when he observed Prof Blood enter the armory, receive a hero's welcome, and take a seat apart from the Passaic bench. Before nearly 5000 spectators, the Arlington boys played admirably, but their efforts were neutralized by a resurgence of the Blood style offense. Pashman's unselfish play set the pace for a stellar

PASSAIC	G	F	T	ARLINGTON	G	F	T
Pashman	6	0	12	Marsters	6	3	15
Adams	11	0	22	Crosby	0	0	0
Harwood	0	0	0	J.Lane	6	1	13
S.Riskin	0	0	0	E.Lane	2	1	5
Rohrbach	10	4	24	Keefe	0	0	0
Pomorski	0	0	0	Dale	0	0	0
Krakovitch	3	2	8	Canty	0	0	0
Russell	3	0	6	**Total**	**14**	**5**	**33**
Goldstein	0	0	0				
P.Riskin	0	1	1				
Total	**33**	**7**	**73**				

Score by quarters:
Passaic 19 33 58 73
Arlington 6 15 21 33

Referee—Harry Wallum. Scorer—David Kaplan, Timer—Irving Burg. Ten-minute quarters.

team performance. Final score: **Passaic 73-Arlington 33**.

The pageantry of the 3:30 afternoon spectacle was history in the making. The loving cups from Rutblatt (149) and Foley (150) were presented to the Passaic players as mementos of their accomplishments.

After traveling for three hours in a blizzard the next day, Arlington stretched the Morristown "Marvel Team" to the limit before bowing 25-19 in a closer game than the final score revealed. Coach Hendricks, who still believed his boys would win the New England championship, was so impressed with Passaic's brand of ball that he said Passaic was the best team he had ever seen. His players more than concurred by adding, "Passaic could whip any other high school in the country."[288]

Echoing growing sentiments of doubt from local fans, Wendell Merrill, the new *Passaic Daily News* sports editor threw a few digs at Coach Marks. Merrill questioned his method of substituting and maintaining team discipline. Following in the footsteps of a legend, Marks was in a rough situation. To make it easier for Marks, Arnold had assigned Ray Pickett to assistant him, but unfortunately, Pickett wasn't popular with

most of the players, nor did he know anything about basketball. No one would argue that Prof's mere presence in the dressing room at half time would do the team more benefit than anything else.[289]

GAME #151 Hackensack, (Wednesday, January 7, 1925) at Paterson Armory. With a concern for fairness and because of the tremendous interest in the rivalry, Passaic moved the Hackensack game to the Paterson Armory. For almost three-quarters, three thousand fans watched the taller and more athletic Golden Comets ignore the Wonder Team's aura. Exhibiting splashes of individualism and conceding most jump balls, the Wonders immediately found themselves playing catch up.

Aided by Freddy Fast's quickness, Coach John Steinhilber's game plan that relied on 6'6" Howie Bollerman to get every center tap caused panic on the Passaic bench. Although out-jumped at center, Nellie Rohrbach was able to out-finesse the taller Bollerman around the basket. The Red and Blue boys regained control of the tempo by outscoring Hackensack 14 to 6 in the second quarter.

The seesaw battle in the third quarter finished with Passaic up by two. In the first few minutes of the fourth quarter, Hackensack made its final surge and took a three-point lead. While the Passaic fans grimaced in despair, the Hackensack fans screamed with delight. Then Captain Pashman, who had been pouting over the criticisms that had been directed his way, pulled off the most sensational move of the game. Dribbling the length of the court at breakneck speed and passing every defender

PASSAIC				HACKENSACK			
	G	F	T		G	F	T
Pashman	6	2	14	Brown	1	2	4
Adams	8	0	16	Weatherby	2	1	5
Rohrbach	7	2	16	Fast	8	2	18
Krakovitch	2	0	4	Bollerman	3	4	10
Goldstein	1	0	2	McGowan	0	0	0
Russell	1	0	2	Greenleese	0	0	0
Totals	**25**	**4**	**54**	O'Shea	0	0	0
Score by quarters:				**Totals**	**14**	**9**	**37**
Passaic	6	20	35	54			
Hackensack	7	13	33	37			

Referee—Harry Wallum.

along the way, he launched an awkward one hander for a "How did he do that?" basket. After breaking the Hackensack spell, Pashman gathered his teammates together for a game-ending rally.

At that point, the superior basketball instincts of the Passaic players and the reappearance of Blood's quick passing attack propelled Passaic through the remainder of the game. The final score was no indication of the close score for most of the game or the struggle involved—the Wonders survived to defend their streak another day. One thing was certain, Passaic was not seventeen points better than Hackensack. Final score: **Passaic 54-Hackensack 37**.

W. J. Madden, the new sports editor for the *Bergen Evening Record,* made this observation of the game.

To the casual observer, it is easily discernible that the present Passaic High School team is not playing the smooth, short passing game which was taught them by their former mentor, Ernest Blood.

Time and time again Krakovitch or Pashman would dribble the entire length of the floor and then pass wildly out of bounds on the sides or else take a desperate shot at the basket.

There was a total lack of short passes and the Red team continually resorted to tosses the entire length of the floor which often as not went into the crowd.

Only in the final drive to victory, which the team staged in the last period, did they forget individual play and resort to the system which Blood had taught them.

Somewhere in the big Armory the little gray haired man sat, almost unnoticed by the crowd. He had piloted them to innumerable victories on the ribbed court and now his place was being filled by another.

It must have been repulsive to him to see the individual playing of the Passaic boys....[290]

Two days later, Arnold and the Athletic Council gave unanimous approval to a challenge game with a NYC basketball kingpin at a New York armory. In spite of this apparent aberration in the administration's *modis operendi*, it helped counter the public's opinion that Arnold and the council were anti-basketball. Commerce High School was chosen over nearly one thousand others because it was acknowledged that a win over Commerce would have the greatest public impact.[291] The approval

for the Commerce game was followed with a letter from Manager Irving H. Burg to the NYC champions.[292]

A multitude of renowned teams were vying for a game with Passaic. Stivers High School, a dominate team from Ohio; Uniontown from the Pittsburgh area, who were offering a $1,500.00 guarantee; the crack West Philadelphia team, who were enjoying a thirty-six game win streak; and Martinsville in Indiana, where John Wooden (former UCLA coach) was then a player, were among the schools looking for the chance to unseat the Wonder Team. Stivers claimed the Ohio State Championship for five of the previous eight years, compiling a 182-22 record with seven of those losses by one point. Unfortunately, the dates that Stivers had available were not open dates for Passaic.[293, 294]

While impersonating a basketball enthusiast, Arnold announced that a victory over the NYC champs would quiet the team's critics. His comments were met with instant public approval, and Arnold feigned a sportsman's persona. To enhance the facade, Arnold and Breslawsky approved the purchase of new team uniforms. Their message was, "Look, we're behind the boys one hundred percent." The administration wanted the public to know that all decisions to participate in challenge games were still subject to the approval of the coach.[295] The policy did not worry the principal or the Athletic Council because Marks was little more than their puppet.

Before Burg's letter was received by Commerce, their Coach Pincus declined the invitation because midyear graduation was about to take most of his players. Minus the graduates, his team would not be strong enough to challenge the likes of Passaic.[296]

GAME #152 Englewood (Saturday, January 10, 1925) at Englewood. This Englewood match-up turned into a benefit game for their injured football star Eddie Smith. Almost one thousand frenzied fans filled their large gymnasium. The energized crowd helped the Maroon and White team chal-
lenge an uninspired Passaic team.

In what might have been the worst played game ever by a Wonder Team, Coach Marks played all fifteen boys in an apparent coaching ploy to accomplish some unknown objective. Unlike Prof's calculated substitutions, Marks

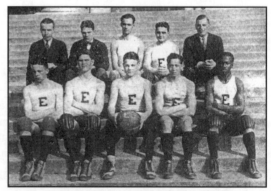

1924-25 ENGLEWOOD TEAM
photo courtesy of The Englewood Historical Society

rushed players in and out without reason. The bewildered boys fumbled their way to a three-point advantage after eight minutes. Bobby Russell replaced Krakovitch a couple of minutes into the game, but his teammates never passed him the ball—not once!

Passaic's misguided play enabled Coach Hurlburt's defenders, especially his all-around star Everett Levinsohn, to break up more Passaic passes than in any previous game. The aimless methods of the Passaic bench frustrated Passaic fans and players. Mike Murberg's defense on Rohrbach was made more effective because no one was looking to get Nellie the ball. To make the situation worse, Englewood's Cal Smith was having a field day popping them in from mid-court.[297]

Something was wrong. The *Bergen Evening Record* reported, "It was easy to see that Earnest [sic] Blood was no longer at the helm of the Red Juggernaut. No longer are there the short careful passes and the sure shooting that had been taught to the Passaic boys in the Blood regime."[298] The finger pointing had begun.

The Bergen newspaper went on to describe the antics of the Passaic captain: "…after having made a shot that practically won the Hackensack game for Passaic, [Pashman] again seems to be somewhat impressed by his own importance. If Pashman should look at the record of the shots that he missed in Saturday's contest perhaps he would realize that it does not pay to consider one's self before his team."[299]

With each passing game, Passaic was playing more and more like five individuals. The tall jovial Marks and his grim assistant were searching for clues to help them turn things around. They were at a loss as how to correct the myriad of problems engulfing the team. The only positive aspect of the game was the brilliant play of Sam Goldstein; this was his best game. Final score: **Passaic 48-Englewood 30**.

Another concern regarding the team's style of play surfaced when it was learned that Dan Daniel, a well-known sports authority who had written for the *New York Sun, New York Herald-Tribune*, and *New York Telegram and Evening Mail,* was coming to Passaic for the Cliffside

PASSAIC	G	F	T	ENGLEWOOD	G	F	T
Pashman	5	1	11	Mittler	3	3	9
S.Riskin	0	1	1	Cirelli	1	0	2
Adams	8	2	18	C.Smith	5	3	13
Harwood	1	1	3	Murberg	0	4	4
Sattan	0	0	0	Campbell	1	0	2
Schere	0	0	0	R.Smith	0	0	0
Pomorski	0	1	1	Levinsohn	0	0	0
Rohrbach	1	0	2	**Totals**	**10**	**10**	**30**
Krakovitch	2	1	5	Score by quarters:			
Goldstein	3	1	7	**Passaic**	13	15	8 12
Russell	0	0	0	**Englewood**	10	4	9 7
Janowski	0	0					
Rebele	0	0	0	Referee—Hobbs.			
Wall	0	0	0				
P.Riskin	0	0	0				
Totals	**20**	**8**	**48**[300]				

game. Would he be impressed with the Wonder Team or would he report that the legendary Passaic boys were overrated?[301]

Ross H. Wynkoop, the former sports editor for the *Bergen Evening Record*, suggested that the second Passaic/Hackensack game be moved back to the Paterson Armory. In the spirit of fair play, he claimed that Hackensack should extend the same courtesy to Passaic that Passaic had extended to them. The move would be popular because it would afford a couple thousand additional fans the opportunity to see the game.[302]

GAME #153 Cliffside (Wednesday, January 14, 1925) at Passaic HS. A rejuvenated Passaic outfit, trying to impress Dan Daniel and the other out-of-town newspapermen, quickly turned the game into a rout. The team engaged in their idea of flashy passing with intent to dazzle. To the contrary, the game was marked by Passaic's puzzling passing combinations and dismal foul shooting. Establishing a benchmark for ineptness, Passaic shot with a "What, me worry?" attitude and, at one stretch, missed eleven free throws in a row. Meanwhile, Stanley Adams was not getting the ball when open because others were either too busy showboating with it or looking to shoot.

The scribes wondered how a team could win so handily without playing much defense. In spite of the decided height advantage that Cliffside enjoyed at the center position, they spent most of the game playing defense. The win was accomplished too easily; it did not help make Passaic a better team;

PASSAIC	G	F	T	CLIFFSIDE	G	F	T
Pashman	9	2	20	Dietler	2	1	5
S.Riskin	0	0	0	Doyle	1	2	4
Adams	4	0	8	Spence	1	0	2
Schere	0	0	0	Rice	0	0	0
Rohrbach	10	2	22	Loretto	1	1	3
Harwood	1	0	2	Borelli	2	3	7
Krakovitch	3	0	6	**Totals**	**7**	**7**	**21**
P.Riskin	0	0	0				
Goldstein	5	0	10				
Russell	0	0	0				
Totals	**32**	**4**	**68**				

Scoring by quarters: **Passaic** 20 16 15 17
Cliffside 2 5 11 3

Referee—Tewhill, Horace Mann High School, NYC. Scorers—David Kaplan and J. Fridlington.

on the contrary, they were getting worse. Final score: **Passaic 68-Cliffside 21**.

On the following Saturday in Newark, Prof was spotted assisting Harry Wallum with the St. Benedict's Prep (SBP) team. It was not known if it was Prof's first day with the prep school team or if he had been working out with them previously. Shortly after Prof's SBP debut appeared in the newspaper, every sports fan in New Jersey was discussing the implications for both schools. Prof's switch to SBP left fans in Passaic frustrated.[303]

A sports writer attending Saturday's practice observed Prof partici-pating in an intersquad scrimmage. The wide-eyed prep players were

responding to the directions of the Grey Thatched Wizard. Harry Wallum, the official coach, eagerly stepped aside for Prof. Without wasting any time, Prof was injecting his system into the receptive prep boys.[304]

GAME #154 Holyoke, Massachusetts, (Saturday, January 17, 1925) at Paterson Armory. Confidence was high in the Paper City in Massachusetts. Holyoke was anxious to play Passaic because they were led to believe the Wonder Team was overrated and ripe for a loss.[305] Arriving in excellent form, Holyoke had just come off two impressive wins, one a 72-23 stomping of Chicopee HS.

Two thousand fans (200 from Holyoke) witnessed the extent of Passaic's readiness. Krakovitch's bullet-like passes made up for eighteen miscues from the foul line. In a fast-paced game, Coach Dotty Whalen's Holyoke five-man defense gave the Wonders the toughest test of the season. After the game, Holyoke left with $341.25 in expense money and a degree of satisfaction. Final score: **Passaic 44-Holyoke 28**.

GAME #155 Ridgewood (Wednesday, January 21, 1925) at Ridgewood HS. The criticism that had been directed at the players and coaches had taken its toll. With coaches emphasizing the successful passing techniques of the past and the boys realizing they needed to sacrifice individualism for the good of the team, the boys reverted to what they remembered from Prof. Passaic got off to a slow start before exploding with a fury of passes and deadeye shooting.

PASSAIC			HOLYOKE			
	G	F	T	G	F	T
Pashman 5	2	12	Williamson 1	3	5	
Adams 7	0	14	McDowell 3	1	7	
Harwood 0	0	0	Cycowski 2	1	5	
Rohrbach 4	1	9	Marchinik 0	1	1	
Goldstein 1	1	3	Dean 0	1	1	
Krakovitch 3	0	6	Carroll 0	2	2	
Russell 0	0	0	Quilette 2	1	5	
Total 20	**4**	**44**	Bauer 1	0	2	
			Total 9	**10**	**28**	

Score by periods: **Holyoke** 5 9 5 9
Passaic 2 24 12 6

Referee—Harry Wallum, St. Benedict's Prep of Newark.

PASSAIC			RIDGEWOOD			
	G	F	T	G	F	T
Pashman 8	1	17	Fermier 6	1	13	
Adams 8	1	17	Chevelier 1	0	2	
S.Riskin 0	0	0	Smith 0	0	0	
Schere 0	0	0	Sheffield 0	0	0	
Rohrbach 5	1	11	Starck 0	0	0	
Pomorski 0	0	0	Heister 0	0	0	
Harwood 1	0	2	McAllen 1	0	2	
Rebele 0	0	0	Hopper 0	0	0	
Krakovitch 2	0	4	Springer 0	0	0	
Goldstein 2	0	4	**Totals 8**	**1**	**17**	
Russell 1	0	2				
P.Riskin 0	0	0	Score by quarters:			
Totals 27	**3**	**57**	**Passaic** 11 12 11 23			
			Ridgewood 9 4 2 2			

Referee—Tewhill, Horace Mann. Scorer—David Kaplan. Timer—Irving Burg.

Paterson Coach Earl Gray, who was scouting Passaic, exited the gym shaking his head while contemplating his team's doom. Captain Pashman led the passing attack by feeding Rohrbach and Adams for most of their thirteen field goals. Final score: **Passaic 57-Ridgewood 17**.

GAME #156 George Washington, NYC, (Saturday, January 24, 1925) at Passaic Armory. James Furey, manager of NYC's Original Celtics (the most prominent of the early professional basketball teams), said before the game, "I want to see the greatest amateur club play."[306] Furey and everyone else got an eyeful.

Sports pundits from all over the country were at the armory to see the Wonders against a NYC team. They caught the Wonders at the top of their game—pass, pass, pass, shoot and score was the Passaic script. A curiosity seeker from Shelbyville, Indiana, said Passaic was the greatest team he had ever seen. A former Doubting Thomas, B. G. FitzGibbon, the sports editor from the *New York Telegram and Mail*, just shook his head and said the Passaic boys were wonderful. They were the finest team he had ever seen play, and now no one from New York would want to play them.

The swiftness with which the boys executed their plays and the accuracy of their shooting left diehard fans and first-time viewers aghast. Twice Pashman scored from the center jump within four seconds. As in other recent games, the swift Wonder Team passing attack ran the challengers into the ground. The Big Apple boys departed with this warning for other New York City schools—keep away from Passaic.

The highlight of the game was the fourth quarter when Passaic exploded for thirty-six points. George Washington Coach Beckman and the rest of the capacity crowd witnessed a hurricane that swept the visitors off the court. Final score: **Passaic 88-George Washington 22**.

PASSAIC			G. WASHINGTON					
	G	F	T		G	F	T	
Adams	9	0	18	Capes	2	1	5	
Pashman	14	3	31	Shea	3	0	6	
Rohrbach	8	2	18	Leaycraft	1	2	4	
Goldstein	3	2	8	Thompson	2	0	4	
Krakovitch	6	1	13	Keeney	1	1	3	
Russell	0	0	0	Kotsaros	0	0	0	
Total	**40**	**8**	**88**	Clemons	0	0	0	
Score by periods:				Aronowitz	0	0	0	
G. W.	6	4	7	5	Stutz	0	0	0
Passaic	17	22	13	36	**Totals**	**9**	**4**	**22**

Referee—Harry Wallum.

After watching one of his city teams get hammered, B. G. FitzGibbons told his *New York Telegram and Mail* readers that the alleged prowess of the Passaic team was no exaggeration. Passaic deserved all the accolades heaped upon them, and none were too extravagant. He hypothesized the

reason for Passaic's domination of the scholastic basketball world: "It comes largely from the backyards of the homes of Passaic. Regardless of the circumstances of the parents, each boy in the place has his eye on one goal, one honor. That is to represent the High School [sic] on the basketball team when he gets big enough. And how they work toward that end!"[307]

Other sports writers frequently wrote about Passaic's accomplishments, but because of jealousy, they were seldom positive. Responding to criticism that Passaic would reject challenges from certain instate schools, Union Hill Coach Courtney (Skeets) Wright went public with his feelings.

Last year Mr. Blood and I had a tentative agreement that were he coach of Passaic, he would gladly recommend a home and home series for this year between Union Hill and Passaic. But Mr. Blood made it very plain to me that the condition only held good in case he was coach. And I want to state plainly here that Mr. Blood has always lived up to any statement he has ever made to me. I am a great admirer of Mr. Blood not only as a wonderful coach, but also as a true gentleman in every sense of the word....[308]

Referring to Passaic's current team, Wright volunteered this opinion.

They are a fine group of boys and a great team. And I also would like to say that they show the result of the greatest coach the game has ever known. This talk of material is bunk. Surely Montclair, Orange, Newark, Trenton, Atlantic City, Camden, etc., have as much material. It only takes five boys to make a team. No matter where Mr. Blood coaches, I predict that his teams would make a great showing....[309]

GAME #157 Emerson, W. Hoboken (Wednesday, January 28, 1925) at Passaic HS. The West Hoboken boys were enjoying a noteworthy season, but it was about to be dampened. Team kingpins Manfredi and Focht were slated to graduate during the midyear commencement a week after the Passaic game. If they were ever ready to topple Passaic, it was now. They were so optimistic that they brought over four trolley cars loaded with 300 fans to witness the termination of the streak.

Coach Burke had his team geared for a physical game to disrupt Passaic's finesse. Late in the first quarter, the strategy appeared wise as Emerson was pleased with its 11-9 deficit, and then it happened. The Blue warriors went on a rampage with eleven straight baskets leaving Emerson without much to shout about.

The game was marred by pervasive roughhousing because Harry Wallum, the contracted referee, never showed up. Wallum later claimed that he wasn't notified of the game. In his place, Fritz Knothe and Coach Martucci of St. Michael's School in West Hoboken were recruited to officiate the

PASSAIC				EMERSON			
	G	F	T		G	F	T
Pashman	12	4	28	Lynch	3	0	6
Adams	10	0	20	Manfredi	4	1	9
Rohrbach	3	1	7	Shataffan	1	1	3
Goldstein	3	3	9	Lukenbehl	0	0	0
Krakovitch	2	0	4	Frankie	0	0	0
Harwood	0	0	0	Focht	4	2	10
Totals	**30**	**8**	**68**	**Totals**	**12**	**4**	**28**

Score by quarter: **Passaic** 15 33 48 68
Emerson 9 9 25 28

Referee—Fritz Knothe. Umpire—Coach Martucci.

game. The game became overly rough because Knothe didn't want to call any fouls on the visitors. Final score: **Passaic 68-Emerson 28**.

It doesn't matter how good you are, if you keep playing, you will eventually lose. While that had not been true for Passaic during the previous five seasons, other teams would attest to it. On the day of the Emerson game, Union Hill and Hackensack were knocked off. Union Hill ran into trouble (14-21) in Rhode Island at Rogers, and Hackensack came up short (28-30) at East Orange. This was why Passaic's scores were published in newspapers throughout the country—they always won.

GAME #158 William Cullen Bryant (Saturday, January 31, 1925) at Passaic HS. In what was to be the penultimate game of the streak, the Long Island City boys exhibited an air of confidence that was no act. The Bryant team had won seventeen of its last eighteen games. They were good; in fact, they were currently rated the best scholastic five in the NYC Public School League. Long Island City's Coach Henry Farb had boys who were serious about defeating the Wonder Team, and when the score read 9-5 in their favor, no one doubted them. Trailing slightly at half time, their resolve was still strong. Bryant's star player, Jimmy Platz, had already netted 15 points.

These two fine teams deserved a better gym in which to exhibit their talents; Passaic's court hampered the effectiveness of both clubs. As time wore on, the quickness of Pashman and the team's passing clearly made the difference. Although the visitors

PASSAIC				BRYANT			
	G	F	T		G	F	T
Pashman	3	12	18	Dieytor	3	2	8
Adams	5	0	10	Fitzpatrick	2	2	6
Rohrbach	6	0	12	Platz	11	1	24
Krakovitch	2	0	4	Madzello	0	0	0
Goldstein	1	5	7	Parcell	0	0	0
Russell	0	0	0	Michellotti	0	0	0
Total	**17**	**17**	**51**	Allessi	0	0	0
				Total	**16**	**6**	**38**

Referee—Harry Wallum.

learned they could stop Pashman if they fouled him, they never came across a solution to counter Passaic's passing attack. Final score: **Passaic 51-Bryant 38.**

After the Bryant game, everyone was predicting that Passaic would enjoy an undefeated season for the sixth consecutive year. The team's poor foul shooting and early season slump appeared to be over. With Passaic's reputation, who would have bet against them? Final score: **Passaic 51-Bryant 38.**

MILTON PASHMAN

GAME #159 Lawrence, Long Island, (Wednesday, February 4, 1925) at Smith Academy. Even though Principal Arnold wanted to appear very supportive, basketball had long been a nuisance to him. Why Arnold didn't schedule the high school facility or look into securing one of the armories for this game is certainly an interesting query.

The Lawrence team became the latest to receive a lesson on the advantages of passing as opposed to dribbling. Trying to defend Passaic, Lawrence's defense quickly tired and became less and less effective as the game continued. Long Island's Ryan, a diminutive, fleet-footed forward, exhausted himself trying to get the ball.

Captain Pashman was beginning to play with the minds of his critics; he was now passing the ball. The speedy forward was taking the ball to the basket and scoring or passing off for assists. Another bright spot was the play of second team captain Johnny Harwood. The "Play of the Day" went to Moyer Krakovitch who, while leaping for a long rebound to the left of the foul line, caught the ball and released it back to the basket for a clean two before returning to the floor.

PASSAIC				LAWRENCE			
	G	F	T		G	F	T
Pashman	9	4	22	Ryan	5	1	11
Harwood	5	2	12	Carolan	2	0	4
Adams	8	0	16	Metzler	0	2	2
Russell	0	0	0	Hicks	0	3	3
Rohrbach	2	0	4	Oxford	0	0	0
Wall	0	0	0	Glaser	1	0	2
Goldstein	2	3	7	**Total**	**8**	**6**	**22**
Krakovitch	3	2	8				
Pomorski	0	0	0	Eight-minute quarters.			
P.Riskin	0	0	0	Score by quarters:			
Sattan	0	0	0	**Passaic** 18 36 57 69			
Schere	0	0	0	**Lawrence** 4 11 18 22			
Total	**29**	**11**	**69**				

Final score: **Passaic 69-Lawrence 22.**

Suddenly, all sights were set on the tiny Hackensack Armory. The Hackensack administration did not want to move the game to the larger Paterson Armory as suggested by many of their own fans. The Passaic fans would have preferred a change in venue as well, but they were too proud to suggest an alternate site. In the minds of most people, a change

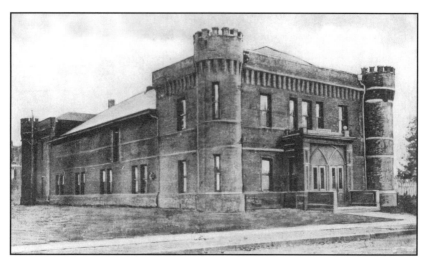

HACKENSACK ARMORY

to the larger armory was not only the more sportsmanlike thing to do, it would also afford more fans the opportunity to attend. In the final analysis, everyone knew that Hackensack had a better chance of winning if the game could be played in its armory.[310]

The teams had two completely different mental approaches to the game. "To Passaic it means just another basketball game, even though a hard one—another milestone in the road of seemingly endless basketball supremacy."[311]

Speaking for Hackensack's chances, Captain Bollerman had this to say about both the game and the much-publicized doomsday forecast of California's "prophetess" Margaret W. Rowan. "We don't know whether the end of the world is coming today. But we feel confident that it will be doomsday for Passaic High. We're not superstitious, but don't forget it's Friday and Passaic's thirteenth game this season."[312, 313]

For this clash, Hackensack's previous game scores became meaningless. The fact remained, the Wonder Team did not match-up well with the (9-3) Comet squad.[314]

Hackensack H.S.		**Opponents**
47	East Rutherford (home)	30
52	Don Bosco (home)	30
43	Rutherford (home)	21
37	Passaic (away)	54 L
37	West New York (home)	33
41	Ridgewood (away)	35
12	NY Military Academy (away)	18 L
59	Cliffside (away)	14

30	Rutherford (away)	17
64	Paterson (home)	19
28	East Orange (away)	30 L
60	Leonia (home)	16

Passaic gave away height and weight at every position.[315]

PASSAIC				**HACKENSACK**			
	Age	Wt.	Ht.		Age	Wt.	Ht.
Pashman	17	139	5'9	Bollerman	17	195	6'6"
Adams	18	150	5'10"	Weatherby	18	165	6'0"
Rohrbach	18	160	6'0"	Fast	18	165	5'11"
Krakovitch	17	155	5'9"	O'Shea	19	175	6'1"
Goldstein	17	145	5'7"	Greenleese	19	180	6'2"
Russell	17	140	5'6"	Brown	18	170	6'0"
Harwood	17	147	5'10"				

The obvious discrepancies in anthropometric measurements fueled the mad rush to the armory. Hundreds were leaving the night before to better their chances of seeing the game. With signs that read, "Hackensack Our 160th Victim," two hundred PHS students decided to bag school, hire jitney buses, and leave Passaic at 9:00 a.m. Upon their arrival, the two hundred proceeded to Hackensack High School where they sang cheers for both teams. Within minutes, the police were called to the campus, and the Passaic teenagers were led back to the armory where they queued up for the game.[316]

By mid-morning, more than 600 Passaic fans, young and old, were milling about the armory, and it was apparent that a problem was in the making. The tiny armory sat only 450 people. A little after three o'clock, long after the doors were to open, the tired but still full-of-life Passaic rooters learned that the doors wouldn't open until the Hackensack fans were admitted through a different door.[317]

An administrative decision by Hackensack Vice Principal George Merrill was responsible for this special privilege to the home fans. And when the Passaic followers were about to be admitted, the local police greeted them with harsh treatment.[318] When a Passaic woman fainted because of the trying circumstances, an annoyed Hackensack policeman was overheard saying, "Let her faint."[319]

If Passaic prevailed, the late afternoon game would decide the league championship and provide a clear path for another undefeated season. In light of the two teams' recent outings, the diehard Passaic fans were spotting Hackensack twenty points, but others were not as confident.[320]

One of those who was less than confident was Prof Blood. He, more than anyone else, understood the complexities of the rematch. Long before

the Hackensack game had become a must-see, Prof had obligated himself to an out-of-town speaking engagement. Invited by the Schoolmaster's Club of Greenwich, Connecticut, Prof was the guest of honor at a dinner attended by teachers, BOE members, and other community dignitaries to honor their basketball team. This commitment kept him from attending the big game.[321]

While en route to Greenwich, Prof's thoughts were on the proceedings taking place in Hackensack. In his mind, he could see the game unfolding on the small armory floor. He could see the seats stuffed with mostly Hackensack spectators who were reaching into the playing area trying to disrupt the Passaic players. He could see the five tall Hackensack boys playing hard with nothing to lose. Prof knew that the 6'6" Bollerman was ready to secure the center jump making it difficult for Passaic to get the ball. He doubted his team would be able to adapt and overcome this disadvantage.

Traveling away from the Peaceful Valley, the Passaic Miracle Man could visualize the waylay his boys were walking into. These Wonder Team kids were local celebrities, but they were also the naïve heirs to a 147 game burden. The pressure that accompanied the load was the real curse, and it had been getting heavier with each succeeding Wonder Team. Prof had known these boys since elementary school; they were his kids. Today in the Hackensack Armory, an opponent was waiting with a plan, the talent, and the determination to best the program he had built. He could feel that this was the day.

Prof also felt for Marks lacked the basketball knowledge to help the unadvised boys in a game like this one. It was a troubling thought; in fact, it was painful because he was helpless to influence the outcome. He could see it clearly—history was about to be served. Knowing what he knew about the rematch, perhaps it was better that he wasn't going to be there to bear witness. During a poignant moment in his address to the Schoolmaster's Club, Prof foretold to a disbelieving audience that the famous streak would end that day. No, they would reply, you must be joking. Prof would not joke about something like that.

GAME #160 Hackensack (Friday, February 6, 1925) at Hackensack Armory. The day that was bound to come came. The *Passaic Daily News* headline that fell far short of expressing the grief that engulfed the city of Passaic read:

PASSAIC DAILY NEWS

PASSAIC HIGH LOSES

There were no excuses, just depression followed later by relief. The Passaic Wonder Team had been beaten at their own game. The great Passaic passing and shooting team was out passed and out played. Hackensack Coach John W. Steinhilber, a Springfield YMCA Training

PASSAIC			HACKENSACK				
	G	F	T		G	F	T
Pashman	7	3	17	Fast	5	4	14
Adams	2	1	5	Weatherby	2	1	5
Rohrbach	2	2	6	Bollerman	4	0	8
Krakovitch	2	1	5	O'Shea	1	1	3
Goldstein	1	0	2	Greenleese	2	5	9
Russell	0	0	0	Brown	0	0	0
Total	**14**	**7**	**35**	**Total**	**14**	**11**	**39**

Score by quarters: **Passaic** 10 7 7 11 **35**

HHS 6 12 14 7 **39**

Referee—Harry Wallum. Umpire—M. Tewhill.

School product and an astute disciple of the Blood short passing system, had a game plan, and his boys were prepared to execute it.

The young warriors were crushed, devastated, shattered (and the players took the loss better than their fans). At first, it seemed there would be no tomorrow. Prof had taught them how not to lose, but this time they had fallen short. Stunned and shocked, they could control their posture but not their tears. With heads held high and with their vision blurred by tears of disappointment, they sought their adversaries to congratulate them. The compassion of their victors helped ameliorate the pain of defeat. They could not have lost to a classier group of young men. Final score: **Passaic 35-Hackensack 39**.

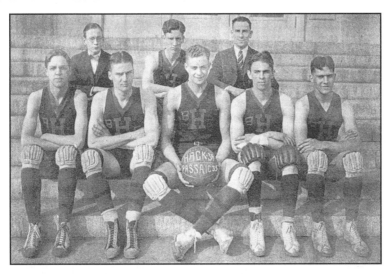

VICTORIOUS HACKENSACK HIGH SCHOOL TEAM

(BOTTOM, LEFT TO RIGHT) RAY WEATHERBY, ROY GREENLEESE, HOWIE BOLLERMAN, TOM "PORKY" O'SHEA, JOHNNY "FRITZ" FAST. (TOP) MANAGER CHARLES ELLINGER, KEN BROWN, COACH JOHN W. STEINHILBER *photo courtesy of Hackensack High School's The Year Book 1925*

Newspapers near and far had a field day relaying the details of Hackensack's stunning victory. It was the Bergen County lad's plan to get the center tap, and Howie Bollerman did. The plan also included running their forwards, Johnny Fast and Ray Weatherby, down to the corners by their basket to receive passes from Bollerman and score on the smaller Passaic guards, which they did. This basic strategy, along with superior foul shooting, enabled Hackensack to score enough.

The suspense and drama in the diminutive armory was unequaled in anyone's experience. It was a close game throughout, and after the first quarter, Hackensack maintained the upper hand. The challenger's strategy was to take Passaic out of their game, and Bollerman's controlling the center tap allowed them to stick with their script. Passaic could never get it going, which was a tribute to Coach Steinhilber's plan.

The Hackensack strategy was obvious to everyone but the Passaic coaches. Never did Passaic call a time-out, nor was a substitute injected into the game with instructions to counter Hackensack's plan. "Passaic Without A Leader," was how Wendell Merrill phrased it in his "Merrill's Sport Talk" column the next day. An outcry came forth to bring Prof back. On the streets, in the alleys, and in stores all over Passaic, the conclusion was the same, "We wouldn't have lost if Prof had been in charge." The price had been paid.

Union Hill's Coach Skeets Wright had fine words of praise for Hackensack. "They deserve all the credit in the world," he said. But he wanted to add, "With all due respect to Coach Steinhilber and his boys, I do not believe they could have beaten Passaic had Blood been at the helm."[322]

Further into his "Merrill's Sports Talk" column, Merrill referred to Passaic School Board President Robert Dix Benson who was believed to be wintering in far off Bermuda. Benson would probably learn of the game by telephone or an Associated Press write-up. How would Benson react if he had been present to see the sadness and depression that the boys and townspeople were experiencing? What might he have done to prevent further unnecessary grief that was caused by a Blood-less Passaic team? Would he hesitate, reconsider, or come up with a plan to get the man back who was responsible for Passaic's pride? Could Benson, a giant in the financial world, be man enough to do this?

The *Passaic Daily News* mentioned that Prof Blood had refrained from commenting on the game. But the *Passaic Daily Herald,* sensing a juicy story, squeezed the Old Master for his thoughts on the loss. They wanted to know, in his opinion, what contributed to the loss. Prof calmly responded, "That's generally known. I didn't see the last game, but I have seen the team slipping. If jealousy hadn't crept in, if the people had left them alone, if the high school principal had kept out of it, all might

have gone well." Searching for more bait for a story, the *Herald* writer finally asked him if he thought the team would win the state championship? The Grey Thatched Wizard replied, "If they have the proper supervision. Evidently they hadn't yesterday."[323]

Out-of-town newspaper writers claimed that Passaic's defeat would be good for instate scholastic basketball. Fred Bender of the *Newark Ledger* tagged this comment to the end of his column, "Passaic Blames it on a Trick Court." It was a fact—the armory court was very slippery, but it was slippery for both teams. Most Passaic people did not use the court as an excuse for the snapping of the streak. In Passaic, the loss was attributed to "the trouble that occurred last spring that caused the greatest coach in the basketball world to sever his connections with the team." The big question now was whether there were men in Passaic capable enough to correct the egregious administrative blunder.[324]

The sun did rise again in Passaic. Even for Margaret W. Rowen, the Hollywood psychic who had famously predicted the end of the world, life continued. Unlike Rowen and her disciples who remained in seclusion when the end of the world did not occur, the Passaic team and residents regrouped and soberly faced their future.[325] Never did anyone anticipate that the loss would be a relief, but it did have a cathartic effect. Without the burden of the winning streak, life was actually okay. In time, the sun began to shine brightly and the air smelled clean, at least, that was the way it seemed.

Philosophical musings about the benefits of finally losing a game were coming in from all over the country. Psychologically, it made sense that without the pressure to maintain the streak, the team would function better. Nevertheless, there were those who continued to predict the team's demise. What happened was that the town rallied around the team even more. Because of the manner in which the players handled the defeat, their appeal in the eyes of the fans only grew. Coach Marks was neither tarred and feathered nor hung in effigy. You must recall that he never wanted the job, nor did he ever claim to know much about the game. Marks was a victim—a likable victim.

Team captain, Milton Pashman, who had been singled out in the past for his individualistic style of play, gave a heroic effort against Hackensack. His performance, even in defeat, would live long in the memories of those present. A few days after the game, he "modestly stated that he was glad he was captain of the team because his sadness at the time might have been greater had the burden fallen on the shoulders of some other youthful leader."[326]

CHAPTER FIFTEEN
THE LAST OF THE WONDER TEAMS

Hackensack's revenge left the boys halfway through their schedule with a load off their young shoulders. The question heavy on everyone's mind now was would they be able to regroup and uphold the Wonder Team reputation? The results of the remaining games from the 1924-1925 season are listed below with a description of how the season played out.

Thursday, February 12, 1925, **Passaic 53-Rutherford 11** at Passaic HS. The name of the team that played the Wonder Team immediately after their streak was broken is a good trivia question. On Lincoln's birthday, an optimistic Rutherford team and their Coach Voile Dupes had hopes of catching Passaic on the rebound. All hopes of hanging another defeat on the wounded Wonders were abandoned after the first quarter. The sobered Passaic squad didn't get into Wonder Team gear until the 19-0 final quarter.

Saturday, February 14, 1925, **Passaic 98-Englewood 25** at Passaic HS.

Sunday, February 15, 1925, **Passaic 42-St.**

1925 RUTHERFORD SQUAD

PASSAIC				RUTHERFORD			
	G	F	T		G	F	T
Pashman	5	2	12	Whitman	1	1	3
Riskin	0	0	0	McKenna	1	1	3
Adams	9	0	18	Berry	0	1	1
Wall	0	0	0	Davie	0	0	0
Rohrbach	9	2	20	Russell	0	2	2
Krakovitch	1	1	3	Scaramelli	0	0	0
Goldstein	0	0	0	Ball	1	0	2
Russell	0	0	0	Logan	0	0	0
Harwood	0	0	0	**Total**	**3**	**5**	**11**
Total	**24**	**5**	**53**				

Score by quarters: **Passaic** 16 7 11 19
Rutherford 3 6 2 0[327]

Benedict's Prep 27** at Shanley Gym.[328] Several differing reports—and

final scores—can be found about this match-up between the Wonder Team and Prof's new squad. Records of this game were not found in the Passaic newspapers perhaps because it was just a scrimmage and/or it was purposely kept quiet so as not to attract attention. If it had been a regularly scheduled game, the public interest would have been overwhelming, attracting a crowd capable of filling a few armories.

Almost a quarter of a century later, in a 1944 news article from *The Herald-News,* reporter Ed Reardon provided a glimpse into how this scrimmage between the two Blood-produced schoolboy powers may have come about.

> *The 'Prof' and some of his Passaic friends were having a little gabfest one evening. One of the party, playfully ribbing him, observed he was probably of the belief Benedict's could defeat Passaic now that he was coaching the Newark team.*
>
> *They couldn't right now, said Blood, but they could in another two weeks.*
>
> *That led to conjecture about what might happen if the teams met. Some one [sic] suggested arranging it, even though no meeting was on that season's schedule. Blood was willing to have them play an 'off-the-record' contest and Marks readily consented.*
>
> *So the game was played in the St. Benedict's Gym. The doors were locked. Aside from the players and coaches, the only other person in the place was Harry Wallum, the referee.*
>
> *In this bizarre setting, Passaic paddled the Benedicts, 47-27.*[329]

Some sources indicate that two weeks after getting thumped, SBP tangled with Passaic again under the same playing conditions. This time the newly fortified Gray Bees got the better of the Wonder Team with a score identical to that of the streak-ending Hackensack game (39-35).[330] With scant and inconsistent records surrounding this story, it is difficult to decipher facts from fiction.

Wednesday, February 18, 1925, **Passaic 42-Cliffside 34** at Cliffside HS Gym. It appeared to the followers of the team that the boys were winning games in spite of Coach Marks's tutelage. After making a couple of substitutions that didn't work out well in the Cliffside game, some Passaic fans could no longer contain their feelings. After the game, a group of disgruntled fans publicly confronted Marks and Pickett and chastised their coaching. It was not pretty, nor did it speak well for the over-zealous fans.

Saturday, February 21, 1925, **Passaic 34-Schenectady 23** at Passaic Armory. The Schenectady boys with a 19-2 record and a fifteen-game win streak took a quick lead (10-14) in the first quarter. Krakovitch and Adams responded to the wake-up call and led a resurgence that sent the New Yorkers home disappointed.

Monday, February 23, 1925, **Passaic 54-Rutherford 21** at Rutherford HS. On top at half time with a 34-7 lead and with Prof Blood sitting on the bench next to Marks, Passaic exhibited the old Wonder Team form.

Later in the evening, 7000 fans in Newark watched Prof Blood coach St. Benedict's Prep over Newark Central 36-21 for the Newark City championship.

Saturday, February 28, 1925, **Passaic 57-Ridgewood 21** at Passaic Armory.

Tuesday, March 3, 1925, **Passaic 62-Paterson 19** at Paterson Armory. In the last scheduled game for both teams, Coach Earl Gray's boys were swept away by an avalanche of baskets and bullet-like passing. Pashman's shooting and Krakovitch's all-around play led a team effort that buried the Silk City quintet.

PASSAIC				PATERSON			
	G	F	T		G	F	T
Pashman	13	0	26	Toretsky	2	2	6
Adams	7	2	16	Krieger	4	1	9
P.Riskin	0	0	0	Pollitt	1	0	2
Harwood	0	0	0	Roughgarden	0	0	0
Krakovitch	2	2	6	O'Neil	0	0	0
Goldstein	2	0	4	Rinaldi	1	0	2
Pomorski	0	0	0	**Total**	**8**	**3**	**19**
Rohrbach	2	6	10				
Total	**26**	**10**	**62**				

Score by quarters: **Passaic** 15 13 19 15
Paterson 3 5 6 5

Referee—Pete Rozzolo. Umpire—Charley Schneider. Scorer—David Kaplan.

First Round of NJSIAA State Play-offs: Thursday, March 5, 1925, **Passaic vs. Morristown** at Paterson Armory. Passaic drew the undefeated (22-0) "Marvel Team" from Morristown at the Paterson Armory. Coach James Angus MacIntyre may have mistaken the Paterson Armory court for the Passaic Armory surface. Coach Mac took a page from Prof Blood's book from the

MORRISTOWN'S "MARVEL TEAM"
photo courtesy of Youth's Bright Years: An American High School, Morristown, New Jersey by John T. Cunningham

326

previous season and refused to play on what he perceived was Passaic's home court.[331]

As an inducement to Morristown to accept the Paterson game site, Walter Short told MacIntyre that he would have the same baskets his team used in the tournament the previous year transported to Paterson. After Mac met with C. P. Allen, his athletic advisor from Morristown, he issued the following statement:

> *We have withdrawn, I regret to say, because we believe we are entitled to play the tourney game on a neutral court. Our case is different than that of Passaic's last year. Passaic objected to the environment; we object to the court. I realize there are slight differences in armory courts, but Passaic is accustomed to the lights at Paterson, while we are not. The boys and myself are extremely anxious to play Passaic. We do not say we would win, but it would be a good game.*
>
> *I realize we would be given a fair reception by the followers of the Passaic team, but feel that the game should be played on a strictly neutral court. If Mr. Short will agree to the game being played on a basis that is fair for both teams we will re-consider our withdrawal. I regret to take this action, but feel that we are doing the right thing.*[332]

MacIntyre's request for the game to be moved to a neutral site was denied. The Morristown coach dubiously reasoned that Passaic would have a home court advantage because they'd played two previous games at the Paterson Armory. Naturally proud of their undefeated team, Morristown ultimately decided not to risk their unblemished record. The young "Crafty Scotsman" unknowingly seized the opportunity for his only undefeated season in what would turn into a thirty-six-year career of coaching basketball (451-275 record) at Morristown.[333]

SUMMARY OF PLAY FOR CLASS A TITLE
FIRST ROUND

Group 1
Union Hill 30-Dickinson 13
West New York 20-Ridgewood 10
Bayonne 20-Hoboken 18

Group 2
Plainfield 34-Battin 14
Hackensack 23-East Orange 20
Orange 19-Central 18

Group 3
Montclair 50-Clifton 25
Rutherford 30-Kearney 22
Morristown forfeits to Passaic

Group 4
Collingswood 31-Woodsbury 24
Camden 26-Neptune 18
Trenton 20-Atlantic City 18
Asbury Park bye

Monday, March 9, 1925, **Passaic 42-Stevens JV 19** at Stevens Institute, Hoboken.

Second Round of NJSIAA State Play-offs: Thursday, March 12, 1925, **Passaic 45-Rutherford 11** at Stevens Institute, Hoboken.

SUMMARY OF PLAY FOR CLASS A TITLE
SECOND ROUND

Group 1
Union Hill 24-Bayonne 19
West New York bye

Group 2
Hackensack 28-Orange 21
Plainfield bye

Group 3
Passaic 45-Rutherford 11
Montclair bye

Group 4
Asbury Park 36-Camden 31
Trenton 26-Collingswood 18

Third Round of NJSIAA State Play-offs: Saturday, March 14, 1925, **Passaic 40-Montclair 29** at Stevens Institute, Hoboken. The Montclair boys (14-2), coached by N. J. Mansfield, were on a hot streak when they ran into Passaic. Captain Charles Mylod and his mates gave Passaic all they could handle before bowing out.

Two other games of significance took place on the same evening as the Montclair/Passaic game. In one game,

PASSAIC				MONTCLAIR			
	G	F	T		G	F	T
Pashman	6	4	16	Lennon	1	0	2
Adams	2	2	6	Scheifler	5	2	12
Rohrbach	3	0	6	Zobian	0	0	0
Krakovitch	5	2	12	Mylod	3	1	7
Pomorski	0	0	0	Cooper	1	2	4
Goldstein	0	0	0	Spurling	2	0	4
Total	**16**	**8**	**40**	**Total**	**12**	**5**	**29**

Score by (eight minute) quarters:

Passaic	9	5	13	13
Montclair	6	4	9	10

Referee—Frank Hill, Rutgers College. Umpire—Ben Silverman, Morristown. Scorer—David Kaplan.

Plainfield shocked Hackensack (and the state) with a 19-18 victory in overtime. The events leading up to the Hackensack shocker are worth mentioning. While attending a school play in the early afternoon, Hackensack's Coach Steinhilber learned that his team was scheduled to play later in the afternoon rather than that evening. Frantically rounding up his players who were present at the school play, Steinhilber hustled his team off to Shanley Gym at SBP. Steinhilber was able to locate all of his players except "colored boy" Herman Neilson, who had played well the night before against Orange.[334]

In the last seven seconds of the extra period, Plainfield's captain Bill Lurie scored from underneath to decide the Golden Comets' fate. In the

dressing room following the game, Hackensack's towering center, Howie Bollerman, broke down and cried.[335]

The second big game that evening was The Peddie School's upset of the "new favorite," Prof's SBP team, by the score of 30-22 at the Junior Three School gymnasium in Trenton.[336] This was the sixth consecutive year

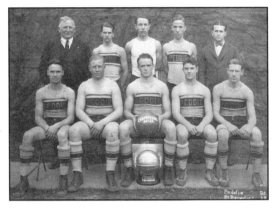

THE PEDDIE SCHOOL TEAM
photo courtesy of The Peddie School Archives.

under the leadership of Coach John Plant that The Peddie School defeated St. Benedict's, and it was their sixth straight preparatory school state title.

SBP was favored to win because they had defeated every team that had beaten Peddie during the season. When everything was on the line, SBP cracked after unsung hero Bruce DuMont drilled three field goals from the entrance door. The Gray Bees, collapsing under the pressure, forgot all of Prof's teaching and resorted to playground ball. Recognizing their mistakes after the game, the Newark boys, like Bollerman, broke down and cried.[337]

The Peddie School's victory meant that Prof's first season "helping out" at St. Benedict's Prep was over. It also matched the 5-14 Plainfield team with the Passaic Wonder Team in the New Jersey State semifinals at the Newark Armory. Because Union Hill defeated West New York 20-18 and Trenton defeated Asbury Park 25-21, the other semifinal match-up would pit Union Hill against Trenton.

Plainfield's big win over Hackensack delayed the crowning of the NNJI League champions. It had been agreed upon previously by Passaic and Hackensack that the league's supremacy was to be determined by the outcome of their anticipated game in the state tournament. Instead, the game to decide the local crown was rescheduled for the first Friday after the state championship game.

NJSIAA state semifinals at Newark Armory: Friday, March 20, 1925, **Passaic 51-Plainfield 25**. The NJSIAA scheduled the Newark Armory to make the playing site equitable for all four teams in the semifinals. Did Secretary Short's memories of the previous year influence his decision?

Efforts to help make it "fair" didn't help Plainfield much as Passaic toyed with them. Passaic's first team played only eighteen minutes and displayed a wonderful brand of basketball. Union Hill held on to down

Trenton 21-20 and earned the right to meet their old nemesis Passaic for the state championship.

NJSIAA State Finals at Newark Armory: Saturday, March 21, 1925, **Passaic 33-Union Hill 26.** Before the 4,500 fired-up fans, heavily favored and not expecting much opposition, the Passaic team took a 9-8 lead after the first eight minutes. Led by their captain Bill "Lefty" Kruse, the 26-2 Orange and Blue team was determined to make this a thriller. Then Murphy's Law took effect; Nelson Rohrbach was quickly grounded with his third foul. With Rohrbach on the bench, Union Hill inched ahead. No sooner had Rohrbach checked back into the game late in the second quarter than he was promptly called for his fourth and final foul.

While Rohrbach was out of the game, Skeets Wright's boys picked up the momentum and pulled ahead 17-13 before reentering the armory's subterranean dressing room at half time. Umpire Ferguson, a reject from the Metropolitan Basketball League whose forte was refereeing boxing bouts, had called all four fouls on the Passaic center. Some of his calls were so farfetched that they surprised his refereeing partner, Frank Hill. The Passaic players were in mental disarray; their eyes were moist with visions of another Hackensack nightmare—the door was wide open for another game to get away.[338]

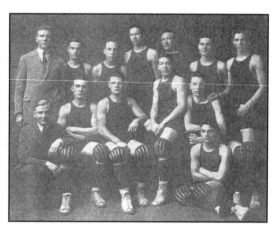

1925 UNION HILL TEAM

Prof, who had been sitting on the Passaic bench at the request of the coaches and players, was attentively observing the game. When the teams exited the court after the second quarter, Union Hill's Skeets Wright was especially

PASSAIC				UNION HILL			
	G	F	T		G	F	T
Pashman	7	6	20	Kruse	5	4	14
Adams	0	0	0	Boyd	1	0	2
Rohrbach	0	1	1	Connors	0	0	0
Goldstein	1	1	3	Littauer	1	1	3
Harwood	0	0	0	Chrust	2	3	7
Pomorski	1	2	4	Doyle	0	0	0
Krakovitch	2	1	5	Siegel	0	0	0
Russell	0	0	0	Besnoff	0	0	0
Total	**11**	**11**	**33**	**Total**	**9**	**8**	**26**

Score by periods: **Passaic** 9 4 11 9
 Union Hill 8 9 2 7

Referee—Frank Hill. Umpire—Frank Ferguson. Time of periods: eight minutes.

attuned to Prof's intended whereabouts. The Union Hill coach, along with many others, noticed the Grey Thatched Wizard following the Passaic coaches and team off the gym floor.

Once in the dressing room, everyone was cognizant of Prof's presence. There they all sat, quiet, motionless and waiting with their attention riveted on him. Glancing at Marks and the players and sensing their desperation, Prof stepped to the front and went to work. In his self-assured manner, Prof described the problems Union Hill had created for the boys, and he explained how they were going to neutralize them in the second half. He showed them how they were going to proceed with Pomorski in Rohrbach's position. With a new sense of hope came self-confidence, and by the time they headed back to the floor, they knew exactly what they had to do.

Sports pundits on both sides of the armory court were well aware of Prof's presence in the Passaic dressing room. Prof's pow-wow with the Passaic players was the talk of the armory. Throughout the entire half time, the drill shed crowd was abuzz with speculation as to what strategy Prof would have the boys employ; it was an interesting phenomenon to observe. Most noteworthy were the Union Hill fans; their team had a four-point lead, but now they were more worried than the Passaic followers.

Playing as if the game were already theirs, Passaic outscored Union Hill 11-2 to take a 24-19 advantage before entering the last eight minutes. Passaic outscored Union Hill 9-7 in the final stanza to pull further away. At Prof's request, his role in the coaching was greatly downplayed. The out-of-town newspapers sensationalized his role, but the local papers remained mute until the Passaic people insisted on being filled in on what really took place.

Finally, by Tuesday, the inside scoop had become public information. While receiving congratulations in the dressing room after the game, team captain Pashman, who had played an exceptional game, told the local scribes, "Don't give us credit. Mr. Blood deserves the honors. He won the game for us."[339] Sports Editor Wendell Merrill reported Pashman's comments to his father in his *Daily News* column.

...coming home from the game Captain Pashman's proud father heaped words of praise upon the boys of the Red and Blue, but by the time the Pashman automobile had reached Delawanna Captain Milton turned to his Dad and said: 'Dad the boys played the game and won, but I want to tell you this: One man deserved the credit for our victory, and he is Mr. Blood. I was crying going down into the dressing room after the first half. Not because of lack of courage, but because of our poor showing against a team I knew we could beat. After Mr. Blood got talking to us

telling us of our mistakes and how to break up the Union Hill offense, which was centered on a play in the center of the court, we went out there in that second half with all the confidence in the world. That's the man you want to give credit to, Dad.'[340]

With the state championship in the bag, Passaic's score to settle with Hackensack took center stage. Since the February 6 shocker at the Hackensack Armory, the rubber game for league honors was on everyone's mind. As it turned out, the Passaic fans were more willing than the team to prepare themselves for the showdown. For whatever reasons, Passaic only practiced once (Wednesday) in preparation for Hackensack following the state championship the previous weekend. Prof attended the one practice and worked to get the boys ready for the important face-saving game. Oddly enough, Pashman did not dress down for this all-important practice session.

Other Wonder Teams had potential player chemistry problems, but with Prof coaching, the problems never surfaced. The players liked Coach Marks (Assistant Coach Pickett—not so sure), but they realized that all he could do as a coach was continue what he had picked up from Prof. His attempts to establish his own coaching identity came across awkwardly. The short passing offense took discipline, and discipline was not the good-natured Marks's forte. Procedures with the team became loose. In the less structured environment that now existed, the temptations for individualism were too great to resist.

The week following the state final was a busy one. The boys had validated their celebrity status and were enjoying the recognition of membership on another state championship Wonder Team. The week was full of distractions comprised of invitations and celebrations; everyone wanted some of their time. What Coach Marks did to counter the distractions is not known. Most of the players spent the week involved with activities far removed from preparing for a big game. On the other hand, Hackensack had its mind set on redemption from its state tournament debacle with Plainfield.[341]

Friday, March 27, 1925, **Passaic 26-Hackensack 37** at Paterson Armory. The result was inevitable, and it was not because it was Passaic's thirteenth game following their last whack. The lack of preparation by the overconfident Passaic team spelled their doom. Passaic played a dismal game of basketball, especially Pashman who argued with anyone and everyone on the court. Prof's presence on the Passaic bench made little difference; the team was not mentally or physically ready to play. During one of Pashman's outbursts, Prof subbed him out of the game to speak to him about his behavior. With the exception of Nelson Rohrbach, Passaic was not ready to play.

According to various newspaper reports, the estimated attendance was between 6,000 and 12,000; no one knew the exact count for sure. Regardless of the numbers, the crowd made Coach Steinhilber's boys nervous.[342] Hackensack wanted this game; they had been working for two weeks preparing for it. The Golden Comets went back and forth with the disorganized Wonders. Down by one going into

PASSAIC	G	F	T	HACKENSACK	G	F	T
Pashman	3	4	10	Fast	4	4	12
Adams	3	2	8	Weatherby	2	0	4
Rohrbach	2	0	4	Bollerman	4	0	8
Krakovitch	1	0	2	O'Shea	2	2	6
Goldstein	1	0	2	Greenleese	3	1	7
Russell	0	0	0	Brown	0	0	0
Pomorski	0	0	0	**Total**	**15**	**7**	**37**
P.Riskin	0	0	0				
Total	**10**	**6**	**26**				

Score by quarters: **Passaic** 7 9 6 4
Hackensack 8 7 8 14

Referee—Frank Hill, Rutgers College. Umpire—Charley Schneider, Central High School. Timers—Burg and Rubin. Scorer—Abe Greenberg.

the final quarter created heart palpitations for the Passaic fans.

For over twenty-eight minutes, the two teams battled it out. Hackensack used Blood's energy-saving, quick, short passing attack and

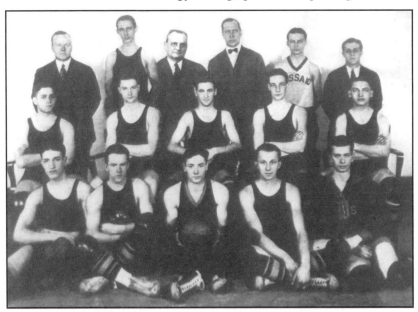

1925 PASSAIC HIGH SCHOOL TEAM
(BOTTOM ROW, LEFT TO RIGHT) PHIL RISKIN, ROBERT RUSSELL, JOHN HARWOOD, JOHN POMORSKI, H. REBELE. (CENTER) MOYER KRAKOVITCH, NELSON ROHRBACK, MILTON PASHMAN, STANLEY ADAMS, S. GOLDSTEIN. (TOP) RAY PICKETT, RICHARD WALL, A. D. ARNOLD, A. A. MARKS, STEVE SATTAN, IRVING BERG.

had Passaic on the run the entire game. The Wonder Team was reduced to individual displays of shooting and dribbling. The Comets had the luxury of standing around and watching as Pashman fired away from long range hoping to get lucky. While it was usually Passaic's opponent who died on the court from defending the passing attack, it was now Hackensack applying the same tactic against Passaic. Hackensack's break came at the twenty-eight minute mark when Fast and Bollerman ran off three quick field goals to eradicate any trace of wonder from the Passaic team.[343]

When it was all over, a team that played the Passaic offense better than Passaic beat Passaic. This defeat was easier for the Passaic people to accept than the famous streak breaker of the month before. This game was no fluke—Hackensack deserved to win. It was not the loss that bothered Prof but how and why the loss occurred. Failing to prepare was preparing to fail as far as the Grey Thatched Wizard was concerned, and he did not mince words with the boys in the dressing room after the game. The specific details of the "bawling out" will never be known, but his diatribe did, as intended, ruffle some players' feathers. As it turned out, Prof would never again return to the Passaic dressing room.

It was a poignant moment for Prof as he left the dressing room. The system he had built and the boys he had taught since grade school had been beaten, and he was unable to prevent it. Besides, the team was no longer his.

CHAPTER SIXTEEN
PROF MAKES A MOVE

In the fall of most great civilizations or dynasties, the first indications of collapse appear from within; Passaic's basketball dynasty was no exception. The administration's harassment of the Maker of Champions spearheaded the fall. Motivated by the most common negative human frailties coupled with political intervention, the school's administration selfishly neutered the "Wonder" in Passaic.

The weekend following the Hackensack game, a more ready-to-play Passaic team traveled to Glens Falls to participate in the prestigious Sixth Annual Glens Falls Basketball Tournament. The annual classic included many of the best squads from the Northeast. Passaic was the top seed in the field of eight and was matched with Lenox from Massachusetts.

Thursday, April 2, 1925, **Passaic 75-Lenox 11** at Glens Falls Tournament, New York. With memories of the Hackensack reality check, Prof's reprimand, and a few days to get refocused, the Passaic boys exhibited a style of basketball still talked about. Lit Atiyeh played for Glens Falls High School during Passaic's first two appearances in the tournament, and he vividly recalls the commotion caused by the famous Wonder Team. "No one had ever seen anything like them," said Atiyeh. "Everything they did was so fast, especially their passing. And, oh, boy, could they shoot the baskets. We knew we were seeing the future of basketball. Those who played against them, including myself, have always been proud to say they played against the famous Passaic Wonder Team."[344]

PASSAIC	G	F	T	LENOX	G	F	T
Pashman	1	2	4	Higgins	4	0	8
Adams	4	2	10	Noonap	0	0	0
Harwood	1	0	2	Butler	0	0	0
Russell	1	0	2	F. Butler	0	2	2
Sattan	0	0	0	Gilligan	0	0	0
Wall	0	0	0	Leary	0	1	1
Rohrbach	8	0	16	**Total**	**4**	**3**	**11**
Pomorski	5	0	10				
Goldstein	6	1	13				
Krakovitch	8	0	16				
Riskin	1	0	2				
Rebele	0	0	0				
Total	**35**	**5**	**75**				

Referee—Don Risley. Umpire—George W. Tilden.

Passaic's speedy passing and accurate shooting left 2000 spectators, not to mention the unfortunate Lenox team, dazed. The score was 50-6 at half time before Passaic eased up. Passaic's final score of seventy-five points broke the previous tournament record by five. Notably, this game was played in four eight-minute quarters compared to the previous record which was set in a game played in two twenty-minute halves. The experts who came from all areas of the country were so impressed that they claimed Passaic was the greatest scholastic team they had ever seen.

Friday, April 3, 1925, **Passaic 44-St. Mary's 25** at Glens Falls Tournament, New York. The following evening, Passaic took on St. Mary's Academy of Glens Falls who had earned the right to advance by defeating Lancaster of Lancaster, New Hampshire (33-18). Passaic resorted to a more conservative and energy-saving passing game. Even though the outcome was never in doubt, the local fans cheered desperately for their home team. The St. Mary's team and fans were powerless as they watched the Passaic boys control the game with their quick passing offense.

PASSAIC	G	F	T	ST. MARY'S	G	F	T
Pashman	4	4	12	O'Neill	1	1	3
Adams	6	5	17	Doherty	2	0	4
Rohrbach	2	1	5	E.Reardon	1	0	2
Goldstein	2	2	6	Tallion	4	1	9
Krakovitch	1	1	3	Donovan	2	1	5
Sattan	0	1	1	B.Reardon	0	1	1
Total	**15**	**14**	**44**	Leary	0	1	1
				Total	**10**	**5**	**25**

Substitutes: PHS—Pomorski, Russell, Harwood, Wall, Riskin. Half time score—Passaic 29, St. Mary's 16. Referee—Don Risley. Umpire—George W. Tilden.

Saturday, April 4, 1925, **Passaic 32-CBA 26** at Glens Falls Tournament, New York. Coach Eddie Kearney's Christian Brothers Academy squad had their work cut out for them if they wanted a rematch with their old rival from last year's Olympic Fund game. To get to the championship game, they first had to defeat St.

PASSAIC	G	F	T	CHRISTIAN BROS.	G	F	T
Pashman	1	0	2	G.Mesmer	1	0	2
Adams	2	2	6	Sheedy	0	0	0
Rohrbach	4	4	12	Maloney	1	0	2
Krakovitch	2	5	9	Dutton	3	1	7
Goldstein	1	1	3	F.Mesmer	4	3	11
Pomorski	0	0	0	Dwyer	2	0	4
Total	**10**	**12**	**32**	**Total**	**11**	**4**	**26**

Score by periods: **Passaic** 10 7 9 6
C.B.A. 4 4 9 9

Referee—Don Risley. Umpire—George W. Tilden.

Joseph's Academy from Pittsfield, Massachusetts (18-17), the defending Glens Falls Tournament Champions, and then defeat New York state power

St. John's Manlius (18-9), who had won the University of Pennsylvania Tournament two weeks earlier.

With the return of Prof's passing game, the superiority of the Passaic game was evident from the opening minutes. Led by Nelson Rohrbach, Passaic took an early lead and stretched it further by half time. Throughout the second half, Passaic passed the ball and ran the CBA boys silly in a game that was not as close as the final score indicated. While Krakovitch was voted the best player, CBA's Freddy Mesmer was declared the tournament's MVP.[345]

All Tournament Selections

First Team	Second Team	Third Team
Donovan, St. Mary's	Adams, Passaic	Vossler, Manilus
D. Dutton, CBA	Wineapple, Salem	Pashman, Passaic
Rohrbach, Passaic	D. Reardon, St. Mary's	Donovan, Salem
Krakovitch, Passaic	Goldstein, Passaic	Wise, St. Joseph's

Throughout the tournament, the coaching was all Amasa Marks, but it was the lingering memory of Prof's admonishment that fueled the players' fire for redemption. After the games, Marks gave Prof full credit for developing the system responsible for the success of the team. He also expounded on one characteristic of Blood's system that teaches the "boys to play basketball and not to talk it." He was referring to the brash comments coming from the CBA players before and during the game.[346]

On another note, it took an unidentified outsider to suggest to the Passaic administration that some action should be taken to recognize Prof's influence during the state finals. Only then did the Athletic Council extend Prof a vote of thanks for his intervention.[347]

In one of his most poignant statements since leaving the *Passaic Daily Herald* for the *Passaic Daily News*, Wendell Merrill went on record to say that there would be no more Wonder Team label used in conjunction with the Passaic basketball team. The only caveat to Merrill's bold statement would be if Prof, the man who knew more about basketball than anyone, were placed back in charge. Prof was instrumental in Passaic's becoming the unprecedented hotbed of eastern United States basketball. Because of Prof's influence, most Passaic kids were bitten with the basketball bug. The numerous youth leagues operating throughout the city abetted the basketball explosion. Because such a favorable environment for good basketball was established, Passaic was guaranteed many more talented teams even without Prof's leadership. But the glory days of the Passaic Wonder Teams were over.[348]

According to some, the hope of getting Prof back at the Passaic helm was still a remote possibility. Only those close to the two opposing camps

(Blood and Arnold) knew that they were continuing to distance themselves. Merrill's hope for a peaceful settlement between Prof and the administration was merely wishful thinking. As far as the school authorities were concerned, the educational process in the city would be better served without a Wonder Team.

The athletically ignorant principal and BOE reveled in the fact that the team had won the state championship again and that they had done it without Blood. With a "how much better can you do than that?" attitude, the school leaders were extremely pleased with their Prof-less basketball program. Now they were in total control of a team that had won the state championship and the prestigious Glens Falls Tournament.

Since the day in mid-January when Prof was first spotted in Shanley Gym instructing the St. Benedict's Prep team, a compatible relationship had been in the making. The prestigious prep school had been searching for a replacement for Coach Jack Fish who had previously mentored their basketball and baseball teams. In desperation, SBP was fortunate to secure the services of the renowned basketball referee Harry Wallum to fill in until a permanent replacement surfaced. A series of events drew Prof to the Newark school: his conflict with Arnold and the BOE, his friendship with Wallum, his impeccable reputation, his passion to continue coaching, and SBP's desire to find a top-notch basketball coach.

The prep school's basketball program had high expectations. The Peddie School team from Hightstown, under the dynamic leadership of John Plant, had captured the last six prep school state championships. From day one, Prof was a hit at SBP; there wasn't any getting-used-to-each-other period. In the short time Prof had with the current prep squad, the boys worked hard at learning his system. Excluding an early setback to big Edd "Lanky" Jones's Orange team, SBP kept improving until they came unraveled against The Peddie School in the prep school state championship game. As a consolation to the disappointing loss of the state championship, the team ended the season with the best overall record (21-2) in the school's history and, in the process, dethroned Central who had won the Newark City Championship for the previous four years.

Prof's impact at SBP was revealed in their yearbook, the *Telolog*. The basketball write-up in the annual failed to mention interim head coach Harry Wallum's name; whereas, Prof was referred to twice. Prof's influence on the Catholic school's basketball season was profound. As one would expect, Prof the showman was well liked by the players and student body, but the most refreshing relationship he enjoyed was with school headmaster Father Cornelius Selhuber. The coaching situation was obviously agreeable from the outset. Unlike the past ten years at Passaic, Prof and his new boss had a sincere respect for one another.

**FATHER CORNELIUS
SELHUBER**
*photo courtesy of St. Benedict's 1926
yearbook, The Telolog*

Whether Father Cornelius or Prof was hoping to extend the relationship beyond the current season was not known.

Back in Passaic, the plot took another turn for the worse when the returning players met to elect a captain for the next season. A logical choice would have been Moyer Krakovitch who had been awarded second and first team all-state honors in his tenth and eleventh grade seasons respectively. But the result of the team's balloting indicated that the majority of the returning lettermen favored the relative newcomer Stanley Adams.

As a result of the voting, Krakovitch was so disappointed and disgusted with the team that he wanted to leave the school. Initially, Moyer's decision didn't fare well in the eyes of the public. Adams was not a poor choice, but if traditional team captain selection procedures had been followed, the more experienced Krakovitch would have been named captain. The newspapers never speculated on why the breach in tradition occurred, but they did mention once that if the "inside story" were known, more people would understand Moyer's decision.[349] Disgruntled with the team, Krakovitch talked of transferring, playing professional basketball with the Original Celtics, or possibly leaving the area.[350]

According to insiders, the root of the captaincy issue was Jew versus Gentile.[351] The majority of returning players were Gentiles, and they were more comfortable voting for Adams. Were these feelings tempered by any annoying personality quirks of their former captain and leading scorer Milton Pashman who, like Krakovitch, was Jewish? Had the ethnicity card been an underlying problem before, or would this problem, like most others, have been easily defused if Prof were still at the helm of the team?[352]

In late July with the summer days flowing by more rapidly than the gentle Passaic River and with baseball occupying most of the sports talk, Passaic was jolted with the news of the final edict in the demise of their Wonder Teams. Most of the city learned the sad news when they read:

 PASSAIC DAILY NEWS

Full Associated Press News Service Special United Press Service—International News Photo Service

Forty-Eighth Year—Passaic's First Daily To something for right time and your news which something for you PASSAIC, N. J. FRIDAY, JULY 31, 1925 Entered as second class matter at the Post Office, Passaic, N. J. PRICE TWO CENTS

"PROF." BLOOD RESIGNS

Prof was giving up his city school district position as Physical Director that he had held for the last ten years. The article went on to report that school authorities were seeking his replacement.[353]

In his letter of resignation to the school, Prof's final comments read as follows:

July 27, 1925

Dr. Fred S. Shepherd,
Superintendent of Schools
Passaic, N. J.

My dear [sic] Dr. Shephard:

I herewith tender my resignation as Director of the Public Schools of Passaic N. J. to take effect September 25, 1925, sixty days from date according to the state law.

It is with regrets that I leave before the one objective for which I came to Passaic and which has been uppermost in my mind is accomplished, viz, the introduction of a system of physical education best adapted to the needs of the girls and boys of Passaic. To this end I have gathered a mass of material, studied local conditions and needs and the most effective means of presentation, so that the pupils would be eager to practice the essentials of good health, safety first, real happiness and loyal citizenship during their spare time.

The quality of play in sports should reflect the standard of the physical education of a school. It was my desire to uphold and justify Passaic's basketball supremeacy [sic] by an equally effective course in Physical Education. Unfavorable conditions have retarded an earlier attempt to give my course in full.

Altho [sic] conditions and the arrangement of the time schedule for the coming year are favorable for the introduction of my course I deem it expedient to resign with best wishes for the girls and boys of Passaic.

Respectfully yours,
Ernest A. Blood
Director of Physical Education[354]

The newspapers confirmed the rumor that Prof was cleaning out his locker at Passaic. The articles also substantiated gossip surrounding Prof's involvement with St. Benedict's Prep in Newark. SBP would be enjoying

the services of the Wonder Coach full time next season. A bitter fact became clear to Passaic fans: there would be no more Wonder Teams in Passaic. It was the dismal end to an electrifying era. The man who often said, "I train my boys for the game of life and not to win basketball games. If I succeed in that I have accomplished something worthwhile," was leaving Passaic High School because he'd had his fill of the administration's abuse.

The final chapter of the Passaic Wonder Teams came prematurely. There were more potential chapters, but they were truncated by a jealous, nearsighted, zealous school administration. To the chagrin of the community, a small number of citizens—a high school principal, members of the board of education, and an influential parent—were responsible for removing one of the city's most famous and accomplished citizens from the high school.

Today, Passaic doesn't have much more than spotted industrial ruins as reminders of a lucrative industry that has long since moved south and an equally fading memory of the days when their high school basketball squads were referred to as the Wonder Teams. While a new cast of ethnic inhabitants now dominate the one square mile, the city is just as ethnically diverse as it was seventy-five years ago. Today, not only in Passaic but throughout all of New Jersey and its contiguous states, when something extraordinary occurs in scholastic basketball, it is put in perspective by its comparison to the Wonder Teams.

When the nostalgic faithful and sport and social historians reminisce about unbeatable athletic dynasties and the unusual events that led to a particular team's downfall, none are more regrettable than the account of the administratively engineered demise of the Passaic Wonder Teams. Now, you too, as many thousands before you, may wonder why reputedly intelligent people could have allowed Prof Ernest A. Blood to be squeezed out when all he did was win too much.

Chapter Seventeen
What Next?

With the advent of the 1925-26 school year, Prof was relieved to leave the highly publicized, tumultuous controversies behind him. At fifty-three years of age, his physical capabilities were on the decline, but his coaching ability was at its peak. He was eager to resume his mission in life as a builder of men at the prestigious St. Benedict's Prep.

It's interesting to note that Prof, who was a member of Passaic's First Baptist Church, was recruited by both the Jewish YMHA and the Catholic prep school. Prof's reputation as a Christian gentleman completely quelled any objections from potential zealots at either post. In the eyes of everyone (with the exception of some jealous Passaic and NJSIAA administrators), Prof's value was readily recognized and sought after.

Father Cornelius Selhuber at St. Benedict's could not have been happier with the arrangement that fell into his lap. But he knew that hiring the services of the famous coach was one thing and keeping him could be quite another. He let it be known from the start that SBP would not stand in Blood's way if a better opportunity came along.

Prof's good fortunes contrasted with the dismal prospects facing Passaic sports fans. The wonder team era was over, and now their "Maker of Champions" was leaving them for another school. To compound their anguish, the rumors surrounding Moyer Krakovitch transferring to another school were true. There was talk that Moyer felt slighted when Stanley Adams was selected captain. Moyer wanted to play for Prof and follow his coach to the Newark prep school.

As outstanding as Krakovitch was on the court, his performance in the classroom was less than spectacular; thus, his application to SBP was denied. During this time, Moyer was "receiving offers from all over," and sources close to him were saying that the manager of the Original Celtics, Jim Furey, wanted to offer him a contract for the coming season.[355]

Moyer's father, Harry Krakovitch, a plumber, wanted him to finish his high school education and not be distracted by such glamorous offers. But Moyer was a great one-handed dribbler, and his talents would mix well with those of Nat Holman, Johnny Bechman, and Chris Leonard

who were established original Celtics players. Sports writers predicted that Krakovitch could help the Celtics.

Krakovitch's decisions turned into a major controversy. Eagerly spurred on by super fan Charles W. Foley, Krakovitch transferred to Union Hill High School. As an incentive, Foley purchased Krakovitch an open Stutz roadster for the daily commute to Union City.[356]

The prevailing mood in Passaic was one of frustration and despair. First, the harassment at the hands of the school officials chased Prof away, and now the best basketball player (guard) in the state transferred out. The thought of Krakovitch playing for Skeets Wright was unthinkable.

With Prof's arrival at SBP, a good basketball program quickly became an excellent one. Prof's presence attracted many of the area's talented players for postgraduate training. Soon a fearsome aggregate was in the making. The gossip centered on warning all opponents to beware because the "Grey Thatched Wizard" was working with a supportive school administration. Public attention focused on what Prof was assembling in Bernard Shanley Gym.

Before and during the 1925 football season, Prof had been in communication with the athletic department at the U.S. Military Academy some forty miles north of Passaic. West Point's last coach, Harry Fisher (a future member of basketball's hall of fame), had lasted only two years, and they were looking to fill the vacancy yet again. The academy's authorities were hoping Blood would not only continue their successful program but also add some stability to it. On the first day of December, the *Passaic Daily News* headlines read: **BLOOD GOES TO WEST POINT**. It was official; he would rejoin Johnny Roosma, his former ace, for his final year. After the acquisition of Prof, West Point publicity man First Lieutenant William Fleming was quick to add that "West Point was very glad to get him…and he [would] report for duty on Friday."[357] His new contract read as follows:

December 8, 1925

Mr. E. A. Blood,
Paterson, New Jersey.

My Dear Mr. Blood:

The Army Athletic Association takes pleasure in offering you the position of basketball coach at the United States Military Academy for the period December 1, 1925 to February 28, 1926, under the conditions outlined below.

Compensation for your services for this period will be two thousand five hundred dollars ($2500) payable to you

by the Army Athletic Association in three equal monthly installments beginning January 1, 1926, and in addition to the Army Athletic Association will pay for your transportation from your home to West Point and return and furnish a room and meals for you while on duty at West Point. A bonus of $250 will be paid to you provided the West Point basketball team defeats the Navy basketball team in the game scheduled for February 27, 1926. This compensation is understood to cover all your personal expenses incident to the performance of your duties as basketball coach.

Your duties will include coaching, training and developing, to the best of your ability, the Corps basketball team and squad of the United States Military Academy, for which you will devote at least four afternoons each week.

The right to terminate this agreement is reserved by the Army Athletic Association, which right shall be exercised only when, if in the opinion of the Athletic Board your duties are not performed to the best of your ability or if misconduct warrants such action.

It is hoped that these conditions will be acceptable to you and that we may count on your assistance with which we shall fully expect a successful season.

> *Very truly yours,*
> *W. A. Copthorne,*
> *Major, C. W. S.,*
> *Graduate Manager of Athletics.*

To the Army Athletic Association:
I accept the foregoing offer and agree to the conditions as outlined above._____ [358]

Suddenly, Prof went from being simply busy to positively hopping. Unlike the last time he pulled double duty, coaching Potsdam's Normal School and Clarkson Tech at Potsdam when he was eleven years younger, SBP and West Point were over forty miles apart. And if that weren't enough, the local newspapers reported that he was also hired to coach the Passaic YMHA basketball team. From the thankless and frustrating situation he left at Passaic, Prof now found himself wanted by everyone, and he was faced with the most daunting challenges of his career. The ubiquitous Prof had his hands full.

On Sunday, December 6, a few days after the news of Prof going to West Point hit the papers, his prep squad opened their season by answering the challenge of St. John's Prep, the Metropolitan champs from Brooklyn. Sportswriter Damon Runyon's numerous articles about the unbeatable Passaic Wonder Teams had aroused the animosity of the Brooklyn fans and boosted anticipation for the match-up. The challenge match was to be the first basketball game played on the new Madison Square Garden which had just opened in late November.

The SBP/St. John's game was scheduled by the Garden's promoter, Tex Rickard, as a preliminary affair to the main event: Jim Furey's "Original Celtics" versus Washington laundry tycoon George Preston Marshall's "Palace Five" from Washington, DC. The Original Celtics proved victorious with a final score of 35-31. But the real draw was the prep school showdown earlier that night.

St. John's Prep had been itching to play Passaic, but with Prof not at the helm the previous year, the whole deal was put on hold. Now with St. John's Prep supposedly stronger than the year before, the New Yorkers were ready to show their stuff against Prof's new squad.[359]

The Garden was teeming with nearly 10,000 fans for the school-boy contest. Blood wanted to show St. John's Prep what they had missed by avoiding his Passaic teams. What was about to ensue would settle the issue for years to come. The *Passaic Daily News* could have used any number of superlatives, but the headlines let the score speak for itself: **St. BENEDICT'S BEATS ST. JOHN'S 53-14**.

The paper reported that "Blood Shows Madison Square Crowd Another Wonder Team…One Would Think It Was Passaic At Its Best To See Uncanny Team-Play." The over-all shooting and passing of Prof's new team (especially by Al Lange, formerly from South Orange High School) bewildered the challeng-ers and silenced their fans. The "big challenge game" was no contest, and the Garden State fans loved it.[360]

Seldom in the history of New York has the out-come of a high school athletic event silenced the quick mouths of the Brooklyn sports advo-cates and the other four borough dwellers as well.

ST. BENEDICT'S	G	F	T	ST. JOHN'S PREP	G	F	T
McKinney	3	0	6	McLoughlin	1	0	2
Jackson	2	1	5	Hesse	1	1	3
Lange	11	3	25	Brounley	0	0	0
Russell	3	0	6	Fitzgerald	0	0	0
Neilan	1	1	3	O'Hea	1	0	2
McEntyre	2	0	4	Burns	0	1	1
Okra	1	0	2	Swietzer	2	0	4
McEbhenery	1	0	2	Mansfield	1	0	2
Totals	**24**	**5**	**53**	**Totals**	**6**	**2**	**14**

Score by periods:
St. Benedict's: 18 35 **53**
St. John's: 5 9 **14**

Referee—Harry Wallum. Umpire—Murray.

For Prof, the first post-Passaic basketball season (1925-1926) was off to a rousing start. In the same news write-up that announced his acceptance of the West Point coaching position, Prof said that he welcomed the opportunity to get into the collegiate ranks. He wanted to make his Army team's style of play similar to his Passaic teams. He believed that if the soldiers grasped his system, the entire collegiate game would be revolutionized.

Those familiar with Prof knew that he did not like the rough style of play on the collegiate level. He was of the opinion that the "game as it is played in collegiate ranks during this modern day is absolutely wrong…. They not only play basketball, but they combine football with it, making it sort of a combination of both. I have tried for years to overcome this fault in the amateur division as any of my former pupils at Passaic will readily testify, but due to the truth that the scholastic division has now reached country-wide proportions, this has been a stupendous task, and I'm afraid my teachings have had no effect in altering any rules."[361]

As Prof planned his schedule, he assured the SBP administration that he was the SBP coach first and the West Point coach second, not vice versa. His older son Paul, who had left Syracuse University after one year and was into his second season as basketball coach at Drake Business College, agreed to assist him at SBP. No one knew the Blood System better than Paul. At West Point, Prof inherited Major Catron as his assistant coach, but unfortunately, Catron was a basketball novice. Even with the practice and game schedules adjusted to avoid conflicts, Prof spent a good part of the season on the road traveling between Newark and West Point.

Apropos of his style, Prof gathered an unusually large number of players for his West Point team. Among the team members were many first year Plebes, which indicated that Prof was in this for the long haul. Prof knew that it took longer to train a large squad, but he wanted to build his team from the bottom up. His revolution of college basketball needed

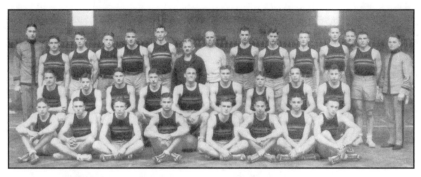

1925-26 WEST POINT BASKETBALL TEAM
photo courtesy of the USMA yearbook, Howitzer, and the USMA Library, Special Collections and Archives Division

a firm foundation, and he was going to do it by surrounding Johnny Roosma with as many first and second year men as possible.

A resume of the 1925-26 West Point basketball season follows:[362]

GAME #1 ST. JOHN'S COLLEGE Prof's West Point home opener on Saturday, December 19, was a typical early season game for the coach. To become more familiar with his players, he used the St. John's game to get a feel for what each player could do in real competition. In spite of the line-up juggling, Army won the game easily 30-18.

ARMY vs. ST. JOHN'S COLLEGE

ARMY	POSITION	ST. JOHN'S
Roosma, Capt.	Forward	Freeman, Capt.
Draper	Forward	Curran
Flood	Center	Page
Strickler	Guard	Feeney
Shepard	Guard	Gallagher

Army Subs: Kammerer, Brentnall, Seeman, Beynon, Zimmerman.
St. Johns Subs: Sokoloski, Polo, Hill.
Referee: Mr. Carl A. Reed. **Umpire:** Mr. O. A. Kinney.

One peculiar note about this game was the appearance of 6'4" James "Buck" Freeman for St. John's. Freeman took over the coaching duties upon graduation and quickly assembled a crack outfit that became known as the "Wonder Five." In later years, Buck became a mentor for some of the other great St. John's coaches who followed.

GAME #2 YALE UNIVERSITY The New Haven visitors were so outclassed that Prof allowed the football players to taste some sweet revenge for their worst football defeat. Phil Draper was the high point man as Army won convincingly 26-13.

GAME #3 LEHIGH UNIVERSITY An aggressive Lehigh team made a game of it for a half. With the score 16-16 early in the second half, Army's passing attack eventually took the legs from the Lehigh Engineers. Johnny Roosma had the opportunity to show why he was an All-American by scoring fourteen points on a variety of shots, including three from mid-court. For the first time, Army center Hank Flood dazzled

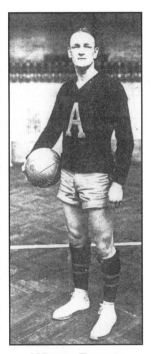

WEST POINT TEAM CAPTAIN, JOHNNY ROOSMA

the academy crowd by running the length of the court backwards, demonstrating how a Blood-coached team advanced the ball without the use of the dribble. Down the stretch, it was all Army winning by a score of 31-22.

GAME #4 MANHATTAN COLLEGE The Jaspers offered little resistance as Roosma was high again with fifteen points in a 35-16 Army victory.

GAME #5 GEORGETOWN UNIVERSITY The season's weakest opponent fell to the soldiers easily 47-20.

GAME #6 SWARTHMORE COLLEGE Army's accurate shooting overcame an early deficit. The five-for-five foul shooting helped make the sixth straight triumph 35-10.

GAME #7 UNIVERSITY OF PENNSYLVANIA In the most evenly matched game in West Point history, the six-game win streak came to an end. It was a seesaw affair all game as West Point held a 13-12 lead at the half and a 23-23 mark at the end of regulation time. In the five-minute OT, the score continued to and fro until Penn's Ramage delivered the winning two as the whistle ended the game with the Quakers on top 32-31.

GAME #8 FORDHAM UNIVERSITY The Fordham game was similar to the Pennsylvania game, fast and physical with this one taking two OT periods before Hank Flood scored the winning basket as time expired—Army wins 25-24.

GAME #9 SYRACUSE UNIVERSITY In what was considered the biggest game in the East, the fans in attendance received their money's worth. After leading 11-5 at the half, the Army squad, led by Johnny Roosma, fell before the outstanding play of Syracuse's number eight, the

5'10", 174-pound Syracuse All-American by the name of Vic Hanson. In its day, this match-up between the two heralded All-Americans (Roosma and Hanson) paralleled that of Lew Alcinder/Elvin Hayes as they dueled in the Houston Astrodome many years later. Plagued with foul problems, Army lost for the second time 20-23. This great Syracuse team coached by Lew Andreas went on to post a 19-1 record and was declared the 1926 National Champions.

This classic match-up not only featured two of the best college players of the day and Prof Ernest Blood, but the man behind the whistle refereeing the game was David Tobey. Tobey, Roosma, Hanson, and Blood

VIC HANSON
photo courtesy of Syracuse University

348

have all since been inducted into the Naismith Memorial Basketball of Fame. In addition to being an outstanding high school and college coach himself, Tobey was considered the top basketball official of his era and contributed the first reference book for referees called *Basketball Officiating*.

To this day, Hanson is regarded as one of the greatest all-around athletes ever to attend Syracuse University. His basketball exploits for the 1927 season earned him "Player of the Year" honors, and in 1952, he was selected by Grantland Rice to the all-time All-American squad with George Mikan, Bob Kirkland, Hank Luisetti, and John Wooden.

GAME #10 LAFAYETTE COLLEGE With Roosma hitting eight field goals, the Lafayette Leopards lost everything but their spots. While Army won the game 44-9, they suffered a signifant loss when Prof's guard, George Shepard, went down with a badly sprained ankle. The loss of Shepard, who played forward, was the main reason for the four straight losses that followed.

GAME #11 COLUMBIA UNIVERSITY On February 6, a talented Columbia team displaying both excellent defense and shooting accuracy stopped Army. With Madden and Mannheim as their two mainstays, Columbia went on to become the Intercollegiate Champions of the East. Army lost one they would have liked to forget by the score of 16-30.

GAME #12 NEW YORK UNIVERSITY Three days later and still struggling, the Violets of NYU overcame Army 20-29.

GAME #13 UNIVERSITY OF PENNSYLVANIA In Philadelphia, Army outscored Penn from the field but lost nevertheless 11-16.

GAME #14 UNION COLLEGE The game with Union College on February 19 was a heartbreaker. After winning most of the game, Army lost 23-24 via a last second shot.

Now that Shepard was back in the line up, and with the most difficult part of the schedule (except Navy) behind them, the team regrouped for the home stretch. During the four-game losing streak, only Columbia was able to truly dominate the Army squad.

GAME #15 COLGATE UNIVERSITY Colgate became the victim (38-15) of a rejuvenated Army team that was beginning to feel comfortable with its new system.

GAME #16 HOLY CROSS Full throttle and brimming with confidence once more, Army ran over the Jesuit College. The outcome was never in question as Army won 41-27.

For the few days leading up to the big inter-service game with Navy, the chant "We want that blanket!" was heard more and more. The blanket belonging to the Navy's goat would be handed over to Army if the sailors lost. The Army/Navy game was a rivalry of the highest order. Even

though the previous games' scores favored Navy, records were useless in predicting a winner between the two academies.

The Navy team anticipated victory, for they had run up a big score against Fordham while Army needed two overtime periods to get a one-point win. Navy also took a classic one-point victory from Columbia University, the team that gave Army their only real licking.

GAME # 17 NAVY The annual classic was played on February 27. USMA's yearbook, *The Howitzer,* gives the following account of the game:

> *The first half was very closely contested, Navy leading after 12 minutes of play 4 to 3, Army regaining the lead shortly afterwards on shots by Roosma, Flood and Draper. The first half ended Army 10, Navy 7. The game was intensely fought throughout. Neither team let down for a single instant. The ball changed hands time after time. Shortly after the second half started, however, the superiority of the Army became obvious. Johnny Roosma started tossing baskets from all parts of the floor. Wilson swooped down and broke up the Navy offensive time and again. Shepard, Mills, Draper and Flood all played as though filled with an unbeatable spirit. Roosma made more field goals than the entire Navy team. Jones and Parrish starred for the Navy. The final score of the game was Army 21-Navy 12.*

LINE-UP

Army (21)		Navy (12)
Roosma	L.F.	Parish
Mills	R.F.	Craig
Flood	C.	Hamilton
Shepard	L.G.	Graf
Wilson	R.G.	Jones

Goals from field: Army—Roosma (5), Mills, Deaper, Flood, Shepard. Navy—Hamilton (2), Parish, Craig. **Fouls**: Army—Shepard, Draper, Flood. Navy—Parish (2), Jones, Graf. **Subs**: Army—Draper for Mills, Mills for Draper, Draper for Mills, Seeman for Shepard. Navy—Hull for Craig, Craig for Hull, Howard for Craig, Signer for Parish, Hull for Hamilton, Shapley for Graf, Graf for Shapley.

Prof's team's record was not as impressive as in previous years, but all things considered, it was a successful season. His propensity for carrying a large number of players slowed the team's progress. That fact was further exacerbated by the unusually large number of Plebes on the team, indicating Prof's concern for the future. But with the Navy blanket

secured for another year and West Point's 200th court victory in the books, optimism abound.

Even Roosma's playing time and point total were less than in previous seasons. When the outcomes of the games were decided, the first and second-year men were given the bulk of the minutes to play. Prof's style was a team game, as was Roosma's, but it diminished Roosma's scoring opportunities. Readapting to Prof's system was not difficult or unpleasant for Roosma because he was only interested in the team. Nevertheless, during the course of his years at the Military Academy, Roosma did manage to become the first collegian ever to score over one thousand points (1126).

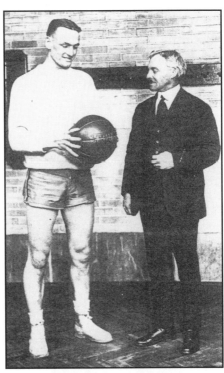

ROOSMA AND PROF AT WEST POINT

How much the three responsibilities (West Point, SBP, and the YMHA) affected his effectiveness is not known, but the SBP record was consistent with a Blood-coached team. *The Telolog,* the prep school's yearbook, indicated "that the 1926 season was without a doubt the most remarkable in the history of the game at St. Benedict's." Playing a demanding schedule, the Gray Bees finished the year with a 24-1 record.

For the second time in a row, the powerful Newark Central team was defeated for the city title. The real high point of the season was the ending of The Peddie School's (Hightstown, New Jersey) reign as prep school state champs. The Peddie School had dominated the games with SBP during the previous six years.

1920	State Semi-Finals	Peddie 46-St. Benedict's 25
1921	State Finals	Peddie 36-St. Benedict's 32
1922	State Finals	Peddie 38-St. Benedict's 34
1923	State Finals	Peddie 35-St. Benedict's 33
1924	SBP was eliminated	Peddie 34-Bordentown 32
1925	State Finals	Peddie 30-St. Benedict's 20

Their supremacy was primarily attributed to their coach John D. Plant and his ability to recruit talented players from the Philadelphia and Trenton areas.

Plant was born in Staffordshire, England, but he was raised in Trenton. He was involved with every basketball team in the school's history. As a student, he organized their first team, and after graduating in June 1906, and taking a few college classes, he was retained as the school's athletic director. In those days, John coached every sport the school offered.[363] He was a living legend, earning the appropriate nickname "The Old Roman." He was very strong and resembled what one might imagine a typical Roman gladiator to look like.[364]

JOHN D. PLANT

Many parallels could be drawn between John Plant and Ernest Blood. They were sportsmen of the highest degree with unquestionable integrity. In their youth, they were outstanding athletes and, until their twilight years, exhibited unusual physical strength. Fortunately for Plant, he was appreciated by his school's administration. There

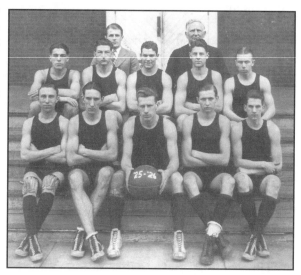

COACH PLANT'S 1925-26 PEDDIE SCHOOL TEAM
photo courtesy of the Peddie School Archives

was speculation concerning who was the better coach, but the question was impossible to settle until this time when their teams would meet for the first time.

The two icons, Blood and Plant, had one notable dissimilarity. Plant was known as a good basketball player, but he was a notoriously poor shooter. Prof, on the other hand, was well known as a player with a great shooting touch.

The expected match-up came during the prep school state championship in New Brunswick. As the game progressed, it became obvious that

SBP was the superior team. It was no disgrace for The Peddie School to relinquish the title to SBP.

Peddie		**St. Benedict's**
Norris (Captain)	R.F.	Jackson (Captain)
Griffin	L.F.	McIntyre
Kammire	C.	Lange
Case	R.G.	Neilan
Ragonetti	L.G.	Russell

Substitutions: Peddie—McKeown for Case, Sawyer for Griffin, Jones for Kammire, Fry for McKeown, Shippley for Sawyer. St. Benedict's—Federeci for Lange, for Jackson, McDonald for McIntyre, Moyna for Federeci, McEleahney for Neilan, O'Connor for Russell. **Field Goals:** Peddie—Norris 4, Griffin, Kammire, Jones, Case, Ragonetti. St. Benedict's—Jackson 6, Lange 5, McIntyre 4, Federeci. **Foul Shots:** Peddie—Jones 2, Norris, Shippley, Ragonetti. St. Benedict's—Lange 3, Neilan 2, Russell 2, McIntyre 2.

Scoring by quarters: **St. Bernedict's** 11 26 33 **41**
Peddie School 11 14 17 **24**[365]

A Passaic version of the game went like this. "That game with Peddie was a debacle. Blood took his regulars out early in the contest, but even the subs continued to pile up points. Finally there was no one left on the Gray Bees' bench but the mascot. So Blood sent him in."[366] This stunt, which greatly irritated The Peddie School administration, was rumored to be why they declined to participate in future state championship competition.

The results of Prof's first full season at SBP were a harbinger of what was to come. For the remainder of the twenties and well into the late thirties, SBP would remain a celebrated basketball program. It wasn't until the game changed and the rest of the country caught up to Prof and his coaching methods that SBP's supremacy as a basketball powerhouse began to wane. Then again, by the time the center jump was eliminated for the 1937-1938 season, Prof was sixty-six years old.

The 1925-1926-basketball team's record was 24-1, but only the scores of twenty-one games could be located.

	SBP	Opponent		SBP	Opp.
St. John's Prep	53	14	Manhattan Frosh '29	64	17
Camden Catholic H.S.	28	21	N.Y. Stock Exchange	42	30
Blair Academy	38	37	Wenonah, MA	35	42 L

St. Peter's H.S. (N.B.) 2	0	Commerce H. S.	64	14	
Trenton Cathedral	44	32	Trenton Normal	35	31
Passaic YMHA	39	33	Princeton Prep	38	25
Asbury Park H.S.	32	19	Newark Central H. S.	32	27
Newark Prep	42	15	**State Tournament**		
Seton Hall Prep	40	32	Blair Academy	42	31
Wenonah, M. A.	55	23	St. Michael's H.S. (J.C.)	29	25
St. Cecilia's H. S.	131	14	Peddie (Prep Champs)	41	24
			Total	**860**	**520**[367]

BACK IN PASSAIC

Amasa A. Marks and the Passaic basketball team managed to continue winning. The pressure of the streak was over, but the fans still expected them to win the state championship. When Prof Blood left the school district, he left behind his system and feeder program. Marks was left with not much more to do than show up and he'd still win.

It was understood that Marks "knew nothing about basketball, and he never once taught his team a play."[368] Even Jack DeYoung, the all-state forward from the 1929 state championship team added that Marks was an easy-going guy who wasn't too strict or knowledgeable. Taking over from a legend, he was doomed to pale in comparison.

The conclusion of the 1925-1926 season was one for the record books. By mid-March, the Stanley Adams-captained team had compiled a 20-1 record and had successfully navigated through the Northern New Jersey sectional rounds of the state play-offs. The final match-ups were Passaic vs. Union Hill and Trenton vs. New Brunswick. Again, Walter E. Short, as in years past, pulled a fast one on the state sporting community by not drawing to determine who should play whom. Instead, he assigned the pairings himself and pitted Trenton against the much weaker New Brunswick team, and he matched the two strongest teams in the state, Passaic and Union Hill, to meet in the semi-finals at the Sussex Armory in Newark.

In September, Moyer Krakovitch, the Passaic all-state guard, transferred to Union Hill High School. In masterminding Moyer's defection, Charles Foley had gone too far and was tagged as a meddler in scholastic sports. The exact reasons for his meddling are not clear, but he did relish being associated with a winner. Since Prof's departure from Passaic, Foley had switched his allegiance to Union Hill. It was common knowledge that he had purchased the Stutz roadster that Moyer used for his daily commutes. But it was Foley's boasting that he was paying Moyer's out-of-district tuition that stretched his tampering too far. Until then, not too much had been said about the situation.

Foley was not satisfied just to have Krakovitch and Union Hill in the state semi-finals. Foley informed Coach Wright that if Union Hill won the state championship, as most basketball fans outside the Passaic area were predicting, he wanted Union Hill to participate in an over-all state championship game with Prof's SBP team. In an even more audacious move, a few days before the semi-finals, Foley told Wright that if he did not consent to his wishes, he would pull Moyer out of school. Coach Wright was incensed with Foley's unwanted involvement and dictatorial tone; he'd had enough. It wasn't long before word got out about Foley's interference. Futhermore, it was rumored that immediately after Union Hill's last game, Krakovitch was going to drop out of school and report to George Marshall's professional team (Palace Five) in the American Basketball League in Washington, DC.

UNION HILL TEAM WITH MOYER KROVITCH STANDING SECOND FROM FROM RIGHT

As the teams prepared for the semi-final showdown, the news of Foley's demands spread quickly throughout the state. Although the rumors had been circulating for some time, Short called a last-minute meeting to address the issue and scheduled it for the evening before the semi-final games at the Robert Treat Hotel. The meeting included the NJSIAA board of trustees, respective school officials, and newspaper reporters. Krakovitch and Foley were also summoned to appear and testify. The righteous Walter Short claimed that the purpose of the meeting was to learn whether Krakovitch was going to Union Hill to play basketball or to study.

In the four-hour plus meeting at the Robert Treat Hotel in Newark, the board presented their accusations of professionalism against Krakovitch. Their charges contained much supposition but no facts. Krakovitch testified that he had no intention of leaving Union Hill and that he had hoped to graduate and attend college. He declared that he was in school to obtain an education and not for the love of basketball.[369] By a 4-3 vote, Moyer was cleared of all charges and declared eligible to continue playing as an amateur. But Short and those who sided with him decided with a another 4-3 vote to call off the tournament rather than let Krakovitch play. Charles E. Lillis, president and spokesman for the association said that "for the good of scholastic sports" it would be better not to finish the tournament.[370]

As always, the architect behind all NJSIAA decisions was Walter Short. It was alleged that Short told Union Hill Principal Stahler that he would resign as secretary of the Interscholastic Athletic Association if Krakovitch played against Passaic.[371] If Short had resigned, most sports followers throughout the state, with the possible exception of those in Trenton, would have greeted his decision as good news.

Throughout the meeting, Foley received much criticism from all corners but none more than that directed towards him by John Plant. Plant told Foley that "men such as you are a detriment to scholastic sports. You are a liar and I don't mind telling it to your face...." This elicited Foley's reply that "you seem to be peeved over losing to St. Benedict's Prep."[372]

At no time during the season or during this meeting was a Passaic official (Marks/Arnold/Passaic School Board) ever associated with complaints or accusations against Krakovitch or his transfer. The Passaic team and fans were confident that their team style of play would overcome Moyer's contribution to the Union Hill squad. When asked why Krakovitch transferred to Union Hill, Coach Marks indicated that it was solely because Stanley Adams was appointed the team's captain.

Gus Falzer, the leading sports writer for the *Newark Call,* felt the contention over the captaincy was rife with racial overtones.[373] Moyer and several of the Wonder Team members were Jewish. Falzer's comments had some validity because "many of the players on the team, especially the substitutes, were gentiles. Many of the subs were football players who weren't really basketball players per se. They were the ones who voted for Stanley Adams because he was in their click."[374]

The *Newark News* sports page offered this prudent advice: "This should be a lesson to schoolboys. It should point out that transferring from one school to another for athletic reasons is not fair to themselves. The case should serve to warn schoolboys that outside influences, such as Mr. Foley served to Krakovitch, are anything but advisable. The case should point a lesson that the 'straight way is the only way.'"[375] This advice is just as appropriate today as it was in 1926.

Prof Blood tried to stay out of the controversy, but when he heard that Foley, who was a Blood advocate, wanted to take Moyer out of Passaic for revenge, Prof had to comment. "I have never harbored any ill feelings toward Passaic," said Blood. "Foley and I were never more than acquaintances. He gave a cup to Passaic on its 100th straight win, which was handled by the Athletic Council. The cup for the 125th victory was handled by Joseph Gardner of the school board, while the cup for the 150th win was after I was no longer associated with the team."[376]

Many speculated that this mess could have been avoided and the winning streak maintained if Prof were still in charge. In fact, Prof did try to persuade Moyer not to transfer. Blood also said that "I have been, and

am now always willing to encourage the boys of Passaic High in every way. I have the same feeling for the boys I had when I was in Passaic… anybody that tries to do anything to hurt the Passaic Team is no friend of mine."[377]

What rankled basketball fans was Short's decision to wait until the last minute to investigate Krakovitch's situation. If something was not in order, why didn't the association look into it back in September? Everyone was aware of the transfer, so it was strange that Short started his probe the day before the semi-finals. It was the consensus of opinion throughout the state that Short and the NJSIAA had done more to harm the sport than a dozen Foley/Krakovitch incidents could have.

After squaring off with Rutherford again for the league championship and eventually losing to Christian Brothers Academy from Syracuse in the finals of the Glens Falls Tournament, the Passaic boys compiled a 24-2 record. With the exception of the 1929 season when Passaic won its next and last state championship, the days of Passaic as an annual contender for top basketball honors were over.

CHAPTER EIGHTEEN
ZEP

Tradition holds that teams from peewee to professional ranks identify with a mascot. The superstitious believe that mascots bring a team good luck. It doesn't matter whether the good luck charm is an eagle, viking, spartan, jaguar, or a senator. The mascots' names and the reasons behind their choices can be quite unique.

The mascot for the Passaic High School athletic teams has always been an Indian, but there was a time in the early twenties when Passaic's basketball Wonder Teams had a black bear mascot named Zep. For the first half of the 1920's, the Passaic Wonder Teams dominated scholastic boys' basketball unlike any other team before or since. If the team itself weren't fearsome enough, the black bear that led them on to the court was.

The days of black bears roaming wild in the Peaceful Valley were long gone. Zep was from out of town. His Passaic debut occurred during Easter vacation in 1921, when Prof Blood took his two-time New Jersey high school basketball champs on a field trip to play Potsdam Normal High School in northern New York. During the Potsdam trip, Zep was presented to Prof as a gift.

Having lived and worked in Potsdam for nine years (1906 to 1915), Professor Blood had established a reputation based on his many extraordinary abilities and a number of his eccentricities. One of the idiosyncrasies that had become part of Prof's lore was his affinity for pets. As fate would dictate, Passaic's field trip

ZEP SHORTLY AFTER JOINING THE BLOOD FAMILY

coincided with the shooting of a mother bear who left behind an infant cub, perhaps two or three days old. Not knowing what to do with the newborn and not wanting to let the helpless cub go, the hunters decided to save the cute ball of fur until they figured out what to do with him.

The solution to the hunters' problem presented itself when it was learned that Professor Blood was back in Potsdam with his new team from New Jersey. They presented the baby bear to him knowing he would appreciate the gift. The timing couldn't have been better.

The cuddly, black, furry infant was immediately adopted by the Passaic team and joined their entourage returning to Passaic. The team spent the train ride home taking turns bottle-feeding Zep. The numerous curiosity seekers attracted the attention of the police as the team and the baby bear made their way through New York's Grand Central Station.[378]

When Prof arrived home, he placed the bear in bed beside his younger son Ben. Seventy-seven years later, Ben Blood still remembered awaking to find his new pet asleep in bed alongside him. "Many a time I went to sleep with him," recalled Ben.[379]

Prof housed an eclectic collection of animals. The array of creatures was a neighborhood conversation staple. In the Blood's basement were two skunks, two raccoons, a rattlesnake, a garter snake, a turtle, and now, to complete the downstairs menagerie, a black bear. To keep peace among the guests, the alligator was kept upstairs under the kitchen sink where it lived for seven years.[380]

Zep literally became one of the family. As most pets do, he loved to be pampered and played with. Nine months after his arrival when the

DAUGHTER ERNESTINE
AND ZEP

PROF'S WIFE MARGARET
WITH A HUNGRY BEAR

basketball season was about to begin, it seemed natural for Zep to take on a role with the team. He was a favorite among the players and was recruited to be their mascot. By mid-December when Dumont High School arrived at the Lafayette School gym, Zep was a butterballish seventy pounds of fur and full of playful energy.

The custom of the captain leading the team on to the court was made to order for the 1921-22 Passaic basketball team because Paul Blood was the captain. Paul and Zep were the first to appear on the court as they led the team into the crowded gymnasiums. The team that Paul captained is considered by many to be the best of the great Wonder Teams, and every game was a history-making event. The novelty of the black bear playing with Prof's younger son Ben at mid-court added to the mystique of a Passaic game.

By half time, when Passaic's lead was usually insurmountable, the show would resume with Ben or Prof wrestling Zep at half court. With each passing week, however, Zep grew bigger, and as he grew, fans and neighbors became more fearful of his presence. For safety reasons, Zep was muzzled, but the long claws were still a deterrent to any potential petter except for those with whom Zep was familiar.

HANGING OUT IN THE BACKYARD

As a member of a basketball family, Zep was expected to know how to handle a basketball. Prof prided himself on his ability to teach all of his players better shooting techniques, and Zep was no exception. "The way Zep held his claws on the ball was just about perfect for set-shooting," claimed Prof.[381] As the bear grew taller and heavier, a few practice shots were added to the half time wrestling shows. The mascot's presence compounded the hysteria surrounding the basketball team that kept on winning and winning.

Having participated in numerous matches with Prof and his sons, Zep developed into an accomplished wrestler.

ZEP KNEW HOW TO HANDLE THE BALL

PAUL BLOOD (BOTTOM) AND PAL BOB SAXER
WRESTLE WITH ZEP

However, as he grew, the bear became too much for the boys to handle. He never seriously hurt anyone, but some of the players had been nipped or scratched from time to time. The only match for the over 400-pound bear was Prof. The black bear, however, eventually grew to be taller than Prof. Wrestling with the born-to-be-wild bear was one of Prof's most enjoyable exercise sessions. Prof always claimed that he could lick Zep with one of the bear's own weapons—the bear hug.[382]

To help explain some of his coaching theories, Prof often referred to his wrestling bouts with Zep. "I wrestle a great deal with Zep," he would say, "and I always win." Prof didn't mean to imply that the bear lacked determination, sufficient mental or physical agility, or strength because he possessed all of them. The same means by which Prof was able to gain the advantage on Zep, he used in basketball—by watching the eyes. "By watching Zep's eyes, I can tell exactly what he intends to do. Consequently, I am prepared and I win."[383]

The same shortcomings Zep exhibited as a competitor were often observed in basketball teams. They wanted to win, they tried hard, they were willing to sacrifice much for victory, but these efforts were not always enough. Many of those teams allowed their opponents to detect their

PROF WAS ZEP'S ONLY COMPETITION

strategies, thereby minimizing their chances of success. Like Zep, the unsuccessful teams hadn't learned to be deceptive. In addition to some good exercise, Prof learned much from his grappling with the bear.[384]

Prof's insight to getting the upper hand on Zep wasn't obvious to everyone. For example, the meter man who read Prof's gas meter in the basement each month must have lacked the coach's intuition. The gas company employee was startled when he saw a rattlesnake slithering slowly across the basement floor towards him. Instinctively moving away, the meter man was cuffed on the back of the head by Zep. In the split second that it took for the meter man to see his entire life flash before him, he bolted from the basement. When the gasman's experience was made public, the Blood's basement became the neighborhood's least likely place to attract loiterers. From that day on, all gas billings were completed by mail.[385, 386]

Towards the end of Zep's tenure as mascot, Prof encountered a few difficulties with the bear that foretold things to come. On more than one occasion after a game, Prof had to walk home with Zep

ZEP WAS ONE OF THE FAMILY

because the bear would become temperamental and refuse to get into anything resembling a cage. One of the most talked about incidents with Zep took place after the benefit game with Reading at the Paterson Armory, the night Bobby Thompson scored his one-thousandth point of the season.

On that miserable, cold and rainy night of March 31, 1922, Prof and Zep took a taxi to the Paterson Armory for the season's finale with Reading High School. Because of the stormy weather, the taxi's windows were rolled up, and Zep couldn't hang his head out as was his routine. Prof and Zep became embroiled in a little spat over the closed window, provoking the angered bear to claw Prof. As far as it is known, this was the only time Zep got the best of his master. After the anxious driver

delivered the odd couple to their destination, news of the back seat scuffle spread quickly.[387]

The perturbed bear had to be kept in the armory basement away from the noise and cheering upstairs. Bobby's historic game crowned a spectacular, undefeated (33-0) season. As he was preoccupied, Prof hadn't given Zep much thought until long after the game was over and it was time to go home. By that time, every taxi and trolley car driver in the area had heard of the wild bear incident. When Prof was finally able to hail taxi after taxi, the drivers, one after the other, said, "No thanks," and refused to have anything to do with

ZEP AND PAUL BLOOD

the unruly bear and his companion. Besides, Zep was in no mood to ride in anything. Because it was so late, Prof had no other choice but to begin his trek back to Passaic on foot.[388]

The image of the two parading down Paterson's Park Avenue under the street lamps in the wind and rain must have cast a silhouette akin to Dino and Fred Flintstone. In the beginning, the young bear was having a good old time frolicking ahead of Prof. Later during their nightmarish jaunt after both man and bear were drenched to the skin, the bear became tired and started lagging behind. What Prof said to the bear during the remaining distance was unfit for publication. By then, the streets where

devoid of all domesticated creatures. Woe be it to any ill-advised thugs seeking a payoff. These two were definitely not happy travelers.[389]

For years, when old timers gathered to relive tall tales from the past, the account of the time Prof Blood had to hoof it home from Paterson with his bear lagging behind was a story always worth retelling.

When anecdotal memoirs of strong-willed coaches who possessed an aura of authority are rehashed, the episode of Prof getting Zep back on a train remains the superlative tale. Prof and Zep were known to take a Pullman car train to Bear Mountain in New York. During these trips, Zep would be kept in the baggage car where he usually managed to get into trouble with the trunk wrangler. On one particular trip, Zep's mischief led to the train making an emergency stop. When the train stopped, Zep hopped off and made straight for the woods. Sticking his head out the door, Prof shouted "Zep, Zep, get back in here." Zep stopped, turned and headed back to the train. When the bear climbed back on board, the conductor protested. "All right," said Prof, "if you don't want him in here, put him off."[390] The conductor decided to let Zep stay.

Prof's ability to teach high school athletes was legendary as was his knack for controlling his teams in the dressing rooms and on the courts. Other coaches possessed unusual talents, but no other maestro had the persuasive power to call a full-grown black bear back who was intent on high-tailing it for the woods.[391] The Napoleon of basketball had that intangible quality that compelled those he supervised to respond.

ZEP SHOWING SOME LOVE

Zep's increasingly unpredictable behavior became too serious to ignore. Once during a half time, Zep clawed Passaic player Chester Jermalowitz, and shortly after that, he bit Paul during one of their wrestling matches. The risk involved with having a big black bear in close proximity to crowds became too great; thus, Zep's days of leading the Wonder Teams on to the court came to an end.

The former mascot spent his final days chained to a post behind the Blood's house, and at night, he resided in the malodorous basement. The neighbors grew concerned because on occasions Zep would get loose and rip up some shrubs. The thought of him getting loose and

hurting a child became too real; therefore, some other accommodation had to be provided for the ursine pet. Prof arranged to give Zep to a man who owned an animal farm in Pompton Lakes about ten miles outside Passaic.[392]

Zep did not enjoy his new lifestyle in his suburban home; he grew increasingly depressed because he couldn't see his master. The bear was homesick for Prof. After about six months of Prof-sickness at the farm, Zep became seriously ill, and shortly thereafter, he died. The cause of death, according to Johnny Roosma, was "a lack of seeing Prof."[393] Zep's body was returned to his home in Passaic where

PROF'S SON BEN (NEXT TO ONE OF HIS DAD'S OLD 60-LB. DUMBBELLS) AND AUTHOR CHIC HESS WITH ZEP'S FUR COAT, JUNE 28, 1998

much of him was buried. His attractive fur coat and head have become an heirloom in Ben Blood's family.

In the early eighties when Ben Blood was in Passaic visiting his old buddy Ray Van Handle, he stopped by his childhood home on Spring Street. He looked into the backyard of the house where he grew up and saw children playing near where his father had buried Zep's remains. He wondered about the children's reaction had he told them that they were playing on the grave site of Passaic's most famous black bear.[394, 395]

Chapter Nineteen
People of Influence

'No man is an island, entire of itself; every man is a piece of the continent, a part of the main...'

—John Donne

Every friend and acquaintance leaves an impression on how we think, feel, or conduct ourselves. Ernest A. Blood had a supporting cast who directly or indirectly took an interest in him and influenced his philosophy and history-making career.

The few special people mentioned here were not the only ones who helped shape Ernest Blood, but they formed the nucleus of those who left indelible marks.

Robert J. Roberts (1849-1920)

Make it a habit of your life to exercise your body every day as regularly as you eat your meals. Then, and only then will you become a healthy and happy looking Christian, wholesome to look at and make glad everyone who may have the pleasure of being in your company.[396]

The term bodybuilding was first coined in connection with the work of Robert J. Roberts at the Boston YMCA. Technological advancements were responsible for rendering Roberts jobless, but because of his astonishing physique, he gravitated to the Boston YMCA's new gymnasium for a source of income. First employed there in the summer of 1876 as a janitor and gymnasium superintendent, he soon enabled the Boston Y to realize the goals envisioned for its new state-of-the-art physical plant.

Through Roberts's association with Dio Lewis (pioneer of light gymnastics) and Dr. Winship (heavy work), Roberts derived a form of exercise that was a compromise between the two. Converts to his system of bodybuilding, as he called it, found his system to be safe, easy and expedient. New members flocked to his gym to learn the details of his system, largely dependent on a circuit of exercises utilizing hand weights. It was no longer a monotonous grind to improve physically; exercise had now become

a means to an end. The circuit of dumbbell exercises Roberts arranged also meshed well with the Y's available space and scheduling.

His own physique, physical strength and teaching methods were stimulating, and they enhanced the appeal of Roberts's dumbbell system. His new exercise regimen spread rapidly through the YMCA system. As a direct result of Roberts's contributions, gymnasiums everywhere began to move away from the more dangerous heavy gymnastics that had been the norm.

The unparalleled success of Roberts's system pushed him to the forefront of the physical movement. He introduced his system to the School for Christian Worker in Springfield (forerunner of the YMCA's International Training School) in the late 1880's. Men who were versed in Roberts's system were in great demand.

No area was more saturated with Roberts's training system than the gymnasiums in the Boston area. Through his association with the area's YMCA's, Blood became a lifelong advocate of Roberts's methods. Evidence of the respect and longevity of their association appeared when Blood invited Roberts to perform during half time at one of his Potsdam games.[397]

As with everything else Blood believed in, he practiced what he preached. Throughout his life, Blood maintained and utilized barbell equipment in his basement. His superior strength developed through gymnastics, apparatus work, fencing, and Indian clubs, and wrestling was augmented by his regimented sessions with the weights. He taught his sons the value of weightlifting. Not nearly as strong as their father, Paul and later Ben, had their own set of dumbbells. To what degree Prof emphasized the benefits of weight training to his players is not known, but it is likely that he exposed all of his teams to various forms of progressive resistance exercise.

LUTHER HALSEY GULICK (1865-1918)

The well-traveled Gulick profoundly influenced the YMCA's nascent physical movement. As a prophetic leader, he gave the Y's physical department a much needed philosophy and direction. A unique style of physical education emerged from his work that put greater emphasis on recreational games in lieu of following one of the European systems. Gulick became the key figure in the emergence of a new physical education in America.

In basketball circles, Gulick is remembered for his role in the creation and early development of basketball. It was he who assigned James A. Naismith the task of creating a new game. The goal was to find an activity that was "interesting, easy to learn, and easy to play in the winter and by artificial light."[398]

The success of Naismith's game created problems within the YMCA. As the popularity of the new sport skyrocketed, it turned into a monster that threatened its own existence in the Y's gymnasiums. Rowdy behavior accompanied by abusive language and fistfights were an unfortunate by-product of the new game. The admired traits of sportsmanship and gentlemanly behavior were cast aside in the quest for victory. The new enthusiasts of the gym were usurping court time and space from traditional gymnasium work, and this did not sit well with the older established physical directors.

As secretary of the YMCA's Athletic League, Gulick set out to address the unchristian-like behavior springing up almost everywhere basketball was played. His emphasis upon clean sport included high standards of Christian honesty and courtesy in athletics. He believed that Christ's kingdom included the athletic world and that the influence of athletics upon character must be on the side of Christian courtesy.[399] In a YMCA publication titled *Association Men,* Gulick circulated a list that he care-fully worded to discourage the undesired behavior. In the YMCA system and in other civilized pockets of sports, his efforts were referred to as the "Clean Sport Roll." (See Introduction)

Gulick published his "Clean Sport Roll" just as Blood was beginning his professional career at the Central Branch of the Brooklyn YMCA. The principles set forth in this document became the cornerstone of Blood's philosophy of physical education and athletics that would guide him through-out his career.

DUDLEY "HERCULES" ALLEN SARGENT (1849-1924)

The Harvard Summer School of Physical Education in Cambridge represented the cutting edge of American physical education. Founded and directed by Dudley Allen Sargent, the summer school was the most recognized of the physical education training schools. Blood was attracted to the school because of its talented and charismatic director.

Blood admired Sargent, who was a dynamic leader, because Sargent stood for everything that Blood thought was important in the profession. Like Sargent, Blood wanted to make a difference in the lives of his students through physical activity. After graduating from Sargent's four-summers-long program, Blood became a member of an elite group; he became one of "Sargent's Regulars." While learning from and working with the premier physical educators in the country, Blood had the advantage of immediately implementing what he learned while performing his YMCA duties. This incubator for learning enabled him to grow professionally at an accelerated pace.

While the influence was obvious, Blood and his mentor Sargent shared many other similarities. Both were:

- Raised by a single mother from a young age.
- Very concerned with pecuniary matters that led to conflict with their employers.
- Continually engaged in summer employment to enhance yearly salary. Sargent had his Harvard Summer School of Physical Education and Blood directed YMCA summer camps.
- Less than tactful (at times) in dealing with their employers.
- Held in high esteem by their students, and their students steadfastly expressed loyalty to them.
- Devoted to their professional commitments.
- Recipients of national visibility and recognition for their achievements.
- Extremely strong physically with well-defined physiques. They understood and appreciated the value of progressive resistance exercise.
- Exhibited an energetic spirit more inclined to expending energy pursuing physical activities than academics.
- Outstanding in gymnastics—especially tumbling and apparatus work. Sargent traveled with a circus for a short time and Blood was once offered a similar opportunity.
- Advocates of incorporating some vaudeville or showmanship into their performances. A "little bit" of showing off was okay.
- Tireless workers who routinely worked long hours and rarely engaged in a social life outside their profession.

Ernest Blood was proud to be one of Sargent's protégés. The skills, methods, philosophies, and contacts he came away with from Sargent's school were invaluable to his career. How much Blood and Sargent actually kept in touch with one another is not known, but if Blood needed help or advice, Sargent and acquaintances from the summer school were dependable resources. When Ernest applied for the Passaic School District position in 1915, Sargent was the first person he listed as a reference.

CARL LUDWIG SCHRADER (1872-1961)

The German-born Carl Schrader became a friend of Blood's when they were associated with Sargent at his school. Schrader, who himself became a pioneer in American physical education, worked side by side with Sargent for seventeen years. Blood admired Schrader's unusual talents in gymnastics. As they were the same age, the two exceptional athletes formed a close working relationship and friendship. Opportunities to learn from each other and the many others who passed through Sargent's program were not wasted on either man.

During his years with Sargent, Schrader distinguished himself as a master teacher—a teacher of teachers. As Blood worked with Schrader each summer, he became more influenced by Schrader's ability to teach skills—not just gymnastics. Schrader had a very effective teaching technique that enabled the students to learn more expediently. Blood learned a great deal about the art and psychology of instruction and how to make adjustments in performances from observing Schrader.

Schrader's philosophy was equally inspiring to Blood because it helped clarify some of his own thoughts. Schrader drew a noticeable distinction between physical training and physical education. He postulated that when one aims to influence mind and character, one teaches instead of trains. To justify this concept, he suggested that such character qualities as truthfulness, fair play, magnanimity, loyalty, chivalry, and control of temper that are often credited as the results of athletic participation are not developed by occasional administering or lecturing. That would be tantamount to teaching posture and health habits by using merely textbooks and informational lectures; it couldn't be done. He contended that these character and health habits must be practiced to become habitual.[400]

Schrader understood the importance of physical education as a vital segment of the bigger picture. To him, physical education was not just a "dangling appendage" that some believed could be snipped off without affecting the educational program.[401] These theories and many others Blood heard from Schrader were congruent with how Blood felt about his profession. Schrader's philosophies and teaching methods were adopted and used by many others, but during their time together in Cambridge, no one was more affected by the enlightened German than Blood. As Dudley Allen Sargent had, Schrader recommended Blood for the position of Director of Physical Training in the Passaic School District. His letter of recommendation follows.

Dr. Fred S. Shepherd
City Superintendent of Schools
Passaic, N. J.

Dear Sir:

> *In reply to your inquiry concerning Mr. Ernest A. Blood, let me speak of him in comparison with the other two men whom you have interviewed in Cambridge. Mr. Blood undoubtedly is the superior of the three, inasmuch as he is strong on the actual gymnastic work in grades and has had ample and varied experience in coaching and managing athletics of all kinds. He is at present associated with the Pottsdam [sic] State Normal School in New York, where he has been*

for a number of years. He is willing to make a change inas-much as supervision of public school work seems to be more to his liking. I am sure that references from that school will give him a strong endorsement. He is not a college graduate and I do not know his preliminary training. He did, however, graduate from the Harvard Summer School a number of years ago and has since that time been on the instruction force of that school. I consider him an excellent teacher of excellent character and a very pleasing and amiable personality. I again repeat that he is a superior man to those whom you interviewed.

Very truly yours,
Carl L. Schrader
CLS.HIM[402]

MARGARET THOMAS BLOOD (1875-1948)

A man could not hope for a more loving, caring, and dedicated wife than Margaret Thomas Blood. Margaret, who was born in Aberganeny, Wales, eventually settled in Richford, Vermont, where she graduated from the local high school in 1893. Family members speculated that Margaret, who lived at 36 Prescott Street, met Ernest during one of her many walks by his house at 12 Prescott Street in Nashua. She had to pass his house to get to the Amherst School for aspiring teachers that was situated around the corner.

Margaret did not fit the image of a "Gibson Girl." Instead of being tall, athletic, socially aloof with that patrician look and possessing that distinctive hairstyle, Margaret was more the cute, wholesome, sweet girl next door. Margaret was much that Ernest was not—an academically oriented college graduate with a license to teach. Throughout her life, she often distinguished her-self through her ability to write and speak well, plus she had an appealing voice for singing. Her teaching career started in East Berkshire, Vermont, and led to the Palm Street Elementary School in Nashua, and finally resumed temporarily in Passaic during the war.

As opposites often attract, Ernest became infatuated with Margaret's sweet personality. And Margaret was equally as fascinated with the young, eligible, athletic YMCA physical director. Within two years of their marriage in 1901, their first child, Ernestine, arrived, and a

ERNEST AND BRIDE MARGARET

MARGARET AND ERNEST

little over a year later, a brother, Paul, followed. As family life set in, Ernest's wont for professional activity consumed his time.

Margaret was the perfect wife for a dedicated coach who enjoyed more than anything else spending time in a gymnasium teaching, coaching or watching an event. It was a different era; the Nineteenth Amendment (Women's Suffrage) came and went, but Margaret never occupied a position of equal status with her husband. The coach called the shots in the gym and at home, and Margaret graciously acquiesced.

How many wives would enjoy having a car's engine sitting in the kitchen for the winter or a menagerie of carnivores and reptiles wandering about the house? Margaret was a saint for enduring Prof's many idiosyncrasies. He was a great coach who was adored by many, but he was not always an easy man to be married to. Ernest was out almost every evening either with a school function or off attending some athletic event. In short, he was never home.

Margaret was the housewife who raised the children, and Ernest was the absentee patriarch who earned the money and pursued his calling. Unlike his father, George Loammi Blood, who abandoned his mother and him, Ernest's love and concern for his family were important to him. Ernest's blemishes as a father and husband may be traced back to his lack of a role model. Months before his younger son's passing in 1999 at the age of 89, Ben Blood affectionately referred to his father as "one tough son of a bitch."[403]

Mrs. Blood accepted her position without misgivings, but because she was an intelligent woman, she sought an outlet to maintain mental stability. After the Wonder Team years, she became actively involved with the Ladies Auxiliary of the Passaic YMCA. Before long, she quietly rose through the ranks of the auxiliary, and in 1928, she was elected their president. After serving a sixth consecutive term, Margaret was then elected president of the New Jersey Women's Auxiliary where she continued to distinguish herself with exemplary service.

Margaret's parenting skills were embellished by her gentle and submissive personality. Her relentless love and devotion to her husband

and children were the twine that bound the family together while her man pursued his first love. Her grandchildren still remember her as their kind and gentle grandma who had skin like peaches and cream and smelled of lavender.

Margaret provided Ernest the love, encouragement, and opportunity for him to accomplish a career worthy of a basketball hall of fame coach. She was the proverbial great woman behind the great man.

ERNEST AND MARGARET

Chapter Twenty
Prof, The Man and
His Philosophy

The very first time Ernest Blood played basketball in early 1892, he knew the game was something special. He was living in Nashua at the time, and, in his own words, he "took to basketball like a duck takes to water."[404]

"I went into basketball when it was invented because I loved it," Blood was oft quoted.[405] He was captivated by the intricacies of Naismith's game. He enjoyed the physical workout and the camaraderie. And like so many after him, he loved the simple thrill of seeing the ball go in the basket.

At first, basketball was entirely a YMCA game. The network of Y's enabled the game to expand at a rapid pace. Neither baseball nor football nor anything that came before was similar to it. For the first few years, Naismith was inundated with requests for guidance in addressing the growing pains his game was experiencing. Later, Luther Halsey Gulick shouldered the responsibility after Naismith took off for a directorship position at the Denver YMCA. Gulick almost single-handedly kept the YMCA communication pipelines flowing with updates on the new sport. Blood avidly followed the developments, and his passion grew with the game.

Little did Blood realize that one day millions would be so enamored of the game that would come to identify his career. Willie Hall, a playground ballplayer at 135th Street Park near Lenox Avenue in Harlem, would say many years later that "there's a love of the game in this city that is very difficult to put into words. You start off when you're very young and you never get it out of your system. You might get married to a woman, but basketball is still your first love."[406] After his first exposure at the age of twenty, Blood was smitten. It would be a love affair that would endure for the next sixty years.

While Naismith explained that the object of the game was to put the ball in the basket, he noticed that players were shooting every time they got their hands on the ball to the detriment of their team. The Canadian advised that a player should shoot only when he had a reasonable chance of making the shot. If you can't get off a good shot, instead of throwing

up a wild one, he advised, use teamwork by passing it to someone who may be in a better position.[407] Blood took his words to heart.

Naismith's advice for defense was just as elementary. He suggested that a player should not merely run after the ball, he should "stick like glue" to his man. Defense was not complicated; all the player had to do was prevent his man from getting the ball.[408]

With the advent of basketball, everyone was a rookie. Others shared Blood's fascination with basketball, but very few became so involved so early. Blood was fortunate because he was an original YMCA gym rat who became a YMCA Physical Director—all of which placed him at the epicenter of the game.

As a player and coach, Blood began formulating his own ideas about how the game should be played. Building on Naismith's initial suggestions, he began identifying what he thought were the key fundamentals. He realized that his shooting accuracy was not enough to ensure a winning basketball game. He learned that coordinating the efforts of all team-mates could increase the odds for team success. Playing nine-on-nine and later seven-on-seven on the small courts required some sense of organization.

Opportunities for Blood to teach and coach basketball soon followed at the St. Johnsbury YMCA. As his destiny beckoned, in 1896, he commenced a decade of short stints as Physical Director in a handful of other Y's scattered throughout the New England states. The experience afforded him the opportunity to develop and refine a system of play. The results of his efforts produced lopsided winning records that, in turn, reinforced his beliefs. During the game's infancy, he was able to experiment and gain valuable insights into the whole basketball experience.

Years later, Blood explained what it was about the game that he felt was so worthwhile. From his perspective, basketball was the best medium for the physical development of the growing boy. To the best of his knowledge, he knew of no other athletic activity that provided exercise, competition, thought, and team play in such generous measures.[409]

The making of Ernest Blood and why he was the way he was is not difficult to decipher. He was an unmistakable product of his heredity and environment. Growing up without the benefit of a nurturing fatherly figure but having a loving Christian mother and the advantages of the programs provided by the YMCA, he prospered. The early philosophy of the YMCA of saving souls from damnation through a wholesome physical experience (Muscular Christianity) had diminished, but its proselytization continued to have a lingering influence. These ideals were reflected in his develop-ment of a wide variety of athletic skills and a keen sense of Christian values. He believed in the goodness of mankind and the value of athletics in a young man's development.

When Blood left the employment of the YMCA for Potsdam Normal School in 1906, he was decades ahead of his contemporaries in basketball coaching experience. It was at Potsdam that his coaching system firmly took root. All of the old records, inaccurate as they may be, indicated that the accomplishments of his teams were remarkable. The few write-ups that the newspaper produced frequently referred to his team's ability to pass the basketball more quickly than their opponents in addition to copious references to crowd-pleasing plays that exhibited teamwork. Keep in mind that many opponents were the best college and professional teams in the Northeast, and his players were high school aged boys. Blood's boys were younger, lighter, smaller, and less physically mature than many of their competitors. Only an organized system relying on teamwork and accurate shooting afforded the high school kids any hope of victory.

As sports became a more important part of society, the newspaper coverage of sporting events improved and expanded. In the beginning, the reporting of high school games was frequently left to amateur student reporters.

Upon his arrival in Passaic, Blood's influence on basketball was immediate. Out of the backwoods of upstate New York and into the proximity of the faster paced northern New Jersey and NYC areas, Blood's teams slowly caught the attention of sports followers. In the wake of the fitness deficiencies revealed during the Great War (many were declared unfit to serve), the results of Blood's work in the elementary schools and throughout the city were also taking root. He strove to raise the level of physical fitness for all children. Blood emphatically believed in the value of sports and games, especially basketball, and how they could be used to improve one's health and quality of life.

What was Prof Blood doing that made his teams different? His approach was holistic. First and foremost, his motives were aimed at training boys to become men, not to win games. He wanted to teach lifelong values through athletic competition. As much as Blood loved the game of basketball, it always remained a means to an end—training for later in life—manhood.[410] He wanted to teach his boys to play the game cleanly because that was how they ought to live their lives. Playing to the best of their abilities was what prepared them to be worthwhile in life.[411] "To play one game clean is better than winning one hundred," was a cliché that all Passaic players became familiar with because of Prof's frequent reminders.[412]

Blood's system was built on teamwork with all five players meshing as vital cogs in a wheel; they all had to be able to pass, shoot, and execute plays in unison. They had to move quickly and in unison. Prof's system was the backbone of the team's record.[413] He capitalized on the fact that players enjoyed shooting. Because his team usually controlled the center

jump, he made offense the focus of his system. Consequently, the boys practiced shooting for long stretches at a time. Keeping shot selection in mind, the players were conditioned to believe that the team that shot the most would win.[414] Blood, an expert shooter himself, taught all his boys to become offensive threats, and several of them became truly exceptional shooters.[415]

Blood trained his boys to keep possession of the ball until they could get a lay up or an open shot near the basket. The team's rapid passes and constant attack on the basket provided the action that thrilled spectators.[416]

As a team, Prof's players not only shot the ball better than their opponents, they also shot it more often. Their shots were taken with a wider variety of styles than other teams. He encouraged his boys to use whatever technique felt natural—whether it be with two hands or one, stationary or

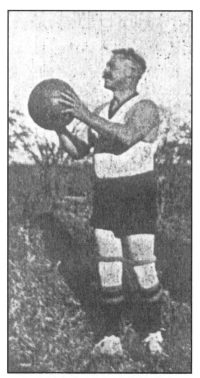

PROF WAS AN EXPERT SHOOTER HIMSELF

on the move; it didn't matter as long as it felt natural. It didn't matter to Prof that the two-hand set shot was in vogue; he was too pragmatic not to recognize a more convenient and expedient way to score points. Prof also taught the hook shot because it had certain advantages within short range. It was also natural that he emphasized offensive rebounding as it encouraged more high-percentage shots.[417]

It was advantageous for Prof's players to have flexibility in scoring techniques because of the way he encouraged them to attack the basket. Everyone who saw a Blood team play wowed over the way his boys could score. Some spectators equated their wrist action while shooting with that of the popular Original Celtics players.[418] Prof was concerned with where the shots were taken from, not just for his team but for the opponent as well. He kept his managers busy tabulating shot charts identifying the location of every shot taken. The charts provided valuable information, and Prof often referred to them at half times.[419]

What made the Passaic offense so effective was the sharpness and high frequency of quick, short passes. The Passaic players were instructed not to hold the ball but to get rid of it quickly.[420] Blood understood that the

quick and accurate passes helped determine the quality of his team's shots.[421]

Blood discouraged the use of the dribble because it was too slow, and he favored speedier play.[422] Rapid, short passes were the norm until an opening appeared. Sports writers and spectators frequently remarked that Passaic's passing bewildered the opposition.

Blood's teams took advantage of the fact that the ball could be passed much faster than any player could dribble or run. The bounce pass was one of the offensive skills he had been teaching for years.[423] Only after the Passaic win streak grew did the basketball world notice that his team was utilizing many of the same techniques as some of the professional teams, such as the Buffalo Germans and the Troy Trojans. In his system, the pass was the offensive catalyst, and it was used with regularity and precision.

Another reason for Blood's use of the pass was to conserve energy. As other coaches learned from watching Passaic, his players let the ball do the work. The Passaic kids conserved their strength by executing quick, short passes that wore out the defense. The dribble was slower, and it was more physically demanding. If that weren't reason enough for the demise of the dribble in the Blood system, the fact that it promoted too much individualism just about outlawed it altogether.

The rapid rise in popularity of the dribble outside of his camp didn't go unnoticed by Blood. He viewed it as a colorful strategy that added interest to the game. He equated teaching the dribble to a player with training a man to shoot a gun—it's good to know but dangerous to use.[424]

Basketball's Little Napoleon did not spend time teaching defense. He would have preferred to stay on the offensive for the entire game, and the center jump made that almost possible. With scoring the main focus, Prof had little use for defense except to regain possession of the ball. Observers agreed that Blood's teams had the ball for at least seventy percent or more of a game, leaving little opportunity for the other team to score.

Prof took Naismith's suggestions about how to play basketball a few steps further. He instructed his players to go after the ball as soon as they lost it and to continue going for the ball until they regained it, a style that often manifested itself in a full court press. Passaic's efforts to get the ball back forced the offense to pass the ball. This was long before others began playing defense all over the court. Blood called pressure defense "Offensive-Defense."[425] It would be a fallacy to say that Passaic did not play defense; they just never needed to play it for very long.

An oddity of the Passaic defense was their proclivity not to foul because fouling was viewed as a sign of weakness. If a player made a deliberate or lazy foul, he was removed from the game.[426] The boys were

taught that to foul was poor sportsmanship and was to be avoided. It was a known fact that no one could remain on a Blood-coached team if he didn't play the game honestly and cleanly. With Blood, molding character was more of an objective than winning games.[427]

Prof's offensive-defense was an overwhelming experience that most teams found very demoralizing; consequently, many teams were swept away for an entire game and never realized what had happened to them. So well trained did Blood have his boys that at a given signal, their aggressiveness or style of defense could change completely.[428]

To score as frequently as the Passaic teams did, the action had to be fast. The timer's clock did not stop after baskets while the ball was tossed up again at center court. This was the primary reason the scores of games increased after 1936, when the center jump was eliminated and play continued uninterrupted. In order to score as rapidly as they did, Passaic employed what was later coined the "fast break." Teams did not fast break back then; the pace was methodical—slowly dribble or pass the ball up and around, then shoot, and the same would happen on the way back down the court. This was how the game was played, but it wasn't true for Passaic under Blood's coaching.

According to Passaic's Maker of Champions, one of the many titles given to him by the press, basketball was a game of speed. Recognizing speed as the great divider, Blood emphasized it, but he had to frequently remind his boys that "you can't play any faster than you can think."[429] He loathed rough and unfair tactics because they interfered with the quick movement of the players. Having a bone to pick with all defenses, Prof especially despised the Five Man or zone defense. He called it immoral and felt it was ruining the game by destroying its best features—action and speed of movement.[430] He would never stoop so low as to have his team play a zone defense.

Blood's strategy was centered on keeping the action flowing. He had a rule that a player must never call a time out to rest. He believed that his boys should play within their strength thereby not requiring rest. He realized that they played better if they could stay in that comfort zone and not get fatigued. Passing was vital to maintaining that comfort zone. The opportunity to pass was used to rest and conserve energy while keeping the opponent on the run.[431]

After a basket, Passaic players hustled back to center court for another center jump ball. It was from the center jump situation that Blood spent time designing and teaching an inventory of set plays. The goal was to get the ball, score, and repeat the procedure but usually with a different play. So effective were Prof's plays and the team's execution of them that Passaic often scored a couple of baskets in the first half-minute of play while neither the opponent nor the floor touched the ball. Johnny

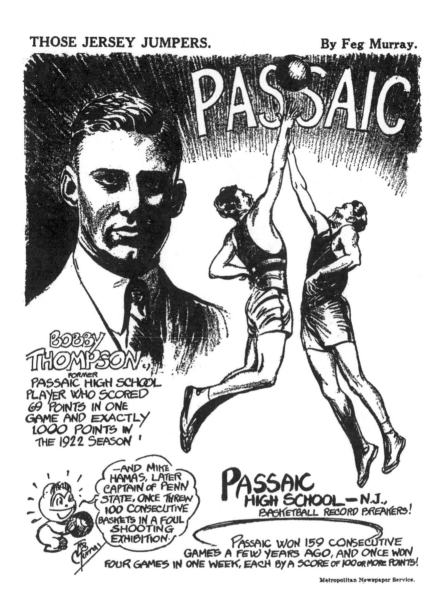

PASSAIC

BOBBY THOMPSON, FORMER PASSAIC HIGH SCHOOL PLAYER WHO SCORED 69 POINTS IN ONE GAME AND EXACTLY 1000 POINTS IN THE 1922 SEASON !

—AND MIKE HAMAS, LATER CAPTAIN OF PENN STATE, ONCE THREW 100 CONSECUTIVE BASKETS IN A FOUL SHOOTING EXHIBITION.

PASSAIC HIGH SCHOOL — N.J., BASKETBALL RECORD BREAKERS!

PASSAIC WON 159 CONSECUTIVE GAMES A FEW YEARS AGO, AND ONCE WON FOUR GAMES IN ONE WEEK, EACH BY A SCORE OF 100 OR MORE POINTS!

Metropolitan Newspaper Service.

Roosma recalled a game against Rutherford when Passaic scored nine straight times from these plays, and the ball never touched the floor.[432] The players practiced these set plays over and over until they were perfected. A unique feature of these daily tap-off drills was that all players moved when the ball was tossed up.[433]

Another factor contributing to Prof's success was the physical conditioning of his players. His players looked stronger in the latter stages of the game than the opposing players. Spectators as well as other coaches marveled at Passaic's apparent advantage late in the game. The other teams seemed to run out of gas while Passaic always performed as if

they had a lot more to give. Blood was frequently asked to respond to this consistent observation. His reply was simple: "I have no training rules. My boys train themselves."[434] "I have no disciplinary system. A man or boy who has to be disciplined I do not want on the team."[435] The Grey Thatched Wizard had other things with which to concern himself.

The ills of tobacco were not as well known in the twenties as they are today. The boys could smoke if they wished, but if they chose to, they wouldn't be on Blood's team because smoking didn't allow them to be in the best shape to play.[436] Prof would never consider sneaking around to catch someone smoking; he left the players on their honor. "Without that sense of honor, the boy is of no use to me as a member of my team." He wanted the boys to realize that a sense of honor could be of great value to them.[437]

Because of Blood's image and the boys' respect for him, the honor system worked. Kids were kids, even in the twenties, and the boys who made up Passaic's teams were celebrities. His players were affected by peer pressure to drift at times. DeWitt Keasler recalled one such incident when he and Fritz Knothe almost strayed too far from the fold. The slip occurred while at a practice session at West Point. For whatever reason that must have seemed good at the time, he and Knothe decided to smoke a cigarette. Sure enough, Prof saw them and gave them a scolding. "That was the only time Prof ever bawled me out for an infraction of rules," confessed Keasler.[438]

Prof knew how to train his boys—mentally and physically. First, he was an athlete himself, but more importantly, he was a practitioner of everything he preached. He was a physical fitness role model who had studied the body and understood how it functioned. The Maker of Champions knew the how and why of physical training, and he applied that knowledge to sports. For that reason, Blood's teams had a decided advantage.

The superiority of the Passaic players was most obvious to the boys themselves. Their confidence stemmed from knowing that they were in good physical condition; they knew they had better basketball skills, their teamwork had become notoriously famous, and besides, they had the Grey Thatched Wizard. Victory was assured; the only question was by how much. Without acting cocky, they had a superiority complex, and it ran directly from the coach to them. With this confidence well in tow, they looked and behaved like winners.[439]

Sometimes the game was over as soon as the opposing team caught sight of a Passaic team taking the court for pregame warm-ups. The intimidation was so palpable that the opponent was usually beaten mentally by the Passaic aura.[440] Passaic's propensity for arriving late to the court served to heighten the tension of having to wait for one's executioner.

Their tardiness may have been due in part to the fact that Passaic dressed between twenty and thirty players for most games. Entering the small court with an army of that size who shared one collective thought—to score every time and never let the opponent gain possession of the ball—had a paralyzing effect. For many teams, their impending fate was difficult to bear. In desperation, the opposition would fight for their lives just to save face.

By his very nature, whether Blood would admit it or not, he was a stern disciplinarian.[441] Can you imagine the effect that the large squads had on team discipline? If a player didn't want to do what was expected of him and do it to the best of his ability every time he was asked to do it, one could predict what the next scene might be. It was sobering for the players to know how expendable they were and the effect it had on their behavior. Over a dozen other players of equal ability were always available to take the place of another in the case of injury, illness, attitude problem, or graduation.[442]

The large Passaic squads affected many different facets of the game. The referee, umpire, timer, and official scorekeeper were challenged by the huge numbers of players, especially because they all frequently saw playing time. Some critics questioned the logic for such large numbers of ready-to-go players when only five could be engaged at one time. For Blood, the answer was simple; he believed in preparing as many as possible for action. According to Prof, the larger the squad, the better. He sincerely believed that it boosted the spirit and caliber of the boys.[443, 444]

As history has revealed, the results were devastating. Very talented teams, many of whom were championship-caliber teams from their areas, entered Passaic's bailiwick with naïve expectations. More often than not, they would become overwhelmed with the intimidating ambiance of a Passaic basketball game and then get blown away. The lopsided outcomes would often leave the bewildered visitors with grim memories of their participation in an historical event. Years later, they would speak with pride and relate what it was like to have played against the Passaic Wonder Team.

Some sports writers and fans from other cities questioned the sportsmanship inherent in annihilating their teams. This was a legitimate concern that deserves comment. It is true that Passaic was not inclined to take any prisoners, but no team ever accused Passaic of poor sportsman-like tactics. The team's integrity; conduct before, during and after games; and officiating were never questioned—quite the contrary, they were universally lauded. In many games, Blood actually tried to keep the score down with his mass substitutions. At times during the streak, Passaic's bench went ten to fifteen players deep.

A letter to the sports editor by former Passaic player Bill Kerr (Class of 1920) addressed this very concern of running up the score. The article was published on the day of the 100th victory against St. Mary's. "Prof taught us to play every game with our head and hands and to take all games seriously," wrote Kerr. "We are always preparing for a harder game to come was Prof's advice." For that reason, according to Kerr, the games were played with so much energy, no let up, no fooling around, no wasted energy, but also no signs of "showing up" an opponent other than by the results.[445]

As a rule, the Grey Thatched Wizard viewed every game as a championship game. The difference was in name only. Shortly after the close of the 1923 season, Blood made this point clear by reminding the boys that their Naugatuck game was a much harder game than their state championship match-up with Asbury Park.[446]

The Miracle Man (yet another moniker) knew that motivation and physical aptitude ran in cycles and that it wasn't natural for a team to continuously compete at peak performance level. Nevertheless, Prof always gave the boys goals to strive for. When they had no opponent strong enough to test them, he told them to beat their own record.[447]

For games that were less challenging, the players would set the score before the game, and if they failed to win by the margin that was pre-dicted, then they missed their goal. This could result in criticism from Blood and from some former players for failing to play as well as they should have.[448]

Losing was something that Prof never dwelled upon, although he did refer to it at times. In fact, he trained his players to be ready to take defeat with the same grace with which they accepted victory.[449] His one loss to Union Hill in 1919 was never rehashed; it was over—history. No one ever remembered hearing Blood talk about what could have or should have been done differently that day. He obviously had his opinions, but he must have felt that it was a waste of time retreading old ground. Blood the psychologist wanted his players to have no fear of losing. He told his boys that "winning matures you a little more than losing, but you have to learn to lose too."[450]

The object of sports, according to Blood, was growth. He looked for growth in the areas of speed, strength, alertness of mind, broadening of the spirit of fair play, endurance, and courage in the development of manhood. He recognized defeat as something that would create a sting but could lead a boy to more lofty accomplishments. Prof felt that victories could serve the same purpose if the principles behind them were of the right sort. Putting winning and losing into perspective, he used to say that the game itself was temporary, but "how the game was played" was permanent.[451]

When Blood spouted off philosophically, he was sometimes dubbed "The Teacher of Life." He had a curious way of relating how to succeed in the game of basketball to how to succeed in the larger game of life. He called his way of looking at it "The Fork in the Road," and he could equate his entire coaching philosophy to real life situations. In deference to his emphasis on offense over defense, he posited, "Suppose you go into business. You fix up your store according to the most modern methods, advertise more extensively than your competitor, purchase the brightest lights, and in other ways prove more enterprising than the next fellow. That's OFFENSIVE business. But suppose you compete with your rival by breaking the windows of their store in the night, by damaging his reputation, by calumniating his character instead of trying to emphasize the good points of your own, etc. This is DEFENSIVE business."[452]

Blood's "The Fork in the Road" theory referred to placing the boys on the right road. Should the road sign say, "Play to Win," or "Play Not to Lose"? The Teacher of Life believed in the latter. Fouling, refusing to give the other fellow a fair chance, the five-man (zone) defense; in fact, any defense incorporating pushing, tripping, hacking, or any unfair means to prevent the opponent from exercising his initiative was the spirit of "Play to Win."[453]

It was not the victory that counted, claimed Prof, but the manner in which the game was played and the importance of playing not to lose rather than playing to win. He loathed the fuss and hurrah made over the team's record because he felt that it was exaggerated merely from the standpoint of victory. When he had an audience, the Teacher of Life reminded everyone of the famous words of Grantland Rice: "For when the One Great Scorer comes to write against your name, He writes not that you won or lost, but how you played the game."[454]

Not only did the Wonder Teams win in epoch proportion, they won with an unmistakable mystique—calm, cool, calculating, methodical, and businesslike. One out-of-town observer described the mystique. "The boys played with none of the half wild enthusiasm observed in most basketball games but with a seriousness and definition that shows their game to be as much a game of the head as of the hands and feet.... The strain noticed when most teams are working for victory was never present. In evidence was merely the well-balanced effort of a group endeavoring to perform its functions as perfectly as possible. There appeared little lost motion and the certainty of the outcome was as striking as the natural dexterity of the individuals."[455]

The Little Professor was often depicted as a man who was serious at all times, someone who played for keeps.[456] Passaic's city historian Mark Auerbach described the man most succinctly by adding that "Prof was

exceedingly passionate."[457] There was little doubt that Blood had a unique talent to elicit exactly what he wanted from his boys.

Passaic's success had to be due in part to Prof's constant drilling and attention to details. Around the time of the Attleboro game (111-5) during the 1921-22 season, outside observers noticed that Blood spent a great deal of time working on the many minute intricacies involved with success. The perfection of the little things, he would say, led to the accomplishment of the complex greater ones.[458] What coach today couldn't relate to that? The key was getting the players to buy into it, and Prof did! In the eyes of his players, Blood was the perfect coach.[459]

The unprecedented winning brought the world to Passaic. Because Prof was coaching in a high school, unlike the loquacious Dr. Forest "Phog" Allen at the University of Kansas who became the self-appointed spokesman for all of basketball, Blood's *avant-garde* methods took much longer to be discovered.[460] When the recognition was finally realized, it arrived in torrents—suddenly, everyone wanted to know how and why a team could win so consistently.

Blood's innovations became the focus of attention only because Passaic won on a scale never achieved by a schoolboy basketball team before (or since). The boys were billed as one of the truly sensational teams in the history of sport, a well-oiled machine, the last word on rhythm and cohesion, and the height of discipline. Those familiar with working with groups know that these things don't just happen on their own. The Grey Thatched Wizard's granddaughter, Dorothy "Arlene" Mickolajczyk (Paul Blood's daughter), slightly understated the fact when she described her grandfather as a strong, kindly man who did not like any fooling around when something serious was to be done.[461] It is ironic to note that long after the Wonder Team Era, Arlene became the president of the Passaic Board of Education.

The intrigue reached many foreign countries, but the most shrewd curiosity seekers came from the state of Indiana where conversation in most cities and hamlets revolved around basketball. In what was to be Prof's final season coaching at Passaic High School, *The Indianapolis News* dispatched sports editor William E. Fox to Passaic to get the real lowdown on this East Coast version of a Wonder Team. Hoosier basketball followers had a yardstick of their own to measure what a wonder team looked like. The exploits of their Franklin High School Wonder Five from Franklin, Indiana, were still fresh. During the four seasons between 1918-1919 and 1921-1922, the Franklin boys won three state championships and amassed a 110-10 record. In the dog-eat-dog competition of Indiana, that was truly a wonderful tribute to their great coach Ernest "Griz" Wagner.[462]

Sports writer Fox, who observed the Rutherford/Union Hill vs. Passaic games, was astute at making comparisons. He agreed that Passaic had a mighty-fine basketball team, but if they were to invade Indiana for a period of five weeks and play the five best teams in the state, he would pick the home teams in three out of the five. Man for man, Fox believed several Indiana teams bested the New Jersey boys.[463]

The Union Hill game that Fox observed with all the noise and excitement reminded him of a Bedford-Anderson game in Indiana. The game had been sold out a week in advance, and the scalpers were getting ten dollars a ticket. The crowd was very noisy (cheerleaders, megaphones, cowbells, and hats and coats flying in the air), but they were not as well organized as the Kokomo fans. The Hoosier reporter thought that the Passaic players physically resembled those at Anderson High School, but they responded like the Franklin players—they didn't get excited, and they didn't worry about what the other team was doing.[464]

Fox did have one wary thought for the basketball worshipers in Indiana—Passaic was not what Passaic had been. It was well understood that the previous year's Passaic team was thirty points better, and the team two years before was better than last year's team. This edition of the Wonder Team survived almost solely on teamwork. In the past, when the talent level was noticeably better, Passaic was a formidable opponent for any team. In Fox's humble opinion, there had never been an Indiana team thirty points better than the present Passaic team.[465]

Prof's system of coaching basketball covered all phases of the game. If he had coached a different sport, it would have been the same; he was thorough in his thinking. Blood's offensive system worked from a diamond formation with a point guard in the backcourt; two wingmen, one on each side; a forward under the basket; and a center in the middle. From the diamond arrangement, Blood wanted the ball passed quickly to either wing and from there to the man under the basket for a score. If the man under the basket wasn't open, he would leave the basket area, and a player from the offside would cut into the area under the basket. While this was taking place, the court was to be kept balanced as the ball continued to be passed swiftly. Players had the freedom to move about to an open space as someone from the off side would cut to the ball looking for a pass and/or opportunity to score. This movement pattern was the nuts and bolts of his man-to-man offense. Blood's system did not utilize picks or screens, nor did he use any setup plays except from the center jump ball situation.[466]

The play developing from the action described above was predicated upon Passaic's opponent coming out to guard them. Prof's boys were constantly attacking by passing and driving to the basket. Compared to other offenses of the day, Passaic's system was alive with ball and player

movement, plus it relied on selflessness. Effective passing and teamwork were the hallmark of Prof's system unlike most other teams that used the popular dribble to beat the defense.[467]

A peculiarity of Prof's teams was a lack of chatter among the players on offense. He instructed the boys to refrain from talking and calling out for the ball. He didn't want to alert the defense to where the ball was to be passed.[468] The offensive player with the ball was instructed to keep his head up to see the court and to quickly pass to an open man. Prof taught his players how to get open, and the pass was to come to the open man at that instant. This action continued unabated until either the defense tired or a good shot was attempted; oftentimes, it was a combination of both.

Prof wasn't called the Grey Thatched Wizard for nothing. He would signal for the guards and forwards to exchange positions during a game to disrupt an opponent's defense. After the first couple of passes, it didn't matter what the defense was doing. By that time, the short, quick passing offense was in high gear.

Among other things, Blood was a psychologist. He knew that much of athletics was mental as well as physical. Always adept at getting the most out of his players, one of his favorite sideshows was to challenge players to foul shooting contests which always came down to him and the team's best shooter—Roosma, Thompson, or Hamas. Prof loved to motivate the boys by giving them something to strive for. One day, Roosma sank eighty-nine in a row, so Prof countered with 105 straight.[469] A few years later, Mike Hamas drilled 70 of 72, so Prof promptly dropped in 105 for 107.[470]

In the final practice before Hamas's team was to play Camden and Asbury Park in the semifinal and final games of that year's state championship, Blood conveniently lost to Hamas in one of their classic free throw duels. Blood left Hamas thinking that if he could beat Prof, the world's best, then he must be pretty good himself. This did wonders for the boy's confidence as he headed into the state championship game. Prof felt that he was giving his boys the incentive to spur them on to greater efforts.[471] Mike went on to score twenty points from the line on that championship weekend thus fortifying Prof's psychological ploy. (Author's note: *If you are a free throw shooter of distinction and you are comparing your best numbers against Blood's, keep in mind that the ball used back then was a couple of inches larger in circumference than the ball in use today.*)

When explaining became cumbersome, Blood demonstrated. Dressed in his gym togs, it was a common occurrence for him to scrimmage with the boys. He and the second team usually went head to head against the first unit. Stories generated from these match-ups revealed that with Prof's guidance, the second team could out-pass and out-execute the

starters. These stories and others were sprinkled with anecdotes about Blood promising to buy ice cream cones for anyone who bettered his efforts.[472] How much more Prof enjoyed challenging his players than eating ice cream cones is not known.

Coaching wasn't all X's and O's with Blood. He penetrated the heads of his players. To some observers, it appeared as if he were a shy, reticent, but driven individual who was devoid of a sense of humor. For those who knew him best, his players and close friends, that supposition couldn't be further from the truth. According to Johnny Roosma, Prof definitely had a sense of humor, and he could talk incessantly.[473]

Ernest Blood was referred to as the Miracle Man because his teams did some amazing things. There is much truth to the coaching adage that a coach is only as good as the talent of his players; in other words, you can't win without the horses. Prof, more so than his contemporaries, was a bit of an exception to that rule.

Coaches often estimate that ninety-percent of their job is performed in practice sessions as compared to ten percent in the actual games. Coaches are also the first to recognize that if you play the game long enough, you will eventually lose, no matter who you are. In Prof's case, what he knew and how he could apply it enabled his boys to continuously win even though they had to dodge an occasional bullet. In tight situations, he had the knack of imparting exactly what he expected his players to do. Time after time, the records revealed that Blood worked his magic in the dressing room between halves to ward off an ominous outcome.

Tales of Blood's ability to snatch a victory from the jaws of defeat continue to linger. Edythe Rohrbach, the wife of Nelson who started center on the last two Wonder Teams, vividly remembers her husband's adulations of his former coach. "Nelson always said Prof. Blood was a really great coach because he could always pick out what was going wrong on the court and tell the team how to correct whatever was wrong. He must have been greatly impressed by this because he said it quite a few times."[474]

Blood was seemingly blessed with an abundance of basketball talent on his teams. How and where he got that talent is a story in itself. The logic of a feeder system must have dawned on Blood sometime during his days working with the YMCA when he coached both youth and adult teams. The first obvious signs of his program perpetuating itself were at the Somerville YMCA where he assembled his first dynasty. The system reached fruition when Prof began anew in Potsdam. In upstate New York, he had teams galore at the school. He taught the fundamentals in physical training classes; each class had its own intramural league, and he had a team to back up his elite "Normal Five." Having younger boys

learning the fundamentals and a system as they grew and matured greatly influenced the quality of the final product.

This system of developing talent from within did not appear to have had a name until Branch Rickey of baseball general managing fame started his network of farm teams. Carved out of the necessity to become a winner in professional baseball in the early 1920's, Rickey put together a farm system. In fact, Rickey is known as the "Father of the Farm System."[475] This is another example of a high profile sports figure getting credit for starting something that Blood had been nurturing for years.

Besides Rickey's and Blood's pragmatic views for developing talent, the two men had very little in common personally. Rickey was a professional, cigar smoking, sanctimonious, hypocritical manipulator of rules and people while Blood was an amateur, clean living developer of character in young men who believed in the highest form of sportsmanship. But Blood would have agreed with Rickey's philosophy that there was a right way to play baseball and that it could be taught. Ironically, both had an unrelenting professional nemesis: Blood had Principal Arthur D. Arnold and Rickey had baseball commissioner Judge Kenesaw Mountain Landis.

While Rickey's empire spread throughout numerous small towns, Blood's was confined to the city of Passaic. According to William G. Mokray, a Passaic graduate who later achieved basketball fame of his own as a contributor to the game, Prof's success was the product of his offensive system, excellent physical conditioning of his players, and his farm system within the city's twelve grammar schools. But Blood's program was in more than just the grammar schools; his influence spread into every corner of the city where basketball was played.

Mokray knew of what he spoke because he experienced it firsthand. In 1915, when Mokray was in the third grade, Blood used to visit his classroom to lead the children in calisthenics. Blood went to each school for a day, and he spotted and remembered the names of the more athletic kids. By the time they reached the high school, Blood knew all the athletes by their first names.[476] Mokray, who later became the VP of the Boston Garden and Chairman of the Honors Committee of the Basketball Hall of Fame, claimed that Blood was the first to develop a farm system.[477]

Long before Rickey started his "Chain Store Baseball" or "Rickey's Plantation" system, Blood had begun hanging baskets in every vacant lot and in every room that was large enough to be called a gymnasium.[478] Valuing the physical and social benefits that youth basketball could provide, Blood became Passaic's Johnny Appleseed of basketball. No sooner was Blood on the job than he was implementing the roots of a system that would propel Passaic to the top of scholastic basketball. One of the

first directives he received instructing him to improve the physical environment for the children came in this letter:

October 27, 1915

Mr. Ernest A. Blood
19 Spring Street
Passaic, N. J.

My Dear Mr. Blood:

Will you please decide what outdoor playground apparatus is needed down at No. 10 School, also at No. 3 School, and how many of each kind of apparatus; also, where upon each playground such apparatus should be placed? Make the list of apparatus separate, of course, for boys and girls, and for the different schools. Then, kindly submit them to me and you and I will take the matter up at once with Mr. Smith, the head of the Vocational Department, who will at once proceed to manufacture such apparatus in our own shops. We want to begin on this work just as soon as possible.

Yours sincerely,
Fred S. Shepherd
Superintendent

Prof's goal was simple—to develop healthy productive men from the boys in his charge. Winning to the extent that was beyond the imagination was what catapulted his insight and acumen into stories of legendary proportion. His knack for developing winning programs has been admired more in hindsight than during his day. Scribes and visitors never failed to notice that "while boys in most cities didn't get a chance to play basketball until they got to high school the kids in Passaic had become shooting wizards before they started wearing long pants."[479]

Blood's reputation quickly spread to all corners of the city. The little Professor was liked and respected; he lost little time getting acquainted with the men who directed the local YMCA, YMHA, and the Passaic Boys Club. The leaders of these organizations became his allies to physically educate the city's youth and spot talent.

Within the grammar schools, Prof and a staff of physical training teachers presented a curriculum laden with activities that would lead to an improvement in physical fitness and character development. Various skill-building games involving catching, throwing, and passing a ball were incorporated. With the services of men such as Rube Bramson, all schools had teams in the 85 and 115-pound weight divisions. Once the

students were taught basic fundamentals in their physical training classes, the popularity of the game and the number of boys playing the new sport grew at a phenomenal rate. Of course, it didn't hurt that during Blood's first season in Passaic, his team went undefeated.

Blood had moveable baskets installed in several of the grammar schools' gymnasiums to teach and encourage the skill of passing the ball. What amounted to an interesting experiment had Blood instructing the coaches at the schools to stress passing not individualism. The kids were allowed to dribble, pass, or position themselves behind the goals.[480] The indented position of the goals on the court enabled the kids to spread out and develop their passing skills as well as the concept of team play. Blood wanted his players to be expert passers by the time they arrived at the high school.

The enthusiasm for basketball spread in the formation of numerous, popular basketball leagues. Churches, factories, the city recreation department, boys clubs, the YMCA and YMHA all had their own programs. In addition, the high school had its annual interclass competition. The grammar schools played each other and anyone else they could schedule. Most high schools scheduled a preliminary game between a couple of the city's grammar school teams or recreation league teams. Wherever basketball was played, Blood had someone earmark the boys who demonstrated a gift for the game. All of Blood's Wonder Team players came up this way. Prof spotted a young Bobby Thompson in YMCA and church league games before inviting him to come out for the team.[481]

Around the same time that the game took root in the schools, Y's, churches, clubs, and factories, baskets began to appear in kids' backyards. Johnny Roosma remembers that he and Dick Rice had basketball rings on poles in their yards before the Wonder Team years.[482] The idea of a boy having his own backyard setup received a major boost after Mike Hamas's neighbors presented him with a small purse of money for his efforts as a substitute on the undefeated state championship team. Mike used the money to buy a basketball, basket, and wood to make a backboard. As the anecdote goes, Mike practiced all summer and evolved into a great shooter. Mike went on to have a Bobby Thompson-like season and lead the Wonders to another undefeated season along with picking up the nickname "Dead Shot Hamas."

After Hamas's accomplishments, almost every able-bodied boy had a hoop in his backyard. The local press revealed the secrets of the teams' successes attributing them to the boys' early indoctrination in the game. By the time a boy finished grammar school, he was a player. His skills were developed to the extent that he was comparable to the average varsity player. The top grammar school players approached a polished, veteran caliber.[483] Another writer from Passaic expressed it this way. "There are

more potato baskets up and played on the back fences in Passaic for the boys to practice on than in any other town of its size in the country."[484]

Damon Runyon commented on Passaic's secret for basketball success in his column in *New York America*. He told how a Passaic businessman and Elk Club member remembered what he first saw when he moved to Passaic. "...I used to wander around the town and in the back yards of at least twenty homes I saw basketball cages on poles, and watched youngsters of all ages from eight years up trying to put the ball in the basket.... They were primarily school kids all with the hope I suppose of someday playing on the 'Big Team' when they reached the high school."[485]

A couple years later, another visiting reporter offered his account of Passaic's success. "It comes largely from the backyards of the homes of Passaic. Regardless of the circumstances of the parents, each boy in the place has his eye on one goal, one honor. That is to represent the High School [sic] on the basketball team when he gets big enough."[486]

A Philadelphia scribe understood the benefits of a boy receiving training in the fundamentals of a sport at an early age. "As soon as the body is strong enough to withstand the pace, it makes sense that by constant practice in grammar school, the boy will be set to play with the best when he reaches the high school."[487]

Blood must have enjoyed philosophizing with eager listeners who wrote for various newspapers and magazines outside the Passaic area. He equated basketball with nature. He felt teaching should take place at the right time in life to be the most effective. Blood was an experienced teacher who understood the advantages of starting young. He once said, "I prefer inexperienced boys to those who know something of athletics and have too much to unlearn."[488]

Five years later and after having won a few prep state championships at St. Benedict's Prep, Blood was interviewed following a 136 to 9 rout of Newton Academy from Connecticut. The reporter asked Prof to explain why his team had lost two games during the season. At the risk of having his reply sound like an excuse, Blood said, "I didn't get them when they were young enough."[489]

While the Passaic boys were riding a sixty-one game win streak, it became obvious that Blood's player-producing system was as prolific as the woolen mills. After the team won its sixty-first consecutive game, he commented that he expected his team to continue on and win another state championship. He predicted that when this so-called "first team" graduated the following June, there would be a dozen or more excellent players to take their places. It was the work of feeder programs that was continuously producing talent for the future. He did interject that there were always one or two players who stood out prominently—Johnny

Roosma, for instance. "Regardless of the talent," he cautioned, "it is teamwork that wins games; no individual makes a team."[490] Blood did not believe in the star system. He advocated the subordination of personal achievements for the good of the team.[491]

Soon after the winning began to attract sports writers from all over, Blood used the metaphor of a well-oiled machine to describe his team. If the player (a part of the machine) failed to play properly, he knew that some cog was out of gear. When he found that one of the cogs was not performing up to the level of expectation, he would pull it out and give it a good oiling.[492]

One essential cog that Blood always took time to develop was the center position. With the exception of 5'10" jumping jack Herbert "Ike" Rumsey, Prof always had a tall center. Because of the required center jump after every basket, Blood started in the lower grades looking for capable tall boys, and he was always successful in locating one or two. The Wonder Teams had a succession of boys who could readily get the tap. But on those few occasions when the tap wasn't guaranteed, he taught his players how to intercept the ball. Before the elimination of the center jump after scores, Blood spent a great deal of time teaching the skills and strategies necessary to get the jump on an opponent. Passaic's domination of this area of the game is what propelled them to such lopsided victories.

During Bobby Thompson's senior year, Blood believed he had the nearest to perfect high school team that he had ever coached. He didn't want to boast, but if he could train the same team for three straight years, he felt that they would be able to beat any basketball team in the world.[493, 494] On another day, when Prof's cup of immodesty overflowed, he made a comment that would raise the eyebrows of many coaches today. At the time when the newly christened Wonder Team was at the sixty-third straight win mark, he nonchalantly mentioned that if he wasn't so busy, he would coach the high school's baseball and football teams to become second to none as well.[495] As strange as this may sound today, no one at the time doubted that he couldn't do it. As if it were a self-fulfilling prophecy, Blood coached St. Benedict's Prep baseball teams to several prep school state championships during the late 1920's.

The Miracle Man of basketball always preached that he learned something new about the game every season. He believed this to be essential to success whether you were a player, coach, or spectator.[496] Johnny Roosma, perhaps his finest player ever, called his old coach a student of the game. Before Blood's coaching dominance of the game showed signs of waning, there was the story of him attending a coaches' clinic facilitated by none other than Converse's Chuck Taylor. The ambassador of basketball was conducting one of his pioneering clinics for over two

hundred coaches at Bloomfield High School. During the presentation, some noticed that Prof appeared to be the only coach taking notes.[497] Prof never stopped learning about the game, and he would not allow his competition to get an edge on him.

To know Prof Blood was to know that he loved to demonstrate, better yet, perform. His audience could be large or small; it didn't matter. At a reception for the basketball team sponsored by the ladies of the faculty at Potsdam Normal, Professor Blood dazzled his audience with one of his circus-like feats. "During the evening the electric lights were switched off and the guests were given a rare treat in watching Prof. Blood perform with lighted torches. The effect was beautiful and only to be thoroughly appreciated by those who saw it."[498]

Blood not only had character, he was a character. A couple generations of players and students who were influenced by him never forgot the sight of him poised in the gymnasium with a basketball balanced on a stick. What would substitute for a stickball bat, Blood would hold in front of him parallel to the ground and have a ball perched upon the end of the bat. His strong shoulder, wrist, and forearm enabled him to keep the ball sitting on the stick. He made it look so easy. He would say that this was the delicate finger touch needed to consistently shoot and make baskets.[499] What made this stunt so memorable was that no else could do it. And as if balancing the ball weren't enough, he would slowly lift the ball up and place it in the basket. Try that sometime!

Legends are not made from one trick with a stick. Strength was part of Blood's legend.[500] His most famous stunt was the one he performed with a sixteen-pound shot put. What he liked to do with the heavy iron ball was to throw it up over his head and catch it squarely on the back of his shoulders at the nape of his neck. When things needed a little extra excitement, Blood would reenact his shot put maneuver. He would challenge some of the more accomplished athletes to try the odd stunt, but very few took the risk. Fritz Knothe remembered the day that Al Patlen (years later, Alden Patlen became a magistrate in Wallington) pulled off the impossible and caught the shot on the back of his neck.[501] Others would just knock themselves semi-unconscious.

In Blood's younger years, the barrel-chested strong man turned down offers to become an acrobat with one of the big circuses. His myriad of athletic talents extended into baseball. If the timing were different, he wouldn't have turned down offers when major league baseball teams beckoned. He also had an unquenchable appetite for watching sporting events. If there was a game within commuting distance, it was fairly certain that Blood would be there. When possible, he was known to see three or four games in one day.[502] Seldom finding time to eat, the Grey Thatched Wizard is remembered for the countless number of bags of

peanuts he consumed. He always seemed to have his pockets stuffed with his peanuts-to-go.[503]

Prof also had interests beyond basketball, as evidenced by his well-known love for animals. A little known detail about Passaic's record-breaking coach was that he was an avid stamp and coin collector. He possessed an assortment of rare stamps and old money, most of which was in vintage gold coins. After Prof's death, his treasure was speculated to have gone to his second wife, Myrtle Dilley Blood. (In 1948, Mrs. Margaret Thomas Blood passed away after a long illness at the age of 73. Little is known about Ms. Dilley.) Buying, selling, and trading was a serious hobby of Prof's that led him to become an active member of the New Jersey Numismatic Society.[504]

Blood's time as the basketball coach in the Woolen City was cut short, as was the city's tenure in the national sports spotlight. At the time, a hero's welcome and a key to the city were never discussed—that would come later. A small handful of people, not the court of public opinion, was responsible for Blood's fate. Forcing him out illustrates what is possible during times of extremely bad judgement. The full extent of his loss to the city was immeasurable.

The school administration's inability to see the big picture can be contrasted with Prof's influence on the evolution of basketball. During the 1920-1921 season when the Wonder Team moniker was first used, the popularity of the team exploded. When too many fans and curiosity seekers wanted to see the team play, a facility larger than the high school gym had to be found, and the Paterson Armory five miles away became the site of choice. Of the three thousand people who made up a capacity crowd at the Paterson Armory, many were high school and college basketball coaches. Many came from miles away to learn what Prof was doing that produced such remarkable results.

The committed coaches of the 1920's were similar to the diehards today; they would do whatever it took to get an edge. Those who actually saw the Wonder Teams play in person can no longer be sorted out, but hall-of-famer Claire Bee, who has been recognized by his latter-day contemporaries as the one coach most likely deserving of the title "genius," admitted that Prof and his teams were an inspiration to him. Bee was a master strategist who frequently observed the innovations and techniques of the Passaic's professor.[505]

Bee incorporated a few characteristics of Prof Blood's teams into his own coaching. For example, Bee's technique of suddenly changing defenses to confuse his opponents and a passing style of offense that allowed the ball to do the work were effective strategies that Prof had been using since his Y and Potsdam days. Although Blood's teams always played man-to-man defense, his defense had different levels of intensity.

Blood orchestrated the variations of the defense with signals to his captain. Claire Bee may have derived his idea of switching defenses from Prof. Bee is credited with originating the 1-3-1 zone defense that he used with a great deal of success at Rider College and later at Long Island University.

Another concept that Bee observed Blood's teams using was the short passing offense. A decade later, Bee's offense became famous for its passing by utilizing all five players and maintaining possession of the ball. While this was the cornerstone of Blood's system, the notoriety for inaugurating the team style of passing offense is credited to coaches who later used it successfully on the collegiate and professional levels.

Another early icon of New York City basketball who would later become a disciple of Claire Bee's was James "Buck" Freeman. During Buck's senior year in 1926, he captained the St. John's College team when they played West Point. That Army team was coached by Blood and led by Johnny Roosma. Using a variety of lineups against the Redmen, Army toyed with them and easily won 30-18. The ease with which the Army team passed the ball coupled with how difficult it was to defend must have impressed Freeman.

The following year, Captain Buck Freeman was appointed head coach of his alma mater. After one year of rounding up city talent, he assembled a team that became known as the "Wonder Five." The St. John's Wonder Five used many of the Passaic trademarks. Between the years 1927-1931, the New Yorkers registered an 86-8 mark with half of those losses coming in their first season. Freeman's teams where successful because they cleverly passed the ball until they were able to take a high percentage shot (lay-up). Nat Holman, the Original Celtic great and coach of the CCNY team, called them "the smartest college club in the country."[506] The pass, pass, pass strategy soon became known as the eastern style of basketball.

A former player and coaching protégé of Buck Freeman's was another coaching great, Frank McGuire. Frank took his guru Freeman and what he learned from him to successful stints at St. John's University, the University of North Carolina at Chapel Hill, the NBA's Philadelphia Warriors, and to the University of South Carolina. The coaching talents of Bee, Freeman, and McGuire had legions of high school and college coaches mimicking their ball control strategies.

Would it be called a coincidence that Frank Keaney (1921-1948) at Rhode Island State College eventually caught the nation's attention with a fastbreaking, high scoring, full court pressing style of play that produced teams scoring "2 points-a-minute"? Keaney really didn't get his system up to full speed until after the Passaic Wonder Team years, but he is still considered the progenitor of racehorse style basketball. Or was the real coincidence the appearance of Bill Mokray, a 1925 Passaic High School

graduate, at Rhode Island State College? Bill, who had seen most of Blood's games, stayed at Rhode Island State as a publicity agent after he graduated in 1929 and helped Keaney exploit the prolific offensive prowess of his team.[507] Again, Prof was not credited with popularizing this style of play even though his teams had been pressing and fastbreaking for years.

Inventions and/or innovations in the game are difficult to trace back to their origins. They often evolved in different places and piece by piece over a period of time. Borrowing among coaches is just as rampant today as it was during Blood's time. Blood's handicap as far as getting recognition for his innovations was his status as a high school coach. He did his creative work before basketball received much newspaper attention, especially on the high school level. Nevertheless, the early titans of the game studied the style and methods of the Blood-coached Wonder Teams to further their own coaching careers.

The coach by whom modern-day basketball coaches are measured is John Wooden of UCLA fame. The unprecedented winning of ten of twelve NCAA Championships has immortalized his place in basketball history. Although Wooden's 88-game win streak fell 71 games short of the Wonder Team's mark of 159, his dominance of college basketball may never be equaled. Under closer inspection, it is astonishing to learn how similar he and Blood were in talent and philosophy.

For starters, the birth dates of the two-basketball hall of famers are October 5, 1872 and October 14, 1910, respectively. Could the same astrological sign be credited for these other similarities? Is self-confidence an essential ingredient to becoming a successful coach? If so, then that explains the reason for their success, and their confidence was reflected in their teams' demeanor. Some of their other similarities included:

- Excellent, accomplished athletes—one of Wooden's two inductions into the hall of fame was for his accomplishments as a college and professional player.

- Great free throw shooters—Wooden once made 134 straight in professional game competition with the Kautsky Athletic Club, while Blood at age 74, sank 484 for 500.

- Physical conditioning devotees—with Wooden, it was an obsession.

- Clean living enthusiasts—adherence to clean living was a must.

- Teamwork advocates—adamantly stressed the importance of teamwork.

- Speed and quickness proponents—recognized the importance of speed and quickness as essentials.

- Crazy eaters—Prof was known to exist solely on large volumes of ice cream. He could almost always be counted on to have his pockets stuffed with peanuts to snack on. While Wooden's dietary routine is credited with his digestive troubles later in life. He was known to gulp down a bowl of chili and chase it with a hot fudge sundae.

- "Wizard" moniker—Blood was the Grey Thatched Wizard and Wooden was the Wizard of Westwood.

- Proponents of a controlled offense, fastbreak, and full court pressing defense.

- Gentlemen who were reserved in social situations.

- Neither man believed in charging a team up before a game. Both wanted a calm assurance in the dressing room and in the pregame warm-ups.[508, 509]

Perhaps the most interesting comparison came indirectly from the great Green Bay football quarterback Bart Starr when he compared Wooden's winning to that of his coach Vince Lombardi. Starr mentioned this about the Wizard of Westwood: "Wooden equates basketball to the game of life. He says you have to be unselfish, that you have to play for the good of the team, that you have to be disciplined and do what he wants you to do as a team, that he will tolerate no individuality within that team. He wants you to play as a unit. This is what you end up doing in life because sooner or later you end up on a team."[510]

Prof Blood certainly took pride in his team's ability to win and win, but the game always remained a means to an end—preparing the boys for the game of life. Before John Wooden ever took his first shot, Prof was equating basketball to the more important game of life. While reading John Wooden's book *They Call Me Coach*, you could substitute Blood's name for Wooden's, and you would accurately describe Blood's philosophy as well.

The major differences between Blood and Wooden were their eras of dominance (20's and 60's) and their arenas (high school and college). These led to the different places they hold in society's memory. Wooden has become a household name synonymous with basketball coaching excellence; Blood's story has never before been accurately told. His ideals, innovations, tribulations, and accomplishments remain faded, distorted, and lost in the annals of basketball.

There has never been a better time than the present to accurately resurrect the memory of a pioneer who stood for the epitome of idealism in sportsmanship and herald his story. Ernest Blood was a giant who walked the talk that is so missing in today's world of athletics. Let us never forget this trailblazer whose contributions and ideals were cast aside in the pursuit of winning. The rewards associated with victory usurped the true legacy of Passaic's Grey Thatched Wizard. All the reasons why winning was incidental were forgotten when winning for winning's sake became the goal.

Overlooking any personality peculiarity, Blood has been acclaimed as the best publicity man the city of Passaic ever had. No one before or since has brought the city as much fame as did this little basketball genius.[511] It is shameful that the school leaders didn't appreciate Blood's contributions at the time.

The great player from the Original Celtics and coach of City College of New York, Nat Holman put Prof Blood in his proper place when he said that he was "unquestionably the greatest coach of his time."[512] Nat was obviously impressed with Prof because he took to heart some of the old master's most sage advice and imparted it to his own teams:

- Stay on the offense. The other team can't score when your team has the ball.

- Never argue with the referees; it's wasted motion.[513]

This bit of wisdom is just as appropriate today as it was when the Grey Thatched Wizard first insisted his teams follow it.

How long would Blood have been able to continue producing undefeated Wonder Teams? One thing is for sure, even under his tutelage, they would have lost eventually. When Prof took over at St. Benedict's Prep, he left Passaic with a plethora of basketball talent and with a system capable of replenishing that talent year after year. Passaic was a basketball city and remained so for many years. However, other ambitious coaches adopted his successful ways and, in time, the others would have caught up, and on one of those nights when fate steps in, one team would have defeated Prof's team fair and square as Union Hill High School did in 1919.

The little professor could coach, and he was a competitor. With a little luck, the uninterrupted parade of victories would have remained incidental for who knows how many more years. Was he a basketball genius? Relatively speaking, yes, but in reality, no. His ideas, methods, and philosophies were just years ahead of his time.

Epilogue

A few weeks after the abrupt ending to the 1925-1926 state tournament, Prof resigned from West Point to devote his full attention to his prep school assignment. Although lacking the notoriety his teams attracted at Passaic High School, his legacy continued at SBP for another twenty-three seasons. If Prof's first year at the school "assisting" Harry Wallum was included in his SBP record as listed in *The Telolog,* he would have amassed a 446-128 ledger before retiring in 1949 at the age of seventy-seven, thus ending a fifty-five year career coaching basketball—twenty-four at SBP.

The old Napoleon of Basketball was never considered an anachronism, although he did nap once in awhile on the bench towards the end of his career. Occasionally, the player seated next to Prof on the bench would gently nudge him, bringing him back to the game proceedings. In an obvious sign of love and respect for Prof, students, athletes, and administrators covered for his age-related shortcomings.

Prof's tenure at SBP was so revered that upon his retirement, the school's athletic board voted that the title of head basketball coach would retire with him. In addition, a resolution in recognition of his services was drafted to commemorate his loyalty to the school. But more importantly, to accentuate the administration's admiration, a retirement pension was granted to their living legend.

While Prof's career win-loss record has been reported by many sources to be 1268 and 165, the accuracy of those numbers could be debated, but no one will argue that he was the first coach to reach the one thousand career victories milestone. During the last decade of his career, Prof's former players from Passaic and St. Benedict's Prep repeatedly honored him with testimonial banquets.

Prof has been recognized by every sports hall of fame possible, including the Naismith Memorial Basketball Hall of Fame. In the second round of inductees, he was one of the first twenty-seven basketball pioneers to be so honored. The other members of his 1960 induction class included Frank Keaney, Ward (Piggy) Lambert, Victor A. Hanson, Easy Ed Macauley, Branch McCracken, Charles (Stretch) Murphy, John Wooden,

George T. Hepbron, and Henry V. Porter. In 1973, all the Passaic Wonder Teams were finally inducted into the basketball hall of fame.

In addition to receiving the key to the city from the mayor, the old gym at Passaic High School was christened the Ernest A. Blood Memorial Gymnasium in his memory. One has to wonder how old cronies Arnold, Benson, Breslawsky, and Drukker would have reacted to this acclaim. Today, Prof is recognized as the best publicity man the city of Passaic ever had in spite of those who opposed everything he held dear during his tenure at the high school.

PLAQUE ON THE WALL AT THE ERNEST A. BLOOD MEMORIAL GYMNASIUM

After the death of his wife Margaret and his remarriage to the former Myrtle Dilley from Michigan, Prof retired and moved to Smyrna Beach, Florida. He enjoyed retirement until February 5, 1955, when a stroke took his life at the age of eighty-two. To the end, Prof remained a regular attendee at Smyrna Beach sporting events.

The Little Professor, who started his professional career in the YMCA where basketball started, deserves the indisputable distinction as the game's first great coach. Never has a basketball coach and his teams dominated their contemporaries as Ernest Blood's teams did until 1930. Let us never forget this incredible man and his contibutions to the game that has captured the hearts of so many of us.

"Praising what is lost makes the remembrance dear."

—William Shakespeare

Endnotes

Preface
 [1] Luther Halsey Gulick, *Men*, XXII (December 19, 1896): 565.

Chapter 1
 [2] Joe Donovan, "Between You and Me," *Newark Star Ledger* (January 1942).
 [3] E. A. Smyk, "Passaic's 125th Anniversary," *North Jersey Herald News* (April 2, 1998): 6.

Chapter 2
 [4] "Injured Players This Fall," *Watertown Daily Times* (November 29, 1912).

 [5] Passing By, with Ed Reardon-"Prof Takes Time Out," *The Herald News* (February 14, 1955).
 [6] Passing By, with Ed Reardon-"Prof Takes Time Out," *The Herald News* (February 14, 1955).
 [7] *The Quill*, (Passaic High School Yearbook) (1916): 23.

Chapter 3
 [8] George H. Greenfield, "Prof. E. A. Blood Decries Victory-Mad Spirit," *Passaic Daily News* (April 7, 1924): Sporting Page.
 [9] Coach Blood, "How I Teach Basketball," *Street & Smith Sport Magazine* (November 25, 1931): 22.
 [10] H. S. Ninde, J. T. Bowne, and Erskine Uhl, Eds. A Hand Book of the History, Organization and Methods of Work of Young Men's Christian Association (New York: 1892) 319.
 [11] H. S. Ninde, J. T. Bowne, and Erskine Uhl, Eds. A Hand Book of the History, Organization and Methods of Work of Young Men's Christian Association (New York: 1892) 319.
 [12] H. S. Ninde, J. T. Bowne, and Erskine Uhl, Eds. *A Hand Book of the History, Organization and Methods of Work of Young Men's Christian Association* (New York: 1892) 320.
 [13] YMCA-Pawtucket and Central Falls, *The Advance*, Vol. VIII, No. 8 (July 1899) 5.
 [14] "E. A. Blood, Basketball Coach, Dies," *New York Herald Tribune* (February 7, 1955).

[15]. Bernice Larson Webb, *The Basketball Man, James Naismith* (Lawrence, Kansas: The University of Kansas, 1973) 81.

[16]. Blair Kerkhoff, *Phog Allen: The Father of Basketball Coaching* (Indianapolis: IN, 1996) 209.

[17]. Joe Donovan, "Between You and Me," Prof. Blood Celebrates Jubilee, Too," *Newark Star Ledger* (January 1942).

[18]. "The Harvard Summer School of Physical Education," *Journal of Physical Education, Recreation and Dance*, Volume 65, Issue 3 (March 1994): 32-37.

[19]. W. Charles Lehey, *The Potsdam Tradition* (New York:Appleton-Century-Crofts, 1966) 101.

[20]. W. Charles Lehey, *The Potsdam Tradition* (New York:Appleton-Century-Crofts, 1966) 118.

[21]. W. Charles Lehey, *The Potsdam Tradition* (New York:Appleton-Century-Crofts, 1966) 113.

[22]. W. Charles Lehey, *The Potsdam Tradition* (New York:Appleton-Century-Crofts, 1966) 106.

[23]. Paul Horowitz, "St. Benedict's Ends St. Peter's Streak," *Newark Evening News*, (January 31, 1940): 25, and *YMCA Archives* (St. Paul, MN).

[24]. "Basketball's Grand Old Man," *The Herald-News*, (October 1947): 10.

[25]. "Winners Of Interscholastic Cup Offered By St. Lawrence University," Poster commemorating the accomplishments of the 1909-1910 team.

[26]. *Souvenir Book - Class of 1910* (Potsdam, NY: State Normal School, 1910).

[27]. *Watertown Times* (November 25, 1911).

[28]. Broughton, Bradford B., *A Clarkson Mosaic* (Potsdam, New York: Clarkson University, 1995) 80.

[29]. The City College of New York 1997-1998 Basketball Press Guide: 8.

[30]. "Normal Defeats New York College," Watertown Times (January 3, 1913).

[31]. "New York Basket Ball Team Meets Defeat," *Watertown Times* (January 4, 1913).

[32]. "Potsdam Normals Defeat CCNY," *Watertown Times* (January 17, 1913).

[33]. "St. John's Defeated," *Watertown Times* (February 4, 1913).

[34]. "Brooklyn Boy Leads Potsdam Team To Defeat," *The Brooklyn Eagle* (January 21, 1914).

[35]. "Niagara Defeated," *Watertown Times* (February 18, 1913).

[36]. *The Notre Dame Scholastic*, Volume 47 (February 21, 1914).

[37]. McMahon, Art, "The Sportsman's Corner," *The Herald-News* (January 31, 1940): 16.

[38]. Passaic Public School Administrative file.

[39]. Passaic Public School Administrative file.

[40]. North, Thomas P., *Clarkson Tech Alumnus* (April 1961): 44-46.

Chapter 4

[41]. "Passaic High School Basketball Team Have Run Up A Record…," *Passaic Daily News* (March 20, 1921).

[42]. "School Day Longer For Physical Work," *Passaic Daily Herald*

(September 7, 1917): 1.

⁴³· Passaic Public School Administrative file.

⁴⁴· Dr. Robert Carlisle, Tape Recorded Interview with John S. Roosma, Verona, New Jersey, 1973.

⁴⁵· "High Ready For First Game," *Passaic Daily Herald* (December 13, 1918).

⁴⁶· *Passaic Daily Herald* (January 5, 1919).

⁴⁷· Wendell Merrill, "Passaic High's First Defeat Costs Students State Title," *Passaic Daily Herald* (March 17, 1919): Sporting Page.

⁴⁸· Dr. Robert Carlisle, Tape Recorded Interview with John S. Roosma, Verona, New Jersey, 1973.

⁴⁹· Dr. Robert Carlisle, Tape Recorded Interview with John S. Roosma, Verona, New Jersey, 1973.

⁵⁰· Dr. Robert Carlisle, Tape Recorded Interview with John S. Roosma, Verona, New Jersey, 1973.

⁵¹· "Union Hill Beats Passaic High For State Championship." *Passaic Daily Herald* (March 15, 1919): 1.

⁵²· "Union Hill Beats Passaic High For State Championship." *Passaic Daily Herald* (March 15, 1919): 1.

Chapter 5

⁵³· "Amasa A. Marks Coaches Quintet For This Season," *Passaic Daily News* (December 31, 1924): Sporting Page.

⁵⁴· "Passaic High Wins 1ˢᵗ Game Of Court Season At Newark," *Passaic Daily Herald* (December 18, 1919): 8.

⁵⁵· "Passaic High School Basketball Team Hands A Whitewash To Springfield," *Passaic Daily News* (January 2, 1920).

⁵⁶· "Passaic High 5 Downs Much-Touted Freshman of New York University," *Passaic Daily Herald (*January 9, 1920): 8.

⁵⁷· "Passaic High School Starts Season In NNJSL By Defeating The Leonia Combination by 58-25 Score," *Passaic Daily News* (January 12, 1920).

⁵⁸· "Passaic Defeats Hackensack In N. N. J. I. S. League Game Yesterday," *Passaic Daily News* January 15, 1920.

⁵⁹· "Passaic High School First And Second Teams Defeat Quintets That Came Here From Englewood," *Passaic Daily News* (January 19, 1920).

⁶⁰· "Passaic High 29, Montclair 24," *Passaic Daily News* (January 26, 1920).

⁶¹· "High School Basketball Team Hangs Up A 40-13 Victory Against Ridgewood," *Passaic Daily News* (January 29, 1920).

⁶²· "Passaic High Outclasses The Leonia Team," *Passaic Daily News* (February 2, 1920).

⁶³· "Passaic High Defeats Hack Boys 58 to 24," *Passaic Daily News* (February 5, 1920).

⁶⁴· "Carlisle, Dr. Robert, Tape Recorded Interview with John S. Roosma, Verona, New Jersey, 1973.

⁶⁵· "Passaic High Defeats Rutherford." *Passaic Daily News* (February 13, 1920): 4.

66. "Passaic High 39, Cliffside 14," *Passaic Daily News* (February 16, 1920).

67. "Passaic High Rolls Up Total Of 85 Points," *Passaic Daily News* (February 19, 1920).

68. "PHS Practically Cinches The NNJIL Championship Pennant," *Passaic Daily News* (February 24, 1920): Sporting Page.

69. "Hasbrouck Hts. Snowed Under By 67-8 Score," *Passaic Daily News* (February 26, 1920).

70. "Boys Of The Red And Blue Capture Their Seventeenth Straight Game Of The Season Saturday Afternoon," *Passaic Daily News* (March 1, 1920).

71. "Passaic High School Hangs Up A 61-11 Victory Over Nutley High," *Passaic Daily News* (March 6, 1920).

72. "Englewood Falls Before Skill of Passaic Basketeers," *Passaic Daily News* (March 8, 1920).

73. "Twenty Victories In A Row For Red and Blue," *Passaic Daily News* (March 9, 1920).

74. Jim Dente, "Wonder Team a headliner in the world of sports," *The Herald-News* (March 7, 1972—100th Anniversary Edition): Section C.

75. "Passaic Beats South Orange On-Its Way to Championship," *Passaic Daily Herald* (March 13, 1920): 8.

76. "North Plainfield Quintet Falls Before Red And Blue," *Passaic Daily News* (March 18, 1920).

77. "Defeat Union Hill Quintet…," *Passaic Daily News* March 20, 1920.

78. "Passaic High Wins Second Championship by Defeating Montclair." *Passaic Daily News* (March 20, 1920).

79. "PASSAIC HIGH WINS!" *Passaic Daily News* (March 27, 1920): 1.

80. "PASSAIC HIGH WINS!" *Passaic Daily News* (March 27, 1920): 1.

81. "Celebration Planned By Principal Arnold In Honor Of PHS Boys' Great Work In Winning State Honors," *Passaic Daily News* (March 29, 1920): Sporting Page.

82. Dr. Robert Carlisle, Tape Recorded Interview with John S. Roosma, Verona, New Jersey, 1973.

83. Dr. Robert Carlisle, Tape Recorded Interview with John S. Roosma, Verona, New Jersey, 1973.

Chapter 6

84. *Passaic Daily News* (December 20, 1920): 8.

85. Dr. Robert Carlisle, Tape Recorded Interview with John S. Roosma, Verona, New Jersey, 1973.

86. "The Story of Joe McCoy," *Passaic Daily News* (February 7, 1921): Sporting Page.

87. "The Story of Joe McCoy," *Passaic Daily News* (February 7, 1921): Sporting Page.

88. "The Story of Joe McCoy," *Passaic Daily News* (February 7, 1921): Sporting Page.

89. Len Plosin, "Hall of Fame His Aim," *Passaic Herald-News* (October 7, 1969).

90. "Just A Few Attended Game," *Passaic Daily News* (February 14, 1921): 8.

91. "What's Wrong With The N. J. S. I. Ass'n," *Passaic Daily News* (March 2, 1921): 8.

92. "Sectional Tournament Under Way; Chicago Trip Hangs On A Hair," *Passaic Daily Herald* (March 5, 1921).

93. "P.H.S. To Play For N.J. Title," *Passaic Daily News* (March 5, 1921): 1.

94. Dr. Robert Carlisle, Tape Recorded Interview with John S. Roosma, Verona, New Jersey, 1973.

95. "Passaic High the 'Real' National Champions," *Passaic Daily News* (March 15, 1921).

96. "Passaic High School Basketball Teams Have Run Up A Record of 6225 Points Against 2290 by Opponents In Six Years," *Passaic Daily News* (March 1921).

97. "Passaic High School Basketball Teams Have Run Up A Record of 6225 Points Against 2290 by Opponents In Six Years," *Passaic Daily News* (March 1921).

98. "Capitol City Quintet Ready To Give Champions A Hard Battle," Unidentified Trenton newspaper (March 19, 1921).

99. Phillip Ellett, *The Franklin Wonder Five: A Complete History of the Legendary Basketball Team*, (USA:RLE Enterprises, Inc., 1986).

100. "Fight Between Players Results in Referee Hill Calling Off Game Between Caseys and Blue & White," *Passaic Daily News* (March 31, 1921).

101. Dr. Robert Carlisle, Tape Recorded Interview with John S. Roosma, Verona, New Jersey, 1973.

102. Dr. Robert Carlisle, Tape Recorded Interview with John S. Roosma, Verona, New Jersey, 1973.

103. Dr. Robert Carlisle, Tape Recorded Interview with John S. Roosma, Verona, New Jersey, 1973.

104. "Cub Bear Captured By Coach Blood In Wilds Of Potsdam," *Passaic Daily News* (April 5, 1921): 8.

105. "School Players Presented With The City's Gifts," *Passaic Daily News* (April 1921).

106. Dr. Robert Carlisle, Tape Recorded Interview with John S. Roosma, Verona, New Jersey, 1973.

107. Dr. Robert Carlisle, Tape Recorded Interview with John S. Roosma, Verona, New Jersey, 1973.

Chapter 7

108. Phillip Ellett, *The Franklin Wonder Five: A Complete History of the Legendary Basketball Team*, (USA:RLE Enterprises, Inc., 1986).

109. "Stepping Out right Perkily Among Merry Sportdom Trail," *Passaic Daily News* (December 28, 1921): Sporting Page.

110. "A. H. S. Loses 111 to 5 Game at Passaic," *Attleboro Sun* (December 31, 1922).

111. "Here's Latest Scream About Passaic High," *Passaic Daily News*

(January 31, 1922): Sporting Page.

112. "Majority Of Red & Blue Victories On Strange Courts," *Passaic Daily News* (February 1, 1922): Sporting Page.

113. "Majority Of Red & Blue Victories On Strange Courts," *Passaic Daily News* (February 1, 1922): Sporting Page.

114. "Bar The Post-Graduate Athletes," *Passaic Daily News* (February 2, 1922): Sporting Page.

115. "Stepping Out Right Perkily Along Merry Sportdom Trail," *Passaic Daily News* (February 6, 1922): Sporting Page.

116. "Stepping Out Right Perkily Along Merry Sportdom Trail," *Passaic Daily News* (February 20, 1922): Sporting Page.

117. "Stepping Out Right Perkily Along Merry Sportdom Trail," *Passaic Daily News* (February 20, 1922): Sporting Page.

118. Wendell Merrill, "Merriel's Sport Talk," *Passaic Daily News* (March 1926): 12.

119. "P. H. S. Suspension To Be Lifted," *Passaic Daily News* (April 26, 1924): 11.

120. "Pennsylvania Team Is Confident Of Defeating P. H. S.," *Passaic Daily News* (March 29, 1922): Sporting Page.

Chapter 8

121. "Professor Blood May Not Coach Basketball during Coming Season," *Passaic Daily News* (October 10, 1922): Sporting Page.

122. Wendell Merrill, "In Sportdom's Glare," *Passaic Daily News* (December 1922): Sporting Page.

123. Dr. Robert Carlisle, Tape Recorded Interview with John S. Roosma, Verona, New Jersey, 1973.

124. Jim Dente, "Case of the Missing Game: Did Prof. Blood Pull a Fast One?" *Passaic Herald News* (March 7, 1972): Sports Page.

125. "Biggest Team In State" Takes A Tall Trimming," *Passaic Daily News* January 15, 1923, Sporting Page.

126. "UNDER THE BASKET," *Passaic Daily Herald* (January 18, 1923): Sporting Page.

127. George H. Greenfield, "BLOOD ISSUES HIS CHALLENGE," *Passaic Daily News* (January 19, 1923): Sporting Page.

128. "Spalding Guide Editor Praises Passaic Record', *Passaic Daily News* (January 22, 1923): Sporting Page.

129. "UNDER THE BASKET," *Passaic Daily Herald* (January 25, 1923): Sporting Page.

130. George H. Greenfield, "St. Mary's Won Great Battle Thursday," *Passaic Daily News* (January 27, 1923): Sporting Page.

131. "Prof. Blood Stands By Proposition To Hoboken High School," *Passaic Daily News* (February 2, 1923): Sporting Page.

132. Tom Dugan, "Union Hill Stars, Boxer and Kruse, Are Eliminated on Post-Graduate Grounds," *Passaic Daily Herald* (February 20, 1923): Sporting Page.

[133.] Peter Nussbaum, "There Was No Beating Our Best Team Ever When Basketball Began," Buffalo Magazine, *Buffalo News* (February 16, 1992).

[134.] "Passaic Sharing A World's Record," *Passaic Daily Herald* (February 26, 1923): Sports Page.

[135.] Frank J. Basloe, *I Grew Up With Basketball: Twenty Years of Barnstorming With Cage Great of Yesterday* (New York: Greenberg, 1952).

[136.] "Shots and Passes" by The Three Basketeers, *Passaic Daily Herald* (February 24, 1923): 4.

[137.] "Unable To Start Tourney," *Passaic Daily News* (February 28, 1923): Sporting Page.

[138.] "Prof E. A. Blood Decries Victory Mad Spirit," *Passaic Daily News* (April 7, 1924): 1.

Chapter 9

[139.] "City Commissioners, While Not Attacking School Board, Declare Their Stand Is for Basketball," *Passaic Daily News* (March 13, 1925): 1.

[140.] "Comment at Rotary Favors Prof. Blood," *Passaic Daily News* (March 13, 1925): 12.

[141.] Conversations with Sam Levine, Passaic High School, Class of 1929, November 21, 1999, and Jack DeYoung, Passaic High School, Class of 1930, August 9, 1998.

[142.] "The True Arthur D. Arnold," *Garfield News* (March 15, 1923): 1.

[143.] William C. Scott, *History of Passaic and Its Environs*, Vol. 2, (New York: Lewis Historical Publishing Company, Inc., 1922).

[144.] William C. Scott, *History of Passaic and Its Environs*, Vol. 2, (New York: Lewis Historical Publishing Company, Inc., 1922).

[145.] Conversation with Jack DeYoung, December 5, 1999.

[146.] "The Basketball War," *Passaic Daily News* (February 27, 1924): 3.

[147.] "The Basketball War," *Passaic Daily News* (February 27, 1924): 3.

[148.] Shots-And-Passes by The Three Basketeers, *Passaic Daily News* (March 3, 1923): Sporting Page.

[149.] Wendell Merrill, "In Sportsdom's Glare," *Passaic Daily Herald* (March 19, 1923): Sporting Page.

[150.] "ARNOLD AND BLOOD BACKERS PLAN SETTLEMENT: MAYOR WANTS INVESTIGATION OF CONTROVERSY," *Passaic Daily Herald* (March 20, 1923): 2.

[151.] "Blood and Boys Are Given Dinner and Theatre Party—Coach Talks," *Passaic Daily Herald* (March 20, 1923): 1.

[152.] "Blood and Boys Are Given Dinner and Theatre Party—Coach Talks," *Passaic Daily Herald* (March 20, 1923): 1.

[153.] "Blood and Boys Are Given Dinner and Theatre Party—Coach Talks," *Passaic Daily Herald* (March 20, 1923): 1.

[154.] "'Prof.' Blood Given Remarkable Reception by Citizens and Boys of Troy, N.Y.-He Makes Three Addresses," *Passaic Daily News* (March 26, 1923): 1.

[155.] Dr. Robert Carlisle, Tape Recorded Interview with John S. Roosma, Verona, New Jersey, 1973.

[156.] "Former Congressman Dow H. Drukker Dies," *The Herald News* (January 12, 1963): Front Page.

[157.] "Bermuda Trip Enjoyed by All On Fort Hamilton," *Passaic Daily News* (April 9, 1923): 1.

[158.] "Dow H. Drukker Buys 230 Shares of Stock of The Daily News," *Passaic Daily News* (April 9, 1923): 1.

[159.] "Former Congressman Dow H. Drukker Dies," *The Herald News* (January 12, 1963): Back Page.

[160.] "Prof Blood Hears From the School Board," *Passaic Daily News* (April 11, 1923): 1.

[161.] "Mass Meeting Tonight to Talk Over Arnold-Blood Case—Mayor and Those On Committee Answer Drukker Writ," *Passaic Daily News* (April 16, 1923): 1.

[162.] "ADMIRES OF BLOOD AT RALLY," *Passaic Daily Herald* (April 17, 1923): 1.

[163.] "Citizen's Committee To Engage Lawyer To Push Blood-Arnold Charges," *Passaic Daily News* (April 17, 1923): 1.

[164.] "Coach Blood Tell Bayonne Industrial Association Name 'Wonder Team' is Distasteful," *Passaic Daily News* (April 19, 1923): 1.

[165.] "DRUKKER WRIT IS DISMISSED," *Passaic Daily Herald* (April 21, 1923): 1.

[166.] "Board Votes Itself, Supreme Control Over All Athletic Matters, Deciding Its Members May Overrule the Council", *Passaic Daily News* (June 12, 1923): 1.

Chapter 10

[167.] George H. Greenfield, "Sports'N'Everything," *Passaic Daily News* (November 22, 1923): Sporting Page.

[168.] "Basketball Followers Hopeful That 'Prof' Will Be On The Job," *Passaic Daily News* (December 4, 1923): Sporting Page.

[169.] George H. Greenfield, "Open Letter To Messrs. Blood and Breslawsky," *Passaic Daily News* (December 6, 1923): Sporting Page.

[170.] George H. Greenfield, "Report 'Prof' Blood Will Coach Team," *Passaic Daily News* (December 7, 1923): Sporting Page.

[171.] George H. Greenfield, "'Wonder Team' Wizard Delivers Inspiring Talk To Basketeers; Aids Coach Marks in Workout," *Passaic Daily News* (December 12, 1923): Sporting Page.

[172.] "'Prof' Puts PHS Candidates Through Snappy Session; Dwells On Importance of Good Headwork," *Passaic Daily News* (December 14, 1923): Sporting Page.

[173.] "Passaic Not In State Tourney," *Passaic Daily News* (February 15, 1924): Sporting Page.

[174.] "Passaic High Boys Get First Workout On New Armory Court And Find It To Their Liking," *Passaic Daily News* (December 18, 1923): Sporting Page.

[175.] "New Armory slightly damaged in Crush of Basketball Fans—1000 Unable to Gain Entrance," *Passaic Daily News* (December 22, 1923): Sporting Page.

176. George H. Greenfield, "Foul Work By Newark Prep and Use of 'Ringers' Fail to Put Crimp In Great Chain of Wins," *Passaic Daily News* December 27, 1923, Sporting Page.

177. George H. Greenfield, "SPORTS 'N' EVERYTHING. They're Still Talking about It," *Passaic Daily News* (January 10, 1924): Sporting Page.

178. "Seek Publicity At Expense Of Passaic Quints," *Passaic Daily News* (January 14, 1924): Sporting Page.

179. "Damon Runyon's Publicity Worth $150,000 to Passaic, Says Ad Man," *Passaic Daily News* (January 15, 1924): Sporting Page.

180. George H. Greenfield, "Spectre of Defeat Looms Up Before Eyes of Fans As Team Continues In Fearful Slump," *Passaic Daily News* (January 24, 1924): Sporting Page.

181. "Pashman May Play Tomorrow," *Passaic Daily News* (January 25, 1924): Sporting Page.

182. George H. Greenfield, "Passaic May Not Enter State Tournament Unless Expenses Are Paid…," *Passaic Daily News* (January 29, 1924): Sporting Page.

183. George H. Greenfield, "Passaic May Not Enter State Tournament Unless Expenses Are Paid…," *Passaic Daily News* (January 29, 1924): Sporting Page.

184. George H. Greenfield, "Passaic May Not Enter State Tournament Unless Expenses Are Paid…," *Passaic Daily News* (January 29, 1924): Sporting Page.

Chapter 11
185. "P. H. S. Basketball Team Is Imperilled [sic] By Another Squabble," *Passaic Daily News* (February 6, 1924): 1.

186. "P. H. S. Basketball Team Is Imperilled [sic] By Another Squabble," *Passaic Daily News* (February 6, 1924): 1.

187. "P. H. S. Basketball Team Is Imperilled [sic] By Another Squabble," *Passaic Daily News* (February 6, 1924): 1.

188. "P. H. S. Basketball Team Is Imperilled [sic] By Another Squabble," *Passaic Daily News* (February 6, 1924): 1.

189. "P. H. S. Basketball Team Is Imperilled [sic] By Another Squabble," *Passaic Daily News* (February 6, 1924): 1.

190. "BLOOD QUITS H. S. TEAM," *Passaic Daily Herald* (February 6, 1924): 1.

191. "P. H. S. Basketball Team Is Imperilled [sic] By Another Squabble," *Passaic Daily News* (February 6, 1924): 1.

192. "BLOOD QUITS H. S. TEAM," *Passaic Daily Herald* (February 6, 1924): 1.

193. "P. H. S. Basketball Team Is Imperilled [sic] By Another Squabble," *Passaic Daily News* (February 6, 1924): 1.

194. "P. H. S. Basketball Team Is Imperilled [sic] By Another Squabble," *Passaic Daily News* (February 6, 1924): 1.

195. "P. H. S. Basketball Team Is Imperilled [sic] By Another Squabble," *Passaic Daily News* (February 6, 1924): 1.

196. "P. H. S. Basketball Team Is Imperilled [sic] By Another Squabble," *Passaic Daily News* (February 6, 1924): 1.

[197.] "P. H. S. Basketball Team Is Imperilled [sic] By Another Squabble," *Passaic Daily News* (February 6, 1924): 1.

[198.] "BLOOD QUITS H. S. TEAM," *Passaic Daily Herald* (February 6, 1924): 1.

[199.] "BLOOD QUITS H. S. TEAM," *Passaic Daily Herald* (February 6, 1924): 1.

[200.] "P. H. S. Basketball Team Is Imperilled [sic] By Another Squabble," *Passaic Daily News* (February 6, 1924): 2.

[201.] "P. H. S. Basketball Team Is Imperilled [sic] By Another Squabble," *Passaic Daily News* (February 6, 1924): 2.

[202.] "'Prof.' Blood and High School Players Will Stick Together," *Passaic Daily News* (February 7, 1924): 1.

[203.] "BLOOD TELLS HIS PLAYERS WHY HE QUIT," *Passaic Daily Herald* (February 7, 1924): 2.

[204.] "Prof. Blood and High School Players Will Stick Together," *Passaic Daily News* (February 7, 1924): 14.

[205.] "Prof. Blood and High School Players Will Stick Together," *Passaic Daily News* (February 7, 1924): 14.

[206.] "Prof. Blood and High School Players Will Stick Together," *Passaic Daily News* (February 7, 1924): 14.

[207.] "Out-of-Town Newspapers Praise Blood, Attack School Board—Hudson County Would Like to Get 'Prof.'" *Passaic Daily News* (February 8, 1924): 1.

[208.] William Spaat, Jr. WHY BREAK IT? *Passaic Daily Herald* (February 8, 1924).

[209.] "Dr. Shepherd Admits Blood Can Quit Job," *Passaic Daily Herald* (February 8, 1924): 1.

[210.] Passaic School District administrative records.

[211.] "Prof. Blood's Proposal to Pay Expenses Incurred in Tournament Receives Approval of Association," *Passaic Daily News* (February 11, 1924): Sporting Page.

[212.] Ross H. Wynkoop, "Credit To Blood," *Bergen Evening Record* (February 11, 1924): Sporting Page.

[213.] "Passaic Not In State Tourney," *Passaic Daily News* (February 15, 1924): Sporting Page.

[214.] "Passaic Not In State Tourney," *Passaic Daily News* (February 15, 1924): Sporting Page.

[215.] "Blood Cancels P.H.S. Entry for Basketball Tournament but Short Ignores Message," *Passaic Daily Herald* (February 15, 1924): 1.

[216.] "Blood Cancels P.H.S. Entry for Basketball Tournament but Short Ignores Message," *Passaic Daily Herald* (February 15, 1924): 1.

[217.] "Blood Cancels P.H.S. Entry for Basketball Tournament but Short Ignores Message," *Passaic Daily Herald* (February 15, 1924): 1.

[218.] "Blood Agrees to Stay," *Herald Daily News* (February 16, 1924): 1.

[219.] "All Is Well In The City Of Passaic," *Newark Evening News* (February 19, 1924): Sporting Page.

220. "Blood Agrees to Stay," *Herald Daily News* (February 16, 1924): 1.

221. "Blood Agrees to Stay," *Herald Daily News* (February 16, 1924): 1.

222. Passaic Public School Administrative file.

Chapter 12

223. "Prof. Blood Gives Out Letters," *Passaic Daily News* (February 28, 1924): 1.

224. "Blood Turns Back Upon Championship," *Passaic Daily Herald* (February 27, 1924): 1.

225. "School Board Members For Playing Team," *Passaic Daily Herald* (February 28, 1924): 1.

226. "Athletic Council Will Meet Tonight To Assure Passaic's Legal Entry In Tournament," *Passaic Daily News* (February 29, 1924): 1.

227. "Prof. Blood Will Lead P.H.S. Team In State Tournament," *Passaic Daily News* (March 1, 1924): 1.

228. "Prof. Blood Will Lead P.H.S. Team In State Tournament," *Passaic Daily News* (March 1, 1924): 14.

229. "Plan Big Game In New York," *Passaic Daily News* (March 10, 1924): Sporting Page.

230. "Plan Big Game In New York," *Passaic Daily News* (March 10, 1924): Sporting Page.

231. "Olympic Fund Game In New York Approved By Passaic School Board," *Passaic Daily News* (March 11, 1924): 1.

232. "Olympic Fund Game In New York Approved By Passaic School Board," *Passaic Daily News* (March 11, 1924): 1.

233. "Prof. Blood Accepts Challenge to Play Game For Olympic Benefit Fund," *Passaic Daily News* (March 20, 1924): 1.

234. "Shots and Passes" By The Three Basketeers, *Passaic Daily News* (March 17, 1924): Sporting Page.

Chapter 13

235. George H. Greenfield, "Blood Demands Neutral Court," *Passaic Daily News* (March 17, 1924): Sporting Page.

236. "State Association Refuses Passaic Fair Chance In the Finals," *Passaic Daily News* (March 17, 1924): 1.

237. "State Association Refuses Passaic Fair Chance In the Finals," *Passaic Daily News* (March 17, 1924): 1.

238. "Jersey Championship Sacrificed By Coach; Morristown Is Put In," *Passaic Daily Herald*, (March 18, 1924): 1.

239. "Blood Sacrifices Championship By Making Demands,' *Passaic Daily Herald* (March 18, 1924): 8.

240. "Blood Sacrifices Championship By Making Demands,' *Passaic Daily Herald* (March 18, 1924): 8.

241. "Blood Sacrifices Championship By Making Demands,' *Passaic Daily Herald* (March 18, 1924): 8.

242. "St. John's Prep Team Of Brooklyn May Meet Passaic For U.S. Fund," *Passaic Daily News* (March 21, 1924): 1.

243. George H. Greenfield, "Commercialism And Sport! The State Association Indicts Itself," *Passaic Daily News* (March 22, 1924): Sporting Page.

244. "Strong New England Team To Oppose Red and Blue On Passaic Armory Court," *Passaic Daily News* (March 21, 1924): Sporting Page.

245. "New Englanders Confident of Putting Crimp In The Locals' Great Record of 143 Straight," *Passaic Daily News* (March 22, 1924): Sporting Page.

246. "Aquinas Wins the National Catholic Basketball Tourney," *Passaic Daily News* (March 29, 1924): 1.

247. "Forces Rallying to Fight For Square Deal For Passaic From The State Interscholastic Association," *Passaic Daily News* (March 29, 1924): 1.

248. "Shots and Passes" by The Three Basketeers, *Passaic Daily News* (March 29, 1924): Sporting Page.

249. "Here Are Some Out-of-Town Answers To Passaic's Jealous Critics," *Passaic Daily News* (March 29, 1924): 1.

250. "SHOTS-AND-PASSES by The Three Basketeers," *Passaic Daily News* (March 29, 1924): Sporting Page.

251. "P. H. S. Had Right to Draw Out of Tourney; 'Unfair,' Says Short," *Passaic Daily News* (March 31, 1924): 1.

252. "What the *Passaic Daily News* Has to Say on 'All-State Basketball Selections,'" *Passaic Daily News* (March 31, 1924): Sporting Page.

253. George H. Greenfield, "SPORTS 'N' EVERYTHING," *Passaic Daily News* (April 8, 1924): Sporting Page.

254. "P. H. S. 'Trial' Set for April 25," *Passaic Daily News* (April 11, 1924): 1.

255. "Vice President Flower and Others Back Mr. Blood," *Passaic Daily News* (April 15, 1924): 1.

256. "Vice President Flower and Others Back Mr. Blood," *Passaic Daily News* (April 15, 1924): 11.

257. "Vice President Flower and Others Back Mr. Blood," *Passaic Daily News* (April 15, 1924): 1.

258. George H. Greenfield, "Babe Obliges Wonder Team Boys With Home Run," *Passaic Daily News* (April 24, 1924): Sporting Page.

259. "P. H. S. Suspension To Be Lifted," *Passaic Daily News* (April 26, 1924): 1.

260. "P. H. S. Suspension To Be Lifted," *Passaic Daily News* (April 26, 1924): 11.

261. "P. H. S. Suspension To Be Lifted," *Passaic Daily News* (April 26, 1924): 11.

262. "P. H. S. Suspension To Be Lifted," *Passaic Daily News* (April 26, 1924): 11.

263. "P. H. S. Suspension To Be Lifted," *Passaic Daily News* (April 26, 1924): 11.

264. "P. H. S. Suspension To Be Lifted," *Passaic Daily News* (April 26, 1924): 11.

265. "P. H. S. Suspension To Be Lifted," *Passaic Daily News* (April 26, 1924): 11.

266. "P. H. S. Suspension To Be Lifted," *Passaic Daily News* (April 26, 1924): 11.

267. "P. H. S. Suspension To Be Lifted," *Passaic Daily News* (April 26, 1924): 11.

268. "P. H. S. Suspension To Be Lifted," *Passaic Daily News* (April 26, 1924): 11.

269. "P. H. S. Suspension To Be Lifted," *Passaic Daily News* (April 26, 1924): 11.

270. "P. H. S. Suspension To Be Lifted," *Passaic Daily News* (April 26, 1924): 11.

271. "P. H. S. Suspension To Be Lifted," *Passaic Daily News* (April 26, 1924): 11.

272. "Blood's Request To Be Relieved of Directing H. S. Sports Is Granted," *Passaic Daily News* (May 13, 1924): 1.

273. "Blood's Request To Be Relieved of Directing H. S. Sports Is Granted," *Passaic Daily News* (May 13, 1924): 1.

274. "Blood's Request To Be Relieved of Directing H. S. Sports Is Granted," *Passaic Daily News* (May 13, 1924): 16.

275. "Blood's Request To Be Relieved of Directing H. S. Sports Is Granted," *Passaic Daily News* (May 13, 1924): 16.

276. George H. Greenfield, "SPORTS-N-EVERYTHING," *Passaic Daily News* (June 6, 1924): Sporting Page.

277. "Milton Pashman To Captain Passaic High Quintet," *Passaic Daily News* (June 6, 1924): Sporting Page.

278. "'Prof.' Blood Accepts Position as Physical Director of YMHA," *Passaic Daily News* (June 6, 1924): 1.

Chapter 14

279. "Out of Town Papers Start 'Picking' on Professor Blood," *Passaic Daily News* (October 22, 1924): Sporting Page.

280. "Passaic High In Practice," *Passaic Daily News* (December 1924): Sporting Page.

281. Conversations with Samuel Z. Levine, PHS class of 1929, March 13, 1999, and Jack DeYoung, the All-State forward from the 1929 state championship team, PHS Class of 1930, August 9, 1998.

282. "Passaic High Court Stars Can Play Only Two Contests a Week," *Passaic Daily News* (December 9, 1924): Sporting Page.

283. "Charles W. Foley Takes Up Cudgel For Wonder Team and in Letter to Newark Paper Challenges All Fives," *Passaic Daily News* (December 24, 1924): Sporting Page.

284. "Merrill's Sport Talks," *Passaic Daily News* (December 22, 1924): Sporting Page.

285. "Shots and Passes" by The Three Basketeers, *Passaic Daily News* (December 29, 1924): Sporting Page.

286. "Paul Blood to Coach Quintet," *Passaic Daily News* (December 30, 1924): Sporting Page.

287. "ARLINGTON, MASSACHUSETTS, HIGH SCHOOL IS STRONG," *Passaic Daily News* (December 24, 1924): Sporting Page.

288. "Arlington Loses To Morristown High By Six Points," *Passaic Daily News* (January 3, 1925): Sporting Page.

289. "Merrill's Sports Talk, *Passaic Daily News* (January 7, 1925): Sporting Page.

290. W. J. Madden, "Red Passaic Juggernaut Crushes Hackensack High School Quintet Under Avalanche in a Late Rally," *Bergen Evening Record* (January 8, 1924): 12.

291. "Athletic Council Gives Approval for Bit Game," *Passaic Daily News* (January 9, 1925): Sporting Page.

292. "Athletic Council Gives Approval for Bit Game," *Passaic Daily News* (January 9, 1925): Sporting Page.

293. "Philadelphia Makes Luring Offer To Passaic," *Passaic Daily News* (January 20, 1925): Sporting Page.

294. "Ohio Champs Would Play Passaic Wonder Team," *Passaic Daily News* (December 30, 1924): Sporting Page.

295. "Athletic Council Gives Approval for Big Game," *Passaic Daily News* (January 9, 1925): Sporting Page.

296. Wendell Merrill, "Commerce Not Willing To Meet Passaic In N. Y.," *Passaic Daily News* (January 10, 1925): Sporting Page.

297. "Passaic Wonder Team Is Given Big Scare By The Englewood High Quintet," *Bergen Evening Record* (January 12, 1925): Sporting Page.

298. "Passaic Wonder Team Is Given Big Scare By The Englewood High Quintet," *Bergen Evening Record* (January 12, 1925): Sporting Page.

299. "Passaic Wonder Team Is Given Big Scare By The Englewood High Quintet," *Bergen Evening Record* (January 12, 1925): Sporting Page.

300. "Passaic Wonder Team Is Given Big Scare By The Englewood High Quintet," *Bergen Evening Record* (January 12, 1925): Sporting Page.

301. "Merrill's Sport Talks," *Passaic Daily News* (January 13, 1925): Sporting Page.

302. "Merrill's Sport Talks," *Passaic Daily News* (January 14, 1925): Sporting Page.

303. "Prof. Blood Coaches St. Benedict's Prep Five," *Passaic Daily News* (January 19, 1925): Sporting Page.

304. "Prof. Blood Coaches St. Benedict's Prep Five," *Passaic Daily News* (January 19, 1925): Sporting Page.

305. "Holyoke Very Anxious To Play Wonders Here," *Passaic Daily News* (January 14, 1925): Sporting Page.

306. Wendell Merrill, "Original Celtic Manager To See Passaic Play," *Passaic Daily News* (January 23, 1925): Sporting Page.

307. "New York Sports Writer Lauds Passaic High," *Passaic Daily News* (January 27, 1925): Sporting Page.

308. "Courtney Wright, Union Hill Coach Says Blood Is Greatest Leader, *Passaic Daily News* (January 26, 1925): Sporting Page.

309. "Courtney Wright, Union Hill Coach Says Blood Is Greatest Leader," *Passaic Daily News* (January 26, 1925): Sporting Page.

310. "Passaic Is Ready-All Aboard For Hackensack!" *Passaic Daily News* (February 5, 1925): Sporting Page.

311. Robert E. Irwin, "Why Passaic Doesn't Fear Hackensack in Game It Admits Is Stiff One," *Passaic Daily Herald* (February 6, 1925): Front Page.

312. "End Of World' Prophetess Calm As The Day Goes," *Passaic Daily News* (February 6, 1925): 1.

313. J. Newman Wright, "Captain Bollerman Looks for Upset—All 6-Footers on His Squad," *Passaic Daily Herald* (February 6, 1925): Front Page.

314. "It's Friday And 13th Game So Hackensack Is Hopeful, But It's 160th For Passaic," *Passaic Daily Herald* (February 6, 1925): Front Page.

315. "It's Friday And 13th Game So Hackensack Is Hopeful, But It's 160th For Passaic," *Passaic Daily Herald* (February 6, 1925): Front Page.

316. "Passaic High School Students Play Hooky To See Hackensack Game," *Passaic Daily News* (February 6, 1925): 1.

317. "Passaic High School Students Play Hooky To See Hackensack Game," *Passaic Daily News* (February 6, 1925): 1.

318. "Passaic High School Students Play Hooky To See Hackensack Game," *Passaic Daily News* (February 6, 1925): 1.

319. "Police Handled Women Rough At Armory Entrance," *Passaic Daily News* (February 7, 1925): Sporting Page.

320. "Passaic Is Ready-All Aboard For Hackensack!" *Passaic Daily News* (February 5, 1925): Sporting Page.

321. "Blood, Coach for Five Years, Off in Greenwich at the Time," *Passaic Daily Herald* (February 7, 1925): Front Page.

322. "Skeets Wright Pays Blood A Tribute," *Passaic Daily News* (February 7, 1925): Sporting Page.

323. "Street Gossip Bears on 'Getting Blood Back'—System Won Games," *Passaic Daily Herald*, (February 7, 1925): Sporting Page.

324. Wendell Merrill, "Merrill's Sports Talk," *Passaic Daily News* (February 7, 1925): Sporting Page.

325. "End Of World Failed Those Who Waited," *Passaic Daily Herald* (February 7, 1924): Sporting Page.

326. "Wonder Team Players Paid A Fine Tribute By Group of Citizens," *Passaic Daily News* (February 11, 1925): Sporting Page.

Chapter 15

327. "Passaic Wonder Team Trounces Rutherford H. S.," *The Rutherford Republican and Rutherford American* (February 14, 1925): Sporting Page.

328. North Jersey Sports: 1920s. 31 December 1999. 150 pars. 22 April 2000 <http://www.bergen.com/sports/1920s199912312.htm> (New Jersey sports: 1920s, par 80).

[329] Ed Reardon, "PASSING BY," *The Herald-News* (January 12, 1944): Sports Page.

[330] Ed Reardon, "PASSING BY," *The Herald-News* (January 12, 1944): Sports Page.

[331] "Rutherford Beaten For Third Time and Wonder Team Shows Fine Ball," *Passaic Daily News* (March 13, 1925): Sporting Page.

[332] Wendell Merrill, "Coach McIntyre [sic] Will Not Play Passaic Quintet On Paterson Armory Surface," *Passaic Daily News* (March 3, 1925): Sporting Page.

[333] *MHS Alumni Newsletter* (March/April 2000).

[334] Wendell Merrill, "Merrill's Sports Talk," *Passaic Daily News* (March 16, 1925): Sporting Page.

[335] "Hackensack Is Beaten By One Point Margin In Extra Period Game," *Passaic Daily News* (March 16, 1925): Sporting Page.

[336] "Coach Plant's Quintet Defeats Coach Blood's Five by Eight Points," *The Peddie News* (March 21, 1925): 1.

[337] "Peddie Quintet Defeats Graybees By A 30-22 Tally," *Passaic Daily News* (March 16, 1925): Sporting Page.

[338] "Passaic Comes From Behind To Capture Fifth State Basketball Title In Thrilling Battle," *Passaic Daily News* (March 23, 1925): Sporting Page.

[339] Wendell Merrill, "Captain Pashman Says Blood Won State Championship For Passaic High School Quintet," *Passaic Daily News* (March 24, 1925): Sporting Page.

[340] Wendell Merrill, "Captain Pashman Says Blood Won State Championship For Passaic High School Quintet," *Passaic Daily News* (March 24, 1925): Sporting Page.

[341] Wendell Merrill, "Hackensack Played Ball As It Should Be Played While Passaic Did Not," *Passaic Daily News* (March 28, 1925): Sporting Page.

[342] "6000 Witness Great Struggle; Many Left Out," *Passaic Daily News* (February 28, 1925): Sporting Page.

[343] David Kaplan, "Golden Comet Rallies In Final Four Minutes To Win League Honors," *Passaic Daily News* (February 28, 1925): Sporting Page.

Chapter 16

[344] Telephone interview with Lit Atiyeh from Canton, New York, August 18, 1998.

[345] "Rohrbach, Hero Of Big Game, And Krakovitch, Named On First Team," *Passaic Daily News* (April 6, 1925): Sporting Page.

[346] Robert E. Irwin, "Passaic Crowned Eastern Court Champions," *Passaic Daily Herald* (April 6, 1925): 6.

[347] Wendell Merrill, "Mr. Blood Did Not Go To Glens Falls To…," *Passaic Daily News* (February 8, 1925): Sporting Page.

[348] Wendell Merrill, "Mr. Blood Did Not Go To Glens Falls To…," *Passaic Daily News* (February 8, 1925): Sporting Page.

[349] "Great Scholastic Guard Defeated For Captaincy Will Not Play Next Year," *Passaic Daily News* (June 19, 1925): Sporting Page.

[350] David Kaplan, "Passaic High's Star Basketeer Receiving Offers From All Over," *Passaic Daily News* (August 1, 1925): Sporting Page.

[351] Interview with Samuel Z. Levine, PHS Class of '29, June 5,1999.

[352] For more on Jewish athletes, see *Sports and the American Jew*, Edited by Steven A. Riess, Syracuse University Press, 1998.

[353] "Prof. Blood Resigns," *Passaic Daily News* (July 31, 1925): 1.

[354] Official letter of resignation from PHS Administrative files.

Chapter 17

[355] "Krakovitch May Go To St. Benedict's," *Passaic Daily News* (August 1, 1925).

[356] Interview with Samuel Z. Levine, Passaic High School Class of 1929 on March 13, 1999

[357] "Blood Goes to West Point,." *Passaic Daily News* (December 1, 1925): 1.

[358] Special Collections and Archives Division of the USMA Library.

[359] Ed Reardon, "Passing By," *The Herald News* (January 12, 1944).

[360] "St. Benedict's Beats St. John's 58-14," *Passaic Daily News* (December 7, 1925).

[361] "Newspapers Now Praising Blood," *Passaic Daily News* (December 7, 1925).

[362] *The Howitzer*, United States Military Academy, 1926.

[363] Paul E. Geiger, *The Peddie School's First Century* (Valley Forge, Pennsylvania: The Judson [1] Press, 1965): 118.

[364] Paul E. Geiger, *The Peddie School's First Century* (Valley Forge, Pennsylvania: The Judson Press, 1965): 118.

[365] *Peddie News* Volume XlV, Number 20 (March 17, 1926).

[366] Reardon, Ed, *The Herald-News,* Passaic, January 12, 1944.

[367] *The Telelog*, the 1926 St. Benedict's Prep yearbook.

[368] Conversation with Samuel Z. Levine, PHS class of 1929, March 13, 1999.

[369] Arthur Johnson, "Krakovitch Declared Eligible, 4-3, after a Four Hour Session," *Passaic Daily News* (March 19, 1926): 19.

[370] Robert E. Irwin, "Basketball Tourney Called Off", *Passaic Daily Herald* (March 19, 1926): 1.

[371] Arthur Johnson, "Krakovitch Declared Eligible, 4-3, after a Four Hour Session," *Passaic Daily News* (March 19, 1926): 19.

[372] Arthur Johnson, "Krakovitch Declared Eligible, 4-3, after a four Hour Session," *Passaic Daily News* (March 19, 1926): 19.

[373] "Krakovitch Case Is Talk Of State," *Passaic Daily News* (March 22, 1926): 10.

[374] Conversation with Samuel Z. Levine, Class of 1929, June 5, 1999.

[375] "Krakovitch Case Is Talk Of State," *Passaic Daily News* (March 22, 1926): 10.

[376] "CHARLES W. FOLEY THREATENS TO SUE JOHN PLANT," *Passaic Daily News* (March 22, 1926): 10.

377. "CHARLES W. FOLEY THREATENS TO SUE JOHN PLANT," *Passaic Daily News* (March 22, 1926): 10.

Chapter 18

378. Dr. Robert Carlisle, Tape Recorded Interview with John S. Roosma, Verona, New Jersey, 1973.

379. Conversation with Ben Blood, June 28, 1998, Burlington, Vermont.

380. Sid Dorfman, "Honesty, Modesty standout traits of 'Prof' Blood, associates recall," *The Newark Star-Ledger* (February 7, 1955): 11.

381 Sid Dorfman, "Honesty, Modesty standout traits of 'Prof' Blood, associates recall," *The Newark Star-Ledger* (February 7, 1955): 11.

382. Sid Dorfman, "Honesty, Modesty standout traits of 'Prof' Blood, associates recall," *The Newark Star-Ledger* (February 7, 1955): 11.

383. Ernest A. Blood, "Tips for victory in Basketball," *The American Boy* (January 1923): 28.

384. Ernest A. Blood, "Tips for victory in Basketball," *The American Boy* (January 1923): 28.

385. Conversation with Ben Blood, June 28, 1998, Burlington, VT,

386. Sid Dorfman, "Honesty, Modesty standout traits of 'Prof' Blood, associates recall," *The Newark Star-Ledger* (February 7, 1955): 11.

387. "Blood Hoofs It Home With Bear Behind," *Passaic Daily Herald* (April 1, 1923): 1.

388. "Blood Hoofs It Home With Bear Behind," *Passaic Daily Herald* (April 1, 1923): 1.

389. "Blood Hoofs It Home With Bear Behind," *Passaic Daily Herald* (April 1, 1923): 1.

390. Stanley Woodward, *Newark Star-Ledger* (February 10, 1955): 12.

391. Stanley Woodward, *Newark Star-Ledger* (February 10, 1955): 12.

392. Conversation with Ben Blood, June 28, 1998, Burlington, VT.

393. Carlisle, Dr. Robert, Tape Recorded Interview with John S. Roosma, Verona, New Jersey, 1973.

394. Conversation with Ben Blood, June 28, 1998, Burlington, VT.

395. Augie Lio, "The Passaic 'Bear' Was Real," *The Herald News* (1983).

Chapter 19

396. Robert J. Roberts, "Bodily Exercise, A Christian Duty," *The Association News* Volume III, Number 1 (March 1895): 6.

397. "Athletics," *The Normal Magazine* (April 1911): 47.

398. James A. Naismith, *Basketball, Its Origin and Development* (New York: Association Press, 1941): 33.

399. E. J. Dorgan, *Luther Halsey Gulick, 1865-1928* (New York: Teachers College, 1943): 54-55.

400. C. L. Schrader, "Physical Welfare of Pupils," *American Physical Education Review* Vol. 29 (1924): 176-177.

401. C. L. Schrader, "Physical Welfare of Pupils," *American Physical Education Review*, Vol. 29 (1924): 176-177.

[402.] Official letter of recommendation from PHS Administrative files.

[403.] Conversation with Ben Blood, June 28, 1998, Burlington, Vermont.

Chapter 20

[404.] Blood, Ernest A., "How I Teach Basketball," *Street & Smith SPORT Story Magazine* (November 25, 1931): 22.

[405.] Kelly, Robert F., "Victory is Only Incidental," *Association Men*, March 1923, p. 320.

[406.] Axthelm, Pete, *The City Game; Basketball in New York from the World Champions Knicks to the World of the Playground* (New York: Pocket Books, 1971): XI.

[407.] Fox, Larry, *Illustrated History of Basketball* (New York: Grosset & Dunlap Publishers, 1974): 20.

[408.] Fox, Larry, *Illustrated History of Basketball* (New York: Grosset & Dunlap Publishers, 1974): 20.

[409.] Blood, Ernest A., "How I Teach Basketball," *Street & Smith SPORT Story Magazine* (November 25, 1931): 13.

[410.] Fork In The Road, Shots-And-Passes by the Three Basketeers, *Passaic Daily News* (January 31, 1923): Sporting Page.

[411.] Kelly, Robert F., "Victory is Only Incidental," *Association Men* (March 1923): 314.

[412.] Kelly, Robert F., "Victory is Only Incidental," *Association Men* (March 1923): 320.

[413.] Blood, Ernest A., "How I Teach Basketball," *Street & Smith SPORT Story Magazine* (November 25, 1931): 16.

[414.] Shots-And-Passes by The Three Basketeers, *Passaic Daily News* (January 31, 1923): Sporting Page.

[415.] Blood, Ernest A., "How I Teach Basketball," *Street & Smith SPORT Story Magazine* (November 25, 1931): 16.

[416.] Blood, Ernest A., "How I Teach Basketball," *Street & Smith SPORT Story Magazine* (November 25, 1931): 17.

[417.] Merrill, Wendell, "Daniel Calls Passaic Truly Sensational at Game of Basketball," *Passaic Daily News* (January 15, 1925): 14.

[418.] Merrill, Wendell, "Daniel Calls Passaic Truly Sensational at Game of Basketball," *Passaic Daily News* (January 15, 1925): 14.

[419.] Gathel, Alan, "In Pursuit of Victory," *Association Men* (March 1924): 300.

[420.] Merrill, Wendell, "Daniel Calls Passaic Truly Sensational at Game of Basketball," *Passaic Daily News* (January 15, 1925): 14.

[421.] Blood, Ernest A., "How I Teach Basketball," *Street & Smith SPORT Story Magazine* (November 25, 1931): 17.

[422.] Dorfman, Sid, "Honesty, Modesty Standout Traits of Prof Blood, Associates Recall," the *Newark Star Ledger* (February 7, 1955): 12.

[423.] "The Three Basketeers," *Passaic Daily News* (February 29, 1924): Sporting Page.

424. Blood, Ernest A., "How I Teach Basketball," *Street & Smith SPORT Story Magazine* (November 25, 1931): 15.

425. Blood, Ernest A., "How I Teach Basketball," *Street & Smith SPORT Story Magazine* (November 25, 1931): 15.

426. "Westerns Talk of Blood's Work," *Passaic Daily News* (February 29, 1924): Sporting Page.

427. Reardon, Ed, "If it is Blood You Want," *The Herald-News* (January 1, 1944).

428. "Passaic Wins 39 Straight Games," *Passaic Daily News* (February 7, 1921).

429. Plosia, Les, "Hall of Fame His Aim," *Passaic Herald-News* (October 7, 1969).

430. Kelly, Robert F., "Victory is Only Incidental," *Association Men* (March 1923): 314.

431. Greenfield, George, "Prof Decries Victory-Mad Spirit," *Passaic Daily News* (April 7, 1924): Sporting Page.

432. Plosia, Les, "Hall of Fame His Aim." *Passaic Herald-News* (October 7, 1969).

433. Gathel, Alan, "In Pursuit of Victory," *Association Men* (March 1924): 300.

434. Kelly, Robert F., "Victory is Only Incidental," *Association Men* (March 1923): 315.

435. "Get Players Young, Says Coach Of Four-Point-A-Minute Team," *The Washington Post* (March 5, 1928).

436. Kelly, Robert F., "Victory is Only Incidental," *Association Men* (March 1923): 315.

437. Kelly, Robert F., "Victory is Only Incidental," *Association Men* (March 1923): 314.

438. "Prof Blood," *The Herald-News* (February 7, 1955): 10.

439. Jenkins, Burris, Jr., "'I Think More of Developing Manhood Than Winning,' Says Coach Blood, Whose Teams Set World's Records for Victory," (March 13, 1924).

440. Gootter, Joe, "Once Again, Passaic Is Out for Blood," *Paterson Evening News* (April 10, 1946): 18.

441. Dorfman, Sid, "Honesty, Modesty Standout Traits of Prof Blood, Associates Recall," *The Newark Star-Ledger* (February 2, 1955): 11.

442. "Sixty-one Straight for Passaic Schoolboy Five," *The New York Herald* (December 24, 1921).

443. "Arnold and Blood Backers Plan Settlement," *Passaic Daily News* (March 20, 1923): 3.

444. Gathel, Alan, "In Pursuit of Victory," *Association Men* (March 1924): 299.

445. Kerr, William, "P. H. S. Basketeers Answers Critics," *Passaic Daily Herald* (January 27, 1923): Sporting Page.

446. Arnold and Blood Backers Plan Settlement," *Passaic Daily Herald* (March 20, 1923): 3.

447. Gathel, Alan, "In Pursuit of Victory," *Association Men* (March 1924): 330.

448. Gathel, Alan, "In Pursuit of Victory," *Association Men* (March 1924): 300.

449. Blood, Ernest A., "How I Teach Basketball," *Street & Smith SPORT Story Magazine* (November 25, 1931): 17.

450. Plosia, Les, "Hall of Fame His Aim," *Passaic Herald-News* (October 7, 1969).

451. Greenfield, George H., "Prof E. A. Blood Decries Victory-Mad Spirit," *Passaic Daily News* (April 7, 1924): Sporting Page.

452. Shots-And-Passes, by the Three Basketeers, *Passaic Daily News* (January 31, 1923): Sporting Page.

453. Greenfield, George H., "Prof E. A. Blood Decries Victory-Mad Spirit," *Passaic Daily News* (April 7, 1924): Sporting Page.

454. Greenfield, George H., "Prof E. A. Blood Decries Victory-Mad Spirit," *Passaic Daily News* (April 7, 1924): Sporting Page.

455. Gathel, Alan, "In Pursuit of Victory," *Association Men* (March 1924): 300.

456. Shoop, James, "The Wonder Team, Passaic High School 1919-1925," New Jersey Studies, (December 1978).

457. Reardon, Ed, "Prof Takes Time Out," *The Herald-News* (February 14, 1955).

458. Conversation with Mark S. Auerbach, January 21, 1998.

459. Dugan, Tom, "It Is in the Blood System to Win," *Passaic Daily Herald* (December 31, 1921): Sporting Page.

460. Goldberg, Hy, "Farm System Nothing New To Prof Blood, He Had It In Passaic," *Newark Evening News* (February 7, 1955).

461. Kerkhoff, Blair, *Phog Allen: The Father of Basketball Coaching* (Indianapolis, Indiana: 1996).

462. Ellett, Phillip, *The Franklin Wonder Five: A Complete History of the Legendary Basketball Team* (USA: RLE Enterprises, Inc., 1986).

463. Shots-And-Passes by The Three Basketeers, *Passaic Daily News* (February 28, 1924): Sporting Page.

464. Shots-And-Passes by The Three Basketeers, *Passaic Daily News* (February 28, 1924): Sporting Page.

465. Shots-And-Passes by The Three Basketeers, *Passaic Daily News* (February 28, 1924): Sporting Page.

466. Frank Fagan, "Blood And No Thunder," *Newark Star Ledger* (December 15, 1936).

467. Ernest A. Blood, "How I Teach Basketball," *Street & Smith SPORT Story Magazine* (November 25, 1931): 17.

468. Alan Gathel, "In Pursuit of Victory," *Association Men* (March 1924): 300.

469. Lloyde Glicken, "Prof Blood and Passaic Five Belong in N. J. Hall," (December 26, 1994).

470. Robert F. Kelly, "Victory is Only Incidental," *Association Men* (March 1923): 315.

471. Robert F. Kelly, "Victory is Only Incidental," *Association Men* (March 1923): 315.

[472] Les Plosia, "Hall of Fame His Aim," *Passaic Daily-Herald* (October 7, 1969).

[473] Dr. Robert Carlisle, Tape Recorded Interview with John S. Roosma, Verona, New Jersey, 1973.

[474] Letter from Edythe Rohrbach, July 20, 1998.

[475] Murray Polner, *Branch Rickey A Biography* (New York: Athenaeum, 1982): 84.

[476] Bill Mokray, "The Wonder Team Streak of 159 Straight Wins," *Converse Yearbook* (1969): 15.

[477] Thomas P. North, "Hall of Fame for an Amazing Coach," *Clarkson Alumnus* (April 1961): 46.

[478] Hy Goldberg, "Farm System Nothing New To Prof Blood, He Had It In Passaic," *Newark Evening News* (February 7, 1955).

[479] Michael Gavin, "Rolled To Fame On Playground Hoops," *New York Journal-America* (January 3, 1949).

[480] Paul Horowitz, "Sports in the News," *Newark Evening News* (January 26, 1950).

[481] Joe Lovas, "Blood Gave Him Confidence to Become Outstanding Player, Say Thompson," *Passaic Herald-News* (February 8, 1955): 16.

[482] Dr. Robert Carlisle, Tape Recorded Interview with John S. Roosma, Verona, New Jersey, 1973.

[483] "Shot-And-Passes" by The Three Basketeers, *Passaic Daily News* (March 21, 1923): Sporting Page.

[484] "Coach Blood Against Five-Man Defense in Basketball Game," *Passaic Daily Herald* (March 1923).

[485] "Gaisel Writes Damon Runyon On Basketball," *Passaic Daily News* (February 7, 1924): Sporting Page.

[486] "Fitz Gibbon Praises Fine Treatment Given Visiting Quintets Here," *Passaic Daily News* (January 28, 1925): Sporting Page.

[487] Paul Prep, "Passaic Success Due To Training: Boys Are Well Drilled in Court Game in Grammar School; Credit to Coach Blood," *Philadelphia Public Ledger* (March 10, 1923).

[488] Robert F. Kelly, "Victory is Only Incidental," *Association Men* (March 1923): 315.

[489] "Get Players Young, Says Coach Of Four-Point-A-Minute Team," *The Washington Post* (March 5, 1928).

[490] "Sixty-one Straight for Passaic Schoolboy Five," *The New York Herald* (December 24, 1921).

[491] Wendell Merrill, "Daniel Calls Passaic Truly Sensational at Game of Basketball," *Passaic Daily News* (January 15, 1925): 14.

[492] Tom Dugan, "It is in the Blood System to Win," *Passaic Daily Herald* (December 31, 1921): Sporting Page.

[493] Ernest A. Blood, "How I Teach Basketball," *Street & Smith SPORT Story Magazine* (November 25, 1931): 15.

[494] Tom Dugan, "It Is in the Blood System to Win," *Passaic Daily Herald* (December 31, 1921): Sporting Page.

495. Tom Dugan, "It Is in the Blood System to Win," *Passaic Daily Herald* (December 31, 1921): Sporting Page.

496. Ernest A. Blood, "How I Teach Basketball," *Street & Smith SPORT Story Magazine* (November 25, 1931): 22.

497. Frank Fagan, "Blood And No Thunder," *Newark Star-Ledger* (December 15, 1936).

498. "Reception to Basket Ball Team," *The Normal Magazine* (March 1908): 33.

499. Sid Dorfman, "Honesty, modesty standout traits of Prof Blood, associates recall, *The Newark Star-Ledger* (February 7, 1955): 11.

500. Lloyde Glicken, "Prof Blood and Passaic Wonder Five belong in N. J. Hall," (December 26, 1994).

501. Joe Lovas, "Blood Gave Him Confidence to Become Outstanding Player, Say Thompson," *Passaic Herald-News* (February 8, 1955): 16.

502. Clarence St. John, "His Teams Had Blood In Their Eyes," *Orlando Sentinel* (April 4, 1954).

503. Joe Lovas, "Blood Gave Him Confidence to Become Outstanding Player, Say Thompson," *Passaic Herald-News* (February 8, 1955): 16.

504. *The Numismatist* (July 1946): 813.

505. Tape Recording of the Fiftieth Anniversary Celebration Banquet honoring the Passaic High School Wonder Team Players, October 10, 1969, Pennington Club, Passaic.

506. Larry Fox, *Illustrated History of Basketball* (New York: Grosset & Dunlap, 1974): 61.

507. Zander Hollander, *The Modern Encyclopedia of Basketball* (New York: Four Winds Press, 1973): 502.

508. Dwight Chapin and Jeff Prugh, *The Wizard of Westwood* (Boston: Houghton Mifflin Company, 1973).

509. John Wooden, *They Call Me Coach* (Waco, Texas: Word Books, 1972).

510. Bart Starr, *A Perspective on Victory* (Chicago: Follett Publishing Company, 1972): 14.

511. "Prof Blood," *The Herald-News* (February 7, 1955): 10.

512. Tape Recording of the Fiftieth Anniversary Celebration Banquet honoring the Passaic High School Wonder Team Players, October 10, 1969, Pennington Club, Passaic, New Jersey.

513. "E. A. Blood, Basketball Coach, Dies," *New York Herald Tribune* (February 7, 1955).

INDEX

restriction on use of piano at
games, 95, 96
rising interest in basketball during
1918-1919 season, 45, 48
Thompson's 1000th point and,
125–126
transport of by railroad to
Northern NJ play-off game,
171
withdrawal of team from 1924
state tournament and, 283
fans, unsportsmanlike behavior of
Hoboken, 118, 141, 158–159,
280
Farb, Henry, 316
"farm system", Blood's development
of young people and, 388–393
Farrell, Jack, 143
fast breaks, 379
February graduates, ineligibility of, 81
See also mid-year graduates
Federici, Art, 173
Ferguson, Umpire, 330
filming of 150th game, 307
Finley, Bill, 196
Fish, Jack, 338
Fisher, Harry, 112
FitzGibbon, B. G., 314–315
Five Man (zone) defense, 379
Flanagan, Father Jerone, 242
Fleming, Leslie, 238, 260, 289
Flood, Hank, 347, 348, 350
Flower, Edwin, 179, 294
Foley, Charles W.
demands for Union Hill-St.
Benedict's match up, 355
hearing on Krakovitch's amateur
status and, 355–357
offer to help build new stadium,
306
presentation of cup to team to
commemorate 100th win, 149
presentation of cup to team to
commemorate 150th win, 305,
307
purchase of roadster for

Krakovitch by, 343, 354
Foley, P. J., 150, 238
Fols, Louis, 193
football
Blood's views on, 15–16
deaths from, 15–16
at Passaic, 15, 18, 49, 67
refusal of basketball coaches to
let players participate in, 67
at Rutherford High School, 154,
303
Ford, John A., 242
Fordham Prep (NJ) against Passaic
(1922), 109–111
Fordham University against Army
(1926), 348
"Fork in the Road" theory, Blood's,
384
Forstmann, Julius, 189, 190
foul shot rule, 233, 238
fouling, Blood's views on, 378–379
Fox, William E., 385–386
Franklin High School (IN), 385
Freeman, James "Buck", 347, 396
Freeswick, Abram, 177
Freeswick, John
1921-1922 season, 95, 121
1922-1923 season, 138
1923-1924 season, 260–261, 286,
290, 292
Frey, Edward, 212–213
full court pressure defense, Blood's
use of, 100, 378–379
Furey, James, 314, 342

G

Gale, Raymond, 63, 64
Game of the Century. *See* Century
Game, Passaic's
Gardner, Joseph M., 179
compensation of for treasurer
duties, 243, 243–244
selection of opponent for 150th
game, 306
Garfield High School (NJ)
against Passaic (1923), 144

two-game a week limit imposed
by, 304

Potsdam Normal School (NY), 11, 32–41, 376
 Blood's responsibilities at, 32
 gift of Zep (black bear) to Blood, 89, 358–359
 hiring of Blood in 1906, 31
 "Normal Five". see Potsdam "Normal Five"
 against Passaic (1921), 89
 against Passaic (1924), 276
Potsdam State University, 38, 40
Poughkeepsie High School, 76–77
Powers, Ralph, 89
Preiskel, Abram, 123, 226
Prep, Paul, 103
Prescott, Nathan O., 25
Prescott, Ralph, 121
Prescott, Robert, 243
pressure defense, 378–379
Princeton University, movement of NJSIAA finals to, 112
principle, Passaic High School. See Arnold, Arthur
professional basketball
 birth of, 29
 Buffalo Germans, 33, 34, 160–162
 Original Celtics, 314, 342–343, 377, 398
 Passaic "Seconds" against pro teams, 89
prophetess (Rowan) on Hackensack-Passaic game, 318, 323
public opinion poll, Blood-Board conflict, 179, 184, 195, 196, 201, 205, 207, 209
Purvere, Lester, 96

R

radio, broadcast of Game of the Century over, 147
Reading High School (PA) against Passaic (1922), 124–126
Reardon, Ed, 325
Rebele, H., 333
records, Passaic High School
 Oswald Tower on consecutive

victories of, 144–145
 single-game scoring record, 105
 Thompson's season scoring record, 94
 Thompson's single-game scoring record, 105
 Thomson's 1000th point against Reading, 125–126, 127
 world record for consecutive wins, 161, 162
 See also winning streak, Passaic's 160-game
referees
 in 1923 NJSIAA state final, 196, 197
 in 1925 NJSIAA state final, 330
 Blood on arguing with, 399
 Cliffside's request for different, 108–109
 Cooke, William, 109, 145
 distracting of Thompson by during 1922 state title game, 120–121, 298
 at Fordham Prep game, 109, 110
 Johnson, Joe, 139
 Lewis, Phillip, unfair calls by, 196, 197, 298
 physical roughness of early basketball and, 28–29
 Schneider, Charles, 153, 274
 Short's selection of, 296
 Tewhill, Horace, 146, 153
 Tobey, Dave, 94–95, 348–349
 Wallum, Harry. see Wallum, Harry
Reimann, Art, 160
Rice, Grantland, 384
Rickey, Branch, 389
Ridgefield Park High School (NJ), 258, 260
Ridgewood High School
 against Passaic (1920), 54, 57–58
 against Passaic (1921), 73–74, 79–80
 against Passaic (1922), 102, 112
 against Passaic (1923), 146, 162
 against Passaic (1924), 238–239, 273

as "Thousand Point Bobby
Thompson", 126
Thorp, Ed, 143
Tierney, Frances, 212–213
tobacco use, 381
Tobey, Dave, 94–95, 348
Tooker, Harold, 46, 59
Tower, Oswald, 144–145
Trenton High School (NJ)
against Montclair (1922), 107
against Passaic in 1919 state final,
46
against Passaic in 1920 state final,
64–65
against Passaic in 1921 state play-
offs, 86–87
against Passaic in 1922 state play-
offs, 119–120
professional players playing on in
1922 play-offs, 119
Trenton, NJ, efforts to move state
finals to, 104, 109
Trenton Professionals, 119
Trenton State Normal School against
Passaic (1924), 240–241
Troast, Paul L., 243, 244, 255
Troast, William, 121
two-hand shots, 377

U

Unger, Elmer, 133, 232
Union College against Army (1926),
349
Union Hill High School (NJ)
attempts to schedule games with,
143, 152–153
Krakovitch's amateur status and,
355–357
against Passaic (1924), 259–261
against Passaic in 1919 state final,
47–48
against Passaic in 1920 play-offs,
60–61
against Passaic in 1922 play-offs,
116–118

against Passaic in 1925 state final,
330–331
"Second Battle of the Century",
259–261
transfer of Krakovitch to, 342–
343, 354
Uniontown High School (PA), 310
University of Chicago, national
championship tournament at,
79, 80–81, 84
University of Pennsylvania against
Army (1926), 348, 349
University of Pennsylvania
Basketball Tournament, 118,
124, 145
unsportsmanlike conduct
of Hoboken fans, 118, 158–159
Passaic-Fordham Prep game
(1922), 109–110
Passaic-Rutherford game (1922),
111
Upham, Ella, 23

V

Valentine, Howard, 291
Van Atta, Rodney, 123
Van Ripper, Edwin, 22
Vander Heide, John, 134, 151
Vanecek, William R., 188, 189, 222, 223
Vannaman, Edward C., 206
Vonk, Ira "Six"
1920-1921 season, 69, 73, 76, 77,
78, 87, 88
1921-1922 season, 93, 102, 105,
106, 107, 114, 121
Blood's decision not to play
because of mid-year
graduation of, 134
Vought, Samuel P., 206

W

Wachenfeld, T., 53
Waczko, Albert, 292
Wagner, Ernest "Griz", 385
Walders, Hughie, 144, 233–234

Foley's demands to for Union Hill-St. Benedict's match up, 355

on Passaic's loss to Hackensack, 322

on post-Blood Passaic team, 315

transfer of Krakovitch to Union Hill and, 343

writ of certiorari, Blood-Arnold investigation and, 215–216, 222

Benson's comments on power of Board of Education and, 221

Drukker's reasons for filing, 216, 217–218

Judge Walter Cabell's attack on, 219–220

overturning of, 224–225

Passaic City Council's move to have vacated, 222

prevention of Arnold's testimony by, 215

Wynkoop, Ross H., 252–253, 312

Y

Yale University
against Army (1926), 347
emphasis on dribble, 27

Young Men's Christian Association (YMCA)
basketball rules and, 17
Blood's directing of YMCA summer camps, 44
Blood's early positions with, 25–31, 375
Blood's fit with mission and ideals of, 26–27
Blood's involvement with as child/young man, 23–24, 375
Blood's training in physical education at, 11
Clean Sport Roll, 8–9, 368
development of basketball at, 13, 24, 374
mission of, 26
movement to oust basketball

from, 29

unable to keep pace with basketball's growth, 28–29, 368

YMCA Leaders' Corps, 25–26

See also specific YMCAs

Young Men's Hebrew Association (YMHA), 15, 17, 300–301, 304

Z

Zep, Passaic mascot, 89, 122, 124, 203, 358–365
basketball skills of, 360
Blood's walking home with after games, 362–364
death of, 365
gift to Blood from Potsdam, 89, 358–359
introduction at Dumont game (1921), 94

Zilenski, Blase, 121

zone defense, 379, 396

PROF BLOOD
AND THE WONDER TEAMS
THE TRUE STORY OF BASKETBALL'S FIRST GREAT COACH

BY DR. CHARLES "CHIC" HESS

A MUST-READ FOR ALL SPORTS FANS!

Please send me _____ copies of *Prof Blood and the Wonder Teams: The True Story of Basketball's First Great Coach.* Enclosed is a check or money order for $29.95 USD per book, $5 shipping and handling for the first book, $1 per additional book. Make payable to Bookmasters, Inc. or bill the credit card below.

NAME _____

ORGANIZATION _____

ADDRESS _____

CITY/STATE/ZIP_____

PHONE _____ EMAIL _____

CREDIT CARD_____

☐ VISA ☐ Mastercard ☐ Discover ☐ American Express

CREDIT CARD # _____

EXP. DATE _____

SIGNATURE _____

TOTAL ENCLOSED OR TO BE BILLED TO CREDIT CARD:
($29.95 USD per book, $5 shipping and handling for the first book, $1 per additional book): $ []

Please return this form to:

Bookmasters, Inc.

30 Amberwood Parkway, Ashland, OH 44805
fax 419-281-6883 **email** order@bookmasters.com
or simply phone in your credit card order to **1-800-247-6553**